Global Visual Cultures

Global Visual Cultures

An Anthology

Edited by

Zoya Kocur

A John Wiley & Sons, Ltd., Publication

Blackwell Publishing was acquired by John Wiley & Sons in February 2007. Blackwell's publishing program has been merged with Wiley's global Scientific, Technical, and Medical business to form Wiley-Blackwell.

Registered Office
John Wiley & Sons Ltd, The Atrium, Southern Gate, Chichester, West Sussex, PO19 8SQ, United Kingdom

Editorial Offices
350 Main Street, Malden, MA 02148-5020, USA
9600 Garsington Road, Oxford, OX4 2DQ, UK

The Atrium, Southern Gate, Chichester, West Sussex, PO19 8SQ, UK

For details of our global editorial offices, for customer services, and for information about how to apply for permission to reuse the copyright material in this book please see our website at www.wiley.com/wiley-blackwell.

Library of Congress Cataloging-in-Publication Data
Global visual cultures : an anthology / [edited by] Zoya Kocur.
 p. cm.
 ISBN 978-1-4051-6921-9 (hardback) / ISBN 978-1-4051-6920-2 (paperback)
1. Art and society. 2. Visual communication. 3. Communication and culture. I. Kocur, Zoya.
 N72.S6G58 2011
 700.1′03–dc22

 2010051058

A catalogue record for this book is available from the British Library.

Set in 11/13pt Dante MT by SPi Publisher Services, Pondicherry, India
Printed in Singapore by Ho Printing Singapore Pte Ltd

1 2011

Contents

Notes on the Contributors

Jaimie Baron received her PhD in Cinema and Media Studies from UCLA. She teaches at UCLA and Pitzer College.

Jon Bird is Professor of Art and Critical Theory at Middlesex University in London. A writer and curator of contemporary art, he is also a practicing artist. He most recently exhibited his paintings at Sideshow Gallery in New York, and is curating a retrospective of Leon Golub for the Reina Sofia Museum, Madrid, for 2012.

Wendy Hui Kyong Chun is an Associate Professor of Modern Culture and Media at Brown University. She is author of *Control and Freedom: Power and Paranoia in the Age of Fiber Optics* (MIT Press, 2006) and a forthcoming monograph entitled *Programmed Visions* (MIT Press, 2011).

Juan F. Egea is an Associate Professor at the University of Wisconsin-Madison. He teaches Contemporary Spanish Literature and Culture in the Spanish and Portuguese Department.

Jean Fisher is the former editor of *Third Text* and editor of anthologies including *Global Visions: Towards a New Internationalism in the Visual Arts* (Kala Press, 1994), and *Reverberations: Tactics of Resistance, Forms of Agency in Trans/Cultural Practices* (Jan van Eyck Akademie, 2000). She currently teaches at the Royal College of Art, London, and is Professor of Fine Art and Transcultural Studies at Middlesex University.

Mary Flanagan is an artist and designer involved in new media art and games. She is the Sherman Fairchild Distinguished Professor in the Emerging Field of Digital Humanities at Dartmouth College. Her book *Critical Play: Radical Game Design*, was published by MIT Press in 2009.

Macarena Gómez-Barris is an Assistant Professor of Sociology and American Studies and Ethnicity at the University of Southern California. Her research areas include memory studies, political violence and its effects, race, and urban studies. She is author of *Where Memory Dwells: Culture and Violence in Chile* (University of California Press, 2008) and is currently working on a book about cultural memory and spiritual practices in the Americas.

Herman Gray is Professor and former Chair of Sociology at University of California, Santa Cruz where he teaches courses in cultural politics, media and cultural studies, and the cultural politics of difference. His most recent book is *Cultural Moves* (University of California Press, 2005).

Marina Gržinić works in Ljubljana, Slovenia and Vienna, Austria. She is Professor at the Academy of Fine Arts in Vienna. She is an artist and also works as freelance media theorist, art critic, and curator. Her latest book is *Re-Politicizing art, Theory, Representation and New Media Technology* (Academy of Fine Arts, Vienna and Schlebrügge Editor, 2008).

Çagla Hadimioglu is an educator and non-fiction filmmaker based in Cambridge, Massachusetts. Her work explores spatial constructs and the socio-political nature of space through moving images. She currently directs foundation studies at The Boston Architectural College.

Joy James is the John B. and John T. McCoy Presidential Professor of the Humanities and College Professor in Political Science at Williams College. She is the author of *Shadowboxing: Representations of Black Feminist Politics* (Palgrave, 1999) and *Resisting State Violence: Radicalism, Gender, and Race in US Culture* (University of Minnesota Press, 1996). Her edited works include *The New Abolitionists* (SUNY Press, 2005) and *Imprisoned Intellectuals* (Rowman & Littlefield, 2005).

David Joselit is Carnegie Professor of the History of Art at Yale University. He is author of *Infinite Regress: Marcel Duchamp 1910–1941* (MIT Press, 1998), *American Art Since 1945* (Thames & Hudson, 2003), and *Feedback: Television Against Democracy* (MIT Press, 2007).

Simon Leung is an artist who was born in Hong Kong and is now living in Los Angeles and New York. His work has been exhibited at the Museum of Modern Art, the Generali Foundation, the Munich Kunstverein, and in the 1993 Whitney Biennial, the 2003 Venice Biennale, and the Third Guangzhou Triennial in 2008. He teaches at the University of California, Irvine.

Xiaoping Lin received his doctorate in art history from Yale University and has published extensively on contemporary Chinese art and cinema. He teaches in the

Department of Art at Queens College, the City University of New York, and is the author of *Children of Marx and Coca-Cola: Chinese Avant-Guard Art and Independent Cinema* (Honolulu: University of Hawai'i Press, 2010).

Suyin Looui is an interactive producer who creates platforms for public participation. Her work has been shown throughout the USA, UK, China, and Canada. Looui holds an MFA from Hunter College in Integrated Media Arts and has over a decade of experience in community outreach and education.

Curtis Marez is Associate Professor in the Ethnic Studies Department at the University of California, San Diego, where his research and teaching focus on race, technology, political economy, and media histories. Marez is the author of *Drug Wars: The Political Economy of Narcotics* (University of Minnesota Press, 2004) and the editor of *American Quarterly*.

Cuauhtémoc Medina is an art critic, curator, and historian who lives and works in Mexico City. He has a PhD in Art History and Theory from the University of Essex, UK. He is Researcher at the *Instituto de Investigaciones Estéticas* at the National University of Mexico and from 2002 to 2008 was the first Associate Curator of Latin American Art Collections at Tate Modern.

Rosalind C. Morris is Professor of Anthropology at Columbia University. She has published widely on topics concerning the politics of representation, the mass media, the relationship between violence and value, gender and sexuality, and the changing forms of modernity in the global South. Her most recent book is *Photographies East: The Camera and its Histories in East and Southeast Asia* (Duke University Press, 2009).

Sarah Nuttall is Professor of Literary and Cultural Studies at the Wits Institute for Social and Economic Research (WISER) in Johannesburg, South Africa. She is the author of *Entanglement: Literary and Cultural Reflections on Post-Apartheid* (Wits University Press, 2009), and co-editor of *Johannesburg: The Elusive Metropolis* (Duke University Press, 2008), and *Load Shedding: Writing On and Over the Edge of South Africa* (Jonathan Bell, 2009).

Scott L. Ruff is an Associate Professor at Tulane University School of Architecture. He received his BArch. and MArch II from Cornell University. He has taught at Cornell University, Hampton University, SUNY Buffalo, and Syracuse University. His area of research is African-American aesthetics.

Simon Sheikh is a freelance curator and critic based in Berlin and Copenhagen. He was Coordinator of the Critical Studies Program, Malmö Art Academy in Sweden, 2002–9. Recent publications include *In the Place of the Public Sphere?* (b_books, 2005) and *Capital (It Fails Us Now)* (b_books, 2006).

Ernst van Alphen is professor of Literary Studies at Leiden University, the Netherlands. His publications include *Caught By History: Holocaust Effects in Contemporaray Art, Literature, and Theory* (Stanford University Press, 1997), *Armando: Shaping Memory* (NAi Publishers, 2000), *Art in Mind: How Contemporary Images Shape Thought* (University of Chicago Press, 2005) and *The Rhetoric of Sincerity* (ed., Stanford University Press, 2009).

Eyal Weizman is an architect based in London with a PhD from the London Consortium, Birkbeck College. He is the director of the Centre for Research Architecture at Goldsmiths College. His books include *The Lesser Evil* (Nottetempo, 2009) and *A Civilian Occupation* (Verso Books, 2003). Weizman is the recipient of the James Stirling Memorial Lecture Prize for 2006–7.

J. Macgregor Wise is Associate Professor of Communication Studies at Arizona State University. He is author of *Cultural Globalization: A User's Guide* (Blackwell, 2008) and *Exploring Technology and Social Space* (Sage, 1997) and co-author of *Culture and Technology: A Primer* (with Jennifer Daryl Slack; Peter Lang, 2005). Wise currently serves as editor of the journal *Communication and Critical/Cultural Studies*.

Andrea Wood is Assistant Professor of Media Studies at Winona State University. Her research interests include transnational comics and animation, contemporary literature and film, popular genres, and feminist and queer theory.

Kathryn Yusoff is a Lecturer in Human (and Non-Human) Geography at the University of Exeter. Her research centers on rethinking the interactions between human and physical geographies within the context of abrupt climate change. Yusoff's upcoming book is on the political aesthetics of climate change.

Acknowledgments

I would like to offer my sincere thanks to Jayne Fargnoli, Margot Morse and the staff at Wiley Blackwell, and Emily Howard, for working so diligently to see this project through. Your expertise, generosity, and good cheer is unsurpassed. I offer my sincere appreciation to all who contributed essays to this volume, especially Juan F. Egea, Jean Fisher, and David Joselit, who were tasked with turning various lectures and talks into essays; thank you for your extra efforts. I owe special thanks to Simon Leung and Jon Bird for providing valuable advice and a critical eye. I am most grateful to all the artists and galleries who generously contributed images. Finally, I'd like to acknowledge the many colleagues who offered encouragement and support throughout the project.

Sources

The editor and publisher gratefully acknowledge the permission granted to reproduce the copyright material in this book.

Chapter 1 Xiaoping Lin, "Globalism or Nationalism? Cai Guo-Qiang, Zhang Huan, and Xu Bing in New York." *Third Text*, 18, 4 (2004), pp. 279–95. © 2004 by Kala Press/Black Umbrella. Taylor & Francis Ltd.

Chapter 2 Marina Gržinić, "Linking Theory, Politics, and Art." *Third Text*, 21, 2 (March 2007), pp. 199–206. © Taylor and Francis Ltd.

Chapter 4 Simon Sheikh, "Constitutive Effects: The Techniques of the Curator." In *Curating Subjects*, Paul O'Neill, ed. (London: Open Editions, 2007), pp. 175–85. Reprinted with permission from Open Editions.

Chapter 6 Mary Flanagan and Suyin Looui, "Rethinking the F Word: A Review of Activist Art on the Internet." *National Women's Studies Association Journal*, 19, 1 (2007), pp. 181–99.

Chapter 7 Cuauhtémoc Medina, "La Lección Arquitectónica de Schwarzenegger (The Arquitectural Lesson of Arnold Schwarzenegger)." *Arquine*, 23 (Spring 2003), pp. 67–85. © 2003 by Cuauhtémoc Medina. Reprinted with permission from the author and *Arquine*.

Chapter 8 Eyal Weizman, "Checkpoints: The Split Sovereign and the One-Way Mirror." In *Hollow Land: Israel's Architecture of Occupation*, Eyal Weizman (London: Verso, 2007), pp. 139–59, 288–92.

Chapter 9 Çagla Hadimioglu, "Black Tents." *Thresholds*, 22 (2001), pp. 19–25. Reprinted with permission from *Thresholds*, MIT Department of Architecture.

Chapter 11 Kathryn Yusoff, "Visualizing Antarctica as a Place in Time: From the Geological Sublime to 'Real Time.'" *Space and Culture*, 8, 4 (November 2005), pp. 381–98. © 2005 by Sage Publications.

Chapter 12 Rosalind C. Morris, "Images of Untranslatability in the US War on Terror." *Interventions*, 6, 3 (2004), pp. 401–23. © 2004 by Taylor & Francis Ltd.

Chapter 13 J. Macgregor Wise, "An Immense and Unexpected Field of Action: Webcams, Surveillance and Everyday Life." *Cultural Studies*, 18, 2/3 (March/May 2004), pp. 424–42. © 2004 by Taylor & Francis Ltd.

Chapter 14 Macarena Gómez-Barris and Herman Gray, "Michael Jackson, Television, and Post-Op Disasters." *Television and New Media*, 7, 1 (February 2006), pp. 40–51. © 2006 Sage Publications.

Chapter 15 Curtis Marez, "Aliens and Indians: Science Fiction, Prophetic Photography and Near-Future Visions." *Journal of Visual Culture*, 3, 3 (2004), pp. 336–52. © 2004 by Sage Publications.

Chapter 16 Wendy Hui Kyong Chun, "Orienting Orientalism, or How to Map Cyberspace." In Asian America.Net: Ethnicity, Nationalism and Cyberspace, Rachel C. Lee and Sau-ling Cynthia Wong (eds.) (New York: Routledge, 2003), pp. 3–36. © 2003 by Taylor & Francis Books, Inc. a division of Informa Plc.

Chapter 17 Scott L. Ruff, "Spatial 'wRapping': A Speculation on Men's Hip-Hop Fashion." *Thresholds*, 22 (2001), pp. 73–7. © 2001 by *Thresholds*. Reprinted with permission from the author and *Thresholds*, MIT Department of Architecture.

Chapter 18 Sarah Nuttall, "Self-Styling." In *Entanglement: Literary and Cultural Reflections on Post-Apartheid*, Sarah Nuttall (Johannesburg: Wits University Press, 2009), pp. 108–31.

Chapter 19 Andrea Wood, "'Straight' Women, Queer Texts: Boy-Love Manga and the Rise of a Global Counterpublic." *Women's Studies Quarterly*, 34, 1 and 2 (Spring/Summer 2006), pp. 394–414. © 2006 by Andrea Wood. All rights reserved. Reprinted by kind permission of the author.

Chapter 20 Simon Leung, "Squatting Through Violence." *Documents*, 6 (Spring/Summer 1995), pp. 92–101.

Chapter 21 Jaimie Baron, "Contemporary Documentary Film and 'Archive Fever': History, the Fragment, the Joke." *The Velvet Light Trap*, 60 (Fall 2007), pp. 13–24. © 2007, by the University of Texas Press. All rights reserved.

Chapter 22 Jon Bird, "The Mote in God's Eye: 9/11, Then and Now." *Journal of Visual Culture*, 2, 1 (2003), pp. 83–97. © 2003 Sage Publications.

Chapter 23 Ernst van Alphen, "Caught by Images." In *Art in Mind: How Contemporary Images Shape Thought*, Ernst von Alphen (Chicago: University of Chicago Press, 2005), pp. 163–79, 210. © 2005 by the University of Chicago.

Chapter 24 Joy James, "Political Literacy and Voice." In What Lies Beneath: Katrina, Race, and the State of the Nation, South End Press Collective (Cambridge, MA: South End Press, 2007), pp. 157–66.

Introduction

In light of the political, social, and economic developments of the post-9/11 world, understanding the terrain of visual culture requires venturing beyond previously covered ground. A critical reading of the current global environment calls for an analysis of regimes of war, global circulation of cultural commodities, and increased presence of visual technologies in the accelerated speed of the global everyday, to cite key examples.

In response to this new environment, *Global Visual Cultures* maps new trajectories in visual culture, engaging in analysis of cultural production (visual art, film, mass media, literature, architecture, fashion) and the visual in relation to the everyday and to larger geopolitical contexts. Bringing together essays on themes of emerging importance in visual culture, the volume focuses on visuality in contemporary society as it relates to conceptions, power relations, and experiences of the body, social space, and technology.

The experience of the everyday has changed dramatically in recent years. The surveillance and tracking of daily movements and actions in technologically driven societies has become pervasive even as it violates the public and private space of citizens in ways that are deeply troubling. Developing technologies such as satellite mapping or technology-embedded architecture are providing increasingly sophisticated means for monitoring and controlling information, movement, and public space. This spread of surveillance technologies demands an assessment of the societal implications of their expanded use and recognition of their role within the matrix of visible and invisible structures of domination in everyday life. Theories on the organization of spaces of enclosure (Foucault's *disciplinary societies* and Deleuze's *societies of control*) and the production of space (especially Lefebvre's triad of spatial practice, representation of space, and representational spaces)[1] provide a conceptual framework for analysis of technologies of domination and

Global Visual Cultures: An Anthology, First Edition. Edited by Zoya Kocur.
© 2011 Blackwell Publishing Ltd except for editorial material and organization © Zoya Kocur. Published 2011 by Blackwell Publishing Ltd.

responses of resistance, and several contributions to this volume build on the foundations laid by these key texts.

Intersecting with theorizations of societies of control and the production of space are conceptions of modernity. As seen in contributions to this volume, versions of modernity are produced via the workings of capital's complex of material, technology, labor, and social relations. Through the project of modernity, urban space and its peripheries are shaped, movement and social visibility engineered. The effects of the elision of the pre-modern and archaic embedded in modernity's drive must also be taken into account, in particular its erasure of indigenous and colonized pasts. This erasure is then projected onto contemporary indigenous peoples and cultures. Modernity thus read functions as a technology of domination, albeit a precarious one under the caveat that peripheral modernities characterized by rapid socio-economic transformation and sustained by cheap labor (see Medina, this volume) exist under threat of social unrest on the part of those left out of the modernizing plan.

Despite its ongoing function as a structuring paradigm for certain societies, modernity has been superseded by globalization as the dominant paradigm for making sense of the world. In *Globalization and Contestation* Ronaldo Munck dates globalization to the neoliberal economic policies implemented in the US and Europe in the 1980s.[2] However, rather than calling on it to explain socio-economic or political conditions, Munck suggests that globalization be taken as shorthand for "the complex economic, socio-political and cultural parameters" by which we refer to the development of societies and whose relationships to one another "must be seen as being mediated through nation-states, regions and locality."[3] Therefore various aspects of globalization must always be addressed within this broad matrix.

Even so, the term is used advisedly. Despite the assumed globalization of the art world, for example, through the interpenetration and increased flow of art around the world in the form of biennials, itinerant artists, etc., the percentage of artists *not* from Western Europe, Canada and the US among the worldwide top 100 artists, has not increased significantly over several decades and remains at a range of 10 to 11 percent.[4] This suggests that in terms of the art market, globalization – understood as a phenomenon of multidirectional capital flows and an increase in number of participants in the global economy – has had a negligible impact in most regions.

Viewed through an economic lens, the global circulation of goods (including cultural products) produced and distributed by dominant world economies has expanded dramatically. Bearing in mind the matrix of social, economic, and political factors outlined by Munck, as well as the fact that much of what circulates as global commodity consists of cultural production, it is clear that economic aspects of globalization cannot be separated from issues of cultural domination. This suggests that issues of representation are as significant today as they were in the 1980s and 1990s, even as both the terms of the debates and the forms and dissemination of cultural production have changed.

In mass media produced in the United States, for example, portrayals of African Americans/African diasporic peoples, Latino/as, Native Americans, Asians, Arabs, gay/lesbian/transgender people, women, and others based on their religious or class backgrounds – despite decades of organized struggle for equal treatment – remain frequently stereotypical and dehumanizing. Due to the global reach of US-produced media, these negative images circulate widely, reproducing discourses of racism, homophobia, sexism, etc. This is not to suggest that the US is the only source of these prejudices, as vigorous critical discourse is also produced within the US, and exported along with its media. It is important to note that racism, sexism, and homophobia are "home-grown" and exist everywhere in the world.[5]

Negative, stereotypical representations are able to travel even further through cyberspace, where the traffic in familiar orientalist fantasies, for example, often flourishes, only now in electronic format (see Chun, this volume). New technologies and forms of communication however are also being used to create contestatory representations and engage in political activism, contributing to shifting notions of global, national, racial, and gender identities and new social formations (see Flanagan and Looui, this volume).

The global circulation of cultural commodities such as mass media and art also raises new questions about the composition of audiences and their role as consumers. Expanded dissemination of cultural products, and possibilities for formerly passive viewers to engage interactively with these through new technologies, have added new dimensions to the processes of building publics. These commodities are circulated and received in varied (and to some extent uncontrollable) contexts, to be taken up in mainstream or contestatory discourses. While cultural products are often interpreted as independently existing entities, they create an audience through their mode of address that may or may not comply with the imagined one, potentially leading to the formation of (resistant) counterpublics. (See Sheikh and Wood in this volume.)

Responses to events such as 9/11, the Iraq War and Hurricane Katrina (including aesthetic responses) also figure centrally in this collection of essays, offering reflection on these traumatic events and their continuing aftermaths. The discourse of terror and in particular the US-led War on Terror is examined in its rhetorical, ideological, and linguistic operations. The occurrence of events such as 9/11, the War in Iraq, and Hurricane Katrina also raise crucial questions about the representation of history, signaling the need to ask similar questions regarding all representations of recent history. The production, circulation, and deployment of historical narratives are key topics for visual culture. As various essays in this anthology demonstrate, these narratives are transmitted not only through language and writing, but are also embedded in architecture, art, mass media, and technologies of memory such as film, voice recording, and photographs.

According to Mieke Bal, "visual culture studies should take as its primary objects of critical analysis the master narratives that are presented as natural, universal, true and inevitable, and dislodge them so that alternative narratives can become visible."[6]

Norman Bryson proposes that one of the defining features of visual culture is "the study of the structure and operations of visual regimes, and their coercive and normalizing effects … it is an area in which sites and occasions for cultural analysis, resistance, and transformations are bound to proliferate and multiply, in tandem with the regime's own expansive tendencies."[7]

Holding these objectives in mind, this volume bases visual culture in a set of concerns that focus on revealing mechanisms of power and control and providing examples of responses, including resistance, while investigating ways in which all of these relate to visuality in the broadest sense. The authors in *Global Visual Cultures* map recent critical paths taken in the study of visual culture through making visible dynamics of power and mechanisms of control. In doing so, they present us with possibility of their transformation.

Notes

1 See: Michel Foucault, *Discipline And Punish: The Birth Of The Prison* (New York: Pantheon, 1977); Gilles Deleuze, "Postscript on the Societies of Control," *October* (59) 1992; Henri Lefebvre, *The Production of Space* (Malden, MA: Blackwell, 1991)

2 Ronaldo Munck, *Globalization and Contestation: The New Great Counter-Movement* (New York: Routledge, 2005), p.1.

3 Ibid, p. 10.

4 The list of the top 100 artists, compiled by the German business magazine *Captital*, is based on representation of visual artists in individual and group exhibitions at major art institutions and also on their presence in leading art journals. See Larissa Buchholz and Ulf Wuggenig, "Cultural Globalization Between Myth and Reality: The Case of the Contemporary Visual Arts," *ART-e-FACT Strategies of Resistance, Glocalogue* (4), p. 11, available at http://artefact.mi2.hr/_a04/lang_en/index_en.htm

5 Anti-western conservative forces often see US hegemony as the source of the problem and a corrupting influence (e.g., "bringing foreign homosexuality" or ideas of women's rights to the people), and at the same time providing tools to undermine local authority over such issues.

6 Mieke Bal, "Visual Essentialism and the Object of Visual Culture: Visual Culture and the Dearth of Images," *Journal of Visual Culture*, 2(1) 2003, p. 22.

7 Norman Bryson, "Responses to Mieke Bal's 'Visual Essentialism and the Object of Visual Culture: Visual Culture and the Dearth of Images'," Norman Bryson, *Journal of Visual Culture*, 2(2) 2003, p. 232.

Part I

Realigned Art Worlds
Art / Agency / Globalism

Introduction

The explosion of contemporary art around the globe in recent decades can be observed in the proliferation of biennials, traveling curators and itinerant artists. The simple fact of globalization and new mobility in the circuits of contemporary art, however, does not address questions of capital, hierarchy, and direction of flows. This most recent globalized circulation of art proceeds along familiar geopolitical axes, mirroring the historic inequalities embedded in those relationships. Many areas are still struggling to emerge from what Gerardo Mosquera has referred to elsewhere as "zones of silence."[1] The essays in this section assess – and reimagine – contemporary art practices and art history in global contexts, offering examples of art that refute the position of a zone of silence and create new spaces and routes of circulation, whether through aesthetic invention, technology, radical activism, poetics, or humor.

The essays in Part I cover a geographically diverse sample of contemporary art produced by artists from China, the former Yugoslav territories, Northern Ireland, indigenous North America, India, Mexico, England, and the United States. Art from these regions and others (including cyberspace) is considered in relation to globalization and nationalism, alternative curatorial practices, and new forms of activism via communication across technology networks. The authors theorize the gender(ing) of images and present new approaches for conceptualizing art practice informed by feminist ideas. The position of the artist is considered from a range of philosophical, poetic, and pragmatic perspectives.

Specific themes in Part I include the history of museum exhibitions, curating and the constitution of art publics (Sheikh); contemporary art in relation to regionalism and globalism (Lin and Gržinić); the concept of agency and the forms engaged or radical art practices may take (Fisher, Gržinić); and feminist art history, activism and cyberfeminism (Joselit and Flanagan/Looui).

Global Visual Cultures: An Anthology, First Edition. Edited by Zoya Kocur.
© 2011 Blackwell Publishing Ltd except for editorial material and organization © Zoya Kocur. Published 2011 by Blackwell Publishing Ltd.

In his essay *Globalism or Nationalism? Cai Guoqiang, Zhang Huan, and Xu Bing in New York*, Xiaoping Lin explores the conflict between globalization and nationalism and its influence on the work of three diasporic Chinese contemporary artists based in New York. Lin's analysis of these artists' work describes a worldview characterized by deep suspicion and fear of US domination. He contends that what motivates them is a grave concern over globalization, especially its everyday impact on people's lives in China, and in Asia in general.

According to Lin, in today's China the Communist Party no longer holds complete sway over patriotic sentiments; in its place nationalism functions as a type of popular consensus. Pointing out ways in which the artists critique both East and West, while simultaneously expressing skepticism and concern about the forces of globalization, Lin suggests that the artists have adopted a postmodern, globalist attitude while remaining rooted in national traditions.

In her essay *Linking Theory, Politics, and Art* Marina Gržinić discusses the challenges faced by the former Yugoslav territories and totalitarian Eastern European countries in trying to forge an independent existence under a newly dominant European Union. Gržinić argues that it is not possible to think of the former Yugoslav space in radical ways from a nationalist perspective based in neoliberal capitalist state ideologies. Considering the activities of the Yugoslavian avant-garde movements of the 1970s and 1980s in Belgrade, Zagreb, and Sarajevo and Ljubljana, Gržinić argues that these postconceptual underground art and cultural movements are connected, but not through a desire for national reunification. Rather, the projects that she characterizes as most significant "contest the forces of global capitalism, multinational expropriations and new right-wing ideologies in the region."

Discussing the status of the copy versus the original in Western art, Gržinić says the copy constitutes a radical presence within the field of contemporary art that introduces ethical, political, and pedagogical questions, and leads to what she feels is a necessary interrogation of the discourse of identity, thus opening up the region's history to questions of migration, inclusion and exclusion, and other critical questions that thus far have been submerged.

Jean Fisher's essay *Art, Agency, and the Hermetic Imagination* centers on a set of art practices situated at the intersection of poetics and ethics. Fisher writes, "it is not the business of art to provide interpretations but the conditions from which we ourselves can re-imagine reality." Speaking in relation to the subject struggling to emerge from colonial histories of dispossession, she asks "what form and tactics of artistic practice, if any, are capable of articulating a space within which the reclamation of will and agency become possible?"

Fisher focuses on a group of works she characterizes as camouflaged transgressions that offer "psychic freedom, cultural survival and a latent source of insurrection." She locates these works in a Hermetic model of artistic practice, which entails the artist mapping her/himself onto sites of authority but simultaneously leads to an encounter with the limits of such a position. The area of geopolitical and psycho-social limits and boundaries is the one that most

interests Fisher, who proposes that creating works in boundary zones allows artists to engage in a critical interrogation, which may in turn serve as a catalyst for productive exchange.

Simon Sheikh begins *Constitutive Effects: The Techniques of the Curator* with a historical sketch of exhibition making beginning in the nineteenth century. He then outlines the most common exhibition formats from the twentieth century, ending with an idea for curatorial practice going forward. From the figure of the nineteenth-century bourgeois reasoning subject through the present, Sheikh shows that exhibition practices have constituted not only systems for viewing objects but have simultaneously created viewing publics or subjects. Sheikh emphasizes that exhibition making has historically been connected to the formation and consolidation of national identity: "the knowledge that became available to the subject was a means of inscribing that subject within a given nation-state, of cultivating the populace into exactly that: a people, a nation."

Critical of traditional modes and forms of exhibition making, including their contemporary versions, Sheikh is more positive about the trend of biennial exhibitions, remarking on "the potential these biennials actually offer for a reflection of the double notion of publicness, for creating new public formations that are not bound to the nation-state or the art world," leading to possibilities for a broader transnational public sphere.

David Joselit's *Do Images Have a Gender?* maps contemporary feminist art history through a discussion of the gendered image. Arguing that the feminist field is delimited by two powerful analytical assertions – that the artist has a gender, and that the viewer has a gender – Joselit theorizes the gender of the image itself, stating: "Images do not have a gender, but they make possible the appearance and recognition of gender."

Following Judith Butler's performative notion of gender, Joselit uses the example of Hannah Wilke's S.O.S. Starification Object Series from 1974 to suggest how the same body "engenders" different roles. Joselit then highlights the important role of avatars as "image agents that deploy subjectivity without possessing it," arguing that the ongoing presence of avatars connects production-oriented 1970s feminist art to later feminist work grounded in spectatorship.

Discussing the work of the collective Bernadette Corporation, Joselit proposes that the novel *Reena Spaulings* may be read as an allegory of engendering, in an enactment of Butler's theory. He concludes with the model of the transsexual text, finding in it (quoting Sandy Stone), "the potential to map the refigured body onto conventional gender discourse and thereby disrupt it … and reconstitute the elements of gender in new and unexpected geometries."

In the final essay of Part I, *Rethinking the F Word: A Review of Activist Art on the Internet*, Mary Flanagan and Suyin Looui address cultural production on the Internet, highlighting the work of new media and cyberfeminist collectives and individual artists. Against an acknowledged backdrop of a dearth of women in computer science and new technology fields, and the lack of progress in the promotion of cyberfeminism as a liberatory ideal, Mary Flanagan and Suyin Looui

present a number of Internet projects showing the potentials and possibilities of Internet-based media art informed by feminism and activism.

Highlighted projects engage with a range of concerns that bridge cyberspace and on-the-ground activism and address phenomena of transnationalism, transculturalism, and global circuits. Sarai, a collective based in New Delhi, and Art-e-Fact, an online magazine based in Croatia, engage with fluid notions of geographic space and work in distinctive ways to promote expansive notions of citizenship and art. The projects of the collective subRosa and artist Angie Waller/Couch Projects address economic aspects of globalization, focusing on consumerism, marketing, biotechnology, and labor, while Isabel Chang's CUT2 presents new ways of constructing Asianness through transformation of personal identity. These projects create routes for reimagined subjectivities and geographies using technology to invent new modes of global interaction and activism.

Note

1 See Gerardo Mosquera, "Alien-Own/Own-Alien: Notes on Globalisation and Cultural Difference," in *Complex Entanglements*, Nikos Papastergiadis, ed. (London: Rivers Oram Press, 2003).

1

Globalism or Nationalism?
Cai Guo-Qiang, Zhang Huan, and Xu Bing in New York

Xiaoping Lin

Keywords

9/11
New York City
China
geopolitics
diaspora
globalism
nationalism
contemporary art
the West
"clash of civilizations"
global anxieties

In the spring of 2003, photographs of Chinatown taken by Lia Chang after the terrorist attacks of September 11 were on view as part of the exhibition 'Recovering Chinatown: the 9/11 Collection', held at the Museum of Chinese in the Americas in New York City. Lia Chang's photographic works effectively documented the experience of Chinese New Yorkers during and after the 9/11 tragedy. The attack on the World Trade Center inflicted profound damage on Chinatown's economy, especially its tourist services, garment shops, and restaurants. Some two years later, the Asian community in Chinatown continued to struggle to recover from the catastrophe. Among the affected Chinese New Yorkers is Zhang Hongtu, an accomplished artist whose ironic Chairman Mao portraits were exhibited at various museums and published in art journals and scholarly books worldwide. Originally from Beijing, China, Zhang has lived in New York for the last two decades, and regards this city as his home. As 'a true New Yorker',[1] Zhang has participated in two exhibitions commemorating September 11, one organised by Exit Art in New York, in January, where he exhibited his photographic installation *Missing Mona Lisa* in which pictures of the missing people after 9/11 overlap with Leonardo da Vinci's masterpiece. Mona Lisa in this installation seems like a pensive mourner gazing at the victims of the WTC attack from a long-distant past.

Many people have mulled over the political and philosophical meanings of September 11. Jean Baudrillard, in *The Spirit of Terrorism*, has voiced a by now familiar opinion on the issues of terrorism, American hegemony, and globalisation:

> It is what haunts every world order, all hegemonic domination – if Islam dominated the world, terrorism would rise against Islam, *for it is the world, the globe itself, which resists globalization.*[2]

With the attacks on the World Trade Center and the Pentagon, we are confronted, says Baudrillard, with the 'pure event' that concentrates in itself 'all the events

Global Visual Cultures: An Anthology, First Edition. Edited by Zoya Kocur.
© 2011 Blackwell Publishing Ltd except for editorial material and organization © Zoya Kocur. Published 2011 by Blackwell Publishing Ltd.

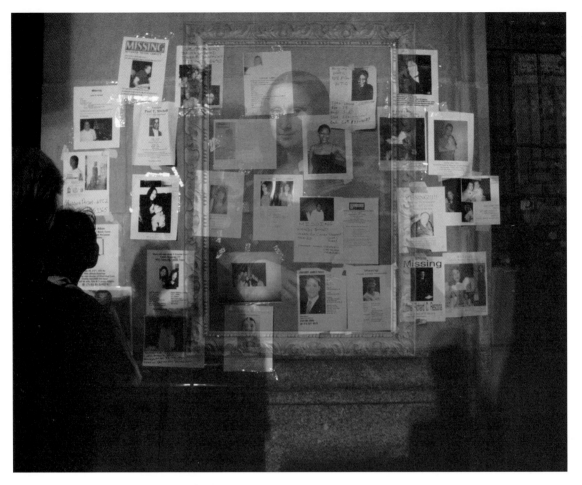

Figure 1.1 Zhang Hongtu, *Missing Mona Lisa*, 2002

which have never taken place'. We had all dreamt of this event because it was impossible 'not to dream of the destruction of American monopolistic power'.[3] This remark may sound very 'anti-American' but is a feeling shared by some Americans themselves. As Fareed Zakaria, a columnist of *Newsweek*, pointed this out in his cover story 'Why America Scares the World', on the eve of the Iraqi conflict: 'What worries people around the world above all else is living in a world shaped and dominated by one country: the United States. And they have come to be deeply suspicious and fearful of us.'[4]

It is from this geopolitical perspective that I examine the artworks of three Chinese diaspora artists active in New York City – Cai Guo-Qiang, Zhang Huan, and Xu Bing. Their work has manifested an ironic anxiety over globalisation long before the 9/11 events.

In this age of globalisation, people no longer have choice in the matter of identity; ready or not, they are already of the world. 'Everyone's social existence' is tied to globalisation and there is no place for anyone to hide. Cai Guo-Qiang, Zhang Huan, and Xu Bing, three Chinese artists, are no exception. They came to New York at

different times and under different circumstances. In his informative *In the Red: On Contemporary Chinese Culture*, Geremie Barme describes Cai Guo-Qiang and Xu Bing and others in New York as a few members of the artistic diaspora that comprises many 'prodigal cultural dissidents' who frequently return to China in order to gather information for their future writing or artwork.[5] But, as Barme argues, they are 'forced into this passive position by the state corporate system, international audiences, critics (or the demon "global culture")'.[6] What dominates these artists' latest work is a grave thematic concern over globalisation, especially its protean and acute impact on people's daily life everywhere, in particular in China and other Asian countries. Dynamic and disruptive globalisation has clashed with a rising nationalism in China and Asia. Political uncertainty in Indonesia and Thailand gives nationalists 'much room to advocate protectionist policies'.[7] China's economic reform has opened the nation to the biggest global capital flow since 1990.[8] A recent opinion poll considered such foreign investments harmful to national industries.[9] Two Chinese journalists found that a shift 'from the 1980's globalism to the 1990's nationalism' has taken place in Chinese society today.[10] I intend to explore how the contradiction or conflict between globalism and nationalism in contemporary life strongly impacted on these artists. They have obtained increasing recognition in a glitzy global art community, yet their work remains rooted in and inspired by national traditions.

Nationalism as a Resistance to Globalisation?

In September 1998, Cai, Zhang and Xu participated in 'Inside Out: New Chinese Art', an exhibition organised by the Asia Society in New York. Holland Cotter, an art critic for the *New York Times*, wrote favourably about much of it but singled out Cai for a 'distinctly nationalistic, implicitly anti-Western bent' discernible in contemporary Chinese art.[11] Cai Guo-Qiang's *Borrowing Your Enemy's Arrows*, though an 'an arresting installation' in Cotter's own words,[12] was illustrative of that 'nationalistic' and 'anti-Western bent'. Cai Guo-Qiang had appropriated a popular Chinese historical narrative from *The Romance of the Three Kingdoms* that elucidated a ruse of war (which I will discuss later). Cotter was heedful of the 'borrowed' symbolic meaning of Cai's installation:

> Is China's new art based on such opportunistic strategies, fulfilling Mao's famous directive to make foreign things serve China? Some of it is certainly geared to turning a fast profit in the Western market, especially while 'Chinese' is hot in the way 'Korean' was a few years ago.[13]

Cotter had a keen eye for the 'anti-West' and 'nationalistic' tendency in Cai's work but ignored the postmodern, global context in which the artist works were created. In that particular context, as Edward Said says, a work of art always 'begins *from* a political, social, cultural situation, begins *to do* certain things and not others', by which Said means a cultural nationalism that aims to distinguish the national canon and maintain its eminence, authority, and aesthetic autonomy.[14] Since the 1990s, a new nationalism has infiltrated China's political, social, and cultural life, a

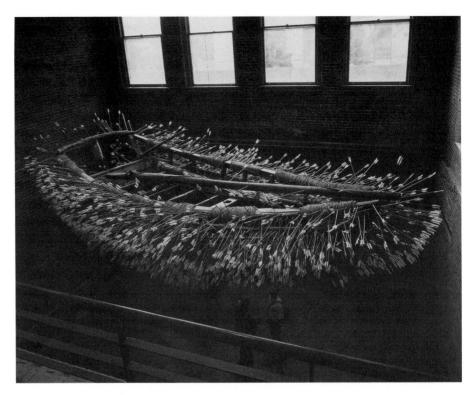

Figure 1.2 Cai Guo-Qiang (b. 1957, Quanzhou, China; lives in New York). *Borrowing Your Enemy's Arrows*, 1998. Wooden boat, canvas sail, arrows, metal, rope, Chinese flag, and electric fan. Boat: approximately 152.4 × 720 × 230 cm, arrows: approximately 62 cm each. Collection of The Museum of Modern Art, New York, Gift of Patricia Phelps de Cisneros in honor of Glenn D. Lowry. Installation view at P.S.1. Contemporary Art Center, New York, 1998. Photo by Hiro Ihara, reproduced by courtesy of Cai Studio

'situation' in which Cai's Asia Society installation was created. This recent development in Chinese politics is explored by Yongnian Zheng, a Princeton-trained scholar, in his 1999 book, *Discovering Chinese: Nationalism in China: Modernization, Identity, and International Relations*. Chinese nationalism has been misperceived by many (like Cotter) in the United States, especially at a time when Sino–American relations have become strained and volatile since NATO's bombing of the Chinese embassy in Belgrade in the summer of 1999 and the US Navy EP–3 Aries spy plane incident in the spring of 2001.

According to Zheng, the rise of new Chinese nationalism during the primarily 'reactive' to a variety of anti-China theories and actual threats from the West, as it has always been historically. From the Opium Wars (1840–42) to the War of Resistance Against Japan (1937–45), the nation has been a victim of foreign imperialism. In his view, 'China is never nationalistic without any external threats'. As China is now able to concentrate on economic modernisation, 'the West also begins to form new anti-China forces'.[15] This Chinese position was categorised by

James Townsend as 'state nationalism' as opposed to the 'popular nationalism'[16] exemplified by a 1996 bestseller, *China Can Say No* (a copy of this book was used by Cai Guo-Qiang as a component of his *Cry Dragon/Cry Wolf: The Ark of Genghis Khan*, an installation for 'The Hugo Boss Prize 1996' exhibition held at the Guggenheim Museum SoHo). Throughout the 1990s, this popular nationalism had been peculiarly 'a reaction' to the humiliations that China suffered at the hands of Western powers[17] – from its lost bid to host the 2000 Olympics, its repeated failure to enter the WTO, and its ravished embassy in the war in Yugoslavia.[18] Such reaction to indignity can be dubbed 'aggrieved nationalism' in Michel Oksenberg's terms.[19]

But there is also a domestic reason for rising Chinese nationalism. In post-Mao China, in which Marxist–Leninist dogma as 'the national canon' has lost its mass appeal, the government either uses or curbs popular nationalism in order to tackle domestic problems. The decay of Maoism has led to a reliance on nationalism as a unifying ideology. In the 1980s the Chinese Communist Party stressed its role as the vital patriotic force in the nation; since the 1990s, however, the Party no longer has a monopoly on patriotic sentiments, so nationalism functions as a consensus that is 'beyond the bounds of official culture'.[20] Barme examined many forms of contemporary Chinese culture, ie, TV series, feature films and pop fictions that conveyed anti-West and nationalistic sentiments (eg, a 1993 soap-opera entitled *A Beijing Man in New York*). He called those writers, filmmakers, and artists 'China's avant-garde nationalists'.[21] Not surprisingly, popular nationalism is best expressed through the mass media, with a plethora of soft porn and obscenities in imagery and language.[22] By contrast, Chen Kaige, a 'Fifth Generation' director and one of Barme's 'avant-garde nationalists', seems bounded by nostalgic, nationalist aspirations in his lavish and elegant filmmaking: 'I'm turning into a royalist … China could not have been a great unified nation but for the imperial powers and Confucius.'[23] Chen's vision of a glorious, epic, and nationalistic past was chided by many young critics at a conference on film theory held in Chengdu in the summer of 1999. So too was Cai by his Chinese fellow artists in New York at the Asia Society show in the autumn of 1998 (a 'situation' implicated in Cotter's *New York Times* review article.

Cai Guo-Qiang: A Deft Narrator of Global Anxieties

Cai's *Borrowing Your Enemy's Arrows* blends the nation's distant past with its present-day realities. The ancient war tale of the Three Kingdoms, ie, 'Borrowing Your Enemy's Arrows (*caochuan jiejian*)', inspired Cai as a national allegory that imparted an air of historical and cultural gravity to his installation. *The Romance of the Three Kingdoms* has served as a paradigm of Chinese thinking about human relations in international affairs. The historical epic tells of the power struggles among three rulers who seek to unify a China embroiled in political and social turmoil. Much loved by the Chinese from all walks of life, the tales are enacted in operas and movies, illustrated in calendars and New Year pictures, and some heroes of the epic are

worshipped as gods in temples.[24] 'Chinese diplomats and military officers often describe their manoeuvres in terms of these stories. The very language is full of reference to it.'[25] Mao Zedong himself was an ardent admirer of *The Romance of the Three Kingdoms* as a classic of astuteness and resourcefulness.[26] But as Nathan and Ross emphasise, 'with his "Sinification" of Marxism, Mao claimed to have combined a national identity with a cosmopolitan one, and to have forged a world-class model of thought and society that was distinctively Chinese'.[27]

The Romance of the Three Kingdoms is a classic exemplar of what Said calls 'national canon', so is a 'Sinocentric' Maoism or neo-Maoism that is still deeply embedded in contemporary Chinese political thoughts. During the 1999 May protests against NATO's bombing of the Chinese embassy in Belgrade, Chinese university students in Beijing chanted 'Long Live Chairman Mao', because they believed that 'Mao was the only Chinese leader who really dared to stand up to anyone' from the imperialist West.[28] Chinese students' identification with anti-Western neo-Maoism is conceivable in a precarious international climate in which 'reconstructed' Chinese nationalism also mirrors what a Beijing-based CNN reporter termed 'a national insecurity complex' that had unravelled in China in the post-cold war era.[29]

As an artist well versed in Chinese classical philosophy and history, Cai embraces the national canon as exemplified by *The Romance of the Three Kingdoms*. As a Chinese who has resided abroad (in Japan and the United States) for almost two decades, Cai seems to share his people's view of a treacherous 'post-cold war' international society in which an American 'cold-war nationalism' still overshadows global politics. New post-cold war realities are still addressed by what Robert J Corber calls 'the trope of the invisible subversive, which was so central to cold-war political rhetoric, [and that] worked to contain opposition to cold-war ideologies'.[30] That is to say, rhetorical discourses merely replace the former Soviet Union with China as the main adversary of the United States – an invisible and incomprehensible communist country in the post-cold war era. It is intriguing to see such a play of the trope revived on both sides of the Pacific. I see no other Chinese artist's work that better represents (or is mostly attacked for) a postmodern 'return' to culture and tradition than Cai Guo-Qiang's *Borrowing Your Enemy's Arrows*, a contemporary masterpiece that has awakened to a new global reality.[31] The wooden boat at the core of the installation was excavated near the artist's hometown Quanzhou, a historic port city in southern China visited by Marco Polo (1254–1324) during the Yuan dynasty (1206–1368). The arrows were made of bamboo tipped with bronze points and furnished with goose feathers. The combined imagery speaks in blunt irony: the newly fashioned arrows perforate the body of the ancient ship, while the five-star red national flag of China sits intact at the stern. The sardonic overtone of Cai's installation should be read as a proverbial metaphor for China, a Third World country that is to some extent a 'passive recipient' of whatever globalisation may stand for. As the aged ship is felled by the fatal arrows, it 'may represent China and the arrows foreign influences, but they might equally well represent self-inflicted pain'.[32] Since China began its economic reform

two decades ago, global capital flow and cultural homogenisation have been 'targeting' the nation efficiently, just as 'the enemy's arrows' pierce through that obsolete, worn-out ship in Cai's work. So it appeared in May 1999 that the Chinese embassy in Belgrade was 'the only target' the CIA picked for NATO's bombing campaign in Yugoslavia.[33] Outraged university students took to the streets and pelted the American embassy in Beijing with rocks. That 'frenzied nationalism' by a generation raised on rock music and Coca-Cola simply resulted from a distrust that a superpower as technologically advanced as the United States could make a mistake in choosing a 'legitimate' military target. As an American journalist observed, 'the demonstrations reflected a society-wide resentment toward the United States that feeds on China's mixture of wounded pride, desire for influence commensurate with its size and shame at its nagging poverty and intractable politics'.[34] Modern Chinese society is ensnared in a cultural war between national identity and global integration at all levels of social life.[35]

Ironically, the grim wounded boat in Cai's work predates the target sign held by civilians during the NATO bombing of Belgrade. Both signify a 'self-inflicted pain' suffered by a nation or people vulnerable to military attack by an all-mighty enemy. In the Chinese war tale of 'Borrowing Your Enemy's Arrows', the genius strategist Zhuge Liang (AD 181–234) was ordered by a jealous commander to produce 100,000 arrows in ten days for his army – a seemingly impossible task. He narrowly survived by devising a plan to trick the enemy into supplying the arrows. In the Kosovo war, 'defensive' NATO transformed itself into an 'institution prepared to impose its values by force'.[36] The armed conflict in Kosovo was all but a one-sided war, or 'borrowing your enemy's arrows' in a sadly satirical sense. The original sense of the Chinese narrative is to 'expose' oneself to the enemy's attack without suffering any 'real' casualties. General Zhuge made straw bales in the likeness of soldiers standing on a battleship, to attract the enemy's arrows. The legendary folk hero Zhuge Liang had the empty boat sail out as if for battle, and paraded the victory of his wisdom over a potent yet heedless war machine. In the Yugoslav war of 1999, the target sign was mockingly 'borrowed' from an American advertisement and appeared in a Belgrade under NATO pounding. This target sign revealed a hapless humanity 'willingly' subject to a sanctioned 'properly Utopian violence'.[37]

In my view, Cai Guo-Qiang is a 'globalist' rather than the 'nationalist' that Cotter believes him to be. I met the artist at the opening of the 1998 Asia Society exhibition, and standing by that afflicted boat I felt utterly dispirited. There was another example of boat imagery by the same artist that is sunny, intact, and cheerful. A few years before, Cai Guo-Qiang had posed as captain of a Chinese boat that appeared at the 1995 Venice Bienniale, as part of the exhibition called 'Transculture'. Cai arranged for the boat to be brought to Venice from Quanzhou. This installation, entitled *Bringing to Venice What Marco Polo Forgot*, shows his good humour and idealism without relinquishing his 'ironising' strategy. The artist himself took charge of sailing, together with two handsome Italian boatmen who helped him to pole the worn yet beautiful and elegant Chinese junk 'from Piazza San Marco down the Grand Canal to the Giustinian Lolin Palazzo,

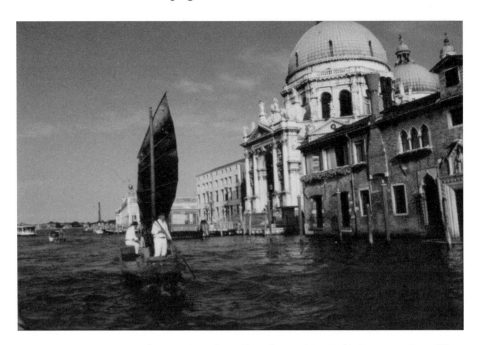

Figure 1.3 Cai Guo-Qiang (b. 1957, Quanzhou, China; lives in New York). *Bringing to Venice What Marco Polo Forgot*, 1995. Installation incorporating wooden fishing boat from Quanzhou, Chinese herbs, earthen jars, ginseng beverages, bamboo ladles and porcelain cups, ginseng (100 kg), handcart, and other works by the artist presented as components: Acupuncture for Venice (1995), Water, Wood, Gold, Fire, Earth (1995). Dimensions variable. Boat: 700 × 950 × 180 cm. Commissioned by the 46th Venice Biennale. Collection of the Museo Navale di Venezia (fishing boat), private collections (other components). Photo by Yamamoto Tadasu. Reproduced by courtesy of Cai Studio

where it will remain docked, as a transcultural icon for the duration of the exhibition'.[38] There were 'texts' and other materials on view in the main hall of the Giustinian Lolin Palazzo. These turned out to be Cai's own statement and a note from a local doctor in Quanzhou explaining the desired result of Chinese herbs. Juxtaposed with these 'texts' were bottled herbal medicines available to museum visitors through a vending machine; and 'hanging from the ceiling near the doors which open out onto the canal is a clear plastic curtain printed with acupuncture charts and filled with water taken from the Grand Canal'.[39] As Dana Friis-Hansen remarked in the 1995 exhibition catalogue: 'We might see this presentation as a witty and sly rebuke to the spread of Coca-Cola across China (as a symbol of Western capitalism, mass marketing, and taste for sugar), as the artist uses modern distribution technology to popularize ancient Eastern Philosophy across the West.'[40]

A few years later, Coke – 'a symbol of Western capitalism' – became a 'new threat' to human security through globalisation. In June 1999, the Belgian government banned Coca-Cola after 40 children were hospitalised with symptoms of poisoning associated with the drink. Many other European countries also limited

the sales of Coca-Cola. Scientists pointed out that the illness linked with it might have been caused by 'fear over contamination rather than any impurities in the soft drink', and they called it 'mass sociogenic illness (MSI)'.[41] Whatever the case, in his 1995 Venice installation, Cai prophesied such a global mass 'Coke scare'; and he was eager to provide a substitute (or 'supplement' in Jacques Derrida's critical terms)[42] for destructive 'Western capitalism' by offering Westerners themselves a try-out of the Chinese herbal medicines available from the vending machine.

Bringing to Venice What Marco Polo Forgot was an intended 'supplement' to the world-famous *The Travels of Marco Polo*, already supplemented by the chronicle of the Italian Jesuit missionary, Matteo Ricci (1552–1610), in 1615. Ricci's report on China seemed more 'truthful' than Marco Polo's wonder-struck, incredulous accounts of the country.[43] But I consider the two books fictional, for they both describe China as the Other from a Christian point of view that 'is no longer an object of passion, it is an object of production'.[44] The image of China presented by the two Italian travellers was nothing but a 'production' of an expanded modern Christianity. Or, to quote again from Cotter's essay on the 'New Chinese Art' show: 'And bit by bit, China came West. During the 1980s and 90s, contemporary Chinese culture, sometimes tailored to non-Chinese tastes, gained international presence. Fiction by mainland writers regularly appeared in English. The opera "Marco Polo" by Tan Dun was produced in New York last season.'[45] I was one of those in New York who went to see the opera, which happened to be Cotter's sample of 'China came West', and was surprised to hear the loud boos from this 'Western' (or Manhattan) audience when the composer/conductor Tan Dun came on the stage to thank his cast at the close of the performance. The crowd booing Tan Dun's controversial operatic play, I think, must have wished to see the 'production' as an exotic mimicry of Western classical opera. Yet, as it turned out, the Chinese composer appropriated a great deal of Chinese opera motifs and musical techniques, which, in the eyes and ears of Cotter and the like, is surely 'anti-Western' or 'nationalistic'.

Modern scholars have pointed out that Marco Polo, the adventurous Italian merchant, might have altered his story to make it believable to his Christian audience of that time (but 'unbelievable' to a Chinese reader); and 'the book is poetry then, not story'.[46] Thus his picture of the 'East' is no more than a mirror of the West or the Same. As Baudrillard puts it, 'with modernity, we enter the age of the production of the other'.[47] *The Travels of Marco Polo* should be seen as the earliest example of 'the production of the other'. Cai reverses 'an artificial synthesis of otherness'[48] by foregrounding 'what Marco Polo forgot' in his Venice installation – Eastern Philosophy and Chinese natural herbs to cure the 'modern ill'.[49]

At the APEC meeting held in Shanghai in October 2001, Cai exhibited his evocative fireworks in which 'the audience will see dragons, red lanterns and willows – all symbols of traditional culture'.[50] Since the firework display was part of the APEC conference sponsored by the Chinese government, at which many world leaders were present, it would seem that the artist identified with global politics in the wake of the 9/11 terrorist attacks. As he said of the occasion: 'China and

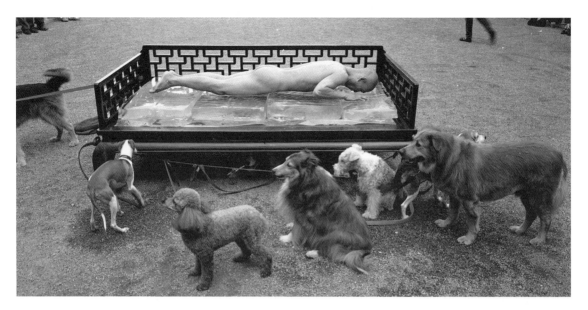

Figure 1.4 Zhang Huan, *Pilgrimage – Wind and Water in New York*, 1998

Shanghai are at a turning point. This is the most exciting moment of a country. Being Chinese, I don't want to be a spectator, I want to get involved and feel the momentum myself.'[51] In this respect, I think, Cai is both an avid 'nationalist' and a 'globalist' who earnestly dreams of a better world in hope and deep anxiety.

Zhang Huan: A Utopian Dreamer on the Streets of New York

Zhang Huan, another artist, came to New York in 1998 with high hopes. He soon found himself sharing a vision of cataclysm with Cai, who had arrived from Japan four years before. Zhang Huan gave a solo performance in October 1999 for the Asia Society's 'New Chinese Art' show, which attracted a large and young audience. The performance was entitled *Pilgrimage – Wind and Water (fengshui or geomancy) in New York*, indicating that the artist intended to voice his response to a global environment – New York City – that was quite new to him both physically and culturally.

 In a short speech delivered before his performance, Zhang Huan sounded as fatalistic as Cai in *Borrowing Your Enemy's Arrows*:

> Every day, we lie on a mutant bed, dreaming without any direction. The deepest impressions in the dream are the living here between dogs and their owners, and the living on the Atlantic City Casino as well [*sic*]. When I watched the ceremony of the Tibetan triumphing over a myriad hardship and hazard, prostrating themselves in the ritual of worship ... I was astonished and moved by the devotion

of the pilgrims. I dreamt of the exhausted and anxious faces in the subway. I really feel sad for them, for myself, for the blue skies and wonderful moments. We are surrounded by the fear of violence, war, catastrophe, death, drugs, pollution, Aids and basic human surviving. Human beings have been evolving for thousands of years; modern civilization and technologies have been developed to an unprecedented degree. I was utterly confused about these changes. However, I doubt if human beings have made any progress. Are we really happier than before? Where is our future? Where are our spirit and faith? I am hungry! Behind me, there is wind and water.

This statement or 'text' in his own words is the key to the artist's performance. He first sat upright and naked on a Chinese-style bed surrounded by 'dogs and their owners'; and a 'mattress' of ice was placed on the bed. He then lay face down on this ice 'mattress' for more than ten minutes. He demonstrated the contrast and contradiction in his particular 'cultural' setting. The warm wooden Chinese-style bed was 'imposed' upon by a freezing Western-style mattress (not as in everyday life). The artist had to endure this icy and 'multi-layered' bed by exhausting his body heat. The naked male artist lies prostrate on this ambiguously juxtaposed 'East vs West' bed. For Zhang, the West, incarnated by New York City, appears like a cold temptress. It requires great effort to resist (or absorb) her seduction. His 'text' alluded to Tibetan Buddhists who used their sexual energy to achieve a spiritual end. But what tempted him here in New York was a spirituality reduced to a corporeal world, such as 'dogs and their owners' or 'the exhausted and anxious faces in the subway' that spoke of the banality of everyday life. Zhang felt himself 'utterly confused' and fearful of 'violence, war, catastrophe' on his arrival in this perilous global city.

Zhang's eclectic approach to life and art would help him to survive, just as it had before in Beijing. He had already made his fame in Beijing by giving performances that demanded greater human endurance and put himself at risk with the authorities. In New York, Zhang adapted a special posture of Tibetan Buddhism that was 'global' rather than 'nationalistic'. Tibetan Buddhist ritual – prostration – inspired the artist as a 'pilgrim' to New York. Traditional Chinese formal postures involve bowing and kneeling, or 'kowtowing', which are primarily Confucian rituals. Prostration peculiar to Tibetan or Esoteric Buddhism is the main constituent of a daily ritual that is called *ke chang tou* (literally 'long kowtowing'). A Tibetan believer would perform that ritual from three times a day up to several hundred.[52] By prostrating himself like Tibetan pilgrims ('their entire bodies touched the ground'), Zhang expressed his admiration for a religion of pious believers that astonished and moved him. A lack of religious piety seemed to him characteristic of daily life in New York. He cried out to an audience consisting of 'dog owners': 'Where are your spirit and faith?' In Zhang's 'performed' reality, everybody is as unsafe in this ephemeral and volatile world as the artist himself is on an ice mattress that may collapse at any moment.

Since settling down in New York, Zhang has studied Eastern and Western symbols that have become essential constituents of his latest works. At Whitney

Museum of American Art's 2002 Biennial, Zhang staged a performance entitled *My New York* as 'part of an ongoing series titled *My America*', which 'reflects his uneasy existence living in the still unfamiliar culture of New York'.[53] As the artist's statement disclosed:

> Something may appear to be formidable, but I will question whether or not it truly is so powerful. Sometimes such things may be extremely fragile, like body builders who take drugs and push themselves beyond the limits of their training on a long-term basis, until their heart cannot possibly bear enormous stress.
>
> In this work I combine three symbols: migrant workers, doves, and bodybuilding. I interpret my New York through concerns of identity, through the Buddhist tradition of setting live animals free [to accumulate grace], and through man's animal nature and machine-like qualities. A body builder will build up strength over the course of decades, becoming formidable in this way. I, however, become Mr. Olympic Body Builder overnight.

The imagery of Zhang's *Mr Olympic Body Builder* combines three American masculine symbols: Superman, Spiderman, and a Schwarzenegger-like body-builder in an American pop culture dominated by Hollywood cinema. These borrowed 'superhuman' symbols in Zhang's performance serve to imply a much less 'heroic' reality. Several Chinese immigrant workers from New York's Chinatown (who were also the artist's fellow-townsmen from Henan province) carried Zhang Huan the 'Mr Olympic Body Builder' onto the 'stage' (a courtyard in the Whitney Museum of American Art), where the artist then walked barefoot on a chilly day in early April. Like his *Pilgrimage – Wind and Water*, this work conveyed a strong sense of cataclysm, the unbearable 'stress' suffered by many body-builders who 'push themselves beyond the limits of their training'. The all-American ideal of 'superman' is more a cinematic fantasy than a reality. As for those migrant workers who participated in the performance, they too may have woken to an unrealised dream from their own experience after 9/11. According to Dean Murphy of the *New York Times*, although it was not physically hit on September 11, a month later Chinatown still 'showed signs of trauma most everywhere, from jobless workers to streets with barricades to shops teetering on bankruptcy. Chinatown has been transformed into a near ghost town since the attacks on the World Trade Center.'[54] Anyone from Chinatown had indeed become a 'superman' in order to survive that catastrophe. Perhaps it is in this traumatic sense that Zhang, out of fervid sympathy with his compatriots, declared: 'I, however, become Mr Olympic Body Builder overnight'.

Zhang's imagery of angst and insecurity is overshadowed by global conflicts and local disasters. He seems the artist most susceptible to 'local' human conditions – the exhausted subway travellers or laid-off migrant workers who cannot be separated from global crises. And in this regard the artist is truly a 'Utopian' dreamer on the streets of New York, as exemplified by his performance series such as *My New York* that invoke a universal appeal to all suffering humanity.

Xu Bing: A Nomadic Player with Restless Intellect

In this age of global turmoil, Xu Bing appears to keep his cool. Xu critiques Eastern and Western cultures not as 'universal values' but as absurd illusions, in his uniquely impassive manner. He engages in a tenacious and self-possessed cultural game, such as the invention of thousands of pseudo-Chinese characters in his *A Book from the Sky* that made fun of the educated elite in China during the late 1980s. His calligraphic games express a frustration with cultures that lay claim to 'universal values'. In Xu's perception, all cultures, whether Chinese or Western, should be reckoned flawed and even meaningless in a certain context. And he is a master at creating such contexts or spaces that disavow language and writing.

Xu gave rein to his savage irony in performances like *A Case Study of Transference*, in which a pair of male and female pigs, imprinted with textual script, mated as a crowd looked on. Cultural theorists, either engrossed or chagrined by Xu's work, discerned an existential absurdity in his 'deconstructionist' play that ventured to collapse a distinction between humans and animals in their cultural and sexual pursuits. He added a postmodern spin to the famous dictum of Tertullian (AD 160–230): 'It is certain because it is impossible [Certum est, quia impossibile est]'. The mating pigs were covered with Chinese characters (female) and Roman letters (male). Xu Bing did not reply to the controversy he generated of 'cultural rape'. The 'disinterested' artist evaded any 'rational interpretation' to his 'irrational' work that aimed at disclosing the meaninglessness of our daily existence, or the absurdity of gender and cultural difference.

As Fredric Jameson remarked of Lévi-Strauss's *La Pensée sauvage*:

> This kind of analysis effectively neutralises the old opposition between the rational and the irrational (and all the satellite oppositions – primitive versus civilized, male versus female, West versus East – that are grounded on it) by locating the dynamics of meaning in texts that precede conceptual abstraction: a multiplicity of levels is thereby at once opened up that can no longer be assimilated to Western rationalism, instrumental thought, the reifications and repressions of the narrowly rational or conceptual.[55]

In this light, Xu's work is a vigorous attack on such 'Western rationalism', which suppresses alternative views of human existence. In his most recent work, *Introduction to New English Calligraphy*, the artist demonstrated how 'Western rationalism' could be as absurd as his calligraphy lesson:

> The basic idea is to create a classroom in the gallery. Each desk has a small container of ink, brush, and an elementary calligraphy book created by myself. You will see that the book is a teaching tool for learning calligraphy and the words will have a square word style resembling Chinese strokes. The square word will look Chinese but not be understood by the Chinese yet will be understandable to Western people because the square words are English. The audience can try to learn these words by following the 'Elementary New English Calligraphy Instruction Video'. When

people try to recognize and write these words, they begin a process of having to forcefully and constantly readjust their ingrained thinking. During this process of readjustment, and transformation, their former concepts are powerfully replaced and attacked. People need to have their routine thinking attacked this way. While undergoing this process of strange and yet familiar (the strangeness comes from within oneself) transformation one can enter a realm never experienced before.

Figure 1.5 Xu Bing, *Practicing Square Word Calligraphy*, 1996. Top: An Introduction to Square Word Calligraphy; bottom: Square Word Calligraphy Red Line Tracing Book (bottom), both "standard edition." 39 × 23.5 cm (closed)

What Xu meant by people's 'ingrained' or 'routine thinking' is that of 'the old opposition between the rational and irrational' which typifies Western modes of thought, as exemplified by Cotter's criticism of contemporary Chinese art in his *New York Times* review. However, there are Western critics who envision the Other in a more enlightened manner than Cotter's. Xu has realised his calligraphy project in many galleries of Europe and America, and one venue was the New Museum of Contemporary Art in New York City. Dan Cameron, the museum's senior curator, wrote about the artist insightfully: '*Introduction to New English Calligraphy* is the Chinese-born artist Xu Bing's most elaborate treatment to date of a traditional expression of his native culture, which he infuses with the rootless, nomadic sensibility found at the core of postmodern, globalist identity'.[56] He also stressed 'the strangeness' of this learning process on the part of the participating visitors:

> For participants who read Chinese, a system of language masquerading as one's own and adapted to Western modes of thought and communication raises other issues of appropriation, displacement and Western dominance. On the other hand, the use of time-honored techniques to teach people a new way to write in English might be taken as an homage to a venerated tradition. But by adding a subtext, that of the non-Chinese world's growing awareness of all manifestations of Chinese culture, both assumptions of cultural superiority are pitted, however fancifully, against each other.[57]

In such works, he concluded, 'Xu mocks certain intellectual under-pinnings of contemporary global society, particularly those notions of cultural authenticity which are rooted in the West's projections onto Asia'.[58]

Xu assailed not only 'Western rationalism' but Chinese culture as well, as Cameron was quick to point out: 'By challenging the venerated Chinese tradition of sericulture through the rule of time-based performance art, Xu collapsed a vast and ancient practice into a spectacle of nature framed by aesthetics.'[59] By collapsing 'the old opposition between the rational and irrational', or West and East, Xu appeared to return to a Buddhist notion that regards any duality as illusion. In the

Figure 1.6 Xu Bing, Quotations from Chairman Mao, 2001. four scrolls, 116 × 27.2 in (each). Ink on paper, Japanese silk backing. Square Word Calligraphy

artist's concept, it is pointless to seek a non-existent cultural superiority from either a Chinese or a Western perspective. Gilles Deleuze, too, dismissed such a duality in psychoanalytical terms long before:

> The question is not, or not only, that of the organism, history, and subject of enunciation that oppose masculine to feminine in the great dualism machines. The question is fundamentally that of the body – the body they *steal* from us in order to fabricate opposable organisms.[60]

Samuel Huntington recently fabricated such 'opposable organisms' in what he called 'the clash of civilizations'.[61] And no one but Slavoj Žižek has brought to light Huntington's self-serving 'theory' in a post-9/11 context:

> This notion of the 'clash of civilizations', however, must be rejected out of hand: what we are witnessing today are, rather, clashes *within* each civilization. ... If we look more closely, what is this 'clash of civilization' actually about? Are not all real-life 'clashes' clearly related to global capitalism? The Muslim 'fundamentalist' target is not only global capitalism's corrosive impact on social life, but also the corrupt "traditionalist" regimes in Saudi Arabia, Kuwait, and so on. ... A proper dose of 'economic reductionism' would therefore be appropriate here: instead of endless

Figure 1.7 Xu Bing, *The Living Word*. Carved, painted acrylic characters, nylon monofilament, 1999. Dimensions variable. Installation view at *Word Play: Contemporary Art by Xu Bing*, Arthur M. Sackler Gallery, Smithsonian Institution, Washington DC (1999)

> analysis of how Islamic 'fundamentalism' is intolerant towards our liberal societies, and other 'clash-of-civilization' topics, we should refocus our attention on the economic background to the conflict – the clash of *economic* interests, and of the geopolitical interests of the United States itself ...[62]

Huntington's claim turns up nothing new but 'the old oppositions' between primitive and civilised, male and female, East and West, which are already critiqued by Jameson and Deleuze. In Gray's analysis, Huntington's 'dualistic' thesis is 'incorrigibly Americocentric, purveying a view of the world that is unrecognisable to the majority of Asians and Europeans'.[63]

These three New York-based Chinese avant-garde artists have assumed a 'postmodern, globalist identity' as defined by Cameron. That is to say, in their work they constantly express a deep concern over all humanity, especially in a world that is not yet clear of a 'war of values conflict'.[64] In this age of global anxieties, a Chinese artist like Xu who remains cool in defiance of any 'clash of civilisations' or 'globalisation' deserves wholehearted admiration. At the Shanghai Biennale held in December 2002, Xu Bing exhibited his new work, *The Living Word*. Hovering across the gallery floor, Xu Bing's airy 'bird' aroused in the viewer an eerie feeling of transient beauty. By now, I think, nobody would be unwise enough to 'read' the unreadable 'living word' that Xu has been searching for all his life.

Notes

1 Jennifer Weyburnribed, 'Drawing on East and West', *Yale-China Review*, centennial issue 2002, p 10.

2 See Jean Baudrillard, *The Spirit of Terrorism*, Verso, New York and London, 2002, pp 12–13.

3 On the Verso book jacket, ibid.

4 Fareed Zakaria, 'Why America Scares the World', *Newsweek*, 24 March 2003, p 23.

5 Geremie Barme, *In the Red: On Contemporary Chinese Culture*, Columbia University Press, New York, 1999, p 198.

6 Ibid, p 198.

7 According to a recent report by PERC (the Political and Economic Risk Consultancy), 'most Asian economies are reluctant to ease existing protectionist barriers to trade, even the regional financial crisis shook Asian governments out of their resistance to change'. See 'Asian Countries Hold on to Protectionism', in *China Daily*, 19 July 1999, 'World Business', p 6.

8 As Reuven Glick puts it: 'Within East Asia and Latin America, the distribution of private capital flows among countries has been highly concentrated. In East Asia, roughly half of the capital flows since 1990 was directed to China.' See *Managing Capital Flows and Exchange Rates: Perspectives from the Pacific Basin*, Cambridge University Press, New York 1998, p 2. And, according the 1999 UN report, 'more than 80% of the foreign direct investment in developing and transition economies in the 1990s has gone to just 20 countries, mainly China'.

9 Song Qiang, Zhang Zangzang and Qiao Bian, *China Can Say No [Zhongguo keyi shuo bu]*, Zhongguogongshang chubanshe, Beijing, 1996.

10 Ma Licheng and Ling Zhijun, *Jiaofeng: Dangdai Zhongguo sanci sixiang jiefang shilu [The Confrontation: A Faithful Record of Three Movements of Ideological Liberation]*, Jini Zhongguo chubanshe, Beijing, 1998, pp. 283–306.

11 Holland Cotter, 'Art That's a Dragon With Two Heads', *New York Times*, 13 December 1998, Art & Leisure, Section 2, p 1.

12 Ibid, p 38.

13 Ibid.

14 Edward Said, *Culture and Imperialism*, Vintage Books, New York, 1993, p 316.

15 Yongnian Zheng, *Discovering Chinese Nationalism in China Modernization, Identity, and International Relations*, Cambridge University Press, Hong Kong, 1999, p 108.

16 James Townsend, 'Chinese Nationalism', in *Chinese Nationalism*, ed Jonathan Unger, M E Sharpe, New York, 1996, pp. 22–3.

17 Zheng, op cit, p 154.

18 China joined the WTO in 2001 and hosted the 2008 Olympics in Beijing.

19 Townsend, op cit, p 112.

20 Barme, op cit, p 256.

21 Ibid, pp 277–80.

22 Ibid., pp 255–9 and pp 275–7.

23 Jianying Zha, *China Pop: How Soap Operas, Tabloids, and Bestsellers Are Transforming a Culture*, New Press, New York, 1995, p 102.

24 Andrew Nathan and Robert Ross, *The Great Wall and the Empty Fortress*, W W Norton, New York 1997, p 21.

25 Ibid, p 22.

26 Gong Yuzhi et al, *Mao Zedong de dushu shenghuo [Mao Zedong's Reading Life]*, Shenghuo dushu xinzhi sanlian shudian, Beijing, 1994, p 196.

27 Nathan and Ross, op cit, pp 23 and 33.

28 Elisabeth Rosenthal, 'China Students Are Caught Up by Nationalism', in *New York Times*, 22 May 1999.

29 Rebecca MacKinnon, 'China at 50: The Search for Identity Continues' [available at: http://cnn.com/SPECIALS/1999].

30 Robert J Corber, '"You wanna check my thumbprints?": *Vertigo*, The Trope of Invisibility and Cold War Nationalism', in *Alfred Hitchcock Centenary Essays*, eds Richard Allen and S Ishii-Gonzales, British Film Institute, London, 1999, pp 311–12.

31 The Museum of Modern Art in New York acquired this artwork in 2000.

32 See the Asia Society exhibit label for this work.

33 Reuters, 'CIA's only target pick led to China embassy hit', 22 July 1999 [available at: http://www.ABCNEWS.com].

34 Seth Faison, 'Rage at US is Sign of Deeper Issues', *New York Times*, 13 May 1999.

35 For instance, a 1996 bestseller, *China Can Say No*, expressed such nationalistic emotion well before

the 1999 May protests against NATO's bombing
of the Chinese embassy in Belgrade.

36 Henry Kissinger, 'The New World Disorder',
 Newsweek, 31 May 1999, p 42.

37 I borrowed this term from Fredric Jameson. See
 his *The Geopolitical Aesthetic Cinema and Space in
 the World* System, Indiana University Press,
 Bloomington and Indianapolis, 1992, p 187.

38 See *TransCulture La Biennale di Venezia 1995*, exhi-
 bition catalogue, Japan Foundation, Tokyo, 1995,
 p 102.

39 Ibid, p 102.

40 Ibid.

41 See BBC report, 'Coke scare blamed on mass hys-
 teria', 2 July 1999, available at BBC Online
 Network.

42 Jacques Derrida, *Of Grammatology*, trans Gayatri
 C Spivak, Johns Hopkins University Press,
 Baltimore and London, 1976, Part II, sec 4, pp
 269–316.

43 See 'The Translator's Preface', in *Li Madou
 Zhongguo Zhaji* [*China in the Sixteenth Century: The
 Journals of Matteo Ricci 1583–1610*], Zhonghua
 Shuju, Beijing, 1983, vol 1, p 9.

44 Jean Baudrillard, *The Perfect Crime*, Verso, London
 and New York, 1996, p 115.

45 Cotter, op cit, p 1.

46 See George B Parks, ed, *The Book of Ser Marco Polo
 The Venetian*, Macmillan, New York, 1927, pxxviii.

47 Baudrillard, *The Perfect Crime*, op cit, p 115.

48 Ibid.

49 See *TransCulture*, op cit, p 102.

50 See the artist's statement quoted by Chang Tianle
 in his article, 'Masterminding the Rare Occasion'
 [available at: http://www.chinadaily.com].

51 Ibid.

52 See Duo Zangjia, *Tibetan Buddhist Mythical
 Culture – Esoteric Buddhism* [*Xizang fojiao shenmi
 wenhua–mizong*], Xizang renmin chubanshe,
 Lhasa, 1995, pp 153–4.

53 See 2002 Biennial programmes at the Whitney
 Museum of American Art [available at http://
 www.whitney.org].

54 Dean Murphy, 'Chinatown, Its Street Empty,
 Quietly Begins to Take Action', *New York Times*, 4
 October 2001.

55 Fredric Jameson, *The Cultural Turn: Selected
 Writings on the Postmodern, 1983–1998*, Verso,
 London and New York, 1998, p 64.

56 See Dan Cameron's review [available at http://
 www.newmuseum.org/exhibitions].

57 Ibid.

58 Ibid.

59 Ibid.

60 Gilles Deleuze and Felix Guattari, *A Thousand
 Plateaus: Capitalism and Schizophrenia*, University
 of Minnesota Press, Minneapolis and London,
 1998, p 276.

61 Samuel Huntington, *The Clash of Civilisation and
 the Remaking of World Order*, Simon & Schuster,
 New York, 1996.

62 See Slavoj Žižek, *Welcome to the Desert of the Real:
 Five Essays on September 11 and Related Dates*, Verso,
 London and New York, 2002, pp 41–2.

63 John Gray, *False Dawn: The Delusions of Global
 Capitalism*, New York Press, New York, 1998, p
 120.

64 I borrowed this expression from Yan Xuetong,
 who believed that 'the Kosovo crisis was a war of
 values conflict'. See his essay entitled 'New
 Strategic Model Evolves', in *China Daily*, 18 July
 1999, p 4.

Further readings

A Political Message from Avant-Garde Artists in
Shanghai, Li Cheng and Lynn T. White III, *Critical Asian
Studies*, 35(1), 2003.

Outside In: Chinese x American x Contemporary Art,
Jerome Silbergeld, (Princeton, NJ: Princeton
University Art Museum Series, 2009).

Related Internet links

Cai Guo-Qiang: http://www.caiguoqiang.com/
Zhang Huan: http://www.youtube.com/watch?v=szy
ZXfq8Z7A
Xu Bing: http://www.xubing.com/index.php/site/texts/
evolving_meanings_in_xu_bings_art_a_case_study_
of_transference/

<div style="text-align:center">2</div>

Linking Theory, Politics, and Art

<div style="text-align:center">*Marina Gržinić*</div>

The linking of theory, politics and art is the only position that one can adopt in a world of structural inequality.

I. Performative Politics of the Copy in the Former Yugoslav Space and Neo-Liberal Capitalist Democracy

The view taken of the former totalitarian countries of Eastern Europe is often a totalitarian one; clear differences are subsumed into just one. Reference to the difference between East and West is a political act. Thus the construction of history is always artificial. It was said then that the fall of the Berlin Wall (1989) had finally brought the 'lost' part of Europe back to the European family. Today things are the other way around. This loss is no longer reflected on and we are merely integrated in an abstract way. In this respect the East of Europe is always out of joint. One can say that there is a non-existent Second World between the First and the Third Worlds. Through the process of 'McDonaldisation', with excessively rapid integration and historicisation, specific histories, practices and theoretical reflections are erased simultaneously – which is supposed to produce an allegedly pure European unity!

We can see art projects and exhibitions today that have several owners who establish contemporary art and artists as brands. These dealings establish new proprietary relations that extend capitalist property rights and lead to the increasingly privatised ownership of public projects and exhibitions. Regarding the artists and artworks coming from former Eastern Bloc, some works are selected and made visible, but the social and political background in most cases is cut out. Merely allowing ideas and imagination to circulate is not enough. If we do not want to be

Keywords

Eastern Europe
history
neoliberal politics
former Yugoslav
 territories
underground
 movements
avant-garde
radicalism
global capitalism
nationalism
logic of the copy
migration
European Union

old-fashioned leftists, then we have to do more than imagine. The power to change the neoliberal capitalist system consists in building new cultural and social infra-structures, of self-sustaining and self-organising micro-systems and political think-ing. One of the most important tasks is to develop structures of resistance within and against the global capitalist system.

Nor is being innovative or creative enough. The capitalist system functions on constantly innovative productivity. The biggest problem is resistance to it. The question remains how to develop social networking and forms of labour that are different and can support a different kind of openness among artists and social and political activists. The question is also how his-(s)tory (as Alexander Brener and Barbara Schurz put it)[1] is constructed and can be written differently.

Various political lobbies and elites, in addition to the economic imbalance that prevailed throughout the former Yugoslav state, carried out the destruction of Yugoslavia. My thesis is that significant change began in the former Yugoslavia in the 1970s and 1980s – before the fall of the Berlin Wall – with the formation of an underground scene in the 1980s and the struggle for a civil society, the radical improvement of the social position of gays and lesbians, and with ecological and peace movements. These processes were tightly connected to the conceptual and post-conceptual art production of the 1970s in Yugoslavia. It was for this reason that I theoretically contextualised this particular avant-garde movement in the 'Retro-Avant-garde' art, social and political movement.[2] This 'Retro-Avant-garde' in Zagreb (Mladen Stilinović), Belgrade (Malevich) and Ljubljana (IRWIN, Laibach and Neue Slowenische Kunst movement), along with Sarajevo (Braco Dimitrijević), was connected to the Russian Necrorealists in a single conceptual movement. There was an active cultural exchange between Belgrade, Zagreb, Ljubljana, Sarajevo, Skopje, etc, and a common mental, cultural and art space far broader than we dare imagine. Through contemporary productions and radical thinking important connections between these centres still exist – the link being provided by a new generation of artists and theorists (attached to postfeminism, theoretical psychoanalysis, Marxism and open source media theories), and through collabora-tive projects carried out by independent cultural and activist organisations such as Multimedijalni institut mi2 – MaMa (Zagreb), Walking Theory (Belgrade), Kuda. org (Novi Sad), Košnica (Sarajevo), Lazareti (Dubrovnik), Metelkova City (Ljubljana).

It is not possible to think in radical, conceptual and theoretical ways of the former Yugoslav space from a national perspective, as this then reflects future per-spectives based solely on neoliberal capitalist state ideologies developed in the region through neoconservative political and cultural managerial elites. The post-conceptual (in Belgrade, Zagreb, Sarajevo and elsewhere) underground and inde-pendent art and cultural productions (in Ljubljana) are certainly connected with each other, but not in terms of national (re)unity. The connections that can be termed productive are a result of forces that contest global capitalism, multina-tional expropriations and new right-wing ideologies in the region, all in perfect balance with the contemporary global capitalist system.

Several artists from ex-Yugoslavia from the 1980s on (Laibach, IRWIN in Ljubljana, Raša Todosijević, 'Malevich' in Belgrade, and Mladen Stilinović, the group of Six Artists from Zagreb) attempted something radically different. They re-conceptualised the socialist ideology from within. Their reworking of the socialist ideology turned out to be far more destructive for state socialism. They took (and in different forms of their work, repeated) things precisely as they were written and stated within socialist ideology. The result of this approach was absolutely horrifying, because it was understood without parody and irony (as in the case of Russia's Soc-Art, for example, or Western strategies of postmodernist art), and it turned things upside down. This repetition of the form that is attached to the strategy of *overidentification* is something that was invented, so to speak, in art in the 1980s, by the Laibach group from Ljubljana. Laibach? Do you need your memory refreshed? The group's lead singer performed with cut lips and a bloodied face, in line with his insistence on adopting the pseudo-military uniform and pose of Mussolini. By such an act of overidentification, and not by deploying a classical critique (directly or in the form of parody or irony) of the socialist totalitarian system, Laibach performed an authentic act of traversing the fundamental fantasy of the socialist's totalitarian ritual.

It is important to make a precise distinction here between an authentic act of traversing the fundamental fantasy and an inauthentic one which further obfuscates the invisible traces of the void around which all things gravitate. Some twenty-five years later, in 2006, it is extremely important to clarify this, since 'repetition' is today the principal strategy of a variety of groups and projects originating in the former socialist East and taken as a strategy in the West. But as Slavoj Žižek (with reference to Alain Badiou) puts it – and I paraphrase – a palpable political consequence of this notion of the authentic act is that in each concrete constellation there is one delicate nodal point of contention that determines where one truly stands.[3] Pursuing this argument, I can state that Laibach was not, as wrongly understood, some kind of a neo-Nazi revival but, on the contrary, undoubtedly a matter of their deep-rooted relationship with the industrial punk music movement of the 1980s, the most radical avant-garde rock-and-roll exploration of the time. Here lies the point of contention of Laibach's absolute radicality, rather than any relation to populist music movements. Had it been otherwise, there would have been a total obfuscation of the void around which the socialist totalitarian system rotated. And this nodal point was for too long, as in Laibach's case, disregarded by interpretation. Insisting on a simple populist logic of repetition would have the effect of a new homogenisation of national identity in connection with the denial of trauma(s) in the present transitional post-socialist societies.

We find ourselves precisely within the performative politics of the copy – another logic of working in the space of ex-Yugoslavia. The sacrilege of the original is at the core of the 'Retro-Avant-garde' principle and central to the work of the Belgrade Malevich, Laibach, IRWIN, NSK, Tanja Ostojić, among others. The copy is not liberation from the tyranny of civilisation and its laws, regressions and norms, but something even more tyrannical than civilisation itself. In the

capitalist First World the copy was, although in a different way, just a style introduced in the 1980s.

An equilibrium between the copy and the original does not exist.

The original is installed as a paradigmatic case of art value, the most total form of commodity, in the space of capitalism. The original is an essential civilisational norm and of vital value both to the capitalist art market and the contemporary institution of art. The copy can instead be seen as an evil positioned in relation to the original. The copy introduces an order of senselessness and uselessness. The despotism of the copy that I am developing here asks for a much more radical positioning: not simply the right to make copies but a favouring of the rights that appertain to the copy itself. An imperative of the copy is to recognise its proper radical presence within the field of contemporary art.

The copy installs a certain law that goes beyond the good and sublime. There is no good intention of an abstract exchange between the copy and the original that can be considered in positive connection to contemporary global capitalist societies. The relation between the original and the copy, that is, the Other (space), is always asymmetric: the relation is one of dominance and submission. The copy is a master of the situation. Its evil positioning contributes to the development of the a-modernity of history, to paraphrase Bruno Latour.[4] The copy has a surplus of knowledge that can be subsumed in this sentence: 'The copy contains the idea of the original and the copy contains its proper concept.' The copy tells us, 'I am enjoying', but that is not possible to say of the original, as it is not capable of such enjoyment. The original is blindly submitted to an absolutely arbitrary law. The original is actually submitted to several laws: those of the art market, of trends, of history, of the stock exchange, and so on. This is why the copy can open up ethical, political and pedagogical questions that are beyond the relation between the master (law) and the victim (original). The copy is senseless; the original is the victim of norms and of capitalist genealogies rooted within the art market and verified in the stock market. Does the original suffer? Oh, yes! But it is actually not cognisant of it, as it is not cognisant of its own ignorance. The copy takes advantage of this ignorance, producing a surplus of enjoyment and a radicalisation of position.

So what is the social texture that propagates or at least provides the best condition for the prosperity of the copy and its political enjoyment? Which is the best and most fruitful social system for the despotism of the copy? Political despotism is not the best solution as it produces a parasitic and, above all, an apolitical relationship. In the Communist times past, the pertinence of the copy was of little importance as state socialism had eradicated the originals anyway. We had no chance of seeing the decisive modern originals of Picasso, Matisse, Duchamp, Malevich and all the rest. The equality of all in the context of Eastern despotism was produced by the total prohibition of the original. We could learn and 'see' history only through reproductions. Something similar is going on today in the capitalist First World by way of media simulacra, virtual money and simulations of the political space. The power of the copy could only be partial, as state socialism did not offer a counterpoint, and the copy was therefore displayed in a psychotic space

of egalitarian ignorance. Socialist High Modernism was an imitation. The 'Brechtian effect' of the copy was only halfway effective because of the eradication of every original.

The despotism of the copy needs capitalist neoliberal democracy. In neoliberal capitalist democracy, authority is not conceived in reciprocity but as a constant alternation between revenge and repayment. The asymmetry of democracy means that the individual is never the author of the law but always subject to it. The despotism of the copy acquires new elements in the so-called space of transition from post-socialism to capitalism. The constellation of a non-egalitarian system appears already installed at the base of the system in which the original and the copy cohabit.

It is not true that if we get rid of copies the way to enjoyment will be open. Civilisation has robbed the body of its original enjoyment. The law of civilisation mediates the originals as signifiers, since the original is precisely the body without enjoyment (submitted to all forms of laws). The signifiers kill the body of the original, but the paradox is that without the signifiers we would not have the body either. If we do away with civilisational norms, we will not get the body that enjoys, and moreover we will lose the original as well. Because of this situation, the original does indeed have something positive (if we set aside for the moment the investments to which it is submitted) because it is capable of the producing surplus enjoyment – that is, the copy! The copy is the cut – the gap left by what civilisation has done to the institution of art, to the body and to enjoyment. This is why it can be described as the surplus of enjoyment. This imperative of primordial enjoyment is already an artefact, an illusion, and a form of defence against absolute devastation left by the signifier on the body, on the institution of art. The copy, as conceptualised by 'Malevich', Laibach, IRWIN and Ostojić, etc, is not driven by the impossible quest for the lost object. It is a push to enact the gap, the cut, and to insist on what is soon to disappear, the 'minimal difference'.

II. From Existential Position to Structural (In)Equality

In order to try to think of Eastern Europe not as a geographical space but a conceptual one with a specific history – although after the fall of the Berlin wall it is increasingly common to say that 'Eastern Europe doesn't exist any more' – it is necessary to radicalise this conceptual space. It is necessary to get rid of stereotypical questions that are resurfacing all the time: 'Are you from Eastern Europe?' 'Tell us about your existential position as an Eastern European.' I propose a reversal – from an existential position to one of structural (in)equality.

What is the specific history of Eastern Europe? What can we learn from this history? What to think about this history, not as identity politics but as something that can produce concepts? Going back to history is therefore a question of politics.

Western Europe exists. This is something we take for granted. Its capital is the one that emancipates, unbelievably. Its changes of clothes, its ways of behaving – just

think of the names given to capital in our time: social capital, inventive capital, capital that has a special social attitude, capital that is emancipated in relation to culture, and so on. These names show the unbelievable flexibility of capital in coping with time. What defines global capitalism and neoliberal politics today? The evacuation of the political. Everything is transferred to art and culture, to some kind of politics of the moral, to ethics. In the last instance, it seems to be about social help. This is how world political questions are removed not only from art and culture but also society. The question is what kind of projects are still possible. In a field governed by the art market and art institutions it is almost impossible to do anything relevant because of hierarchy, of censorship through funding and so on, which demand fake morality and a status quo to be performed and represented.

It is not about identity but about the allocation of capital. It is far more important to analyse the way we are attached to structures of power and especially economic power than to pursue identity politics. It behoves us to destabilise this virtual space by going back to a real one. We must return to real space in order to read back the virtual. We have imagined that in the *post* of everything and in the virtual we would get our scenarios, the phantasmatic constructions with which to make our analysis of real space. Today it is actually a back to the real, because the most frightening scenarios are there.

Such specific histories cannot be read as an excess, as an error or a mistake that can be evacuated as soon as possible. And if there was excess, it must not be culturalised but remain a paradox. Developing such histories means linking them today to technology, as it becomes obvious that what was very local and particular has to be connected to migration, to the exclusion of bodies, to transitional bodies really pushed to the edge of society. If we are interested in what democracy is, in what the possibilities are of really radically rethinking the perspective of society – if it is possible to draw up a society that is not just an economic agreement but one that can develop a community in which social questions matter and in which social alliances are important we have to make a turn towards histories. The particular has to emancipate and connect its historical position to transitional and precarious labour processes. It has also become obvious that histories of practices such as feminism, the underground, and even theory itself have to be re-evaluated in the light of new media and technology. Analysis of ideology must replace the discourse of identity and reflect on contemporary art and culture with regard to bio-politics, capital, class struggle, as well as forms of institutional, theoretical and critical power, and expropriation. If we do not to take such a path, then the proclaimed politics will *remain* a never-ending *play of empty signs*.

Therefore the only possibilities are in opening the history of Eastern Europe to questions that were not until now part of 'the agenda', from migration to inclusion and exclusion. France provides an excellent example of so-called migrants who are in fact second generations born in France, already there but never included. Or excluded by fake inclusion. The only possibility for a consistent history is a radicalisation of binaries, because it seems that academic theories, academic postcolonial theories and cultural studies are stuck in binaries. They cannot prise

open these radical questions. This can only happen through a universalisation that connects histories to labour, precariousness and the question: Who is allowed to speak and in what circumstances? Former East Europe – with a new European Union 'face' for at least half of its states – is becoming a place of investments and therefore of different interests. Economic investments, political manoeuvres and new legislation demand a familiar cultural and artistic context. These geographical places and mental spaces with their material infrastructures are to be made visible, accessible and friendly (they are the same as we are). What will be left of Visibility, History, and 'the Map', and who will be seen as the new actors, agents, producers, artists, curators, and last but not least, cultural managers, will depend on the power structures, capital investments issues and branding.

The EU regime – with all its laws, trading acts, allocations of capital and invest-ment fundings imposed on all members of the EU (through a different system of equality and inequality) – not only regulates the mobility of migrants and the political stance on asylum seekers but also the strategies of the labour market and the precarious conditions of labour. It would be mistaken to think that all these protocols have nothing to do with art and culture and nothing to do with freedom of expression and creativity. They are strongly conditioning the field of art and culture, and even detrimentally conditioning the ways in which we organise our lives, the ways we perceive and write history.

How do these relationships appear on the level of art and culture in relation to the world that is not one? There is an almost axiomatic work of art – a sentence uttered by Mladen Stilinović from Zagreb who in 1997 accurately defined multicul-turalism as an ideological matrix of global capitalism: 'An artist who cannot speak English is no artist!' This synthesised capital's 'social sensitivity' for all those multi-cultural identities that revealed themselves to the global capitalist world in the 1990s and began to talk to that world – in English, no matter how broken that English was. However, today's performative logic, which is in perfect harmony with the abstraction and evacuation of global capitalism and its snobbish posture, requires a correction of this sentence: 'An artist who cannot speak English *well* is no artist!'

Jonathan L Beller in his attempt to formulate a political economy of vision also explores the processes of abstraction and evacuation.[5] He connects the growing abstraction of the 'medium' of money in capitalism with abstraction procedures in the fields of contemporary art, culture and theory. We are today confronted not so much with the abstraction of our senses (this being a typically modern phenome-non) but with the absolute sensualisation of abstraction, that is, the absolute sensu-alisation of the contemporary neoliberal emptiness within global capitalism. This is a new turn in the genealogy of capitalist abstraction. Such alienation cannot be treated in the old way that Theodor Adorno described the alienation of our senses. The current state is just the opposite. It is characterised by the sensualisation of totally formalised values emptied of all content in the 'historical' sense. We can illus-trate this with the sudden popularity of the sentence uttered by Herman Melville's character Bartleby: 'I would prefer not to do it.' This statement from Melville's 1853 short story 'Bartleby the Scrivener: A Story of Wall Street' indexed a 'gesture' of refusal. Today it is becoming paradigmatic and elevated in philosophy as a gesture of

the only possible withdrawal from contamination by and implication in global capitalism. Not plainly to say NO, but to prefer in a Bartleby style not to say no is not so much a refusal of any specific content as a mere formal gesture of refusal. But in which spaces and for what reasons can we just play refusal as a formal gesture?

The sensualisation of abstraction is well illustrated by two films that are not ordinary Hollywood blockbusters. One is *Lost in Translation* (2003) by Sofia Coppola and the other *Broken Flowers* (2005) by Jim Jarmusch.[6] In both films the image of white capitalist emptiness and disinterest in any kind of engagement reaches a maximum. The white kind (portrayed by Bill Murray, the main actor in both films) elevates its own hollowness to a level of sensuous delight that the Second and Third World will never be 'capable' of reaching. In this process we can observe Giorgio Agamben's genealogy of the human from animal to snob.[7] Using 'paradigmatic forms of the human',[8] Agamben establishes this human genealogy in an arrangement of animal-like figures escalating to and ending in headless and thoughtless snobbish figures. These are not just metaphorical but political figures of human development within the capitalist First World's genealogy administered by the anthropological machine which is clearly moving in the direction of an increasingly vacuous abstraction and formalisation of what is to be perceived as human.[9] A transition is taking place from the politics of memory to a memory of that which used to be a political act.

Notes

1 Stated in the lecture by Alexander Brener and Barbara Schurz at the Post-Conceptual Art Practices Class/Prof. Dr. Marina Gržinić, Academy of Fine Arts in Vienna, Austria, November 16, 2005.

2 This was done in the text with the title 'Mapping Post-Socialism', presented in 1996 at the international conference on Politics and Aesthetics in Ljubljana.

3 See Judith Butler, Ernesto Laclau and Slavoj Žižek, *Contingency, Hegemony, Universality*, Verso, London and New York, 2000.

4 Cf. Bruno Latour, *We have never been modern*, Harvard University Press, Cambridge Mass., 1993.

5 See Jonathan L Beller, 'Numismatics of the Sensual, Calculus of the Image: The Pyrotechnics of Control', *Image [&] Narrative*, web magazine on visual narration, no. 6, February 2003, http://www.imageandnarrative.be/mediumtheory/jonathanlbeller.htm

6 Coppola, and even more so Jarmusch, are firmly contextualised within the art film scene.

7 See Giorgio Agamben, *The Open: Man and Animal*, Stanford University Press, Stanford, 2004.

8 Ibid, pp. 9–12.

9 Ibid. Agamben writes about an increasingly abstracted formalisation within the genealogy of the human, depicting in this way the development of the human towards a mere form or a snobbish gesture without content.

Further readings

The Balkans Does Not Exist, Louisa Avgita, *Third Text*, 21(2), 2007.
Twin Towers: The Spectacular Disappearance of Art and Politics, J J Carlesworth, *Third Text*, 16(4), 2002.

Related Internet links

Laibach: http://www.laibach.nsk.si/l2.htm
IRWIN: http://www.nskstate.com/irwin/irwin-books.php
Yugoslav Retro-Avant-Garde: http://www.artmargins.com/content/feature/grzinic.html

3

Art, Agency, and the Hermetic Imagination

Jean Fisher

As a prologue, it may be noted that from a scientific perspective the world is a unity of interdependent particles, flows and energies. What has belatedly been understood by Western science, but has long been obvious to more ecologically sensitive cultures is that to isolate one part of the system is to lose the bigger picture, which includes social and psychic dimensions: even stones have 'souls', as it were. To create turbulence in one part of the system will have repercussions elsewhere. That a butterfly flapping its wings in the Amazon can eventually create – or prevent – a tornado the other side of the world (one of chaos theory's more exotic propositions) may also be seen as an *ethical* metaphor since, as the Uruguayan artist Luis Camnitzer splendidly asserted, "I had discovered on one day of September 1971 that if I made a minimal pencil mark on a piece of paper I irrevocably altered the order of the universe."[1] Thus, following Mikhail Bakhtin, one may propose that every performed act has its consequences; every new situation demands an ethical evaluation of our actions, thoughts and feelings arising from it.[2]

The approach to writing about art demonstrated here is in part coincidental with its subject. This approach conforms neither to art history nor criticism, but is directed by what the work itself suggests, and may best be characterised as a vulgar form of Paul Ricoeur's definition of hermeneutics as a practice of 'deciphering *indirect* meaning': it begins from the premise that the self is not transparent to itself, but comes to understand its existence through a continuous process of exchange with and interpretation of the signs and symbols, stories and ideologies of the world in which it finds itself.[3]

Hermeneutics notes that language is shared by community, therefore it possesses *universality*; but that language is used by an individual according to its own historical contingency, therefore it is also *particular*. Particularity is also the sphere

Keywords

hermeneutics
language
poetics
communication
desire
agency
resistance
transgression
trickster figure
aesthetics
mythology
hermetic model
artistic
 intervention

of poetics, by contrast to instrumental or scientific language, which, through uniformity, measurement and rationality, strives to efface ambiguity and heterogeneity. Poetics, however, plays with the essential indeterminacy of words and images and is therefore capable of disarticulating conventional meanings. As Gadamer proposed, in its polyvalent play with meaning, poetics reveals the *limits* of language: in its dialogue between inner and outer worlds it voices what instrumental language fails to account for.[4] Thus, it is the play of limits and boundaries and the re-mapping of subject-positions in and against often-hostile socio-political environments that prompts this dialogue with certain forms of art practice.

For Ricoeur, the central function of hermeneutics is the 'critical interrogation of the socio-political *imaginaire* that governs any social sphere and motivates its citizens.'[5] I hope to demonstrate that this is the task that art sets us. That is, it is not the business of art to provide interpretations but the conditions from which we as interlocutors can re-imagine reality.

One situation that has demanded a critical hermeneutic interrogation of the socio-political imaginary is that of the subordinated subject struggling to emerge from colonial histories of cultural dispossession. Violent severance from ancestral belonging to land, language, social structures and belief systems precipitates a traumatic crisis in identity and a deprivation of the will to imagine new narratives of existence. Haunted by loss and bereft of any ground from which to speak and narrate itself in the world, the dispossessed self is reduced to what Agamben calls the biological state of the 'inhuman', or 'bare life.'[6] Whilst this tragic state is now the condition of increasing populations around the world, we are not exempt from the disciplinary forces that engender it. As in the colonial scenario, to impose an abstract-logical militaristic model of space on society, policed by techniques of surveillance and censorship, is to suffocate lived social space and dispossess the body as a free agent in networks of social exchange of goods and information, work and pleasure. This produces a psychic landscape of suspicion, fear and insecurity, in which the self either withdraws, or maps its relations to others through a paranoid gaze.

This has been a consistent theme of Willie Doherty's work, which, drawing on his experience of the violent conflict in Northern Ireland, speaks to alienation as a condition of contemporary society *tout court*. *Non-Specific Threat*, 2004, alludes to the way media representations manipulate our emotional responses to events, places and people, but fundamentally concerns the failure of discourse. The work presents a 360° tracking shot around a man whose appearance is ambiguously coded as thug or gay, located inside what appears to be a derelict building (Figure 3.1). The voiceover weaves the threatening language of social and communications breakdown with the psychic ambivalence of fear and desire in self/other relations: 'There will be no water…no electricity…no TV…no computers…I am invisible…I am unknowable…I am your victim…I am your desires…' As we become subtly drawn into complicity with this commentary, so it becomes ambiguous whether the voice is a projection of 'his' thoughts or 'ours'; whether we are the victims of his prejudice or he is the victim of ours.

Figure 3.1 Willie Doherty, *Non-Specific Threat*, 2004 (video still). Reproduced by courtesy of the artist and Matt's Gallery, London

The question posed by survivors of colonial repression like Doherty has been how to reclaim will, agency and collective solidarity. Will entails forging a pathway out of the melancholy inertia of cultural trauma. Agency means understanding the structures of power and the representational languages that sustain them, in which the self is entangled as both symptom and mediator. It means, in turn, a critical scepticism towards the truth claims of those regimes that police what is sayable and who speaks. This is no easy task. In the Foucauldian schema, power and resistance are mutually caught in a self-generating cycle of disciplinary forces; that is, the subject is not only oppressed by power but is itself its product. How then is one to imagine acquiring a subjective or collective agency capable of exiting from this impasse? Frantz Fanon insisted that it was impossible to do so through nostalgia for a foundational moment, that is, lament for a fragmented or lost ancestral past, which only perpetuates victimry. One needed to begin from the dynamics of repression itself. Resistance became possible through recognising the antagonisms of repressive power and reconfiguring social narratives from the situation of the present. For Fanon this was the role of the intellectual and storyteller.[7] In another context, Michel de Certeau attributes this role to the 'shifter,' who crosses the threshold of different realities and representations, and who through bartering functions as an agent of change.[8]

However, what forms and tactics of artistic practice, if any, are capable of articulating a space in which the reclamation of will and agency become possible? Agency requires connecting with power, but this doesn't mean complicity with it. In speaking of strategies that 'navigate' and often 'short-circuit' or 'substitute' a set

of social rules, Certeau points out that 'analogy is the foundation of all these procedures, which are transgressions of the symbolic order and the limits it sets. They are camouflaged transgressions, inserted metaphors and, precisely in that measure, they become acceptable, taken as legitimate since they respect the distinctions established by language even as they undermine them. From this point of view, to acknowledge the authority of rules *is exactly the opposite of applying them.*' He adds rather presciently: 'This fundamental chiasm may be returning today, since we have to apply laws whose authority we no longer recognise.'[9] Such 'camouflaged transgressions' are embedded in the history of colonial relations: subversive tactics against the colonial authority that cannot overtly oppose its language, but subtly insinuate its codes to unravel its certainties. They may not produce political emancipation, but they represent psychic freedom, cultural survival and a latent source of insurrection. They are what the Anishinaabe writer Gerald Vizenor refers to as 'trickster hermeneutics': 'a wild, imagic venture in communal discourse, an uncertain tease and humour that denies aestheticism, literal translation and representation.'[10] That is, trickster is the ambiguous figure that makes possible a critical hermeneutics of the social through its very resistance to inflexible and untenable interpretations of reality.

To illustrate what is psychically at stake I shall digress into an abbreviated account of a 20th century Brule Sioux version of a traditional trickster tale as recounted by the Tewa anthropologist Alfonso Ortiz, which, with a dry wit, voices anxiety and caution over the destruction of their life-world by the instrumental technologies of Western culture.

Iktome relates to his trickster comrade Coyote that he woke up in a sweat after a bad dream. He dreamt he spied a beautiful chief's daughter in the distance, and, overcome by lust, his penis elongated and snaked across the road to impregnate her. Whereupon Coyote interrupts and says: 'This sounds like a good dream to me!' Iktome continues to describe how, in the process of accomplishing this act, a white man's horse-drawn wagon, with its heavy ironclad wheels, suddenly appeared on the road, driving at full-tilt … At which Coyote concedes, yes, this was indeed a nightmare.[11]

It is not gratuitous that anxiety is related as a nightmare since it is one of the symptoms by which the traumatic event returns to haunt the sufferer. But the storyteller understands this; trauma is retold as a tragicomic tale, which becomes the conduit for dispelling its negative effects and for sustaining hope in cultural survival.

Alongside the civil rights-inspired American Indian Movement of the 1970s, the trickster from ancestral narratives entered contemporary indigenous art and literature as a symbolic vector of cultural resurgence. This was also true for diverse contemporary expressions of trickster traditions from Africa and the African diaspora: for example, Melvin van Peebles' film *Sweet Sweetback's Badaaaas Song*; Patrick Chamoiseau's novels *Solibo Magnificent* and *Texaco*; Amos Tutuola's *The Palm-Wine Drinkard*; Ishmael Reed's *Mumbo Jumbo*, in which, significantly, the tricky spirit Jes Grew is called a 'contagion.'

Trickster hermeneutics is not engaged in confrontational politics but with a critical interrogation of the languages of dominance and their impact on the subordinated self. It is remobilised particularly but not exclusively where oral tradition informs vernacular communication, and where there exists a need for reconstituting traumatised cultural identities through the invention of new social narratives. In contemporary Native American art, for example, Harry Fonseca presented Coyote trickster as a persona insinuated in various disguises into Western culture.

Meanwhile, Jimmie Durham made more subtle use of the tricky tropes of language manipulation. Durham's *Current Trends in Indian Land Ownership* is a small scriptovisual work seemingly torn from a textbook and part of a critical parody of ethnographic displays called *On Loan from the Museum of the American Indian*, 1985. The sequence of maps (Figure 3.2) demonstrates what we may know of the dispossession of indigenous America by colonialism, although we may not know that the title introduces a Western concept of property incommensurate with indigenous philosophy. Couched in the dispassionate, 'neutral' language of science, the title avoids accusation whilst capturing North America's obfuscation of one of the most protracted genocides in world history.

Durham's tactic of confounding the viewer with a seemingly capricious play of words, images or objects is a way of inviting us to relinquish the Western hierarchical gaze and imagine a different configuration of relations, and stems from his understanding of the treachery of language. His work, therefore, raises some pertinent questions about the capacity of the aesthetic to alter our perceptions of the world, and by extension, to function as a form of resistance to mediated interpretations of reality. Although Durham speaks *from* the colonial experience, he speaks *to* wider issues of the truth of representation. Hence, whilst art may not be fully understood outside the socio-political and historical context from which it emerges, it is neither reducible to it nor to the psychology of the maker; to privilege either is to ignore art's affect in its encounter with the viewer. Irrespective of intentionality, the aesthetic experience derives from the contingency of an immediate,

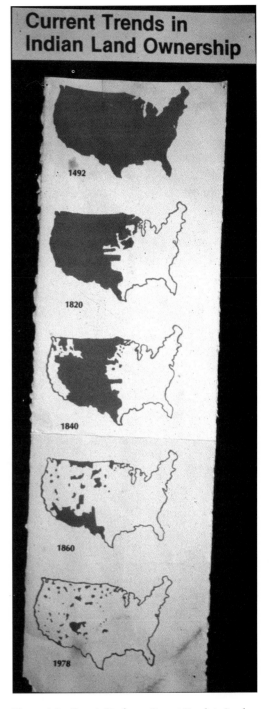

Figure 3.2 Jimmie Durham, *Current Trends in Land Ownership*, detail. On Loan from the Museum of the American Indian, 1986, mixed media, dimensions variable.

not mediated interaction between the work and the viewer's own psychic formation and interpretative tools. Art's affectivity lies neither in any overt message nor in prescriptions of taste, but in what art *does*. In this sense it possesses the nature of an 'event,' in the archaic sense of an opening to the air – an insight. As an event, the artwork, by contrast to mediated representation, doesn't present what is already known but, precipitates a crisis of meaning. Or, as Adorno said of Beckett's plays, it 'puts meaning on trial.'[12]

Acquiring insight is central to trickster hermeneutics. Here's an abbreviated episode from the Winnebago trickster cycle as re-narrated by the anthropologist Paul Radin. Trickster is extricating himself, yet again, from the consequences of his gluttony – he has eaten forbidden food and is now suffering chronic diarrhoea, landing himself, literally, in his own shit. He comes to a river where he can wash, and the story goes on:

> As he was engaged in cleaning himself up, he happened to look in the water and much to his surprise saw many succulent plums. After surveying them very carefully, he dived down into the water to get some. But only small stones did he bring back in his hands. Again he dived into the water. But this time he knocked himself unconscious against a rock at the bottom. After a while he floated up and gradually came to. He was lying on the water, flat on his back and, as he opened his eyes, there on the top of the bank he saw many plums. It was then he realized that what he had seen in the water was only a reflection. "Well", he says to himself, "and what a grand piece of foolishness that was! Had I recognized this before I might have saved myself a great deal of pain."[13]

What trickster recognizes by literally seeing from a different perspective is the distinction between reality and representation, but it took a moment of suspended consciousness to reveal this. Catherine Clément describes this state of suspension as 'syncope': a suspended breath, an asthmatic or epileptic seizure, an ecstatic flight, or a delayed beat in a jazz rhythm. In this momentary fall out of everyday space-time, the ego-self is disarticulated, a process that Clément equates with the movement of creative insight.[14] In Trickster's case, this is prompted by desire: driven by 'insatiable greed,' he is fooled by appearances because he *wants* the stones in the water to be plums; even so, it is want that drives and structures a new insight. Reflection here concerns an *act of mind*; and it is worth noting that the trickster tale is a performed narrative that does not itself offer explanation, but, as Walter Benjamin points out, something that the listener can reflect upon through its own experience.[15] (It is not by chance that shit triggers the chain of events leading to trickster's insight, because shit – as we also see in Bakhtin's popular carnivalesque – belongs to the liminal domain of recyclable, discarded matter linking death to the renewal of life.)

As with the Brule Sioux story, I cannot know how the Winnebago historically understood this tale, or interpret it nowadays, but can only note what it says to me. However, whilst trickster tales have elements specific to cultural context, they share a fundamental *situatedness*: trickster acts within specific situations and encounters; and narratives are transmitted through the *contract* between teller and listener in

the collective experience of storytelling. Situatedness and transaction connect trickster agency with the event of art articulated through viewer reception.

However, the fact that trickster is framed by the language of cultural anthropology limits its broader significance. For instance, anthropology's emphasis on trickster as a 'character' (or even a 'hero') in Western narrative terms misses the point that trickster may be a humorist, but is not a humanist, much less a hero: its world is not anthropocentric but cosmogonic. The Yoruba trickster Eshu is known as the 'iconographer of the cosmos'; and, incidentally, the philosopher Jean-Luc Nancy has asserted that art too has to do with cosmogony, 'it is the birth of a world … origin meaning not from which the world comes, but the coming of each presence of the world, each time singular.'[16] Although it is conventional to speak of trickster as masculine, this does not imply exclusive male potency; trickster shape-shifts across genders, or is linked to female principles, or may in fact be female like Mexican Tlacuache (opossum).

One way of realigning trickster hermeneutics to something more familiar to Western tradition is by way of the mythographer Karl Kerényi. He suggests that Nietzsche's dualistic division of human culture into the rational Apollonian and the non-rational Dionysian should be supplemented by a third aspect, the Hermetic: 'a specific quality in the nature, achievements, and life patterns of mankind, as well as the corresponding traits of roguery to be found on the surface of man's world.' The Hermetic – note – is written with a capital H, and as Kerényi emphasizes is 'to be understood in terms of mythological antiquity and not in the Gnostic or alchemical sense, much less as a movement in modern poetry.'[17] The term, of course, derives from Hermes, the classical Greek 'messenger' of the Gods, and the subject of a lecture Kerényi delivered in 1942 in Switzerland having fled Nazi-occupied Hungary.

For Kerényi, Hermes is 'charm of the divine, charm of the all too human, and charm of the spirit that "opens" the way in both directions.'[18] Of Hermes' ambivalent attributes, the following cluster is shared, to a greater or lesser extent, by indigenous American and West African tricksters: artful prankster, gambler, deceiver and opportunistic thief (whose motto might be 'finder's keepers'); compulsive journeyer, trespasser and transgressor of boundaries; *stropheus* – the door hinge and thus keeper of the portal, the gate and crossroads; *hermeneus* – interpreter, divinor and mediator between gods and humans, secrecy and revelation, life and death.[19] 'He' is also associated with the transitions, sunrise and nightfall (Mexican Coyote relates to dusk and Tlacuache to the half-light of dawn); and the number four (meaning, a divine totality). Trickster encompasses both the exuberance of life and the enigmatic obscurity of death, and acts with a disruptive energy at the threshold of potentialities and networks of meaning. Thus, as Gates says of 'signifyin' monkey,' trickster is the pivot of hermeneutics: it provokes a re-translation of the given world by cunning and a skilful, often humorous articulation of the corporeal and the linguistic.[20]

Opportunism is significant because it not only concerns chance and mischance, but etymologically has its roots in the Greek *poros* and *aporia* – passage and

impasse – which tells us that the Hermetic is not aimed at resolving contradictions, but in disclosing the gaps and inconsistencies in everyday life. This de-familiarisation of the familiar is the function of *stropheus*, the hinge that produces a different angle of perception, literally presented in Marcel Duchamp's *Door, 11 rue Larrey*, the door that opens as it closes, articulates solid and void, framing and de-framing, inside and outside, but 'disappears' at the mid-point of its movement.

Among the seductions of the Hermetic as a model of artistic invention and intervention is that it concerns agency: trickster acts by attempting – not always successfully – to position and map itself into sites of authority in order to acquire its powers, but in the process discovers its limits. Opportunism – taking advantage of chance encounters by shameless thievery, deceit, sexual licence and gluttony – all refer to transactions involving the violation of socially sanctioned boundaries. The Hermetic operates at sites of exchange – the feast, marketplace and cross-roads, where diverse peoples meet to barter goods, jokes, abuse, gossip, sexual favours, or even to plot political insurgency. Agency thus concerns the articulation of boundaries at the crossroads of diverse codes and meanings, which, paradoxi-cally, considering Trickster's amorality, is the site of the ethical if this is under-stood, as Bakhtin argues, as answerability to an event or performed act. As is said of the Ashanti 'spider' trickster: '[Ananse] does not act from noble motives by rational, straightforward methods, but by following faithfully his own way of mak-ing connections – by shattering the accepted boundaries of language, actions, and even modes of being.'[21]

The Hermetic acts not through force but by manipulation of signs and mean-ings and therefore links agency to the acquisition and mastery of language. Hermes is attributed with the invention of language for the purpose of bartering and, like West African tricksters, is the translator or instigator of chaos and order. Coyote and Tlacuache replay the ontology of the human: born immature and vulnerable, without innate skills or language, they must listen to and mimic the language of others before they can successfully speak and inhabit the world. Kerényi interprets Hermes' shamelessness as a consciousness of origin, one that is unconcerned with Christian values of sin and atonement, but rather with the symbiosis of spirituality and vulgarity as the material reality of body and world; and with the 'innocence of becoming.' As the figure of 'becoming,' the Hermetic speaks for repressive situa-tions, which demand the opening of a passage towards cultural transformation. Moreover, storytelling is itself a transaction (listening and speaking). Kerényi's Hermetic aspect therefore provides a possible model by which to associate the tropisms of art with those of various archaic and contemporary figures ranging from tribal tricksters to Certeau's 'shifter' to Michel Serres' 'parasite.'

Serres proposes that if there is a human universal it is the desire for exchange / change: the development of networks of circulation and communication of con-cepts, vocabularies and experiences. At the same time, he asks, how does one activate a successful communication? He concludes that it requires two *contradic-tory* conditions: the presence of noise, since the meaning of a message emerges only against a background of noise; and total exclusion of what it needs to

include, namely, background noise. Two interlocutors are united against inter-ference and confusion, or against individuals with some stake in interrupting communication. To hold a dialogue is therefore to presuppose a 'third man' and to seek to exclude 'him.'[22] Thus, for Serres, the most profound dialectical prob-lem is not the Other (who is only a variation of the Same) but the *third man*, whom he also calls the demon, parasite, Don Juan and Hermes. The 'third man' functions as a vector of communication (or mis-communication) between two or more 'stations,' or fixed points; without a vector, communication would be impossible.

An Afro-Cuban variant of a Yoruba tale involving Eshu-Elegguá parallels Serres' point. It concerns two friends who owned adjoining farms and had sworn eternal friendship. But they had forgotten to include Eshu-Elegguá in their pact, so he decides to teach them a lesson. Dressed in a cap red on one side, white on the other, with his pipe stuck to the back of his neck, he rides his horse backwards on the border between the two farms. Later the friends begin to argue about the col-our of the rider's cap and which way he was going, the dispute becoming so vio-lent that Eshu-Elegguá himself is called to settle it. He admits the rider was himself and that both friends were correct, pointing out however that they were so bound by habit and suppressed animosity that they could no longer perceive the truth nor acknowledge each other's perspective. The narrative articulates the play of boundaries, paradox and indeterminacy, with Eshu-Elegguá as the mischievous vector, like Serres' 'third man,' of a social perturbation. But the point is that, by forcing a different perception, he discloses what is repressed in the situation and consequently the source of a potential instability; balance must be restored, but on a more ethical plane of organisation. Notably, Eshu-Elegguá is not the privi-leged subject; the narrative does not concern his own becoming but that of the collective.

Eshu-Elegguá's masquerading tactics are remobilised in a European context in the work of Yinka Shonibare. In European modernism the Hermetic imagination is partly assumed by the *dandy*: the outsider-within, Serres' parasitic guest at the host's feast, who transgresses class boundaries through his mastery of style, guile and wit. Oscar Wilde called him the 'liar,' by which he meant one who uses his imagination. Shonibare is well known for masquerading as the dandy; and for pro-ducing visually seductive works that satirise familiar artworks from the Western art historical canon and which may aptly be described as 'camouflaged transgres-sions.' His photo series *Diary of a Victorian Dandy* (Figure 3.3), 1998, revises Hogarth's satire on 18th century aristocratic decadence *The Rake's Progress*. However, Shonibare displaces Hogarth's scenario to the 19th century with himself centre-stage as the urbane Man of Letters, invoking on the one hand the sup-pressed figure of the black intellectual in British history, exemplified by the 18th century writers and abolitionists Olaudah Equiano and Ignatius Sancho, and on the other, the extent to which fashion and style have been central to the recon-struction of African diaspora agency. The dandy reappears in *Dorian Gray*, 2001, the artist's version of the 1945 *grand guignol* film of Wilde's Faustian novel.

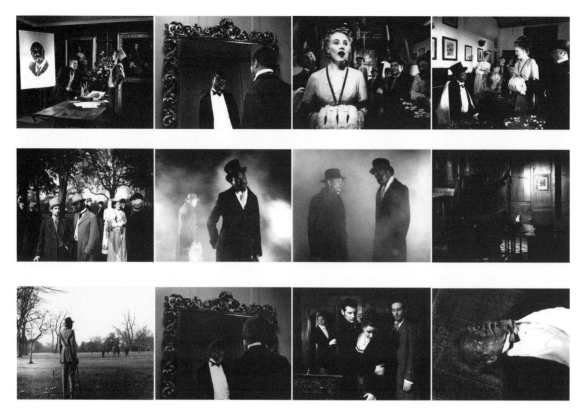

Figure 3.3 Yinka Shonibare, MBE, *Dorian Gray*, 2001. 11 black and white resin prints, 1 digital lambda print, 122 × 152.5 cm each, Edition 2 of 5. Images reproduced by courtesy of the Artist, Stephen Friedman Gallery (London) and James Cohan Gallery (New York)

Shonibare assumes the role of the doomed gentleman caught in a paradox between his own desire and restrictive social constructions of subjectivity, against which masquerade or madness are among the few available responses. By displacing the black man from subaltern other to an embodied *desiring* subject, the work provokes 'noise' around the psychosocial dynamics of race, class and gender that institutionalised British identity during 19th century imperialism.

My final comments concern the nature of the boundary itself and the ethical position of the artist seeking, in Ricoeur's terms, a 'critical interrogation of the socio-political imaginary' in relation to contemporary conflicts. This is a terrain of contesting narratives and sensitive borders. For instance, Steve McQueen, the Imperial War Museum's war artist to Iraq, found that the bureaucratic restrictions of embedding with British troops severely limited his engagement with the situation. His solution was *Queen and Country*, 2007, a set of commemorative postage stamps portraying British soldiers who had lost their lives, mounted in sliding panels in an oak cabinet (Figure 3.4) ('Hearts of oak' is a line from a traditional song celebrating the British military). This transgressed the sensibilities of the

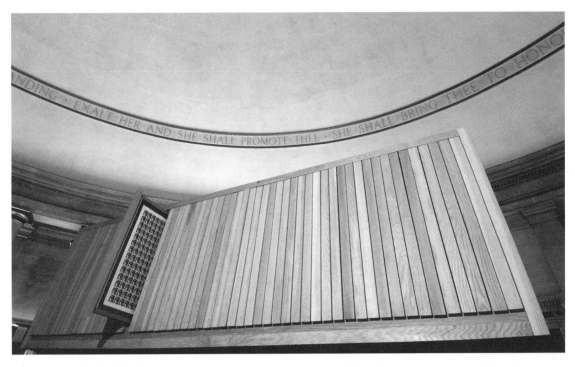

Figure 3.4 Steve McQueen, *Queen & Country*, 2007. Official set of postage stamps commemorating the British servicemen and women killed during the conflict in Iraq, co-commission between Manchester International Festival and Imperial War Museum. Installation view at the Manchester Central Library (28 February until 14 July 2007)

Ministry of Defence, which tried to censor the work, a story that made the front page of *The Independent* newspaper, and the Royal Mail continues to procrastinate on decisions to issue the set commercially. These sheets of multiple portraits, mostly smiling, are haunting, as are also the empty panels 'waiting' to be filled; but *Queen and Country* powerfully invokes a raft of contradictory associations to political rhetoric and the relations of power concealed behind the symbols of national identity, which impoverish communicable narratives of personal sacrifice and loss. The significance of the postage stamp is that it is an object of exchange; it circulates as a vector of messages and is indifferent to socio-political boundaries.

The final work discussed here, Francis Alÿs's *The Green Line*, begins with a contentious map reference, sadly reminiscent of Durham's, invoking the erosion of Palestinian territories since 1948. Alÿs performed a 15-mile filmed walk through Jerusalem, following the line drawn on a map with a thick grease pencil by Moishe Dayan (the 'green line') to separate Israeli and Palestinian territories. The artist retraced this line with green paint from a leaking can (Figure 3.5). The walk was designed to test the axioms, 'Sometimes doing something poetic can become political' and 'Sometimes doing something political can become poetic,' but posed

Figure 3.5 Francis Alÿs, Sometimes Doing Something Poetic Can Become Political and Sometimes Doing Something Political Can Become Poetic (The Green Line), 2004. In collaboration with Rachel Lee Jones, Philippe Bellaiche and Julien Devaux, Photographic documentation of an action, Jerusalem. Video, 17 minutes 45 seconds; color, sound. © Francis Alÿs, Reproduced by courtesy of David Zwirner, New York

the question, who owned the width of the line?, since the map reference topographically represented a wide tract of land. The 'extended' work is a video projection of Alÿs's journey 're-framed' by taped interviews that discuss the personal and political consequences of the 'green line' from differing perspectives, not all of which are favourably disposed towards Alÿs's act of 're-drawing' it.

The dilemma Alÿs faced was that in a situation like Jerusalem to act 'objectively' would be to fall into the compromised strategy favoured by Western media of presenting a liberal 'balanced view' of conflicts, whose unequal relations of power in reality demand an ethical critique, without which the status quo is tacitly condoned. But given that, as an 'outsider,' the artist also could not be partisan, what 'position' was available to him? To draw a line is to create and separate two sides but also to unite and suspend them irresistibly in a state of tension. But Alÿs's paint line, wavering between continuity and discontinuity, figures the ambivalence of the very concept of the border as both an aporia (the sign of a psychic and political impasse) and its actual or potential porosity. Alÿs's action was both bleakly comic and provocative, insofar as the terrain is technically the no-man's land of the boundary itself, a place from which no one can speak, and yet fraught with contested political and symbolic meanings. It is this occupation of the indeterminacy of the boundary itself that unites the actions of both Alÿs and Eshu-Elegguá. A boundary that is not on the margins of society but internal to its very identity.

The Hermetic imagination does not offer a determinate political position, but neither is it neutral; its function is that of the mobile vector of ex/change. Its effect, to repeat Adorno, is to 'put meaning on trial.' Meaning lies not in Alÿs's action as such, but in what it discloses of the situation. *The Green Line* speaks to questions of human belonging and dispossession, and of the cartographies of colonialism; but this is not all. Like the other works mentioned here, it discloses the inconsistencies in ideologies that dehumanise us of fellow feeling. If the effect of contemporary politics and its technologies is to disable human exchange and shrink existence to the limited world of 'interests,' the impulse of the Hermetic is to let in some air, to provoke new ways of perceiving and experiencing the world towards a more expansive politic of 'solidarity' and 'conviviality.'

Notes

1 Luis Camnitzer, *Chronology*, an ongoing, constantly revised summary of the artist's artistic and intellectual trajectory.

2 Mikhail Bakhtin, *Toward a Philosophy of the Act*, trans. Vadim Liapunov, Austin: University of Texas, 1993, p. 48.

3 Richard Kearney, 'Ricoeur', in *A Companion to Continental Philosophy*, [eds.] Simon Critchley and William R Schroeder, Oxford: Blackwell, 1998, p. 443.

4 Hans-Georg Gadamer, *The Relevance of the Beautiful and Other Essays*, trans. Nicholas Walker, Cambridge: Cambridge University Press, 1986, pp. 22–3.

5 Kearney, op. cit., p. 448.

6 Giorgio Agamben, *Remnants of Auschwitz: The Witness and The Archive*, trans. Daniel Heller-Roazen, New York: Zone Books, 1999.

7 Frantz Fanon, *The Wretched of the Earth*, [1961], trans. Constance Farrington, Penguin, Harmondsworth, 1985, p. 193.

8 Michel de Certeau, *The Capture of Speech*, trans. Tom Conley, Minneapolis: Minnesota University Press, 1997, pp. 95–7, 120.

9 Michel de Certeau, *The Practice of Everyday Life*, trans. Steven F Rendall, Berkeley and Los Angeles: University of California Press, 1984, pp. 54–5.

10 Gerald Vizenor, 'Trickster Hermeneutics: Curiosa and Punctuated Equilibrium', in *Reverberations: Tactics of Resistance, Forms of Agency in Trans/cultural Practices*, [ed.] Jean Fisher, Maastricht: Jan van Eyck Akademie Editions, 2000, pp. 142–50.

11 Richard Erdoes and Alfonso Ortiz, *American Indian Myths and Legends*, Pantheon Books, New York, 1984, pp. 381–2.

12 Theodor Adorno, *Aesthetic Theory*, [1970], trans. Robert Hullot-Kentor, London: Athlone Press, 1999, p. 153.

13 Paul Radin, *The Trickster: A Study in American Indian Mythology*, New York: Schocken Books, 1972, p. 28.

14 Catherine Clément, *Syncope: The Philosophy of Rapture*, trans. Sally O'Driscoll and Deirdre M. Mahoney, Minneapolis: Minnesota University Press, 1994, p. 21.

15 Walter Benjamin, 'The Storyteller,' in *Illuminations*, trans. Harry Zohn, New York: Schocken Books, 1968, p. 89.

16 Jean-Luc Nancy, *Being Singular Plural*, trans. Robert D. Richardson and Anne E. O'Byrne, California: Stanford University Press, 2000, p. 14.

17 Karl Kerényi, *Mythology and Humanism, The Correspondence of Thomas Mann and Karl Kerényi*, trans. Alexander Gelley, Ithaca and London: Cornell University Press, 1975, p. 9.

18 Ibid. p. 52.

19 Karl Kerényi, *Hermes: Guide of Souls*, trans. Murray Stein, Woodstock: Spring Publications, 1976, pp. 140–5.

20 Henry Louis Gates, Jr., *Figures in Black: Words, Signs, and the "Racial" Self*, Oxford: Oxford University Press, 1987, p. 54.

21 Robert Pelton, *The Trickster in West Africa*, Berkeley: University of California Press, 1980, pp. 49–51.

22 Michel Serres, *Hermes: Literature, Science, Philosophy*, (eds.) Josué V. Hari and David F. Bell, Baltimore & London: The Johns Hopkins University Press, 1982, pp. xxv–xxvi and 66–7.

Further readings

Inadvertent Monuments, Ilana Salama Ortar and Stephen Wright, *Third Text*, 20(3–4), 2006.

Conversation Pieces: The Role of Dialogue in Socially-Engaged Art, by Grant Kester, in *Theory in Contemporary Art Since 1985*, Zoya Kocur and Simon Leung, eds. (Oxford: Blackwell, 2005).

Related Internet links

Willie Doherty: http://www.jca-online.com/doherty.html

Jimmie Durham: http://www.heyokamagazine.com/HEYOKA.2.JIMMI%20DURHAM.htm

Yinka Shonibare: http://www.yinka-shonibare.co.uk/yinka-shonibare-home.html

Steve McQueen: http://www.artfund.org/queenandcountry/index.php

Francis Alys: http://www.postmedia.net/alys/alys.htm

<div align="center">

4

Constitutive Effects
The Techniques of the Curator

Simon Sheikh

</div>

Keywords

exhibition making
bourgeois subject
production of
 publics
national identity
politics of
 representation
counterpublics
community
constituency
contemporary
 exhibitions
biennials
transnationalism

In contemporary art a great deal of attention is given to the activity of exhibitions. Exhibitions are one of the primary vehicles for artistic production. However, this activity of exhibiting and exhibition making is largely predictable and repetitious, involved in specific circuits and structures, as well as economies (both symbolic and real). Perhaps we could even speak of a typology of exhibitions – specific modes of address meant to produce certain meanings and audiences, and we could discuss these modes of address according to history, contingency and potentiality. In the following, I shall try to do so according to the three premises outlined in this book: the past, the present and the future.

Past

Historically, exhibition making has been closely related to strategies of discipline and enlightenment ideals, not as a contradiction or dialectic, but rather as a simultaneous move in the making of the 'new' bourgeois subject of reason in 19th century Europe. Exhibition making marked not only a display and division of knowledge, power and spectatorship, it also marked a production of a public. By making museum collections open to the public and by staging temporary exhibitions in the salons, a specific viewing public was imagined and configured. What we would now call curating, in effect this organizing of displays and publics, had constitutive effects on its subjects and objects alike.

The collection and display of specific objects and artifacts according to certain curatorial techniques, represented not only the writing of specific colonial and national histories, but also crucially, the circulation of certain values and ideals. The emerging bourgeois class was simultaneously positioning and assessing itself, and thus extending its world-view onto objects – things present in the world, both

historically and currently – and therefore onto the world. But this dominant, or hegemonic, gaze was not to be seen nor visualized as a sovereign dictum, or dictatorship, but rather through a rationalist approach, through a subject of reason. The bourgeois class attempted to universalize its views and visions through rational argument rather than by decree. The bourgeois museum and its curatorial techniques could not articulate its power (only) through forms of discipline, it also had to have employed an educational and pedagogical approach, present in the articulations of the artworks, the models of display of the objects, the spatial layout and the overall architecture. It had to situate a viewing subject that not only felt subjected to knowledge, but was also represented through the mode of address involved in the curatorial technique. In order for the mode of address to be effectively constitutive of its subjects, the exhibition and museum had to address *and* represent at the same time.

The cultural theorist Tony Bennett has aptly termed these spatial and discursive curatorial techniques, 'the exhibitionary complex' as a means of describing the complex assemblage of architecture, display, collections and publicness that characterize the field of institutions, exhibition making and curating. In his article of the same name, Bennett has analyzed the historical genesis of the (bourgeois) museum, and its production of relations of power and knowledge through its dual role, or double articulation, of simultaneously being a disciplinary and educational space:

> The exhibitionary complex was also a response to the problem of order, but one which worked differently in seeking to transform that problem into one of culture – a question of the winning of hearts as well as the disciplining and training of individual subjects. As such, its constituent institutions reversed the orientations of the disciplinary apparatuses in seeking to render the forces and principles of order visible to the populace – transformed, here, into a people, a citizenry – rather than vice versa. They sought not to map the social body in order to know the populace by rendering it visible to power. Instead, through the provision of object lessons in power – the power to command and arrange things and bodies for public display – they sought to allow the people, and *en masse* rather than individually, to know rather than to be known, to become subjects rather than the objects of knowledge. Yet, ideally, they sought also to allow people to know and thence to regulate themselves; to become, in seeing themselves from the position of power, both as the subjects and objects of knowledge, knowing both power and what power knows, and knowing themselves as (ideally) known by power, interiorizing its gaze as a principle of self-surveillance and, hence, self-regulation.[1]

Whereas the 'strictly' disciplinary institutions (in a Foucaultian sense), such as schools, prisons, factories and so on, tried to manage the population through direct inflictions of order onto the actual bodies and thus behavior, the exhibitionary complex added persuasion to coercion. Exhibitions were meant to please as well as to teach, and as such needed to involve the spectator in an economy of desire as well as in relations of power and knowledge. In a sense, the exhibitionary complex

was also meant to be empowering, in that you could identify with the histories on display and act accordingly. In this way, exhibition making was directly connected to the construction of a national body, and as such it was involved in identitarian as well as territorial politics of representation. The knowledge that became available to the subject was a means of inscribing that subject within a given nation-state, of cultivating the populace into exactly that: a people, a nation.

Access to knowledge then also involved an acceptance of certain histories and ways of understanding them. The exhibitionary complex not only curated histories and power-knowledge relations, but also indicated ways of seeing and behaving. Hence the specific rules of conduct in the museum: slow-paced walking, lowered speech, no physical contact with the objects on display, a general discretion. In this way, regulation gets added to representation, interpellation is coupled with identification, and the bourgeois subject of reason becomes both subject and object of power in a complex relation of knowledge. In fact, representation of your values and histories goes hand in hand with proper behavior – relations of power and knowledge become internalized through behavior and empowerment: *self*-regulation and *self*-representation. You must behave properly in order to be (allowed) in the museum. Not touching the objects indicates not only respect towards them and their status, but also an acceptance of the rules, of given prohibitions and, more crucially, an intimate knowledge of your own position: that one is in the know, capable of watching, of being cultivated, in both the active and passive sense of being. And thus the importance of the art opening, the *vernissage*, as a bourgeois ritual of initiation and cultivation: one is not merely the first to watch (and, in some cases, buy) but also to be watched: to be visible *as* the cultivated bourgeois subject of reason, in the right place and *in* your place.

Present

In an attempt to describe how this history has also conditioned present day exhibition making and institutional foundations, as well as its critique, Frazer Ward has described the museum as 'haunted'. This was to do with certain histories and contingencies, and how the museum continues to construct a specific subject, not only individually, but also collectively as a public:

> The museum contributed to the self-representation of and self-authorization of the new bourgeois subject of reason. More accurately, this subject, this *"fictitious identity"* of property owner and human being pure and simple, was itself an interlinked process of self-representation and self-authorization. That is, it was intimately bound to its cultural self-representation *as a public*.[2]

The modes of address in exhibition making can thus be viewed as attempts to at once represent and constitute a specific (class-based) collective subject. This also means that a double notion of representation is at play, at once the narrations and

sensations of the displayed artworks themselves – the aspect most commonly referred to in both curatorial discourse and criticism – and the representation of a certain public (as spectator), being represented, authorized and constituted through the very mode of address. Making things public is also an attempt to make a public. A public only exists 'by virtue of being addressed', and is thus "constituted through mere attention" as Michael Warner puts it in his recent book *Publics and Counterpublics*.[3] What is significant here is the notion of a public as being constituted through participation and presence on the one hand, and articulation and imagination on the other. In other words, a public is an imaginary endeavor with real effects: an audience, a community, a group, an adversary or a constituency is imagining, and imagined through a specific mode of address that is supposed to produce, actualize or even activate this imagined entity, 'the public'. This is of course crucial to exhibition making, to the techniques of the curator.

However, as Frazer Ward points out, the spaces in which such exhibitions are produced and received are conditioned by certain histories, by certain residues of imagination, behaviour and reception. It is not my point to endlessly repeat a project of institutional critique, but rather to point out how the construction of a certain site was complicit with a certain subject, what Ward called 'the bourgeois subject of reason', and how this has produced the plethora of strategies and responses we see in contemporary exhibition making. Within the history of institutional critique, art institutions are mainly seen as the instruments of the bourgeoisie, and as a machine that can include and thus neutralize any critical form through its exhibitionary techniques, such as the infamous 'white cube' of the gallery space. This is a process also known as cooptation, indicating that the institution needs, even desires, critique in order to strengthen itself and its neutralizing gaze. But this needs to be examined more carefully, and in the context of the historical appearance of museums, salons and galleries during the bourgeois revolutions, where the exhibition place functioned as a space for cultivated discussion, for self-representation and self-authorization through a rational-critical discourse. In other words, the discourse (including criticism) was rational and the objects (and to some extent the artist subject behind them) were irrational. The objects had to be irrational in order to be rationalized, which, in turn, produced the rational-critical subject whose values and judgments were represented by the exhibition. Exhibition making then became the staging of this discourse, of this debate, making curators caterers of taste and the artists as much objects of the gaze as the artworks. Seen in this light, so-called institutionally critical artworks were allowed into the institutions by default, as products of more or less rational artist-subjects, as mere contingency.

We are thus resting on the pillars of tradition in more than one sense, and in a sense of articulation and representation not always reflected in contemporary exhibition making. If the historical role of exhibition making was to educate, authorize and represent a certain social group, class or caste, who is being represented today? Arguably, the bourgeois class formation of the 19th century cannot be directly transferred to today's modular societies, neither as the goal for

representation nor for critique or counter articulation(s). So which groups – imagined as real – are being catered to by contemporary exhibition making and institutional policies? And what modes of address would be required and desired to represent or criticize these formations? Answering this question directly will, partly, require a turn to the futuristic section, and partly a reversal: to ask what spectators can be said to be represented by the current strategies of exhibition making, whether reflected or not by the exhibition makers, since these strategies can be analyzed as modes of address, and thus as operating through specific articulations and imaginaries. This will require, though, a certain typology of exhibitions.

As mentioned in the beginning, the exhibition format is the main vehicle for the presentation of contemporary art, but this does not mean that the exhibition is a singular format with a given public and circulation of discourse. Rather, the format of the exhibition should be pluralized; obviously different types of exhibitions are speaking from different locations and positions, with different audiences and circulations, be it the self-organized group show in a small alternative space or the large scale international biennial. What they do share is a sense of a double public: the local, physically present (if only potentially) audience as well as the art world public (if only potentially). Exhibitions find themselves placed within an ecosystem as well as a hierarchy of exhibitions (and exhibition venues). This can, naturally, be employed strategically and cynically, but the important issue here is how – within the given exhibition format – to reflect upon its placement and potentiality in order to stretch it, circumvent it, sabotage it, or, if you will, affirm it, which happens to be the most common usage of a given exhibition format these days. The notion of 'alternative', for example, is infused with a large degree of symbolic capital within the arts, and is potentially transferable into real capital, thus making 'the alternative' into a stage within artistic-economic development, into a sphere placed on a time line rather than on a parallel track.

Exhibitions often seem tiresome, their use-value given and predictable in an endless repetition of the same formats and intentions. We find this in the very fixed format of historical museum exhibitions, retrospectives of either: 1) a specific period (always a 'golden' age), 2) a specific movement (preferably a clearly definable painterly style) or 3) a specific artist (the monographic exhibition of the artist as genius). Such exhibitions exist in more or less luxurious variants, usually curated by museum experts rather than freelancers, and feature some sort of art historical research. According to the prestige of the institution or theme / artist, a catalogue book of some substance accompanies this exhibition type: the prestige and importance can be directly measured in the volume of the publication. One is often led to believe that such exhibitions have the most un-reconstructed notion of their publicness, expressing a discrete charm of the tradition, but actually this format has proven extremely adaptable to changes in the public sphere from the bourgeois model of enlightenment to the current culture, or even entertainment, industry. Such exhibitions offer a feeling reminiscent of bourgeois rationality and taste in the form of light entertainment for the family; spending a couple of hours in the museum, with its gift shop and café, as an alternative to a trip to the mall.

Although exhibitions of contemporary art are not always popular, populism is as present within such exhibitions as it is in the retrospective museum shows. Again and again, we are offered the 'new' – the generational show being an ever-popular and career-building move, just as we constantly are subjected to the most retrograde exhibition format of all, the national show, regularly combined with the generational, producing 'new' miracles in the discovery of new happening scenes. Not only do such shows fit seamlessly into the demands for new trends and products of the art markets, but they will very likely also receive assured funding from national cultural agencies, making them a perfect example of the currently ever-so desirable merger between corporate and public funds. If such shows do not guarantee large numbers of visitors the way certain retrospective shows do, they tend to privilege that other imagined public, the art world, and give access to the strange circuit of magazines, discourses, word-of-mouth, curatorial attention, teaching jobs, galleries and money.

A merger between funds, economies, national interests and the production of art world trends are also at issue in the most international of all formats, the ever-growing biennials. It would not be difficult to be critical, even dismissive, of the biennial circuit and its relationship to market and capital, and lack of reflection on 'local' audience – indeed such a critique is almost commonplace among art professionals, often in a cynical form of fatigue (it must be the jetlag…), but this would be overlooking the potential these biennials actually offer for a reflection of the double notion of publicness, for creating new public formations that are not bound to the nation-state or the art world. By being perennial events, both locally placed and part of a circuit, they have the potential for creating a more transnational public sphere, with both difference and repetition in the applied mode of address and implied notion of spectatorship and public participation.

Future

In order to alter the script of the existing formats, we need more rather than less reflection on the conception of publics, and the contingencies and histories of various modes of address. As I have tried to argue, all exhibition making is the making of a public, the imagination of a world. It is therefore not a question of art for art's sake or art for society, of poetics or politics, but rather a matter of understanding the politics of aesthetics and the aesthetic dimension of politics. Or, put in another way, it is the mode of address that produces the public, and if one tries to imagine different publics, different notions of stranger relationality, one must also (re)consider the mode of address, or, if you will, the formats of exhibition making.

There not only exist public spheres (and ideals thereof), but also *counterpublics*. According to Michael Warner, counterpublics can be understood as particular parallel formations of a minor or even subordinate character where other or oppositional discourses and practices can be formulated and circulated. Counterpublics

have many of the same characteristics as normative or dominant publics – existing as imaginary address, a specific discourse and / or location, and involving circularity and reflexivity – and are therefore always already as much *relational* as they are *oppositional*. A counterpublic is a conscious mirroring of the modalities and institutions of the normative public, all be it in an effort to address other subjects and indeed other imaginaries. Where the classic bourgeois notion of the public sphere claimed universality and rationality, counterpublics often claim the opposite, and in concrete terms this often entails a reversal of existing spaces into other identities and practices, a queering of space. This has indeed been the model of contemporary feminist (and other) project exhibitions that use the art institution as a space for a different notion of spectatorship and collective articulation that runs counter to the art space's historical self-articulations and legitimations, what Marion von Osten has described as 'exhibition making as a counter-public strategy'.[4]

An exhibition must imagine a public in order to produce it, and to produce a world around it – a horizon. So, if we are satisfied with the world we have now, we should continue to make exhibitions as always, and repeat the formats and circulations. If, on the other hand, we are not happy with the world we are in, both in terms of the art world and in a broader geopolitical sense, we will have to produce other exhibitions: other subjectivities and other imaginaries. The great division of our times is not between various fundamentalisms, since they all ascribe to the same script (albeit with a different idea of who shall win in the end …), but between those who accept and thus actively maintain the dominant imaginary of society, subjectivity and possibility and those who reject and instead partake in other imaginaries, as Cornelius Castoriadis once formulated it. For Castoriadis, society is an imaginary ensemble of institutions, practices, beliefs and truths, that we all subscribe to and thus constantly (re)produce. Society and its institutions are as much fictional as functional. Institutions are part of symbolic networks, and as such they are not fixed or stable, but constantly articulated through projection and praxis. But by focusing on its imaginary character, he obviously also suggests that other social organizations and interactions can be imagined:

> [The] supersession [of present society] – which we are aiming at *because we will it* and because we know that others will it as well, not because such are the laws of history, the interests of the proletariat or the destiny of being – the bringing about of a history in which society not only knows itself, but *makes itself* as explicitly self-instituting, implies a radical destruction of the known institution of society, in its most unsuspected nooks and crannies, which can exist only as positing / creating not only new institutions, but a new *mode* of instituting and a new relation of society and of individuals to the institution.[5]

It is thus not only a question of changing institutions, but of changing how we institute; how subjectivity and imagination can be instituted in a different way. This can be done by altering the existing formats and narratives, as in the queering of space and the (re)writing of histories – that is, through deconstructive as well as

reconstructive projects, *and* by constructing new formats, by rethinking the structure and event of the exhibition altogether. Either way, I would suggest that curating in the future should center around three key notions: *Articulation, Imagination* and *Continuity*.

By *articulation* we shall mean the positioning of the project, of its narratives and artworks, and its reflection of its dual public and placement both in and out of the art world. An exhibition is always a statement about the state of the world, not just the state of the arts, and as such it is always already engaged in particular imaginaries, whether or not it claims to be so engaged. A work of art is, at best, an articulation of something as much as it is a representation of someone: it is a proposal for how things could be seen, an offering, but not a handout. Articulation is the formulation of your position and politics, where you are and where you want to go, as well as a concept of companionship: you can come along, or not. In cultural production, there is no separation possible between form and content, between means and ends: modes of address articulate and situate subject positions, and where you want to go and how you get there are one and the same question. Thus, the more clearly the articulatory element is stressed, the more productive it will be in partaking in other imaginaries and subject positioning.

By *imagination*, we shall take our cue from the thinking of Castoriadis, and his analysis of society as self-created, as existing through institutions. It is, as stated, a question of imagining another world, and thus instituting other ways of being instituted and imagining, so to speak. To say that other worlds are indeed possible. For our present situation, we can also say: another art world is possible (if we want it). Secondly, the imaginary, as articulation, naturally has to do with the processes and potentialities of artistic production itself: to offer other imaginaries, ways of seeing and thus changing the world. An artwork can indeed be seen as new modes of instituting, of producing and projecting other worlds and the possibility for the self-transformation of the world: An institutionalization that is produced through subjectivity rather than producing subjectivity. It can, quite bluntly, offer a place from which *to see* (and to see differently, other imaginaries).

By *continuity*, we shall refer to the very work processes of curating itself, and how it can appear as lost in repetitions and trends. Rather than feeding the market, repetition could be transformed into continuity, literally doing the same in order to produce something different, not in the products, but in the imagination. I propose not only working in the same field or theme as a researcher, but actually radicalizing this aspect, as well as the resistance to the market, by working on a long-term plan. Not a five-year plan, but rather a ten-year plan; constantly doing the very same exhibition with the same artists. Imagine this: constantly asking the same artists to contribute to the same thematic exhibition, thus going into the depths of the matter rather than surfing the surface. Indeed, going off the deep end as it were, by refusing the demands for newness, for constantly new (re)territorializations – 'painting now!', 'the return of the political', 'new British art show', etc. – and insisting on working on the very same show, whether it is traveling or within the same institution or city. Now, one could argue that this is what a lot of

curators are already doing, regardless of the fact that they might change topics, scenes and generations regularly; but rather than dismissing or hiding this fact, I would suggest articulating it, and through this self-imposed and self-transformative continuity, going deeper into the artists' production and thinking, as the artists then would with the curator's thinking and methods, as well as developing – quite literally, and for better or for worse – long-term relationships with one's imagined audience, constituency and / or community. Producing a public is making a world. It is also making other ones possible …

Notes

1 Tony Bennett, 'The Exhibitionary Complex', in R. Greenberg, B. Ferguson, S. Nairne (eds.). *Thinking About Exhibitions*. London: Routledge, 1996, p. 84.

2 Frazer Ward, 'The Haunted Museum: *Institutional Critique and Publicity'. October 73*, 1995, p. 74.

3 Michael Warner, *Publics and Counterpublics*. New York: Zone Books, 2002.

4 Marion von Osten, 'A Question of Attitude – Changing Methods. Shifting Discourses. Producing Publics. Organizing Exhibitions'. Simon Sheikh (ed.). *In the Place of the Public Sphere?*, Berlin: b_ books, 2005.

5 Cornelius Castoriadis. *The Imaginary Institution of Society*. London: Polity Press, 1987, p. 373. (French original published 1975).Notes

Further readings

Desires for the World Picture: The Global Work of Art, Caroline A. Jones (forthcoming).

The Postcolonial Constellation: Contemporary Art in a State of Permanent Transition, Okwui Enwezor, *Research in African Literatures*, 34(4), 2003.

Related Internet links

Biennials: http://www.universes-in-universe.de/english.htm

Independent Curators International: http://www.ici-exhibitions.org/exhibitions/exhibitions.html

5

Do Images Have a Gender?

DAVID JOSELIT

How do images exert power? Must they behave like humans in order to gain agency? And if so, are they gendered? Feminist thought makes two fundamental suppositions regarding gender, which are intimately tied to the relation between persons and pictures. First, gender is transactional (produced and reproduced through encounters with others), and second, it is distinct from biological difference, inhering instead in complex cultural networks that simultaneously reach within and extend beyond particular bodies. In other words, feminist thought envisions gender as a dynamic system where the terms "female" and "male" are fully relational and thus impossible to fix. Judith Butler has expressed this dynamism in the language of images – in terms of unstable figure ground relationships:

> Within lesbian contexts, the "identification" with masculinity that appears as butch identity is not a simple assimilation of lesbianism back into the terms of heterosexuality. As one lesbian femme explained, she likes her boys to be girls, meaning that "being a girl" recontextualizes and resignifies "masculinity" in a butch identity. As a result, that masculinity, if that it can be called, is always brought into relief against a culturally intelligible "female body."… Similarly, some heterosexual or bisexual women may well prefer that the relation of "figure" to "ground" work in the opposite direction – that is, they may prefer that their girls be boys.[1]

For Butler, as for many feminist theorists informed by psychoanalysis, the relation between a person and her image – both the image she has of herself *internally* and that which she projects to the world – is fundamental. Images, then, are the vehicles of gender: they have a transitive capacity to *engender* in the context of particular situations, and this, as I will argue, accounts for one species of their power.

The practice of feminist art history is delimited by two powerful analytical assertions: The first is that the *artist* has a gender (which is conventionally

Keywords

agency
gender
feminist art history
image
the body
performance
Hannah Wilke
avatars
Adrian Piper
Reena Spaulings
transgendered
 subjectivity
spectatorship

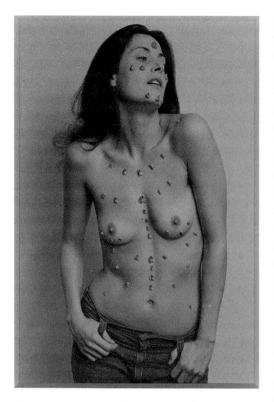

Figure 5.1 Hannah Wilke, *S.O.S. Starification Object Series*, 1974. Black and white photograph. Performalist Self-portrait with Les Wollam, paper size: 5 × 7 inches. Reproduced by courtesy of Ronald Feldman Fine Arts, New York

associated with historians' active recovery of suppressed histories of art made by women beginning in the 1970s), and the second is that the viewer has a gender (which is typically associated with feminist visual theory of the 1980s and 1990s deeply influenced by psychoanalysis and theories of spectatorship).[2] These complementary positions of women as producers and women as consumers pivot on an absent term: the image itself. Does this third term – the art object – have a gender? I have already hinted at my own answer. Contrary to W.J.T. Mitchell for whom "it's clear that the 'default' position of images is feminine,"[3] in my view, images do not *have* a gender. Instead, they participate in visual procedures of gendering – in short, they *en*gender. I mean this in two ways: first, following Butler I will argue that gender is a performative species of image that must be produced – or engendered – over and over by every subject. What is femininity (or masculinity) if not a picture whose medium is the body? Images *engender* because it is through them – through their ingestion or embodiment by subjects – that gender is experienced for oneself and for others. In this view the regulative system of gender is a *visual* system – thus offering a fundamental object for artists and art historians alike. Images do not *have* a gender, but they make possible the appearance and recognition of gender. The repetition inherent in such gender performance demonstrates the second means through which images engender: they proliferate – one image engenders another in an endless quasi-biological process of reproduction. The kind of engendering that images accomplish, then, is never once and for all. The representation of gender is a doorway into the destabilization of its terms, precisely because *engendering* is necessarily ongoing and repetitive, and each repetition offers the possibility for creative distortion.

One of the central theoretical problems of feminist art has been to theorize the nature and status of the body. Body art of the 1970s has often been criticized as essentialist because viewers have had a tendency to elide the body (or biological sex) and gender, and in doing so to cause a further elision between bodies and art objects. Such a slippage suggests (erroneously) that an image, because it is the image of a woman, must have a gender. A work like Hannah Wilke's *S.O.S. Starification Object Series* (1974) (Figure 5.1) makes clear that the artist's body is not an object, but an *agent*, and that this agent *engenders* in the two ways I have outlined. First, in photographing herself in a spectrum of gender roles ranging from submissive to resistant, Wilke demonstrates both that the same body (her own)

may engender many different attitudes, and that one such role may engender many others in the erotic play of postures that her grid of photographs registers. In fact, as in language, where the choice of a word always exists between a meta-phoric (or substitutive) logic and a metonymic (or sequential logic) Wilke under-stands that a gender-utterance can never be unique, but always differentially defined against what is "sayable" for the performing body of a particular sex and in a particular time and place.

Tattooing, like practices of scarification that Wilke makes reference to here, is precisely a mode of linking the individual body to the social sayability of gender (as well as ethnicity and class). As the anthropologist Alfred Gell argues in his provocative 1993 study, *Wrapping in Images: Tattooing in Polynesia*, tattooing in non-western contexts has traditionally produced political subjects through inscriptions on the body that situate the marked person within a world view. Gell argues that in the west, tattooing has exerted its regulative function largely in terms of class (traditionally marking criminals, sailors, workers and prostitutes), and in our present world it functions as a subcultural marker for those interested in alterna-tive lifestyles – or the simulation thereof. "Starification," like the mechanism of stereotyping that the photographs enact, is thus a means of linking a body with a broader social world.

Whether the chewed gum forms that Wilke applies to her photographs are interpreted as vaginal or not, these "scars" (or stars) are produced, as Amelia Jones has argued in a different context,[4] through a transfer from an ostensible "interior" of the body (connoting its subjectivity) to its exterior. It is its *elasticity* that makes the choice of gum particularly apt as both the material form and alle-gory of the image. The gum has been ingested – literally chewed – by the artist (or her collaborators) and then applied to her series of photomechanical effigies. This too is perfectly consonant with Gell's anthropological reading of tattooing. As he writes, "The basic schema of tattooing is thus definable as the exterioriza-tion of the interior which is simultaneously the interiorization of the exterior."[5] In other words, ingestion and projection – the two dimensions of engendering that I have identified – pivot in this work on the same elastic, shape-shifting material substance – gum – just as in the performance of gender they comple-ment one another as two dimensions of an integrated process. As Butler demon-strates, the *performative* and the *proliferative* (the two modes of engendering that I have identified) are profoundly linked.[6]

As Wilke's punning title – *Starification Object Series* – explicitly suggests, in our world celebrity serves some of the same roles as scarification or tattooing – in that its spectacular norms serve to integrate bodies into social networks. Instead of scarring ourselves, we *star* ourselves through images that place us within an array of licit roles and attitudes. Even if one isn't famous (most of us are not), in a media world the currency of subjectivity is celebrity, and celebrity is that realm in which images *engender* gender itself. How might one fashion a feminist practice that responds to such conditions? One answer has been the production of avatars. As image agents that *deploy* subjectivity without possessing it, avatars may *engender*

Figure 5.2 Eleanor Antin, *The King of Solana Beach*, 1974–5. Life performance. Reproduced by courtesy of Ronald Feldman Fine Arts, New York

Figure 5.3 *The Mythic Being: Cruising White Woman*, 1975. 1 of 3 black and white photos, 8 × 10 inches. © Adrian Piper Research Archive, Collection of Eileen Harris Norton

without *having* a gender. Feminist art is rife with transgendered avatars, ranging from the various masculine and feminine characters played by Eleanor Antin (Figure 5.2) or Adrian Piper (Figure 5.3) in the 1970s to those of Cindy Sherman (Figure 5.4), and more recently Sharon Hayes. In fact, one might argue that the uninterrupted invention of avatars, as prosthetic subjects, bridges the divide I have alluded to between production-oriented feminism of the 1970s and later modes of reception or spectator-oriented feminism. It makes perfect sense that women, who are disproportionately (though not exclusively) oppressed by gender regulations, should be so drawn to the possibilities of a projected subject whose purpose is not to *have* a gender but rather to demonstrate the procedures of *engendering*. Through their non-identity to any particular biological person (Adrian Piper, for instance, *is not* the male persona of the Mythic Being, though this character is supported by her body), avatars challenge popular culture's presumption that individuals should *consume* and *possess* identities like private property – an assumption shared across the political spectrum from conservative advocates of family values to the proponents of

Figure 5.4 Cindy Sherman, Untitled Film Still (#13), 1978. black and white photograph, 10 × 8 inches. Reproduced by courtesy of the Artist and Metro Pictures

progressive identity politics. Avatars arise under the conditions of a media public sphere where, in order to address a large public, one must assume (or be forced into) the position of an intelligible character, often closely associated with stereotyped identities like "gay," "conservative," or "African American." If visual media such as television, film and the Internet alienate viewers from their own representations through a skewed identification with commodified norms, avatars both acknowledge this alienation and attempt to combat it by inventing new "social lives" or pathways for such readymade characters.[7] Avatars function as political agents by bringing persons and pictures face-to-face to produce publics.

Let me give an example of recent practices of the avatar. In 2004, the Bernadette Corporation, an artists group known for its forays into fashion, activism, and art-dealing published a novel called *Reena Spaulings*. This work, which like many fictions, is both a theoretical treatise and a form of entertainment, demonstrates a technics of the avatar in at least two ways. First, it was produced anonymously and collectively under the aegis of the Corporation's name. Shorn of individual ego, such a blank vehicle can shuttle between the art world and politics in the manner of other anonymous collectives like ACT-UP or the Guerrilla Girls (Figure 5.5). Second, on the register of diegesis, the novel's eponymous protagonist offers a

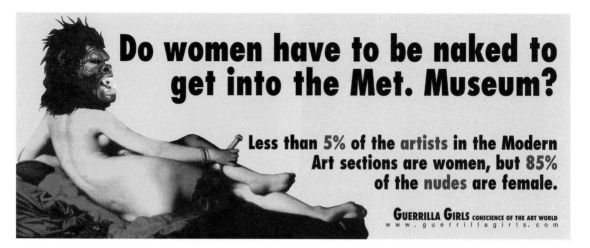

Figure 5.5 Guerrilla Girls, *Do Women Have to be Naked to Get into the Met?*, 1989. Reproduction courtesy of Guerrilla Girls

catalogue of the avatar's capacities as an image-agent which are not coincidentally suffused in a kind of genderfuck. *Reena Spaulings* may be read as an allegory of engendering, in which pictures and persons produce one another in an enactment of Butler's theory of performativity. Let me outline a schematic progression of such moments as they occur in the novel. 1) *Persons identify with pictures.* In the opening chapter Reena, working as a guard at the Metropolitan Museum of Art, falls into an extended meditation on Manet's *Woman with a Parrot* (1866). Over and over again, the book stages encounters between persons and images where the differences between them begin to blur. Here is how this mechanism is narrated: "She stood up a little straighter and fixed her eyes on a Manet on the opposite wall. The woman in the painting had Reena's blank pallor and below-the-radar presence. Reena could be a Manet, one of these thinking pictures you can't see through, no matter how long you stare at them."[8] 2) *Persons become pictures.* The second type of encounter I will point to is precisely such a transformation from persons into "thinking pictures you can't see through, no matter how long you stare at them." Reena becomes such a creature when Maris Parings, a flamboyant entrepreneur, recognizes her particular brand of bohemian chic and transforms her into an underwear model. I can't help but see this operation as an allegorical reversal of Yve-Alain Bois' concept of *Painting as Model*, into its converse, the *Model as Painting*,[9] wherein Reena's new social mobility as a celebrity (i.e., a human picture or avatar) allows her to build new communities through a delirious sequence of live and mediated representations. 3) If person meets picture in the first kind of encounter the novel stages and *becomes* a picture in the second, in the third paradigm explored by *Reena Spaulings, Person-pictures operate as agents.* Such a shift into image-agency occurs most explicitly in a choreographed riot produced by Parings' company, Vive la Corpse and titled *Cinema of the Damned* (or a Battle on Broadway) in which a performance starring Reena and a full cast of insurgents in the street shades into

an actual riot. When images act, the fictional has real consequences and art has the potential to function as politics. The social world is thus established between three points: 1) Persons identifying with images; 2) Persons becoming images; and 3) Images functioning as agents. This tripartite dynamic is beautifully summarized in the novel's preface, which states: "This is a novel that could also have been a magazine. It's a book written by images, about images, to be read by other images, which is to say it is uninhibited and realist."[10]

In certain theories of transgender experience such as those of Sandy Stone, where a strict dichotomy between masculine and feminine is purposefully confounded, the pleasure of the transgendered subject is situated not in "passing" (i.e., perfectly impersonating the "opposite" gender) but rather in inventing destabilized forms of gender-utterances. In her foundational 1991 essay, "The Empire Strikes Back: A Posttranssexual Manifesto," Stone writes, "In the transsexual text we may find the potential to map the refigured body onto conventional gender discourse and thereby disrupt it, to take advantage of the dissonances created by such a juxtaposition to fragment and reconstitute the elements of gender in new and unexpected geometries."[11] I propose that in response to my question, "Does the image have a gender," that we answer: "The image is *transgendered*." Wilke herself came to this conclusion when, in discussing Duchamp's fascination with the metaphor of the Bride, she declared, *"As the essence of creativity is honored as the virgin state of the new, the Bride is the transsexual state of the male artist, his female self separate from and above other men in society."*[12] Indeed, as I have tried to articulate in this essay, the power of images lies in this "trans" (or transitivity) – in the dual motions of ingestion and proliferation that are exemplified by the elastic molded gum scars / stars of Hannah Wilke, or in the polymorphous agency of the avatar as narrated by *Reena Spaulings*. In the writing of feminist art history we must always be alert to this logic of dynamism – this *trans* that, in simultaneously rendering gender as a process and undermining the commodified solidity of things, is one of the great accomplishments of feminist art.

Notes

An earlier version of this text was delivered in "The Feminist Future: Theory and Practice in the Visual Arts," a conference at The Museum of Modern Art, New York, January 26–27, 2007. My particular thanks to Alexandra Schwartz, who organized the conference.

1 Judith Butler, "Subversive Bodily Acts," in *Gender Trouble: Feminism and the Subversion of Identity* (New York: Routledge, 1990), p. 123.

2 For a very helpful introduction to this extremely complex history see Helena Reckitt and Peggy Phelan, *Art and Feminism* (London: Phaidon Press, 2001). Phelan's "Survey" is an excellent start and this volume also brings together several primary source texts from the 60s to the time of publication.

3 This statement is part of a rather crude elision of images and feminine spectatorship in Mitchell's essay, "What do Pictures Want?" which self-consciously (and I think rather problematically)

aligns Freud's notorious question about women with the nature of contemporary images. See W.J.T. Mitchell, "What do Pictures Want?" in *What do Pictures Want? The Lives and Loves of Images* (Chicago: The University of Chicago Press, 2005), p. 35.

4 Jones discusses *S.O.S. – Starification Object Series* in light of Wilke's "strategic narcissism," a collapse of subject object relations that, in Jones' view, allows a way out of the male/female or subject/object binarisms that structure Western knowledge while consigning women to an inferior position within it. The inside/out dynamic is one aspect of this larger economy of signification across Wilke's own body. See Amelia Jones, *Body Art/Performing the Subject* (Minneapolis: University of Minnesota Press, 1998), pp. 180–5.

5 Alfred Gell, *Wrapping in Images: Tattooing in Polynesia* (Oxford: Clarendon Press, 1993), p. 39.

6 Butler's now canonical theory of the performative is famously elaborated in "Gender is Burning: Questions of Appropriation and Subversion," in Judith Butler, *Bodies that Matter: On the Discursive Limits of "Sex"* (Routledge: New York, 1993). I say the performative and proliferative are profoundly linked in this theory because it is the nature of the performative to be repeated.

7 I am referring to Arjun Appadurai's call for a history of the "social life of things." As commodified subjectivities, avatars could be submitted to the same analysis. See Arjun Appadurai, "Introduction: Commodities and the Politics of Value," in Appadurai, ed, *The Social Life of Things: Commodities in Cultural Perspective* (Cambridge: Cambridge University Press, 1986), pp. 3–63.

8 Bernadette Corporation, *Reena Spaulings* (New York: Semiotexte; distributed by the MIT Press, 2004), p. 7.

9 See Yve-Alain Bois, *Painting as Model* (Cambridge: MIT Press, 1990.

10 Ibid, unpaginated.

11 Sandy Stone, "The Empire Strikes Back: A Posttranssexual Manifesto" [1991], in Susan Stryker and Stephen Whittle, eds., *The Transgender Studies Reader* (New York: Routlege, 2006), p. 231.

12 Hannah Wilke, "OBJECT Memoirs of a Sugargiver (Edition Coup de Couteau)" [1988], in Thomas H. Kochheiser, ed., *Hannah Wilke: A Retrospective* (Columbia: University of Missouri Press, 1989), p. 148. [Italics in the original]

Further readings

Reena Spaulings, Bernadette Corporation, *Semiotext(e)*, September 2005 (distributed by MIT Press).
What do Pictures Want?, in *What do Pictures Want? The Lives and Loves of Images*, W. J. T. Mitchell (Chicago: University of Chicago Press, 2005).

Related Internet links

Hannah Wilke: http://www.hannahwilke.com/
Bernadette Corporation: http://www.bernadettecorporation.com/
Adrian Piper: http://www.adrianpiper.com/
Eleanor Antin: http://www.pbs.org/art21/artists/antin/index.html
Cindy Sherman: http://www.cindysherman.com/art.shtml
Guerrilla Girls: http://www.guerillagirls.com/

6

Rethinking the F Word
A Review of Activist Art on the Internet

MARY FLANAGAN AND SUYIN LOOUI

In an era when new technology and media increasingly infiltrate all facets of our lives, and progress on gender, racial, and other forms of equity appears excruciatingly slow, now seems a critical time to examine new technologies and their potential value for feminist activism. Since its public emergence in the late 1980s, the internet has been simultaneously criticized as oppressive and heralded as empowering for different communities. In this review, we will examine some of the emerging forms that feminist activist art is taking in relation to the internet and consider how technology has contributed to the goals of feminist artists and activists.

It is important to contextualize this review by considering the conflicted term "cyberfeminism" (Braidotti 1996; Gajjala 1999; Sollfrank 2002). Since the mid-1990s, the term cyberfeminism has been used to investigate the ways in which technology, especially new media and internet technology, and gender interact. Cyberfeminists investigate the celebratory yet contradictory nature of new technologies and work to determine methods of appropriation, intervention, or parallel practice to insert women's issues into the dominant technology discourse. While many women working with technology have regarded this term suspiciously, feminist activist artist Faith Wilding pointed to the possibilities and optimism inherent within it. In her influential article, "Where is Feminism in Cyberfeminism?" Wilding asserts that "cyberfeminists have the chance to create new formations of feminist theory and practice which address the complex new social conditions created by global technologies" (1998). Prominent feminist theorist Rosi Braidotti noted that a central aim of cyberfeminism was the breakdown and disintegration of contemporary gender boundaries (1996).

Cyberfeminism as a liberatory ideal has not yet achieved its potential, in part because of larger societal pressures surrounding the information technology fields. If a fundamental aim of cyberfeminism is to change and reorganize social

Keywords

activism
cyberfeminism
new media
collectives
urban space
India
race
transculturalism
globalization
resistance
Croatia
migration
democracy
internet art
Asianness

and political realities by engaging technology to address gender issues, little progress has been achieved for women. In the United States, for instance, the dearth of women, especially women of color, in computer science and technology studies and professions has been described by researchers as a social justice issue (Wardle, Martin, and Clarke 2004). Female enrollment in information technology academic areas continues to decline, and the current gender imbalance in computing and new technology areas such as game and software development, hinders progress for women in social equity, equal access, and empowerment (AAUW 2000; Margolis and Fisher 2001). And unfortunately, counter to cyberfeminist calls to appropriate technological resources for women, research shows that women, especially those from racial and ethnic minority groups, continue to veer away from software design studies; the number of women pursuing computer science degrees has declined considerably in the last twenty years (Commission on the Advancement of Women and Minorities 2000). Black and Hispanic Americans represent less than 10 percent of the computer systems analysts and computer scientists working in the field and less than 10 percent of programmers (U.S. Department of Commerce 2002). The inequities that result are troubling, especially at a time when computers have become central to most disciplines, and when computer games are emerging as a dominant medium. A similar challenge exists in the United Kingdom within technological fields such as the computer gaming industry; Natalie Hanman notes that women are on the "gaming" sidelines in play and employment, constituting only 17 percent of the games industry workforce (2005). As noted by many industry insiders, the vast majority of technology companies that produce games do not target women or people of color as players (Koster 2006; Slagle 2004). Cyberfeminist critiques of computer gaming, then, continue to remain relevant without new models to replace them (Flanagan 1999; Kennedy 2002; Schleiner 2001).

Given the dire state of the commercial context, one could ask, "Where are the cyberfeminists?" Have the idealistic views of early cyberfeminists had any impact on work created by artists on the internet today? In this review, we attempt to respond to this challenging question. Together we examine five websites, highlighting specific art works that utilize the internet to demonstrate how a variety of artists and artist's groups from around the globe are working to use internet technology effectively for activism aligned with feminist aims.

In our review of websites, we encountered difficulty locating women artists who are producing theoretically challenging and technologically "cutting-edge" websites that are also explicitly feminist. Indeed, even women known for their feminist activism seem to be altering their creative practices. We found that some feminist artists who once worked alone are now working in allied collectives; others are creating websites and web-accessible video documentation of work not explicitly named by the artist as "feminist." Emerging art activism, as readers shall see, takes many forms, including some single-authored politically engaged works of cyberart by women artists, as well as

work by collectives where women work from the inside of institutions and collective entities to contribute to a larger voice and to foster a broader sense of social equity and inclusion.

The works reviewed here could all be used within women's studies courses and curricula, serving as models for "cutting-edge" feminist activist art. However, we hope the discussion of these works will expand outside the classroom and beyond the art world and move into larger arenas for discussion of cultural production in cyberspace.

Site I: Sarai: New Media Initiative

http://www.sarai.net

> The streets of Delhi are now dug up to lay fibre optic cable, and tracks for a long awaited metro. Frequent power cuts, evictions, demolitions, and the everyday violence of a harsh and unequal city speak of a different order of reality. We live in desperate times, in Delhi. And it is the very nature of our times that make communication, and reflection crucial to survival. (Sarai 2006)

The central mandate that binds Sarai projects is a concern with media, city space, and urban culture. Sarai is a mixed-media, mixed-gender group of 27 members that breaks ordinary notions of working as a collective due to the immense size of the group and the diversity of its members. Based in Delhi, India, Sarai is composed of documentary filmmakers, media theorists, historians, writers, anthropologists, programmers, and poets. Initiated in 2001, Sarai is part of an artistic and technological movement that reframes South Asia as an active site for new media art and production.

City and space

Postcolonial theorist Homi K. Bhabha stresses the importance of moving beyond prescribed identities toward liminality, the space in between competing cultural traditions, in order to "bring language to a space of community and conversation that is never simply white and never singly black" (1998, 23). By focusing on media projects that address larger concepts of city and space, Sarai attempts to locate all people as citizens of larger communities and refuses divisive definitions of gender, sexuality, or membership into a certain class, caste, or social group. By defining people as citizens of city and space, Sarai is able to open up dialogue beyond categories of difference.

CityLives[1] is a Sarai project that explores and documents the life of the city and its "rhythms and routines" (Sarai 2006). By providing an expansive forum for storytelling, documenting, and media-making about their city, South Asians are able to recollect and represent the places where they live.

These writings, resources, and projects allow residents/contributors to imagine and re-imagine their city, with city-specific projects and proposals such as *Sahibabad Sounds*, a media project about youth mandali, or performative "gang" cultures.[2] Text from this project explains:

> we have collected conversations and stories on some 45 hours of tape. there are stories of cricket matches – played endlessly in the sahibabad sun, or competing with city teams in delhi [sic]. there are stories of shrewd money making in school that are also stories about second hand clothes markets in delhi [sic]. there are stories of schools – stories with moods of oppression, of hated teachers and smart subversive kids, of the endless question of english [sic], there are stoires [sic] about relatives from the village. (Sarai 2006)

As a "developing country," and as a culture highly exoticized in the Western imagination, India occupies a marginal position within the Eurocentric framework of the world. *CityLives* creates a sense of unity for inhabitants of Delhi who understand those same streets and those same city sounds, as well as creates a clear identity for Delhi within the world's exoticizing gaze.

Looking beyond the city, Sarai strives to build a network and an identity that ultimately exists beyond geography. Another project, *Circuits*,[3] describes real and yearned for connections and collaborations with other organizations throughout South Asia, Europe, and the world: "Travelers and communications arrive at Sarai following different routes, and transmissions from Sarai reach distant destinations in cyberspace to form interlacing networks of support, solidarity and collaborations" (Sarai 2006). In doing so, Sarai expresses a commitment to building an identity that extends beyond that of South Asians working in Delhi, to include international artists and media activists seeking others willing to work on the issue of new media and social change. With *Circuits* and other related projects, Sarai questions the artificiality of borders and the importance of moving beyond them toward a larger sense of community and connection.

Sarai's focus on global citizenship parallels a critical, ongoing shift from more traditional forms of identity politics – the ways in which people are defined by gender, race, class, sexuality – toward attempts to move beyond these dividing factors. The relevance of this new transnationalism and transculturalism is supported by globalization and the flow of labor and capital across borders, as well as "the development of the Internet and other global communication systems [where] the idea of a fluid identity has again become prominent" (Armstrong 2005, 1). This focus beyond traditional feminism and other strict definitions of identity allows for women involved in Sarai such as Monica Narula, also active in the RAQS Media Collective, to take a pivotal role in initiating and developing media work and theory from within a larger and highly successful collective entity. The focus on global citizenship in Sarai allows for the successful integration of men and women in the move toward a larger and more inclusive world for all genders and socially defined communities.

Democracy and inclusivity

In India, according to official government sources, information technology (IT) is the fastest growing economic sector with billions of dollars in U.S. investments in telecommunications and software outsourcing by companies such as Microsoft, IBM, and AT&T (Embassy of India 2006). It is also the world's fastest growing wireless market. As many of the benefits of the IT industry remain minimal in terms of gross domestic product (GDP), and as the IT industry is geographically centered in Bangalore, India is grappling with the tension of being both a "developing" country and, simultaneously, a country that is extremely "networked." With this position comes the urgent need for social responsibility toward segments of Indian society with little or no access to technology. According to the United Nations Educational, Scientific, and Cultural Organization (UNESCO), in 1999, only 23 percent of internet users in India were women (UNESCO 1999). Within the IT industry, labor is feminized as women often do not have the level of education needed for more skilled positions and are relegated to low-wage employment such as secretarial work or customer service in call centers.

To counter the hegemony of information technology corporations in India and across the world, Sarai strives to open up the digital world to a wider audience beyond skilled IT workers in Bangalore by distributing tools and techniques for media production. This is particularly important for Indian women, who often may not have the access or resources to pay for university and engineering college fees, which then inhibits their participation in IT and IT-related fields. Through their projects on the internet and in real space, Sarai strives to empower people by developing skills and distributing free software to enable them to participate in global media.

One such project is *FreeSoftware*,[4] a group of initiatives dedicated to "the free exchange of code, information and cultural products … [which is] central to [the] conception of the digital public domain" (Sarai 2006). Sarai offers free software links and the beginnings of a free software kit, as well as mailing lists to encourage dialogue and the free exchange of ideas and information pertaining to digital technology. Of the *FreeSoftware* projects, *Opus*[5] (also see "Compositions" on the Sarai website) has the most creative potential. *Opus* is a space that allows "people, machines and code to play and work together" (Sarai 2006). Unlike other websites that act as a repository for art and work by individuals, *Opus* enables users to enter the website as consumers and leave transformed as producers. Illustrating Sarai's mandate to build community and connections, all text, sound, art, video, and code in *Opus* are free to view, download, modify, and re-upload for public view, creating an online public art project and an international community of creative producers within a digital commons.

Through their interactions with the Sarai website, users are able to engage with media theory and ideas, view projects by global contributors, learn about the possibility of artistic creation with free software and code, and produce their own works of digital art. Sarai builds ideas and skills that transform the

user, regardless of their self-identifications or geography, into a state of empowerment and action.

Site II: *ART-e-FACT: STRATEGIES OF RESISTANCE*

http://artefact.mi2.hr/index_en.htm

*ART-e-FACT: STRATEGIES OF **RESISTANCE*** is an online, international magazine of contemporary art and culture that brings together various forms of feminist activist work. Much of the approach of the magazine relies on feminist principles as well as larger scale social critique to unite, rather than separate, various forms of political and social activism. Published out of Zagreb, Croatia, the editors Nada Beros (Croatia), Trudy Lane (New Zealand), Antonia Majaca (Editor in Chief, Bulgaria), Dalibor Martinis (Croatia), Tihomir Milovac (Croatia), and Leila Topic (Croatia) work to circulate feminist concerns within larger, artistic, and socially progressive communities.

The online project was initiated in 2003 as a way not only to foster contemporary art and culture but also to create a public forum for the critical consideration of social practices that are influenced by the introduction of technology, including the creation of new artistic practices and forms. In addition, the online collection of essays and artworks engages in the theoretical implications of representation and the role of the network in both artistic and non-artistic contexts. The editors of *ART-e-FACT* initiate their investigation in Eastern Europe, but like Sarai, they imagine geography as characterized by its fluidity. Feminist geographer Liz Bondi argues that such ambiguous conception of space is a hallmark of contemporary feminist spatiality; feminist positions are usually contradictory positions that work both within and against traditional disciplines and boundaries (Bondi 2004, 3).

Migration

Issue One of *ART-e-FACT*[6] focused on the social and political sources and problems of illegal migration. One site explored is Jezevo, a "reception center" in Croatia for thousands of illegal migrants before they are sent back to their home countries. The editors and artists explore illegal traffic in people (women in particular) between East and West, noting the "EU Fortress" as a common destination for Eastern European refugees. In this first issue, artists, theoreticians, and critics explored immigration in diverse ways. Writer Zoran Eric, for example, explores the controversial projects of Tanja Ostojic in *ART-e-FACT*'s first issue. Ostojic is a Croatian artist whose diverse works include *Personal Space*, first presented in 1996, which explores the interior and exterior perceptual states of the body, and *Black Square on White* in 2001, in which the artist shaved her body hair to match the composition of the Russian Suprematist Kazimir Malevich's 1915 painting, *Black Square*. Her work, *I'll Be Your Angel* (2001), was a performance in which the artist shadowed

the curator of the 2001 Venice Bienniale. Here, Ostojic used her body to place herself among dominant male figures of the art world, calling into question public, social hierarchies, the age-old consumption of women's bodies in art, and the complex relationship between the curator and artist. Her work, *Looking for a Husband with an EU Passport*, is an ongoing work since 2000, first established through an online advertisement by Ostojic in which she literally advertised for a husband with an EU passport. Being Croatian and investigating boundary crossing between European nations, Ostojic endeavors a transgression of the limitations inherent in having a non-EU passport. The artist met the chosen respondent, German artist Klemens Golf, and their interactions led to personal exchanges, and ultimately, to their wedding. The work, however, continues; it currently explores the details of immigration and the development of heterosexual, intimate relationships. In the work, she repositions the "physical" body and its engagement in a social milieu, in order to challenge public and private hierarchies in the complex world of identity politics.

Myth and Utopia

Issue Two of *ART-e-FACT*[7] focused on themes of utopian thinking. One short essay features work from the German Finger collective and publication venue (http://www.fingerweb.org/). Finger conducted a competition that challenged artists to think about design from a social perspective. For instance, rather than looking at design as solely a "graphic" issue, Finger urged artists to consider it as a "new point of reference" for the reconsideration of existing social structures and discourses on the interpretation and production of contemporary culture (German Finger Collective 2006). The call produced a great number of new design strategies from all over the world, highlighting the internet as an ideal model of transnationalism.

Issue Three of *ART-e-FACT*[8] focuses on "technomythologies." The contents include an essay by the curators Tanja Vujinovic and Zvonka Simcic that featured installations, photography, web art, and video-film production by artists from Belgrade, Serbia, Montenegro, and Ljubljana, Slovenia. This issue also included the Basque project, *The Rodriguez Foundation Robot*, which documents the post-Marxist critique of cyborgs and robots, ending in dystopian confusion about the work itself as it struggles between "high tech" sophistication and a celebration of human processes. *ART-e-FACT*'s focus on borders, immigration, and migration is relevant to electronic media and cyberfeminism, for factors such as globalization and biological warfare are frequently the cause of such shifts. The reviewers here note the strong political and utopian aspects of this collective work, seeing that these more collaborative, jointly authored processes are directly addressing third-world or disadvantaged groups' critiques of cyberfeminism that characterized 1990s' cyberfeminist debates (see Gajjala 1999; Sundén 2001).

Issue Four[9] focuses on the topic of "Glocalogue." Editors Zarko Paic, Marina Grzinic, and Zoran Eric (all from Serbia) stage a dialogue between the forces of globalization and artistic interpretations and interventions into the phenomenon

of global capitalism. In their essay, "Cultural Globalization Between Myth and Reality: the Case of the Contemporary Visual Arts," Larissa Buchholz and Ulf Wuggenig look at concepts of globalization as they both undergo critique and manifest within the art world. Artists such as Vlad Nanca (Romania) explore the popularized name for pig's feet in his native country, "Adidas," much like people in the United States refer to a "Xerox" as a photocopy, inscribing actual pig's feet with commercial athletic shoe logos. Croatian artist Lara Badurina takes a psycho-geographic approach to the experience of the city by collecting souvenirs from various districts representing different periods of her study.

Throughout the survey of artists in *ART-e-FACT*, the exploration of issues of poverty, materialism, and nation-states are paramount and the artists' contributions push toward an understanding of feminist principles, including the impact and individual experiences of the phenomena of globalization and culture. As María Fernández notes in her extensive critique of Euro-centric cyberfeminist practices, many involved in the cyberfeminist movement simply excluded issues of race, language, and other historical and material specificities in cyberfeminist discourse (Fernández 2002). The aims of collective art groups such as these are not in conflict with the aims of feminist action groups, because they reflect the greater societal goals of feminism; thus, the original aims (and claims) of cyberfeminism are more readily met.

In each of the *ART-e-FACT* essays and artworks discussed, the contradictions inherent in the use of technologies, such as the internet for community building and action, are constantly in play. The journal focuses on the inherent tensions between theory and practice, between action and inaction, between visions of electronic democracy and activism. Indeed, it even acknowledges that the internet is merely one means, among many approaches, that links international women's movements. In fact, some groups are very careful with their use of the internet, for there is almost an inherent bias toward the status quo. This is noted in various research projects on emerging media technologies in developing areas. Leslie Regan Shade, for example, notes that consumption, rather than production or critical analysis, is fostered by the corporate interests that introduce new technologies. The creation of such a tight link between new technology and consumer culture is cause for concern, and Regan Shade is quick to analyze the ways that the internet can be said to be "feminized" as a site for popular content and consumption (Regan Shade 2003, 61).

The works featured in *ART-e-FACT* attempt to counter this trend through radically different readings of social challenges and the examination of larger international systems of representation, politics, and power. The editors are careful to maintain a nuanced conceptual and theoretical exploration that could be found at times to lack a strong social activist art agenda. Yet this fledgling site/journal, in its plurality and international, intellectual, and grassroots contributions, crosses into powerful new territories and provides a way to link institutions such as galleries and universities to the social and cultural organizations working every day with the issues explored. It also provides a new working model for cyberfeminists to

lose, according to Fernández, its "colorblindness" (2002). Beyond mere exhortation or critique, the contributors are encouraging those who wish to experiment with possible answers to the crisis of power in communication systems such as the internet as a model for collaboration and social change.

Site III: subRosa

http://www.cyberfeminism.net/

subRosa, a collective of cyberfeminists engaged with new media art and social and political issues since 1998, is perhaps the most established feminist collective discussed in this review. The collective works both on and offline to interrogate the political role of "data" in everyday life. For instance, the project *Can You See Us Now? (¿Ya Nos Pueden ver?)* took the form of an installation at MassMOCA[10] that made visible the relationships between women, media, materials, and labor in a Massachusetts town and Ciudad Juarez, Mexico. Maps were used in the gallery to mark sites of refuge, power, and different products and services between the towns. The focus in this mapping project is on everyday life: the banal ways in which global change manifests on workers' bodies, and in particular, how the lived experience of women is continually inscribed through labor conditions and information and telecommunication technologies. Here, the critique helped create a critical space or site of social liberation and capitalist production (subRosa 2004). The connections between the seemingly random cities becomes apparent when examining issues such as transportation, which enables further exploitation of women in factories – in fact, the artists argue that multinational corporations, including 70 percent of the Fortune 500 companies, own the maquiladoras (factories) but do not contribute to taxes, provide safe working conditions, or create a decent standard of living for those employed.

In their ironic web project, *SmartMom: Technology that Grows on You*, subRosa critiques body surveillance through medical and military technologies by marketing wearable "smart" technologies integrated into a "Smart Maternity Dress" (see Figure 6.1). The faux product website markets the shirt to address the "problem … that pregnant and birthing women who are moving freely among the general population are hard to control and surveilled [sic] at all times" (subRosa 2006b).

The site includes additional "programs" related to the technology. Some of these, such as the "Cyborg Soldier Reproduction Program" enlists women into a "Repro Corps" to breed military personnel, eerily reminiscent of Margaret Atwood's dystopic novel *The Handmaid's Tale* (1986). subRosa's "Surrogate Mother Protection Program" encourages those who have hired surrogate mothers to monitor the health of the baby through technologies such as the Pregnancy Dress. The dress is outfitted with an abdominal screen in order for others to visually monitor the progress of the fetus.

Another example of inquiry into the intersection of bodies and technology, *Expo Emmagenics*, is a prank website about a conference "By Women, for Women,

and for Those Who Care." On the "conference" website, the "organizers" claim to celebrate women's contributions to the DNA data pool and fertility industry but in fact provide data about the primarily male-owned and led corporations, which advance reproductive technologies (subRosa 2006a). The site lists presenters, conference themes, a section on expert opinions, and even a shop for alleged products made available to the biotech community. In both *SmartMom* and *Expo Emmagenics*, subRosa works to illuminate underlying assumptions about biotechnology and the marketing of technologies designed to enhance everyday life.

Figure 6.1　Drawing for SmartMom Sensate Pregnancy Dress [1998], Faith Wilding and Hyla Willis (subRosa)

Information technology

Feminist artist Martha Rosler argues, "art with a political face typically gains visibility during periods of social upheaval" (Rosler 2004, 218). The information revolution continues to be a disruption of older, more traditional modes of production and labor. With this change comes both an inscription of new technologies onto more traditional social roles, family relations, and work environments and also a shift toward the monitoring and control of the individual (collecting personal and bodily data, tracking movement in space). This technology adoption – and adaptation – creates a continued disparity among working conditions, access to privacy, privilege, and fair wages, even in Western high tech arenas (IGDA 2005).

With the work of subRosa, the notion of "internet art" is expanded to include "information art" which explores the dimensions of digital culture and disenfranchisement. The artists, for example, compare live data streaming from particular economic or political regions alongside data from the body, focusing on how such data creates meaning for women and girls and allows others to monitor the experiences of workers around the globe. The information assembled in the subRosa projects highlights the connectivity inherent in global capitalistic practices and the information garnered from the body, and thus the group, uses the internet as a site of connection as well as space for questioning such connectivity.

Site VI: Couch Projects, Artist Angie Waller

http://www.couchprojects.com/

Angie Waller and her online presence, Couch Projects, document a compelling set of cultural interventions in commercialism and shopping. Her work sometimes

takes on a performative quality in that she engages with the very spaces of consumption, both online and off.

Consuming data

In her work, Waller investigates issues around the collection of data; whether among individuals or groups, one can see how certain kinds of data, such as purchasing patterns or e-mail communications, support larger aims of capitalistic consumption. A cornerstone of this work is that the outcome of performative consumption might be able to generate local and larger effects in critical thinking and socio-political evolution. In her work *Data Mining the Amazon* (2001–2002),[11] for example, the artist explores the data of purchasing and the connections it raises. The "Amazon" here is the large online book vendor, and Waller manages to survey the data filters for transactions, noting the recommendations for customers and aggregating them. Waller selects particular recommendations between books, customers, and music purchases and triangulates such choices politically in what the software industry benignly calls "data mining."

Waller's mining project incorporated a political point of view by monitoring relationships between books consumed by known liberals and known conservatives, as well as books recommended by the U.S. military or listed under profiles of political figures. Waller links those books purported to be favorites of George W. Bush, Margaret Thatcher, and other figures, and inputs these for recommendations through the automated Amazon system, which connects political figures to others in a novel kind of social network. Much like *Friendster* or *MySpace* social networks, these networks of consumption and ideology are constructed between people, yet Waller's networks are used to demonstrate systems of ideology and power. Relying on the rules of connection from Amazon's automated "agents," Waller generates books which in themselves represent a critique that is for sale in the format that it investigates. The book she assembled as a result of the research represents a millisecond's worth of uncanny systematized recommendations by the Amazon software; her aim is to repurpose software, which is supposedly a "helpful" customer service, into an amusing and even frightening window that monitors and reflects popular culture and values. The project, both a website and a publication, also asks how media and commercial trends disseminate into public opinion through both national and global outlets like Amazon.com.

Waller's work *Infinite Depot* (2005)[12] documents the space of Home Depot stores through the wanderings of two main characters through the large aisles of a Secaucus, New Jersey, branch. In the store, the characters interact with the products and materials for sale while shoppers zoom by in fast motion. The performative space of the U.S. store in *Infinite Depot* can be contrasted with her video/book work researching the *Home of Tycoons*,[13] both the title of a project as well as a high speed transformative housing project in Beijing. In *Tycoons*, Waller has created a catalogue that extensively documents the aesthetic facets of real estate development in Beijing as it has developed through its internet advertising,

virtual models, sales lobbies, and virtual "fly-throughs" of the three-dimensional computer graphic representations of actual real estate projects. In a performance- or audience-based context, Waller mixes these sources of information, working across media and incorporating internet feeds as well as video feeds from Beijing. These media are taken out of context and remixed for use in an artistic critique of consumer culture.

Waller's research-based art projects could result in the kind of "factual" report or data chart familiar in corporate annual reports or activist websites. However, she uses the data collected from various online information sources to form more impressionistic, systematic visualizations (photos, images, charts), which offer a strongly visual arts perspective on economics and politics. Waller's work is an example of a contemporary trend in which "net.culture" and its globalization are explored through the data that globalization generates. Such data manifests in a variety of forms, integrated into live performance and books.

Site V: CUT²

http://www.afsnitp.dk/onoff/Projects/projectsisabelch.html, Artist Isabel Chang Offline version: *Hvedekorn Magazine 2001* (Copenhagen, Denmark)[14]

> The status of both race and cyberspace as virtual objects demands that we examine the specific ways and instances in which they inflect and project each other in the realm of cultural representation. Does race "disappear" in cyberspace? (Lisa Nakamura 2000b, 11)

Isabel Chang is a New York-based web artist and designer whose experimental projects address race and gender in the United States. Her inclusion in this article is as an emerging artist who is unafraid to make direct comments on the exoticization of race and culture. Few new media works and websites feature the creative talents and ideas of Asian women, and fewer still highlight Asian women who choose to create web productions that are explicitly critical of contemporary American life.

Chang uses her personal identity explicitly to create web art narratives that con- struct new visions of Asians and "Asian-ness" in the United States. Her own iden- tity as an Asian woman does not disappear into cyberspace. Witnessing acts of racial tension, Chang uses this identity to frame her creative practice.

Combining fashion, story, and politics, *CUT²* is a web art project by Chang that is a humorous and potent commentary on the objectification of culture and the construction of identity. *CUT²* follows the stories of two racially ambiguous paper dolls, Razor and Slash. By selecting different outfits, the user can make fashion choices for the characters while further investigating the personalities and emerg- ing storylines of the illustrated personalities.

There are four fashionable outfits to choose from. Outfit One introduces Razor and Slash in black and white striped, "criminally-inspired" styles. Razor "the

Criminal" is punky and extremely spirited, and mistakenly believes that her alter ego is a criminal with fashion sense. In Outfit One, Razor enters her local coffee shop "fresh straight outta prison and cravin for nice cup of joe" (Chang 2001). In contrast, Slash "the Victim" is shallow yet fashionable and "is always on the look-out for the next new style" (Chang 2001). In Outfit One, she remarks excitedly, "Like all I'm going to wear this Fall is this. It's going to be such a hit, cause no one will expect the Prison as my inspiration! Oui, oui!" (Chang 2001).

As we progress through the series of four outfits, it becomes apparent that Razor "The Criminal" is "the Warrior" and "the Hero" of the story who fights fiercely for what she believes in, regardless of the consequences – and often narrowly missing police encounters. In Outfit Four, her final outfit, Razor attacks a Chinese restaurant named "Wok Don't Run" with her sharpened chopstick weapons:

> What the hell?! Razor skimmed the menu. None of this stuff is real! Moo Shu my ass! Gai Pan this in yer face! They ain't keeping it real. They ain't representin'. With a leap and a CTHD bound (Crouching Tiger Hidden Dragon, duh!), Razor dashed over the counter much to the chagrin of the lady standing behind it. (Chang 2001)

By challenging the authenticity of the Chinese restaurant catering to Western tastes, Razor becomes "the Hero" of the story. Razor is proud to represent Asians with authenticity and challenge those who consume and produce false versions of "Asian-ness."

In contrast, Slash "The Victim" is a "culture vulture," the posh fashion victim ready to consume all things Asian and otherwise for style and caché. She shows little progression of thought or intelligence throughout the series of four outfits, idly hopping from one fashion trend to the next. In her fourth and final outfit, Slash wears a tight pink and red floral "Oriental" cat suit with accompanying chopsticks as hair accessories and closes her storyline by saying, "Like what are we supposed to call them? Orientals or Asians? I'm so confused!" (Chang 2001). Slash represents ignorance and exoticization – the consumption of pop culture representations of race and culture without an understanding of its history or social and political context. Seemingly harmless, the actions of Slash are more deeply dangerous than they appear, signaling a clear misunderstanding and even disrespect of race and culture.

In her article "Race In/For Cyberspace: Identity Tourism and Racial Passing on the Internet," Lisa Nakamura argues that:

> **Asianness** is co-opted as a "passing" fancy, an identity-prosthesis which signifies sex, the exotic, passivity when female, and anachronistic dreams of combat in its male manifestation. (2000a)

For Nakamura, identity can be fluid on the internet; both producers and users can construct their racial, sexual, gender, cultural and subcultural identity through the choice of avatars or through text in e-mail and message board interactions. Identity

can be co-opted as a source of entertainment or distraction. In *CUT²*, Chang plays with the fluidity of identity and challenges users who choose the identity of "Asian-ness" as a "passing" fancy or as an identity that one can simply inhabit or claim to understand. Chang, through the character Razor, encourages users to rethink popular culture representations of Asian women. Paper dolls in Chang's work represent childhood play and the fragile dreams of young girls. In her use of the paper doll trope, Chang also references the flatness and one-dimensionality of her character-archetypes. Through both image and text, Razor and Slash represent dichotomies of race and gender: Princess vs. Warrior, Other vs. Authentic, Victim vs. Hero. The role of both Razor and Slash in *CUT²* is to encourage people to think more deeply about their actions and the meaning of their actions, and to see beyond the surface of racial and cultural identity toward the deeper social and political implications of how they are constructed and represented.

The strength of Chang's project *CUT²* lies in its potential to capture the interest of a new generation of women, in a humorous and accessible way – "stealthily" drawing a new audience interested in women's issues onto the internet. The success of the project lies in its drawing young women, particularly Asian women and women of color, into imagining the possibility of the internet as a space for art and activism – as well as a space to create new images of the self.

Conclusion

Our aim in presenting these varied projects is to expose the readership to new creative practice using the internet and also illustrate the challenges and possibilities faced by artists producing "hybrid" media art that is informed by activism, or with explic-itly feminist aims. New instances of "classic" cyberfeminist art in the beginning of the twenty-first century appear infrequent, even scarce.[15] Indeed, cyberfeminist politics and artists have faced a backlash when their artwork has been categorically positioned. Established cyberfeminist networks based on the dominance of female voices – even ironically, such as with the Old Boys Network (OBN) at www.obn.org – have faced a lack of critical mass and capital to sustain themselves. The OBN claim that "the mode is the message – the code is collective!" (2006) has been expanded in new models of collective cyberfeminist work, which increasingly involves both men and women actively supporting a larger feminist agenda. In the recent work examined in this essay, artists have moved beyond what has been traditionally accepted as "feminist art" and have carried their feminist activist impulses into web-related art projects that seek to strengthen activist connections and provide opportunities for many voices to be heard. Individual artists (such as Chang and Waller) and collectives or groups (subRosa, Sarai, *ART-e-FACT*) attempt to broaden the way the works of art themselves maneuver among an audience who may be tentative or unconvinced of the reality and validity of particularly Western feminist aims.

Martha Rosler has argued that "activists and hacktivists have stepped into the space vacated by video, whose expansively utopian and activist potential has been

depoliticized, as 'video art,' much like photography before it, was removed from wide public address by its incarceration in museum mausoleums and collectors' cabinets" (2004, 219). Perhaps the activists and hacktivists will too, at some point, be replaced. The work reviewed in this essay has engaged with the utopian and public activist potential of new media: the artists discussed here have not fallen prey to a depoliticized, glamorous "museumification" of the sort Rosler sees as typical of the "high" art world. The collective, hybrid nature of the works discussed here – moving fluidly from on screen to off, moving from art spheres to community centers, from one author to many, may help to keep the public dialogue in place and energize those engaged in collective action.

Notes

1 *CityLives* is available at http://www.sarai.net/ citylives/projects/projects.htm.

2 *Sahibabad Sounds* is available at http://www. sarai.net/citylives/projects/essays/hansa.htm.

3 *Circuits* is available at http://www.sarai.net/ circuits/circuits.htm.

4 *FreeSoftware* is available at http://www.sarai.net/ freesoftware/resources/resources.htm.

5 *Opus* is available at http://www.sarai.net/ compositions/opus/opus.htm.

6 *Art-e-Fact* Issue One is available at http://artefact. mi2.hr/_a01/lang_en/index_en.htm.

7 *Art-e-Fact* Issue Two is available at http://artefact. mi2.hr/_a02/lang_en/index_en.htm.

8 *Art-e-Fact* Issue Three is available at http://arte-fact.mi2.hr/_a03/lang_en/index_en.htm.

9 *Art-e-Fact* Issue Four is available at http://artefact. mi2.hr/_a04/lang_en/index_en.htm.

10 *Can You See Us Now? (¿Ya Nos Pueden ver?)* is available online at http://canuseeusnow.refugia. net/.

11 *Data Mining the Amazon (2001–2002)* is available at http://www.couchprojects.com/amazonweb/ pages/title.htm.

12 *Infinite Depot* is available at http://www. couchprojects.com/.

13 *Home of Tycoons* is available at http://www. couchprojects.com/.

14 For other web projects of interest by Isabel Chang, see http://www.foxfatale.com. Under projects, go to Aspergillium Gently, Word 4 Warn.

15 VNS Matrix, Dyke Action Machine, slitscan, WebgrrlsDeutchland, Chicas-Linux sites are either low-activity sites or completely shut down.

References

AAUW. 2000. *Tech-Savvy: Educating Girls in the New Computer Age*. New York: American Association of University Women Education Foundation.

Armstrong, Rhiannon. 2005. "Performing Identity in the Digital Age." Retrieved 7 March 2006, from http://www.csa.com/discoveryguides/perform/overview.php.

Atwood, Margaret. 1986. *The Handmaid's Tale*. New York: Knopf.

Bhabha, Homi K. 1998. "The White Stuff." *Artforum* 36(9):21–3.

Bondi, Liz. 2004. "10th Anniversary Address for a Feminist Geography of Ambivalence." *Gender, Place and Culture – A Journal of Feminist Geography* 11(1):3–10.

Braidotti, Rosi. 1996. "Cyberfeminism with a Difference." Retrieved 2 March 2006, from http://www.let.uu.nl/womens_studies/rosi/cyberfem. htm.

Chang, Isabel. 2001. *CUT2*. Retrieved 11 March 2006, from http://www.afsnitp.dk/onoff/Projects/projectsisabelch.html.

Commission on the Advancement of Women and Minorities in Science, Engineering and Technology Development (CAWMSET). 2000. *Land of Plenty, Diversity as America's Competitive Edge in Science, Engineering and Technology*. Washington, D.C. Retrieved 12 March 2006, from ww.nsf.gov/pubs/2000/cawmset0409/cawmset_0409.pdf.

Embassy of India. 2006. "India-U.S. Economic Relations." Retrieved 10 March 2006, from http://www.indianembassy.org/Economy/economy.htm.

Fernández, María. 2002. "Is Cyberfeminism Colorblind?" *ArtWomen.org*. July. Retrieved 1 March 2006, from http://www.artwomen.org/cyberfems/fernandez/fernandez1.htm.

Flanagan, Mary. 1999. "Mobile Identities, Digital Stars, and Post-Cinematic Selves." *Wide Angle: Issue on Digitality & the Memory of Cinema* 21(3).

Gajjala, Radhika. 1999. "Third-World Critiques of Cyberfeminism." *Development in Practice* 9(5):616–19.

German Finger Collective. 2005. Retrieved 21 March 2006, from http://www.fingerweb.org.

Hanman, Natalie. 2005. "Jobs for the Girls." *The Guardian*, 23 June. Retrieved from http://technology.guardian.co.uk/online/story/0,3605,1511985,00.html.

IGDA (International Game Developers Association). 2005. "Game Developer Demographics Report." Retrieved from http://www.igda.org/diversity/report.php.

Kennedy, Helen W. 2002. "Lara Croft: Feminist Icon of Cyber Bimbo? On the Limits of Textual Analysis." *Game Studies* 2:2. Retrieved from http://www.gamestudies.org/0202/kennedy/.

Koster, Ralph. 2006. *A Theory of Fun for Game Design*. New York: Paraglyph.

Margolis, Jane, and Alan Fisher. 2001. *Unlocking the Clubhouse: Women in Computing*. Cambridge: MIT Press.

Nakamura, Lisa. 2000a. "Race In/For Cyberspace: Identity Tourism and Racial Passing on the Internet." In *The Cybercultures Reader*, eds. David Bell, and Barbara M. Kennedy, 712–20. London: Routledge.

Retrieved from http://www.humanities.uci.edu/mposter/syllabi/readings/nakamura.html.

Nakamura, Lisa. 2000b. "Where Do You Want to Go Today? Cybernetic Tourism, the Internet, and Transnationality." In *Race in Cyberspace*, eds. Beth E. Kolko, Lisa Nakamura, and Gilbert B. Rodman, 15–26. New York: Routledge.

Old Boys Network. 2006. Retrieved from http://www.obn.org.

Ostojic, Tanja. 2001a. *Black Square on White*. Author performance.

Ostojic, Tanja. 2001b. *I'll Be Your Angel*. Author performance.

Ostojic, Tanja. 2000. *Looking for a Husband with an EU Passport*. Retrieved from http://www.cac.org.mk/capital/projects/tanja.

Ostojic, Tanja. 1996. *Personal Space*. Performance by artist.

Regan Shade, Leslie. 2003. "Whose Global Knowledge? Women Navigating the Net." *Development* 46(1):61–5.

Rosler, Martha. 2004. "Out of the Vox: Martha Rosler on Art's Activist Potential." *Artforum International*. 43(1):218–20.

Sarai. 2006. *Sarai Web Site*. Retrieved 15 March 2006, from http://www.sarai.net.

Schleiner, Ann-Marie. 2001. "Does Lara Croft Wear Fake Polygons?" *LEONARDO* 34:3, 221–6.

Slagle, Matt. 2004. "Women Make Small Inroads in Video Game Industry." *ABQ Journal*. Retrieved 13 September, from http://www.abqjournal.com/venue/videogame_news/apgame_women09-13-04.htm.

Sollfrank, Cornelia. 2002. "The Final Truth about Cyberfeminism." *Artwarez*, 1 March. Retrieved 1 April 2006 from, http://www.artwarez.org/?p=80.

subRosa. 2006a. *Expo Emmagenics*. Retrieved from http://www.cmu.edu/emmagenics/home/.

subRosa. 2006b. "SmartMom." Retrieved from http://www.andrew.cmu.edu/user/fwild/home.html.

subRosa. 2004. Retrieved from http://www.subrosa.net.

Sundén, Jenny. 2001. "What Happened to Difference in Cyberspace? The (Re)turn of the She-Cyborg." *Feminist Media Studies* 1(2):215–32.

United Nations Educational, Scientific, and Cultural Organization (UNESCO). 1999. Statistical Yearbook. Retrieved from http://projects.aed.org/techequity/India.htm.

U.S. Department of Commerce, National Telecommunication and Information Administration. 2002. *How Americans Are Expanding Their Use of the Internet.* Washington, D.C.

Wardle, Caroline C., Diane Martin, and Valerie A. Clarke. 2004. "The Increasing Scarcity of Women in Information Technology Is a Social Justice Issue." In: *Challenges for the Citizen of the Information Society: Proceedings of 7th International Conference ETHICOMP 2004*, 893–903. April, Syros, Greece.

Wilding, Faith. 1998. "Where is Feminism in Cyberfeminism?" *n. paradoxa: international feminist art journal.* Volume 2, July. Retrieved 10 March 2006, from http://www.andrew.emu.edu/user/fwild/faithwilding/wherefem.html.

Further readings

Towards the Feminine Sublime, or the Story of "A Twinkling Monad, Shape-Shifting Across Dimension;" Intermediality, Fantasy and Special Effects in Cyberpunk Film and Animation, Livia Monnet, *Japan Forum*, 14(2), 2002.

Next Level: Women's Digital Activism through Gaming, by Mary Flanagan in *Digital Media Revisited: Theoretial and Conceptual Innovation in Digital Domains*, G. Lienstol, A Morrison, and T. Rasmussen eds. (Cambridge: MIT Press, 2003).

Related Internet links

Sarai: http:/www.sarai.net/
ART-e-FACT: http:/artefact.mi2.hr/index_en.htm
subRosa: http:/www.cyberfeminism.net/
Couch Projects: http:/couchprojects.com/
Isabel Chang: http:/www.afsnitp.dk/onoff/Texts/brogger artinacul.html
Mary Flanagan: http://maryflanagan.com/default.htm

Part II

(In)Visible Architectures
Space / Geopolitics / Power

Introduction

The essays in Part II explore ideas of history, modernity, geopolitics and techno-logy, focusing on analysis of the visual in the production of local geographies. A key concern of this section is to show how power is embedded in, and enacted through, architectural forms. In addition to the built environment, architecture here refers to the system of networks of surveillance and control, and may also be thought of as a framework for visualizing geopolitical imperatives and the produc-tion of space through various cartographic projects.

In *Geographies of Resistance* Steve Pile and Michael Keith note that authority pro-duces space, through dividing it, marking it, and controlling movement within it. They add that spatial technologies of domination, from military occupation to urban planning, must continually work to resolve specific spatial problems such as surveillance, movement of people, communication, etc.[1] The essays in this Part deal with precisely such technologies of domination, describing how they produce specific kinds of spaces (and subjectivities), through government architecture, state-mandated dress codes, control of movement of people within and across borders, and televisual and virtual spaces.

Various essays in Part II implicate the body and its role in shaping the city and architectural space, and reveal how bodies assume architectural forms, situating architecture as a site of both domination and resistance. (This theme also appears in the essays by Scott Ruff and Simon Leung in Parts III and IV.) The idea of archi-tecture as a site of monumentality is discussed in relation to buildings but also in the form of the mobile architecture of the chador. As Çagla Hadimioglu writes in *Black Tents*, there is a correlation between the monumental building and the chador in their "operations as sites of memory and political intent."

The other central theme of these writings is the connection between visual imagery, technology, and war, such as the deployment of images as part of the discourse on the US "War on Terror." The use of scientific imagery as a distancing mechanism for portraying destruction, and of mediatic techniques as a means to thwart substantive discussion of social and political relations, are taken up respectively in the essays by Kathryn Yusoff and Rosalind Morris. Both authors address the relationship of real-life events to images and their circulation in divergent ideological discursive contexts.

In the opening essay, *The Arquitectural Lesson of Arnold Schwarzenegger,* Cuauhtémoc Medina suggests that Paul Verhoeven's use of buildings easily recognizable as symbols of state power in *Total Recall* locates the film's dialogue within a specific architectural school and its aesthetic and political values. Medina suggests that what is referred to as the contemporary movement in Mexican architecture, and expressed through an artificial amalgamation of pre-Hispanic, colonial and modern histories, serves to prop up the official discourse of Mexican nationalism and the myth of a modernizing state.

He argues that through its portrayal of specific buildings and urban settings, *Total Recall* reveals a theory of state architecture characterized by authoritarian discourse and the embrace of a luxury aesthetic sustained by cheap labor, and manifested in official monuments surrounded by sterile, isolated urban spaces. Mexico's official architects Medina argues, "have understood architecture as a means of retroactive reconciliation of historical pasts that constitutes the only condition from which to aspire to modernity," while overlooking present day conflicts and tensions in Mexican society.

Eyal Weizman's chapter *Checkpoints: The Split Sovereign and the One-Way Mirror*, is part of larger project on the architecture of occupation, focusing on the conflict between the Israeli government and Palestinians in the Occupied Territories. The chapter included here focuses on the political and diplomatic processes that have emerged as an offshoot of the Oslo Process (1993–2000), in particular, the role of mechanisms of control over the movement of Palestinian people and the architectural embodiment of this surveillance and discipline in the example of the Allenby Bridge border terminal. Weizman notes that the architecture of this and the other border crossings connecting the disputed territories represent the Israeli government's attempt to "resolve the structural paradox that resulted from the seemingly contradictory desire to enable the functioning of Palestinian autonomy while enabling Israel to maintain overall control of security."

Pointing out the way in which the architecture of the terminal has been made to embody military, political, and economic logic of the Oslo process, which replaced direct Israeli occupation with the creation of a Palestinian Authority, Weizman argues it was "not the Palestinian passenger, but the agent of the Palestinian Authority, who had to internalize the disciplinary power of surveillance and be under the gaze of the Israeli security personnel." Diverging from Deleuze's model of the evolution from disciplinary societies to control societies,

Weizman contends that in the case of the terminal's design, the two systems of domination coexist "as two components of a vertically layered sovereignty, which is here horizontally separated across the sides of the one-way mirror."

In *Black Tents* Çagla Hadimioglu theorizes the architecture and social space of the *chador* (typically referred to as the veil in English), a garment designed to cover a woman's body, leaving a small portion of her face visible. Using the analogy of a black tent, the author conceptualizes the *chador* as a "mobile home that facilitates a woman's movement around the city and her dealings with men" but also as monumental architecture, thus supporting multiple readings of the garment. Focusing on the history of the *chador* in Iran, she points out that Islam does not prescribe the *chador*. Thus, Hadimioglu notes, "the rationale for its continued enforcement in Iran must lie elsewhere – in its function as a site of memory and symbolism," maintaining that with the Revolution, the *chador* became a form of mobile monument.

Drawing on the work of artist and filmmaker Shirin Neshat, Hadimioglu writes: "A black screen cannot display an image that is projected onto it. Perhaps the black of the chador should be considered not as a void but as the result of an accumulation of inscriptions or projections so dense that they become solid …" The chador becomes in these works a site of resistance, and also poetic pleasures. "Functioning as a site of memory and representation of power, these images and texts might constitute a contemporary Iranian monument, articulating a monumentality characterized by surface."

In *Subterranean Modernities: The Spanish City and its Visual Underground*, Juan Egea engages in a reading of modernity and the processes of urbanization through the comparison of aboveground and underground built environments in Madrid, Barcelona, and Bilbao. He contends that the subway maps of each of these cities display a visual underground, a "subterranean modernity" that shares characteristics with their aboveground modernities, made visible and experienced in city streets and architecture.

Egea illustrates how each city's underground system represents and reflects its aboveground identity, aspirations and political history. The subway maps that are the focus of the essay are valuable images for the study of the modern city. According to Egea, "As representations of modern urban space … these subway maps are part of the 'cultural imaginary' of the Spanish city," contributing to the visual identity of the metropolis they represent. Through performing a cognitive mapping of the modern metropolis, Egea concludes that the history of the underground is an underground visual history of the Spanish city.

In *Visualizing Antarctica as a Place in Time* Kathyrn Yusoff presents an analysis of the geopolitical imperatives revealed through the production and global dissemination of topographical satellite maps of Antarctica. The NASA RADARSAT map constructs a particular kind of visualization of Antarctica that according to Yusoff "ties the map firmly to the visual technologies of war that precede this visual simulation and the contemporary politics of global warming." Documenting the dramatic collapse of the Larsen B ice shelf, Yusoff places this visual data in the

context of an American obsession with the spectacle of destruction, using Andy Warhol's Death and Disaster series from the 1960s as an example. Yusoff argues that the RADARSAT map simultaneously aestheticizes and depoliticizes the territory and landscape of Antarctica, exercising the potential of technology to isolate time and space, and by association, the continent itself, in historically and environmental terms.

In *Images of Untranslatability in the US War on Terror* Rosalind C. Morris discusses the televised "9/11 Commission" hearings of 2004. Asserting that the hearings disseminated a particular imagery of democracy, Morris analyzes the place of mediatic technique in this particular formation of US democracy and seeks to elucidate the place of images and symbols in relation to actual acts of terror and violence.

Arguing that from the beginning of the Iraq war the administration of George W. Bush used televisual imagery to elicit sympathy and support for its position, Morris characterizes the deployment of these images as fetishistic and narcissistic. Referring to Paul Virilio's concept of technical fundamentalism, Morris contends that the privileging of images for their "truth telling" quality over their symbolic capacity was made visible in the replacement of substantive openness by a concern over technique. The central problem according to Morris lies in the "presumption that an image can constitute an address, and that it can traverse the space where language, history, and language difference would require translation." The dangerous outcome is that politics "is thus reduced to an image of its procedures."

In the essay *An Immense and Unexpected Field of Action*, J. Macgregor Wise considers the proliferation of webcams and the implications of their growing presence in everyday life. Offering examples of projects that explore the intersections of technology and everyday life, Wise argues that the camera's gaze not only reveals but contributes to new social formations related to life in a surveillance society. Incorporating the theories of Mark Andrejevic on the digital enclosure and Michael Goldhaber on the attention economy of the Internet, as well as Deleuze's notion of control societies, Wise offers examples of projects that seek to evade or refuse participation in the new "attention" economy of webcam surveillance.

Wise rejects a model of vision as disembodied process, countering with a model for understanding the relation of body to technology as assemblage, an "and" rather than "either/or" procedure. He goes on to invoke Heidegger's concepts of "care" and "Dasein" (Being – emphasizing its collective character), extending these to digital communities, who Wise suggests are not composed of isolated selves connecting through technologies but, rather, exist in a collective humanity into which technologies are incorporated. Wise acknowledges networks of control but also points to the possibilities for revealing new subjectivities through assemblages of networks.

Note

1 See *Geographies of Resistance*, Steve Pile and Michael Keith, eds. (London: Routledge, 1997), p. 3.

7

La Lección Arquitectónica de Arnold Schwarzenegger
The Arquitectural Lesson of Arnold Schwarzenegger

CUAUHTÉMOC MEDINA

1. Geopolitics of Forgetfulness

Keywords

Total Recall
history
representation
architecture
Mexico
state power
contemporary
 movement
materials
nationalism
modernity
cultural symbols

"I dreamed about Mars again… it was bizarre, yet it was so real…"(Ronald Shusett and Steven Pressfield: Fifth revision of the screenplay of Total Recall.)[1]

Doug Quaid (Arnold Schwarzenegger) awakes with a start at the side of his wife, Lori (a stunning Sharon Stone). Bathed in sweat, the mediocre Quaid has been visited for the nth time by the dream of an alien world and an alien love, a social nightmare and the hounding of an impossible desire. Once more, Quaid has dreamed of Mars.

In other circumstances this might be a distorted symptom emerging out of Quaid's unconscious; "Mars" appearing as the substitution, condensation and displacement (to) use the well-known trio formulated by Freud in his *Interpretation of Dreams*) of a thought repressed by the ego. But as is well known to all those who have seen *Total Recall* (U.S., 1990), the apparatus of repression is clearly objectified. Technology is capable of generating or suppressing memories at will in our minds, "extra-factual implants" that render our identity malleable and programmable. In short, a device capable, of inserting ideology, nostalgia or guilt into our heads as easily as a program is installed in a computer.

The movie unfolds from there, as though we were opening a series of Russian *matrioshkas*, or perforating the onion skins of a series of personalities, each one covering others. Douglas Quaid is, and is not, a construction worker. Before his memory was altered, Quaid was no less than Charles Hauser, the strategist of a monopolistic corporation that oppresses Mars, the planet colony, in order to

extract the energy source "trebinium" from its mines. Before being sent to Earth, however, Hauser had deserted, (or pretended to desert) and gone over to the side of the rebels working to overthrow the colonial regime on Mars. We learn later that this defection was a pantomime: Charles Hauser was a mole that the colonial administration used to infiltrate the revolutionary movement, the "Martian, liberation Front". So Quaid's memory is a veritable palimpsest that crosses not only gravitational fields, but also social classes and political affiliations.

Like much science fiction, *Total Recall* is a drama inhabited by the Cartesian "evil demiurge": it suggests the possibility that we are living through an historical, epistemological and metaphysical farce, in which the ego is divested of authority, a victim of the disappearance of all evidence. Paul Verhoeven, who directed *Total Recall* (as well as *Robocop*) even treats it as a sequel to *The Metamorphosis:* the movie "is about identity– it's the Kafkaesque nightmare of the theft of the mind. In other words, a modern psychosis."[2] In fact, the Philip K. Dick short story on which the movie is based, *We Can Remember It For You Wholesale* (1966), is above all an exploration of a peculiar syndrome of recovered memory: "Douglas Quaid" ("a miserable wage-earner", according to Dick) goes to "Rekall Incorporated" to have an interplanetary adventure implanted in him. The brainwashing (Figure 7.1) simply reveals that his most extravagant fantasies are all true: not only did he used to be an "Interplan" secret agent, but at the age of nine he saved the Earth from an invasion of aliens.[3]

In the film, this anecdote of a "return of the repressed" is subordinated to the saga of an interplanetary revolution. In fact, *Total Recall* can be read as a Hollywood reflection on the recent history of tensions between the United States and Latin America: the "trebinium" extracted by Earth from the planet Mars is nothing less than oil, and the dirty war and exploitation on the planet colony are clearly a representation of the neocolonial administration that American capital carries out south of the Río Grande, confronted all the while by Latin American Marxist guerilla movements. But in presenting a fable of north/south economic and political relations, *Total Recall* implicitly formulates a theory of its own conditions of production.

Later dubbed into Spanish and entitled *El Vengador del future* ("The Avenger of the Future"), *Total Recall* was almost entirely filmed in the Churubusco Studios in the south of Mexico City. Like *Dune, Titanic* or *The Mark of Zorro*, it bears witness to a process of economic reconversion starting in the mid-1980s whereby the Mexican film industry –which at its peak, in the so-called "golden age" of the forties and fifties, was the movie-making capital of the Spanish-speaking world – has been practically dismantled to be turned into a supplier of cheap film labor: the southern maquiladora branch of the Hollywood dream factory.

It was therefore for economic reasons, rather than poetic ones, that *Total Recall* was filmed at a number of real locations in Mexico City. And in that, it contains, beyond its psycho-technical fantasies and action scenes (the movie Schwarzenegger wanted to be his *Blade Runner*), an extraordinary vision of architecture in Mexico.

Figure 7.1 Still from *Total Recall* ("Doug Quaid")

2. "I saw Mexico City again… it was bizarre, yet it was so real…"

All of the locations in the first part of *Total Recall* (that is, the part that supposedly takes place on Earth) are fantastic excursions through buildings in Mexico City, in large part examples of the architecture of the later stages of the PRI regime, from the end of the 1960s to the beginning of the 1990s. All of these buildings exemplify the failed project to put Mexico on the road to modernization (third-world or integrated, paternalistic or neo-liberal) carried out under the direction of the presidential monopoly on power. Verhoeven has Schwarzenegger act in at least four buildings clearly recognizable to a resident of Mexico City. Spaces that are barely disguised by the camera's faculty of abstraction and recomposition, and by the careful substitution of a few street signs. Significantly, in all cases the locations are public buildings, so the movie could be said to contain a cameo appearance by the Mexican government – at least insofar as it agreed to allow the locations to be used – or more exactly, by its recent architecture.

The cross-section offered by *Total Recall* of Mexico City's architecture is extraordinarily canonic: it focuses on the most prominent element of late-twentieth-century urban infrastructure in Mexico, the "Metro", or subway system, side by side with some prominent examples of the central corpus of the so-called "contemporary Mexican movement" in architecture. To start with, the apartment scenes and the housing project where Quaid lives are really shots of the "Heroic Military College" on the highway to Cuernavaca, the most celebrated work of Agustín Hernández. *Total Recall* uses the monumental, statist character of the complex to evoke the image of an authoritarian and hyper-technological future. On the way

Figure 7.2 Image of cars, still from *Total Recall* (robotic "Johnnycab")

Figure 7.3 Military College / Colegio Militar. Photo by Oscar Ramírez

back to *Rekall* in a robotic "Johnnycab" (Figure 7.2), Schwarzenegger moves along a highway lined with retention walls giving access to the College, before being greeted with a long view of the famous pyramidal buildings that constitute the ceremonial center of the complex (Figure 7.3). It is only then that the film subverts the continuity of real life to integrate imaginatively into the city a building isolated in a military suburb: the vestibules of the military college connect in the imagination with the corridors and tunnels of the Chabacano subway station in Mexico City (Figure 7.4), adapted to the futurist aesthetics of the film by an absolutely simple touch: the orange and yellow coaches of the subway trains are painted a silvery gray. The color change not only projects them into the future, but also lends them a certain military air. The result of this compound of martial / functional architecture is a representation of the future civilization of the "Northern block" as a city

Figure 7.4 Subway station, still from *Total Recall*

that has totally succumbed to an exacerbation of anodyne circulation space: Quaid inhabits a miniscule private dwelling set in an urban context without streets, because everything has been converted into overpasses, tunnels, stairways, railings and corridors. This urban landscape is nothing less than the "non-place", a circulation space that for Marc Augé defines "supermodernity":

> (…) the totality of aerial, rail and auto routes, the mobile cabins classified as "means of transportation" (aircraft, trains and automobiles), airports and train stations, hotel chains, amusement parks, enormous shopping centers and, finally, the complex wire and wireless network that mobilizes extraterrestrial space for communication so peculiar that it often puts the individual in contact only with another image of himself.[4]

Quaid inhabits a world where, as Augé suggests, "transit points and temporary dwelling places proliferate under both inhuman and luxury conditions", migrating perpetually from hotels to customs-houses to plazas closed onto themselves, to office buildings, warehouses, viaducts, etc. Places dominated by an illusion of transparency, carried to its extreme by the X-ray booth through which all subway passengers have to pass to prove they are not carrying arms. But all of these spaces are stripped of historical and biographical associations. Instead of establishing a practical and cultural relationship with a site, individuals pass through these non-places as through a semiotic space, that is, by means of signs and instructions.[5] The

Figure 7.5 Subway station signs, still from *Total Recall*

very fact that it is enough to substitute a couple of street signs to project a Mexico City subway station into the future is indicative of its historical and cultural "non-place-ness" (Figure 7.5). This fluid geography of the city in *Total Recall* leads to two places that, although they are not interchangeable, function as ceremonial nodes of the narration: Quaid's apartment and the corporate office, the two stopping places on the capitalist daily routine. It is especially ironic that the settings of both spaces are provided by the headquarters of a Mexican government institute hypothetically dedicated to the construction of low-cost housing: the General Offices of the National Institute for Workers' Housing, INFONAVTT (1973–1975) (Figure 7.6), designed by Abraham Zabludovsky and Teodoro González de León. The plaza, facade and lobby of the INFONAVIT building are the seat of the corporation dedicated to implanting dreams and self-deception to which Quaid goes in search of the illusion of having gone to Mars: *Rekall*. Using this building, the pride of the Mexican bureaucracy in the 1970s, as the entrance portico to a world of dream merchandise produces a whole series of strange visual collisions. On the one hand, the decontextualization, not at all infelicitous, of a group of works of art. On the walls of the *Rekall* offices hang the landscape serigraphy prints of Jan Hendrix, a Dutch engraver who settled in Mexico in the mid-1970s. The serigraphy prints belong to a series Hendrix executed in the 1980s, projecting the fantasy of a new naturalist. Still more striking is the fact that *Rekall* exhibits various *Magiscopios* by Feliciana Béjar, sculptures made with fish-eye glasses, like enormous magnifying glasses, that refract their surroundings as a series of parallel worlds. Relatively isolated examples of local art, precisely those that establish a dialogue with the science of optics.

Finally, there is a moment in the movie that registers, phantasmally enough, the textures of third-world street life. In the course of the chase sequence that brings the first part of the movie to a climax, Quaid, who has discovered that his

Figure 7.6 Central Offices of INFONAVIT, 1974–75. Photo by Oscar Ramírez

identity is false, takes refuge in the sunken plaza that leads into the Insurgentes subway station. Though the darkness conceals the Mayan and Mexican Colonial decor of the station, the movie makes very explicit use of its layout, configured by two circular overground constructious. These even appear on the electronic tracer employed by the agents pursuing Quaid. The fact that the Insurgentes plaza (Figure 7.7) is sunken situates Schwarzenegger in "another space" denoted exclusively by the illuminated advertisements of various transnational companies: Coca-Cola, Montana, Sony, etc. Making the, most of the exotic location, Verhoeven also allows himself the luxury of an advertisement for *Tacos Beatriz*, which in another context might have served to recreate the catastrophic multicultural territory of *Blade Runner*. But its role in *Total Recall* is completely marginal: it is the unconscious indication of a site reduced to serving as the background to a futuristic class struggle.

Of course, this advertisement for *Tacos Beatriz* does not entirely justify the use of *Total Recall* as a reading of the postmodern condition of Mexico City, a thesis that has been advanced by both the historian Serge Gruzinski and the writer Juan Villoro. Gruzinski has seen in Schwarzenegger's rambles through the Insurgentes subway station a confirmation of the neo-Baroque character of post-Colonial Mexican society and culture, which blurs to some extent the order of time and the "frontiers of the imaginary and the real"[6]. Villoro, on the other hand, believes they demonstrate the post-apocalyptic character of the city, a commentary that might be more applicable were it a question of *Terminator* or *Mad Max*. These generalized readings have the defect of restoring the setting of the film to a mythology of

Figure 7.7 Insurgentes Plaza. Photo by Oscar Ramírez

"Mexicanness". In fact, the excavation undertaken by *Total Recall* implies a much more restricted commentary, a vision not so much of the metropolis as of certain architectural spaces. It is only *through* the reflection of these spaces that the film may perhaps allow us to comment on the imaginative processes (or certain imaginative processes) of the society that produced them. The choice of urban and architectural spaces in *Total Recall* is determined by an image of technological and administrative order in which the spectator does not glimpse the entropy or poverty usually associated with the third world. The purpose of the architecture that the film re-uses is, on the contrary, to represent a territory governed by an authoritarian and geometrical obsession, the blend of a strictly-governed post-industrial metropolis and the ambition of the prison spaces of Piranesi. Some of the buildings, moreover, are characterized by their capacity to eliminate all notion of context. One might say that what makes them characteristic of their place of origin, and defines them architecturally, is that they are designed to stand out from, repudiate, and break themselves away from their surroundings.

3. A State Setting

It really is surprising enough that the buildings chosen by Paul Verhoeven lend themselves so easily to being appropriated cinematically. It was only necessary to remove a few signs and change the users, for these subway platforms, lobbies,

vestibules, corridors and façades no longer to form part of a late-twentieth-century third-world megalopolis but rather to represent the terrestrial capital of a future interplanetary empire. This possibility is written into the architecture itself, due to conditions that can be outlined very schematically as follows:

a) Authoritarian spaces: The buildings are constructed on monumental lines, according to an aesthetic not only of physical largeness, but also of uniformity of materials, lack of decorative softening and, in general, extreme sobriety. They abound in progressions of perspectives that seem to represent a social machinery of imposing planes and depths, in a construction style of large masses, sparse fenestration, and few ornamental details or descriptive elements. This language generates a visual rhetoric that I will designate, for lack of a better term, "authoritarian", in which the individual is constantly confronted not only by the large size of a construction and the vastness of its design, but also by a space intended to be peopled by anonymous masses. A space, in short, that suggests an invisible creator, because it directly confronts the user with an authorial entity: the architect and, behind the architect, the State.

b) State fiction: If these buildings lend themselves so readily to being used as Hollywood locations, it is because they themselves originate from stage scenery, a category that has been abused somewhat by modernist criticism, but which in this case can be invoked more or less literally. It is not only that all of the buildings belong to a series of currents (the so-called contemporary Mexican movement) that has affirmed the need for an artistic will in the architect (the "will of the creator", to use the title of a book about Teodoro González de León), in opposition to the supposedly anesthetized dogmatism of strict modernism. One feature that distinguishes the movement is that, instead of filtering or negotiating with the urban surroundings, the architect seeks obsessively to create isolated spaces (especially reception plazas) in order to generate points of view free of the ambient "noise".

This insistence on constructing autonomous buildings is splendidly exemplified in the way González de León and Zabludovsky designed the INFONAVIT building, giving it a circular plaza that commands a panoramic view, and thus freeing itself of all intrusive urban elements. The same isolation is achieved by the sunken plaza of the Insurgentes subway station: on entering it one is literally transported, to a space cut off completely from the city, which runs its dizzying and noisy course all around. This passage to "another place" can even destroy the previous streetscape, as photographs of the former intersection of Insurgentes and Chapultepec make clear. The construction of the subway station completely eliminated the buildings that completed the original design of the Colonia Roma. And the use of stage settings certainly entered into Agustín Hernández's motives in his work on the Military College, which was built with a very specific type of theatrical representation in mind: military parades and honors. This ritual consciousness was expressed by the architect himself:

Military College / Scale for marches eight rows deep, not for a man walking alone (…) reminiscences of pre-Hispanic ceremonial centers / urban reflection and geometrized cosmogony.[7]

c) The work as decoration: As we all know, cinematic fiction depends on comprehensible editing, for otherwise the filmed montage would simply be a Dada or Cubist mélange. Total Recall could not jump from one side of Mexico City to the other unless there were a minimum identity of visual media among buildings designed by such different architects. Let us keep in mind that a movie does not just demand a certain unity of style in its locations: it should give the impression that we are looking at constructions peculiar to a given civilization. This style of a civilization goes beyond the mere suggestion of common tastes: it can only be achieved when buildings, or works of art, suggest shared values and living conditions.

We have already mentioned one element of similarity common to the buildings appearing in *Total Recall*: a geometrical architecture of large masses. A second element is the question of color and surfaces, which contains, in the final analysis, an economic significance.

With the INFONAVIT building Mexican architecture adopted a decorative resource that has been so generally abused that it seems almost natural to us now: cladding in bush-hammered concrete mixed with marble. As González de León and Zabludovsky have repeatedly affirmed, this cladding was a practical solution, to the problem of the lack of expressiveness of the concrete surfaces of the Modernists, and a way of dissimulating the poor quality of the finishes of local masons. But the fact that this kind of cladding has been used in the greater part of Mexican public buildings and corporate offices for the last twenty-five years is also an indicator of exploitation. It bears witness to an availability of cheap manpower characteristic of underdevelopment, since it requires a quantity of manual labor that is only financially feasible in conditions of poverty-line wages.

In fact, these materials come equipped with an entire social rhetoric. If high-tech finishes indicate a level of development that has not only industrialized architecture, but even given it a high dose of aesthetic obsolescence, the bush-hammered concrete cladding endows Mexican architecture with Pharaonic characteristics. These are buildings that transmit, consciously or unconsciously, an enormous waste of effort. They have the beauty of inequality.

It is not by chance that banks and public bodies in Mexico have chosen to attire themselves in accordance with this labor holocaust aesthetic. More than just the invention of two architects: in the 1970s, this labor-intensive aesthetic satisfies a prevailing taste in the circles of political and economic power. Put in very simple terms, this cladding has naturalized the brutality of the social context in the form of architecture. For if González de León and Zabludovsky intended to achieve by this texture a sort of artificial stone, warm and easily replaceable, they also managed to lend a pebbly, hand-crafted quality to structures that might otherwise openly display their geometrical and structural harshness.

4. Archaeo-architecture

It is ironically appropriate to use the word "emblematic" to designate the buildings in *Total Recall*. Though some-what invisible in the film, the Insurgentes plaza contains an entire iconographic program, largely because it was the station chosen for the inauguration ceremony of the subway system in 1969. In other words, it is a construction conceived to serve as background to a presidential epiphany. Gustavo Díaz Ordaz, accompanied by members of the then all-powerful ICA construction firm boarded a subway train coach that carried him under television lights and flashbulbs from Metro Insurgentes to the Zaragoza station. For this inauguration ritual and the unveiling of a commemorative plaque that bears witness to the marriage of power and public works in Mexico, the Díaz Ordaz administration chose the station that reflected in its architecture the obsession of the official PRI ideology with historical synthesis. For the Insurgentes station is also, in its way, a "Plaza of Three Cultures".

In effect, the plaza evokes in its decoration the three stages into which the official discourse of Mexican nationalism is divided: "Pre-Hispanic, Colonial and Modern". The very circularity of the sunken plaza alludes to the Utopia of modernity that synthesizes the two previous historical stages: the exterior of the subway station construction is covered in Mayan glyphs, while the circular interior is decorated with reliefs alluding to the Conquest and the Colonial period.

This function of summarizing Mexican history is a generalized characteristic of official Mexican architecture. It operates at the very center of the work of González de León, Zabludovsky and Hernández. They have understood architecture as a means of retroactive reconciliation, in which the architect acts as a mediator in the process of eternal symbiosis of "Mexicanness".

> Pre-Hispanic architecture has to be understood, and we have to salvage it, as well as colonial architecture, two architectures that were in conflict. One was a mathematical architecture, of open spaces. (...) Mediterranean culture, the culture of the conquistadors, [is an architecture] of interior space. (...) Mexicans therefore inherit these two contradictory spaces, Our task is to reconcile these two spaces, to reconcile these two cultures, through the analysis of what our culture has been. This is the only way we can plot out our future, by remembering our past, manifesting it in our present and projecting it into our future.[8]

In effect, "reconciling these two conflicting cultures" (something different from examining the development of the post-colonial tensions of two groups and traditional cultures) appears to be an unquestioned cultural command: it is the voice of the State, defining not only the task of architecture, but also – I dare say – the role of all producers of national culture. This allegorical reconciliation of two pasts is, in Hernández's words, what constitutes "the only" way of participating in the future, the only condition from which to aspire to modernity. Whatever rivalries may exist between him and his contemporaries, González de León agrees

completely with Hernández on this point, as shown by his response to a question posed to him in the mid-1980s about the nature of modern Mexican architecture:

> There is a frank use of analogy (through a profound analysis) with pre-Hispanic cultural expressions and certain spatial expressions of the Colonial period and of traditional Mexican architecture. (…) (p. 54)

For the same reason, the designers of the INFONAVIT building explain their preference for the central patio or courtyard as "the most natural solution to articulate space in buildings with complex programs" by its supposed historical genealogy:

> (…) We inherit it from the two cultures that converged to form our own: on the one hand, pre Hispanic (Uxmal, for example), where everything is organized by means of patios. And on the other, Spanish, which brought us its own version of Mediterranean architecture."[9]

An organization of spatial references which finds its expression, to be sure, in the two patios of the INFONAVIT building: the exterior plaza modeled on Mayan and Teotihuacano citadels, and the central space that clearly recalls convent cloisters.

5. Architecture and Fiction

All critiques start whenever the ordinary is subjected to a process of defamiliarization. We are so accustomed to supposing that the task of the intellectual and the artist in Mexico consists of operating as a mediator of the nation's psycho-history that we easily take for granted the legitimacy of this type of program. We see it as something natural to conceive the "indigenous past" as a mythical time haunting us at every step, the "Spanish/Catholic" period as a still living past in traditional Mexican religious life, and "modernity" as a space inhabited by the elite that formulates, of course, these discourses. These three elements are, above all, historically conditioned projections of contemporary forces negotiating and struggling for a place in the political and economic present, rather than time strata perceived from the perspective of the intellectual, who conceives of himself as the very model of a modern subject. If anything characterizes the ideology we know as a "philosophy of Mexicanness", it is the subordination of the entire catalogue of "our" artistic and intellectual culture to the collective task of exercising, and renovating, the supposed superposition of mestization.

I do not intend to perform a detailed criticism here of this ideology, which Roger Bartra dismantled in his *La Jaula de la melancolía* [*The Cage of Melancholy*] (1987),[10] but such a criticism has not yet been extended to architecture.

We can conclude, therefore, that the locations in *Total Recall* are not a random sampling of spaces in Mexico City, and still less a visual encounter with the postmodern character of the metropolis. In an attempt to give the film continuity and

open a space for pure fiction, the production team took up examples of the architecture of a specific school, formed by architects who share common aesthetic and programmatic premises. In other words, the dialogue of *Total Recall* is not with Mexico City, but rather with a certain period architecture and its aesthetic and political values. In this sense, the movie constitutes a sort of theory, a perfectly consistent one, of the character of this architecture in four fundamental aspects:

1) That it is the architecture of an authoritarian discourse that subjects the individual to the contemplation of its monumental grandeur.
2) That it is an architecture with the luxury aesthetic characteristic of a peripheral modernity sustained by cheap labor.
3) That it is stage scenery architecture, not only due to its predetermined function of serving as the space for a theatrical representation of power, but especially because one of its objectives is to create fictional spaces isolated from the surrounding urban chaos.
4) That it is an architecture derived from the project of a nationalist synthesis of a series of historical and cultural archetypes. In other words, an architecture conceived as the "reconciliation" of contradictory historical forces. Thus, its apparently unclassifiable character in terms of historical time periods, which makes it possible to project it as emblematic of a civilization situated in some indefinable time.

Of course, it is not by chance that these examples of fictional architecture are located just kilometers from each other in the middle of the chaos of our megalopolis. Because this architecture is neither more nor less than a form of official art.

Among the many historical myths we have embraced in Mexico is the idea that official art is a thing of the past. On the one hand, it is not at all clear that the movement designated "Mexican muralism" can be judged an official art through the whole course of its existence: the history of its development in the 1920s and 30s is proving to be ever more complex, and it is ever more clear that it was in the postwar period, that is, under the PRI administrations, that the so-called "big three" were retroactively canonized as the summum of Mexican national identity.

On the other hand, we tend to feign ignorance of the fact that the canon of contemporary Mexican architecture after Luis Barragán and Mathias Goeritz consists fundamentally of a corpus of works commissioned to a handful of individuals to transmit in stone and cement the ideology of the modernizing Mexican State. To face the fact would imply taking seriously the "artistic" pretensions of this hegemonic school.

For while the so-called "Rupture" produced a series of tensions between autonomous artistic production and government cultural policy, starting in the mid-1960s a specific group of architects established a hegemony protected by the needs of the PRI state in its various phases for monumental constructions, creating a series of solutions which, as the new PAN building demonstrates, may well be too important an inheritance to be simply thrown away under the supposed transition

taking place in Mexico since July of the year 2000. Although the Mexican state in the 1960s succumbed to confusion with regard to its visual representation in the plastic arts, to the point of refusing to collect art produced in Mexico, its architectural decisions have been terribly precise. After the controversies involving neo-colonialists in the 1920s, neo-indigenist currents in the 1930s, supposedly orthodox functionalism in the 1940s and emotional architecture in the 1950s, a relatively homogenous school emerged in the 1960s to design the cultural, corporate and public buildings in the country. This is the practice that has established a sort of official aesthetic of the modernizing Mexican state.

It is an elitist architecture, representative of the values of the elite. We all know that architecture leads a sociologically marginal existence in Mexico: most buildings and houses are the work of engineers or are built by their owners, a sort of vernacular functionalism. Thus, the authorial function in architecture has essentially been acquired on the basis of commissions received from the government or from entities that, though nominally private, function as virtually state-owned corporations: banks, insurance companies, major corporations. From Pedro Ramírez Vázquez to Legorreta, passing through González de León, Zabludovsky and Agustín Hernández, there has emerged a group of styles in design and construction that, in spite of their individual peculiarities and differences, converge in the model of a monumental synthesis of the Mexican cultural psychodrama. If this power of visual invention has proven so coherent and repetitive, it is in large measure because it conveys an equally recurrent discourse: the fiction of a reconciliation between Mexicanness and modernity.

Here we have to value *Total Recall* as a precise reading of the character of this architecture, inasmuch as the Mexico it projects is, in effect, the futuristic fantasy of an authoritarian state, which legitimizes its handling of peripheral capitalism by conceiving of itself as a synthesis of disorderly post-colonial life. Schwarzenegger's epic renders visible the role of the modernizing Mexican elite: a regime of maximum natural and social exploitation cloaked in a discourse about national identity. To confirm this idea, nothing better than the words of Vilos Cohaagen, the dictator of Mars, describing his position as governor:

> "Richter, do you know why I'm such a happy person? (...) It's because I have the greatest job in the solar system. As long as the Trebinium keeps flowing, I can do anything I want. Anything. And I fear that if the rebels win, it all might end."

Words that could be placed perfectly well in the mouth of a Mexican president. Unlike the charges leveled against the muralist movement to the effect that it depicts the fiction of a nonexistent revolutionary saga, the official Mexican school of architecture has dedicated itself to making real the fantasy of a peripheral modernity in perfect accord with its past.

That is why the INFONAVIT building is the headquarters of *Rekall* in the movie: such constructions implant in our heads a programmed memory to make us experience the kind of narrative produced in writing by people like Octavio Paz and

Carlos Fuentes. With the advantage that, unlike literature, concrete transmits the idea of the solidity of material evidence. As the head of *Rekall* says to Quaid: *"As real as any memory in your head"*.

Notes

1 http://www.godamongdirectors.com/scripts/totalrecall.shtml

2 Verhoeven, interview by *Movies USA*. Quote: http://www.8ung.at/arnold/recall.htm

3 Collected Stories of Philip K. Dick (Vol. 2): We Can Remember It For You Wholesale (Citadel Press, 1990).

4 Marc Augé: *Non-Places. Introduction to an Anthropology of Supermodernity. Tr. By John Howe.* London. Verso, 1995. p. 79

5 Ibid. p. 94–5

6 Serge Gruzinski: "Del Barroco al Neo Barroco: Las Fuentes colonials de los tiempos posmodernos" in: Olivier Debroise, The Bleeding Heart, Boston, Mass. The Institute of Contemporary Art, 1991. p. 64–5.

7 Agustín Hernández in: Pablo Quintero (comp…) *Modernidad en la arquitectura maxicana (18 protagonistas),* México: Universidad Autónoma Metropolitana, 1990. p. 182.

8 Ibid. pp. 174–5.

9 Teodoro González de León in Quintero, op. cit. p. 139

10 Roger Bartra, *La jaula de la melancolía*, México, Grijalbo. 1987.

Further readings

Border Postcards: Chronicles from the Edge, Teddy Cruz (2004) url: www.cca.qc.ca/documents/Cruz_Stirling_Lecture.pdf

Architecture, Al-Qaeda, and the World Trade Center: Rethinking Relations Between War, Modernity, and City Spaces after 9/11, Julian Reid, *space and culture*, 7(4), 2004.

Related Internet links

Teodoro González de Leon: http://eng.archinform.net/arch/3529.htm

Agustín Hernández: http://www.epdlp.com/arquitecto.php?id=3250

Abraham Zabludovsky: http://eng.archinform.net/arch/16909.htm

Rafael Lozano-Hemmer, Voz Alta: http://www.lozano-hemmer.com/english/projects/vozalta.htm

Checkpoints

The Split Sovereign and the One-Way Mirror

Eyal Weizman

Keywords

occupation
Gaza
control
architecture
Israel
security
border terminals
West Bank
Oslo Accords
Palestine
management
surveillance
IDF
UN
human rights
international aid

Without drawing a single line, the Israeli and Palestinian peace bureaucrats meeting in Oslo in the summer of 1993 conceived one of the most complex architectural products of the occupation. Article X of the first Annex to the Gaza-Jericho Agreement (also known as Oslo I) is called 'Passages'; it is concerned with the interfaces between a variety of differently defined territories, in particular the border connections between the 'outside' world and the areas handed over to limited Palestinian control.[1] The architecture of the terminals connecting these territories sought to resolve the structural paradox that resulted from the seemingly contradictory desire to enable the functioning of Palestinian autonomy while enabling Israel to maintain overall control of security. For the Palestinian negotiators, the border terminals and the process of passing through them were important symbols of an emergent, autonomous national self-government. For the Israeli military officers leading the negotiations, the terminals were to articulate a new security concept that delegated direct, on-the-ground control of West Bank and Gaza Palestinians to the nascent Palestinian Authority under Israel's overall 'invisible' control. Israeli security personnel and Palestinian politicians considered various options; the architecture finally agreed upon reflected a last-minute compromise achieved shortly before the planned signing ceremony at the White House on September 1993. This architecture allowed Israel to control on a case-by-case basis who would be allowed to pass through the terminal (described in Article X as a large military base), and to keep 'the responsibility for security throughout the passage', but for Palestinians to run the terminal building, and for Palestinian national emblems to be the only ones visible on the ground.[2]

Article X describes in exhaustive detail a flowchart which separates the Palestinian crossings through the border terminals into different colour-coded lanes and sub-lanes. Together, these make up a complex choreography of pathways and security checkpoints that divide passengers according to destinations

Global Visual Cultures: An Anthology, First Edition. Edited by Zoya Kocur.
© 2011 Blackwell Publishing Ltd except for editorial material and organization © Zoya Kocur. Published 2011 by Blackwell Publishing Ltd.

defined by the geography of the Oslo Accords: by the end of the Oslo process, the several hundred separate enclaves, about 40 percent of the territory of the West Bank, under autonomous Palestinian self-rule (areas A and B); the rest of the West Bank under Israeli control (area C); Gaza; and East Jerusalem. Incoming Palestinians would not see the Israeli security personnel who exercise overall control: Article X stipulated that the Israeli security agents, although present throughout the terminal building, would be separated from travellers by one-way mirrors.[3] The travel documents of Palestinians were to be 'checked by an Israeli officer who [would] also check their identity indirectly in an invisible manner'.[4] Within the terminal, Palestinian police officers would conduct some security checks, but provision was made for Israeli security personnel to emerge into the main hall from behind the mirror in the event of what they perceive to be an emergency situation. As a 'last resort', they were permitted to use their firearms.[5]

The unassuming Allenby Bridge, which spans the Jordan River on the historical Amman–Jerusalem–Jaffa road, is the main connection between the West Bank and Jordan. At the western end of the bridge, on the Israeli-controlled bank of the Jordan River, the existing old terminal was expanded and remodelled, according to Article X in the following manner:

Figure 8.1 Palestinian border control at the Allenby Bridge terminal, 1999. Photo by Miki Kratsman

several interconnected rooms, partly glazed with one-way mirrors, were positioned at different intersections within the terminal's various pathways. Access to the rooms concealed by the mirrors was provided by a back door. In accordance with Article X, incoming Palestinians would see only 'a Palestinian policeman and a raised Palestinian flag'. They would also see a Palestinian police counter in front of one of several large mirrors facing the 'incoming passengers' hall. The mirrors were positioned so that Israeli security behind them could observe, unseen, not only the Palestinian passengers but also the Palestinian police personnel themselves (Figure 8.1).

The waiting room itself is a large open hall with rows of plastic benches fixed to the tiled floor. In 1996, at the height of the Oslo process, the Palestinian poet and PLO activist Mourid Barghouti described the scene when he crossed the bridge back to Palestine for the first time after thirty years of exile: 'I entered a large hall, like the arrival hall in an airport … a row of windows to deal with people going to the West Bank and those going to Gaza … Thousands of Palestinians like me

passing with their bags for a summer visit or leaving for Amman to get on with their lives.' Barghouti goes on to describe a hall crowded with large families and many children. There was a very long wait to be checked. On the benches, on their mothers' laps, or on the floor, children were sleeping.

> – ' "Where do I go now?"
> – "To the Palestinian officer, of course." '[6]

The Palestinian border policeman, standing behind a large counter, receives the passport of an incoming passenger, examines it, and then slips it into a drawer hidden behind the counter, which is then opened on the other side by the Israeli security staff. There, the information of the passport is processed, a decision regarding entry is made, and the passport is pushed back with one of two coloured paper slips denoting whether or not an entry permission could be given. The Palestinian police officer subsequently welcomes the passenger or denies him or her entry, and stamps the passport accordingly.[7] On the other side of the terminal is the usual commotion of emotional meetings, vendors, kiosks, buses and taxis.

More than a mere solution to a specific security / political problem, the architecture of the terminal is a diagram of the new power relations articulated throughout the Oslo process (1993–2000).[8] Embodied in the architecture of the terminals was the very military, political and economical logic of the Oslo process, one that sought to replace direct occupation and management of the occupied Palestinians, and thus direct responsibility for them, with the creation of a Palestinian Authority – a prosthetic political system propped up by the international community – and the delegation of local functions to it. According to this logic of governance, Israel remained in control of the Palestinians by regulating their movement through space, without resorting to managing their lives within the separate enclaves it sealed around their towns and villages. In assuming the duties of day-to-day governance within the enclaves under its control, the Palestinian Authority has freed Israel of its obligations as an occupying power by international law.[9]

The architecture of the Allenby Bridge terminal incorporated within the scale of a building the principle of surveillance that dictated the distribution of settlements and military bases across the Occupied Territories. However, unlike these mechanisms of surveillance and discipline, which, following principles set up in the nineteenth century, called for power to be 'visible but unverifiable,'[10] the architecture of the terminal is designed to hide from the passengers the mechanism of power and control altogether. Here, power should be neither visible nor verifiable. The aim of the terminal's architecture is not to discipline the Palestinian passengers but rather to mislead them as to the effective source of power, to make them believe that they are under the control of one authority, whereas they are in fact under the control of another. Significantly, it was not the Palestinian passenger, but the agent of the

Palestinian Authority, who had to internalize the disciplinary power of surveillance and be under the gaze of the Israeli security personnel. This hierarchy of surveillance could be understood in relation to the almost maternal rhetoric with which Israel argued the Oslo agreement as an attempt to inaugurate the Palestinian Authority into a differentiated world, where, after taking its first steps in supervised self-government, it would, in due time, function separately from Israeli power.[11]

Modulating Flows

Israel's conception of security has always included a complex territorial, institutional and architectural apparatus, conceived in order to manage the circulation of Palestinians through 'Israeli' space. The Israeli writer-activist Tal Arbel has called this Israel's mobility regimes'.[12] Until 1966, Israeli military administration was imposed on Palestinian citizens of Israel, with checkpoints located in and around their towns and villages, denying them the possibility of travelling without special permits. After 1967, Minister of Defence Moshe Dayan's 'open bridges policy' extended the 1966 easing of travel restrictions on Palestinian citizens of Israel going to the Occupied Territories by allowing West Bank and Gaza Palestinians to travel to Jordan and to enter Israel. It was part of a general policy he called 'the invisible occupation', the goal of which was that 'a local Arab can live his life … without needing to see or speak to an Israeli representative'. Dayan wanted to allow for a situation whereby Palestinians would run their own lives and societies under imperceptible but overall Israeli control. In the context of this policy the Israeli military was to avoid patrolling Palestinian cities, keep Israeli flags to a minimum, and avoid interfering in Palestinian daily life.[13] The policy also sought to incorporate Palestinian laborers into the Israeli workforce. Dayan's initiative was argued as 'humanitarian' but the ability to open and close the Allenby Bridge was also, according to Dayan's coordinator of government activity in the occupied territories Shlomo Gazit, part of a behaviouristic 'carrot and stick' policy, which allowed the 'denial of privileges' when the security or political situation demanded.[14] In reality, more often than intended, the bridges between the West Bank and Jordan were closed, or open in one direction only – allowing only the departure of Palestinians. Throughout the years of occupation, restrictions on Palestinian movement gradually increased. Travel permits were first introduced with the creation in 1981 of the Civil Administration – a subsidiary of the IDF tasked with governing the Palestinians in the West Bank and Gaza. Their use accelerated during the first Intifada (1987–91), when villages, towns and cities were placed under curfew for extended periods.[15] In 1991, for the duration of the first Gulf War, Israeli Prime Minister Yitzhak Shamir ordered the closure of the entire Occupied Territories for the first time from Israel and the rest of the world.

During the Oslo years, the politics of closure was further extended, perfected and normalized. During 1994, Israeli security control retreated into the roadways

that connected centres of Palestinian population. Between 1994 and 1999, Israel installed 230 checkpoints and imposed 499 days of closures.[16] Israeli sovereignty was exercised in its ability to block, filter and regulate movement in the entire Occupied Territories, and between it and the 'outside'. The occupation effectively shifted to the road network, working as a system of on/off valves of checkpoints and roadblocks. The Israeli occupying forces further ruled by modulating flows of other kinds: labor, goods, energy and waste. Even the level of flow in the water pipes connecting the separate Palestinian enclaves throughout the territories was controlled by the Civil Administration.[17]

The Allenby Bridge terminal was merely one node in the complex legal-spatial-ideological apparatus of Oslo. The governing system not only comprised a network of civilian structures (although, as we have seen, the number of buildings in the settlements doubled during the Oslo years[18]) and new roads reserved for the exclusive use of settlers, other Israelis and the military. Significantly, it was also composed of an array of 'legal' and bureaucratic procedures that attempted to manage the Israeli settlers and the Palestinian inhabitants of the Occupied Territories as two territorially overlapping but increasingly insular, autarkic networks.

Indeed, the bureaucratic infrastructure of the Oslo process sought to replace an 'occupation' with 'management'. The Israeli sociologist Yehouda Shanhav recounted how during the Oslo years, the Israeli military launched an experimental project: the implementation of Total Quality Management (TQM) for the administration of all relations between Israeli security and Palestinians in Gaza. TQM is a client-oriented 'management approach … based on participation, aiming at long-term success through customer satisfaction, and benefits to all members of the organization …'[19] The system is internationally used in manufacturing, education and the service industries. It was first introduced to the IDF in 1991 by Ehud Barak, then Chief of Staff, in order to manage military staffing and supplies. In 1995, a young officer and recent graduate of an MBA programme managed to convince the IDF command in Gaza to apply this management approach to its relations with the Palestinians. Following this system the military occupation was reinterpreted as the provider of services and security, and the Palestinians and settlers as its customers. In this way, Israeli–Palestinian interactions, which by the standards of international law were still performed within the framework of belligerent occupation, were depoliticized into a smilingly neo-liberal 'service economy', a mere business transaction.[20] The aim of TQM and the Oslo process in general was to reduce 'friction' between the various groups that inhabited the Occupied Territories (Palestinian residents, Palestinian police, Israeli soldiers, settlers, even tourists) and avoid, as much as possible, the application of Israeli military force.

Within this larger system of control the architecture of the border terminals operated as valves regulating the flow of Palestinian passengers under Israel's volatile regime of security; simultaneously, and to those who passed through them, the terminals became an ideological apparatus that aimed to naturalize and normalize the powers of the Palestinian Authority.

Transparent Border

Unlike the one-way mirrors we become accustomed to seeing in almost every police station, detention facility and control room worldwide, the one-way mirror system of the terminal/camp of Allenby Bridge was more than the mere apparatus of control – it functioned also as an international border of sorts. In fact, not only did the mirror demarcate a border, but in its positioning and function it created a new conceptual border to the concept of sovereignty. It is in this context that one-way mirrors have become important components in the redesigning of sovereignty across the frontiers of the 'war on terror', enabling, for example, the United States' 'politics of deniability' (almost Clintonian in style) that allows US agents to engage in torture without resorting to physical contact. The process which the Bush administration calls 'extraordinary rendition' was conceived in order to bypass the outlawing of 'cruel, inhuman and degrading treatment of prisoners in US custody' by turning terrorist suspects over to foreign governments that do engage in torture.[21] The one-way mirror behind which US agents and behavioural science consultants observe and perhaps even guide the process of torture in Saudi Arabian, Moroccan or Syrian prisons has effectively become an extension of US borders, acting as the physical and optical medium across which a previously unified sovereignty has now been split.[22]

A similar, if more complex, prosthetic power relation was established through the one-way mirror of the Allenby Bridge terminal. Although Article X renders the Palestinian Authority's border procedures mere performance, the nature of this performance is nevertheless significant The Oslo process was designed in such a manner that Palestinians would no longer identify themselves merely as the individual *objects* exposed to military power but also as political *subjects* of another. If Israeli security control was always directed at the occupied Palestinians, the same was not true of the Israeli ideological project. The attempt to 'produce' and discipline a political subject remained distinct from the security control that dominates the individual via threats and violence.[23] Under the Oslo Accords, Palestinians were still, as before, subjugated to Israeli security domination in that they were exposed to the threats of its military actions, but encouraged to believe themselves the subjects of their own political authority. (This had the effect of directing Palestinians' anger and frustration for the deterioration of their freedoms and economy at their own Palestinian Authority rather than at Israel.) This separation between the functions of direct discipline and indirect control no longer fits the theoretical narrative that presupposes an evolution from 'disciplinary societies' to 'control societies',[24] and makes these two systems of domination coexistent as two components of a vertically layered sovereignty, which is here horizontally separated across the sides of the one-way mirror.

Throughout the second Intifada, the 'exception' clause in Article X, which allowed Israelis to break temporarily into the terminal in order to enforce 'security', was permanently in effect. On the rare occasions that the terminal was open to traffic,

Palestinians needed to appeal directly to Israeli border police without the mediation of Palestinian border policemen. Palestinians became exposed to the naked, overt military power. If they cooperated, acquiescently complied with military orders or lowered their eyes in front of the architectural machine, they did so out of fear of violence rather than by internalizing a citizen-like relation of subjugation.

The Architecture of Checkpoints

The discontinuous lines of fences, ditches, concrete walls and high-tech sensors – referred to by the Israeli government as the 'seam-line obstacle', by the general Israeli public as the 'separation fence', and by those Israelis and Palestinians opposing it as the Wall or sometimes as the 'Apartheid Wall' – are only the most visible and mediatized barriers built in a frenzy of fortification construction that has pockmarked the entire West Bank since the beginning of the Oslo Process in 1993, with the aim of separating Palestinians from Israelis at every opportunity.

Since the beginning of the second Intifada in September 2000, Israeli attempts to isolate and fragment Palestinian resistance and limit the possibility of suicide bombers arriving in Israeli cities have further split the fragile internal matrix of Palestinian society and the geography of the Oslo Accords. Using a complex, ever-present system of closures and traffic restrictions, the Israelis brought the Palestinian economy to a virtual standstill. This system relied upon an extensive network of barriers that included permanent and partially manned checkpoints, roadblocks, metal gates, earth dykes, trenches, 'flying' or mobile checkpoints, all of which were operated according to a frequently changing assortment of bans and limitations (Figure 8.2). According to a report prepared by OCHA – the UN Office for the Coordination of Humanitarian Affairs, which has been monitoring this policy of traffic restrictions – by September 2006 the number of these restrictions comprised a system of 528 physical obstacles. During one week in December 2006, OCHA researchers registered 160 new 'flying checkpoints' and an extra 38 kilometres of roadways that were fenced off to prevent use by Palestinians.[25] These barriers sustained the creation of a new geographic, social and economic reality.[26] Although the checkpoint system gradually emerged as a series of local responses to what military officers saw as a series of tactical necessities, it has gradually assumed an overall strategic layout, constituting a complete territorial system whose main aim is to dominate and manage the lives of the Palestinians, without having to encroach on their cities, towns and villages, and (mostly) without need for overt violent force. The various barriers splintered the West Bank into a series of approximately 200 separate, sealed-off 'territorial cells' around Palestinian 'population centres' (roughly corresponding to the boundaries of the Oslo era, areas A and B) with traffic between these cells channelled through military-controlled bottlenecks. Palestinians have to apply for more than a dozen different travel permits, each allowing different categories of persons to travel to different categories of space through different categories of checkpoints. Palestinians are,

Figure 8.2 Checkpoint, 2002. Photo by Pavel Wolberg

furthermore, barred from the Jordan Valley, Jerusalem and the enclaves trapped between the Wall and the Green Line unless they have still further kinds of almost-impossible-to-get permits.[27] The checkpoint system is also designed to impose and maintain a policy of total closure – complete prohibition on movement from the Occupied Territories to Israel. This is put into effect whenever there is an alert or suspicion of a terror attack, but also as a matter of routine on Jewish festivals and holidays, often on Muslim festivals and holidays, on special occasions (such as the death of Yassir Arafat), or when there are large, international sports events in Israel, such as a European basketball championship match. (This alone should be a good enough reason for international sports bodies to rethink agreeing to stage events in Israel.) According to the Union of Palestinian Medical Relief Committees, 85 per cent of people in the West Bank did not leave their villages during the Intifada's first three years due to the curfews and closures.[28]

The security rationale for the checkpoint system is further founded on the belief that the less Palestinians are permitted to circulate through space, the more secure this space will be.[29] As director of the GSS (General Security Service, or Shabak), Avi Dichter was one of the strongest advocates of the checkpoint system to the degree of accusing those military officers who removed some checkpoints, when they felt they were unnecessarily punishing entire cities, of murder.[30]

Machsom [checkpoint] *Watch* – an organization of women dedicated to monitoring human rights abuse at military checkpoints – has painstakingly recorded and reported the violence and humiliation caused by the checkpoint system; the

delaying of the sick, the elderly, and infants needing medical care, the births and deaths occurring on the hard shoulder; the manner in which the circulation regime penetrated and violated every aspect of Palestinian daily lives, delaying, humiliating and exhausting people in a daily struggle to survive, attempting, as they claimed, to make Palestinian political resistance beyond their capacity to undertake.[31] At Huwwara checkpoint south of Nablus, *Machsom Watch* activists reported the arbitrary and random nature of Israeli orders designed to make travelling by Palestinians an uncertain experience, and often discourage it altogether. For example, on 6 September 2004 Israeli soldiers decided to detain every ninth adult male wishing to cross the checkpoint, on the 19th of the same month, every man whose name was Mohammad was detained, which accounted for very large numbers. Sometimes, again at random, some passengers were asked to wait four hours; at others, without warning or announcement, the checkpoint would be closed. While the queues of Palestinian passengers stretch on both sides of the checkpoints, Jewish settlers cruise unhindered through separate gates and down protected corridors that lead to segregated Jewish-only roads.

The checkpoint system has become so omnipresent and intrusive that it has grown to govern the entire spectrum of Palestinian life under occupation. In *Checkpoints*, the recent book by the Palestinian-Israeli member of parliament, writer and political activist Azmi Bishara, Israel is no longer called by its name but termed 'the state of the checkpoints', the Occupied Territories are the 'land of checkpoints', the Israelis 'owners of checkpoints' and the Palestinians 'the people of the land of checkpoints'. 'The checkpoint takes all that man has, all his efforts, all his time, all his nerves … the checkpoint is the chaos and the order, it is within the law and outside of it, operating by rationality and idiosyncrasy through both order and disorder.'[32] The long wait to pass through checkpoints has given rise to a secondary economy, which feeds off the arbitrariness of the first – an improvised food and goods market that Palestinian passengers sardonically call 'the duty-free'. Because of the deep depression of the Palestinian economy, these markets have gradually expanded to become almost the only functioning Palestinian public space. The neighbourhoods, cities or villages that the checkpoint cut apart have become its suburbs.

> In the beginning the checkpoint was made up of large tin barrels filled with stones … the barrels were later filled with concrete. They were soon replaced by red and white plastic road barriers, which were later themselves replaced with concrete road barriers, to which large concrete cubes were added, to which fencings of barbed wire were added and then rocks of many sizes … In the beginning soldiers stood under the open skies; later on, a steel tower was erected next to them with a plastic water container on its top. The field-tent was replaced by a pre-fabricated structure … From time to time the soldiers used rocks or dust bins as a creative touch to their art work.[33]

The checkpoints not only carve up space, but divide up time as well. Israel changes to daylight-saving time a month after the rest of the world because of coalition agreements with ultra-Orthodox parties whose constituency's hours of prayer are

governed by celestial composition and level of daylight. The Palestinian Authority shifts its clocks to daylight-saving time in tune with the rest of the northern hemisphere. In spring, a one-hour time difference opens up across the two sides of the checkpoints, creating two time zones.[34] 'The working day ends at 6pm local time but 7pm checkpoint time. The checkpoint shuts at 7pm its time. Until everybody got used to move the clock backwards and finish work an hour earlier, the checkpoint was blocked with hundreds of winter time people begging the summer-time soldiers to allow them back home.'[35]

Humanitarian Design

In the middle of 2003 the IDF inaugurated the programme 'Another Life' whose aim was to 'minimize the damage to the Palestinian life fabric in order to avoid the humanitarian crisis that will necessitate the IDF to completely take over the provision of food and services to the Palestinian population'.[36] This programme has turned 'humanitarianism' into a strategic category in Israeli military operations, and influenced the design of its various instruments of control. In January 2004 Ariel Sharon appointed Baruch Spiegel, a recently retired IDF officer working at the Ministry of Defence, as 'IDF director of civilian and humanitarian issues'. One of Spiegel's tasks was to overhaul the inefficiencies and humanitarian problems caused by the checkpoint system. Upon assuming his post, Spiegel sent Israeli representatives all over the world to examine technologies of control along the borders between Finland and Russia, on the borders of China, between Malaysia and Singapore, the United States and Mexico; even the French-German border arrangements after World War II were studied.[37] Two months later, in March 2004, Spiegel published the first part of a plan devised ostensibly to 'ease the lives of Palestinians in the West Bank and Gaza'. Spiegel's plan, written in English to placate foreign governments, severely criticized the harshness and inefficiencies of IDF soldiers at checkpoints, and proposed some significant changes.

Spiegel's plan followed military terminology in referring to checkpoints according to two general categories: the 'envelope checkpoint' (Machsom Keter), a checkpoint that regulates movement between different Palestinian 'territorial cells', whose total number Spiegel wanted to reduce; and the 'closure checkpoint' (Machsom Seger) that regulates movement between the Palestinian areas and the western side of the Wall, usually called the 'Israeli' side – even though it is sometimes located within the occupied areas. According to the Spiegel plan, twelve permanent 'closure checkpoints' (Figure 8.3) were to be built along the length of the Wall, to be operated by the Israeli Airport Authority as if they were international borders.[38] Their construction was to be partially funded by the '2005 US Emergency Aid to the Palestinians' which was intended, according to President Bush, 'to support Palestinian political, economic, and security reforms'. However, the 'pro-Israeli' US Congress made it difficult for the White House to hand out any of this aid directly to the Palestinian Authority. Out of $200 million allocated for

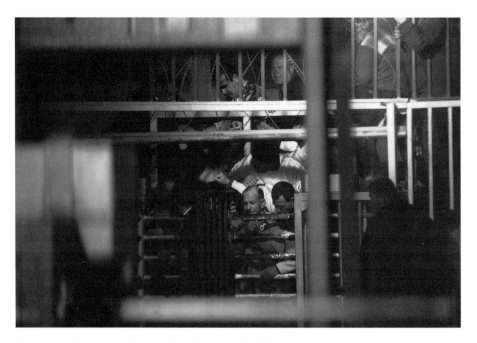

Figure 8.3 Erez terminal, Gaza, 2004. Photo by Nir Kafri

the use of Palestinians in 2005, Israel received $50 million to help fund the construction of the terminals.[39] American money meant to help Palestinians was therefore used to fund one of the most blatant apparatuses of the occupation, demonstrating how distorted American perception could be when they believe, contrary to all evidence gathered during four decades of occupation, that Israel knows best how to spend Palestine's money on its behalf, and that oiling the cogs of the occupation is somehow in Palestinian interest.

An 'artist's impression' of one of the terminals, Sha'ar Ephraim, near the Israeli-Palestinian town of Taibeh, in the northwest part of the West Bank, designed for the Airport Authority by the Haifa-based architectural firm Loyton-Shumni, gives the impression of a respectable international border crossing. It appears to be clad in tiles and glass like a giant suburban shopping mall. It has a parking lot with disabled parking spaces, gardens, and a series of spacious halls that can accommodate hundreds of passengers. The architectural impression of the Sha'ar Ephraim terminal appears under the heading 'humanitarian concerns' on the Ministry's of Defence website, which also promises that the terminals 'will employ advanced technological systems that will minimize human friction'.[40] The Ministry of Defence further announced on 15 January 2006 that, in order 'to lessen the existing friction in the security checks, humanize the process and improve standards of service', security will be privatized and civilians rather than soldiers will conduct all security checks.[41] Spiegel called this privatization 'taking the army out of the checkpoints'.[42]

It would later become clear that this and other plans of a 'humanitarian' nature that were aimed at reducing the extent of closures sustained by the checkpoint system, or making it more efficient, would either not be implemented by the military officers in command, or would make the treatment of Palestinians harsher. In fact, according to OCHA, the number of physical barriers throughout the West Bank has steadily increased since the Spiegel report was released.[43]

Towards the middle of 2004, the improvised checkpoint system began to be regularized. Whereas previously there was chaos now things appeared to operate according to strict procedures. At this time revolving gates or turnstiles started to be installed in many of the permanent checkpoints throughout the West Bank, ostensibly to make more ordered, efficient, secure and 'human' the process of passage. The turnstiles became the centrepieces of a new 'design' for the checkpoint system that attempted to slow, regulate and organize the crowded mass of Palestinians seeking to cross the checkpoints into sequenced and ordered lines in which one Palestinian at a time would face the soldier checking his permits and baggage. In most cases, the checkpoint had two sets of turnstiles with space between them. The first set was placed several tens of metres away from Israeli military positions so as to keep the congestion away from them. Soldiers regulate the pace of passage by using an electrical device that controls the turning of the gates. One person at a time passes through at a push of a button. Every few seconds soldiers stop the rotation of the turnstiles, so that several people remain caged between the gates. Sometimes they trap people within the arms of the turnstiles. Tal Arbel discovered that the manufacturer of these turnstiles had been asked by Ministry of Defence contractors to change their production specifications and reduce the length of their metal arms from the Israeli standard of 75–90cm (used at universities, swimming pools, railway stations, etc.) to a mere 55cm in the West Bank and Gaza,[44] so that the turnstiles physically press against the passengers' bodies, ensuring there is nothing under their clothes. According to testimony from *Machsom Watch*, the tight turnstiles ended up causing more harm and chaos. 'People got stuck, parcels got crushed, dragged along and burst open on the ground. Heavier people got trapped in the narrow space, as were older women and mothers with small children.'[45] It is hard to imagine the cruelty imposed by a minor transformation of a banal, and otherwise invisible architectural detail, ostensibly employed to regulate and make easier the process of passage.

The upgrade of the Qalandia terminal crossing, which connects (or rather disconnects) Jerusalem from Ramallah, was completed, according to the principles of the Spiegel plan, at the end of 2005 (Figure 8.4). The new system includes a labyrinth of iron fences that channels passengers en route to Jerusalem via a series of turnstiles. All commuters must go through five stages: the first set of turnstiles, the X-ray gates, the second set of turnstiles, the inspection booth and an X-ray machine for the bags. This entire process is captured by a dense network of cameras, and the passenger is given instructions via loudspeakers. From their protected booths, Israeli security personnel operate the revolving gates remotely, regulating the rate of passenger flow. The inspection booths are encased in bulletproof glass.

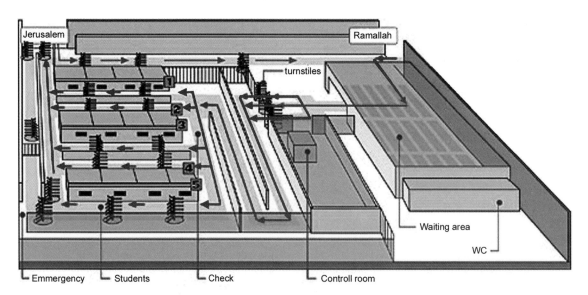

Figure 8.4 Flow Diagram of Walandia Crossing, 2005. Originally published in *Hollow Land: Israel's Architecture of Occupation* By Eyal Weizman. Verso, 2007

The glass is so thick that it tends to reflect the outside light rather than letting it through, thereby obscuring the security personnel inside, and effectively functioning as a one-way mirror. Palestinians must insert their identity cards and travel permits into a small slot under the windows. Communication takes place through push-button speakers. Still in the process of installation, new detectors operated by biometric cards will eventually make even this minimal interaction redundant. After crossing this checkpoint, the passenger is allowed through another turnstile and then through the Wall. Near the exit of the terminal a large sign mockingly greets in Hebrew, Arabic and English: 'The Hope of Us All'. Some Israeli anti-occupation activists have sprayed on it the words 'Arbeit Macht Frei'.

Each of the large terminals also includes what the military calls 'humanitarian gates'. These gates have a small waiting area with a bathroom and a water cooler, designed for the passage of those in wheelchairs, parents with baby strollers and people over the age of 60.[46] Indeed, 'humanitarian' has become the most common adjective in matters of occupation-design: 'humanitarian gates', 'humanitarian terminals', 'humanitarian technology' and 'humanitarian awareness', as well as – according to a procedure already in effect since the beginning of the Intifada – a 'humanitarian officer' (usually a middle-aged reserve soldier) employed at checkpoints to smooth the process of passage and mediate between the needs of Palestinians and the orders of soldiers. The 'humanitarian' rhetoric of the current phase of the occupation is part of a general attempt to normalize it. The urgent and important criticism that peace organizations often level at the IDF – that it is dehumanizing its enemies – masks another more dangerous process by which the military incorporates into its operations the logic of, and even seeks to cooperate directly with, the very humanitarian and human rights organizations that oppose

it. In March 2006, Chief of Staff Halutz received some members of *Machsom Watch* at a mediatized meeting where he claimed he was ready to hear their suggestions with a view to improving IDF conduct at its checkpoints and to addressing the problems of the Palestinians under occupation in general. Cases of colonial powers seeking to justify themselves with the rhetoric of improvement, civility and reform are almost the constant of colonial history. Currently, moreover, the massive presence of humanitarians in the field of military operations means that the military no longer considers them as bystanders in military operations, but factors them into the militarized environment, just like the occupied population, the houses, the streets and the infrastructure. Beyond that, as we have already seen, the new terminals built according to Spiegel's plan are the physical infrastructure that sustains a political illusion: two states politely separated by a border and connected by a terminal.

The most extreme act of architectural-political camouflage, however, must surely be the new terminal in Rafah, between Gaza and Egypt. In November 2005, following the Israeli withdrawal, 'The Agreed Principles for the Rafah Crossing' were reached after another last-minute compromise was brokered by US Secretary of State Condoleezza Rice. The logic of the Agreed Principles recreated, this time electronically, the spatial logic of the one-way mirror terminals of the Oslo era terminal.[47] The document specified that the Rafah terminal 'will be operated by the Palestinian Authority on its side and Egypt on its side according to international standards' but that the entire process of passage will be overseen by Israeli security. 'A liaison office, led by the 3rd party [i.e not Israelis or Palestinians] would, according to the agreement, receive real-time video and data feed of the activities at Rafah … [and] resolve any disputes arising from this agreement.'[48] A Joint Control Room was thus constructed off-site within Israel and was staffed by European observers and Israeli security officers. The control room receives constant live video streams from a network of CCTV cameras operating at the terminal. The face of each passenger standing in front of the Palestinian border police is thus transmitted to the control room as well as the real-time video feed from the machines X-raying luggage. From the control room the Israeli and European observers can communicate with the on-site Palestinian security, demand a rescan or a search in this or that bag, or halt the transit of suspected passengers altogether.[49] When Israel wants the terminal closed it simply denies the European observers access to the control room. According to the agreement, Egyptian border police must then close the passage on their side. In this way, Israel has kept the Rafah crossing, the only gateway Gaza has to the outside world, closed for 86 per cent of the time since June 2006 when an Israeli soldier was kidnapped and taken into Gaza.

But neither the architecture of the Oslo-era Allenby Bridge terminal, nor Israel's pseudo-'border terminals', and not even the new Rafah crossing should be mistaken for metaphors for new forms of domination exercised by Israel; rather they should be seen as components in its ubiquitous and fractalized logic. The logic of the late occupation is not represented by but embedded and saturated within these structures. The Wall itself reiterates some of these built physiognomies. It is not

only an instrument of partition but also an apparatus of observation and control, a sensitive linear sensor directed at Palestinian towns and cities. The biometric passes that will soon be used to permit Palestinians to travel through the Wall will make Israel's demographic data on Palestine more complete than the data Palestinians themselves could ever hope to compile.[50]

Enclaves Exclaves

The open frontier of conflict has spread this politics of separation throughout the entire Israeli political territory. In Israeli cities, manned checkpoints and guarded entrances have been erected to protect bus stations, shopping malls and inner-city residential neighbourhoods from suicide attacks. Even entry into shops and coffee houses generally requires an identity check. Physical and manned fortification systems (electronic surveillance alone is no longer seen as adequate in face of the intensity and immediacy of threats) are available to the public on the open market, and to the global security market as Israeli 'innovations'. Exported globally, these Israeli practices and technologies have connected the uniqueness of the conflict with worldwide predilections to address security anxieties through 'circulation management', applied now, to state but two examples, along the shifting external borders of the EU as well as along the United States–Mexico and United States–Canada borders.

Within Israel, the barriers between Jews and Palestinian citizens of Israel have had, for legal reasons, to camouflage their real motivations. The high earth rampart, which was raised in 2003 between the poor Palestinian coastal village of Jisr al-Zarqa and the very wealthy town of Caesarea, half an hour's drive north of Tel Aviv, was planted with trees and flowers and presented as a supposedly innocent landscape feature in order to disguise its real function of national-economic separation (Figure 8.5). Following this example, the affluent, previously agricultural and presently suburban Moshav Nir Ziv, quarter of an hour's drive east of Tel Aviv, demanded that the government construct a 1.5-kilometre long and 4-metre high 'acoustic wall', which would in effect separate it from the inhabitants of the predominantly Palestinian-Israeli, government-neglected and drug-plagued neighbourhoods of the city of Lod. Residents of Moshav claim that Lod's inhabitants bother them, steal from them and generally disturb their quality of life. The territorialization of Israel's demographic phobia has generated increasing numbers of barriers between Jewish and Arab communities in neighbouring villages or shared cities, and has led to the further fractalization and fragmentation of the terrain into an archipelago of enmity and alienation.

The physical exclusion of Palestinian citizens of Israel from Israeli space obviously mirrors their increased political exclusion. That the inner borders of the conflict are constantly multiplying is not surprising given the fact that Israel's own Palestinian minority, comprising more than 20 per cent of its population, have been cast as second-class citizens. They are included within the Israeli economy (mainly, but not only, to provide cheap labor and services), but are increasingly

Figure 8.5 The Israeli/Palestinian village of Jisr al Zarka and the landscape feature separating it from the town of Caesarea, 2004. Photo by Eyal Weizman

excluded from other spheres of life – and are often even described as a 'demographic problem' that upsets rather than forms part of an Israeli public.[51] New legislation forbidding Palestinian married couples (even if one of them is an Israeli citizen) to reside in Israel and subsequently become naturalized citizens is part of this cognitive and practical system that sees the physical separation of Jews and Arabs, and the total control of Palestinian movement, as an important component of Jewish collective security.[52]

Prosthetic Sovereignty

Although the terror of the second Intifada heralded a security response of 'permanent emergency', and led to the total breakdown of political negotiations and to the current Israeli policy of unilateral action, the most important aspect of the Oslo Accords' articulation of sovereignty remained in place: a Palestinian government is still apparently in charge of all civil matters under Israel's overarching security control (Figure 8.6). Whether the Palestinian Authority under Hamas recognizes Israel, or whether Israel is at all willing to negotiate with it, are secondary questions to the facts created and daily confirmed by the very existence of such a Palestinian Authority. The victory of Hamas in the January 2006 Palestinian legislative elections demonstrates not the collapse of the system of prosthetic

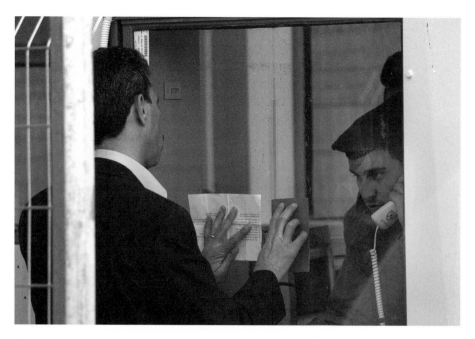

Figure 8.6 Huwwara checkpoint, 2005. Photo by Nir Kafri

sovereignty but, paradoxically, its culmination. The Hamas government's ideology and practice of resistance confirm more than anything else an independent agency, external to Israeli sovereignty.

Why should Israel's security control seek to appear invisible? The Fourth Geneva Convention of 1949, which defines the international laws of belligerent occupation, demands that an occupying power assume responsibility over the management of the institutions – welfare, healthcare, judiciary and education, among others – that govern the life of the occupied Palestinians. Of special relevance is Article 55 of the Fourth Geneva Convention: 'To the fullest extent of the means available to it, the Occupying Power has the duty of ensuring the food and medical supplies of the population ...'[53] Inscribing Palestinian lives under Israel's military regime made them objects of state responsibility. This responsibility operated as a mechanism of restraint in moderating military violence, as it was Israel itself that had to face the consequences of any destruction it inflicted.[54] However, considering the costs of day-to-day government of 3.5 million Palestinians, and of the violent resistance during the two Intifadas (1987–93 and 2000 to the present), Israel has wanted to absolve itself of the responsibilities it had assumed as the occupying power, without losing overall 'security control'. If Israel's excessive security actions had previously been moderated, however lightly, by considerations of an economic and functional nature, since the Oslo Accords, increasingly since the start of the Intifada and increasingly still, in Gaza, since the evacuation of August 2005, Israel's security control could be assumed without the duties of governance, and could freely penetrate every aspect of Palestinian life, consequently aggravating the

desperate Palestinian economic situation without having to pay the price in an adverse impact on its own economy. That this logic was guiding the politics of Israeli retreats from Palestinian-populated areas during the Intifada became apparent in Sharon's speech of May 2003, delivered to Likud Party members ahead of his decision to evacuate Gaza. Surprisingly echoing the rhetoric of the Israeli centre-left, Sharon stated that 'the occupation cannot go on indefinitely', and further asked his colleagues to make their choice: 'Today there are 1.8 million Palestinians fed by international organizations. Would you like to take this upon yourselves? Where will we get the money?'[55]

By assuming a degree of political autonomy, the Palestinian economy and the mobility of its labor force have become completely dominated by Israeli security considerations.[56] The temporary/permanent policy of road and checkpoint closure and traffic restrictions effectively disconnected the Occupied Territories from the labor market in Israel and brought the Palestinian economy to a virtual standstill. By imposing itself from above and diffusing throughout the territories from within, Israel's security devastated the Palestinian economy and any possibility of effective local government. Indeed, since the Oslo Accords, the Israeli economy, benefiting from wider access to the global markets, has been rapidly expanding while the Palestinian economy, with restricted access to the Israeli and global economy, was actually shrinking.[57] According to the UN Office for the Coordination of Humanitarian Affairs, the closure system is presently the primary cause of poverty and humanitarian crisis in the West Bank and the Gaza Strip.[58]

The costs of managing this crisis were (conveniently for Israel) subcontracted to the international community. Increasingly since 2000, international aid to the West Bank and Gaza has been cast as crisis management, with much of the funding allocated for emergency aid, and directed to essential provisions, hospitals and infrastructure, which would otherwise have collapsed. The ensuing crisis has been regarded (in both Israel and the international community) as 'humanitarian', as if it had an unforeseen natural cause, although its reasons are in fact clearly embedded in the political-security situation described above. Recasting the crisis in terms of 'humanitarian polities' was itself a political decision by the European and American donor countries; in doing so, they effectively released Israel from its responsibilities according to international law and undermined their own potential political influence in bringing the occupation to an end. Between 1994 and 2000 the donor community disbursed $3.2 billion – the equivalent of 20 per cent of the GDP of the West Bank and Gaza Strip; between 2000 and 2006, the level of aid averaged about $800 million per year.

An existing Palestinian Authority with an elected 'government' and 'parliament' disguises a reality of social and political fragmentation and total chaos within Palestinian society. Government control was lost to armed organizations (and the conflicts between them) and local gangs on the one hand and to international and humanitarian organizations on the other, with the effective services and provisions bypassing the mechanisms and bureaucracy of the Palestinian Authority altogether.[59] Most of the $800 million annually donated to the Palestinian Authority

since the start of the Intifada by the international community has been spent on crisis management, some of it – amazingly enough – earmarked to repair the damage caused by periodic and ongoing Israeli military incursions. Israel could therefore indiscriminately bomb indispensable Palestinian infrastructure safe in the knowledge that its excessive violence would be mitigated, and the damage caused repaired by other states. Another way of manipulating the involvement of international organizations and independent NGOs engaged in humanitarian relief efforts in the occupied areas was through the checkpoint system. 'Internationals' must obtain 'security clearance' from Israel in order to enter the Occupied Territories and move through Israeli-controlled checkpoints. Israel can simply suspend or withhold these permits from organizations and individuals it doesn't like.[60] Certain international aid organizations, in particular the International Committee of the Red Cross (ICRC), questioned whether their mandates included performing actions that international law defined as the responsibility of Israel as the occupying power; they even engaged in several one-day strikes to protest over the conditions of their work.[61]

Ariella Azoulay has claimed that although the Israeli government has brought the Occupied Territories to the verge of hunger, it tries to control the flow of traffic, money and aid in such a way as to prevent the situation reaching a point of total collapse, because of the international intervention, possibly under a UN mandate, that might follow.[62] The 'occupation' of Gaza has been thus reconceptualized as 'crisis management' modulated by Israel through the opening and closing of checkpoints and terminals. It is through this regulation of international aid, under the guise of security, that Israel still controls the Palestinian economy – and, in effect, life – in Gaza and the West Bank.

The illusion that the policies of Israel after Oslo were instrumental in the 'production' of the Palestinians as sovereign *subjects* – proto-citizens of their own political representation – has paradoxically led to them becoming the *objects* of humanitarian assistance. From the perspective of these subjects / objects, it is precisely when, starting in the Oslo years, they perceived themselves to be almost liberated from repressive occupation that they have become most exposed to its unrestrained powers.

Given these conditions, Palestinians are right to question whether it would not be better if the Palestinian Authority dismantled itself completely until conditions for full sovereignty are met. Dismantling the Authority would place responsibility for government of the territories squarely in Israeli hands. Israel would have a choice of either recognizing its obligations as the occupying power under international law, thus using its own budget to cater for the occupied people, or desisting immediately from its policy of intentional economic strangulation and ending the occupation, in all its various dimensions. From the Palestinian perspective, accepting a walled off, aerially policed, infrastructurally dependent and security-controlled territory as a 'state' is bound to perpetuate the logic of the one-way mirror rather than mark an effective stage to full sovereignty. A call to reconnect the concepts of security control and government, and amend the split described within the function of sovereignty, is not a call for a return to nineteenth-century type

imperialism, with its technologies of government and production of colonial sub-jects. It is rather a call for power either to assume the expensive full responsibility for the people under its security control or to avoid 'security' action when it can-not, is unable or unwilling to do so.

The Palestinian sociologist Elia Zureik has noted that the Palestinian passengers crossing the Allenby Bridge terminal in the late 1990s were in fact fully aware of its architecture.[63] The final perspective of this chapter will therefore be theirs. Late in the afternoons, when sunlight falls through the outside window of the Israeli con-trol room facing west, the balance of light between the control room and the now-darkened hall is rendered almost equal by the setting sun. This makes the one-way mirror transparent enough to expose the silhouette of the Israeli security agents behind it, and with it the designed charade of prosthetic sovereignty. On his return to Palestine, Mourid Barghouti was similarly not fooled by the architectural manip-ulation of the terminal. 'I did not concern myself for long with the odd situation of the [Palestinian police] man. It was clear that the Agreements had placed him in a position in which he could make no decision.'[64]

Notes

1 Gaza-Jericho Agreement, Annex I: Protocol Concerning Withdrawal of Israeli Military Forces and Security Arrangements, Article X: Passages, http://telaviv.usembassy.gov/publish/peace/gjannex1.htm. During a period which the agreement defined as 'interim', Israel was to be responsible for land passages between the Palestinian Territories and Egypt and Jordan, as well as (with some adjust-ments) to the terminal at the Gaza seaport (which was never built) and in all Palestinian airports (the only Palestinian airport – the Dahanieh airport in Gaza – was bombed and destroyed during the early days of the Intifada in 2000).

2 Gaza-Jericho Agreement, Annex I, Article X, clause 2.b.1.

3 Israeli security would be 'separated [from passen-gers] by tinted glass'; Gaza-Jericho Agreement, Annex I, Article X, clause 3.d.2.

4 Gaza-Jericho Agreement, Annex I, Article X, clause 3.d.1.

5 Gaza-Jericho Agreement, Annex I, Article X, clauses 3.e, 9.c.

6 Mourid Barghouti, *I Saw Ramallah*, Ahdaf Soueif (trans.), London: Bloomsbury, 2005, pp. 12, 20.

7 Gideon Levy, 'Twilight zone: more than meets the eye', *Ha'aretz*, 3 September 1999. See also a discussion of the terminal in an excellent article about Israeli surveillance technologies in Israel and the Occupied Territories: Elia Zureik, 'Constructing Palestine through Surveillance Practices', *British Journal of Middle Eastern Studies* 28, 2001, pp 205–27.

8 The eight separate Oslo Accords are: (1) Declaration of Principles On Interim Self-Government Arrange-ments (13 September 1993); (2) The Paris Protocol on Economic Relations (29 April 1994); (3) Agreement on the Gaza Strip and the Jericho Area (4 May 1994); (4) Agreement on Preparatory Transfer of Powers and Responsibilities Between Israel and the PLO (29 September 1994); (5) The Israeli–Palestinian Interim Agreement on the West Bank and the Gaza Strip (also known as Oslo II) (28 September 1995); (6) Hebron Protocol (17 January 1997); (7) The Wye River Memorandum (23 October 1998); (8) The Sharm el-Sheikh Memorandum (4 September 1999).

9 The Fourth Geneva Convention (12 August 1949), Part III/Section III: Occupied Territories, http://www.yale.edu/tawweb/avalon/lawofwar/geneva07.htm.

10 Michel Foucault, *Discipline and Punish: The Birth of the Prison*, Alan Sheridan (trans.), New York: Vintage, 1977.

11 In this way these articles of the Oslo Accord were presented to the Palestinians and to foreign governments. Domestically they were obviously presented as harsh security measures.

12 Tal Arbel, 'Mobility Regimes and the King's Head: A History of Techniques for the Control of Movement in the Occupied West Bank' (presented at 'Comparative Occupations: Chechnya, Iraq, Palestine, Governing Zones of Emergency' Workshop, Middle East Institute, Harvard University, 25–26 February 2006).

13 Gorenberg, *Accidental Empire*, p. 131.

14 Shlomo Gazit, *The Carrot and the Stick: Israel's Policy in Judaea and Samaria, 1967–68*, New York: B'nai Brith, 1995, p. 204.

15 'Within the first year of the first Intifada, for example, no less than 1,600 curfews were imposed, so that by late 1988 over 60 per cent of the population had been confined to their homes for extended periods of time.' Neve Gordon, *Israel's Occupation: Sovereignty, Discipline and Control*, Berkeley, CA: California University Press, forthcoming (chapter 6).

16 Leila Farsakh, 'The Economics of Israeli Occupation: What Is Colonial about It?' (presented at 'Comparative Occupations: Chechnya, Iraq, Palestine, Governing Zones of Emergency' Workshop, Middle East Institute, Harvard University, 25–26 February 2006).

17 The Accord left to Israel the right to determine what the diameter of water pipes in the water networks connecting the archipelago of Palestinian enclaves would be when these pipes ran through Israeli-administered zones. In this way Israel could effectively control the rate of flow and the quantity of water transported between locations. See Amira Hass, 'Colonialism under the Guise of a Peace Process', *Theory and Criticism*, 24, spring 2004, p. 192.

18 In the context of the Oslo Accords, the Israeli government guaranteed the Palestinians and United States that no new settlements would be established and existing settlements would not be expanded, except for the 'natural growth' of existing settlements. Under the banner of 'natural growth', Israel has established new settlements under the guise of 'new neighbourhoods' of existing settlements. Between September 1993, on the signing of the Declaration of Principles, and September 2000, the time of the outbreak of the second Intifada, the population of the West Bank settlements (excluding East Jerusalem) grew from 100,500 to 191,600, representing a growth rate of some 90 per cent. In East Jerusalem at the same time, the population grew from 146,800 in 1993 to 176,900 in 2001, an increase of just 20 per cent. See Lein and Weizman, *Land Grab*.

19 This is the definition according to the International Organization for Standardization (ISO) – the international standard-setting body composed of representatives from national standard bodies (www.tqm.org).

20 Yehouda Shenhav, *Manufacturing Rationality*, Oxford: Oxford University Press, 1999. See also Uri Ben-Eliezer, 'Post-Modern Armies and the Question of Peace and War: The Israeli Defense Forces in the "New Times"', *International Journal of Middle East Studies*, 36, 2004, pp. 49–70.

21 An amendment to a 2005 Pentagon spending bill sponsored by Senator John McCain bars 'cruel, inhuman and degrading treatment' of prisoners in US custody, but still allows such treatment when the prisoners are not in US custody. This bill was rendered immediately unenforceable by a specially tailored counter amendment, the Graham-Levin Amendment that seeks to limit judicial review.

22 A major US project to create a 'virtual border' seeks to extend American surveillance networks and compile and share vast amounts of biometric and other data so that 'terrorists' can be identified and intercepted while still nominally 'abroad'. See Eric Lichtblau and John Markoff, 'Accenture Is Awarded U.S. Contract for Borders', *New York Times*, 2 June 2004.

23 Ariella Azoulay and Adi Ophir, 'The Monster's Tail', in Michael Sorkin (ed.) *Against the Wall*, New York: The New Press, 2005, pp. 3–4.

24 Gilles Deleuze, 'Postscript on the Societies of Control', *October*, 59, Winter 1992. 3–7.

25 OCHA, West Bank, 'Closure Count and Analysis,' September 2006. In the year between the evacuation of Gaza in August 2005 and September 2006 these restrictions increased 39 per cent. See

www.ochaonline.un.org. According to a position paper by B'Tselem, *Freedom of Movement – Siege*, there are 457 mounds of earth, 95 concrete blocks and 56 ditches. See the full report at www.btse lem.org.

26 According to the conservative estimates of the World Bank, per capita gross domestic product (GDP) in the West Bank and Gaza dipped by about 30 per cent between 1999 and 2005. In 2005, unemployment in the Palestinian Authority was 40 per cent in Gaza and 29 per cent in the West Bank, with 56 per cent of the residents of Gaza currently below the poverty line (75 per cent are estimated to be below this line in 2007), more than double the rate before the second Intifada (22 per cent), some 70 per cent of the population of Gaza are now unable to meet their families' daily food needs without assistance. According to the World Bank, the main reason is restrictions on the movement of people and goods. See World Bank, 'West Bank and Gaza Economic Update and Potential Outlook', http:// www.worldbank.org/we. A recent report by the United Nations Relief and Work Agency (UNRWA) warns of a lack of basic food supplies due to frequent closures of the border crossings that prevent goods from reaching Gaza from Egypt. See http://www.un.org/unrwa/news/ index.html.

27 Amira Hass, 'Israeli restrictions create isolated enclaves in West Bank', *Ha'aretz*, 24 March 2006.

28 Alice Rothchild, 'Pitching in for health on the West Bank', *Boston Globe*, 6 March 2004. Quoted in Gordon, *Israel's Occupation* (chapter 6).

29 Zygmunt Bauman, *Society Under Siege*, London: Polity, 2002.

30 Raviv Drucker and Ofer Shelah, *Boomerang, The Israeli Leadership Failures during the Second Intifadah*, Jerusalem: Keter Books, 2005, p. 330.

31 www.machsomwatch.org.

32 Azmi Bishara, *Checkpoints: Fragments of a Story*, Tel Aviv: Babel Press, 2006 [Hebrew], p. 10.

33 Ibid., p. 17.

34 Eyal Weizman, 'The Subversion of Jerusalem's Sacred Vernaculars', in Michael Sorkin, *The New Jerusalem*, New York: Monacelli, 2003, pp. 120–45.

35 Bishara, *Checkpoints*, p. 231,

36 Amos Harel and Avi Isacharoff, *The Seventh War*, Tel Aviv: Miskal – Yedioth Aharonoth Books and Chemed Books, 2004, p. 343.

37 Baruch Spiegel, 'Issues of the Wall, presentation at the Van Leer Institute, Jerusalem', 17 February 2006. The plan was published in English as it was meant to placate, amongst other things, the American administration, and be officially adopted by the government.

38 Ministry of Defence Press Release: 'Defence Minister Mofaz appoints Brig.-Gen. (Res.) Baruch Spiegel to head team dealing with civilian and humanitarian issues vis-a-vis security fence', 27 January 2004, http://www.israel-mfa.gov.il/MFA/ Government/Communiques/2004; Druker and Shelah, *Boomerang*, p. 331.

39 Glenn Kessler, 'US aid to Palestinians goes to checkpoints, Zionist organization', *Washington post*, 5 May 2005.

40 http://www.securityfence.mod.gov.il/Pages/ ENG/Humanitarian.htm

41 Ministry of Defence Press Release: statement, 15 January 2006, http://www.mod.gov.il/WordFiles/ n32301062.doc

42 Baruch Spiegel, 'Balancing Rights – The Security Fence and the Palestinian Civilian Population', presentation transcript, 18 March 2006, the Jerusalem Centre for Public Affairs, http://www. ngomonitor.org/issues/Balancing%20RightsThe SecurityFenceandthePalestinianCivilianPopulation Text.htm.

43 OCHA, 'Closure Count', footnote 27.

44 Arbel, *The Kings Head*. See also Machsom Watch, *A Counterview, Checkpoints 2004*, www.machsom watch.org.

45 Machsom Watch, *Checkpoints 2004*.

46 Amira Hass, 'The humanitarian lie,' 28 December 2005, www.counterpunch.org.

47 Aluf Benn, Arnon Regular and Akiva Eldar, 'Rice: Israel and PA Clinch Deal on Gaza-Egypt Border Crossing', *Ha'aretz* 15 November 2005; Jamie Chosak, 'Opening Gaza to the Wider World: The Israeli–Palestinian Agreement on Movement and Access', Washington: The Washington Institute, 30 November 2005, http:// www.washingtoninstitute.org/templateC05.php? CID=2412.

48 The principles for Rafah Crossing are outlined in the 'Agreement on Movement and Access', http://www.usembassy.it/viewer/article.asp?article=/file2005_11/alia/a5111510.htm.

49 Israel controls the observers' access to the crossing: the European (currently Italian) observers live in Israel. In order to get to work, they have to pass through a military crossing, which Israel often closes on the grounds that it has received information of planned terrorist attacks. Without the observers the Rafah border crossing is closed. Source B'tselem to Defence Minister: 'Stop using Rafah Crossing to pressure Gaza civilians', www.btselem.org, 30 August 2006.

50 Through the permit system Israel continues to control the population registry in the West Bank and Gaza. Almost every change in the registry made by the Palestinian Authority requires the prior approval of Israel. By controlling the population registry, Israel can determine who is a 'Palestinian resident' and who is a 'foreigner'. Only 'residents' are allowed to enter via the Rafah and the Allenby crossings.

51 See the way this policy has been dealt with in Jerusalem in Chapter 1, p. 47–52 [of the original publication].

52 The Law of Citizenship and Entrance into Israel, 2003/544 – this law forbids the spouses of Israeli citizens from Gaza or the West Bank to gain the status of Israeli residency.

53 For an in-depth analysis, see Eyal Benvenisti, *The International Law of Occupation*, Princeton: NJ Princeton University Press, 1993, pp. 7–25 and pp. 107–48. Although the position of Israeli governments since 1967 has been to reject the applicability of the Geneva Convention to the West Bank and Gaza (claiming that no internationally recognized sovereignty existed there prior to the occupation), it has however taken upon itself to abide by what it called the 'humanitarian' clauses of the convention.

54 James Ron, *Frontiers and Ghettos: State Violence in Serbia and Israel*, Berkeley, CA: University of California Press, 2003, p. 262. See the review of this book in Neve Gordon, 'Theorizing Israel's Occupation', *HAGAR, Studies in Culture, Polity and Identities*, 6 (2) 2006, pp. 115–35.

55 'Sharon Defends pro-peace Stance', *New York Times*, 28 May 2003.

56 Leila Farsakh, 'The Economics of Israeli Occupation'. After Oslo, Israel started replacing its low-wage Palestinian labor force with guest workers mainly from Africa and southeast Europe.

57 Real GDP in the West Bank and Gaza Strip grew by 2.3 per cent per annum between 1994 and 1999, implying a decline in per capita income, in view of the population growth rate of 4 per cent. GDP per capita in the West Bank and Gaza Strip fell by 18 per cent between 1995 and 1996, which were years of frequent border closures. It fell a further 35 per cent between 2000 and 2005. During the thirty-two months when the Labor Party was in government (September 1993–June 1996), Israel's real GDP per capita grew at an annual average rate of about 3.4 per cent, compared to only about 1.3 per cent annually previously. Between 1995 and 2000, Israel's GDP rose from 270 billion shekels to 470 billion (in 2004 prices). From an annual level of $14.8 billion in 1993, exports increased to about $20 billion in 1996, about 11 per cent growth rate per year since Oslo, which is higher than the 7 per cent rate of growth in exports during the comparable pre-Oslo years. Leila Farsakh, 'The Economics of Israeli Occupation'. Also Sara Roy, 'Decline and Disfigurement: The Palestinian Economy after Oslo', in Carey, *The New Intifada*, London and NY: Verso, 2001, pp. 91–110.

58 OCHA, 'Closure Count'.

59 The World Bank, the IMF and the Ad Hoc Liaison Committee (AHLC) have acquired oversight of the Palestinian Finance Ministry, helping it to manage economic policy. The World Bank has effectively become the manager of the donors' funds.

60 A demonstration of Israel's control over humanitarian action was provided in April 2006 when local Palestinian employees of UNRWA dealing with food and health aid refrained from coordinating with Hamas officials because they feared being blacklisted by Israel and the United States. This lack of cooperation has been mentioned as one of the likely reasons for the rapid spread of avian flu in Gaza in the spring of 2006. Akiva Eldar, 'Coming Soon: Kosovo in Gaza? Aid Organizations in Gaza Paralyzed Fearing Ties with Hamas-led Government', *Ha'aretz*, 4 April 2006.

61 This situation is at the heart of what Rony Brauman, David Rieff and others called the 'humanitarian paradox', the dilemma faced by humanitarian organizations and NGOs operating in war zones. It implies that while operating on a purely humanitarian level (the humanitarian hopes to gain better access to places of crisis by presenting the humanitarian space as an apolitical, neutral one), they will not be able to avoid political instrumentalization and thus may play into the hands of power itself. Furthermore, by attempting to pull out from situations where they may be instrumentalized and by acting as 'witnesses' (Brauman's position), humanitarians are in danger of themselves politicizing relief work (Rieff). See Rony Brauman, 'From Philanthropy to Humanitarianism', *South Atlantic Quarterly*, 2/3, Spring 2004, pp. 397–417; and David Rieff, *A Bed for the Night: Humanitarianism in Crisis* (New York: Simon and Schuster, 2002). David Shearer, head of OCHA, claims that the situation in Gaza is becoming similar and will demand similar measures to those undertaken following the Kosovo crisis in 1999; that is, an international UN mandate on the area. OCHA, *Gaza Strip Situation Report*, 29 March 2006, http://www.humanitarianinfo.org/opt/docs/UN/OCHA/ochaSR_Gaza290306.pdf

62 Ariella Azoulay, 'Hunger in Palestine: The Event That Never Was', in Anselm Franke, Rati Segal and Eyal Weizman (eds), *Territories, Islands, Camps and Other States of Utopia*, Cologne: Walter Koening, 2003, pp. 154–7. According to chief of military intelligence Amos Gilead, 'hunger is when people walk around with a swollen belly, collapse and die. There is no hunger in Palestinian territories.' Druker and Shelah, *Boomerang*, p. 329. Azoulay, *Hunger*, pp. 154–7. Since Hamas was elected to power in January 2006, Israel has used the weapon of economic strangulation as a means of political pressure by withholding all Palestinian tax monies – about $60 million a month – which it is legally obligated to transfer to the Palestinian Authority. Israel has also mobilized the international community to suspend aid until Hamas recognizes 'Israel's right to exist' and enters into a political process. However, the international boycott of Gaza residents to pressure the Hamas government has been counter-productive, with both Israel and donor countries desperately seeking for a way out. The poverty created in Gaza is more threatening.

63 Elia Zureik, 'Surveillance Practices', p. 227.

64 Barghouti, *I Saw Ramallah*, p. 10.

Further readings

Israel's Occupation, Neve Gordon (Berkeley: University of California Press, 2008).
Reporting from Ramallah, Amira Hass, *Semiotext(e)* July 2003 (distributed by MIT Press).

Related Internet links

Francis Alys's Green Line, Jerusalem: http:/www.thefreelibrary.com/Walking+the+line-a0145872683
Gaza photographs: http:/www.laurajunka.com/

9

Black Tents

ÇAGLA HADIMIOGLU

Keywords

women
chador
hijab
Iran
space
monumental
 architecture
memory
Lefebvre
Ayatollah
 Khomeini
Iranian Dress Code
resistance
Shirin Neshat
poetry
representation

A shadow passes against the playful colors and intricate patterns of a *faience* portal of Safavid Isfahan. The shadow is echoed in form by many more: large black triangles with feet that carry them across the scene. Not a shadow, but a black screen, a surface that has been swept around a woman's body to form what is not simply an item of clothing but an extended skin, a tent, an architecture (Figure 9.1). This is the *chador*: a large semi-circle of black cloth designed to cover a woman's body, held at her chin with one hand, leaving a small triangle of her-face visible.

The chador is one manifestation of *hijab* in women's clothing. Hijab has come to be equated with an Islamic dress code and is often rendered in English as "veiling."[1] In Iran women wear the chador in mosques and in state buildings. Although a less inhibiting form of covering such as a scarf and long loose coat is considered acceptable outside such buildings, many women choose to wear the chador in all spaces outside the home. Even in the home – wherever "forbidden" eyes are present.[2] This extends to the presence of the camera eye that might distribute a woman's image to others outside the space.

Etymologically, the Persian *chador* is derived from the Turkish word *chadir*, which in Turkish still means tent. The chador is thus conceptualized as a mobile home that facilitates a woman's movement around the city and her dealings with men. It essentially describes an extended boundary that assures that she always occupies a private space. In Iran this black tent may be identified not only as architecture but perhaps also as a monumental architecture that supports a multiplicity of inscriptions. The chador is a politically and historically defined surface, one that yields alternate readings dependent on the political position of the reader. It attracts voyeuristic attention from the West, where it is viewed as "exotic." Yet within the particular Islamic society in which it is worn, the chador aims to act as a foil to the masculine visual regard. A woman inhabiting this "screen," upon which not only ideology but also desire is projected, is politicized within a global

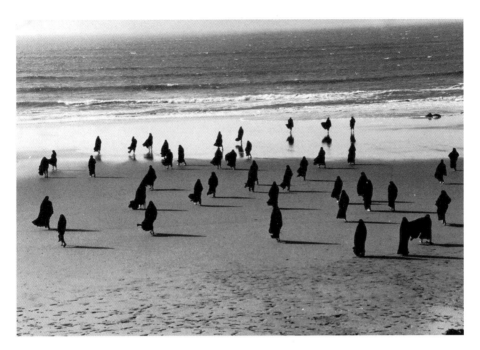

Figure 9.1 Still from *Rapture*, Shirin Neshat, 1999

context despite, or because of, the original local objective that the chador renders her *neutralized*.

The correlation of the Safavid building entered from that *faience* portal and the moving black tent lies in their operation as sites of memory and political intent. As maintained by Henri Lefebvre, "Monumentality… always embodies and imposes a clearly intelligible message. It says what it wants to say – yet it hides a good deal more: being political, military, and ultimately fascist in character, monumental buildings mask the will to power and the arbitrariness of power beneath signs and surfaces which claim to express collective will and collective thought."[3] The chador operates as such a surface, fluidly masking multiple "wills to power" that have tramped the stages of Iranian history, although not all Iranians subscribe to the clerics' claims that the chador expresses collective will. Collective memories, however, are woven into the black of the fabric of the tent, spanning a few hundred years.

The chador is an urban phenomenon that appeared in Iran as a result, of women's removal from the public realm "with the transition from tribal and feudal communities into expanded urbanism caused by… capitalism."[4] With the establishment of Pahlavi rule in 1925, Iran engaged in a process of westernization equated with modernization, within which the adoption of western clothing was a central symbolic and practical component. The urban work force would be increased by enabling women to participate, her hands liberated from the task of holding her chador. Debate on the hijab burgeoned; "anti-clerical intellectuals"

ridiculed the chador as un-modern,[5] while an equally virulent opposing voice argued for its necessity. Women expressed opinion on both sides of the debate: some despised it as a form of oppression; others found in it a source of pride and an index of identity.

In 1936 Reza Shah outlawed the chador, ordering soldiers to tear them from the bodies of women who insisted on wearing them. Ayatollah Khomeini would later call this action "the Movement of Bayonets."[6] When the Shah abdicated in 1941, his edict was rescinded, at which point "women who had felt humiliated by the Shah's dress code put on black chadors and flaunted them in the streets, reveling in the freedom to wear what they wished."[7] The chador had become, and would remain, a political emblem.[8]

During the late sixties and seventies, inhabiting the chador became a form of personal expression and protest against the Shah and what was seen as western cultural contamination. The chador was assumed by many previously unveiled women; theirs was a political and cultural occupation, in some cases not even remotely religious. Yet despite these decades of pro-veiling activity, upon the victory of the Revolution, Ayatollah Khomeini was not immediately able to enforce the wearing of the chador. His institution of the Islamic Dress Code in 1983 was the culmination of a four-year incremental process, accompanied by the protests of many women. Many continue to fight against it, wearing hijab out of necessity and fully aware that it is a politicized occupation. Some inhabit the chador as another type of architecture, a prison: "the veil is literally a mobile prison, a terrifying form of solitary confinement for life."[9] The various adaptations of hijab by women in Teheran, such as the shortening and tightening of their *rupushes* (coats) and the invention of attractive and revealing ways to tie a headscarf, may constitute resistance.

In 1995 the Leader of the Islamic Republic, Ayatollah Khomeini, stated that "there is no doubt that the chador is a desirable cover and among Iranian costumes is considered the best hijab, but religiously no specific dress has been designated as necessary cover for women, and making the chador mandatory has no ground."[10] His comment reveals the Iranian clerics' awareness that they cannot justify the chador (or "veiling" of any sort) on a Qur'anic basis.[11] Nevertheless, the chador is retained and considered "the best hijab." Since Islam does not prescribe the chador, the rationale for its continued enforcement in Iran must be found elsewhere – in its function as a site of memory and symbolism. It had become, with the Revolution, a form of mobile monument.

As elaborated by Paidar, the position of women in society and thus their legal rights and appearance, constituted a central issue in the formation of an identity for the Islamic State.[12] Recognizing this, even the more liberal clerics, while opposing enforced Islamization, nevertheless supported Ayatollah Khomeini's call for the chador. Pro-democracy cleric Ayatollah Taleghani maintained that the chador should be embraced voluntarily since "we want to show that there has been a revolution, a profound change."[13] The message of a profound change was directed not just to the citizens of the new state but also to those outside, who

had provided the model against which the change had taken place.

The West has twice been implicated in the politicizing of the chador. In the discourse of cultural imperialism, the chador was marked first as a negative symbol of backwardness against modern Europe, and then as a positive nationalist symbol of vulnerable tradition. Since 1983, Western media has condemned the Revolution's enforcement of the veil, seldom venturing beyond a superficial critique of veiling as a mode of women's oppression.[14] Furthermore, the chador maintains an exoticizing tendency – emphasizing a difference between an "us," the West, and a "them," Iranians. It is this function of the chador as an index of difference, representing an identity in a polarized environment that constitutes the operative motivation behind the Iranian clerics' continued call for its use, as demonstrated by Ayatollah Taleghani's justification.

The discourse that analyzes and supports the need for the chador is typically centered on vision. Covering is necessary, as men have eyes, "Eyes are considered not to be passive organs like ears which merely gather information … eyes are active, even invasive organs, whose gaze is also construed to be inherently aggressive."[15] Hijab can therefore be primarily considered a visual prophylactic. Yet

Figure 9.2 One of Gatian de Clérambault's images of Moroccan women. Gatian de Clérambault 'Femme et fillette drapées' 1918–1934. © Copyright 2009 musee du quai Branly / Scala Archives, Florence

such a model does not fully explain the chador. Hijab is manifested in various forms in different societies, and the chador is not the most conservative. Photographs taken at the beginning of the twentieth century by Gatian de Clérambault document, for example, the more extensive covering of Moroccan women's hijab, which was also far more articulated, ironically increasing the effects of those apparently seductive voluptuous curves of folds (Figure 9.2). The Iranian Dress Code demands black, a dictate that departs from the lively colors and patterns still worn by women in rural Iran. The effect of this black is shadow; it creates a negation. In photographs, women appear as holes.

Epigraphs

The faience of that Safavid portal in Isfahan, before which a black shadow sits, bears the words of the Qur'an and testifies to the greatness of a particular patron Shah. The script is articulated in a decorative configuration, rendering it difficult

Figure 9.3 Shirin Neshat, *My Beloved*, 1999. Black and white RC print & ink, 11 × 14 inches (27.9 × 35.6 cm). Copyright Shirin Neshat, reproduced by courtesy of Gladstone Gallery

Figure 9.4 Woman with uzi at an anti-American demonstration. Photo by Jahanshah Javid, http://iranian.com

to decipher. For those who untangle the dates and phrases, both religious and secular, the epigraphy provides clues to the monument's purpose and period: political, religious, and functional. Before operating as a historical document, these same "clues" established the monument as "a collective mirror more faithful than any personal one."[16]

A black screen cannot display an image that is projected onto it. Perhaps the black of the chador should be considered not as a void but as the result of an accumulation of inscriptions or projections so dense that they become solid – an ostensible black "hole" that is in fact saturated with intention, memory, and meaning. The *Women of Allah* photographs of Shirin Neshat support this interpretation (Figure 9.3). White sheets cloak a woman, the artist herself, sometimes with her son or with a gun. Upon the photographs, within the boundaries of the sheet, poems of Forugh Farokhzad (1935–67) are written in black script. The script follows the simple folds of the sheet, suggesting that the words have been applied onto the sheet itself rather than onto the surface of the photograph. The gun sometimes shown at the side of the figure is perhaps the instrument or *qalam* that writes this inscription. Such an instrument evokes stories wrought by the women of the revolution, stories of violence in the name of Islam. The chador, more than just a uniform, was their site of resistance and remains the slate of their struggle, bearing the marks of their beliefs manifested in action (Figure 9.4).

One photograph depicts the face of a child peering from within a white sheet, the script circling the child's face in two different scales (Figure 9.5). The limited area of dense script suggests that the text is incomplete, that the writing will grow, will spread upon the whiteness that covers the child's body. In other photographs the sheet is black, a chador (Figure 9.6). The words have crawled beyond the confines of the now-black sheet onto the skin of the artist. In some of these images the script wanders with the logic of the bends of limb or fold of skin as it also conforms to the shape of the white sheet. In other photographs, the script is flat upon Neshat's face as a layer unattached to the skin (Figure 9.7). Only her eyes remain without inscription. The text appears to be a projection, yet the woman's mouth is closed shut, sealed with what has been projected.

Neshat's inscriptions of Farokhzad's poems – rather than the words of the revolution or the Qur'an – complicates a reading that her once-white tent is simply a site of oppression. Farokhzad remains a pioneering figure for women artists in Iran. Her sensual poetry effects an unveiling, an exploration of the inner space of a woman's thoughts and desires. The juxtaposition of her words with Neshat's tented figures challenges both a simplistic critique of the Muslim woman as passive, mercilessly bound, and gagged by the clerics' chador and also the reading that as a self-determined woman she is struggling to escape this tent. While inhabiting the tent, she is inscribed with desires of her own making, and this inscription twists the weave of her chador, altering our perception of it. The chador, a political battlefield and site of resistance, is also a potential site of poetic pleasures.

The epigraphy presented by Neshat supplements the inscriptions commonly found in contemporary Iran.

Maintaining some continuity with the Safavid portal, these utilize Qur'anic verse and identify contemporary power with quotes and maxims of the Revolution (Figure 9.8). In an innovative turn, decorative schemes employ the image of Ayatollah Khomeini, the most visible symbol of the Revolution (Figure 9.9). Numerous walls bear the giant faces of martyrs of the revolution, men killed in the Iran-Iraq war (Figure 9.10). Guns and hands with tulips (the symbol of martyrdom) are also popularly erected. These images and texts, hovering somewhere between graffiti and billboard, constitute a form of decoration independent of its supporting structure. Any surface may be adorned – freestanding wall or building of any function; the architecture is treated as an assemblage of canvases that circumscribes an irrelevant interior.

Functioning as a site of memory and representation of power, these images and texts might constitute a contemporary Iranian monument, articulating a monumentality characterized by surface. Social space in Iran, however, is not equivalent to a western "postmodern" space, of which the billboard may be a manifestation. A monument both embodies a society's or a hegemony's concept of space and also imposes it; in Iran, the chador, not the billboard, meticulously performs these roles.

Spatial Habit

Henri Lefebvre's triadic structure of space and his discussion of the monument usefully demonstrate the monumental potential of the chador. Lefebvre distinguishes between perceived space (*spatial*

Figure 9.5 Shirin Neshat, *Innocent Memories*, 1995. Black and white RC print and ink, 11 × 14 inches (27.9 × 35.6 cm). Copyright Shirin Neshat, reproduced by courtesy of Gladstone Gallery

Figure 9.6 Shirin Neshat, *Faceless*, 1994. Black and white RC print & ink, 11 × 14 inches (27.9 × 35.6 cm). Copyright Shirin Neshat, reproduced by courtesy of Gladstone Gallery

Figure 9.7 Shirin Neshat, *I Am Its Secret*, 1993. RC print & ink, 11 × 14 inches (27.9 × 35.6 cm). Copyright Shirin Neshat, reproduced by courtesy of Gladstone Gallery

practice), conceived space (*representations of space*), and lived space (*representational spaces*).[17] Hijab is determined by an "Islamic" conceptualization of space that is essentially moral, generated by a binary categorization of familial and sexual relations, the *mahrem and namahrem*.[18] Mahrem, meaning unlawful or forbidden, refers to a consort, an intimate, a family member with whom it is unlawful to marry, but before whom a woman is permitted to appear unveiled. Namahrem (not-*mahrem*) refers to those who may not see her unveiled, strangers. The fundamental moral opposition, mahrem/namahrem, structures a concept of space in terms of who may be present and who may not, describing space conceptually as either forbidden or permitted depending on who is occupying it.[19] Hijab provides the curtain of physical separation. Use of the chador effectively limits the forbidden space to the interior of the tent, liberating all other space for occupation by men who are namahrem. Indicating the monument's relationship to power, the prescribing/proscribing function of the chador is characteristic of Lefebvre's monumental space: "Such a space is determined by what may take place there, and consequently by what may not take place there (prescribed/proscribed; scene/obscene)."[20]

The social practice of separation, the utilizing of hijab, is an example of Lefebvre's *spatial practice*. "The spatial practice of

Figure 9.8 The Arabic reads: "There is one God and Khomeini is the leader." Photo by Jahanshah Javid, http://iranian.com

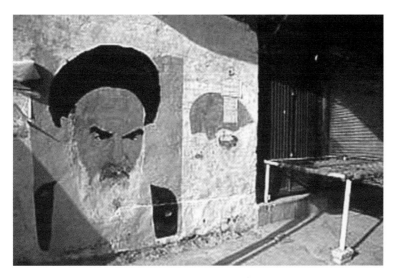

Figure 9.9 A mural in a southern town near Ahvaz. Photo by Jahanshah Javid, http://iranian.com

Figure 9.10 Film still from *The Faces on the Wall* (Les Murs ont des Visages), 2007. Iran/France, Documentary, Directors: Bijan Anquetil and Paul Costes

a society secretes that society's space; it propounds and presupposes it, in a dialectical interaction; it produces it slowly as it masters and appropriates it."[21] This interaction is demonstrated well in Iranian society where the moral code of segregation is a spatial construct both in concept and in practice. This interaction between the concept and practice of hijab produces a *representational space*, which is also served by the chador.[22] As already noted by the clerics who call for its use as a symbol, the chador not only represents the conceived space of a specific moral code but also a particular hegemony.

Moreover, the chador is another skin, a place of inhabitation such as a home. As a *lived space* it is a "place."[23] It is a place of security, a place of liberation, and resistance. A place of domesticity, of camouflage. As a place of inhabitation, the chador alters a local geography. The space of the chador is not limited to those who are covered in its folds. The assemblage of black tents constructs a type of sub-city of fluid walls that may be occupied just as is any city constructed of individual stationary buildings. Exterior surfaces congregate and disperse; the exterior spaces circumscribed by these surfaces, although never constant, assert established social regulations for inhabitation. Those who inhabit the interior of the chador perceive the interstice of screen and skin, and those who dwell among the tents perceive their own distance from she who is inside.

Figure 9.11 Billboard advertising the first fashion show in Iran since the revolution. Reproduced by courtesy of Hasan Sarbakhshian/Associated Press/Press Association Images

> For millennia, monumentality took in all the aspects of spatiality that we have identified above: the perceived, the conceived, and the lived; representations of space and representational spaces ... Of this social space, which embraced all the above-mentioned aspects while still according each its proper place, everyone partook and partook fully – albeit, naturally, under the conditions of a generally accepted Power and a generally accepted Wisdom. The monument thus effected a "consensus," and this in the strongest sense of the term rendering it practical and concrete. The element of repression in it and the element of exaltation could scarcely be disentangled.[24]

Women's dress continues to constitute a barometer of the political climate in Iran. The monuments of the revolution, fashioned, as monuments are, on an "effected consensus," are beginning to peel. The first fashion show since the Revolution was recently held in Tehran, and advertisers of the event erected billboards displaying the image of women in "fashionable" hijab on a scale that evokes Ayatollah Khomeini or the martyrs (Figure 9.11). These billboards, like the chador two decades ago, signal that there has been a change. Whether it is profound or not remains to be seen.

Notes

1 *Hijab* denotes a variety of objects that conceptually participate in a function of separation and/or division: a partition, a veil, a curtain, a membrane. It is also used as an abstract noun – veiling, concealing; also modesty, bashfulness. In the Qur'an, the word hijab is not used to refer to a women's dress code but rather to an earlier, abstract concept of modesty.

2 The presence of men who are not defined as "mahrem" – a term that will be elaborated later.

3 Henri Lefebvre, *The Production of Space* (Oxford, UK and Cambridge, USA, Blackwell, 1984) 143.

4 Hamid Dabashi, "The Gun and the Gaze; Shirin Neshat's Photography," *Women of Allah: Shirin Neshat* (Torino: Marco Noire Editore, 1997): Unpaginated.

5 Paul Sprachman, "The Poetics of Hijab in the Satire of Iraj Mirza," *Iran and Iranian Studies: Essays in honour of Iraj Afshar*, ed. Kambiz Eslami (Princeton, NJ: Zagros Press, 1998): 341.

6 See Spracheman, 345.

7 Memoir of Farman Farmanian quoted in Sprachman, 347.

8 The relationship of politics and the veil was already demonstrated early in the nineteenth century when Tahereh Qurral al-Ayn threw off her veil in order to "engage in radical political activities." See Hamid Dabashi, op. cit.

9 Farzaneh Milani quoted in Anne McCann-Banker, ed. *Stories by Iranian Women Since the Revolution* (Austin, Texas: Center for Middle Eastern Studies The University of Texas at Austin, 1991): 13.

10 *Iran News* 03/14/95 quoted on www.netiran.com.

11 His statement echoes those made by the revolutionaries in 1979.

12 Parvin Paidar, *Women and the Political Process in Twentieth-Century Iran* (Cambridge, UK: Cambridge University Press, 1995).

13 Ayatollah Taleghani quoted in Paidar, 233. Paidar explains how "This profound change was to be marked by the appearance and behavior of women."

14 Iranian-American CNN Correspondent Christiane Amanpour donned a headscarf to interview President Khatami in 1998, but in her CNN documentary "Revolutionary Journey" two years later, she ripped the scarf from the head of her unsuspecting cousin *on camera*.

15 Hamid Naficy, "Veiled Vision/Powerful Presences: Women in Post-revolutionary Iranian Cinema," *In the Eye of the Storm: Women in Post-revolutionary Iran*, ed. Afkhami and Friedl (Syracuse, NY: Syracuse University Press, 1994): 141. Ayatollah Ali Meshkini explains it thus: "Looking is rape by means of the eyes… whether the vulva admits or rejects it, that is, whether actual sexual intercourse takes place or not."

16 Lefebvre, 220.

17 As Lefebvre points out, this triad of spaces will not be cleanly applicable and may interact fluidly in different societies.

18 That is, the representation of space, "the conceptualized space, the space of scientists, planners, urbanists, technocratic subdividers, and social engineers." Lefebvre, 38. The social engineer in this case is the Iranian cleric, following Iranian tradition and religious law to concretize the concept in practice.

19 Returning to an earlier example, if a camera is used in a harem, the women are likely to put on their chador. The forbidden space once extended to the bounds of the entire room is effectively contracted into the space of each woman's tent.

20 Lefebvre, 274.

21 Ibid. 38.

22 I am suggesting that the representation of space reflects hijab's meaning as *modesty* – a modesty grounded in the moral code structure by the familial and sexual relations noted above. Spatial practice is a practice of hijab (modesty) utilizing hijab, this time denoting curtain, physical divider Islamic dress code.

23 The correlation of "place" and "lived space" is pointed out by Edward W. Soja, *Thirdspace: Journeys to Los Angeles and Other Real-and-Imagined Places* (Cambridge, USA and Oxford, UK: Blackwell Publishers, 1996).

24 Lefebvre, 220.

Further readings

Poetics and Politics of Veil, Voice and Vision in Iranian Post-Revolutionary Cinema, Hamid Naficy, in *Veil: Veiling, Representation, and Contemporary Art*, David Bailey and Gilane Tawadros eds. (INIVA and MIT Press, 2003).

Islam in Public: New Visibilities and New Imaginaries, Nilüfer Göle, *Public Culture*, 14(1), 2002.

Related Internet links

Shirin Neshat: http://heyokamagazine.com/HEYOKA.4.FOTOS.ShirinNeshat.htm

Ghazel: http://universes-in-universe.org/eng/intartdata/artists/asia/irn/ghazel

10

Subterranean Modernities

The Spanish City and its Visual Underground

Juan F. Egea

Keywords

maps
modernity
representation
subways
cities
Madrid
Barcelona
Bilbao
visual identity
history
mapping
film
literature
Frank Gehry
Norman Foster
cultural imaginary

> To speak of the metro first of all means to speak of reading and of cartography.
>
> (Marc Augé[1])

In the beginning, there was Harry Beck's map of the London Underground. Designed in 1931, in this rendition of the public transit network beneath the city, distances are distorted, and lines intersect each other only at 45- and 90-degree angles. The center is enlarged and the outer areas are compressed allowing urban space to be more readily grasped. The city is color-coded, manageable, and easy to understand. The city, mind you, is not represented: it has been diagrammed. This is not geography, but geometry. The city here is reduced to a vertical, horizontal, and diagonal expression of underground transit termini and connections.

A classic in twentieth century graphic design, "the most original work of avant-garde art in Britain"[2] – and often mentioned in the same breath as Mondrian's paintings, Beck's diagram quickly became not only an icon for a city but also for urban modernity itself.[3] (Figure 10.1) As such, the graph also inspired the representation of other subways in other cities: cities that were not London, cities that were in a different stage of both their modernization and their self-representation. The Spanish cities of Madrid, Barcelona and Bilbao are on this score exemplary. They display a visual underground, a subterranean modernity that occasionally runs parallel to their troubled urban modernity above ground. Each of the following sections of this essay will travel one of those subways to see what the city underneath can tell us about the one above ground. My text will situate itself at the critical transfer point where geometry confronts cartography, where the representation of urban space also represents its visual identity, where the history of the underground is an underground visual history of the Spanish city.

Please, mind the gap.

Figure 10.1 Harry Beck, London Underground map, 1933. © TfL, London Transport Museum Collection

Madrid or the Sun's Gate

In Madrid, all roads lead to that centric public space known as The Sun's Gate, *La Puerto del Sol* or simply, *Sol*. "National roads", as they are called in Spain, are numbered, and they are supposed to literally radiate from *Sol*. The famous, so-called "kilometer zero" is there, commemorated on the pavement, surrounded by picture-taking tourists. Of course, no major roadway actually reaches *La Puerto del Sol*. However, the mental map many Spaniards may have of the Spanish road system is intuitively radial, sun-like.[4] This distinctive central point of origin is situated at the very heart of what constitutes the XVII-Century Madrid of the Habsburgs, the "imperial" Madrid. Historically, the first modern means of urban transportation in the Spanish capital did originate from *Sol*. Sporadic omnibus lines transported passengers from the core of the city to the outer districts of *Veritas* or *Vallecas*. In 1871, the first tramway line connected Sol with the upscale *Salamanca* neighborhood. By 1897, seven routes converged on, or started from, an overcrowded *Puerta del Sol*. Early unrealized projects for an underground transit system (the first by Pedro García Faria in 1892, and six years later another by Manuel Becerra) followed the pattern of making *Sol* the origin of all routes. When the conditions were such that the dream of a modern underground could finally become a reality, it was impossible not to think of *Sol* as its hub.[5]

Inaugurated in 1919, *Sol-Cuatro Caminos* (today's blue line) was the first subway route. It was extended first to *Atocha* (1921), then to *Puente de Vallecas* (1923), and finally farther north to *Tetuán* (1929). *Sol-Ventas* (1924), the red line, was the second one built. In a subsequent phase it was extended to *Quevedo*, and eventually linked up with *Cuatro Caminos* (1929). Against all common (modern) sense, the first two subway lines started from, and ended in, the same spot. *Goya-Diego de León*, a short portion of today's brown line, was inaugurated in 1931 as a bifurcation of line two. *Sol-Embajadores* (1936), the beginning of the yellow line, was the initial itinerary of the third underground line. This blue, red, yellow and brown made up the whole underground public transport network before the Spanish Civil War halted any further construction.

Let us state the obvious first: this graph is a representation of time as much as of space. Numbers signify history; so do colors. Secondly, those numbered, colored lines lend themselves to a historical socioeconomic analysis. If one reads more closely (maybe deeply is the word) each number-color combination speaks of the social distribution of the urban space aboveground. Areas in white, for instance, mean ignored space, districts mapped out of existence, or, at least, not worth a stop. In Beck's diagram, South London was "left on its own" writes David L. Pike, because it was less wealthy. Beck's map, of course, did not scorn those zones. Those who designed the network itself did. But, as Pike notes, one of the diagram's effects was "the social map it engraved on its readers."[6] For Pike, what the map is mapping – and mapping socially – seems to be also the mind of the city dweller and the visitor.

The social map that Madrid's diagram engraved on its readers is that of a public transit system underground that, unlike London's, ignored the fashionable upper class districts. The first tramway lines in 1871 connected the two brand new upscale zones of the city, *Salamanca* and *Pozas* (today's *Argüelles*), through *Sol*. In contrast, the first metro line was designed to link up the heart of Madrid to a working class district of shantytowns located at the ever-changing margins of the city. To be precise, the first metro line was an underground trail that would bring workers to a recently remodeled Sol, and return them, unseen, to their humble dwellings in *Cuatro Caminos*. Line number two served the same purpose. This time the frontier-like district was *Veritas*, where a bullring was then being constructed. At this juncture, Engels' 1844 Manchester cannot but come to mind. What these first two subway lines in Madrid may have meant for the dynamics of social visibility in the modern metropolis seems equivalent to the meaning of the famous removal of poor and homeless from the arteries that connected Manchester's financial district to the affluent suburbs of the city. In their daily commute, Manchester's urban elites would be able to move between home and work without any unpleasant sights.

In contrast, Madrid's metro would make the more modest citizens of the city the ones who move, yet in pushing them underground, it would in fact alter the possibilities of moving around the city as well as the dynamics of social visibility and city spectacle that selfsame urban movement entailed.[7] Above ground, the two upper-class, grid-patterned districts already mentioned (*Salamanca* and *Argüelles*) were to be linked by a "great road," that is, a surface thoroughfare whose greatness had to be seen while traveling it. In fact, the socioeconomic reading of the first underground lines must be harmonized with the reading of two other physical and social phenomena that were taking place above ground; the construction of the *Gran Vía* during the first third of the twentieth century, and also, the so-called "outskirts problem" (*problema del extrarradio*). The latter, an urban planning headache inextricably linked to the exhaustion of the nineteenth-century model of metropolitan renovation (the ever-popular *ensanches*, or widening of the city) and the images it evokes are addressed below, but for the moment I want to emphasize that what takes place at the heart of the city, beneath its surface, and at its outer limits, are phenomena that demand to be read in light of one another.

In this dynamics of metropolitan movement and urban visibility, of core and expansion, the *Gran Vía* was destined to become the thoroughfare that, first, would incite movement itself, and second, would redefine the value and the function of a modern city center. A restricted, belated, one-boulevard Haussmanization, the Gran Vía cuts through a dense district of the old city to create a dynamic urban hub that challenges the stationary models of *La Puerto del Sol*, or *La Plaza Mayor*.[8] The paramount feature of the great new avenue is its function as a space of circulation rather than congregation, a space for the traffic of people – traffic of consumers and spectators, that is – not only for vehicles. The spectacles to be seen are not only those inside the recently built monumental theaters and movie-theaters, but also the buildings themselves; their modern, vertical monumentality, their

sumptuous façades, and the eye-catching storefronts at street level As Luis Fernández Cifuentes points out, the building façades in the *Gran Vía* "accurately represented, or set the stage for, an economic performance of European proportions."[9] Banks were after all the most conspicuous institutions that craved to be seen soaring over this fancy city strip.

At the same time, down below, the new urban scene of modern cafeterias and lavish, well-lit displays meant that the "city strollers now found their ways of seeing and being seen, as well as their habits of moving, dressing and acting in the streets, considerably influenced."[10] This great boulevard, in sum, would make people circulate – even behave – in a manner directly opposite to that imposed by the first underground. The riders of the *Gran Vía* would not have to give up the spectacle of a city that was finally becoming a modern metropolis, or looking like one, however precarious its modernity.[11] For precariousness seems to be the key feature of Madrid's urban modernity, and the city's underground literally underlines this condition. In Edward Baker's apt summary:

> [Madrid] is neither the outcome of many centuries of historical continuities and breaks whereby a complex urban civilization undergoes a process of construction, sedimentation, destruction and recreation, as in London or Paris, nor is it the result of a modernity built on a vast and accelerated process of capital formation, as in New York and Berlin. Rather than ancient or modern, Madrid has been intermittently, precariously modern and profoundly and lastingly archaic, as befits a city that is both relatively new by European standards and simultaneously the synthesis of an archaic and crisis-ridden social order.[12]

By 1919, as Benjamin would say about Naples, in Madrid parts of the village were still playing hide-and-seek with the city. Madrid's underground, unlike London's, was indeed growing with the city, trying to keep up with it. If, as David L. Pike argues: "In the nineteenth century, the underground was the locus of modernity because it was the material sector most being developed at the time by capitalism, [and in] the twentieth century it remained the locus of modernity because of its transitional link to everyday life",[13] in the Spanish capital this locus of modernity was being developed *and* simultaneously turned into the transitional link to an urban everyday of very localized modernization. The city discovered the possibilities of its underground space and of verticality all at once. Uneven, accelerated development is the key concept in the historical analysis of the expanding Spanish capital and its expanding underground. A deep reading of the primitive map of Madrid's underground reveals the meaningful interrelations with the new dimensions of the visual and the visible in the big city at the dawn of the twentieth century.

Let us move on now to the current versions of the diagram. What kind of everyday reading of the city does it enable? What mental image of urban space does it offer to the city dweller and to the visitor? If *Sol* nowadays cannot be clearly perceived as the point in which all routes converge, the cluster of stations that surround *Sol* still present a somewhat radial image. The highest concentration of stops

is there. As lines move away from the center, stops become less frequent. A subway thus designed replicates a dynamic of center and periphery where the latter remains disconnected, with wide gaps of unmarked and unreachable space. In Madrid, a gray line was needed to provide an outer ring of connection for lines that were not only growing, but growing apart. That line, predictably, was called the *circular*, although there is no circle to be seen. The city aboveground presents two encircling motorways, the M-30 and M-40, which delineate a symbolic economy of inner and outer space exploited and reinforced by recent films and novels. In Pedro Almodóvar's 1984 film *¿ Qué he hecho yo para merecer esto?* (*What have I done to deserve this?*), the M-30 becomes the marginal space that metonymically underscores the marginal condition of the central characters. According to Michael Ugarte: "While most of the sequences in this neo-naturalist story of a working class mother take place within the apartment, the M30 overpowers the entire film."[14] Ugarte goes on to emphasize the structural importance of this urban referent when he concludes:

> The filmic interaction between interior and exterior creates a Brechtian distance, and invitation for us all to reflect on the reality of the object of representation and on the entire city encircled and strangled by the M30 – its conflicts, its immensity, and its ordered chaos.[15]

More recently, Fernando Leon de Aranoa's 1998 film *Barrio* (*Neighborhood*) tells the story of three lower middle-class teenagers struggling with a variety of family crises, facing unemployment and the temptation of petty crime. During most of the film the three roam the barren spaces of the M-40, making it in great measure their own. At least two scenes show the teenagers sitting on an overpass, bodies seen through a banister whose metal supports ominously double as jail bars. There is no doubt about it, the M-40 is the new encircling, strangling city limit. Interestingly enough, one of the crucial scenes of this filmic tale of urban displacement presents its three young protagonists walking through a "ghost" subway station. It now houses scores of destitute immigrants, most of them clearly foreign and possibly illegal. In the spatial re-imagining of the movie, the underground connects the center of the city to its geographical boundaries, yet it remains, at heart, a place to hide the marginal and the marginalized.

In recent Spanish literature, novels like Francisco Umbral's *Madrid 650* or José Angel Mañas' *Ciudad rayada* (*Scratched City*) also make those encircling motorways the frontier beyond which a no-man's land of crime or loss begins.[16] Here, literature's symbolic use of urban space mirrors an official discourse rich in metaphors of circular limits beyond which the city, literally, ceases to exist. In the historical, pragmatic discussions regarding where Madrid ends – that is, where services will not be provided, where what may happen is not the mayor's but somebody else's problem – one can find a plethora of belts, rings, satellites and *extrarradios* (outskirts).[17] Whether all these literary and official images of circularity aboveground mirror the one underground or vice versa is a debatable question. Yet the fact remains that the images are there, that they keep on "centering" the city; or,

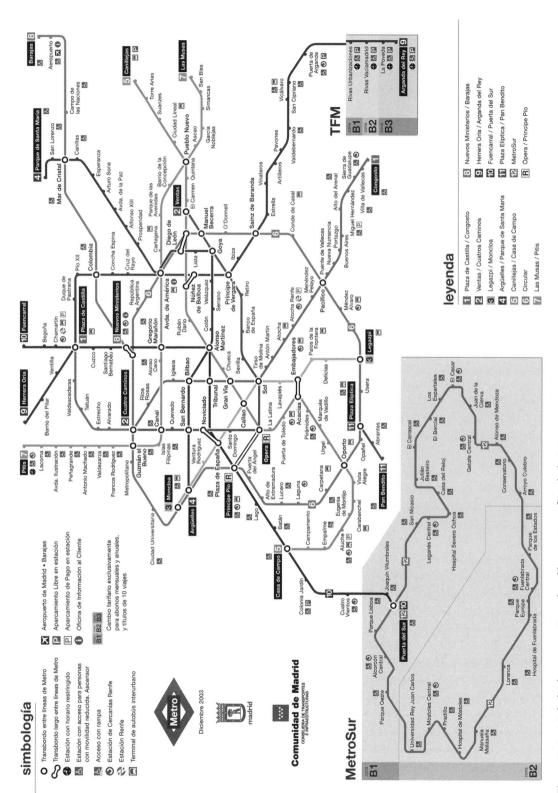

Figure 10.2 Madrid subway map. Reproduced by courtesy of Madrid Metro.

better still, that they draw attention to what Lefebvre called "the dialectical move-ment of centrality."[18] Thus approached, centrality is, rather than a geographical term, a mental and social *form*, a *logic*, an *effort* of symbolic concentration in the face of urban sprawl and dispersion.

No one claims authorship of Madrid's metro diagram these days. Only a copy-right signals its institutional status.[19] Actually, the diagram, as a London-influenced design, started circulating for the first time in 1981. Now, this is not an unremark-able year. Spain is at the end of the political transition from a thirty-six-year old dictatorial regime to parliamentary democracy. Culturally, it is in the midst of the famous so-called *movida madrileña*, that artistic and vital explosion that turned the capital of Spain into "the place to be" in Europe. This is the Madrid of mayor Tierno Galván.[20] This is the Madrid of Pedro Almodóvar's first films, and the Madrid of visual artists such as Ceesepe, El Hortelano, Costus, Ouka Lele, Miguel Trillo and Alberto García-Alix. The question of what kind of belated Modernity or Postmodernity Spain entered into during the 80s is, even today, far from being resolved, but the fact that Madrid's Beck-inspired diagram of the underground appeared just then, speaks, at least, of belatedness in the field of graphic design, which is also belatedness in representing and visualizing the city. Graphic design and the city is, indeed, the key connection at this point.

Once more, the *Gran Vía* was the city space that introduced Madrid to highly visible, modern-capitalist commercial advertisement. The prominent Capitol Building is the paradigmatic example of the new façade-ad or building-display. As Malcolm Alan Compitello notes, "one could study the evolution of consumption in Spain in the transformations of the advertising that adorns buildings like the Capitol."[21] Graphic design, at this monumental scale, was thus present in Madrid since the early twentieth century, but graphic design, in general, came of age in Madrid precisely in the early 80s, when some of the visual artists associated with *la movida* start working on record covers, or on poster design for, say, a brand of ciga-rettes (Ouka Lele for *Gitanes*). If those years produced, more than a new visuality, a new kind of observer, such a spectator would be the result of this encounter of visual arts and graphic design.

Among all the new urban images the *madrileños* witnessed during those years, their brand new, Beck-inspired subway map is arguably the most pervasive, yet the cluster of relations it establishes with other textual and visual representations of the city remains to be studied.[22] (Figure 10.2) The use of basic, contrasting colors, for instance, is an attribute of both the new representation of the city as under-ground and, say, of Ouka Lele's colored snapshots. In fact, one of this photogra-pher's most famous pictures is a photomontage of the emblematic Cibeles square, with the lions of the monument painted over in a vivid blue. It stands to reason that if we cannot study the photographic image and the subway diagram side by side, it is a reasonable use of critical imagination to say that Ouka Lele is coloring the city above ground while the new metro map is coloring the one below. In any case, graphic design has achieved the representation of this underground of intense basic colors in the city center but for a – fittingly enough – gray encircling line.

The newest, still *Beckian* version of the diagram of Madrid subway network appeared in April 2007.[23] (Figure 10.3) Lines have been straightened even more, the diagonal has been dropped, and the 45-degree angle reigns supreme. The city looks somewhat tougher: a space of multiple squares and hard edges. The network has grown wilder. It has also grown appendices (*Metro Sur* and *Metro Ligero*). While this overgrowth threatens the geometrical centrality of The Sun's Gate, *Sol* station reclaims its visual notoriety. It is the only station that appears within a "bubble," and in larger capital letters than the rest. Beyond geographical or geometrical considerations, in Madrid the logic of centrality seems to remain in place. As was to be expected, Barcelona is a completely different case.

Barcelona: The Past, The Sea and Constant Transformation

Barcelona's subway traverses the city along a north to south axis. Only lines Three and Four – briefly – run perpendicular to the coastline. The Mediterranean Sea is the horizontal axis of this diagram, not its focal point.[24] (Figure 10.4) The old city center is not the heart of the underground transit network either. Does this design dialogue (or clash) with previous schemes for redesigning and modernizing the city? Does the image of the Catalan capital in this diagram offer another way to envision the relation of the city with its past and with the sea?

The story has been told many times.[25] In 1859 Barcelona's local authorities held a competition to design the new city, the Barcelona that would expand beyond the old medieval quarters. Two proposals competed from the beginning with more than urban planning glory at stake. The first, by the architect Antoni Rovira i Trias, preserved the medieval district as the heart of the modern city. His ideal new Barcelona radiated from that core as if it were radiating from the past, from a Golden Age of Catalan culture. Ildefons Cerdà's plan, the contending proposal, offered a grid that would radically alter the layout of the city. It proposed rationality, equality, utopian urban planning, as befits the design by a utopian socialist engineer: four long avenues chart the future, the Gran Via, the Diagonal, the Meridiana and the Parallel. The intersection of the first three constituted a new center for a city whose old center owed as much to public health hazards as to medieval splendor.

In one of the most quoted instances of the struggle between Madrid's centralism and turn-of-the-century Catalanism, Barcelona's municipality chose Rovira's plan only to be overruled by the central Government in Madrid, who decreed that Cerdà's plan must be the one implemented. Against the background of the struggle between the plan of a civil engineer and the dream of an architect, one can subsequently read the distinctive buildings by Antoni Gaudí, Lluís Domènech i Montaner and Josep Puig i Cadafalch as slaps in the face of utopian urban socialism. Those unique buildings ultimately contest the design of the urban space in which they have been erected. They are built, in fact, to fight the egalitarian grid. As Joan Ramón Resina aptly puts it:

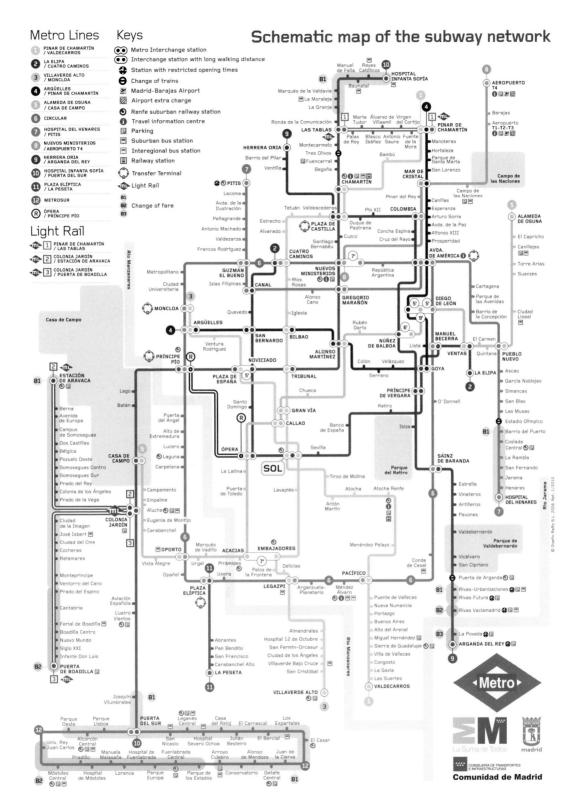

Figure 10.3 Madrid 2007 subway map. Madrid Metro Map © Diseño Raro S.L. 2009

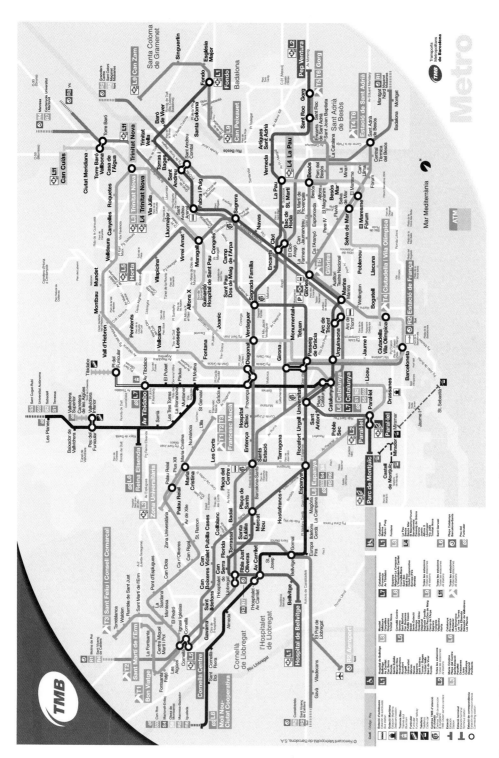

Figure 10.4 Barcelona subway map. © Ferrocarril Metropolità de Barcelona, S.A.

[architects] fought horizontal boredom with their imaginative use of the façade, or by introducing monumental structures such as Domènech's new Hospital de Sant Pau, Gaudí's Sagrada Familia, or the new Industrial University, which break up the regularity of the plan and produce their own insular spaces.[26]

Barcelona's winning design was drawn using the same lines that simplify the representation of the London Underground: the horizontal, the vertical and the diagonal. The surface design encourages an underground replica of the city above, a strategy proved feasible by the precedence of Buenos Aires's *subte*, the first underground transit system in Latin America (1919). In Buenos Aires, lines underground follow the path of avenues above, duplicating a city imagined as a primordial grid. However, Barcelona's subway does not have lines that run beneath the Diagonal or the *Gran Via*. They do so only occasionally. The equivalent to Rovira's design was there also as a possibility, even if the converging point was not the medieval quarters. Barcelona's underground speaks of a city that does not want to make lines converge in the historical center and is not interested in creating another one. Neither do the lines lead to the coastline. A Mediterranean city with its back to the sea: that is one of the most repeated conceptions of a seashore city that indeed had to wait for the reconstruction of public spaces for the Olympic Games in 1992 to finally "open the city to the sea." Barcelona's subway system mostly represents the city as the possibility of south to north, or north to south transit. It is the underground continuation of a physical and symbolic itinerary that for decades has made the whole city the transfer point where the north enters the south, where Europe enters the Spanish state.

In its history and in the history of its representations, together with the "north of the south" view, Barcelona is a city repeatedly associated with the idea of change and constant renovation. Modernity here means the vertigo of incessant transformation with the ever-present threat of social unrest. Joan Ramón Resina, for instance, argues that "It is not an exaggeration to say that Barcelona owes its modern image to its quarrelsomeness."[27] The *Sagrada Família*, the city's emblematic building, has become so as much for its grandeur as for its incompleteness. The temple, as the city, is a perennial work in progress.[28] After the umpteenth remaking of Barcelona in 1992, at least two more projects of renovation, the Fòrum 2004 and the Plan 22@, with their respective salvos of backlashes and endorsements, maintain the image of a restless city whose essence is change, a city that seems always to be "in excess of itself."[29]

In Barcelona's subterranean modernity, constant change and even confusion were manifest from the very beginning. Here numbers do not signify history. Today's Line Three was the first one constructed (1924); Line One, the second. Line Two did not exist until 1992: for quite some time, Barcelona had four subway lines numbered One to Five.[30] Initially, there were two different companies operating the network (*Gran Metro* and *Metro Transversal*), and two rail gauges (Spanish and international) were in place. The story of Barcelona's underground construction and ownership is indeed more complicated than that of Madrid's. Nor is centrality a

guiding concept. Instead, it was purposely rejected, as was the case in the second "urgent plan" for expansion in 1966. Among its "social principles," the plan stated that the subway network should not be concentrated in the city centre.[31]

In one of its more recent official versions, the representation of the city as the possibility of rapid transit has reverted to a complex, confusing blend of diagram and map. Different railway transit systems superimposed on surface references multiply colors and numbers. Not only underground and surface lines are noted, but funicular lines too, adding a new level to be imagined in this two-dimensional graph. If Beck's diagram moved away from geographical references and sought graphic legibility in basic colors, Barcelona's visual *carte de visite* for millions of visitors is the multiplication of represented depths, and the apotheosis of the shade and the hue. Seeing the city, in this case, is not really apprehending it, at least not completely, and not without some difficulty. The industrial city is there, in lines that were constructed to link surface railroad stations. The so called "Barcelona Grisa," the gray Barcelona, the Barcelona of twenty years of Porciolism,[32] is also there, growing as wildly as the city itself in the 50s and 60s. The post-industrial Olympic Barcelona is there too, since the non-existent Line Two, once abandoned and forgotten, was suddenly remembered and completed in time for the spectacular display of the city that were the 1992 Olympic games. The post-industrial, touristic Barcelona is, after all, the final version of what the underground map represents. As it happens, the logic of urban post-industrialism reserves a space for the remnants of the industrial past, and its cartographic abstractions seem to favor an image of layers rather than expansions. This is indeed Barcelona's case. An old factory chimney may be left standing in the Olympic Village; an inoperative water tower may be allowed to adorn a district of newly erected apartment blocks. The latest multicolored, multilayered diagram of the *Transports Metropolitans de Barcelona* may offer itself as an exuberant, anti-grid, non-centered version of the city that nonetheless connects and contains all the pre- and industrial Barcelonas that made up the post-industrial one.

Although if we speak of post-industrial cities in Spain, of their dialectic relation with the pre-industrial past and of how they look above and underground, the best case study is, of course, Bilbao.

Bilbao, or the Appeal of the Global

Bilbao's subway is a river; or, in any case, it runs parallel to the course of one. No need to elaborate on the history of its construction: two colors, two lines. Bilbao's metro system is a post-industrial one, like the city itself nowadays. The first underground line opened in 1995, two years before the inauguration of the Guggenheim Museum, the emblematic image of Bilbao's renewal. The meaning of Frank Gehry's building for the city has been extensively discussed.[33] Standing on the site of abandoned docks in the industrial left bank of the river, the museum represents the desire to overcome the city's past while keeping it as a visual quote. Notoriously

non-referential, Gehry's massive structure has been likened, among an array of things, to an abstract blast furnace. A mountain of iron and a booming steel industry at the turn of the century were the reasons behind Bilbao's industrial preeminence in Spanish economy from the late nineteenth century until its final collapse in the 1990s. Fittingly, the architect's original intention was to use iron in the construction, although, for practical reasons, titanium was finally used. Site, (intended) material and likeness (or one of them, at least) invoke the industrial past as much as the still standing Biscay Transporter Bridge and the so-called Blast Furnace Number One in the municipality of Sestao do, both declared "cultural monuments" in spite of their non-cultural origin.[34]

The Gehry building also placed the Basque capital at the avant-guard of transnational culture by bringing both an international star architect and a global museum franchise to a devastated area where industrial ruins were still everywhere to be seen. Gehry's involvement in the project to make Bilbao, of all places, a Guggenheim city came about only after the architect visited the city and admired what he called its "tough beauty."[35] The industrial wasteland was to be redeemed by the sheer power of a building, by the sheer power of the image of the building. It was to be redeemed also by another type of industry (tourism) and by a different kind of technological progress altogether. As Xon de Ros points out, the use of the computer program *Catia*, and its role in the success of the project, makes the building "not only a physical symbol of urban renaissance but also a symbol of the break from styles of the past through its identification with expanding economic sectors, from the world of design and high technology to the media."[36] Other former industrial sites along the Nervión have been "recovered" for the new post-industrial city since the creation of the company Bilbao Ría 2000 in 1992. From Santiago Calatrava to César Pelli and Jeff Koons, star architects, artists and designers have been enlisted in this spectacular recuperation of what the metallurgic industry ruined. Unsurprisingly, the space underground the city is no exception.

Bilbao's subway network has its own international star architect: the British Sir Norman Foster. And one does not have to look beneath the city to see his brilliance. If Paris had Guimard's Art Nouveau *édicules* announcing at street level an otherworldly experience to those who enter the underground, Bilbao's line one exhibits its "fosteritos" as the *bilbainos* call them. (Figure 10.5) According to the architect's official web page, "These curved glassy structures announce movement itself with their shape evocative of inclined movement and generated by the profile of the tunnels themselves." The most notable stations are large caverns design to alleviate any feelings of entrapment. Natural light has been invited in as much as possible, as in the exemplary case of the award-winning Sarriko station. Instead of the customary *fosterito*, a massive glass atrium filters the daylight to illuminate a magnificent descent to the spacious mezzanine and the ticket dispensers. Spaciousness is indeed the crucial concept of a project that ultimately seeks above all to make the underground into a welcoming space; design – first-rate, internationally acclaimed design – is the medium. One has to be well aware of the history of this city to duly measure what all this means.

Figure 10.5 Bilbao *fosterito*

The birthplace of Basque nationalism, and one of the historic hot spots of working class activism, Bilbao is, in Joseba Zulaika's words, "the womb of Basque industry and finances, as well as a primary force in shaping the entirety of Basque society, politics, and culture."[37] Furthermore, it is also the city "where urban and rural Basque society meet and mingle, as well as where Euskadi [or the Basque Country] articulates with Spain, Europe, and the world."[38] This articulation has the potential to be extremely contentious. The initial reactions to the idea of a Guggenheim-Bilbao museum themselves attest to a resistance that is not based on architectural principles. In 1992, the most radical and separatist Basque left felt compelled to intervene in the negotiations between the Basque Government and Thomas Krens, the Director of the Guggenheim Foundation in New York. They wrote to him demanding transparency in his talks with the PNV, or *Partido Nacionalista Vasco* (Basque Nationalist Party). Days before the inaugural ceremony, a member of the local police was killed when a bomb attack by the terrorist group ETA was aborted. The explosives were to be hidden inside Jeff Koons's monumental floral stature called "Puppy." Architectural taste, at least for some, was a question of life and death.

At times a city of embattled nationalism, Bilbao is, by virtue of its industrial past, a city of high immigration too; and it can be considered as "the least Basque part of the Basque Country."[39] Bilbao is, to some extent, a city of scars:

Figure 10.6 Bilbao subway map. Reproduced by courtesy of Bilbao Metro

the highly visible, environmental scars caused by wild industrialism; and the scars left by state repression and political violence. Hence, to build in Bilbao, and to build in such a way that forms and structures are indigenous and transnational at once, is to intervene, consciously or not, in the existing politics of local identity, as well as to engage with a culturally specific urban visual past. This combination of intervention and engagement is as visible in Norman Foster's underground design as it is in Frank Gehry's titanium marvel; Even the evident concern with alleviating claustrophobia in the underground stations may betray some kind of anxiety that goes beyond that which the idea of underground travel has provoked since its beginning. Bilbao's subway needs to be spacious. It must offer, say, a livable underground. For some, this spaciousness underground will compensate for a suffocating political environment; yet the most likely symbolic compensation is the one that makes up for the memory of the most literally asphyxiating spaces of mining. In the post-industrial recuperation of spaces, underground space appears to be recoverable – and redeemable – too.

A renowned foreign architect, a sleek subway design for an underground that also wants to be seen at street level, a modern means of railroad transportation that dispels the images of polluting nineteenth-century rail transport of iron and people; it all speaks of an urban renewal that entails breaking with the past as much as struggling with it. For Bilbao's metro network is still a river.[40] (Figure 10.6) It follows the same route that iron followed towards the Atlantic during the city's industrial heyday. It is the least metropolitan of all Spanish subway networks. Line One gets to the surface after the Erandio stop, offering a view of what Joseba Zulaika calls Bilbao's dystopia of a devastated Nervión Valley.[41] One can talk at this point of an underground transport network that craves surface visibility, and that craves it in two seemingly opposing ways. The *fosteritos* claim a postmodern stake in the physiognomy of a city they obviously alter. They represent movement, they gesture towards a non-specific, non-traditional, smooth, sleek global future. In the city center stops, even the traditional M's at the entrances have given way to three overlapping red rings atop long, slick masts.

The signage, incidentally, adds another star designer to the inventory of celebrity re-makers of post-industrial Bilbao since they are the creation of the legendary German designer Otl Aicher. Not only engineering or architecture, but also graphic design arrives in the city with this spectacular underground. However, the surfacing of the subway trains on their way to *Plentzia* points to the opposite symbolic direction: they revert to being regular railroad trains, and they offer a ghostly view of the industrial past as well as of the city's rural surroundings. Whatever Frank Gehry's building did or did not do in the re-imagining of the city, whatever citational practices it deploys, and whatever transnational or post national ambitions it betrays, Norman Foster's subway may be doing, deploying and betraying too.

Last Stop, End of Line

It has become cliché to invoke Michael de Certeau's "Walking in the City" in any discussion of the interrelations between urban space, vision and movement.[42] The panoptic view from above versus the liberating comings and goings though the city streets that opens de Certeau's text is the paradigmatic dichotomy for an analysis of the city where looking and moving have competing ideologies. Since Kevin Lynch used them in connection with the city,[43] the terms "cognitive map" and "cognitive mapping" have also become *loci classici* in the study of how we experience the modern metropolis, of how we see, and how we navigate its more puzzling spaces.[44] Modern subway maps certainly partake of this economy of height and depth, of gaze, cognition and bodily movement. They offer views from above that indicate the possibility of movement way below. They are cognitive maps that orient and reassure because they falsify reality or distort space. Above all, they are underground images that prove crucial for the study of the modern city and its representations, for the study of the modern city *in* its representations. I have been shuttling (or transferring) from a history of the subway as underground means of transportation to the history of the representation of the subway system, and, in the case of Bilbao, to the subway's physical presence in the cityscape. Subway maps have been considered here, alternatively, as a socioeconomic x-ray of urban space aboveground, as pieces of graphic design, and as images to apprehend or comprehend the metropolis. "Please, mind the gap," I wrote at the beginning. "Please, mind the gaps," is what I should have written. Gaps notwithstanding, several things should be very clear after all. As representations of modern urban space – as privileged ones, since they themselves circulate, and are not only read but also used – these subway maps are part of the "cultural imaginary" of the Spanish city. They can be made to interact with that repository of textual and visual images that allow us to imagine, to navigate, to mentally manage those cities. Most importantly, they can contribute to what we can call the visual identity of the metropolis they, in more than one sense, represent.

Notes

1 Marc Augé, *In the Metro* (Minneapolis: University of Minnesota Press, 2002), p. 9.

2 Eric Hobsbawn, *Behind the Times: The Decline and Fall of the Twentieth-Century Avant-Gardes* (New York: Thames and Hudson, 1998), p. 39.

3 For a detailed story of Beck's map and its vicissitudes, see Ken Garland, *Mr. Beck's Underground Map* (London: Capitol Transport, 1994). For a contextualized study of this pioneer design, its predecessors, and its legacies, see Maxwell J Roberts, *Underground Maps after Beck* (London: Capitol Transport, 2005), and also David Leboff and Tim Demuth, *No Need to Ask! Early Maps of London's Underground Railways* (London: Capitol Transport, 1999). A color version of the map can be seen at: http://homepage.ntlworld.com/clive.billson/tubemaps/1933.html

4 Incidentally, the same can be said of the railroad system. A diagrammatical representation of its network would present another radial structure, another imperfect spider web, although no mark on the ground reveals any fantasy of centered origin.

5 Madrid's metro not only originates in Sol, it was conceptually born there in 1913, in the middle of a crowd waiting to take the tramway to the then remote district of *Cuatro Caminos*. According to Aurora Moya in *Metro de Madrid (1919–1989): sesenta años de historia* (Madrid: Metro de Madrid, 1990), it was in this queue that the engineer Carlos Mendoza "contó el número de viajeros probables, barajó números y empezó a diseñar la posibilidad de dar otra opción al transporte" [he counted the number of probable passengers, made some calculations, and begun thinking about the possibility of providing another option for urban transportation] (p. 39). As described here, it is impossible to know if Mendoza's mental calculations belong to the engineer or to the businessman in him. At any rate, there was money to be made because there was a very specific clientele to be transported to the financial core of the growing metropolis.

6 David L. Pike, *Subterranean Cities: The World Beneath Paris and London, 1800–1945* (Ithaca and London: Cornell University Press, 2005), p. 23.

7 The aforementioned first tramway lines in 1871, the ones that connected the two brand new upscale zones, were indeed public transportation, but for the upper classes. The first coaches had two levels, the upper one open so that the passenger could see, and, arguably, be seen.

8 José Gavira Martín and Carmen Gavira Golpe. *Madrid: centra y periferia.* (Madrid: Biblioteca nueva, 1999), p. 89.

9 Luis Fernández Cifuentes, "The City as Stage: Rebuilding Metropolis after the Colonial Wars", *Arizona Journal of Hispanic Cultural Studies* vol. 3 (1999), p. 119.

10 Ibid., p. 120.

11 In fact, Miguel de Otamendi, one of the fathers of Madrid's *metropolitano*, attest to the seemingly universal objection to the idea of underground transit:

> …la repulsión de los vecinos a entrar en el túnel, a subir y bajar escaleras y a su decidida preferencia a ir por las calles, alegres, animadas, contemplando los lujosos escaparates, la belleza de las mujeres, la animación de sus vías, cruzadas por tanta y tan diversa gente, por autos, tranvías, autobuses, a la luz radiante del sol o del profuso alumbrado eléctrico [… the repulsion of the neighbors at entering the tunnels, to go up and down stairways and their clear preference for walking the cheerful, animated streets, crossed by so many and so diverse people; by cars, trams, and buses; all illuminated by the radiant light of the sun or by the profuse electric street lighting] In: Moya, *Metro de Madrid*, p. 61.

It is hard to give up the spectacle of the modern metropolis, especially when it is becoming to display a new world of commodities and technologies.

12 Edward Baker, "Introduction: Madrid Writing/Reading Madrid", *Arizona Journal of Hispanic Cultural Studies*, vol. 3 (1999), pp. 73–84.

13 Pike, *Subterranean Cities*, p. 16.

14 Michael Ugarte, "Madrid: From 'Años de Hambre' to Years of Desire," in Joan Ramón Resina (ed.), *Iberian Cities* (New York and London: Routledge, 2001), p. 114.

15 Ibid., pp. 114–15.

16 See Dieter Ingenschay, "Bees at a Loss: Images of Madrid (before and) after *La colmena*", in Joan Ramón Resina and Dieter Ingenschay (eds.), *After Images of the City* (Ithaca and London: Cornell University Press, 2003), pp. 129–38.

17 One of the first attempts at tackling the problem is P. Núñez Granés' *"Proyecto para la urbanización del Extrarradio"* [Project for the Urbanization of the Outskirts] (1910). By 1985, Madrid Municipality's "General Plan" considers the M-30 the physical limit of the city. What lies beyond is called in the document the *"cinturón metropolitano"* (metropolitan belt). In 1993, the *"Plan Integral de desarrollo social y lucha contra la marginación"* [Integral Plan for Social Development and Fight Against Marginalization] moves the physical frontier of the city to the M-40 and M-50 and calls the rest "the periphery". See José Gavira Martín, *Madrid: centro y perifero*, p. 115.

18 Henri Lefebvre, *The Production of Space* (Oxford and Cambridge: Blackwell, 1991), p. 331.

19 Beck's first published diagrams had his name on them. However, his name was soon removed, as others tweaked the design. The official "standard map" of the London Underground credits its original designer with the text: "This diagram is an evolution of the original design conceived in 1931 by Harry Beck." The latest version of Madrid's subway map, to which I will refer later, is credited to a design firm.

20 Even though there is still controversy regarding its nature, its duration and even its existence, the *movida* refers to the cultural production and performances – but also to the new quality of the nightlife – during the late 70s and mid 80s in Madrid. The *movida* has been characterized as an expression of youth subculture made possible by the end of the dictatorship, and by the encouragement of the new local authorities, especially the aforementioned mayor Tierno Galván. Music, visual arts (especially photography) and fashion are the most prolific areas of cultural production during the heyday of the "movement."

21 Malcolm Alan Compitello, "From Planning to Design: The Culture of Flexible Accumulation in Post-Cambio Madrid," *Arizona Journal of Hispanic Cultural Studies*, vol. 3 (1999), p. 207.

22 A slightly later version directly inspired by the 1981 map can be found at http://www.donquijote.org/tourist/maps/spain/files/metro-madrid.pdf

23 See: http://www.metromadrid.es/export/sites/metro/comun/documentos/planos/PlanoInglesJunio109.pdf

24 A color version of this map is available at: http://www.tmb.nel/img/genplano.pdf

25 For two of the best descriptions and analysis of the Cerdà vs. Rovira case, see Bradley Epps, "Modern Spaces: Building Barcelona," in Joan Ramón Resina, *Iberian Cities*, pp. 148–97, and Joan Ramón Resina, "From Rose of Fire to City of Ivory," in Joan Ramón Resina and Dieter Ingenschay, *After Images*, pp. 75–122.

26 Joan Ramón Resina, "From Rose of Fire to City of Ivory," p. 87.

27 Ibid., p. 88.

28 For a detailed study of the temple's symbolic relations with the city, see Josep Miquel Sobrer, "Against Barcelona? Gaudí, the City, and Nature," *Arizona Journal of Hispanic Cultural Studies*, vol. 6 (2002), pp. 205–20.

29 Bradley Epps, "Space in Motion: Barcelona and the Stages of (In)visibility," *Arizona Journal of Hispanic Cultural Studies*, vol. 6 (2002), p. 203.

30 Line Two existed from 1959 to 1970, when it was absorbed by Line Five. It was then dropped from the map, leaving a projected tunnel half-excavated. This is the tunnel that was "rediscovered" when the 1992 Olympic Games created the need for a new subway line.

31 Robert Schwandl, *Metros in Spain: The Underground Railways of Madrid, Barcelona, Valencia, Bilbao* (London: Capitol Transport, 2001), p. 61.

32 Josep Maria Porcioles i Colomer, Francoist Barcelona's mayor from 1957 to 1973. His sixteen-year mandate saw a city abandoned to speculators.

33 In all this section I draw heavily from Joseba Zulaika's "'Miracle in Bilbao': Basques in the Casino of Globalism," *Basque Cultural Studies* (2000), and "Tough Beauty: Bilbao as Ruin, Architecture, and Allegory" in Joan Ramón Resina, *Iberian Cities*, pp. 1–17.

34 The bridge connects the working class town of Portugalete with the upper middle-class district of Las Arenas in Getxo.

35 Joseba Zulaika, "Tough Beauty: Bilbao as Ruin, Architecture, and Allegory," in Resina, p. 4.

36 Xon de Ros, "The Guggenhiem Museum Bilbao: High Art and Popular Culture," in Jo Labanyi (ed.), *Constructing Identity in Contemporary Spain: Theoretical Debates and Cultural Practice* (Oxford: Oxford University Press, 2002), p. 285.

37 Joseba Zulaika, "'Miracle in Bilbao': Basques in the Casino of Globalism," p. 263.

38 Ibid.

39 Ibid.

40 The map may be found at: http://www.metrobilbao.net/eng/usuario/mapainteractivo.html

41 The dynamics between Gehry's building and the blast furnaces, also Zulaika's concept, is embedded in this trip. He nevertheless notes that Line One, the one that runs parallel to the right bank, was the first constructed because that bank is more residential. The left bank is the industrial one.

42 Michel de Certeau, *The Practice of Everyday Life* (Berkeley: University of California Press, 1988), pp. 91–110.

43 Kevin Lynch, *The Image of the City* (Cambridge: Technology Press, 1960).

44 Both terms were subsequently popularized by Fredrick Jameson in *Postmodernism, or, The Cultural Logic of Late Capitalism* (Durham: Duke University Press, 1991). The term "cognitive map" comes originally from psychology, from E.C. Tolman's essay in 1948 entitled "Cognitive Maps in Rats and Men." Jameson's use of the concept, while made far more complex by ideological and aesthetic considerations, is still very close, at least in spirit, to Tolman's. It is about orienting oneself in space; a space that, being postmodern, usually disorients; a space in which the subject cannot map his position cognitively.

Further readings

The Walt Disney World Underground, David L. Pike, *space and culture*, 8(1), 2005.

The City: Between Topographic Representation and Spatialized Power Projects, Saskia Sassen, *Art Journal*, 60(2), 2001.

Related Internet links

Frank Gehry, Guggenheim Bilbao: http://www.netropolitan.org/gehry/bilbao.html

Norman Foster, Bilbao metro: http://www.fosterandpartners.com/Projects/0445/Default.aspx

11

Visualizing Antarctica as a Place in Time
From the Geological Sublime to "Real Time"

Kathryn Yusoff

Keywords

mapping
Antarctica
environment
Clinton-Gore
visual culture
global warming
US
imperialism
cold war
Virilio
satellite imaging
Baudrillard
Warhol
Barthes
geopolitics

This *chronogeography* examines the American-led RADARSAT (Figure 11.1) mapping of Antarctica. From the late 1980s onward, Antarctica was referred to as a key site in the negotiation of global environmental politics. This shifted the metanarrative of Antarctic spatialities from a robust and challenging space of action during the heroic era (1890s to 1910s) and the International Geophysical Year (IGY) (1957 to 1958) to a fragile, threatened space on the verge of catastrophe. In light of America's nonratification of the Kyoto climate-change agreements of 1997, this topology serves to highlight how the advancement of scientific knowledge and industrial practices through visualization form a mutually constitutive but often contradictory relationship with responsive environmental practice. By tracing the movement of the map from the secret cartography of *cold war politics* to the *hot war of environmentalism* (under the Clinton-Gore administration), the topology highlights how politics are inflected through the image. The visibility of Antarctic political spatialities is discussed with regard to how the politics of visualizing Antarctica has affected the political forces of images to historically shape Antarctic politics. Through an examination of American visual culture and American-Antarctic relations, I discuss how narratives of global warming that are sited in Antarctica can have the effect of giving visibility to the Antarctic and simultaneously displacing it, resituating it as the site of a media event.

Globalizing Visions

> O, how glorious would it be to set my heel upon the Pole and turn myself 360° in a second!
>
> Joseph Banks (70South, 2005)

Global Visual Cultures: An Anthology, First Edition. Edited by Zoya Kocur.
© 2011 Blackwell Publishing Ltd except for editorial material and organization © Zoya Kocur. Published 2011 by Blackwell Publishing Ltd.

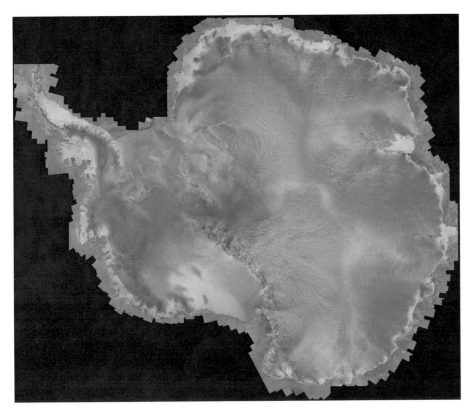

Figure 11.1 RADARSAT Composite Map Mosaic, NASA / Goddard Space Flight Center –
Scientific Visualization Studio / Canadian Space Agency, RADARSAT International Inc.

When the southern continent was no more than a utopian dream, the English
botanist Joseph Banks wanted to curve the world around his vision and mold the
geography of space to his gaze. His fantasy was the privileged optical viewpoint of
the pole, where he could see and be seen, making the 360° of space obey the cen-
trality of his subject position. Banks voyaged with Captain Cook to confirm an
absence of place, thereby closing the world map, putting pay to the speculative
geographies of terra incognita. On January 30, 1774, at 71°S, the expedition reached
its farthest point south and confirmed that no temporal zone was to be found. This
same drive for a globalizing vision that Banks had pursued led directly to the satellite
technologies that in 1997 produced the first "complete" satellite map of Antarctica.[1]
By the time of the second mapping mission in 2000, the global vision that the tech-
nology enabled was an image of global destruction. The view came in the form of
the collapse of the Larsen B ice shelf, a document of global climate change.

 Antarctic visions have traversed many different viewpoints as a result of techno-
logical innovation and political aspirations, from the "albatross's view" (Figure 11.2)
offered by the airplane to the globalizing vision of satellites. With the Amundsen-
Scott South Pole Station in place[2] and a sign hung over the door that reads "United

Figure 11.2 The 'Albatrosses' view from a US Hercules flying to Ross Island, Antarctica, 1999. Photograph by Kathryn Yusoff

States welcomes you to the South Pole," bodily and aerial possession of the landscape has now been obtained. American activities in the Antarctic increasingly occupied the interior[3] and spiraled out from the mythological center of the pole across the entire continent. Dispensing with the horizon,[4] America has sought a higher and higher viewpoint, to find a new virtual frontier of Antarctica *out of place*. Ironically, even though American mapping reached far into space, Antarctica remained unmapped by remote sensing until 1997 because of climatic conditions. While geographic information systems (GISs) translate specific places into a topology of digital values, ironically, the obscuring effect of weather highlights the tensions between the abstraction of GISs and the transformation of dynamic environments into information.

Antarctica exists as a remainder to modernity's incomplete project of global mapping and can be framed within its utopic dreams and failed horizons in the contemporary era. The ambitions of global mapping reveal the increasing cost of progress, which registers in Antarctica in the stores of scientific information on pollution in ice cores to the location of the ozone "hole at the pole." As the technological eye of RADARSAT probed into Antarctic space, it was to reveal the effects of global warming and thus visibly located Antarctica as the dramatic site of the failed narratives of unlimited industrial production. As Antarctica was environmentally marked by modernity's progress, as the last blank space on the map, it simultaneously provided an imaginary respite from the problems of disorder.[5] David Trotter (2001) makes a convincing argument for modernism's paranoia as the

recognition of the problem of disorder, which he sees as *trauma theories* written against a world of increasing chaos. Viewed as a trauma theory, Antarctica's ordering seemed to offer a last space of uncomplicated representation, as spaces of representation were fracturing in Europe at the beginning of the new century.[6] As a phantasm of the furthest terrestrial territory, Antarctica offered a global visualization that could be viewed as symptomatic of anxieties over the increasing closure of the globe. In the RADARSAT map, a similar anxiety can be witnessed, over a space unenclosed by the American imperial eye, a space that until 1997 thwarted the project of planetary enclosure. Yet this global mapping, rather than offering a homogeneous global artifact, has revealed the trauma of an ecological disaster narrative.

The RADARSAT eye establishes a new frontier on Antarctica by occupying the reaches of another visual space to generate a vision of place. It directs a dual colonizing gaze toward both Antarctica and outer space. Rather than move the tactics of empire from Antarctica to outer space, the achievement has been to occupy both simultaneously, neatly joining the American concerns for Antarctica as a model for outer space. This concern to make Antarctica a model for the occupation of outer space was by no means simply an American desire, as one 1958 Soviet IGY postcard of the Sputnik satellite 'launching' off Antarctica demonstrates (Figure 11.3). Rather, during the cold war period, Antarctica and outer

Figure 11.3 International Geophysical Year, 1958 Soviet souvenir postcard of Sputnik 'launching' off Antarctica, with Russian flag at the South Pole. Photo by Kathryn Yusoff

space were joined as territorial remainders in a global vision that was increasingly predicated on a satellite mentality. More pragmatically, Antarctica was the "awkward" testing ground for new technologies to be used in outer space. Paul Virilio (1989, p. 2) comments that this "cybernetics of the heavens" directly descends from the history of the military line of aim: a line of vision that strategically and symbolically delineates a territory. Yet there is no simple scopic regime that denotes this territory. The technical eye of RADARSAT beamed images of satellite surveillance to the laboratory of the Byrd Polar Research Center at Ohio State University,[7] yet the satellite is Canadian, so it cannot be understood solely as a nationalized vision of place.[8] However, viewed as a product of NASA that circulates in the global media, it is appropriate to consider the map within the context of American visual culture.

The complexities of the visual regimes that produced the Antarctic map are located in the modalities of global scientific visualization, the mode of representation employed on NASA's Web site, and the circulation of these images in American visual culture. The politics of visualizing place that arise are intractable from the histories of the media in which they are embedded. Within the differing media

that characterize the conditions of viewing this map are different mythologies of time, which Kittler (1999) argued "are no longer history" (p. 115). As new technologies significantly depart from traditional media in their narratives of time and geographies of circulation, they also build on existing narratives of landscape to visualize virtual places.[9] The chronogeography of satellite technology and the circulation of the Antarctic map in global media both invoke and erase historical geographic perspectives. To situate the RADARSAT map within the tensions of this exchange, I briefly discuss Antarctica's ordering in American visual culture.

Ordering Antarctica in the American Imagination:
From Cold War to Global Warming

In the lexicon of the American cultural imagination, the Antarctic has a significant, albeit marginal, historical place, unlike the Arctic (a clearly "productive" landscape of capital). In 1837, Jeremiah N. Reynolds[10] fantasized that Americans should

> circle the globe within the Antarctic circle, and attain the Pole itself; yea, to cast anchor on that point where all the meridians terminate, where our eagle and star spangled banner may be unfurled and planted, and left to wave on the axis of the earth itself! (Lenz, 1995, pp. 120–121)

At work here in the desire to "circle the globe" is a globalizing imaginary of American Antarctic policy that will find its expression, finally but not irrefutably, in the RADARSAT map.

Throughout the 19th century, Antarctica remained at the margin of US interest as an imperial and literary spatiality until the shifting politics of concern, from the cold war to global warming, saw a change in America's strategic interests in Antarctica. The military imperatives of spy satellites that had mapped and hidden in Antarctic space in the mid-1970s and early 1980s neatly translated into *new* images for the environmental frontier that was delineated in the Antarctic after the Protocol on Environmental Protection to the Antarctic Treaty of 1991 and in domestic American politics. This shift represents not just a change in political imperatives but also a change in how the visual politics of Antarctica were managed, from the secrecy of the cold war period to the confident deployment of the technologies of visibility in the mapping of environments. The Clinton administration brought Antarctica in from the cold periphery. On September 15, 1999, the president delivered a speech titled "Protecting Antarctica and the Global Environment" at the International Antarctic Centre in New Zealand to coincide with the declassification of modified satellite images of the Antarctic Dry Valleys (from the cold war era) to "help scientists measure environmental fluctuations."

The release of the satellite images connects very clearly the shifting territory of the technologies of war to the territories of environmentalism. In this sense, the

hidden gaze of surveillance becomes the scrutinizing gaze of new geographies of fear. As a British Antarctic Survey (2002) press release later declared (after the release of the Larsen B ice shelf collapse), "satellite spies on doomed Antarctic ice shelf." The decision to make these images available coincided with the increased desire for America to be seen as an environmental steward in Antarctica, reflecting a husbandry approach to "wilderness" rather than an overtly colonial model of settlement. Unlike the claimant states in the Antarctic (such as Argentina, New Zealand, and Britain), American Antarctic policy has been characterized by an ambiguous approach toward ownership claims, as Christopher Joyner and Ethel Theis (1997) identify:

> The ingenious solution of "freezing" claims to territory has served US Antarctic interests well. By removing sovereignty as an issue, the United States was relieved of its own sovereignty dilemma. This also permitted the United States unrestricted access to the entire continent, (p. 37)

So whereas claimant states are constantly in the process of defending the cultural and physical possession of their self-designated sectors, America has freely wandered across the Antarctic, occupying its center and its peripheries as well. America's occupation of the South Pole symbolically, if not strategically, provides a continuous territorial claim. As Joyner and Theis (1997) note, "a claim could therefore diminish American freedom to move and establish bases anywhere on the continent" (p. 40). As is the convention with areas designated under the common-heritage-of-man principle, in reality, dominance is secured by the largest financial and logistical investment: "From the late 1920's to the time of the signing of the AT, the US flew more planes, mapped and photographed more territory, and sent more expeditions to Antarctica than any other state" (p. 225).

Through dominance in the air and on the ground, and the largest investment in cultural activities, such as the Artists and Writers Program, America seemed to achieve the much desired global reach. The accumulation of information, alongside a physical and virtual presence in the landscape, secured ascendancy. Through physical and cultural mapping, and declining to formally "claim" a territory, America secured an implicit dominance in Antarctic politics.

What characterized this period of the Clinton and Gore administration (1993 to 2001) was not only the clear links made between global warming (Antarctica New Zealand, 1999)[11] and the changing Antarctic environment, but their personal interests in the Antarctic and a commitment to financially investing in that future.[12] In his speech at the Antarctic Centre, Clinton expressed his disappointment that "he was not able to fulfill a lifelong desire to go to Antarctica." And Al Gore (1992), in his book *Earth in the Balance*, locates his personal experience firmly in an American cultural conception of the world's geography:

> At the bottom of the earth ... I stood in the unbelievable coldness and talked with a scientist ... about the tunnel he was digging through time....At the bottom of the

world, two continents away from Washington DC, even a small reduction in one country's emissions had changed the amount of pollution found in the remotest and least accessible place on earth. (p. 21)

The world Gore imagines is reconfigured around a US military gaze, its plastic geography, molded around a conception of the *reach* of US power, from the center (Washington, DC) to the bottom of the world and back. Although this belies a model of cold war notions of near and far, it also firmly connects a line between US environmental policy (the Clean Air Act, in this case) and environmental effect, a line that was to be erased by the next administration of George W. Bush.

The Aesthetics of Destruction

In the context of the nonratification of the Kyoto climate-change agreements of 1997,[13] the RADARSAT map, as the product of American mapping technologies, presents a troubling visual representation of disintegrating Antarctic environments. The image of fracturing ice is a popular visual signifier for global warming that makes explicit the connection between CO_2 production and the destruction of polar environments.[14] As one image of melting ice imaginatively chases another, the political stance of America[15] over climate control ironically produces Antarctica as isolated and remote from human impact, in precisely the same way as the map's aesthetics collude to produce a decontextualized environment of a "floating" continent.

Conceptualizing the RADARSAT map within the rhetoric of an "aesthetics of destruction" ties the map firmly to the visual technologies of war that precede this visual simulation and the contemporary politics of global warming.[16] American visual culture has relentlessly engaged in the spectacle of destruction in all areas of cultural and military production, characterizing the language of both the cold war and the contemporary period. As Jean Baudrillard and Virilio have argued, America's self-identity is intimately bound up in the rhetoric of the cinematic. Contextualizing the map within a cinematic aesthetics of destruction elucidates on the topologies of American landscape narratives that the map builds on (and competes with) as an image circulating in mass media. Viewed on NASA's Web site (Figures 11.4 to 11.8), the fragmentation of the Larsen B ice shelf[17] over a 7-year period unfolds within the dynamics of movie time (270 frames in 15 seconds). One can experience the compression of the reality of time and space within this simulation, in which the predominant narration becomes about witnessing the spectacle of change. The accelerated narratives about Antarctica and its imagined place in time invoke American cinema's insistence on a "landscape of events" (Virilio, 2000). Similar to a plethora of American disaster movies, the emphasis is on the dénouement: the moment when disaster strikes. As the accompanying text

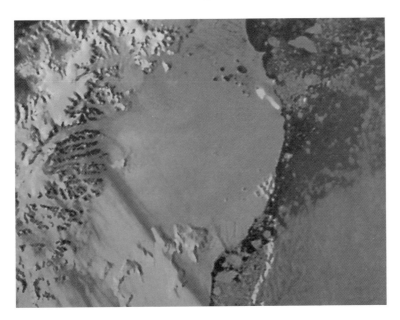

Figure 11.4 Larsen B ice shelf collapse (1993–2000), December 26, 1993. NASA/Goddard Space
Flight Center – Scientific Visualization Studio/Canadian Space Agency, RADARSAT International Inc.

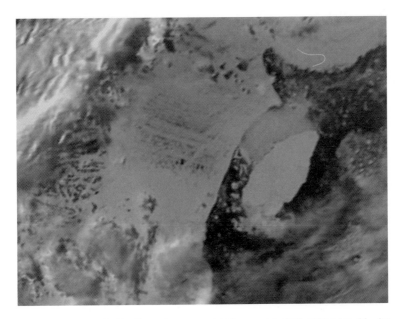

Figure 11.5 Larsen B ice shelf collapse (1993–2000), February 13, 1995. NASA/Goddard Space
Flight Center – Scientific Visualization Studio/Canadian Space Agency, RADARSAT International Inc.

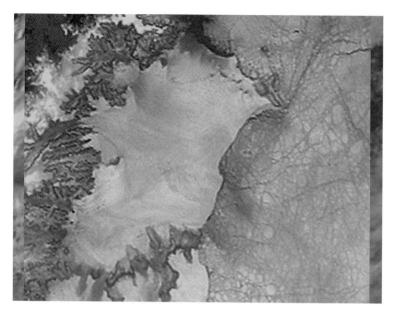

Figure 11.6 Larsen B ice shelf collapse (1993–2000), March 21, 1998. NASA/Goddard Space Flight Center – Scientific Visualization Studio/Canadian Space Agency, RADARSAT International Inc.

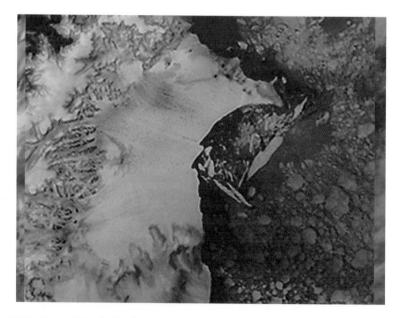

Figure 11.7 Larsen B ice shelf collapse (1993–2000), November 21, 1998. NASA/Goddard Space Flight Center – Scientific Visualization Studio/Canadian Space Agency, RADARSAT International Inc.

directs, the "main collapse can be seen in the last scenes." Antarctica, the sublime sign of the beginning of time, of geological origins, is visualized as fragmenting, heralding the breakup of an estimated 12,000 years of stability, conceptually signaling the end of time through ecological catastrophe.

Figure 11.8 Larsen B ice shelf collapse (1993–2000), March 2, 2000. NASA/Goddard Space Flight Center – Scientific Visualization Studio/Canadian Space Agency, RADARSAT International Inc.

Temporally and contextually, the image is dislocated to become an *event* for a moment's entertainment that can be replayed over and over again in senseless repetition, unlike the corresponding reality of the simulation. This repetition has two modalities: It offers the psychic fantasy of starting over and assuages terror through the banality of such repeatability. This neutralizes the power of destruction as a psychological imperative to act. In this simulation, Antarctica is envisaged as an aesthetic space of the cinematic, both as the nemesis of American culture and as the extension of its fantasies about time, and the end games of time. As still images, the RADARSAT maps become fetishistic fragments of destruction. The maps engage with the protofilmic in the partiality of images taken on sweeps of the landscape and then electronically "sewn together" to be cast into the fiction of one time. Locating the RADARSAT images within American popular visual culture, it is useful to consider Warhol's *Death and Disaster* series, which calls forth a fascination with death and the aesthetics of destruction that had been building in America in the 1950s and 1960s (such as *5 Deaths 17 Times in Black and White*, 1963). Warhol's repetition of virtually the same casts us into a relationship with the filmic; the image as *mechanical reproduction* makes it not a representation but a still, an image within an imaginary form inherently embedded in the machines' movement of time.

Warhol's images of car crashes, made at the height of the cold war, suggest an emergent obsession in the American popular culture with the catastrophic *event* and its documentation. The series, whose aesthetic appearance the RADARSAT map echoes, indicates the estrangement of events and their representation in the visual culture of catastrophe. The single event, documented as the same again, becomes one event happening over and over, such as fracturing ice shelves as a

signifier of environmental disaster or, as one British Antarctic Survey (2002) press release reads, "The collapse of the ... ice shelf is the latest drama in a region of Antarctica that has experienced unprecedented warming." Like Benjamin's (1992) image of the angel of history, "he sees a single catastrophe which keeps piling wreckage upon wreckage" (p. 259). Imaginatively, the visual memory of photographs of breaking ice, and warnings over global warming, collide together into the spectacle of destruction. And as Virilio (1989) comments, "the audience itself no longer knows whether the ruins are actually there, whether the landscape is not merely simulated in kaleidoscopic images of general destruction" (p. 49).

With ecological destruction as an event marking the fall of modernity, the assumptions about the nature of historical time are most evident: Antarctica as the limit of modernity's progress and modernity as no progress, only destruction, wherein historical process reveals itself to be a progression only of change. Walter Benjamin (1992) defines the extreme moment of the fascist aesthetic as when "self alienation has reached such a degree that it is capable of experiencing its own destruction as an aesthetic enjoyment of the highest order" (p. 242). Benjamin highlights the potential risks that culture runs when it aestheticizes politics. As Neil Leach (1999) argues,

> It is not simply that aesthetics may dress up an unsavoury political agenda and turn it into an intoxicating spectacle. Rather, with aestheticization a social and political displacement occurs whereby ethical concerns are replaced by aesthetical ones. A political agenda is judged, therefore, not according to its intrinsic ethical status but according to the appeal of its outward appearance. (p. 19)

The displacement of ethical concerns for aesthetic ones through aestheticization operates in the event of the RADARSAT map, akin to Warhol's concern with the surface and appearance of media events that structure the subject's relation to the image. The simulation of the event of the Larsen B collapse conspires to produce Antarctica as the site of the spectacle of global warming. Yet this same site is relatively absent within a contemporary economy of American environmental practice. Primarily, Antarctica's appearance is as an aesthetic image rather than an environmental space. The vision of the technical optic is thus haunted by a narcissistic drive to regard destruction and to celebrate this as aesthetic pleasure. The pleasure is heightened by two kinds of distancing: that which the technology affords by reproducing familiar disaster narratives and the geographic distance of placing disaster in Antarctica. Such a visual space, as Virilio (1996) writes, "operates within the space of an entirely virtualised geographical reality" (p. 16).

The ambiguous collusion of aesthetic imagery and environmental politics is no more evident than in the concluding remarks of Clinton's (1999) speech:

> It is a bridge to our future and a window on our past. ... Let us vow, in this place of first light, to act in the spirit of the Antarctic Treaty, to conquer the new challenges that face us in the new millennium, (http://www.nsf.gov/od/opp/antarctic/clinton/start.htm)

Clinton's imagery echoes early visual conceits that imagined the unknown – which was often transmuted into the Antarctic – as a symbolic arch of experience to the "untraveled world," just as RADARSAT imagined a "new window" on the Antarctic continent. Within this conceit, Antarctica is imagined as *a place in time* as much as a geographic place: a temporal bridge into the future and onto the past. Clinton thus clearly ties the declassified satellite images with the *symbolic production of truth*, the visuality of the technological eye seen as the guarantor of the real and thus invested with its symbolic weight. The "untraveled world" is aligned with visual darkness, and Clinton urges the illumination of the images to prompt a "bridge" to positive action. The Christian symbolism of a place of "first light" is connected to the enabling vision of the American gaze into the unknown. Thus, Clinton reinvests the potency of the imaginary spaces of Antarctica, drawing together the technological and the poetical into an idea of the *technological sublime*.

The technological sublime is characterized by a dispassionate aesthetic engagement with mass destruction rather than the possibility of the subject's destruction that characterizes the Kantian sublime. After Kant, the technological sublime drew together the traditional aspects of awe and elevation with the rationality of a mathematical sublime. Awe in nature was replaced by awe in technological nature, a technology that is productive of its own nature. As such, global warming has a technological sublimity, as it is the event of a nature created through technological expansion, viewed as an aesthetic image generated through technologies of vision.

Topologies of Surface

The RADARSAT map is probably one of the most abstract images of Antarctica ever produced, fearfully large and "unearthly" in its cool coloration, but reassuringly contained within the recognizable dimensions of conventional mapping techniques. The American vision transcended the lines of claimant states across the surface of Antarctica, thereby producing the territory as "whole." This aesthetic effects a "clearing out of space" for the American imagination by erasing human presence and furnishing investment in another terra incognita unmarked by human activities.[18] Thus, the map enacts the transparent violence of enclosure and the simultaneous opening up of the territory. The uniformity of the satellite vision and the aesthetics of scientific visualization render plastic and homogenize the living skin of Antarctica's surface. In an age when the dynamics of ice flow and the constantly changing shape of Antarctica's borders are well known, if not fully understood, the impetus to *promote* a stable view of these shifting boundaries offers a nostalgic search for a coherent unity of vision. The map consists of over 45,000 images electronically sewn together to produce the map in one time. Only at the edges of the projection does the map reveal itself as an incomplete assemblage of vision, and the illusion of coherence slips away (Figure 11.9).

Figure 11.9 Partial sweep of RADARSAT Map Mosaic, NASA/Goddard Space Flight Center – Scientific Visualization Studio/Canadian Space Agency, RADARSAT International Inc.

The first car at the bottom of the world.

Figure 11.10 Volkswagen Advertisement for Antarctica no. 1, 'The first car at the bottom of the world' (Volkswagen of America Inc, 1963). This claim is not strictly true as Robert F. Scott took motorized vehicles to Antarctica on his *Terra Nova* Expedition (1910–13). Photo by Kathryn Yusoff

To achieve this unity, techniques of scientific visualization use "isosurfaces," which give all surfaces the same value. The surfaces are given qualities borrowed from things we are familiar with (transparent/plastic/sensual) and use ambient and direct light to create regimes of viewing, to conform to ideas of what already mythologized landscapes look like (in the case of the Mars images, the North American landscape). In the RADARSAT map, Antarctica floats in a sea of darkness, presenting its sharp boundaries against the flat space of the unknown, refuting the oceanic. The void of the blank color provides a lack of geographical context. The position of elevation means that the map does not mimic the eye, suggesting that our prosthetic sight has become so comfortable that such an embodied space is symbolically redundant. At the same time, this perceived technical/scientific impartiality is propelled by a very human desire to penetrate a territory beyond corporeal exploration. One of the stated aims of the RADARSAT map was "to simply expand our ability to explore the vast, remote, and often beautiful, southernmost continent" (*RADARSAT-1 Antarctic Mapping Project*, n.d.). Such a statement is evidence of the apparent reluctance to give up the romantic dimensions of terra incognita even at the height of its apparent technological mastery (Figure 11.10).[19]

The role of unknown space can be seen as indicative of the shifting horizon on the globe: an elusive and challenging horizon of meaning and its limits. By completing the global map, we turf out the angels and signal the limits of our imaginative *reach*. As Baudrillard (2002) argues, "now, the phantasm of the ends of the earth is a phantasm of the territory having some extreme furthest point – the symbol of a possible end and of the outer reaches of thought" (p. 129). However, what the visual technologies of satellite mapping have achieved is not the destruction of those imaginative spaces but their recasting, and thus reinvestment, in the technological sublime. What may well see the eventual destruction of the terra incognita is the erasure (that is also amnesia) that accompanies such an imaginative projection that removes Antarctica from the concept of a global ecosystem by insisting on its "otherness" in time and in space. It is visually and conceptually removed from the harm of our activities elsewhere on the planet.[20] Whereas the angels traditionally signaled an unknowable but heavenly place at the edge of maps, the contemporary terra incognita signals an artful distancing, productive of topographies of absence.

Geographies of Distance

The RADARSAT map presents a complicated vision revealing a territory that opens its surface for the investiture of imaginary projections but is simultaneously inexhaustibly occupied by the disembodied optic of American technology. The NASA-RADARSAT technology carried an image of Antarctica into a realm of factitious topology, in which the surface of the physical landscape is directly present in one time, as an "event" and a globally circulated image (Figure 11.11). It thus casts out any relation to landscape-based systems of duration (which is a condition of all representations). On this structure, science *presents* itself as an active agent in vision. Rather than debunking the mythic time of terra incognita, this scientific visualization builds on it as it erases, not only through its aesthetic production (the sublime surface) but also through the *availability* and narrative of new technology to present itself actively in time (global circulation). As speed is a metaphor identified with modernity's progress, scientific visualization naturalizes the political territory of Antarctica as a *continent for science* (designated under the Antarctic Treaty of 1961) through its production of accelerated frontier knowledges. As Virilio writes, "technological space ... is not a geographical space, but a space of time." It is a space with a history "that is the product of representations" (quoted in Burgin,

Figure 11.11 The 'before' (1992) and 'after' (1997) of the Larsen B ice shelf collapse, NASA/ Goddard Space Flight Center – Scientific Visualization Studio / Canadian Space Agency, RADARSAT International Inc.

1996, pp. 43–44). This, as Doreen Massey (2003) has commented, "is, in effect, to turn space into time, geographical difference into historic sequence" (p. 114). By turning space into time, this scientific visualization is productive of a political chronogeography of Antarctica. Thus, it is appropriate to consider scientific visualization in the context of Antarctica as imperial science, because science is the primary practice and instrument of making national claims in the Antarctic (designated under the Antarctic Treaty).

These constructions of Antarctica *in time* may be viewed as ideological, in the way that Roland Barthes speaks of ideology as the "imaginary of a time, the cinema of a society" (quoted in Burgin, 1996, p. 264). The imaginary of terra incognita is inflected through the image, yet, as I have argued, it is not inscribed in the image as a stable ideological meaning but through the image's geopolitical moment. The movement of images from one context to another makes it impossible to view the map as an ideological product, but as it enters specific political contexts, the map can take on an ideological role. When place becomes predominantly marked as a moment in time, it also runs the risk of becoming a virtually that allows, and perhaps even promotes, a reckless abuse of environments. The geopolitical moment of the RADARSAT map suggests that the capacity to bring destruction into view is where power is located, not exclusively in the environmental politics of that view.

Thus, the RADARSAT map offers only a partial vision of the technological landscape it travels in. Time is artificially stabilized in the satellite sweeps of the landscape and is then collaged into a globalized image. Once the image enters NASA's Web site, it is mobilized into *real time*. As each image of Antarctica floats in its own reality – an electronic pulse without dimensions, remote from place – it calls forth the need to recognize the *isolating potential* within new technologies, *of time* and *of space*. The technological inhabitations that the RADARSAT map affords simultaneously exercise a particular American narrative about time, displaced onto the Antarctic. The technological form, creating discontinuous realities of place, doubles this displacement of narrative over place.[21]

The impact of disaster narratives is a question of scale and duration. The compression of a global atmospheric event into a temporality similar to a car crash renders the event fascinating, while the excitement stems from the *proximity to the real* event. The aesthetics of simulated disaster stimulates because of the reality of that destruction that occurs but is displaced to an abstracted but geographic space. The proximity between the real and the viewing of the real begins to collapse. Proximity to disaster, Freud argued, was an unconscious sublimation of immortality that kept death other by representing it, and insulating ourselves against life. Life regains its fullness in proximity to death, but for this to happen, spectatorship needs to be shaken. I have argued that the repeatability of the destruction is a seduction of the idea that we can begin again, and so defers the subject's time to that of technological capacity for producing the same again, without challenging spectatorship. When the subject is located by the shocks and time of the viewing machine, the subject can become (as Benjamin

has argued) an effect of the machine's reproductive faculty. By extension, the relation that we accord to place can become simply an effect of the representational faculty. Antarctica as a landscape of events becomes one more American disaster movie.

The political implications of the image are deferred through the normalizing repetition of the aesthetics of destruction and are thus productive of a numbing to the fear of destruction. The illusion of repeatability thus secures the deferral of a responsive political act. Ironically, one recent American disaster movie, *The Day After Tomorrow*, begins on the Larsen B ice shelf. The disaster unfolds with die disintegrating Antarctic, which sets off a chain of catastrophes that lead to the destruction of the Hollywood sign, thereby inverting the narrative of displacement within the medium that constructs it. In this movie, the Antarctic landscape is a computer-generated image. This Hollywood event contrasts Antarctica's "narrative failure" at a political level with its "narrative success" in the visual economy.

Conclusion

We might conclude that there is no historic topology that can adequately account for the geopolitics of this stream of visual data that makes a territory of Antarctica. The RADARSAT map dispenses with the limits of a horizon, yet finds it again in the abstract aesthetic qualities that exhibit an elliptical relation to the completion of a globalizing project. As a global ordering, this ecological disaster narrative has folded into it utopic fantasies of its own, displacing disaster from western inhabitations through a spatializing operation. Simultaneously the Hollywood disaster narrative presumes a shared condition of time between Antarctica and Hollywood, in which landscape is reduced into the same temporality of catastrophe. In this, Antarctica is superseded not only by the technological form of its transmission but by a globalizing American cinematic narrative. The RADARSAT map unhinges a vision of Antarctica, isolating it from the Western world, both aesthetically and politically, while reinstating it as the *product* of an American global reach.

The duration of RADARSAT's long view over the landscape is compressed into the duration of the technological event: a moment of arrest that may or may not have a longer political duration. The continued reception of the map as an environmental event rather than an entertainment event will depend on the political arena that the image is drawn into. The fictional instantaneity of the RADARSAT map may prove to be the nature of its political event, as speed uproots landscape from its duration. If space is contested ground, the contest is to make space somewhere we can inhabit, and not to be virtualized out of our ecological body. By recognizing the types of isolation that new technologies generate, and the geographical sites that these images represent, the floating image may well acquire some gravity.

Notes

1 The "Antarctic mode" provided capability for the first time of *nearly* instantaneous, high-resolution views of the entirety of Antarctica. The dates of the first Antarctic Mapping Mission were September 9 to October 20, 1997. The second mission took place from September 3 to November 17, 2000 (http://www.svs.gsfc.nasa.gov/vis.l 1.12.2000). The images are now available at http://svs. gsfc.nasa.gov/stories/antarctica/index.html.

2 The South Pole Station was created under the program of research carried out during the IGY, and it was rebuilt and enlarged in 1999 and 2000.

3 Bases in Antarctica, from the first permanent settlements at Discovery Point, Cape Evans, and Cape Royds during the "heroic era" (1890s to 1910s), were constructed at the continental margin until the development of flight technologies allowed the possibility of permanent settlement in the interior.

4 Louis Marin (1993) comments,

"The use of the term horizon is attested from the second half of the 13th century. At first the word signified 'limit,' the limit of the gaze, the limit of the sky and earth. ... 'horizon' which originally meant limit, the power of circumscribing a place, came to mean immensity, infinity – such as the limitless horizon of the ocean. ... Then beyond the horizon, in the imagination, appear Utopias (pp. 7, 813)."

The dispensing of the horizon that had framed the US expansion in the West inverts the limits of perception into utopic fantasy.

5 Klaus Theweleit (1987) argues that modernity's ordering complexes are gendered masculine: a paranoia that demanded a female abjection predominately articulated in the representational practice and space of landscape. Echoing the sexualization and genderization argued by Gillian Rose (1993, p. 7) as an intrinsic part of geographical practice, the virgin territory of the South unequivocally provided an alternative site for the narrative of exclusively masculine orderings uncomplicated by natives or women. Denis Cosgrove (2001) notes,

"Like the summits of the World's great mountain ranges, the 'purity' of the white, empty Polar Regions acted as imaginative opposites to equatorial 'hearts of darkness.' Devoid of disturbing human presence, they were silent stages for the performance of white manhood (p. 217)."

6 European representational space underwent tremendous conceptual changes in response to industrialization and global wars. The extreme point of this was futurism and cubism, which broke the representational planes of perspective and realism. Cubism paved the way for the conceptual art project, which took the destruction of the representational plane to its logical terminus in the dematerialization of the art object.

7 The American Richard Byrd was the pioneer of flight in Antarctica, producing the first aerial maps of the continent, achieving the mythologized "albatross's view"; but again, at the height (of what was then) technological achievement, Byrd's utopian, heavenward propensity was strong. He reflected,

"Here is a door ajar through which one may escape a little way and for a short time out of our little world, from the noise and chaos of civilisation into the silence and harmony of the cosmos and for a moment be part of it (quoted in Weiss, 1986, p. 12)."

8 The original scheme of Canada's RADARSAT mapping did not include mapping Antarctica. Canada's interest, spurred by the 1970s oil crisis, lay in identifying ice in the Arctic to allow the safe extraction of oil, coal, and minerals. The Canadian Space Agency invited NASA to join the mapping project and to launch the satellite in exchange for certain data rights. NASA was interested in mapping Antarctica, and this led to changes in the satellite technology, because the previous designs had a northward-looking satellite that needed to be turned around and flown backward to map the south.

9 Although the occupation of the landmass has accelerated relatively slowly, in comparison, the visible and invisible communication networks have rapidly increased in the form of Web cams at the South Pole, satellite mapping, and "real-time" images of the continent.

10 Reynolds had previously been a strong supporter of Symme's hollow earth theory (the idea of a "hole at the pole"), but in his fantasy, he takes command of the hole at the pole. And rather than conceive of it as an edge, he thus sees it as a globalizing axis.

11 "'The overwhelming consensus of world scientific opinion is that greenhouse gases from human activity are raising the Earth's temperature in a rapid and unsustainable way' the President said."

12 President Clinton requested an increase in funds from $675 million to $4.75 billion for the National Science Foundation for 2001; $136 million of this was for research into biocomplexity in the environment, including Antarctica research (http://www.enn.com/enn-news-archive/2000/02/02162000/nsfunds_10058.asp).

13 The Kyoto Protocol of 1997 set targets and a timetable for 38 nations to control emissions of greenhouse gases (predominately CO_2). Rather than reduce CO_2 output, the US has raised its emissions by about 12% over 1990 levels, and its emissions are on track to rise by another 10% by 2008 (Victor, 2000).

14 Although the connection between global warming and melting ice sheets is contested, not least by those with substantial interests in fossil fuel, scientific consensus does exist on global warming. One of the reasons given for such a polarized public understanding of the problem has been unbalanced media coverage:

"The effect of such coverage may be to encourage the view that no scientific consensus exists on global warming; to position global warming as a hypothesis rather than fact, even though the IPCC [Intergovernmental Panel on Climate Change] has declared there to be a 'discernible human influence on the climate system' (Newell, 2000, p. 82)."

The basic document of the IPCC also states that "average sea level is expected to rise as a result of thermal expansion of the oceans and the melting of glaciers and ice sheets" (Ragnar Gerholm, 1999).

15 Internationally, the Bush administration has refused to sign up to the agreed measures of the Kyoto Protocol and has further shunned attempts at global environmental management by refusing to attend the Earth Summit in South Africa (August 26, 2002). Locally, in the Ross Sea region of Antarctica, the US refused to participate with New Zealand's *Ross Sea Region State of the Environment Report* of 2001 (the first comprehensive environmental report for this region of Antarctica), which includes within its boundaries the largest human settlement (and thus human impact) in Antarctica, McMurdo (a US station).

16 Despite the extensive use of images by environmental campaigners, John Miller (1997) comments that in a desire to gain the widest possible acceptance, the environmental community has "decided that appeals to aesthetics are unscientific," preferring to advance scientific and economic arguments for environmental protection rather than "to recognise the legitimacy of aesthetics."

In contrast, Miller argues that an aesthetics sensibility is the fundamental "means to bridge the conceptual and emotional gap between the natural and the manmade" (pp. 137, 145).

17 The main collapse of the Larsen B ice shelf was visualized between January 31 and March 7, 2000, when about 3,250 km^2 of ice shelf disintegrated over a 35-day period, displacing an estimated 720 billion tons of ice that is thought to have existed since the end of the last major glaciation 12,000 years ago. During the past 50 years, the Antarctic Peninsula has warmed by 2.5°C, much faster than mean global warming, including the retreat of five ice shelves (British Antarctic Survey, 2002).

18 For a discussion of "human erasure" in landscape, see Jonathan Bordo's (1994, pp. 292–4) discussion of portraying "wilderness" in his essay "Picture and Witness at the Site of Wilderness." Also see Mary Louise Pratt's (1992) *Imperial Eyes*, in which she argues that the erasure of the human creates an empty place/space a priori for imperial imaginings, "a landscape imbued with social fantasies … all projected onto the non-human world" (p. 125).

19 Lyotard "has argued that aesthetics is the transgressive realm where libidinal desires remain uncontained and so reveals the limitations of an ordering theory" (Carroll, 1987, p. 24).

20 This map is a reversal of the integrated systems of the globe, which the eye of the Apollo satellite initially produced. See Cosgrove (1994) for a fuller discussion of the historic geography of satellite perspectives.

21 The discontinuity of what may be called physical space and virtual spaces of engagement is by no means a new phenomena, but the acceleration of those fractures through new technologies are productive of what Frederic Jameson (1992) calls untenable formations.

References

Antarctica New Zealand. (1999, September 14). Press release. Christchurch: Author.

Baudrillard, J. (2002). *Screened out* (C. Turner, trans.). London: Verso.

Benjamin, W. (1992). *Illuminations* (H. Arendt, ed., H. Zohn, trans.). London: Fontana.

Bordo, J. (1994). Picture and witness at the site of wilderness. In W. J. T. Mitchell (ed.), *Landscape and power* (pp. 291–316). Chicago: University of Chicago Press.

British Antarctic Survey. (2002, March 19). *Satellite spies on doomed Antarctic ice shelf* [Press release]. Available at http://www.antarctica.ac.uk/News_and_Information/Press_Releases/story.php?id=13

Burgin, V. (1996). *In/different spaces: Place and memory in visual culture*. Los Angeles: University of California Press.

Carroll, D. (1987). *Paraesthetics: Foucault/Lyotard/Derrida*. New York: Methuen.

Cosgrove, D. (1994). Contested global visions: On-world, whole-earth, and the Apollo space photographs. *Annals of the Association of American Geographers*, 84(2), 270–94.

Cosgrove, D. (2001). *Apollo's eye: A cartographic genealogy of the earth in the Western imagination*. Baltimore: John Hopkins University Press.

Gore, A. (1992). *Earth in the balance: Ecology and the human spirit*. Boston: Houghton Mifflin.

Jameson, F. (1992). *The geopolitical aesthetic: Cinema and space in the world system*. Bloomington: Indiana University Press.

Joyner, C. J., & Theis, E. R. (1997). *Eagle over the ice: The US in the Antarctic*. Hanover, NH: University Press of New England.

Kittler, F. A. (1999). *Gramophone, film, typewriter* (G. Winthrop-Young & M. Wutz, trans.). Stanford, CA: Stanford University Press.

Leach, N. (1999). *The anaesthetics of architecture*. Cambridge, MA: MIT Press.

Lenz, W. E. (1995). *The poetics of the Antarctic: A study in nine-teenth-century American cultural perceptions*. New York: Garland.

Marin, L. (1993). The frontiers of utopia. In K. Kumar & S. Bann, eds., *Utopias and the millennium* (pp. 7–16). London: Reaktion.

Massey, D. (2003). Some times of space. In O. Eliasson, *The weather project* (pp. 7–118). London: Tate.

Miller, J. (1997). *Egotopia: Narcissism and the new American landscape*. Tuscaloosa: University of Alabama Press.

Newell, P. (2000). *Climate for change: Non-state actors and the global politics of the greenhouse*. Cambridge, UK: Cambridge University Press.

Pratt, M. L. (1992). *Imperial eyes: Travel writing and transculturation*. London: Routledge.

RADARSAT-1 Antarctic mapping project, (n.d.). Retrieved from http://polarmet.mps.ohio-state.edu/radarsat/radarsat.html

Ragnar Gerholm, T. (ed.). (1999). *Climate policy after Kyoto*. Brentwood, UK: Multi-Science.

Rose, G. (1993). *Feminism and geography: The limits of geographical knowledge*. Cambridge, UK: Polity.

70South. (2005). *Famous Antarctic quotes*. Retrieved October 18, 2001, from http://www.70south.com/resources/quotes

Theweleit, K. (1987). *Male fantasies*. (S. Conway, trans.). Cambridge, UK: Polity.

Trotter, D. (2001). *Paranoid modernism: Literary experiment, psychosis, and the professionalization of English society*. Oxford, UK: Oxford University Press.

Victor, D. G. (2000). *The collapse of the Kyoto Protocol and the struggle to slow global warming*. Princeton, NJ: Princeton University Press.

Virilio, P. (1989). *War and cinema: The logistics of perception* (P. Camiller, trans.). London: Verso.

Virilio, P. (1996). *Polar inertia* (P. Camiller, trans.). London: Sage Ltd.

Virilio, P. (2000). *A landscape of events* (J. Rose, trans.). Cambridge, MA: MIT Press.

Weiss, R. (1986). *Imaging Antarctica*. Boston: Nordico Polarities.

Further readings

Networking Security in the Space of the City: Event-ful Battlespaces and the Contingency of the Encounter, Caroline Crozer, *Theory and Event*, 10(2), 2007.

An Introduction to Critical Cartography, Jeremy Crampton and John Krygier, *ACME: An International E-Journal for Critical Cartographies*, 4(1), 2006.

Related Internet links

RADARSTAT Antarctic Mapping Project: http://nsidc.org/daac/projects/activemicro/radarsat.html

Andy Warhol's Death and Disaster Series: http://www.christies.com/features/videos/interviews/gerard-malanga-discusses-warhol.aspx

12

Images of Untranslatability
in the US War on Terror

Rosalind C. Morris

Preliminary Speculations

Keywords

image
spectacle
9/11 Commission
translation
language
mass media
Virilio
technical
 fundamentalism
'War on Terror'
noise
suicide
democracy
Al Jazeera
narcissism
Barthes
Lacan
fetishism
McLuhan

In 2004, while at war in Iraq and Afghanistan, and undertaking military actions across Central and Southeast Asia, Americans may have wondered not 'why do they hate us?' as the pundits demanded to know, but 'who is hating us?' This is another way of asking, who or what constitutes America's others. To the logically entailed question of what constitutes America, the US government responded less with a discourse than with an image track. In spring 2004, it offered up a spectacle of self-reflection to the remotely controlled universe of televisual spectatorship. The form of this spectacle was the 'National Commission on Terrorist Attacks Upon the United States', otherwise referred to as the '9/11 Commission' (published as *The 9/11 Commission Report*). The televisual transmission of the commission's daily hearings gave audiences the image of democratic process in one of its grandest forms: a mass-mediated, bipartisan body of interrogators empowered to ask questions of intelligence, government, military and civilian authorities. The hearings have been followed by various policy recommendations for intelligence reform, but the global impact of the Commission may ultimately lie in its capacity to disseminate a particular imagery of democracy. Thus far, American democracy has appeared as the form of auto-critique in which revelation stands in for transformation, surveillance and oversight for listening and translation. This paper is an effort to understand the place of mediatic technique in the formation of that democracy, and to comprehend the place of images and symbolic practice in general in the violence that now terrifies us all.

People in the United States have perhaps come to expect image-spectacle as the mode of 'response' in which display substitutes for explanation. In 2004, however, this spectacle was sutured into a strange new kind of reversibility. The President of the United States frequently told his citizens that 'we can see' the horror of war in Iraq, *'because'* it is 'on television'. Hence, they could know of its existence. Silently,

Global Visual Cultures: An Anthology, First Edition. Edited by Zoya Kocur.
© 2011 Blackwell Publishing Ltd except for editorial material and organization © Zoya Kocur. Published 2011
by Blackwell Publishing Ltd.

his administration added: 'They will know us as we know them, via the images we send.' But what did 'we' or 'they' see? And in what sense do any of us know it?

From the beginning of the war, the Bush administration deployed television images to communicate its perspective and to elicit sympathy and support for its position, in a manner that obviated transformative response or dialogue. It could do so because televisual imagery merely reveals the appearance of war. Insofar as television is a medium of images, television war, even that artificial war of anticipatory imagery that characterized the prelude to the First Gulf War (Baudrillard 1995 [1991]: 30), is a war of unsignifying signs: of corpses and wounded bodies, broken buildings and other ruins which are incapable of saying anything other than that they are there. The image of a fly-crowned body at the road-side does not testify to geopolitical history, the pursuit of oil, or the recycling of Vietnam War policy. Nor does it bear witness to the mercenary war of Iraq on Iran, or the vengeance heaped on Iraq when it transformed victory over Iran into vindictiveness against the Kurds. So much the better for a US regime that refuses to answer questions about the false pretenses on which it argued for war (Select Committee on Intelligence 2004). However, the consequences of television's stupefying orientation toward visually verifiable facticity are not merely to be found in their powers of occultation. They lie also in the ways that television becomes the medium of address to a world which is presumed to be watching. They lie, moreover, in the presumption that an image can constitute an address, and that it can traverse the space where language, history, and language difference would require translation.

In this paper I argue that the deployment of imagery, often in lieu of language, rests on particular developments in the mass media, and on the emergence of what Paul Virilio has termed 'technical fundamentalism' (2002a: 53). In an episteme dominated by photographic technologies, images (including cinematic and digital images) are treated as mere excretions of a technical apparatus, and hence as linguistically neutral bearers of truth. Accordingly, they are assumed to achieve their immediacy and relative efficacy by reducing reading to a matter of recognition, which is then thought to solicit mimesis. Such privileging of images is stereotypically fetishistic, in the sense that an imaginary investment in images obstructs social relations based in fully symbolic, which is to say, linguistic practice (Lacan and Granoff 1956). During the 'War on Terror', as the US government calls its military opposition to Al Qaeda, it can be seen not only in a general proliferation of images (even when these are opaque or vacuous), but in the emergence of a discourse of 'noise' and in the representation of the speech of others as being either mere noise or the signs of a meaninglessly violent intention. Equally important, it is associated with the rise of narcissistic politics writ large: a demand for mirroring on the part of one's interlocutors and an incapacity to imagine real otherness, the consequences of which can be seen, on the one hand, in refusals to negotiate in the pursuit of peace and, on the other, in the elevation of suicide to a political mode.

These developments are not merely internal to discourse (they are not ideological); they are born of a dialectical relationship between medium and message, technique and purpose. The consequences for democratic politics could not be

more acute, for in the thrall of technical fundamentalism (which nonetheless reads all opposition as ideological fundamentalism), the substantive openness which characterizes ideal forms of democracy is being supplanted by a concern with its technique, and especially the technique of display. Politics thus reduced to an image of its procedures – and a veritable fetish of proceduralism – not only loses its capacity to distinguish between terrorism and fundamentalism, and hence to engage in self-protective measures, but the violent cycle of image exchanges that it generates threatens precisely to undermine any possibility of mediated settlement, and thus peace-making. What is left, I suggest, is the noisy specter of suicide. Let us begin with the fetish of imagery and the abandonment of dialogue.

Looking, Speechlessly

Mutely, the looks of televisual spectators on either side of the globe appear from the US perspective to be linked in a mutual exchange. Despite or because of institutional parallelism – Al Jazeera to CNN – the exchange is posited from the US not in the moment of reciprocation, but in the moment that subjects elsewhere are thought to be watching television 'just like us'. And resemblance or reflection is mistaken for reciprocity. This narcissism in the guise of mutuality is perhaps best understood as the legacy of a military-technological pedagogy, which rests on the idea of a generalizable but hostile and purely scopic reversibility. The soldier's paranoid adage, 'if you can see them, they can see you', has become the basis of US diplomacy, conducted in the form of a public relations campaign. Seeing in this sense, the seeing of one soldier by another, takes place where language is absent. Had there been a real linguistic exchange – a dialogue conducted in the space of translation – there might not have been war. Instead, defensive surveillance and aggressive image-making take place in silence.

It will be admitted that television is not a purely visual medium; its soundtrack is the locus of narrative discourse. Yet, it functions as imagery because it is treated in the mode of the photograph, to solicit recognition rather than interpretation, imitation rather than comprehension. Accordingly, the televised hearings of the 9/11 Commission did not narrate the social objectives of American democracy but instead showed the procedures by which it would be safe-guarded, procedures that are ultimately concerned with the process of revelation itself. Moreover, the reportage of the hearings made disclosure and democracy appear to correlate. The Commission became a theatre of visibility, and a scene of exposure. Cameras were always in-frame. As a result, the spectacle of a failure became the means for laying claim to success: the maintenance of a political form whose essence is self-reflective criticism, ideally coupled with a laborious and constant drive to self-improvement.

To the extent that television in America is construed as the medium of visibility (rather than discourse) photographs of the Commission exhibit something of its internal logic. Conversely, something photographic appears in the Commission:

namely, an aura-generating theatricality. The widely circulated images of National Security Advisor Condoleezza Rice are exemplary in this regard. The images of Rice, seated at an unadorned table, ringed by red-carpeted space and then by rows of photographers, distilled for audiences both the force of the Commission and the distance-sustaining aura that accrues to one who is imagined as someone to look upon. This is mass-mediated aura; here, power belongs to the one that everyone else looks to for the image of power. But Rice was not merely herself. She embodied an office, just as the other state representatives represented their offices. A careful dramaturgy rendered them as the personifications of American democracy in the televisual age. They answered questions and they answered to the demand for a government that could be questioned – without ever having to be accountable. For a moment, the memory of September 11 was eclipsed. Then, however, it returned, as it would have to: as the imagistically reiterated event of a catastrophe whose traumatic dimensions seemed to afflict the media with a veritable repetition compulsion. It was in the US media's coverage of the events of 9/11 that the full dimension of American image politics became apparent.

When the second plane hit the World Trade Center in New York, it not only proved that this was not an accident but an intentionally produced event, it inaugurated a period of constant imagistic repetition, the function of which was not to explain the event but to declaim it as having occurred and, thus, to produce a reality effect. While the images threatened to introduce a question about the verity of 'real-time' coverage by extending the duration of the event almost indefinitely, their repetitious broadcasting also made them resistant to analysis. Saturating every television screen, they seemed to testify only to the incomprehensibility of the event/image. This was quickly mobilized for ideological effect, so that the incomprehensibility of the image/event also became a way of conveying the idea that the terrorist act is that which exceeds moral calculation.

In the moral discourse of the moment, a normative perversion took place, such that this incomprehensibility of the terrorist act became a prohibition on questions about political causes (or invisible factors). With news agencies marketing their coverage by promising viewers the most revealing shot, the event quickly became its image, and questions of causality were consequently deferred along with the need for reading. The substitution was made possible by virtue of those other substitutions on which photographic logics rest: of appearance for truth, of what can be seen for what can be known. Theorists of the so-called digital age suggest that informational technologies have increased the degree to which language is experienced as visual sign, and even more, they have suggested that the capacity to read purely linguistic signs – rather than, say, ideographic or iconographic signs – is diminishing (Kirschenbaum 2003). But, even before the advent of digital technologies, photography threatened to undermine the practice of reading simply because the photograph rarely achieves the radical arbitrariness of the linguistic sign. Photographs, it must be admitted, almost always appear to have a content, to be bound to reality (Barthes 1981 [1980]).

It is in this context that one can rightly refer to the United States as the Empire of Images. But to read it thus, is also to read it as an empire in decline and eclipse (Ndebele 2001: 138). Moreover, it is precisely as an Empire of Images that the US fails to respond to the demands of the current moment and, in particular, its emergent political forms. For if the old dictum '*translatio imperii*' made the imperative to translate (by which is meant the transport of power) the ground of empire, then the Empire of Images is the empire founded upon a belief that the need for translation has itself been surpassed by the fact of the image. The Empire of Images displays rather than explains itself. It demands imitation not understanding. At the same time, it authorizes itself through reference not to the image as sign but to the image as trace of the real. Its success, as we are already beginning to see, entails its own negation. Its failures must be understood in terms of a more general failure of political critique, for it is in this broader context that technical fundamentalism emerges.

Democracy and Its Others

The 9/11 Commission staged the United States in the image of a self-questioning democracy, and implicitly posed the question of an undemocratic opposition. Significantly, the Public Law (107–306) by which the Commission was established to investigate the 'facts and causes' associated with the 'Attacks on America' did not make the discovery of perpetrators an issue. Nor did it consider testimony from suspected or convicted perpetrators. It concerned itself instead with the discovery of systemic vulnerabilities, and in so doing permitted an ironic ambiguity to intrude. For, if television imagery reveals only the fact of vulnerability, and if revelation itself constitutes a source of exposure, if, moreover, revelation is the essence of democracy, then there emerges the possibility that the display of self-critical technique will be apprehended as the very essence of vulnerability. Many conservative critics of the 9/11 Commission made this worry public, thereby suggesting that televisual democracy could bring about its own undoing. What they did not seem to comprehend was that this could occur only because the Commission partakes of a wider trend by which mediatic technique has become a Cause unto itself.

Such developments are not only the effect of catastrophic experience; they occur in a context of discursive crisis, wherein terrorism and war, war and peace-keeping, military and police action, have all become indistinguishable. A general failure in the language of political critique has threatened all analysis in the post-Soviet period, but it is especially visible in the conflation of Americanism with globalization, and in the western incapacity to imagine an internationalism other than globalization. Since 1989, but especially since 9/11, 'globalization' has been embraced as the name of a post-ideological state, somewhere beyond the binary opposition of capitalism and socialism. The ghost of that third internationalism, neither capitalist nor socialist, that had so worried Lenin (1966: 149), namely Islamic internationalism, returns now to trouble US and Western European narratives of both Manichean opposition and capitalist triumph. A certain anxiety afflicts the efforts

to represent this force, for the emergence of a renewed theologically based internationalism troubles US and European conceptions of the international order as one founded on rational economy (understood since the eighteenth century as the natural form of secular law). The irreducibility of theological internationalism to economy also demands that western self-representation find a new idiom within which to represent itself as the other of Islamism. Hence, where capitalism stood off against socialism we now have a political discourse organized around the antinomy of democracy and something else. Increasingly, the answer is enfolded in the pairing of fundamentalism and terrorism. It is the mode and the technique of differentiation that now concerns us, and that ultimately thwarts the appeal to categorical opposition.

We need not embrace the fantasy of a post-ideological condition *à la* Francis Fukuyama (1992) to acknowledge the limited capacity of ideological criticism to help us understand what is at stake now. Political authority is no longer intelligible as a function of the monopoly on violence or control over the means of production. Such monopolies are everywhere under threat from emergent syndicates (mafias and drug cartels) and the privatized militia that now perform the work of both the police and the military on behalf of the wealthy in security states around the world. Nor does political authority accrue strictly to those who command the means of representation. Even in states with strong media censorship, piracy and underground media organizations ensure the dissemination and dissembling of ambiguous messages. Indeed, representation – as political practice and as ideological production – is under threat from both the left and the right. Today, political rhetoric no longer appears devoted to representing ideal order – as the *not-yet* but *still-to-be-desired* ends of action. Shunning utopianism in the name of supposedly sincere pragmatism (we cannot promise what we cannot guarantee), or in the open-ended instrumentalities of opposition (we cannot envision the future until we have destroyed what hinders its emergence), politics is increasingly dominated by the question of technique. It is not that 'ends' now justify any 'means', as Hannah Arendt said of an earlier moment, but that violence is lifting off from the means-ends relation and is increasingly deployed as the pure expression of sovereignty and / or the will-to-sovereignty.

Arendt (1970: 55) called such an autonomization of violence 'terror' and did not distinguish between the terrorism of states and that of individuals in this regard. In the post-9 / 11 world, we can consider this autonomization in terms of what Paul Virilio calls 'technical fundamentalism'. Technical fundamentalism is the reactive form of politics to which westerners would retreat, prophesied Virilio, if thrust out of the 'sanctuary' that earlier geopolitical relations afforded them by the fact of war (or terroristic violence) at home (Virilio 2002a: 53). However, to call the autonomization of violence in terrorism a kind of fundamentalism is to admit to a transformation in the relations between Cause and technique and, in fact, a conflation of the two. This conflation is the awful accomplishment of our present moment, the effect of both a technological history and an ethical failure to imagine sovereignty as anything other than the will-to-power. Technical fundamentalism in

this sense is both the essence and the mirror image – in Lacan's sense (1977 [1966]: 1–7) – of a democracy that no longer functions democratically. Inevitably, then, we are led to ask, what is the other of democracy?

In many ways, the question of democracy's other inverts and extends Roland Barthes' query about the opposition between imperialism and its possible other. In an earlier moment, still defined by the frigid opposition between Soviet socialism and American capitalism, Barthes labored to escape what he perceived to be the ideologically over-determined opposition of imperialism/socialism (and any call for a commitment to the latter) by proffering an alternative binary pair, of which the latter term would remain radically open. This is the pair, 'imperialism/something else'. Barthes describes the necessarily empty category of 'something else' as a 'gaping utopia' and a 'text without a title' (1985 [1981]: 127). Wildly determinate, this form, which Barthes is careful not to label democratic, nonetheless invokes a conception of democracy as the political mode of openness.

Although it is a form of openness, democracy nonetheless regularly suspends itself in order to protect its principles – lest majoritarianism become, as it repeatedly has, the ground of an oppressively exclusionary politics. There is, in fact, a dangerous duality within the democratic project, one that risks subverting the principle of self-protection in the moment of its enactment. Ironically, this is the principle that seems to root itself in auto-critique – as formalized in electoral processes and supplemented by the media, which makes it available to everybody. To the extent that auto-critique is represented as a 'right', however, it limits the forms by which otherness may enter into the democratic process, and forecloses the possibility of a self-transforming relation with truly different kinds of individuals and regimes (Derrida 2003: 106). Which is to say: democracy, construed as the *right* to auto-critique, can conceive of a relation to other kinds of regimes only if they accept the discourse of rights, thereby entering into the logic of democracy rather than opposing it. Democracy thus understood has no others, then, just an absolute Otherness. In the United States, the response to this fact has led to a practice in which relations with other kinds of states constantly threaten to become mere shadow-dancing with projected self-images. The result of this narcissistic tendency is that it is perceived to be arrogantly and culturally imperialist elsewhere, while feeling itself to be vulnerable to unknown and unknowable enemies at home.

Today, American democracy designates its opponents in the idiom of fundamentalism and terrorism, representing these twin possibilities as domination either by Cause or by technique. On the one hand, there circulates an image of a politics in which individual will is entirely effaced by the demand for adherence to a Cause, one that always exceeds technique; this is the politics of fundamentalism. The etymologists delight in relaying the translation of Islam as submission for this very reason. For it supposedly demonstrates the (il)logic of a claim to sovereignty on the basis of submission to a Cause. On the other hand, there is a politics in which the pure expression of self-interest or sovereignty (whether construed in individual, social, or cultural terms) exceeds any demand for adequation between Cause and technique; the latter domination by technique is termed terrorism. What is significant

about contemporary US discourse on terrorism is that it presumes that violent technique has itself become the hypostatized Cause for terrorists. *Let us call this hallucinatory binding of Cause and technique the American imaginary of terrorism.* And let us observe that it renders its enemy, precisely, as an inverted image of itself: a substantivized negative of the society which has reduced auto-critique to technique (whether in legal proceduralism or the endless side-show of mediatic self-exposure).

What, then, is the relationship between fundamentalism and terrorism? Roland Barthes was perhaps overstating the matter when he claimed that 'weapons and signs are the same things' and that 'every combat is a semantic one' (1985 [1981]: 127). Yet, Barthes was more than perspicacious when he endeavored to distinguish between dogmatic discourse and terrorist discourse on the grounds that the former is 'based on a signified, and tends to valorize language through the existence of an ultimate signified…[which] often takes the form of a Cause'. Terrorist discourse, by contrast, 'has aggressive characteristics one may or may not approve of, but it remains within the signifier: it manipulates language as a more or less ludic deployment of the signifier' (Barthes 1985 [1981]: 161–2). For Barthes, terrorism is defined by the incapacity of others to locate an origin or ultimate motivator for terrorist acts. Such acts, which work as signs and which are able to operate on a global level because they are transmitted via the mass media, always seem 'excessive'. They always appear to have caused more damage than could be accommodated within a calculus of either vengeance or just return, and they always appear to wound 'innocents' with no immediate relationship to the perpetrators or to the powers against which the terrorists organize themselves. They manifest at random and the putative 'reasoning' behind them is either never disclosed or is ultimately resistant to disclosure. They are claimed after the fact, and occasionally telegraphed before the fact, but their efficacy and their legitimacy (for perpetrators) are not at all dependent on their capacity to bear meaning. In fact, terrorist acts communicate terror, but little more, and it is their nature to resist hermeneutic gestures.

The banal recognition of this undecidability of the terrorist act is expressed in the 'National Security Strategy' document of the US government, which states that '[t]he struggle against global terrorism is different from any other war in our history. It will be fought on many fronts against a *particularly elusive* enemy over an extended period of time' (US Government 2002: sec. III, emphasis added). The same document provides a terse definition of terrorism, as 'premeditated, politically motivated violence perpetrated against innocents'. It apprehends a gap between the motivation and the form of violence undertaken, calling for a recognition and resolution of 'legitimate grievances' and 'underlying conditions' as part of the effort to combat terrorism. Initially, it suggests that the excessiveness of terrorism lies only in its methods, interpreting this excess as something that emerges in relation to a gap or asymmetry between those who partake of the world's wealth and those who do not, between those who suffer the violence of history and those who are its beneficiaries. The structural inequity that is experienced by individuals as an historical accident (such as where one is born) is thus the scene of an emerging potentiality for intentionalized randomness.

The official rhetoric finds its counterpart in the popular American effort to read such excess in affective terms, as rage born of envy ('they hate us because they want what we have'), or as the improper expression of an accusation that belongs, more properly, in a legal domain cleansed of the Furies. Of course, the US needs others to want what Americans have, both in terms of commodities and in terms of political form. According to dominant political discourse in the US, it is only because 'they' do not possess what Americans have that war occurs. War, then, is rationalized by a reading which renders the symptom of a difference in means as a difference in being. And here a contradiction emerges. Because the recognition of legitimate grievance is articulated simultaneously with a description of the factors that predispose one to an excessive response, the National Security document cannot help but posit a certain excess at the origin of terrorism. That which orients individuals to excessive response thereby becomes the truer cause of terrorism in a world wherein the negative experience of inequality is determined by historical accident. This cause is then *originarily* excessive; it determines a future of always excessive action. The 'Muslim world' is singled out in the National Security Strategy (in a call for the promotion of moderate governments) because it is said to harbor 'ideologies that *promote* terrorism'. Thus does the causality of terrorism become conflated with a Cause.

Yet, however indiscriminate terrorist acts may be, arguments like that which structure the National Security Strategy misrecognize the nature of terrorist acts, which ultimately reside beyond the question of Cause. For, terrorism is irreducible to an ideological rationale. It is, rather, a technique of violence that attempts to proliferate effects without instrumentalizing them toward a finite and fully described end. Its causality, whether this be disaffection with geopolitical violence or economic inequity, is not its Cause. Thus, for example, while videotapes featuring Osama bin Laden have included references to the plight of Palestinians, the presence of the US military in Saudi Arabia, and other such issues, they do not articulate a political end or describe an ideal polity. A comparably post-ideological situation pertains in the United States, where the mere spectacle of disclosure increasingly stands in for the description of social justice, whose achievement would constitute a separate order of political practice. If there is a utopic drive at either location, it is mute. In the absence of such vision, terrorism responds literally and mimetically to the violence of a mass-mediated global system of structural violence – without ever delineating the end to which it would submit itself as means. Accordingly, there is no necessary relationship between a particular ideology and terrorism.

However, terrorism can be differentiated in terms of its technique, and especially its image technique. The hallmark of that technique is the opening of the image to the future, and the insinuation that it will become reality – but at an unspecified time and location. One might say that terrorism derives its affective force in the tension opened between the specificity of the image and the uncertainty of its future realization. Nonetheless, it may achieve this end in one of two forms – each revealing a different understanding of the proportionality by which symbolic power is generated in and through images of the real.

In an example of the first form, the US military devises a strategy to bomb the city of Baghdad in a way that makes its military technology visible while also implying an unlimited capacity to deploy such technology elsewhere. Here the symbolic value of the image is proportionate to the enormity of its reality effect, which is to say the damage done. But the terror effect is directed in a vectoral manner. In the US, almost no images of actual deaths or identifiable corpses appear in the public sphere. In Iraq and elsewhere, the graphic depiction of the bombings' fatal consequences works to disseminate an anticipatory panic about what horrors might yet be experienced.

In the second example, a videotaped beheading of a single American worker (later to be repeated with other, coalition workers) is transmitted via cable television in a manner (and with accompanying speech) that threatens the repetition of this act at any time. In this case, the narrow focus of the image track and the adherence of the image to its referent, an individual whose biography is also available via the media, work in the opposite manner, exploding the particularity of the image by appealing to a sense that an individual is potentially any individual, and, thus, that no one is safe. Notwithstanding the technical bypassing of censorship which the Internet affords, the US media's decision to withhold the imagery of deaths and the dead acknowledges the relative efficacy and symbolic potency that can accrue to such images. Nonetheless, they retreat into photography's ideology as though a discourse of truth would be adequate to the demands for the nearly magical power that language affords. Perhaps this is because the US military itself does not doubt its capacity to substitute mechanical force for symbolic power. On the other side of the globe, symbolic power accumulates on the basis of the relatively small-scale acts of violence (when compared to US bombings), as these proliferate in images of the enormity that they may yet become.

Images of Death, and Symbolic Suicide

In this context, it is necessary to distinguish between the deployment of images *in place of language and the symbolic* and the deployment of images *as symbolic forms*. This is what is at stake in the image war now being waged between the US and Al Qaeda, and this is what distinguishes the terrorisms that they deploy. Rarely is an image ever assumed to be absolutely bereft of symbolic value, but often, and especially when treated in a photographic mode, its symbolic value is treated as a secondary feature or function. Images treated in a photographic mode are invoked mainly for their evidentiary function. As such, they are the fulcrum for a more general fetishistic practice, which, as Lacan and Granoff said of all fetishism, 'does not imagine the symbol...[but] gives reality to the image' (Lacan and Granoff 1956: 269). It does so by treating the image as that to which reality adheres – and, in this sense, the notion of photography's indexicality provides the ideological cloak for imageric fetishism. For psychoanalysts, fetishists are those who are subject to the image, to a '*captation of and by the image*' (ibid). And this predicament,

which corresponds to the narcissism of its practitioners, makes them incapable of entering into fully social relations with others. An awful felicity describes such a predicament as captation by the image, for it is precisely this 'captivation' which now governs the American response to images of decapitations performed on captives. Moreover, this self-same fetishism is precisely solicited by the knowing disseminators of those images, as they send them to circulate on global airwaves.

Videotapes of executions – beheadings and shootings – move via Al Jazeera to the European Press, to the US press where they are tempered by the censorious policies of the Bush Administration. Since 1991, when then-Defense Secretary Dick Cheney instituted a ban on the media coverage or depiction of coffins being sent from combat zones, the US media has observed (with minor exceptions) a general prohibition on graphic displays of American deaths, extending the ban beyond Pentagon policy for US citizens and deaths caused by the US, without at the same time extending it to non-citizens. Photographs of the bodies of Saddam Hussein's sons were transmitted directly to tele-spectators in Iraq via the Iraqi media, then under the control of the US military. Other images, including those obscene photographs of torture in which Iraqi men are seen in moments of humiliation, have been transmitted in modified form to the American media public, and, in less censored form, via Al Jazeera to Iraq and elsewhere, These images function first and foremost to testify to the facticity of death or physical duress. They say: a man is dead, a man is being killed, a man is being wounded or mocked. But their symbolic force resides elsewhere. They terrify, or are terroristic, because they signify the possibility of a repetition. Partly, then, the differences between terroristic and other images lies in the reading to which they will be subject, depending on the presumptive context in which they will circulate.

Some historical context is necessary here. For, the deployment of images as both evidence and promise in that mass-mediated agon which Marshall McLuhan termed the 'war of icons' is not new. In 1963, when the United States, with support from Britain and Israel, and with opposition from France and Germany, backed the overthrow of the Iraqi leadership in the person of General Abdel Karim Kassem (whom they had previously tolerated as counter-balance to Egypt's Nasser), his summary trial and swift execution were followed by the display of his body on television (US Office of the Historian 1961–3). And this, rather than the display of Uday and Qusay Hussein's autopsy-scarred bodies in 2003, constituted the inauguration of a strategy by which television would permit the staging of a belated claim to victory through the televisual display of corpses.

Nor was the strategy of saturation bombing, for which 'shock and awe' would become the mere and belated slogan, an invention of the Gulf Wars. It had its infamous origins in Britain's air assaults on Iraq in 1924, when Air Marshal Sir Arthur Harris carried out sorties against both Kurdish and Iraqi villages. In his recollection of that episode, Harris not only described the nascence of a strategy that would later guide US military policy in Japan, Vietnam, Kuwait, and Iraq (and British policy in Second World War Germany), he also articulated a conception of symbolic value which would inform the image wars of the future. This was a conception

of symbolic value as quantitatively proportionate (but still excessive) to the enormity of actual experience: 'The Arab and Kurd ... now know what real bombing means, in casualties and damage; they now know that within 45 minutes a full-sized village ... can be practically wiped out and a third of its inhabitants killed or injured by four or five machines' (Omissi 1990: 154). Harris thought that the sheer magnitude of destruction (intensified by temporal compression) would enforce a surrender more expeditiously than a merely 'moral victory', in part because it negated the opportunity for its victims to engage in heroic combat (and thus suicide) or escape. He thereby made technologized violence (the effect of only four or five machines) the instrument for making reality a source of symbolic power. The greatest symbolic violence would be achieved by the fact of the greatest actual violence. Here, Harris expressed that naive conception of the symbolic, the flip side of photography's imageric fetishism, which would later ensure the failure of strategies like 'pacification', aimed at the conversion of 'hearts and minds'.

It was not death itself, but a death made to bear witness to technological superiority, that rendered it a source of symbolic power for Harris. Indeed, what Virilio (2002a) saw emerging in the First Gulf War was already well developed nearly a century earlier. American image politics retain something of this quantitative conception of symbolic value today, and in the assiduous evasion of the depiction of actual dying, the image censors tacitly, if unwittingly, acknowledge the limit that would be posed and crossed were death and the symbolic to be linked. As Baudrillard has rightly noted, such a fusing occurs most purely in the act of suicide. And this is where terrorism gains its momentous power, according to Baudrillard. By appropriating the death which has been so widely disseminated (by military technology and economic policy) in the act of suicide, terrorism combines the absolute event of death and the power of the symbolic (Baudrillard 2002: 17–18).

When making this claim Baudrillard is, of course, writing about the hijackers of the planes which became bombs on September 11, but his analysis applies equally to Palestinian suicide bombers. It also applies to fireman and soldiers whose deaths are represented, belatedly, as sacrifices made on behalf of a city, a nation, or a democratic ideal (and all of these causes have been attributed to the men and women who died in New York, Washington or the field in Pennsylvania). A death chosen and not merely risked, a death submitted to for the sake of others, becomes social by becoming symbolic. This does not guarantee its meaning however, even when the cause of that death is known. And suicide in itself does not terrorize. Only when suicide transmits itself as such to others, and only when that transmission suggests the possibility that another may at some time be in the place of such an event (and thus an unwilling subject of an other's will-to-power), can it incite terror. That capacity is both intensified and generalized by the mass media. The display of a corpse or of a death is, of course, an act performed by one who survives; and in this sense it is an attenuated version of the morbid symbolic practice that suicide bombers engage in. When used to claim power for its bearer, however, all such imagery must be understood to partake of the hostage-takers' impulse, for it allows the conveyors of images to reap a symbolic power which they have not

themselves generated. Although the symbolic logic differs (one gathering force through magnitude, the other deriving power from ambiguity), one cannot distinguish the aims underlying the imagery of 'shock and awe', which put Iraqi civilians in the place of both Al Qaeda and Saddam Hussein, thereby anticipating their deaths, from that informing the videotapes of beheadings, which convey the deaths to which American and Coalition individuals are put when they are similarly made to stand in for US foreign policy by its victims-turned-aggressors.

Poor Reception: A Problem of Translation

Reversibility is not reciprocity. And communications reduced to the transmission of images reflect and materialize a lack of reciprocity. Images thus deployed are signs treated like weapons: hurled into the space where translation might have occurred. Nowhere is the turning away from the symbolic dimension of social relations, and hence the need for translation, more visible than in the kinds of reaction that images are thought capable of generating, and that they seem actively to solicit. Advocates of cultural propaganda, such as those who authored the Bush administration's Arab-oriented television addresses for Al Jazeera and Al-Arabiya, are concerned with the successful appropriation of images at the receiving end. For them, the only index of an image's felicitous arrival is to be found in its reproduction and further transmission. Imitations of American cultural form are accordingly read as proof of a successful communication between the US and elsewhere. These imitations do not simply function as instances in a chain of mechanical reproduction, however. They are also made to signify the legitimacy of the image which was 'originally' sent. Spectacles of US-style elections (often held at great risk to voters), or media broadcastings of counter-corruption hearings and show trials of deposed autocrats, all exemplify this process, providing, as they do, evidence that a logic has been internalized in a manner that nonetheless permits itself to be visible.

The narcissistic demand that makes resemblance to the US the ground for receiving its political recognition (in the form of foreign aid or bilateral trade agreements) has been explained in a variety of ways. Whatever the reasons, this narcissism is not only associated with the presumption that successful communication generates visible imitation, but it is also and even more dangerously linked to the emergence of a *discourse of noise*. That discourse represents not only 'terroristic discourse,' but linguistic alterity in general as an abrasion in the system which would otherwise have operated, smoothly, to produce reversibility based on visible resemblance (which narcissism confuses with reciprocity). The discourse of noise reveals another dimension of our current predicament, and contains evidence of a history otherwise foreclosed. It reveals the degree to which imagistic strategies have been deployed by the US administration precisely because they are thought capable of covering over the gap produced by language itself, and, more specifically, by the fact of linguistic plurality. Not only are images presumed to be loquacious, but they are presumed to transcend difference, to be universally legible.

The suspicion of language difference, and the deafness that it effects, has a form. It can be discerned in the popular US cultural and especially cinematic inscription of Muslims as mere 'acousmatic' presences (Žižek 2002: 38–9; Chion 2000). Grunting, language-less brutes haunt the news media in the repeated imagery of mobs, whose collective cries remain untranslated, and who therefore function as the image of untranslatability on television screens throughout the US. In this case, the noise which emanates from the place whence language might have issued implies the impossibility of a social relation. It also betrays a limit to knowledge, revealing the impotence of surveillance technologies which confine themselves to the visual apprehension of phenomena. The sensation of such impotence generates further anxiety of course, and that anxiety only encourages the fetishization of images, which further obstructs communicative relations in a deathly cycle of missed opportunities.

One cannot underestimate the significance of noise – as a discourse and as perceptual experience – at the present moment. In the US context, where images are mistakenly assumed to be transparent and thus able to travel without translation, noise is the misperception of language: the stubborn sign of both monolingualism and imagistic universalism in a world of linguistic multiplicity and cultural plurality. Evidence that talk about 'noise' marks such a predicament can be seen in the security discourse which represents intelligence not as interpretation or comprehension, but as recognition of communicative activity carried out by enemies in foreign languages.

The reaction to linguistic opacity has been a persisting refusal to learn how to listen in and to other tongues. It has also entailed an imagination of translation as an instrument of mere intelligence gathering, rather than the medium of negotiation or peace-making. In lieu of support for the long, slow process of language-learning, the US government has offered massive capital investments in mechanical technologies of translation. It has also substituted visual codes for all communication, attempting to circumvent a feared secrecy in language with a surfeit of images whose constant broadcast seals over the spaces into which questions might be inserted. Via the US media, whose 'embedding' with the armed forces merely formalized a relationship of uncritical dependency on the administration's public relations department, Americans were bombarded with repeated replays of the image/events of 9/11. They were then incited to fear by a new sign system which transformed and generalized the code of urban movement to signify the risk of another catastrophe: a traffic light indicating states of ideal alertness. Thus was the demand for vigilance and attentiveness, which democracy also requires (as Rousseau insisted), perverted into a lunatic anticipation of disaster. In the end, the repeated imageries of inassimilable violence and the reduction of communications from the US Department of Defense and Homeland Security to a mere visual code converged to reinforce the already widespread tendency to treat communication on the model of a purely informational system based on military command structures.

That model had its origins in the cold war. Previously, during what Marshall McLuhan termed the 'hot wars', people used 'weapons to knock off the enemy,

one by one'. By contrast, the 'cold war' was, for him, an 'electric battle of information and of images that goes far deeper and is more obsessional than the old hot wars of industrial hardware' (McLuhan 1994 [1964]: 340; also Virilio 2002a: 7). In this sense, the proxy wars of the Cold War era, those in Afghanistan and Latin America, for example, remained hot, brutally physical, and blind. It is nonetheless shocking to realize that McLuhan's diagnosis of a warfare defined primarily by the management of information should have been proffered so early – when parades of military hardware were the voluptuous center-pieces of national political theater on both sides of the Iron Curtain (the US devoting its dramaturgy to the display of singular technological mastery, such as the launching of space rockets, while the Soviet Union displayed the massness of mass technology in the regimented continuum of men and projectiles). But image-spectacle was already a part of information management. Even so, McLuhan's argument about epochal conflict assuming the form of technological subversion was cast in arrogantly defensive terms: 'The backward countries can learn from us how to beat us,' he wrote, without apparent irony (McLuhan 1994 [1964]: 343). It is, he said, because they retain the habits of orality, and the skills of both listening and overhearing, whereas Westerners have become the atrophied worshippers of the image, deaf and as a result dumb in the face of a transforming technological economy. Such stupidity would make the West vulnerable to terror. For McLuhan prophesied a global village – one whose primary affect, he had suggested in the earlier *Gutenberg Galaxy*, would be that of 'terror'. For him, terror described that affect which afflicts a technologized social formation in which events are experienced simultaneously at all sites, in which 'everything affects everything all the time' (McLuhan 1962: 32).

Not just fear, but the fear of the network. McLuhan's vision is that of a metastasized crowd of hyper-receptive auditors who are not so much 'on call', as Avital Ronell, following Heidegger, would perhaps say of technology's ethicized subject, but 'hooked' on information (Ronell 1989). McLuhan's villagers would be dependent and therefore vulnerable to information to such an extent that even an absence of signs (or the appearance of untranslatable signs) would signify the threat of an event. They would respond with a demand for more and more coverage, expanded media and more surveillance. They would mistake disclosure for understanding, and they would abandon themselves to the spectacle of watching. They would be what Virilio has since called technical fundamentalists.

For Virilio, the autonomization and automation of warfare in an aggressive vision machine has its exemplary form in entities like the Global Hawk, an unmanned aerial vehicle that senses the terrain and thereby transforms it into a potential space of battle. The first Gulf War was, for him, evidence that the 'function of "arms" [has become] integrally that of the eye'. We might add that such an identity emerges precisely when the function of the ear, the organ of openness to the other, is by-passed or negated. This is also the moment in which the possibility of negotiation is foreclosed. And in this sense, war is noisier now than ever before. Barthes' analysis of language has been realized in a literalist mode: as the sign of aggressivity and the call to defensiveness.

Periodically, since September 11,2001, a National Security representative has held a press conference, covered by CNN and other television networks, and disseminated to the world via satellite. On these occasions, it has been remarked that noise has been detected, and more importantly, that an increase in noise levels has been registered. US intelligence agencies produce their estimations of risk of terrorist attacks in relation to the *quantity* of noise that they perceive in the 'system'. By noise, audiences are to understand the fact of communication, usually cellular telephone communication, between individuals who are presumed to be members of a shadow organization. They need not know what might be the content of the communication, but the coalescence of the network via cellular telephone is read as a sign that it will deploy a particular kind of 'interactive' weaponry. This weaponry might be used anywhere that can be videotaped, for terrorism wants to communicate itself both at the level of deed and at the level of future possibility. It is this continuous anticipation of being in the place of a catastrophic event that defines what McLuhan suggested would be the condition of the electronified global village.

Other theorists of information technology, many of them heirs to McLuhan's technical apocalypticism, remark that the regime of information is defined by a binary opposition between noise and communication, connection and disconnection. This is a system in which flow rather than meaning is the object of analysis. Here, noise is the name of an interruption, or an exteriority. It is what inhibits a presumptively transparent relation, but it is also the sound of contact between otherwise incommensurate modes of communication. And this is what the concept of noise in national security discourse points to: contact at a point of untranslatability.

Compared to the noise of the anonymous cell-phones, Al Jazeera's familiar televisual transmissions – echoes of a form we know too well – come almost as a relief. But sound itself can interrupt – and language can appear to be noise in the system. It is, indeed, in sound's register that television viewers realize the imaginary nature of the encounters with others that television simulates. For, despite the seamless flow of images – their repetitiousness creating the illusion of continuousness – transmissions fail, satellite image and voice transmissions lose synchronicity, and time lags intrude between questions and answers as they traverse the globe in news broadcasts. Here, a literal space opens up and reveals a symbolic chasm. Ironically, the failure to communicate is felt as the possibility of secret relations and clandestine communications between others, whom one overhears without comprehending.

What haunts television viewers – because a specter has been conjured there – is the possibility that messages are being sent in a manner that the viewers themselves cannot even detect in the form of noise. When CNN and other US cable network news stations screened tapes of Iraqis depositing weapons disclosures statements prior to the commencement of war, they terminated the broadcast with a warning that messages might be being sent. Al Jazeera's tapes of Osama bin Laden, which were then broadcast on CNN and network television in the US, were edited so as to prevent the possible transmission of encrypted and otherwise secret

communications. For National Security reasons, the broadcasts were interrupted, not with noise but with silence. This was an effort to reduce videotape to mere imagery, an ironic and regressive effort to eliminate language, reducing the audio-visual to the visual, signs to mere images, images to photographic traces of the real, from which they are thought to be inseparable.

Messages might be sent. Noise can be heard. The official US response has been to attempt to interrupt communication, not to listen, to eavesdrop, not to converse. It seems pathetically obvious to remark the translational crisis that has afflicted the US intelligence agencies, but it is surely not irrelevant to remark how the question of translation has been confined to the domain of security, or how intelligence has been relegated to a property of the same conceptual and institutional apparatus. This is why the sexuality of translators can be deemed a greater risk than the lack of linguistic knowledge (in November 2002, nine translators were discharged from the military on the basis of their admitted homosexuality). But that's another story; this story is about the misrecognition of language as a transparent visualizable code. Such a misrecognition responds to translational crises with devices like the 'phraselator', a computer system developed by Applied Data Systems with money from the Defense Advanced Research Projects Agency, to translate English phrases into other languages. Over 1,000 of them were shipped to Afghanistan in 2001; more than 100 with Arabic and Kurdish capacities were being used in Iraq in April 2003 and several thousand had been purchased by the Defense Department. According to the promotional materials for the device, it [contains] a versatile library of phrases' like; 'Hello, may I help you' and 'Stop or I'll shoot', played in sound files of native speakers. The sound files are the only advancement on the language phrase-cards that US soldiers carried in Vietnam, which also offered translations of basic commands. Needless to say, the new technology is not motivated by the military's submission to a McLuhanesque analysis oriented to the residual orality of Dari or Kurdish speakers; it is merely a function of the incapacity of the soldiers to translate their meanings into a commanding: speech that could be heard and recognized by native speakers. It materializes a technical fundamentalism rooted in an absolutely instrumental conception of both language and translation, which neither comprehends the symbolic nor imagines power as anything other than force.

And Otherwise?

Inevitably, it seems, technical fundamentalism is informational in structure and vectoral in the form of its movement; it is as incapable of facilitating real reciprocity as are the fetishistic imageries emanating from diplomatic public relations campaigns. Phraselators only move out of English, permit the dissemination of only one language, one set of commands at a time. There can be no expansion of English through the phraselator's pseudo translations, nor any transformation in the perception of the technology's bearer. Perhaps this is not surprising when one

realizes that, in military parlance, aircraft which deploy radar sensors in order to track moving targets, are said to 'talk' to a weapon if they effectively co-ordinate its destruction of the target. Moreover, such 'talking' systems are said to be 'smart', which is to say, they are of the 'global positioning satellite type'.

It is surely not irrelevant to ask, here, about the possibility of 'real' symbolic politics. If American image politics are over-determined by a fetishistic investment that derives from a still-photographic conception of the image, and if this fetishism is recognized and mobilized by others, who nonetheless apprehend the affective power that can be derived from less realist theories of the image, there remains the question of what dialogue might have achieved. Could a discursive address, perhaps of the sort that the apartheid regime made to the ANC, or that the British government was forced to make to the IRA (albeit after histories of failed efforts at more violent repression) have had the effect of transforming war into political opposition? And did the US administration forgo this possibility because it did not recognize the legitimacy of the other with whom it would have to converse? Or did it turn away from negotiation because it believed real violence could ensure a more resolute victory than could symbolic violence, thus obviating the need to fabricate a peace between different and differing entities? The former refusal is rooted in an incapacity to imagine an other and in a corollary demand that interlocution be undertaken only between like entities; it is a repudiation of difference. The latter refusal is rooted in an aspiration to asymmetry, not as the ground of interlocution but as its absolute termination; it is also a repudiation of difference. Although they appear to be contrary, these two refusals are entwined, one with the other. They are linked in a context in which the US both aspires to the status of global hegemon (but has not achieved it), and requires asymmetry as the ground on which it can assert its relative sovereignty.

Ironically, of course, it is precisely such asymmetry coupled with the demand for resemblance that facilitates and perhaps incites the tactical subversions and terroristic image politics through which the US is currently being resisted. This is why Baudrillard (2002) has asserted that the current wave of anti-US terrorism is merely the suicidal expression of an expanding power which has reached the impossible limit where it cannot be opposed by anything comparable to itself. But, if Baudrillard is correct to identify something like a death drive in US thought and policy, he nonetheless mistakes for cause the mere dream wish of an aspirant empire that is already waning, despite the lack of an opponent comparable to the Soviet Union. Nonetheless, the state which wars against another in the hopes that the other will come to resemble itself is indeed veering toward pre-emptive suicide. Plato had already suggested as much in his reading of democracy en route to tyranny. Insofar as war, which often seems to provide a democracy with the means of sustaining its otherwise fragile unity, is also the condition from which tyranny arises, the democracy which wars against its other always risks inciting tyranny at home while making democracy abroad meaningless (Plato 1935: 313–22).

It is not so much that the suicidal narcissism of the US seeks to annihilate itself by killing the other, but that it risks annihilating everything because it will engage only with another which resembles itself. Popular discourse about the 9/11 hijackings

elevates and occludes the recognition of this suicidal logic in a narrative principle of subversion. The hijackers, it is frequently noted, used only what America made available: technology, the accouterments of everyday life, and an ethos of openness. The banality of box-cutters and ATM machines is important to this narrative, insofar as it makes American culture, as much as its military-industrial installations, appear to be under threat. However, subversion from within takes place only when there is asymmetry. The current war on terror is a function of such asymmetry, a fact that even the National Security Policy recognizes. But it is also an effort to restore and reaffirm that asymmetry.

We have moved beyond the violent equilibrium of the cold war, in which everyone was threatened by the general acquisition by all of a particular technology of death. Not incidentally, McLuhan had discerned the origin of that drive to awful equality even earlier, when Afghanistan's King Amanullah first fired a torpedo in 1928. On that occasion, Amanullah is said to have announced, 'I feel half an Englishman already' (McLuhan 1994 [1964]: 340). But England was soon to be in eclipse, and the torpedo was similarly on the verge of its own surpassing. So too was the form of military engagement characterized by an exchange of artillery between national entities. What remained was the possibility of using an aggressor's own technology of domination against itself. What would emerge, as we have seen, is the possibility of using the mass mediatized image as part of the arsenal.

The First Gulf War gave us the literal fusion of weapon and image in the form of the missile-mounted camera, and virtualized what had previously been the awful naturalism of wartime photography (and cinematography) in green filtered images that made death appear to be a digital effect of video games. The War on Terror gives us a doubled image track. It has generated a veritably nostalgic traffic in theatricalized pictures of death in the moment that it occurs. These images explode outwards like bombs, taming evidence into the specter of future death. Conversely, it has given us imagery of political processes, as well as that of the media apparatus itself (in the reflexive accounts of the embedded media). The second set of images is inert and achieves power only through accumulation. Despite the different image politics deployed by the US and Al Qaeda, however, the new forms of warfare to which all people are now subject produce symbolic violence through the destruction of the real and, reciprocally, they produce reality effects through the destruction of symbolic targets, albeit on the basis of different calculations of proportionate force. To reclaim the symbolic and, thus, the possibility of peace in this context will entail something other than the relay of images. It will require an understanding of language in which foreignness is not conflated with noise, and communication is not reduced to the conveyance of commandments. It will require attention to the other, and not merely alertness to the possibility of disaster. And it will require listening, as well as looking. In short, it will require the reclamation of democracy from technical fundamentalism. If we do not do so, difference will become mere opposition, and this will be even more completely displaced by that of internal destructiveness; the violence of the self-referential system, of the Empire of Images, will then find itself overwhelmed in the *auto-da-fé* of terrorism. To fail now will be to commit to suicide.

References

Arendt, Hannah (1970) *On Violence*, New York: Harcourt Brace.

Barthes, Roland (1981) [1980] *Camera Lucida: Reflections on Photography*, trans. Richard Howard, New York: Hill & Wang.

Barthes, Roland (1985) [1981] *The Grain of the Voice: Interviews 1962–1980*, trans. Linda Coverdale, Berkeley: University of California Press.

Baudrillard, Jean (1995) [1991] *The Gulf War Did Not Take Place*, trans. Paul Patton, Bloomington, IN: Indiana University Press.

Baudrillard, Jean (2002) *The Spirit of Terrorism and Requiem for the Twin Towers*, trans. Chris Turner, New York: Verso.

Chion, Michel (2000) *The Voice in Cinema*, New York: New York University Press.

Derrida, Jacques (2003) *Voyous: deux essais sur la raison* (Rogues: two essays on reason), Paris: Galilée.

Fukuyama, Francis (1992) *The End of History and the Last Man*, New York: The Free Press.

Kirschenbaum, Matthew G. (2003) 'The word as image in an age of digital reproduction', in Mary E. Hocks and Michelle R. Kendrick (eds.) *Eloquent Images: Word and Image in the Age of New Media*, Cambridge: MTT Press, pp. 137–58.

Lacan, Jacques (1977) [1966] 'The mirror stage as formative of the function of the I', in *Écrits: A Selection*, trans. Alan Sheridan, New York: Norton, pp. 1–7.

Lacan, Jacques and Granoff, Wladimir (1956) 'Fetishism: the symbolic, the imaginary, and the real', in Sándor Lorand (ed.) *Perversions, Psychodynamics, and Therapy*, New York: Random House, pp. 265–76.

Lenin, V. I (1966) 'Theses on the national and colonial questions,' in *Collected Works*, vol. 31, trans. Julius Katzer, Moscow: Progress Press, pp. 144–51.

McLuhan, Marshall (1962) *The Guttenberg Galaxy*, Toronto: University of Toronto Press.

McLuhan, Marshall (1994) [1964] 'Weapons: war of the icons', in *Understanding Media: The Extensions of Man*, London and Cambridge, MA: MTT Press, pp. 338–45.

National Commission on Terrorist Attacks Upon the United States (2004) *The 9/11 Commission Report: Final Report of the National Commission Terrorist Attacks Upon the United States*, authorized edn, New York: Norton.

Ndebele, Njabulo (2001) 'After the eleventh: a series of responses – Njabulo Ndebele', *CONNECT: art, politics, theory, practice* 3: 138.

Omissi, David E. (1990) *Air Power and Colonial Control: The Royal Air Force 1919–1939*, Manchester: Manchester University Press.

Plato (1935) *The Republic*, trans. Paul Shorey, Book VIII, 566E, Loeb Classical Library, Cambridge, MA: Harvard University Press.

Ronell, Avital (1989) *The Telephone Book*, Minneapolis, MN: University of Minnesota Press.

Select Committee on Intelligence, United States Senate (2004) *Report on the U.S. Intelligence Community's Prewar Assessments on Iraq*, Washington, DC: US Congress.

United States Government (2002) *The National Security Strategy of the United States of America*, Connecticut: Winterhouse Editions, Sec. III, no page numbers.

United States Office of the Historian (1961–3) 'United States policy on Iraq', in *Foreign Relations, 1961–1963*, Vol. 17, *Near East, 1961–1962*, released by the Office of the Historian, Documents 293–314.

Virilio, Paul (2002a) [1991] *Desert Screen: War at the Speed of Light*, trans. Michael Degener, New York: Athlone.

Žižek, Slavoj (2002) *Welcome to the Desert of the Real*, New York: Verso.

Further readings

"To Veil the Threat of Terror": Afghan Women and the "Clash of Civilizations" in the Imagery of the US War on Terrorism, Dana L. Cloud, *Quarterly Journal of Speech*, 90(3), 2004.

"Security Moms" in the Early Twenty-First Century United States: The Gender of Security in Neoliberalism, Inderpal Grewal, *Women's Studies Quarterly*, 34(1–2), Spring/Summer 2006.

Related Internet links

Welcome to the Desert of the Real, 10/7/01, text by Slavoj Žižek: http://www.egs.edu/faculty/zizek/zizek-welcome-to-the-desert-of-the-real-1.html

9/11 Commission Report: http://www.9–11commission.gov/

13

An Immense and Unexpected Field of Action
Webcams, Surveillance and Everyday Life

J. Macgregor Wise

Walter Benjamin once wrote that 'the enlargement of a snapshot does not simply render more precise what in any case was visible, though unclear: it reveals entirely new structural formations of the subject' (1969, p. 236). The camera 'manages to assure us of an immense and unexpected field of action'. There are at least two different ways of reading the term 'subject' in this quotation. On the one hand, the subject is the subject of the photograph, that which is photographed. Therefore, the photograph reveals new levels of detail, new structures, to that being photographed. Things look different as the image is frozen, and one zooms in, revealing what could not be seen before (Bachelard once wrote: 'The destiny of every image is enlargement'; quoted in Virilio 2000, p. 13). Early photography contributed to a modern regime of truth: the camera could reveal the world in a new way. Benjamin points out elsewhere that the world poses for the camera in a different way than for the photographer: 'For it is another nature that speaks to the camera than to the eye: other in the sense that a space informed by human consciousness gives way to a space informed by the unconscious' (Benjamin 1979, p. 243). The camera captures that which we are unaware of (for example, how we step out when we walk). Benjamin terms this the 'optical unconscious':

> Details of structure, cellular tissue, with which technology and medicine are normally concerned–all this is in its origins more native to the camera than the atmospheric landscape or the soulful portrait. Yet at the same time photography reveals in this material the physiognomic aspects of visual worlds which dwell in the smallest things, meaningful yet covert enough to find a hiding place in waking dreams, but which, enlarged and capable of formulation, make the difference between technology and magic visible as a thoroughly historical variable. (1979, pp. 243–4)

On the other hand, we can read 'subject' as referring to subjectivity, and 'structural formations' as mechanisms of subjectivity and subjectification. The capture of

Keywords

Benjamin
Virilio
subjectivity
Foucault
everyday life
surveillance
control society
webcams
longue durée
Lefebvre
Deleuze
digital enclosures
assemblage
digital community
Heidegger

Global Visual Cultures: An Anthology, First Edition. Edited by Zoya Kocur.
© 2011 Blackwell Publishing Ltd except for editorial material and organization © Zoya Kocur. Published 2011 by Blackwell Publishing Ltd.

images of people, places and things can be read through the disciplinary project of that same regime of truth; as Foucault (1977) has shown of the panopticon: reveal, document, discipline. The camera's gaze not only reveals the world in a new way and reveals aspects of us that we are unaware of (habits, expressions), but contributes to new social formations.

In a postphotographic era – when images are electronic and not chemical, digital and not analogue (Tomas 1996) – what are the new structural formations of the subject? In the age of the webcam, what is the immense and unexpected field of action? The field of action, I am arguing in this essay, is everyday life in a society of surveillance and control.

Subject

Web cameras (or webcams or simply cams) are small digital cameras of varying quality that are connected to the internet, uploading either intermittent or constant (streaming) images of whatever is in front of the camera to a webpage for public viewing. In 1991, the first camera of this type transmitted live images of a coffee pot in the Trojan Room of Cambridge University to an intranetwork of computer scientists (Stafford-Fraser 1995). Since then, cameras have been connected to the World Wide Web, transmitting images of offices, landscapes and homes to the world (sometimes for a fee). Some people live most of their lives in front of such cameras (e.g. nerdman.com, jennicam.com) and some have even tried to make a living doing so (dotcomguy; see Andrejevic 2004). With the rapidly declining costs of both high-speed Internet access and the cameras themselves, webcams are becoming a common sight on new personal computers and on the web.

The subject matter captured and transmitted by webcams is varied and vast. Webcams capture public spaces (streets, parks, mountains, nature preserves) and personal spaces (offices, living rooms and bedrooms); they range from African safari parks to amateur porn; they are broadcast to potential tourists and to a small circle of close friends or family. Given the numbers and diversity of webcams available on the Internet, there is a tendency to want to totalize their gaze, to argue that everything can now be seen somewhere online via a webcam.[1] For example, Virilio, with typical hyperbole, writes of webcams:

> The Earth, *that phantom limb*, no longer extends *as far as the eye can see*; it presents all aspects of itself for inspection in the strange little window. The sudden multiplication of 'points of view' merely heralds the latest globalization: the globalization of the gaze, of the single eye of the *cyclops* who governs the cave, that 'black box' which increasingly poorly conceals the great culminating moment of history, a history fallen victim to the syndrome of total accomplishment. (2000, p. 18)

This has parallels with what Baudrillard once referred to as obscenity ('The most intimate operation of your life becomes the potential grazing ground of the

media. ... The entire universe also unfolds unnecessarily on your home screen', 1988, pp. 20–1). The geography of the webcam is a specific one, shaped by access to computers, telephone connections and the Internet, as well as by the banality or exoticness of the subject matter, and its regimes are far too specific to submit to totalizing.

The bulk of the images broadcast by webcam are not the clear, carefully composed, well-lit snapshots of the tourist office or even the family photo album. Indeed, there is an overwhelming presence of the *in-between*, like all those photos with your eyes shut or in mid-sneeze, or where someone moved, blurring their features, or moved partially out of frame. These are the photos that never make it into the album, the ones discarded or deleted almost immediately. Yet, these are the images that we tend to be met with when we pull up a webcam. One of the most famous (or infamous) webcam sites is by Jennifer Ringley (jennicam.com), a young woman who broadcast her life to the Internet from 1996 to 2003. However, as Burgin (2000) has pointed out in an essay on jennicam, most of the day Jenni was not home and one was left watching her empty couch or occasionally her cats. Galleries of earlier images and image archives are often supplied to make up for these absences on webcam sites.

In a way, all of these in-between moments allow for a certain scrutiny of the everyday, because in-betweenness is the essence of the everyday. However, this scrutiny is not at the level of the close-up or enlargement (such as in film or photography), or a result of an increase in detail (because of the limitations of the medium, there is sufficient loss of detail), but a product of time. On the one hand, we have the momentary, the moment caught on camera, or a succession of such moments (a certain this-ness, this moment and then this moment). Benjamin writes:

> No matter how artful the photographer, no matter how carefully posed his subject, the beholder feels an irresistible urge to search such a picture for the tiny spark of contingency, of the Here and Now, with which reality has so to speak seared the subject, to find the inconspicuous spot where in the immediacy of that long-forgotten moment the future subsists so eloquently that we, looking back, may rediscover it. (1979, p. 243)

The difference with the webcam is that we are not necessarily 'looking back' but looking at a Here and Now that is Now (though perhaps not Here in any direct sense).

On the other hand we have the long stretches of time where we can watch a room or street or landscape for hours.[2] It is in this *longue durée* (in terms of rhythm, perhaps, if we are to follow Lefebvre's (1996) rhythmanalysis) as well as the momentariness that webcams reveal aspects of everyday life.

The *longue durée* of the webcam is easily derided as being really, really boring. Indeed, as a direct commentary on the lack of eventfullness of the average cam, there is a live webcam pointed at a wall of peeling paint.[3] The images and the technology do not verge on the magic that Benjamin described with photography, but retain a certain fascination nonetheless. If they are not the sublime, they are a step

down from that – the 'cool' perhaps. They also hold other fascinations, which we will consider below. One way of dealing with this boredom is to consider these images as ones to be surfed, to be clicked past, not studied at length. Senft has argued that one views the webcam image not with the gaze of the film audience or the glance of the television audience, but as a grab (in McLemee 2001). Palmer (2000) puts the situation this way:

> Like TV, Webcams are especially interested in everyday rhythmic routines at the heart of workplaces, homes, streets, or offices. But unlike TV, at most live Internet camera sites precisely *nothing* happens most of the time. Pointing your browser to a Webcam will more often than not result in the peeling back of an image of an empty (and often dark) bedroom, street, or cityscape. Aside from reminding us of our longitudinal anchoring [Palmer is in Australia], there's often only the very faint sense that something might happen.

If we are not so quick to dismiss the *longue durée*, we can learn something new about the subject; indeed, we can watch the subject transform as we continue to scrutinize it and watch the slow progress of time and light rework the subject over the day(s). This is one of the effects of Andy Warhol's 1964 eight-hour film *Empire*, which consists of a static shot of the Empire State Building over the course of an evening. Our impatience over the speed and eventfulness of webcam images reveals as much about our own cultural presuppositions and habits, as well as the historical construction of attention itself (Crary 1999), than about the subject itself. For example, videos shot by aboriginals in Australia exhibit an aesthetic of time, composition and storytelling, favouring long shots of what some would describe as empty landscapes, that would also be considered boring by Western audiences (Michaels 1994).

However, as a means of studying everyday life, webcams can provide only a quite attenuated version of it. Despite what it can deliver (momentariness and *longue durée*), it cannot come close to presenting the thick description, if you will, the level of detail, density and embodiedness of everyday life usually sought by the myriad projects on everyday life since the turn of the last century (see Gardiner 2000, Highmore 2002). Though some webcams provide sound, and a few allow for camera movement, many sensory and spatial dimensions are lost. They lack a sense of presence.

The dream of telepresence has been alive for a long time. Different from the broader idea of teleactivity (being able to be active at a distance, that is, remote control), the idea of telepresence essentially is the idea of being in two places at once – to be where you are, but to feel like you are someplace else. With the telegraph and telephone, and their sense of instanteneity and simultaneity, we began to move closer to this idea.

However, we have never come close to meeting any of the definitions of telepresence, such as the feeling that one is completely immersed in a scene (feeling, touching, tasting, smelling, and so forth). Campanella (2000), following Thomas Sheridan, lists three dimensions for determining true telepresence: the level of

sensory information received, the ability to change one's viewpoint in the virtual environment, and the ability to modify the virtual environment. Campanella suggests that with webcams we have at best something that might be called 'low telepresence' or 'popular telepresence' (2000, p. 30). For Campanella, the fact that webcams can show such a multitude of scenes globally makes up somewhat for their grainy, intermittent images. Nevertheless, it is extremely doubtful that anything we will come up with in the near future will even begin to address full telepresence, no matter how cool the latest immersive gear and environments are.

Despite this, there are more connections between the attenuated webcam images and the thickness of everyday life. However, we have to get at these through the second reading of the Benjamin quotation.

Subjectivity

> This is a modern panopticon, wherein the cell of privacy is open to an impersonal gaze, and the sense that someone is always watching, potentially at least, is part of the structure of feeling of modern life. (Carey 1998, p. 129)

In terms of the 'structural formations' of subjectivity, what is revealed by webcams (that is, what is revealed by having live images of oneself captured and broadcast on the Internet even without one's knowledge) is that these structural formations are shaped within a society of surveillance. Though the processes of subjectivation exceed any particular formation (Deleuze 1988, p. 89), we need to consider the gaze of surveillance as part of these formations. The structure of feeling of modern life is that we are being watched.

> All societies that are dependent on communication and information technologies for administrative and control processes are surveillance societies. The effects of this are felt in ordinary everyday life, which is closely monitored as never before in history. ... Today, routine, mundane surveillance, usually mounted by agencies and organizations that are geographically remote from us is embedded in every aspect of life. (Lyon 2001, p. 1)

Cameras in public spaces can become flash points for protests over diverse encroachments on civil liberties. For example, 2002 saw protests and debates about the number of cameras being placed not only around monuments and public buildings in Washington, DC, but public spaces more generally (see www.observ ingsurveillance.org). The number and type of cameras aimed at public spaces is quite diverse, from Closed Circuit Television (CCTV) used by police and security guards to cameras on ATMs, and even webcams aimed out of apartment windows. The city of Tempe, Arizona, even sports a couple of live webcams (entitled Sneaky Peak) on its municipal webpage (www.tempe.gov/millcam/default.asp). The cameras are aimed at popular intersections of the college town.

For the most part, as the obvious cameras work their way into the familiar landscape of our lives, they can be ignored. Indeed, Jennifer Ringley claims that she ignores the cameras in her home (Snyder 2000), that they are just there and that what we see on her website is virtually everything that goes on in the house unedited and uncut. However, there is only a certain extent that we can ignore the cameras; we are aware of their presence at some level (again, there is a felt quality of being watched). Despite having at least six live cameras in the house, Jennicam provides only one feed at a time to the website. The switching of the cameras is not automatic, and so the fact that Ringley has to change the feed manually throughout the day belies her claim. The conceit of behaving as if the cameras were not there is one that underlies the current boom in 'reality television', especially shows such as the *Big Brother* series. In an exit interview after being voted off the show, a contestant on the first season of the US *Big Brother* (2000) stated that it was difficult to ignore the cameras, especially since they made noise when they panned or tilted.[4] The conceit is undergirded by the qualities of what Bolter and Grusin (1999) term 'immediate media', media that tend to erase their own presence, offering windows on the world.

Perhaps it is not a question of whether or not we can ignore the cameras, but rather a question of caring about or minding the cameras. As Ringley writes in her discussion of the concept of her website, 'I keep JenniCam alive not because I want to be watched, but because I simply don't mind being watched. It is more than a bit fascinating to me as an experiment, even (especially?) after five years' (jennicam. com). There are those who do not mind being watched – so long as they are compensated in some way for being watched – and there are those who do mind being watched. Let us take the first group first.

Kellner (1999) writes that these new communication technologies create the possibility for democracy, once everyone has their own channel to broadcast on, their own show and means of expression. However, Andrejevic (2004) has argued that this move towards encouraging personal expression has a darker side in that people are being encouraged to put much of their everyday life on a medium that is easily surveilled, tracked and logged. He argues that capitalism has always worked by means of enclosures: fields, the factory floor and now what he calls digital enclosures. The new digital enclosures include leisure spaces that become work spaces as well, where one's leisure time and activity becomes a means of work. One gets paid for doing what they do everyday, but now they let people watch them and log their movements, purchases and habits: Will live *live* for food.

One perhaps extreme version of this is the site Icepick.com, which connects webcams to household events so that when an event occurs a picture is taken and notation made of time and duration. Events include the front doorbell ringing, the microwave opening, the refrigerator opening, the treadmill working, the toilet flushing (no camera), the cat eating, the cat entering the litterbox and more. A database of images, events and frequency of events is available on the site so that, for example, one can access a graph of the frequency of doorbell rings over the last week by time of day. A barcode scanner has also been installed on the kitchen trashcan to record every item thrown away.

Payment for one's work on such sites comes in many forms: subscriptions to your site, ads on your site, and 'click throughs' (icepick.com is a free site). But it also comes in the much less direct – but no less powerful – forms of convenience (the fruits of direct marketing) and attention. With regards to the latter, in 1997 Goldhaber argued that the economy of the Internet needs to be understood as an 'attention economy', where attention and stardom become the currency and the goal. The term attention economy has recently been used to explain in part the seeming explosion of diaries posted to the web (called weblogs or just blogs). Such diary sites often come in conjunction with a webcam. A competitive economy is established where bloggers seek to out-do each other in some way to increase their fan base. A 2001 article in Salon.com describes the competitive environment of a subset of bloggers with webcams who are young teenage girls, some of whom post wish lists of products they would like (Mieszkowski 2001) – and admirers do send them gifts. Even without the explicit nudity that would make such sites illegal (most of the girls are under 18), the prurience and morality of such sites has been the subject of intense debate, some viewing the sites as harmless fun and others arguing that they present a version of prostitution (some are rumoured to exchange explicit photos of themselves for gifts). Burgin (2000), in his essay on jennicam, argues that her webcam is a 'transitional object' designed to ease Ringley's transition from girlhood to adulthood. Ringley established Jennicam in her college dorm room. From Ringley's perspective, Burgin's argument goes, her webcam is a mirror and not a window and, like all good Lacanian mirrors, brings up questions of identity. Following Winnicott's re-reading of Lacan, Burgin emphasizes the look *from* the mirror as a form of recognition, and therefore the webcam as a bid for attention. The camera itself is a confidante in the absence of parents. One could argue that since these young women are presenting their own images of themselves that this practice has the potential to empower them to be more active agents in the formation of their sexual subjectivity.[5] Whether they actually follow through on this potential is something that deserves careful study.[6] But given the sorts of images used to advertise sites on the major webcam portals, as a group they do not. Such activities may simply reinforce young women's roles as subjects under a patriarchal gaze despite the presumption that they are empowering themselves by doing so. This is much like the assumption that consumers are empowered as they choose amongst the products of capitalism.

Another way of approaching the analysis of digital enclosures and attention economies is through Deleuze's (1995) notion of control societies. Take, for example, a comment from Deleuze on communication: 'Repressive forces don't stop people expressing themselves but rather force them to express themselves. What a relief to have nothing to say, the right to say nothing, because only then is there a chance of framing the rare, and ever rarer, thing that might be worth saying'; and earlier: 'we're riddled with pointless talk, insane quantities of words and images' (Deleuze 1995, p. 129). Given the fact that some populations do not even get the choice of whether to express themselves or not, this comment is problematic, save that it begins to get at the boom in self-expression on the Internet (as well as on television and talk radio): personal web pages, blogs, webcams, etc. When one is

forced to talk incessantly, to have an opinion on everything, to always express one-self, there remains little room for thoughtful consideration of what one is saying (not to mention time to listen to others). In addition, 'everyone' expresses themselves but things matter less and less – the control of communication through the proliferation of communication, the compulsion to express more and more. For Rose (1999) this incessant push towards individual autonomy and freedom within the culture of control makes the individual seem empowered. Consumption technologies thus allow consumers to 'narrativize their lives [and provide] new ethics and techniques for living' (Rose 1999, p. 86). Enter the new web technologies. Writing on first-person video technologies, Dovey writes that

> these expressions of subjectivity are to be found across a range of media (print journalism, literature, the Web) and are not exclusive to the technologies of video, film or the medium of TV. It is rather that the regime of truth generated by and for contemporary western culture *requires* subjective, intimate, exposing expression as dominant form. The camcorder has technical characteristics that lend themselves to this work … (Dovey 2000, p. 57)

Webcams as well lend themselves to this work, and can be viewed as a particular instance of a cultural form produced within a society of control.

However, not everyone wishes to participate in this new economy. The Surveillance Camera Players in New York City provide walking tours of some of the 2400 surveillance cameras found in Manhattan. The tour focuses on Times Square, but the Players also provide a map (www.notbored.org/scp-maps.html) of all these cameras. The group Applied Autonomy has connected a similar map up to a program they call iSee (www.appliedautonomy.com/isee/). By clicking on one's location on the map, and then clicking on where one wishes to go, the software will generate a path that will take you by the least number of cameras possible (sometimes taking you miles out of your way).

Some of those who wish not to participate in this new attention economy come from groups who are overrepresented in surveillance images: minorities, women, and youth.[7] For youth, the space of the street is an especially important cultural space. The coming of CCTV in Britain meant that youth on the streets were even more heavily surveilled, forcing the youth to adapt (Toon 2001). They find the camera's blind spots, and map their own routes through city centres; they know how to blend into the background so as to not cause notice when they are surveilled. These are the tactics of the everyday for these youth.

The Awareness of Everyday Life

Modern subjectivity is not simply about being watched, but also of *watching*. Most studies of surveillance ask the question of why we watch, and many turn to theories of the voyeur (see, for example, Calvert 2000), but I want to ask not why we watch but

what is it that is being seen. It is not the real, nor the hyperreal, and what we are seeing through webcams is not everyday life, as we discussed above, since webcams can only present an attenuated version of everyday life. Perhaps it is not a question of whether everyday life is being represented accurately or not. Rather what is being produced through webcams is an *awareness* of everyday life. Lefebvre, discussing the novel *Ulysses* as a 'momentous eruption of everyday life into literature', goes on to say that '[i]t might, however, be more exact to say that readers were suddenly made aware of everyday life through the medium of literature or the written word' (Lefebvre 1971, p. 2). One could argue that television, at first, also made audiences suddenly aware of everyday life through its 'liveness'. Perhaps this is what is happening with webcams.

Webcams provide views of the exotic or the domestic (personal cams) where we are treated to views of houses or spaces. There is a parallel here with reality television and the distinction between the exoticism of *Survivor* and its ilk and the domestic banality of *Big Brother* or *Loft Story*. These cams provide a break from everyday life, and take us into Lefebvre's discussion of leisure in the modern world: 'Leisure must break with the everyday (or at least appear to do so) and not only as far as work is concerned, but also for day-to-day family life' (Lefebvre 1991, p. 33). Hence, the exotic locales and popular focus on sexuality: 'Displays of sexuality and nudity break with everyday life, and provide the sense of a break which people look for in leisure: readings, shows, etc.' (1991, p. 35). However, as noted by Andrejevic, the sphere of leisure is becoming a sphere of work; it does not provide a break in and of itself. Still, webcam images, while being a part of and apart from everyday life, contain their own critique of everyday life.

To represent everyday life one must be a part of it and apart from it; one cannot leave it, but one must break with it. The formation of the modern world for Lefebvre contains 'a complex of activities and passivities, of forms of sociability and communication' (Lefebvre 1991, p. 40), which connect everyday life with the escape from it (the world of leisure and illusion to which we turn). For Lefebvre, this complex of activities is able to be studied by the sociologist: 'Although he cannot describe or analyse them without criticizing them as being (partially) illusory, he must nevertheless start from the fact that they contain within themselves their own spontaneous critique of the everyday. They *are* that critique in so far as they are *other* than everyday life, and yet they are in *everyday life*, they are *alienation*' (Lefebvre 1991, p. 40).

Everyday life of the webcam is part of a transfiguration of everyday life that Virilio (2000) discusses:

> As with *stereoscopy* and *stereophony*, which distinguish left from right … to make it easier to perceive audiovisual relief, it is essential today to effect a split in primary reality by developing a *stereo-reality*, made up on the one hand of *the actual reality* of immediate appearances and, on the other, of the *virtual reality* of media trans-appearances. (Virilio 2000, p. 15, original emphasis)

Virilio's notion of stereo-reality avoids the postmodern trap of thinking that reality has become fully virtual (through TV or the internet), yet acknowledges that

the experience of media is part of everyday life. Everyday life becomes a combination of the dual perspectives (one looks out one's window *and* at one's TV or computer). But, I would add, we must not ignore the places where these perspectives overlap, influence each other, and presuppose one another. For example, Siegel (2002) argues that the large-screen video displays found in sporting arenas, at concerts, and other places brings about this sort of double vision of the immediate and the mediated. Giant screens display the same space as the space of the audience, and so the geography of the technology and the phenomenological space is different from what Virilio is talking about, but the relation between the mediated and the immediate is similar: 'The mediated view subsumes the immediate view, even as the immediate consumes the mediated, resulting in an entirely new view characterized by neither one not the other but by the dynamism of their mutual interrelation' (Seigel 2001, p. 51; original emphasis deleted).

The notion of stereo-reality allows us to begin to talk about the virtual nature of the webcam experience in an embodied way. As Grosz has argued, the space of the screen 'can't be your only space. This computerized or virtual space is always housed inside another space – the space of bodily dwelling' (2001, p. 24). 'There can be no liberation from the body, or from space, or the real. They all have a nasty habit of recurring with great insistence, however much we may try to fantasize their disappearance' (2001, p. 18).

Even our model of how we look at the screen leads to this idea of separation of body and virtual space because our model of vision appears a disembodied process. Webcams can remind us of the deterritorialization of the eye. Deleuze (1981) distinguishes between three types of optical space: digital space, which is purely optical space (what we assume the internet to be); tactile/manual visual space, which subordinates the eye to the hand (in painting, the eye follows the hand); and, finally, haptic space where there is no longer strict subordination in either direction. Vision involves the hand. Webcams are not pure digital, optic spaces; they are haptic. Viewing webcams involves looking and clicking.

The awareness of embodiment (both of oneself and of the object of one's gaze via the webcam) brings a corporeal dimension to the otherwise attenuated version of everyday life we had been discussing before. The problem with discourses of the body and technology is that much of the discussion turns to the limits of the body, the line where the body and the technology become radically distinct (subject/object, self/other). We can avoid this through the idea of assemblage – of seeing the question of the relation of the body and technology not as a disjunction (either/or) but of a conjunction (and). This is not the conjunction of the hybrid, the cyborg (part this, part that), but a series of conjunctive syntheses (and … and … and … body and chair and keyboard and mouse and electricity and computer and …; see Wise 1998). Grosz writes that 'there is a boundary beyond which the body ceases to be a body. This point is the limit of the viability of technology' (Grosz 2001, p. 17). The boundary is 'a point beyond which things start to function differently – not necessarily worse, but differently. We would then have different kinds of bodies and different kinds of body functioning, and perhaps even the

possibility of different becomings' (2001, p. 17). Assemblages of corporeality become articulated to assemblages of incorporeality.

So by prodding us to an awareness of everyday life, webcams make us aware of our assemblages as well, and the living and functioning of ones assemblages in everyday life. I would hesitate to draw a firm distinction between assemblage and everyday life. Webcams are an entry into this revealing of everyday life, but they are only one small part of the assemblage. Webcams lead us to the questions of surveillance, digital enclosures and societies of control, but those too are only just parts of the new assemblages of everyday life. These assemblages (just appearing in a few places today) rely on information and communication to an unprecedented extent. They are also increasingly mobile.

Steve Mann has been studying how this new assemblage is embedded in everyday life through his work on wearable computers (Mann with Niedzviecki 2001). Mann engages in much of his daily life wearing several small computers that act to mediate his experience with the world. A camera captures images of the world around him, eyewear projects those images and other information onto his eye (sometimes filtering out aspects of the environment, like advertising), and a transmitter uploads everything to the internet. Mann builds his systems on the principle of individual autonomy; the system allows users to control the symbolic environment through which they move. He recognizes that the environment created by *other* wearable computers and technologies – the ones produced by the military and corporations – create a world in which we are more easily tracked. Mann's work is to produce viable alternative assemblages to resist the encroachment of control and enhance autonomy. He recognizes that the very technologies he creates can be appropriated for other uses, but insists that one must engage with this technological assemblage using technology itself. But, more importantly for our purposes, he insists that we must engage this assemblage on the level of everyday life, as we move through spaces both private and public.

What differentiates Mann's online experiments from Jennicam and other personal webcams is that rather than pointing the camera at himself he uses the camera to show what he sees.[8] As Mann puts it:

> [O]n my 'channel', the absence of a central subject or character constantly challenges the viewer. ... The tables are turned in my experiment: the watcher cannot rely on objectifying the subject of the spectacle, turning the subject into a stand-in for one's own less eventful life. A (subjectless) life on the Web implicitly demands of the viewer: Why are you watching this? In refusing to provide a real subject, the story is left characterless, and viewers are forced to admit that they have been the subject all along, whether they are watching Steve Mann's hand raise a spoonful of cereal to his mouth or watching Jenni hunched over the breakfast table sipping coffee. (Mann with Niedzviecki 2001, pp. 134–5)

In addition to challenging the webcam viewers to rethink their own subjectivity, one of Mann's projects seeks to confront surveillance cameras directly in everyday life by pointing his own camera at CCTV cameras in stores and challenging

employees and customers on the logic of the institution's cameras. From this project, he derives the term *sousveillance*, by which he means inverse surveillance, from below, from the level of the person, that is 'from down under in the hierarchy' (Mann 2002, np). It is a democratization of surveillance, an attempt to 'level the playing field' (Mann with Niedzviecki 2001, p. 146).

The isolation of the individual using such apparatus does not go unnoticed or unnoted by Mann, but he points out how the apparatus can be used to be in constant communication with others, to allow them to see the same things that he is seeing and for him to see what they are seeing, simultaneously – to almost literally walk in someone else's shoes. As these new assemblages of everyday life become more mobile, they are no longer about watching in any simple sense (or even data gathering, in the broader sense of surveillance), but connectivity with others. Let me give you an example. Rheingold (2002) has coined the term 'smart mob' to describe the behaviours of groups that organize by means of text messages sent via cell phones. Through this technology, a message can quickly be disseminated throughout a decentralized network of people. In 2001, opposition groups in the Philippines were able to use the technology to gather quickly crowds of tens of thousands that eventually brought down President Estrada. This sort of decentralized coordination can also be found among groups of youth in Japan and Finland. The youth coordinate group meetings (changing plans and meeting places on the fly) and simply keep in touch throughout the day. These are haptic technologies, combinations of eye and thumb (used to key in messages, even without looking). In Japan, these groups of youth have been referred to as Thumb Tribes.

Rheingold describes these new networks as 'swarming', a term that may evoke the romance of resistance, the tactics of the oppressed, as they (youth, protesters, etc.) move through spaces they do not control. One turns to de Certeau (1984) and the first volume of *The Practice of Everyday Life* (as Toon (2000) does in his discussion of youth and CCTV, discussed earlier). But we should recall that Foucault (1977) noted that disciplinary mechanisms also 'swarm'. Rather than pit one swarm against the other, it is best to situate these practices within another swarm, 'the swarming structures of the street' that de Certeau refers to in the *second* volume of *The Practice of Everyday Life* (1998).[9] These are practices consisting of both contingency and structure, chance and ritual within everyday life. These terms are not in opposition but are grasped in the same movement.

Rheingold writes that it is a mistake to think of mobile connectivity of this sort as similar to the surfing of the Internet done on personal computers; it is a very different network put to very different uses. Therefore, this is a different set of practices and a different assemblage from that of the desktop webcam discussed above. But these networks highlight a dimension that we can then read back through the webcam assemblage. If we are to understand this new assemblage of everyday life we have to consider that studies of these youth indicate that these mobile technologies are not communication and information technologies but *phatic* communication technologies – that is, technologies that maintain relationships.[10] Indeed, this assemblage is one of distributed presence, but not in Turkle's

(1995) sense of distributed personality or multiple windows of the self. Rather, following Coyne's (1999) turn to Heidegger, this type of presence is marked by care rather than personal experience per se.

Heidegger writes that part of Dasein (Being) is Being-with, and that this sense of being-with (or nearness) is part of what it means to be in the world.

> There is a collectivity to Dasein that precedes the notion of many selves, society, or intersubjectivity … Digital communities are not to be understood primarily as those formed from isolated selves communicating through networks, but there is already a solidarity, a being-with that is the human condition, into which we introduce various technologies, such as meeting rooms, transportation systems, telephones, and computer networks. (Coyne 1999, p. 147)

Being-with then becomes a starting point for one's analysis and not its end result, the starting point of our encounter with a webcam (to return to that technology), not its result. To clarify this notion of being-with, Coyne draws on Heidegger's concept of 'care'.

> Care is not simply an individual disposition of philanthropy or a concern for people and things, but a disposition of Dasein toward the world as it presents itself to us at any moment. Within our experience of being in the world, there is a pragmatic understanding of proximity or closeness, and this closeness precedes any (ontic) notion of *measurable* distance. Distance is a function of our being concerned, or caring, about aspects of the world. So that which we care about the most at any particular moment is the closest to us. In our walking down the street, the pavement is as near as anything could be (measurably), yet it is remote compared with the nearness of an acquaintance one encounters several paces away. The commuter on her mobile phone is measurably close to her fellow travelers in the railway carriage but nearer ontologically to the person at the end of the phone. (Coyne 1999, p. 149)

The cell phone users amidst the crowds that Rheingold describes are closer to their friends than those they jostle past as they cross the street. Reading this dimension of smart mobs back across our discussion of webcams, we could say that ontologically we are much nearer to the place and person in the webcam image than to those physically nearby. Care, however, is not an ontological necessity in this instance. Just because someone appears on my screen does not mean that I feel closer to them. Care is, however, one of the territorializing forces shaping these assemblages. It does allow another dimension of everyday life to be added to the repertoire revealed by the study of webcams: thisness, the *longue durée*, an awareness of everyday life, embodiment and assemblage, and care. Though we have not reproduced the sensoria of that place does not mean that one cannot be close to it or that it cannot clue us in to the processes and dimensions of everyday life.

The immense and unexpected field of action is not the unfolding of view upon remote view of the world, but a revealing of intertwined networks of care and control that constitute a particular formation of contemporary everyday life.[11]

The assemblages of everyday life are territorialized by networks of control and regimes of truth, but they also contain within them networks of care, at least as a possibility. These are not distinct networks but inhabit the same technologies and practices, as we saw in our discussion of the digital enclosure. What the notion of networks of care and networks of control gets us is the beginning of a map of articulations of the assemblages of everyday life that takes seriously the technological stratification of everyday life without solely remaining on the plane of technology. To return to Benjamin's commentary on photography from which we began, we cannot exclude the apparatus itself. The field of action is not simply a visualization of the subject or even a regime of subjectivity but also the revealing of assemblages that include subject, subjectivity, camera, photographer and so forth, and that articulate the moment of image capture to the moment of visualization in complex ways. Immense and unexpected, indeed.

Notes

1 Like most of the Internet, counting webcams is a difficult process. Cameras go on and offline at different times; some transmit constantly, and some only once. Webcam portals (such as Earthcam. com and webcamworld.com) typically provide links to 3,000 to 5,000 cameras at a time, but the number of potential live webcams is easily in the millions worldwide.

2 Despite their potential for this *longue durée*, webcams can be particularly transitory as well, continually going on and offline.

3 www.sudftw.com/paintcam.htm – the site also has a feature where one can view a timelapse of the last 30 days; and even at this accelerated speed it is difficult to see paint actually peeling. The point is made whether this is a 'real' image or not.

4 Baudrillard addressed this conceit in his discussion of *An American Family*, the TV verité programme of the life of the Loud family in 1973.

> More interesting is the phantasm of filming the Louds *as if TV wasn't there*. The producer's trump card was to say: 'They lived as if we weren't there'. An absurd, paradoxical formula – neither true, nor false, but utopian. The 'as if *we* weren't there' is equivalent to 'as if *you* were there' … In this 'truth' experiment, it is neither a question of secrecy

> nor of perversion, but of a kind of thrill of the real, or of an aesthetics of the hyperreal, a thrill of vertiginous and phony exactitude, a thrill of alienation and of magnification, of distortion in scale, of excessive transparency all at the same time. (Baudrillard 1983, p. 50)

5 See, for example, Snyder's discussion of Ana Voog's webcam (Anacam.com) as 'pushing the boundaries of what people think a woman is and isn't' (Voog, quoted in Snyder 2000, p. 70).

6 Senft's forthcoming book *Camgirls: Gender, Microcelebrity and Ethics on the World Wide Web* (Peter Lang) should make a contribution in this regard.

7 Studies of CCTV in Britain have shown that when women were surveilled, 10 percent of the time it was for purely voyeuristic reasons (Norris and Armstrong 1999).

8 We should note that the particular comparison that Mann makes of his project and Ringley's tends to reproduce the gendered relations of surveillance: men look, women are looked at. The gendering of the gaze is not a question that Mann addresses.

9 See Felski (2002) for a brief discussion contrasting the character of the two volumes of *The Practice of Everyday Life*.

10 The term *phatic* is used by Jakobson (1960), who borrows it from Malinowski (1953).

11 It is worth noting that Lyon writes that surveillance has two faces: care and control: 'The same process, surveillance – watching over – both enables and constrains, involves care and control' (2001, p. 3). Although he is not using 'care' in Heidegger's sense, but in an ethical sense, this adds an important dimension to the argument presented here.

References

Andrejevic, M. (2004) 'The webcam subculture and the digital enclosure', in *Media/Space: Place, Scale, and Culture in a Media Age*, eds. A. McCarthy & N. Couldry, Routledge, New York.

Baudrillard, J. (1983) *Simulations*, trans. P. Foss, P. Patton & Philip Beitchman, Semiotext(e), New York.

Baudrillard, J. (1988) *The Ecstasy of Communication*, trans. B. Schutze & C. Schutze, ed. Sylvère Lotringer, Semiotext(e), New York.

Benjamin, W. (1969) 'The work of art in the age of mechanical reproduction', in *Illuminations*, ed. H. Arendt, trans. H. Zohn, Schocken, New York.

Benjamin, W. (1979) 'A small history of photography', in *One-Way Street and Other Writings*, trans. E. Jephcott & K. Shorter, New Left Books, London, pp. 240–257.

Bolter, J. and Grusin, R. (1999) *Remediation: Understanding New Media*, MIT Press, Cambridge, MA.

Burgin, V. (2000) 'Jenni's room: exhibitionism and solitude', *Critical Inquiry*, 27, pp. 77–89.

Calvert, C. (2000) *Voyeur Nation: Media, Privacy, and Peering in Modern Culture*, Westview, Boulder, CO.

Campanella, T. J. (2000) 'Eden by wire: webcameras and the telepresent landscape', in *The Robot in the Garden: Telerobotics and Telepistemology in the Age of the Internet*, ed. K. Goldberg, MIT Press, Cambridge, MA, pp. 22–46.

Carey, J., with Game, J. A. (1998) 'Communication, culture, and technology: an Internet interview with James W. Carey', *Journal of Communication Inquiry*, 22, 2, pp. 117–30.

Coyne, R. (1999) *Technoromanticism: Digital Narrative, Holism, and the Romance of the Real*, MIT Press, Cambridge, MA.

Crary, J. (1999) *Suspensions of Perception: Attention, Spectacle, and Modern Culture*, MIT Press, Cambridge, MA.

de Certeau, M. (1984) *The Practice of Everyday Life*, trans. S. Rendall, The University of California Press, Berkeley, CA.

de Certeau, M. (1998) 'Entrée', in *The Practice of Everyday Life, Volume Two: Living and Cooking*, eds. M. de Certeau, L. Giard, P. Mayol & L. Giard, trans. T. J. Tomasik, University of Minnesota Press, Minneapolis, pp. 1–4.

Deleuze, G. (1981) *Francis Bacon: Logique de la Sensation*, Editions De La Difference, Paris.

Deleuze, G. (1988) *Foucault*, trans. Seán Hand, University of Minnesota Press, Minneapolis.

Deleuze, G. (1995) *Negotiations, 1972–1990*, trans. M. Joughin, Columbia University Press, New York.

Dovey, J. (2000) *Freakshow: First Person Media and Factual Television*, Pluto Press, London.

Felski, R. (2002) 'Introduction', *New Literary History*, 33, pp. 607–22.

Foucault, M. (1977) *Discipline and Punish: The Birth of the Prison*, Peregrine, Harmondsworth.

Gardiner, M. (2000) *Critiques of Everyday Life*, Routledge, London and New York.

Goldhaber, M. H. (1997) 'The attention economy and the Net', *First Monday*, 2, 4, available at http://www.firstmonday.dk/issues/issue2_4/goldhaber

Grosz, E. (2001) *Architecture from the Outside: Essays on Virtual and Real Space*, MIT Press, Cambridge, MA.

Highmore, B. (2002) *Everyday Life and Cultural Theory: An Introduction*, Routledge, New York.

Jakobson, R. (1960) 'Closing statement: linguistics and poetics', in *Style in Language*, ed. T. A. Sebeok, MIT Press, Cambridge, MA, pp. 350–77.

Kellner, D. (1999) 'Globalisation from below? Toward a radical democratic technopolitics', *Angelaki*, 4, 2, pp. 101–13.

Lefebvre, H. (1971) *Everyday Life in the Modern World*, trans. S. Rabinovitch, Transaction Publishers, New Brunswick.

Lefebvre, H. (1991) *Critique of Everyday Life, Volume One*, trans. J. Moore, Verso, New York.

Lefebvre, H. (1996) *Writings on Cities*, trans. E. Kofman and E. Lebas, Blackwell, Cambridge, MA.

Lyon, D. (2001) *Surveillance Society: Monitoring Everyday Life*, Open University Press, Buckingham.

Malinowski, B. (1953) 'The problem of meaning in primitive languages', in *The Meaning of Meaning*, 9th edn, eds. C. K. Ogden & I. A. Richards, Harcourt, Brace and Co., New York, pp. 296–336.

Mann, S. (2002) 'Sousveillance, not just surveillance, in response to terrorism', *Chair et Métal/Metal and Flesh*, vol. 6, available at http://www.chairetmetal.com/cm06/mann-complet.htm

Mann, S., with Niedzviecki, H. (2001) *Cyborg: Digital Destiny and Human Possibility in the Age of the Wearable Computer*, Anchor Canada, Toronto.

McLemee, S. (2001) 'I am a camera'. *Lingua Franca*, February, pp. 6–8.

Michaels, E. (1994) *Bad Aboriginal Art: Tradition, Media, and Technological Horizons*, University of Minnesota Press, Minneapolis.

Mieszkowski, K. (2001) 'Candy from strangers', *Salon.com*, 13 August, available at http://dir.salon.com/tech/feature/2001/08/13/cam_girls/index.html

Norris, C. & Armstrong, G. (1999) *The Maximum Surveillance Society: The Rise of CCTV*, Berg, New York.

Palmer, D. (2000) 'Webcams: the aesthetics of liveness', *Like, Art Magazine*, vol. 12, pp. 16–22, available at http://users.bigpond.net.au/danielpalmer/webcams.html

Rheingold, H. (2002) *Smart Mobs: The Next Social Revolution*, Perseus, Cambridge, MA.

Rose, N. (1999) *Powers of Freedom: Reframing Political Thought*, Cambridge University Press, New York.

Siegel, G. (2002) 'Double vision: large-screen video display and live sports spectacle', *Television and New Media*, 3, 1, pp. 49–73.

Snyder, Donald (2000) 'Webcam women: life on your screen', in *Web.studies: Rewiring Media Studies for the Digital Age*, ed. D. Gauntlett, Oxford University Press, New York & Arnold, London, pp. 68–73.

Stafford-Fraser, Q. (1995) 'The trojan room coffee pot: a (non-technical) biography', available at http://www.cl.cam.ac.uk/coffee/qsf/coffee.html

Tomas, D. (1996) 'From the photograph to postphotographic practice: toward a postoptical ecology of the eye', in *Electronic Culture: Technology and Visual Representation*, ed. T. Druckery, Aperture, New York, pp. 145–53.

Toon, I. (2000) ' "Finding a place on the street": CCTV surveillance and young people's use of urban public space', in *City Visions*, eds. D. Bell & A. Haddour, Prentice-Hall, New York, pp. 141–65.

Turkle, S. (1995) *Life on the Screen: Identity in the Age of the Internet*, Simon and Schuster, New York.

Virilio, P. (2000) *The Information Bomb*, trans. Chris Turner, Verso, New York.

Wise, J. (1998) 'Intelligent Agency', *Cultural Studies*, 12, 3, pp. 410–28.

Further readings

The Webcam Subculture and the Digital Enclosure, Mark Andrejevic, in *MediaSpace: Place, Scale and Culture in a Media Age*, Nick Couldry and Anna McCarthy eds. (New York: Routledge, 2004).

Consumption and Digital Commodities in the Everyday, Mark Poster, *Cultural Studies*, 18(2–3), 2004.

Related Internet links

Surveillance Camera Players: http://www.notbored.org/the-scp.html

Applied Autonomy: http:/www.appliedautonomy.com/isee.html

Part III

Mediated Bodies
Representation / Circulation / Self

Introduction

An analysis of representation in mass media (Hollywood film, television, print media, the Internet, *manga*, advertising, fashion) calls for an examination of how these media forms produce and reproduce narratives of race, ethnicity, gender, sexuality, and class. The essays in Part III explore ways in which mass-circulated representations contribute to the formation of cultural and national identities, and reveal modes through which mass media products and commodity culture contribute to redefinitions of race and gender.

The discourse around representation has shifted during the past decade, in part through the establishment of the idea that categories of race, ethnicity, gender, and sexuality are unfixed and mutable, or alternatively, through a belief that these categories have decreasing relevance in a globalized world (i.e. the debate over whether or not we live in a "post-racial" society, most recently revived by the election of President Barack Obama). The essays included here suggest that these discursive shifts are not "either/or" propositions; rather, they point to changing socio-economic factors that are intersecting in complex ways to transform identities and produce new subjectivities and conceptions of the subject.

The first three essays in this group offer critical examinations of mainstream representations of Native/indigenous peoples, African Americans, and Asians, in Hollywood films, television, and cyberspace. These essays show that dehumanizing and stereotypical images continue to be produced and circulated in popular culture and mass media, reflecting anxieties in sectors of mainstream society about issues such as immigration, homosexuality, and race (the latter two are highlighted particularly in Gómez-Barris and Gray's essay on Michael Jackson). The essays by Marez and Chun relate how mass media and Internet portrayals have produced ahistorical interpretations of historical events such as conquest and slavery, and

Global Visual Cultures: An Anthology, First Edition. Edited by Zoya Kocur.
© 2011 Blackwell Publishing Ltd except for editorial material and organization © Zoya Kocur. Published 2011 by Blackwell Publishing Ltd.

propagated orientalist fantasies, particularly through their narrative uses of the science fiction genre.

The last three essays in this section examine hip-hop fashion (Ruff), South African township culture and fashion (Nuttall), and Japanese *manga* (Wood). Each essay illustrates means by which consumers and creators express and assert new forms of political and cultural identity through their relationship to these cultural products. To understand how these products function, it is critical to consider the participation of transnational audiences as consumers, as well as acknowledge the ongoing traffic in cross-cultural flows, both of which play a role in how these commodities (including fashion and style) are consumed, circulated, and accrete meaning. The embrace of hip-hop fashion in the United States, or of township styles by young people in Johannesburg, simultaneously signify forms of resistance and a reimagining of racial identities, leading to transformations in the way race is enacted and consumed. Extending Nuttall's theorization on the remixing of (racial) identities in Johannesburg, Wood's essay on the romantic, homoerotic genre of Japanese comics referred to as boy-love *manga* suggests that the diverse reception of these texts by readers opens up new spaces for remixing gender identities as experienced through sexual desire. Together, these essays highlight aspects of racial, gendered and sexual identities that are characterized by fluidity, mutability and contingency.

In *Michael Jackson, Television, and Post-Op Disasters*, Macarena Gómez-Barris and Herman Gray locate the US public's fascination with Michael Jackson within different and sometimes competing contexts. Focusing on the 2003 television documentary "Living with Michael Jackson," Gómez-Barris and Gray suggest that in the context of the insecurity of a post 9/11 world and the impending US invasion of Iraq, for the 27 million Americans who watched the program the Michael Jackson spectacle was a welcome diversion. Coverage and discussion of the program circulated in many media, including newspapers, magazines, websites, advertisements and television, showing how documentaries such as this one blur the boundaries between news and entertainment, in the process generating higher profits for all sectors of the media industry.

The preoccupation with Jackson however signals more than an insatiable public demand for celebrity gossip. Gómez-Barris and Gray argue that Jackson is a symbol of unresolved tensions around racial and sexual identity in the United States. The unfixable characteristics of Michael Jackson's body in terms of racial appearance and speculation about Jackson's sexuality confound those who would seek to impose a conservatively defined and inflexible "moral core" of values onto both individual bodies and broader society. The spectacle of Michael Jackson raises unsettled questions about gender, sexuality, and racial identity in a country that continues to struggle to define these in social and legal terms.

Aliens and Indians: Science Fiction, Prophetic Photography and Near-Future Visions, by Curtis Marez focuses on a different kind of media analysis and history, the portrayal of Native Americans in relation to narratives of encounter and conquest in Hollywood films. Marez examines blockbuster science fiction films with themes

of alien abduction such as *Contact* and *Men in Black*, explaining how these movies appropriate and re-stage histories of Indian slavery in North America. Specifically, he highlights how films construct the relationship between science fiction aliens and humans in ways that refer to the encounter between native peoples and settlers/whites.

Marez begins by describing the role of Native peoples in the emergent mass media in the United States, beginning with nineteenth-century photography and the newly developing cinematic medium. He points out that from the vantage point of indigenous critics, whose analysis of modernity begins with the conquest, "the use of the mass media to reinforce white property rights over Indians appears more as repetition than novelty – a new means for reproducing older structures of domination," arguing further that these images support "an imaginary intimacy with Indian cultures that … reproduces ideologies of white supremacy and Indian subjugation …" Offering the example of *Contact*, starring Jodie Foster, Marez shows how filmic representations of alien contact and captivity "enable non-Indians to occupy the position of the oppressed and appropriate the pathos of the victim for whiteness." Marez closes with a series of quotations from Leslie Marmon Silko's writings, a pointed reminder to those who have erased indigenous people from the map of the Americas, "The Americas are Indian country and the 'Indian problem' is not about to go away."

In *Orienting Orientalism, or How to Map Cyberspace*, Wendy Hui Kyong Chun locates the narrative of cyberspace in an exoticized vision of the "Orient." Drawing on Edward Said's mapping of Orientalism as Europe's other, Chun parallels the relationship between Orient and Europe (along with its implicit alienation and desire) with the relationship between virtual and non-virtual spaces. She argues that it is through high-tech orientalism that cyberspace offers direction and comfort in a world disoriented by rapid change, suggesting that the orientalizing impulse to contain the foreign renders cyberspace comprehensible, if only through desire. Analyzing cyberfiction such as *Neuromancer* and the anime film *Ghost in the Shell*, she asserts that "through the orientalizing – the exoticizing and eroticizing – of others those imagining, creating, and describing cyberspace have made electronic spaces comprehensible, visualizable and pleasurable." In noting the fusion of Japan and the West in *Neuromancer*, Chun suggests that entering cyberspace is "analogous to opening up the Orient" allowing one to "conquer a vaguely threatening oriental landscape."

Concluding with the example of web sites advertising "Oriental" mail-order brides, Chun describes how "Asian" has become a pornographic category that has been expanded to include all economically disadvantaged women for purposes of global capitalism, indicating how Internet technology serves to disperse orientalism around the globe.

Linked thematically with Çagla Hadimioglu's essay in Part II on the *chador*, Scott Ruff's essay *Spatial wRapping: A Speculation on Men's Hip-Hop Fashion* analyzes modes of dress, theorizing linkages between hip-hop fashion and African-diasporic resistance. Arguing that hip-hop reflects a non-Western aesthetic, Ruff

draws on examples of West African clothing to suggest parallels between African and African American modes of dress, while citing local socio-economic factors that have influenced the fashion. Discussing the significance of various style elements, Ruff also comments on the function of the logo in hip-hop fashion, which "reinforces the use of clothing as a way of laying claim to social space through signaling the wearer's status and affiliations." Focusing on hip-hop fashion as a cultural practice and a means of self-representation, Ruff locates its emergence "beyond Black culture within the context of a longer tradition of sartorial flamboyance born out of material and political stresses," making the case that hip-hop culture and its creative processes represent a "tradition of resistance to cultural erasure."

In *Self-Styling*, Sarah Nuttall analyzes the emergence of a Johannesburg youth culture called Y, or *loxion* (a synonym of township) culture that began to develop in the mid-1990s. She theorizes how this emergent culture moves across media to articulate a post-apartheid remaking of the black body, arguing that Y culture plays with ideas of racial hypervisibility, in reference to the alternating invisibility and explicit racial marking of the black body.

Nuttall suggests that Y/*loxion* culture translates the connotations of socio-economically stagnant township culture into hip urban experience. Key to the success of Y culture, she believes, is the resulting dual remixing "of the township and the city, and the township in the city." Regarding the growing black middle class and numbers of young black South Africans with disposable income who have created a new market for fashion and cultural products, Nuttall remarks "Y is a hybrid phenomenon that appeals to young people across borders of class, education and taste." Commenting on the privileging of brand over look in the intra-cultural success of local fashion labels and looking also at a series of popular advertisements around Johannesburg, Nuttall explains how the market is working both to reinforce and commodify new images of race in South Africa.

"Straight" Women, Queer Texts: Boy-Love Manga and the Rise of a Global Counterpublic by Andrea Wood takes as its topic the global readership of the genre of Japanese graphic novel (*manga*) referred to as *shonen-ai* and *yaoi* which comprise what is called "boy-love *manga*." Aimed at adolescent girls and women and presenting romantic narratives involving erotic relationships between males, boy-love *manga* has a large readership in Japan and a rapidly increasing audience in the United States.

Wood argues that the transnational audience for this genre of comics offers an opportunity to demonstrate that its readers comprise a global counterpublic that is "both subversive and fundamentally queer," not simply because of the homoerotic relationships the *manga* portray but because they reject a monolithic conception of gendered and sexual identities. Wood cites the possibility of playful sexual role-changing between dominant and submissive male characters within the stories as indication that boy-love comics are cognizant of the performative nature of such roles. Further, she suggests that "transnational readers' shared investment in queer subcultural texts establishes them as part of a resistant counterpublic, and one that

subverts the accustomed expectation of a 'romance reading' public of women as only being interested in heterosexist narratives …" Pointing out that publics come into being through texts and their circulation, Wood argues that boy-love *manga* readers are part of a global network of readers who actively participate in a web-based community of fandom, amateur *manga* production and consumption that transcend both language and geographical borders.

14

Michael Jackson, Television, and Post-Op Disasters

Macarena Gómez-Barris and Herman Gray

In February 2003, a date that coincided with the increased threat of war and invasion of Iraq, US television viewers were bombarded with a series of documentaries on Michael Jackson. The deluge began with the airing, during television's sweeps-week competition, of British journalist Martin Bashir's strange interview with Michael Jackson titled *Living with Michael Jackson*, based on the interviewer's eight-month series of interactions with the pop star and icon.[1] On February 6, 27 million viewers in the United States watched ABC to see Michael Jackson's bizarre revelations, including his claims that he was "Peter Pan in his heart," that he had had "only two nose operations in his life," and that he "enjoyed sleeping with young children, because it was very sweet." The interview piece marked yet another chapter in the Michael Jackson ("Wacko Jacko," as the British dubbed him) saga, by which time the US public had grown accustomed to his outlandish behavior. This included the supposed purchase of the Elephant Man's skeleton, a promotional stunt on the part of the Jackson camp; Michael Jackson's marriage to Lisa Marie, Elvis Presley's only daughter; and the now infamous dangling of his son Prince over a balcony in Berlin.

With this interview, Jackson thought ahead and simultaneously recorded the same footage as Bashir. This enabled him to subsequently contest the veracity of the documentary and to argue that the journalist edited out many key parts of the narrative to make him appear more bizarre and unusual than he really was. Jackson's counterattack explicitly debunking Bashir's moral incriminations aired on Fox a week or two later and was again viewed by millions. For two months, as the networks were embedded in Iraq and the "reality" depictions of the war and invasion became the centerpiece of network and cable television coverage, little was seen of the Jackson affair. In May, Jackson again became the star of prime time, with his *Michael Jackson's Private Home Movies*.

Keywords

Michael Jackson
war
Iraq
mass media
neoconservative
 backlash
moral panics
race
sexuality
gender
public discourse
the family

Although the timing of sweeps week was not predetermined to coincide with the lead time necessary for preparation for the war in Iraq, at least one journalist, Alessandra Stanley (2003) of the *New York Times*, suggested in February that "the more we see of Mr. Jackson right now, the healthier we are as a nation: at least it indicates that we're not at war" (p. E1). Stanley argued ironically that the preoccupation with Jackson was a form of US democracy, when anything could be the topic for television, even amid a national crisis. Watching Jackson was, in this light, a particular US form of democratic media coverage that gave equal weight to heavier political dramas and lighter spectacles of stardom. Extending Stanley's point that the Jackson documentaries put into relief the kind of democratic choices available in the United States, we analyze the continuing fascination with Michael Jackson. We look at the recent Jackson craze, especially in the context of contemporary US politics, the politics of fear and the neoconservative backlash, which has proliferated in terms of both visibility and social policy in the period since September 11, 2001. More specifically, we argue that because Jackson is a cultural icon and the subject of continuing media and public scrutiny, the sustained attention on him coincides with, expresses, and reconciles social and moral anxieties about race, sexuality, gender, and traditional values. What is the cultural work that the Michael Jackson media craze does in this cultural and political landscape? How does coverage of the Jackson celebrity scandal construct US public discourse? We address these questions by thinking about how race, sexuality, and family formations are normatively constructed in the US media, made explicit, spun, and ultimately quieted in the politics of representation mobilized by the attention to Michael Jackson. In particular, we focus on Martin Bashir's piece, because it sparked a chain reaction of media attention and ratings booms, and it is at the center of the Michael Jackson spectacle.

Media Politics, Media Reality

What is *Living with Michael Jackson?* Is it a docudrama, reality television, documentary, film, journalistic report, ethnography? What? The strategy of representation and the spectacle it produces are ambivalent and indeterminate with regard to genre, exploring the world of celebrity, visibility, intimacy, and accessibility through the trope of Michael Jackson. These qualities give the television special and its presentation a kind of immediacy and urgency that straddle news, public relations, and highly orchestrated media events, on the part of the network, on the part of Jackson's operation, and on the part of his record company. It is the sheer spectacle of it all that ensures that these elements (and the interests that motivate them) work with a degree of complementarity, for each provides a pay-off (ratings, publicity, buzz). For instance, consider the newscasts and the coverage that provided the basis for the news story: the Jackson story is featured as one of the lead stories for the eleven o'clock news; in terms of promotion, the lead-in not only works for the day of broadcast but is promoted over several days leading up to both the

television special and the newscast that followed. Thus, the teaser and promo, which intoned "be sure to see tonight's broadcast," is simply the culmination of a promotional strategy designed to get and hold viewers through a broadcast cycle that can be measured for ratings purposes in any number of ways. Such visibility in national and local broadcast markets can easily be translated into the promotional logic required for record sales, because the news teaser "Jackson sets the record straight" keeps him present for both news audiences and record buyers. In a brand economy in which value is added at the level of representation and brand identity, these overlapping sites of production and circulation within and across different media are self-referential and mutually constitutive of the brand identity.

The program aired during sweeps week, scheduled in highly profitable time slots, and traveled or circulated intertextually across different genres and mediums, including news, public affairs, magazines, Web pages, chat shows, promotions, and teasers. Again, these travels and the exposure they ensured were productive for all of the parties involved (Jackson, recording companies, the networks, media firms, and local stations), creating a crosspollination of narratives and profit throughout.

The pervasiveness of the genre of reality television in contemporary television pushes on the boundaries of television programming, documentary forms, public relations, and news. Moreover, the transparency of the form, as documentary, is supposed to carry its own authority, borrowing in this case from ethnography, news, documentary, interrogation, and objective journalism. *Living with Michael Jackson* straddles and unsettles news conventions. Is it entertainment or news, or both? This kind of genre is highly profitable and relatively cost effective to produce and at the same time infinitely malleable and flexible, open to breaking stories and yet stable enough for productions and scheduling well in advance of airdates. In short, in terms of production, the program and its spin-offs have been a good investment for the networks. At the same time, the documentary seems committed to representations of race, sexuality, family, and more recently citizenship that contribute to the terms of increasingly conservative public discourses.

Racial Tensions and Fixations

In their book on media and race in the United States, Robert Entman and Andrew Rojecki (2000) attend to how "subtle material pertinent to Black-White relations structures all media productions." It is important "for a new understanding of the political nature and effects of news, entertainment, and advertising, all the more so as accelerating economic competition blurs the lines between these genres" (p. 5). Following this logic, it would make sense that shifting trends in politics would show up on television and in other forms of representation.

The contemporary political terrain regarding race and racial politics is not particularly encouraging. In fact, it seems that we are at a moment when conflicts about race and the desire to either fix race through racial categories and hierarchies or eliminate it as a meaningful indicator of social health are at all-time highs.

For instance, in addition to racial profiling and new racial projects, on April 8, 2003, the Supreme Court heard a challenge to the University of Michigan's affirmative action program. The Bush administration eagerly signed onto this project, which has continued to find resonance in the popular American imagination. It makes sense that the Michael Jackson documentaries find traction in this kind of political and cultural environment.

At the heart of the current neoconservative agenda and backlash of 1960s civil rights gains is a preoccupation with race, even though the discussion is coded as a desire for a colorblind society. Historically, skin color and phenotypes have been at the core of the arguments for the biological distinctiveness of race, in which the basis for racial projects is rooted in the presumed normativity of Whiteness. Underlying this attempt at distinction has been an anxiety about racial identification, including blood origins and the "problem" of racial mixing. The preoccupation with race, though more subtly, is also central to the Michael Jackson spectacle. The figure moves from "cute, young, Black singer" (i.e., your racial identity is legible, and hence, "we know who you are") to "weird, unfixed racial identity" in his adult years (i.e., your racial identity is illegible and incomprehensible according to the codes of American racial meaning, hence, "we have no idea whom you've become"). This has been a constant source of news stories, perhaps since the release of the *Thriller* album in 1982.

The preoccupation with Michael Jackson's racial identity, and transformation, is heightened and reified in *Living with Michael Jackson*. For instance, after exploring themes about Jackson's childhood, performances, and children and marriage, Bashir turns to the question of plastic surgery, and Jackson's physical features, his skin and nose, become the topic of the interview. The incessant questions from Bashir – "How many nose operations have you had?" "You don't mean to say that you haven't bleached your skin?" – set up a confrontation with Jackson about his bodily transformations of the past twenty years. Bashir, as Foucault might have it, expects Jackson to confess the "truth" of his race as it is written on the body. The television spectacle and Jackson's disclosures on it do the cultural work of locating and then fixing race on the body – skin and nose – fixing the truth of race at precisely the moment when the biology of race as a source of racial knowledge has been attacked from the Left (i.e., through the notion of social construction) and the Right (i.e., through the notion of colorblindness). Almost imperceptibly, the discourse here refixes race, even while it makes claims to be neutral and objective journalism. Underneath the audible questions, the interviewer is asking about the truth of race, its veracity, its representability, its historicity: what is the real story with the skin and nose? Bashir's questions were followed by extensive coverage of the story on subsequent evenings, on *20/20* and local newscasts on which medical and scientific experts, including plastic surgeons and dermatologists, aimed to get at the truth of Jackson's body. On *Primetime*, a prestigious plastic surgeon vouched that his eyebrows were excessively high, that his lips had been thinned out and probably tattooed, and, as she put it, "the nose speaks for itself ... it is a crucified nose, a nose beyond the point of no return." Notable by their absence in this

mobilization of experts were social and cultural critics, as if the truth of the body can be read only by a science whose knowledge, methods, and disclosures are unmediated by culture and representation. This search for truth is also what television, news, documentary, and reality programming depend on for their authority.

Toward the end of the interview, there is a second moment when Michael Jackson is asked about race and racial mixing. Bashir offers his expert testimony about the maternal racial origins of Michael Jackson's offspring: "Was the baby's mother White? I saw the child, he is not Black." Jackson responds to the question about the racial identity of the surrogate mother by saying, "No, she is not White. … In fact, she's Black." The interviewer is in turn incredulous. He cannot seem to swallow the notion that regardless of the "truth" of Jackson's response, within the context of the US racial imaginary, a light-skinned baby could be fathered and mothered by Black parents. Neat definitions of race and racial mixing are complicated in this exchange, drawing attention to the social constructions of race and the categories by which race is made meaningful and legible.

This moment in the program is fraught with tension and confusion. As viewers, we are asked to believe that the journalist is able to discern the biological background of Jackson's child, and we simultaneously feel betrayed by what appears to be Jackson's lie. At the same time, the journalist's "phenotype" or racial identity of both interviewer and interviewee is on display and subject to interrogation. The juxtaposition between Jackson's post-op illegibility and the apparent readability of the journalist's racial attributes (all made apparent through camera close-ups) heighten the suspicion of Jackson's betrayal to Blackness and Black identity. The series of close-ups and alternative shots of Jackson and Bashir works to increase the interviewer's authority on Jackson's race. Jackson resolves the emotional moment by saying, "That's why we're called colored people … we come in all colors." Clearly, there is confusion between biological and social constructions of race in the piece, and Jackson's words do not ease this confusion. Jackson projects a soft form of multiculturalism throughout the discussion, but most poignantly when he suggests that he hopes to adopt a boy and a girl from every continent in the world. There is something to Jackson's inarticulate comment, a pointing out of the film's desire to pin down racial difference on skin color and physiognomy, which also serves as a metaphor for the media and audience's preoccupation with Jackson's made-over face. The nose and skin are the focus of controversy and "truth" about Jackson's claims: is it real? Is he a traitor to his race? Jackson responds to this subtext in the dialogue by explaining his skin disease and more perceptibly by saying, "No one points to White people when they use suntan lotion to darken their skin. The suntan lotion industry is a million-dollar industry."

During 2001, there was a similar preoccupation with Jackson's racial identity, when he held a press conference in Harlem, accusing his label, Sony Music, and its chairman Tommy Mottola of systematic racism against Black performers and songwriters. The surprising and seemingly incomprehensible specter of Michael Jackson not just discussing but advocating a critique of his corporate employer on the issue of race is notable. As one journalist stated,

> Michael Jackson: Black activist. This was something to consider, given the remarkable change to his own appearance in 20 years. Al Sharpton, unflappable to the end, flinched and tried to smooth things over after the attack on Sony. Two days later, Jackson appeared at Sharpton's National Action Network headquarters in Harlem for a seminar on black artists' rights … every bit the angered black man. This got to something unintentional and profound and correct in the most insane way: A black man is a black man, underneath it all, no matter where life takes him, even if that man is Michael Jackson. (Steuever 2002: C1)

The banality of the commentator's assessment that "a black man is a black man, underneath it all" is the essential piece of the quotation. Jackson, as an unconvincing Black man, troubles the operations of smooth conceptions of race, prompting analysts to continue with simple and easy answers about racial identity. The quotation reaffirms the idea that media discourse structures racial identity, especially in terms of the Black-White paradigm, even when the subject of the report does not easily fit into such static categories.

Representations of Sexuality and the Family

On the domestic front, the neoconservative agenda includes a return to family values, an exercise in nostalgia for the dreamed-up existence of a time when White nuclear families were whole and virtuous. As Deborah Chambers (2001) shows, in the aftermath of the 1960s counterculture, a right-wing majority "formed in reaction to the sexual and familial experiments of privileged middle-class white youth on campuses across America" (p. 142).[2] At the same time, in nations such as Britain, the United States, and Australia, notions of sexuality, relationships, and the socialization of children were formed through ossified conceptualizations of the nuclear family, often predicated on Whiteness. (See Deborah Chambers' chapter one "Representing The Family" for a skillful discussion of the history of the relationship, in social science and in wider society, between whiteness and the nuclear family, (2001: 1–32). As Foucault showed, power and knowledge operate through the cultural fields of representation, producing discourses in the public realm. As such, conservative claims on values serve as a bid to define and regulate the boundaries of the family within wider culture; these skirmishes and the effects they produce are often taken up and explored as principal themes in television. The exploration of these conflicts and themes is not static; thus, the moral scrutiny with regard to single mothers, gay and lesbian relationships, and "dysfunctional" families, especially prevalent during the Reagan era of the 1980s, has now been replaced by the exigencies of a market that recognizes difference and the diversity of families. The presence of shows such as *Will and Grace* and *The Osbournes*, on which contentions over morality have been eased for the purpose of entertaining, appear in the genre of sitcom or reality television and circulate between cable and commercial television networks. Even within this new formulation of diversity, the conception of

the family as heteronormative, middle class, and White remains. Thus, the market logic of niche audiences is targeted and catered to without displacing or reconfiguring existing dominant conceptions of the family.

In the mixed genre of *Living with Michael Jackson*, which was produced by a British company, the depiction of Michael Jackson as a single parent, both father and mother to his child, and his unidentified sexual identity is entangled with and predicated on moral fears and cultural anxieties about the state of the family and the nation, especially in the aftermath of 9/11. When the politics of fear, in terms of threats to national security, have been mobilized for international "conquests," on the domestic front, moral anxieties and their narrative resolution work to stabilize a world that seems chaotic and out of control.

Given the suspicions about his race and his parenting, Michael Jackson is not to be trusted and is the embodiment of the conservative claims of all that's wrong with America today. Here is an excerpt from the interview:

BASHIR: Do any of the children's mothers live with you now?

JACKSON: Live with me now? No.

BASHIR: And is that difficult?

JACKSON: No, why would that be difficult?

BASHIR: Are the children not looking for their mother?

JACKSON: How many babies live with their mothers, and they don't have fathers around them, and nobody says nothing to them while they have a good time?

BASHIR: So with you, it's the other way around?

JACKSON: They're having a great time. They have enough women in their lives. They're everywhere. Women are everywhere in my house. They're with them all day long.

In this exchange, Bashir has taken a moral line of questioning, turning into an advocate of the "idealized family" before moving on to questions of race: "What do you say to people who say, 'When Michael Jackson was a boy, he was a Black kid, and now as an adult, he looks like a White man'?" The move from questions about normalized family constructions to questions about racial identity invites suspicion, if not outright ridicule, about Jackson's mental health, fitness for parenthood, and competence as an adult. Bashir marks Jackson as a questionable parent and racial subject.

In another instance, when Jackson was carried away as his excited fans chanted to him from below his Berlin hotel room, he dangled his baby over the balcony. In response to the incident, Jackson said, "I got caught up in the excitement of the moment. I would never intentionally endanger the lives of my children." In a post-screening interview with Chris Wallace after the US airing of *Living with Michael Jackson*, Bashir commented on this incident and a number of other events that occurred in Berlin and at Jackson's ranch, Neverland. Bashir stated in a forceful and austere tone,

I never saw him hit his children, I never saw him scream at his children, but I think my concern about the way he behaves in relation to his children is the way they are being brought up. They are restricted. They are over protected. I was angry at the way his children were made to suffer, at the way they were dragged around the world. And I was disturbed about the life Michael Jackson now leads.

Bashir made these comments after the documentary was finished, although Jackson's camera captured quite a different opinion and tone.[3] He continued with his condemnation: "One of the most disturbing things is that disadvantaged children go to Neverland. It's a dangerous place for vulnerable children to be." Bashir then clarified, "What I'm saying is that children who are vulnerable should not be going into the house of a billionaire superstar where they sleep in his bed. That is entirely wrong." Although he is British, Bashir's observations perfectly expressed the moral authority and weight of family values discourse in the United States. He was concerned with the issue of power between "disadvantaged children"; he did not expand on his comments, instead turning to the tabloid-sounding phrase "where they sleep in his bed" and concluding, "That is entirely wrong."[4] By this point, in other words, the film has already tried and convicted Michael Jackson as perhaps "unfit." After all, because Jackson refuses to assume the responsibilities and betray the knowledge of an adult, how can he, a perpetual adolescent and sexually illegible person, care for three children?

Conclusion

One reporter concluded that the reaction of the recent series of the "ongoing Michael Jackson Freak Show" is not as much shock or outrage as pity: "We aren't as outraged by him as we are embarrassed for him" (Carlton 2003:F1). *Living with Michael Jackson* works to produce this uncomfortable reaction to the pop icon, within the conservative political terrain on issues of race, sexuality, and the family, hypostatizing Jackson as a "freak" in the public realm. If embarrassment is the primary viewer response to Michael Jackson, this in itself is revealing. There is a long history in the United States of making subjects through the assignment of racial categories, which informs this film. Because Jackson does not comply with normative categories of race and sexuality, the film attempts to assign and thereby regulate his indeterminacy.

Michael Jackson is a kind of representational figure of contemporary contestations over race, the family, and sexuality, within the discourse of the doctrine of national security. In the contemporary period, his representation as a "freak" works in similar ways to how "the welfare queen," usually depicted as Black, single, and poor, did during the 1980s. The welfare queen was usually depicted as a Black single mother who lived off the government and was the scorn of public and media discourse. One difference between Jackson and the welfare queen trope is Jackson's position as a pop icon and entertainment giant. More specifically, Jackson has

repeatedly refuted the claims put on him by the media, and we hear about, whereas single Black women (as the "objects" of moral scrutiny) had little access to strategies and markets of representation. Even while Jackson attempts his repair work, there are persistent questions about his race, sexuality, and domestic sphere, which show the force of the discourses put on him.

This article repositions Michael Jackson in an effort to resist the temptation of the force of categories and assumptions about race, sexuality, and the family already in place in US society.

Postscript

As a discursive matter, we locate Jackson's legal troubles within three overlapping fields of representation: journalism, legality, and celebrity status. When taken together, these discursive constructions produce Jackson as an alleged criminal, but they also serve as a stage for Jackson's performance as an iconic figure. As a topic of journalism, he is the topic of an ongoing news story; as a subject of a legal indictment and trial, he is an alleged criminal; in the discourse of celebrity and pop stardom, Jackson is an international pop icon and thus the subject of endless publicity and curiosity. Of course, each discursive field relies on specific conventions, operations, and assumptions, which in turn do certain work in the production and representation of Jackson as a subject. Where legal discourse criminalizes Jackson and in turn is concerned with ensuring a fair trial and equality before the law, in a trial of this magnitude, in serious journalism, there is at least the pretense to fairness and objective news coverage, whereas in the case of Jackson's notoriety and celebrity, the discursive commitments are to public relations, publicity, Jackson's iconic status.

We think it possible to detect and identify the different registers and discursive commitments at work (including Jackson's own performance of subjectivity) in the media coverage and representation of events surrounding Jackson's legal trouble. For instance, on the day of his arraignment, Jackson brought in busloads of fans to bear witness to the formal leveling of criminal charges. That day, Jackson also danced on top of his limousine, poked fun at the security guards' badges, appeared with family members, and videotaped the adoring crowds. In what some observers regarded as an equally bizarre move, Jackson also invited fans to Neverland for an after-arraignment party. These moments are not just interesting because they seem so out of character to the seriousness of the circumstance, but also because in each of them, Jackson treats these rather serious scenes or theaters of legality, journalism, and celebrity for his own ends, as if they were public stages for his own stardom. Although in clear legal trouble, Jackson seemed to be using these public stages as opportunities to gain sympathy from his fans by performing as a star and pop icon rather than as the subject of a criminal indictment and/or serious news story.

The interlocutors for each of these discursive moments are jurors, readers and audiences, and fans. Jackson resists the overdetermination of his identity as a

criminal by actively creating theaters out of these discursive fields for his own celebrity performance. These moves we think are very much in keeping with the discursive dynamics and operations on display in *Living with Michael Jackson*.

Notes

1 In this article, we focus on Martin Bashir's documentary as the basis of our analysis of Michael Jackson's representation and media construction. Since we first completed this article, Jackson has been formally charged with child sexual molestation and child endangerment. Although this is not the main concern of the article, in the postscript, we briefly consider the role of representation in the public discourse about Jackson's legal troubles. For a statement of the full indictment and all charges brought against Jackson by the Santa Barbara sheriff's department, please see http://www.thesmokinggun.com/archive/0430041jackol.html.

2 Judith Stacey and Stephanie Coontz have made similar points in their work about the US family and its representation.

3 Bashir was captured as saying to Michael Jackson,

Your relationship with your children is spectacular. And in fact, it almost makes me weep when I see you with them because your interaction with them is so natural, so loving, so caring, and everyone who comes into contact with you knows that.

4 Jackson had revealed this information to Bashir earlier in the film. In his conversation with twelve-year-old Gavin, Jackson asserted, "Whenever kids come [to Neverland], they want to stay with me." Kathryn Flett commented on this: "Of course they do–it's like getting to live at Disneyworld with Mickey as your host" (p. C4).

References

Carlton, Bob. 2003. Viewers Can Beat It if Jacko Shows Won't. *The Birmingham News*, February 23.

Chambers, Deborah. 2001. *Representing the Family*. London: Sage Publications Ltd.

Entman, Robert, and Andrew Rojecki. 2000. *The Black Image in the White Mind: Media and Race in America*. Chicago: University of Chicago Press.

Flett, Kathryn. 2003. Bashir'd, but not beaten. *The Observer*, February 9.

Stanley, Alessandra. 2003. With Michael Jackson, the Gloves Are Now Off. *The New York Times*, February 17.

Steuever, Hank. 2002. Moonwalker in Neverland. *The Washington Post*, December 11.

Further readings

Watching Race: Television and the Struggle for Blackness, Herman Gray (Minneapolis: University of Minnesota Press, 2004).

Queer Figurations in the Media: Critical Reflections on the Michael Jackson Sex Scandal, John Nguyet Erni, *Critical Studies in Media Communication*, 15(2), 1998.

Related Internet links

Living with Michael Jackson: http://www.youtube.com/watch?v=m7RDCDLLlm8

Michael Jackson's Private Home Movies: http://www.youtube.com/watch?v=-6lzRz1pD6M

15

Aliens and Indians
Science Fiction, Prophetic Photography and Near-Future Visions

Curtis Marez

Keywords

science fiction
history
modernity
Indian slavery
native peoples
Victor Masayevsa
Leslie Marmon Silko
aliens
photography
Hollywood film
conquest

With few exceptions, science fiction literature and film have largely avoided direct representations of indigenous characters, settings and scenes. Echoing the history of official US discourses and practices that projected Indian disappearance, science fiction imaginatively removes Indian[1] people from speculation about the future. Along with other imperialist discourses, it suggests that there is no future in being Indian. Although Indians are often consigned to the past, mass mediation has made Indian images available for thinking about the future. Hollywood blockbusters such as *Contact* (1997) and *Men in Black* (1997) are obsessed with Indians and, in particular, with the institutions of Indian enslavement that have been so central to US modernity. This is in part because, historically, a settler-colonial structure of feeling with presumed proprietary rights over Indian land, labor and culture has powerfully shaped the mass mediation of Indians, from early photos and films to contemporary digital images.

In order to historicize science fiction in relationship to Indian slavery, I begin by investigating 19th and early 20th-century mass media as formative precursors, especially since the history of media technology is an important source of speculation about the future and the role of Indians within it. This account indicates that for all of their historical newness, when it comes to native peoples modern media tend to reproduce imperialist fantasies that significantly qualify claims for their novelty. Granted, and as I will show, mass media images of Indians disseminate the ideologies and fantasies of Indian slavery in newly effective and compelling ways. Nonetheless, Indian media-makers and critics such as Ward Churchill, Jimmie Durham, Jacquelyn Kilpatrick, Victor Masayesva, Leslie Marmon Silko and Beverly Singer stress the long-term historical continuities among dominant images of Indians, at different times and places and in diverse forms, more or less from Columbus to the present. From this perspective, the much-described and analyzed modern and postmodern experiences of discontinuity, novelty and rapid change

Global Visual Cultures: An Anthology, First Edition. Edited by Zoya Kocur.
© 2011 Blackwell Publishing Ltd except for editorial material and organization © Zoya Kocur. Published 2011 by Blackwell Publishing Ltd.

appear less salient to thinking about the future than the larger continuities of imperialism and resistance. With a significantly wider historical view than is generally common in western media studies, Indian artists and critics articulate long historical continuities in direct opposition to the shortsighted and narrowly presentist preoccupations of dominant perspectives.

Building upon the insights of Indian media-makers and critics, I analyze the ways in which science fiction about alien abduction incorporates and transforms histories of Indian slavery. The contemporary fascination with supposed cases of abduction in the US is partly a response to the historical dispossession and enslavement of Indian peoples in that region. During the 18th and 19th centuries, Indian slavery was particularly common in and around what would become the contemporary capitals of alien speculation, area 51 in Nevada and Roswell, New Mexico. The history of Indian slavery thus continues to shape popular alien discourse.

This emphasis on long-term historical continuities does not mean that nothing ever changes in representations of Indian peoples. On the contrary, the emergence of mass media helped to bring the fantasies and ideologies of Indian slavery within the imaginative horizons of mass audiences for the first time. In the present case, I will argue that images of alien abduction rearticulate histories of Indian slavery in response to contemporary contexts that challenge white supremacy, most notably the ongoing migration of Indian peoples from Latin America to the US. I find support for this claim in the remarkable work of Laguna Pueblo artist and critic Leslie Marmon Silko, whose apocalyptic near-future novel *Almanac of the Dead* (1991) suggests the extent to which much contemporary speculation about the future appropriates the imperial past in order to make sense out of the contemporary crisis of the Indian South in the North. Here, and in her writing on prophecy and photography, Silko contradicts visions of an Indian-free future by projecting a time when indigenous peoples will take back the Americas.

Indian Slavery and the History of Old and New Media

As the historian Jack Forbes has shown, institutions of Indian slavery have a long and influential history in various regions of the US (Forbes, 1993). In what follows I am particularly interested in the southwest, where slavery served as part of the historical substrate for the subsequent development of film and other media in the region. During the 18th and 19th centuries, Spanish, Mexican and Anglo slavers captured thousands of Utes, Paiutes and Navajos for the slave markets of New Mexico and California. After the US–Mexican War of 1848, in which the US took the southwestern territories from Mexico, the legality of Indian slavery was officially ratified in New Mexico. In fact, a mid-century visitor to the capital of Santa Fe would have found that each and every US government official there owned Indian slaves. And even after the Civil War theoretically put an end to slavery, related forms of captivity or neo-slavery of different sorts continued unabated. In this context we should keep in mind not only direct labor exploitation but also the

forced reservationing of Comanches, Kiowas, Navajos, Apaches and others in the 1860s and 1870s; the transportation of so-called Indian war criminals, who were forced to work on prison plantations in Alabama and Florida during the the 1870s and 1880s; and finally the forced removal of Indian children from their families and their confinement to boarding schools during the late 19th and early 20th centuries. And like African slavery in the south, Indian slavery in the southwest was accompanied by forms of violent sexual exploitation that produced generations of *mestizo* or mixed offspring (Brooks, 2002; Marez, 2001, 2003).[2]

Although seemingly remote from conventional accounts, Indian slavery is in fact central to an emergent US mass media. And given longstanding associations linking media technology, futurism and science fiction, the early history of Indians in the mass media set the stage for subsequent representations. Emerging roughly in the second half of the 19th century, the development of the mass media of photography coincided with the violent suppression of Indian resistance, reaching its nadir with the massacre at Wounded Knee in 1891 and the subsequent consolidation of new systems of Indian control or neo-slavery such as prisons, the boarding schools and reservations. Moreover, one center of US media, Los Angeles, was built by Indian slaves. Between 1850 and 1869, Indians who were arrested for debt and vagrancy, or who were simply kidnapped from other areas, were placed routinely on the auction block in the city's downtown plaza (Forbes, 1964). Such histories influenced the subsequent treatment of Indian photographic subjects and film performers.

A good example is the case of Geronimo, the first Indian celebrity of an emergent mass media. The famous Apache and his band successfully resisted US efforts to confine them to reservations until 1886, when they were forced to surrender – a scene that reporter and photographer C.S. Fly documented in photos that were reproduced in *Harpers*.[3] The Apaches were even photographed at a stop in the train trip that transported them to prisons in Florida and Alabama, posed in front of the carriage where they traveled under heavy guard and 'subhuman' conditions (Turner, in Geronimo, 1996[1906]: 140). Once in southern prisons, one-quarter died from disease and overwork. In 1894 they were confined to the reservation at Fort Sill, Oklahoma, a good distance from their homes around Arizona (Turner, in Geronimo, 1996[1906]). While so imprisoned, Geronimo was displayed, under armed guard, at the Trans-Mississippi and International Exposition at Omaha (1898), the Pan-American Exposition in Buffalo (1901) and the St. Louis World's Fair (1904), along with other novel modern spectacles such as the panorama and the Ferris Wheel. In his own account of the St. Louis World's Fair, Geronimo emphasized his captive status, for whereas other visitors 'did nothing but parade up and down the streets', his movements were tightly circumscribed by his 'keeper' – a word he also used to describe the owner of a performing bear he saw on the midway (Geronimo, 1996[1906]: 155–62). The most influential signs of his ritual enslavement, however, are the numerous, widely disseminated photos of the warrior after his capture. Geronimo is perhaps the most photographically reproduced Indian in the world, most famously in a photo of 1886, taken shortly after his final surrender at Fort Sill: a portrait of him kneeling, rifle in hand and flanked

by prop cacti. For well over a century this image has been reproduced on newspapers, postcards, murals, T-shirts and internet sites. How do we account for the mass popularity of this image of armed Indian resistance? Part of the explanation has to do with the way in which media framing filters Indians for mass audiences, such that in this case the borders of the photo served as the jailkeeper's symbolic surrogate, making Geronimo safe to view because he was symbolically reservationed to the surface area of an image at the disposal of individual viewers.

As Beverly R. Singer (Santa Clara Pueblo) suggests, Geronimo's counterparts in the world of early film were the so-called 'Inceville Sioux', a group of Sioux recruited from the Pine Ridge Reservation by film producer Thomas Ince to work as extras in Hollywood films. In 1911, only 20 years after Wounded Knee, 25 Sioux began working in Hollywood under conditions that recalled earlier forms of Indian slavery. Singer notes that Ince contracted with an Indian agent at the reservation in order to transport the Sioux to California, where they 'boarded at a ranch with beds in animal stables' and were paid very little for their difficult and often dangerous work. Underlining the manner in which Hollywood was partly built on the labor of Indian performers, Singer concludes that:

> Ince's westerns were enormously successful and within a short time he was one of the first movie directors to build a mansion in Hollywood. The Inceville Sioux, on the other hand, disappeared from history. (Singer, 2001: 16–17)

In these and countless other examples, the exploitation of indigenous peoples is the precondition for the mass reproduction of their images.

In addition to highlighting the manner in which long histories of Indian enslavement and domination shaped the employment of Indian models and actors, these examples further illustrate two ideological implications of dominant mass media for the representation of Indian peoples. First, historically, media images have encouraged non-Indian viewers to take pleasure in the prospect of subjugating and even 'owning' Indian people. In the early decades of the 20th century, the immediately preceding periods of Indian slavery were revised and reshaped into important elements of an emergent mass culture. One index of US domination over Indian people is the ubiquity of photos and films depicting supposedly conquered or 'vanishing' people. Early films represented Indian captivities, battles and imprisonments as if to ritually rehearse and reaffirm frontier imperialism and the domination of indigenous peoples. These forms of ritual imperial spectatorship indirectly helped to reproduce conditions of domination by constituting Indian cultures as property and by encouraging a proprietary relationship to images of Indians. In his essay called 'Geronimo!' about photos of the Apache warrior, Jimmie Durham (Wolf Clan Cherokee) argues that: 'All photographs of American Indians are photographs of dead people, in that their *use* assumes ownership of the subject' (Durham, 1992a: 56). The photo-conversion of Indians into property is particularly pronounced in the case of mass-produced images of Indians on picture postcards and other popular formats, for such representations made 'Indianness'

discrete, portable and affordable to own. And although the average spectator could not own a film in the same way, nonetheless they could 'rent' images of Indians for the length of a film screening. The very ubiquity, and hence ephemerality, of Indian images attest to the privileged orientations that they encourage, constituting such representations as highly disposable property. Put another way, film and photography reified Indian culture, opening it up to real or imaginary appropriation as private property by non-Indians.

Second, late 19th- and early 20th-century media images support an imaginary intimacy with Indian cultures that, while recalling Indian slavery, reproduces ideologies of white supremacy and Indian subjugation in relatively novel ways. Leslie Marmon Silko argues that imperialist photographers, most famously 'voyeurs/vampires like Curtis, Voth and Vroman', reinforce white supremacy by freezing Indians in a primitive and pre-technological past (Silko, 1996: 184). In one photo, for example, Edward Curtis reinforced his belief that Indians were a 'vanishing' people who were inevitably excluded from technological modernity by airbrushing out the image of a clock owned by two of his models. From the earliest researchers and tourists, Pueblo peoples confronted photographers who presumed an intimacy with them that reinforced paternalist imperial authority:

> At first, white men and their cameras were not barred from the sacred kachina dances and kiva rites. But soon the Hopis and other Pueblo people learned from experiences that most white photographers attending sacred dances were cheap voyeurs who had no reverence for the spiritual. Worse, Pueblo leaders feared the photographs would be used to prosecute the caciques and other kiva members, because the United States government had outlawed the practice of the Pueblo religion in favor of Christianity exclusively. (Silko, 1996: 176)

With such instances of enforced intimacy, the use of photography to police Indian peoples is a concrete expression of white entitlement. Similarly, Luana Ross (Salish) (1998) and David Wallace Adams (1995) show how photography served as an important tool of discipline and control for Indians in prisons and boarding schools. As a result, the volume *Partial Recall* (1992), edited by Lucy Lippard and with a foreword by Silko, includes several early 20th-century photos of Indian people who were clearly angry or upset about having their picture taken, or attempting to avoid having their image captured. Silko concludes that because Pueblo people were acutely aware of 'the intimate nature of the photographic image' they ultimately 'refus[ed] to allow strangers with cameras the outrages to privacy that had been forced upon Pueblo people in the past' (1996: 177). The mass mediation of Indians supports a white settler colonial fantasy of virtual intimacy with Indian peoples and their cultures and this simulation of intimacy reproduces presumptions of a privileged access to, and knowledge of, Indian realities. Such early photos and films of Indian peoples constituted symbolic forms of ownership that imaginatively mimicked the historical forms of intimacy with Indians that characterized conditions of slavery.

American-Indian accounts of early media complement and complicate conventional accounts. Like Walter Benjamin and many of his contemporary interpreters, Durham and Silko analyze the historically novel experiential and ideological effects of modernity. If, in his work of 19th-century Paris, Benjamin analyzed modernity in terms of speed, change, the ephemeral and a new mass anonymity, then Indian critics suggest that the recollection via photos and films of older forms of white mastery over Indians served to restabilize white subjectivities that modernity had helped to destabilize in the first place. At the same time, however, Indian readings of mass media history significantly depart from accounts derived from European critical theory traditions by situating the newness and specificity of representational technology within the larger historical arch of European conquest in the Americas. For example, while work on early film has broadened the historical scope of cinema research, prompting studies of 19th-century precursors to cinematic experience such as the department store, the train and the World's Fair, by and large film scholars continue to employ a relatively narrow temporal and conceptual definition of modernity, beginning somewhere in the second half of the 19th century and concentrating on new, largely urban, technologies. By contrast, although indigenous critics such as Durham and Silko suggest the unique, historically specific workings of modern mass media, and although other Indian critics such as Ward Churchill (Keetoowah Band Cherokee), Jacquelyn Kilpatrick (Choctaw, Cherokee and Irish descent) and Singer analyze proto-cinematic precursors such as dime novels and wild west shows (Churchill, 1998; Kilpatrick, 1999; Singer, 2001), they nonetheless situate an emergent mass culture within a more expansive sense of modernity that begins with the European conquest. From this vantage point, the use of the mass media to reinforce white property rights over Indians appears more as repetition than novelty – a new means for reproducing older structures of domination. Thus, whereas academic critics of early mass media emphasize a discrete, local periodization for modernity and its relative rupture with the past, Indian critics often presuppose a much wider view of European modernity and its long, relatively continuous history of imperialism.

This perspective is well represented in Hopi director Victor Masayesva's *Imagining Indians* (1992). Partly constructed out of the continuities among various dominant ways of imagining Indians, Masayesva juxtaposes an interview with an extra from a classic John Ford western to one with a Sioux extra for the more recent *Dances with Wolves* (1990); both men recount similar dangers and difficulties. Recalling the animal-like treatment received by the Inceville Sioux, the contemporary Sioux extra noted that on the hot desert set of *Dances* the animal performers were given water while the Indian actors were left thirsty. Similarly, *Imagining Indians* connects Hollywood films from widely different periods, juxtaposing, for example, contemporary works and Griffith's *Battle of Elderbush Gulch* (1914). Masayesva further focuses on Indian opposition to cinematic practices and ideologies of white ownership and intimacy when he interviews an Indian electrician on the *Dances* set who objected to the film's use of Ghost Dance songs; or the interview with a Navajo man who criticizes Hollywood's commercialization of the

figure of the skin walker; or interviews with Indian activists who opposed the film-ing of ceremonial objects or sacred places. Indeed, Masayesva has said that as a Hopi director, one of the most important things that he tries to keep in mind is what *not* to film so as to best protect the sacred from what I have called a proprie-tary intimacy. All of these scenes and concerns are framed finally by the long-term European conquest of the Americas.

Indigenous histories of mass media have important implications for the study of science fiction and other speculative discourses about the future, including cyber-studies or new media studies. By analyzing old (and new) media from the long view of conquest, Indian critics undermine the progressive historical narratives implicit in much speculation about the future, particularly with regard to the inter-net. Early in its history, for example, the internet was imagined as absolutely new and unprecedented in ways that echoed the claims sometimes made at the advent of the old 'new' media of photography and film. The internet, commercials told us, would break with the injustices of the past because online there was no race, gender, age or disability. At the same time, however, mainstream commentators and academic critics described the internet in ways that recalled early imperial histories, as in phrases such as 'the new frontier' or, echoing *Star Trek*, 'the final frontier'. One of the most influential cultural studies of the internet, for example, was Howard Rheingold's *The Virtual Community: Homesteading on the Electric Frontier* (1993). For many Indian peoples throughout the Americas, these were not just metaphors since, as the work of Manuel Castells suggests, the internet supports a new information economy that functions like a frontier, dividing the world into those who have access to, and those who are excluded from, computer networks and the power to use them. Castells cautions that internet access alone cannot necessarily improve the life chances of those in impoverished areas or groups, since being 'hooked up' can serve as a means of subordinate integration into glo-bal capitalism. Nonetheless, he concludes that access to both the web and the knowledge and other capacities necessary to benefit from it remains 'a prerequi-site' for addressing inequality in a world 'whose dominant functions and social groups are increasingly organized around the internet'. This is because

> under the current social and institutional conditions prevailing in our world, the new techno-economic system seems to induce uneven development, simultaneously increasing wealth and poverty, productivity and social exclusion, with its effects being differently distributed in various areas of the world and in various social groups. And because the internet is at the heart of the new socio-technical pattern of organization, this global process of uneven development is perhaps the most dra-matic expression of the digital divide. (Castells, 2001: 264)

Given that, increasingly, economic success and survival depend upon being hooked up to computer networks, the fact that so many Indian homes, schools and com-munities remain unhooked serves to reproduce longstanding patterns of subordin-ation, albeit through new cyber-means.

Indian Slavery and Alien Abduction

The previous analysis provides a useful model for reading Indian slavery in contemporary science fiction as historical difference within continuity. From the long view of continual conquest, representations of alien abduction revisit histories of Indian slavery in response to contemporary contexts that call into question the property rights and entitlements of white North Americans. In other words, speculation about alien visitation and abduction draws upon the history of conquest to help make sense out of a contemporary moment in the ongoing struggle over the Americas. This is evident in an interview with Dr Seth Shostak of the Search for Extra Terrestrial Intelligence Institute (SETI) who, when asked if alien visitors would be 'friendly', responded that:

> The history of such expeditions on Earth has always been that it is better to be the visitor than the visitee. Consider the Indians of North and South America; their societies didn't survive contact with the Europeans, even in those few instances when the latter weren't deliberately malicious. (*Contact* homepage, 1997)

While one could challenge Dr Shostak's incorrect, ideological claim that Indian peoples have not survived European imperialism, for now I want to stress that in his striking analogy, aliens are to humans as Europeans are to Indians. This suggests that the larger cultural obsession with alien contact and abduction in the southwest speaks to the continuing influence of Indian slave histories in the form of an appropriative identification with Indians. Here and elsewhere, such speculations invite audiences to revise an imaginative proprietary intimacy with Indian peoples by incorporating 'Indianness' as a feature of subjectivity and as part of the way in which one interprets power relations. In other words, many futuristic conflicts projected on the screen ask: who are the Indians and who are the invaders, and what does that mean for the future?

Partly influenced by similar images in mass culture, white individuals who report being abducted by aliens often recall slave histories in their accounts, but with an important difference, such that 'alien abductees' imaginatively occupy the position of the slave. Abductees frequently claim to have a particular affinity for Indian peoples and spiritualities, even arguing that in prior lives they were Indians. Others believe that Indian shamans are intimate with, or have privileged access to, extraterrestrial worlds. Perhaps revising slave histories that forcibly generated *mestizo* children, female abductees report being inseminated by aliens and producing or seeing 'hybrid' human/alien babies. The fact that these hybrid babies are described as 'tan' or part 'black' further suggests that abduction narratives presuppose fantasies of miscegenation (Denzler, 1999). In a related but distinctly homoerotic instance, in the film *Independence Day* (1996), a former Vietnam vet who was abducted and probed by aliens is represented as the single parent of *mestizo* offspring – two seemingly Latino children (Rogin, 1998).

Representations of alien captivity that encourage whites to occupy imaginatively the position of the Indian respond to recent political-economic conditions

that call white entitlements into question. In a 1995 essay called 'America and the World: Today, Yesterday, Tomorrow', Immanuel Wallerstein (1995) projected the following 'vision of the coming fifty years' in the Americas:

> On the one side, an increasingly wealthy North, a relatively internally egalitarian North (for its citizens) and a United States no longer in the lead economically or even geopolitically but in the lead in terms of social equality; on the other side, an increasingly disadvantaged South, ready to use its military power, which shall increase to disrupt the world-system, often turning against all the values the West has cherished, with a large part of its population trying the route of individual migration to the North and creating thereby the South within the North. (p. 205)

He concludes that the unprecedented migration of the largely Indian South to the North could provoke several extreme US responses. In an attempt to 'isolate itself from the hopelessness of the Third World wars', it might protect its wealth by becoming 'fortress America'. Or, failing to control migration,

> it might turn toward creating a dyke between the entitlements of citizens and those of noncitizens. Within no time, the United States could find itself in a position where the bottom thirty percent, even fifty percent, of its wage-labor was noncitizens, with no suffrage and limited access to social welfare. (p. 205)

Given the militarization of the US–Mexican border and the so-called 'war on terror', it would seem that Wallerstein's prediction about 'fortress America' is coming to pass. Yet, rather than representing mutually exclusive alternatives, actually the building of fortress America has coincided with an increasing gap between 'the entitlements of citizens and those of noncitizens'. In the 1980s and 1990s, often US policies were aimed precisely at depriving non-citizens and their children of government services. The focus on entitlements suggests that such measures were more concerned with managing populations than excluding them from the US completely. I would argue that this combination of border policing and entitlement enforcement ultimately constitutes a set of makeshift efforts to manage the crisis of the Indian South in the North. Or, as Durham (1992b: 433) writes, 'the profound division in the Americas is not between North and South, but between Indians and settlers'.

Representations of alien abduction register this crisis by rehearsing scenarios where invaders from space endanger white humans, in effect threatening to treat them like Indians. Such scenes reference white fears of a dramatic power reversal as the Indian South takes over the North. As Wallerstein projected, and as recent immigration debates in the US confirm, one response to the crisis of the Indian South in the North is the effort to safeguard the white entitlements that new immigrants seemingly endanger and alien abduction is an ideological case in point. Representations of alien contact and captivity often enable non-Indians to occupy the position of the oppressed and appropriate the pathos of the victim for whiteness. Images of endangered white captives thus serve to rally concern and support

for crumbling white entitlements. Furthermore, the analogy 'Indian' is to European imperialist as (white) human is to alien ultimately converts whites into 'natives' and hence naturalizes the European displacement of indigenous peoples in the Americas. In these ways, images of alien abduction encourage identification with the slave in order to reinforce ideologies of mastery.

A good example is the film *Contact*, directed by Robert Zemeckis, starring Jodie Foster as Dr Ellie Arroway, a scientist who searches the universe for signs of intelligent alien life. Her quest leads her to the Very Large Array (VLA), a collection of massive white satellites in Socorro, New Mexico. In a particularly dramatic scene, Dr Arroway picks up the sound of an alien signal that contains coded plans for a spaceship. Foster's character is selected to take the first voyage on the new ship and she is transported through a black hole to another universe where she meets an alien who appears to her as her late father. Since her father died of a heart attack when she was only nine, the scene of their re-encounter is represented as the moving, romantic return of a lost love object. Back on earth, Dr Arroway's story is widely disbelieved but as the film ends she returns to New Mexico and the VLA, secure in her intimate knowledge of alien life and seemingly reassured by a visit from her alien-simulated father.

Contact figures the relationship between aliens and humans in ways that recall contact between Indians and whites. The film's title, for example, is suggestive in this regard, since internet searches for the keyword 'contact' yield an almost equal number of texts concerning aliens and Indians. Indeed, as the quote from Dr Shostak suggests, it would seem that familiar science fiction idioms of 'contact' or alien 'encounters' are partly drawn from discourses about European exploration and colonization of the Americas. According to the press kit for *Contact*, the film 'explor[es] the frontier of the human spirit' ('Contact Production Information', 1997: 16). The association between space exploration and the western frontier is reproduced in the setting, for Dr Arroway's first audio 'contact' is with aliens via a satellite in southern New Mexico, in the heart of historic Indian slavery territory. The film further underlines this 'Indian' setting by populating it with a small but significant number of Indian extras. Once the existence of the alien signal is announced, hundreds of people make a pilgrimage to the VLA, including a group of Indians who sing, dance and drum around the satellites. This scene is reminiscent of the events that marked the 40th anniversary of the rumored crash-landing of an alien space ship in nearby Roswell, where in 1997 a group of Laguna Pueblo performers danced at the crash site.

An even more striking suggestion of the implicit link between aliens and Indians is the sound of the alien transmission. The scene in which Arroway first hears it is perhaps the centerpiece of the film. The director, producer and star all comment on its importance to *Contact*'s success and the sound of the alien signal was even reproduced at the entrance to the film's official webpage, making it a sort of audio trademark (*Contact* DVD, 1997; *Contact* homepage, 1997). The alien signal is a rhythmic throbbing that sounds like an electrified tom-tom. From this perspective, the alien transmission is not simply from the science fiction future but is also the sound of an Indian past.

Nonetheless, the film uses Indian themes in order to refocus whiteness. In the film's poster, both the whiteness of Foster's shirt and the white satellite dishes that function as her giant prosthetic ears stand out in contrast to the dark colors of earth and sky. As if to emphasize further the character's whiteness, a light whose source remains invisible highlights her fair face and blonde hair against the night sky. Indeed, while alien contact potentially opens up various vectors of difference, the film contains race and sex alterities within a white, hetero-normative frame. Just as her character's romantic pairing with a white male love interest (Matthew McConaughey) symbolically 'straightens' Foster's notoriously queer celebrity image, it also serves to whiten her. Put another way, Dr Arroway's desire is like a 'straight arrow' aimed in a white, heterosexual direction. The character's intense love for her father further supports this claim. Whereas the often violent interracial sexual congress that characterized Indian slavery in the US raises questions about paternity that challenge assumptions of white racial purity, the film symbolically props up Anglo patriarchy by reuniting Dr Arroway with her dead white father. The film's alien contact narrative thus gestures towards the genre's historical origins in Indian slavery, yet it ultimately subordinates that history within a plot about contact between a white heroine and her father.

What is more, the film symbolically recolonizes Indianness by imaginatively annexing it to whiteness; experiences of displacement, dispossession and alienation that have historically clustered around Indian identities are appropriated instead for the film's central white character. In *Contact* it is the white heroine, not the Indian, who represents the pathos of the orphaned and the oppressed, her opinions and beliefs undervalued or disbelieved by those in power. Dr Arroway's status as a sort of 'white Indian' is evidenced not only by her name, with its suggestion of Indian artifacts, but also by the film's southwestern settings. In two scenes, Foster's character contemplates the universe while gazing into a dramatic, red-rock canyon with the omnipresent satellite dishes in the background. The setting is actually Canyon De Chelly in northern Arizona, hundreds of miles from the film's primary location in southern New Mexico, and so the filmmakers digitally spliced the two sites together. In the words of the film's producer, Steve Starkey, Canyon De Chelly is 'a very special Indian place', by which he means that it is the famous site of ancient Indian cliff dwellings (*Contact* DVD, 1997). Foster's second scene at this 'very special Indian place' is particularly noteworthy since it closes the film. Near the end of *Contact*, Dr Arroway gives a tour of the VLA to a group of local Indian schoolchildren. The film then cuts to its final scene of Foster before Canyon De Chelly. With her long blonde braided hair, she sits on a Navajo rug and stares into the distance as an indigenous-sounding flute plays on the soundtrack. By the end of the film, then, the Indian children of the earlier scene have been swallowed up by Dr Arroway's symbolically Indianized whiteness.

The whitening of alien contact narratives reworks histories of Indian slavery so as to imaginatively reassert white entitlements. Leslie Marmon Silko's *Almanac of the Dead* provides a revealing gloss on this phenomenon by suggesting how dominant speculation about the future, in both science fiction and the projections of

powerful institutions such as multinational corporations and the World Bank, continues to be influenced by longer histories of conquest.[4] Presupposing over 500 years of conflict and spanning the Americas, *Almanac* focuses on the apocalyptic, near-future struggle between European imperialism and indigenous resistance. On the one side there are legions of evildoers, including corrupt policemen, judges, government officials, capitalists, arms dealers and racist killers. On the other side there are Yupik shamans, Yaqui drug smugglers, prophetic Mayan rebels and a multiracial army of the homeless. While the novel is filled with examples of what Silko calls 'capitalist slave-masters', I want to briefly analyze a character called Serlo, an aristocratic Argentinean who has gone to extreme lengths to distance himself from the people of color that he exploits. He articulates a South-American version of the forms of white supremacy that Silko depicts in North America. Serlo is proud and protective of his '*sangre pura*' (or pure white blood), and in order to protect it against contamination he becomes a white-supremacist mad scientist who builds his own space colony. Serlo reasons:

> In the end, the earth would be uninhabitable. The Alternative Earth modules would be loaded with the last of the earth's uncontaminated soil, water and oxygen and would be launched by immense rockets into high orbits around the earth where sunlight would sustain plants to supply oxygen, as well as food. Alternative Earth modules would orbit together in colonies and the select few would continue as they always had, gliding in luxury and ease across polished decks of steel and glass islands where they looked down on earth as they had once gazed down at Rome or Mexico City from luxury penthouses, still sipping cocktails … [T]he Alternative Earth modules had been designed to be self-sufficient, closed systems, capable of remaining cut off from earth for years if necessary while the upheaval and violence threatened those of superior lineage. (Silko, 1991: 542–3)

To be sure, Serlo's near-future vision is more explicitly racist than is *Contact's*, which presupposes a more romantic, liberal appropriation and displacement of Indianness. And yet while various incarnations of *Star Trek* and similar science-fiction productions have conditioned us perhaps to think of outer space in multi-cultural terms, Silko reminds us that a liberal extraterrestrial imaginary can serve also as the final frontier of white supremacy.

Indian Slavery and the Future of the Border

As *Men in Black* begins, Agent K (Tommy Lee Jones), an officer from a secret government group that polices the alien presence on earth, confronts several 'illegal aliens' crossing the US–Mexican border in the deserts of Arizona. In order to ensure that there are no space aliens in the group, Agent K lines up the Indian and *mestizo* immigrants and begins to question them in Spanish. When one of them – a dark, long-haired man dressed in an elaborate woven poncho – appears unable to understand Spanish, Agent K concludes that he is in fact an extra-terrestrial alien hiding

inside the body of an illegal alien from Mexico. When informed that he has violated numerous treaties and therefore must be arrested, the space alien bolts for freedom but Agent K shoots him in the back before he can escape.

While perhaps we are used to thinking of 'illegal aliens' simply as 'Mexicans',[5] historically the ascription of Mexican nationality at the border has served often to partly obscure Indian identities. The 2000 US Census helped to make this process visible by counting Latin-American Indians as part of the larger Indian population for the first time. It recorded thousands of Indians from Mexico and Central America in California alone, helping to give that state the largest Indian population in the US. *Men in Black* represents the illegal alien as Indian in a number of ways, including language (like the alien, many Latin-American Indians do not speak Spanish as their first language or at all), the reference to treaties and the alien's previously described long hair and 'Indian' costume. Such associations are reinforced when the alien menacingly extends a halo of feather-like flippers around his head that resembles a Plains Indian war bonnet. Further, surrounded by saguaro cactus props, the scene's desert setting recalls the western. Numerous film westerns focus on the upper Sonoran desert region of Arizona, the historical territory of the Apaches. According to Churchill (1998: 170): 'In fact more films have been dedicated to supposedly depicting Apachería than the domain of any other native people, the "mighty Sioux" included.' Thus with his Texas accent and 'shoot now, ask questions later' attitude, Agent K recalls many a Hollywood Indian hunter, while the alien suggests a 'savage' Apache warrior. When Agent K shoots his detainee, it is filmed for laughs as the Indian/alien splatters the officer like a brightly colored cream pie. This comic routinization of police violence against 'illegal' Indian aliens recalls the possible future imagined by Wallerstein, where the crisis of the Indian South in the North provokes the formation of 'fortress America'. In this way the film revises Geronimo's captivity narrative in order to speculate on a contemporary situation where information technologies and networks of capital represent a new development within a larger pattern of conquest.

From an indigenous perspective, however, Europeans are the real aliens. As Silko (1996: 93) emphasizes, to this day the US continues to impose 'an alien form of government' on Indian people. In the complex body of her writings, Silko connects historically and regionally specific contexts to a larger historical arch, beginning with the European conquest and ending with its projected demise. In contrast to dominant assumptions of Indian extinction, Silko argues that it is Europeans who are destined to fade into the past as Indian peoples reclaim the future. In her brilliant essay 'The Indian with a Camera', Silko suggests that Indian appropriations of visual technologies represent the future anterior of white supremacy:

> Pueblo cultures seek to include rather than exclude. The Pueblo impulse is to accept and incorporate what works, because human survival in the southwestern climate is so arduous and risky ... Euro-Americans project their own fears and values in their perception of a conflict between Native American photographers and traditional native artists. Traditional artists reassure the Euro-Americans that,

while not extinct, Native Americans are not truly part of American society. The
Indian with a camera is frightening for a number of reasons. Euro-Americans des-
perately need to believe that the indigenous people and cultures that were
destroyed were somehow less than human; Indian photographers are proof to the
contrary.

The Indian with a camera is an omen of a time in the future that all Euro-
Americans unconsciously dread: the time when the indigenous people of the
Americas will retake their land. Euro-Americans distract themselves with whether a
real, or traditional, or authentic Indian would, should, or could work with a camera.
(Get those Indians back to their basket making!)

Euro-Americans desperately try to deny what has already begun, that inexorable
force which has already been set loose in the Americas. Hopi, Aztec, Maya, Inca –
these are the people who would not die, the people who do not change, because they
are always changing. The Indian with a camera announces the twilight of Eurocentric
America. (Silko, 1996: 177–8)

As Silko (1996) suggests, the vernacular use of 'alien' technology such as photo-
graphy – not to mention the films and digital videos of Indian directors – speaks to
the immanence of an alternative future represented by tribal prophecy. Hopi direc-
tor Victor Masayesva has given visual form to such prophecies in his *Imagining
Indians*, where he presents interviews with racist Euro-American collectors of
Indian artifacts and objects but then digitally 'disappears' the speakers' images
mid-sentence (Kilpatrick, 1999).

For Euro-Americans accustomed to denigrating native thought, the claim that
native peoples will one day take back the Americas may seem at worst to be 'super-
stition', and at best, wishful thinking. And yet Silko's reading of the Indian with a
camera as an 'omen' that signals 'the twilight of Eurocentric America' makes
visible a crisis in the world system and the place of the US in it. She concludes:

Deep down the issue is simple: the so-called Indian wars from the days of Sitting Bull
and Red Cloud have never really ended in the Americas. The Indian people of south-
ern Mexico, of Guatemala and those left in El Salvador, too, are still fighting for their
lives and for their land against the cavalry patrols sent out by the governments of
those lands. The Americas are Indian country and the 'Indian problem' is not about
to go away. (1996: 123)

In support of this claim she describes the 'dark young men, Indian and mestizo'
who cross the US–Mexican border daily:

I was reminded of the ancient story of Aztlan, told by the Aztecs, but known in other
Uto-Aztecan communities as well. Aztlan is the beautiful land to the north, the origin
of the Aztec people. I don't remember how or why the people left Aztlan to journey
farther south, but the old story says that one day, they will return. (1996: 123)

In contrast with dominant images, the Indian with a camera represents a coming
attraction for a future that belongs to native peoples.

Notes

1 Throughout this article I use the broad terms 'Indian(s)' and 'indigenous people(s)' so as to refer to groups throughout the Americas, while I reserve the term 'Native American(s)' for peoples living in the US.

2 Here and in the larger claims about how science fiction often represents long-term continuities of imperial history, I have been influenced by creative and critical works concerning 'Afro-futurism', a perspective partly defined by an interest in how histories of technology and science fiction suggest parallels with different moments in the history of European imperialism in Africa, such as the transatlantic slave trade and the late 19th-century colonial scramble for Africa. See John Akomfrah's (1995) documentary, *The Last Angel of History*, and the 'Afrofuturism' special issue of *Social Text*, especially Anna Everett's 'The Revolution Will Be Digitalized: Afrocentricity and the Digital Public Sphere' (2002: 137–8).

3 Geronimo actually surrendered twice in 1886. After the first surrender, he and his people escaped from their military captors. See Frederick Turner's introduction, 'Geronimo' (1996[1906]: 29–31).

4 For more extensive analysis of *Almanac*, see Marez (2004).

5 Indeed, Dean reads the characters in *Men in Black* simply as Mexicans and argues that the film presupposes a 'link between aliens and immigration anxieties' (Dean, 1998: 155).

References

Adams, D.W. (1995) *Education for Extinction: American Indians and the Boarding School Experience, 1875–1928*. Lawrence: University Press of Kansas.

'Afrofuturism' (2002) Special issue of *Social Text* 71 (Summer).

Akomfrah, J. (1995) *The Last Angel of History*. New York: Icarus Films.

Brooks, J.F. (2002) *Captives and Cousins: Slavery, Kinship and Community in the Southwest Borderlands*. Durham: University of North Carolina Press.

Castells, M. (2001) *The Internet Galaxy: Reflections on the Internet, Business and Society*. New York: Oxford University Press.

Churchill, W. (1998) 'Fantasies of the Master Race: The Cinematic Colonization of American Indians', in *Fantasies of the Master Race: Literature, Cinema and the Colonization of American Indians*, pp. 167–224. San Francisco, CA: City Lights Books.

Contact (1997) DVD, Warner Brothers.

'Contact' homepage (1997) Warner Brothers Studio, URL (consulted November 2001): http://contact-themovie.warnerbros.com.

'Contact Production Information' (1997) Press Kit for *Contact*, Warner Brothers.

Dean, J. (1998) *Aliens in America: Conspiracy Cultures from Outerspace to Cyberspace*. Ithaca, NY: Cornell University Press.

Denzler, B. (1999) *The Lure of the Edge: Scientific Passions, Religious Beliefs and the Pursuit of UFOs*. Berkeley: University of California Press.

Durham, J. (1992a) 'Geronimo!', in L. Lippard (ed.) *Partial Recall: Essays on Photographs of Native North Americans*, pp. 54–8. New York: The New Press.

Durham, J. (1992b) 'Notes on Art, Literature and American Indians in the Modern American Mind', in M. Annette Jaimes (ed.) *The State of Native America: Genocide, Colonization and Resistance*. Boston, MA: South End Press.

Forbes, J.D. (1964) *The Indian in America's Past*. Engelwood Cliffs, NJ: Prentice-Hall.

Forbes, J.D. (1993) *Africans and Native Americans: The Language of Race and the Evolution of Red-Black Peoples*. Chicago: University of Illinois Press.

Geronimo (1996[1906]) *Geronimo, His Own Story: The Autobiography of a Great Patriot Warrior*, as told to S.M. Barrett, intro. Frederick Turner. New York: Meridian.

Kilpatrick, J. (1999) *Celluloid Indians: Native Americans and Film*. Lincoln: University of Nebraska Press.

Lippard, L. (ed.) (1992) *Partial Recall: Essays on Photographs of Native North Americans*. New York: The New Press.

Mack, J.E. (1999) *Passport to the Cosmos: Human Transformation and Alien Encounters*. New York: Crown Publishers.

Marez, C. (2001) 'Signifying Spain, Becoming Comanche, Making Mexicans: Indian Captivity and the History of Chicana/o Popular Performance', *American Quarterly* 53(2): 267–307.

Marez, C. (2003) 'The Rough Ride Through Empire: "Los Comanches" and the New Mexican 1898', in J. Aranda and C. Torres-Saillant (eds) *Recovering the US Hispanic Literary Heritage*, Vol. 4, pp. 267–307. Houston, TX: Arte Publico Press.

Marez, C. (2004) 'Drug Wars are Indian Wars', in *Drug Wars: The Political Economy of Narcotics*, pp. 247–83. Minneapolis: University of Minnesota Press.

Rheingold, H. (1993) *The Virtual Community: Homesteading on the Electric Frontier*. New York: Harper.

Rogin, M. (1998) *Independence Day, or How I Learned to Stop Worrying and Love the Enola Gay*. London: British Film Institute.

Ross, L. (1998) *Inventing the Savage: The Social Construction of Native Criminality*. Austin: University of Texas Press.

Silko, L.M. (1991) *Almanac of the Dead*. New York: Simon and Schuster.

Silko, L.M. (1996) *Yellow Woman and a Beauty of the Spirit: Essays on Native American Life Today*. New York: Simon and Schuster.

Singer, B.R. (2001) *Wiping the War Paint off the Lens: Native American Film and Video*. Minneapolis: University of Minnesota Press.

Wallerstein, I. (1995) 'America and the World: Today, Yesterday and Tomorrow', in *After Liberalism*, pp. 176–206. New York: The New Press.

Further readings

Ghost in the Machine, Paul Chaat Smith, in *Strong Hearts: Native American Visions and Voices*, *Aperture*, 139, 1995.

Earthling Dreams in Black and White: Space, Representation and US Racial Politics in "The Space Traders," Julie Moody-Freeman, *African Identities*, 7(2), 2009.

Related Internet links

Victor Masayesva: http://www.nativenetworks.si.edu/eng/rose/masayesva_v.htm

Leslie Marmon Silko interview: http://www.altx.com/interviews/silko.html

16

Orienting Orientalism, or How to Map Cyberspace

Wendy Hui Kyong Chun

Why Cyberspace?

Keywords

cyberspace
science fiction
Neuromancer
orientalism
Ghost in the Shell
race
voyeurism
pornography
women
global capitalism
disembodied space

Cyberspace seems an odd name for a communications medium. Unlike *newspaper* (*news + paper*) or *film*, cyberspace does not refer to its content or to the physical materials that constitute it. Unlike *cinema*, derived from *cinematograph*, it does not refer to the apparatus that projects it.[1] Further, unlike *television* (*tele + vision*; vision from afar), cyberspace does not refer to the type of vision it supposedly enables and, unlike *radio*, derived from radiotelegraphy, it not does refer to the physical phenomenon (radiation) that enables transmission. Although all these terms – *newspaper, film, television*, and *radio* – erase sites of production, *cyberspace* erases all reference to its content, apparatus, process or form, offering instead a metaphorical mirage, for cyberspace is not spatial. Contrary to common parlance, you do not meet someone in cyberspace. Electronic interchanges, like telephone conversations but unlike face-to-face ones, do not take place within a confined space. Not only are there at least two "originary" places (the sender's and receiver's computers), data travels as independent packets between locations and can originate from a local cache rather than the "real" location. At most, one could trace the various packet routes and produce a map of the interchange after the fact.

Part of the peculiarity of cyberspace stems from its science-fiction origins. William Gibson coined the term *cyberspace* in 1982, 11 years before Mosaic, the first graphics-based web browser, became available.[2] Although other media forms such as photography and television had literary precursors – or, at least texts that were labeled precursors after the fact – no other form takes its name from a fictional text. Inspired by the early 1980s arcade scene in Vancouver, Gibson sat at his typewriter and outlined a 3-D chessboard/consensual visual hallucination called the Matrix or cyberspace, in which corporations existed as

Global Visual Cultures: An Anthology, First Edition. Edited by Zoya Kocur.
© 2011 Blackwell Publishing Ltd except for editorial material and organization © Zoya Kocur. Published 2011 by Blackwell Publishing Ltd.

bright neon shapes, and console cowboys stole and manipulated data. In *Neuromancer*, cyberspace is navigable and conceptualizable in a way the Internet, or "real" cyberspace, is not since cyberspace is a "graphic representation of data abstracted from the banks of every computer in the human system."[3] Other than a common fan base driven by a burning desire to see Gibson's vision as the end and origin of the Internet, Gibson's cyberspace has little in common with the Net.[4]

Cyberspace moved most definitively from a science fiction neologism to a legitimate name for communications technology with the US Judiciary's Communications Decency Act decisions' "Findings of Facts" section. In it, the district judges delineated the differences between the various "areas" within cyberspace (cyberspace was chosen over the Internet presumably because it can include configurations, such as local area networks and bulletin boards, not linked to the Net). Even so, cyberspace still remains part science fiction, not only because the high-tech visions of Gibson's Matrix, and later Neal Stephenson's metaverse, have not yet been realized (and they never will), but also because cyberspace mixes science and fiction. Cyberspace is a hallucinatory space that is always in the process of becoming, but "where the future is destined to dwell."[5] Condemning cyberspace for misrepresenting "reality" or "space" thus misses the point – namely, that cyberspace as fact or fiction alters space, cybernetics, and "reality." Most often, cyberspace's alterity has been imagined and examined in terms of disembodiment, with critics and enthusiasts arguing over the fallacies and possibilities of cyberspace as a frontier of the mind. This debate, however, obfuscates the ways that narratives of cyberspace, since their literary inception, have depended on Orientalism for their own disorienting orientation.

Through the orientalizing – the exoticizing and eroticizing – of others, those imagining, creating, and describing cyberspace have made electronic spaces comprehensible, visualizable and pleasurable. In this essay, I expose the ways that cyberspace as mind-to-mind communication relies on another disembodiment – namely, the other as disembodied representation through readings of Gibson's *Neuromancer* and Mamoru Oshii's *Ghost in the Shell*. Conceived before the popularization of the web, these literary and animated texts underscore the rhetorical importance of cyberspace: it is not simply that, until the 1990s, cyberspace's existence has been mainly rhetorical, but also that cyberspace functioned rhetorically – without cyberspace, the Internet would never have become as sexy, utopian and dystopian as it was once represented as being. It also would never have been viewed as so empowering: if online communications threaten to submerge users in representation – if they threaten to turn users into media spectacles – the mind as disembodied construct allows people to turn a blind eye to their own vulnerability, and high-tech orientalism allows them to enjoy themselves while doing so. Significantly, both *Neuromancer* and *Ghost in the Shell* also offer subtle critiques of disembodiment precisely through their portrayal of cyberspace as exotic, erotic, and reductive, critiques that were obfuscated routinely in Internet propaganda.

Spacing Out

Fundamentally unlocatable, cyberspace functions as a space in which to space out about the difference between space and place.[6] Although space and place are often used interchangeably (one definition for place, according to the *Oxford English Dictionary*, is "a two- or three-dimensional space"), place designates a finite location, whereas space marks a gap. Place derives from the Latin *platea* (broad way), space derives from the *spatium* (interval or period). Place has been tied to notions of civilization and of connected locations, while space has been untied and evokes emptiness. Dave Healy, quoting from Yi-Fu Tuan's analysis of the New World, argues that "place is security, space is freedom: we are attached to one and long for the other."[7] In contrast, Michel De Certeau, while agreeing that place designates stability or proper relations whereas space has "none of the univocity or stability of a 'proper,'" argues that space is a practiced place. Place is on the level of *langue*; space is on the level of *parole*. We see places on maps; we articulate space through our everyday lives. Space destabilizes place by catching it "in the ambiguity of an actualization, transformed into a term dependent upon many different conventions, situated as the act of a present."[8] According to Certeau, space is not what one longs for while one is encumbered in place. Rather, it is how we negotiate place – it is how we *do* or *practice* place.

Cyberspace, however, practices space: it rehearses space, it rehearses an actualization. Consider, for instance, the ways in which one "surfs," or "browses" the web. By typing in an address, or by clicking from location to location, one teleports rather than travels from one virtual location to another, and one gets lost through typos rather than wrong turns. Traveling through cyberspace takes out the scenery between fixed locations, or, to be more precise, cyberspace reminds us of the temporal aspect of space by converting the "spatial" interval into an often-unbearable space of time in which one anticipates the next page and tries to decipher the page that emerges bit by bit on one's screen.[9] This teleporting does not mean that we no longer catch place "in the ambiguity of an actualization, transformed into a term dependent upon many different conventions, situated as the act of a present."[10] Indeed, through our surfing, through our never-ending caching of web pages, we catch and transform virtual spaces.

Cyberspace both remaps the world and makes it ripe for exploration once more. Cyberspace proffers direction and orientation in a world disoriented by technological and political change, disoriented by increasing surveillance and mediation, through high-tech orientalism. Edward Said, in *Orientalism*, argues that the Orient – as defined by and for the West – is "the place of Europe's greatest and richest and oldest colonies, the source of its civilizations and languages, its cultural contestant, and one of its deepest and most recurring images of the Other."[11] Pluralizing and merging Michel Foucault's notion of a heterotopia and Said's analysis of the oriental as a "surrogate and even underground self,"[12] Lisa Lowe defines oriental spaces as heterotropical, where heterotropical spaces are multiple and interpenetrable

rather than singularly defined against normal or utopian spaces.[13] According to Foucault, in "Of Other Spaces," heterotopias are "like counter-sites, a kind of effectively enacted utopia in which the real sites, all the other real sites that can be found within the culture, are simultaneously represented, contested, and inverted. Places of this kind are outside of all places, even though it may be possible to indicate their location in reality."[14] Foucault categorizes heterotopias into crisis heterotopias (the boarding school and honeymoon), heterotopias of deviance (rest homes and prisons), heterotopias of illusion (nineteenth-century brothels) and, most important for our purposes, heterotopias of compensation (colonies).

In order to set up this compensatory space, Foucault must gloss over the fact that this placing of pure order simultaneously obfuscates, if not annihilates, other spaces/places already in existence – namely, Native America. And these other spaces do not completely dissolve, but rather continually threaten "pure order." Puritan societies had to defend themselves against indigenous populations that threatened their colony, preventing the effective realization of their utopia. Regardless, and perhaps because of the difficulty of maintaining heterotopias, Foucault settles on the figure of the boat as "the heterotopia *par excellence*." For Foucault, "in civilizations without boats, dreams dry up, espionage takes the place of adventure, and the police take the place of pirates."[15]

This displacement of the limitations and promises of occidental societies onto heterogeneous oriental spaces comes with no guarantees, since orientalist narratives cannot entirely displace the actual territories and ships are routinely wrecked. As well, since the Orient serves as one of Europe's first points of identification, it destabilizes the notion of Europe it also grounds. Thus, it is not simply that the Europe stands as subject and the Orient as object, but also that the Orient *haunts* Europe and fissures European identity.[16] This relationship of identification, desire, and alienation serves as a model for the relationship between virtual and nonvirtual spaces – and, just as the multiplicity of "Oriental spaces" works against totalizing myths, so too does the multiplicity of electronic spaces threaten to disorient the user they seek to orient.

Literary Inceptions

Cyberspace, like the Orient, is a literary invention.

Said, arguing for the textual construction of the Orient, writes that "even the rapport between an Orientalist and the Orient was textual, so much so that it is reported of some of the early-nineteenth-century German Orientalists that their first view of an eight-armed Indian statue cured them completely of their Orientalist taste."[17] According to Said, this textual delusion stemmed from the Orientalists' preference for "the schematic authority of a text to the disorientations of direct encounters with the human." In so doing, they assumed "that people, places and experiences can always be described by a book, so much so that the book (or text) acquires a greater authority, and use, even than the actuality it

describes."[18] The status of the Orient as fictional yet indexical to an "other" space parallels the status of cyberspace as science fiction made digital, as well as the status of science fiction-based cyberspace.

As noted earlier, William Gibson coined the term *cyberspace* in 1982, but he offered the most compelling description of it in *Neuromancer*, a cyberpunk novel published in 1984. In *Neuromancer*, Case – the console cowboy protagonist – "live[s] for the bodiless exultation of cyberspace," and his "elite stance involve[s] a certain relaxed contempt for the flesh. The body was meat."[19] Case's stance has been mimicked by cyberpunk fiction writers and by the so-called cyberelite who published in and were publicized by magazines such as *Wired* and *Mondo 2000* in the 1990s.

Orientation and disorientation mark cyberpunk worlds. As opposed to science fiction and fantasy novels set in other worlds or universes, cyberpunk plays with the world as we know it, offering different contexts for recognizable places (Boston in Gibson's fiction becomes the endpoint of BAMA – the Boston Atlanta Metropolitan Axis). As Pam Rosenthal notes, "the future in the cyberpunk world, no matter how astonishing its technological detailing, is always shockingly recognizable – it is our world, gotten worse, gotten more uncomfortable, inhospitable, dangerous, and thrilling."[20] Gibson writes that cyberpunk is "all about the present. It's not really about an imagined future. It's a way of trying to come to terms with the awe and terror inspired in me by the world in which we live."[21] As with BAMA, Gibson effects this shocking recognizability through seemingly gratuitous descriptions, and descriptions embedded in specialty language:

> The sky above the port was the color of television, tuned to a dead channel.
>
> "It's not like I'm using," Case heard someone say, as he shouldered his way through the crowd around the door of the Chat. "It's like my body's developed this massive drug deficiency." It was a Sprawl voice and a Sprawl joke. The Chatsubo was a bar for professional expatriates; you could drink there for a week and never hear two words in Japanese.
>
> Ratz was tending bar, his prosthetic arm jerking monotonously as he filled a tray of glasses with draft Kirin. He saw Case and smiled, his teeth a webwork of East European steel and brown decay. Case found a place at the bar, between the unlikely tan of one of Lonny Zone's whores and the crisp naval uniform of a tall African whose cheekbones were ridged with precise rows of tribal scars. "Wage was in here early, with two joeboys," Ratz said, shoving a draft across the bar with his good hand. "Maybe some business with you, Case?"[22]

As these three opening paragraphs reveal, the "gratuitous" details Gibson uses usually entail the surprising juxtaposition of the natural and technological, the "primitive" and the high tech, written matter-of-factly. He also uses foreign (mainly Japanese) brand names (such as Kirin) in the place of more familiar American ones (such as Budweiser), or some very odd mix (such as the Mitsubishi Bank of America, Hosaka, Ono-Sendai, Tessier-Ashpool, Maas-Neotek). Corporate names as modifiers have become essential: it is never simply a coffee maker, but a "Braun coffee-maker" and later a "Braun robot device." He also insists on unfamiliar proper

names, such as Lonny Zone and the Sprawl. Gibson's "explanations" or descriptions are perhaps appropriate in a series all about "information": they are noninformative, but written in such a way that one would think they would be informative.

Although Gibson argues that nation-states in his new world have mainly disappeared or become reconfigured, nationality or continentality (when it comes to non-American white characters) has become all that stronger: Ratz's teeth are a webwork of East European steel and brown decay, and Case's fellow bar inhabitant is a tall African whose cheekbones were ridged with precise rows of tribal scars. In general, racial otherness is confined to stereotypes that serve as local details (which thus proves the "global scope" of this future) and that offer no movement. And these "dark" others in *Neuromancer* are marked as technologically outside, as somehow involved in an alternative past of tribal scars, and the shock value of the prose lies in this juxtaposition of their past with our future. Istanbul – the classically "oriental" space – is described as a sluggish city that "never changes," seeped in history and sexism.[23] Certain things that never change anchor the reader and serve as her orienting points.

The future world, "gotten worse, gotten more uncomfortable, inhospitable, dangerous, and thrilling," however, invariably translates into the world gotten more Japanese.[24] Gibson magnifies the 1980s burgeoning economic power of Japan so that, as Yoshimoto Mitsuhiro notes, "the future world does not seem to be able to function without things Japanese."[25] Whereas golden-age science fiction incorporated Greek togas into their sunny futures, *Neuromancer* incorporates parts of the Japanese past, such as ninjas, in their dystopian ones. As Lisa Nakamura argues, "anachronistic signs of Japaneseness are made, in the conventions of cyberpunk, to signify the future rather than the past."[26] These anachronistic signs of Japaneseness are not chosen randomly. Rather, samurais, ninjas, and shonen are drawn from Japan's Edo period and they confine the Japanese past to the period of first contact between the West and Japan. Cyberpunk thus mixes images of the mysterious yet-to-be-opened Japan (which eventually did submit to the West) with the conquering corporate Japan of the future. In addition, the "near" Japanese past (i.e., the present) is represented by technological badlands produced through contact with the West. Describing Night City, Case says, "the Yakuza might be preserving the place as a kind of historical park, a reminder of humble origins."[27] But Night City, as the opening page of *Neuromancer* makes clear, is filled with gaijin paradises, places where "you could drink … for a week and never hear two words in Japanese."[28] Night City, the "deliberately unsupervised playground for technology itself," is not entirely Japanese.[29] Rather, the past that Night City marks is the moment of fusion between East and West, the moment of the Japanese adopting and surpassing Western technology.

This denial of the coeval, as Johannes Fabian has noted, is how anthropology constitutes its object – the native other, who is consistently treated as though his existence does not take place in the same time. This "time machine" effect of anthropology is magnified within cyberpunk in its literal construction of a time

machine, in which the reader is supposedly transported into the "near" future – a future whose recognition and misrecognition is created by juxtaposing archaic (non-Western) pasts with present (Western) pasts. Thus, the much-lauded ability of cyberpunk to enable us to finally "experience" our present depends on the construction of those others as past and future (which is just as much a "failure" as – Fredric Jameson argues – their inability to imagine the future).[30]

Within the grim Japanified landscape of *Neuromancer*, the software industry marks the last vestige of American superiority. In cyberspace, American ingenuity wins over Japanese corporate assimilation. In "reality," those who succeed efface their own individuality and become part of the corporate machinery. Cyberspace seems to stand as a Western frontier against this world of accommodation and assimilation. The meatless console cowboy is an individual talent: he paradoxically escapes this machine-organism fusion by escaping his body – by becoming a disembodied mind – when he merges with technology.

In effect, cyberspace allows the hacker to assume the privilege of the imperial subject – "to see without being seen."[31] This recovery of wholeness and power also recovers American ideals. As Frederick Buell argues, "cyberspace becomes the new U.S. Frontier, accessible to the privileged insider who happens to be a reconfigured version of the American pulp hero."[32]

Perhaps, but not because cyberspace is outside the Japanified world; cyberspace in *Neuromancer* is not a US frontier and good old American cowboys cannot survive without things Japanese. First, cowboys cannot access cyberspace without Japanese equipment (Case needs his Ono-Sendai in order to jack in). Second, cyberspace is still marked by Asian trademarks and corporations. However, cyberspace – unlike the physical landscape – can be conquered and made to submit: entering cyberspace is analogous to opening up the Orient. *Neuromancer* counters American anxieties about "exposure to, and penetration by, Japanese culture" with a medium that enables American penetration.[33]

Entering cyberspace thus allows one to conquer a vaguely threatening oriental landscape. As Stephen Beard in his reading of Ridley Scott's *Blade Runner* argues, "through the projection of exotic (and erotic) fantasies onto this high-tech delirium, anxieties about the 'impotence' of western culture can be, momentarily, screened out. High-tech Orientalism makes possible 'cultural amnesia, ecstatic alienation, serial self-erasure.'"[34] In *Neuromancer*, high-tech orientalism allows Case to erase his body in orgasmic ecstasy. Or, to be more precise, high-tech orientalism allows one to *enjoy* anxieties about Western impotence. It allows one, as Gibson puts it, "to try to *come* to terms with the awe and terror inspired in me by the world in which we live."[35] That is, ecstasy does not obliterate impotence, but rather allows one to make do with it. This portrayal may also highlight the limitations of such sexual fantasies and conquest, for this orgasmic ecstasy constructs cyberspace – the supposed consensual hallucination – as a solipsistic space.

In cyberspace, Case runs into no other people – or perhaps more precisely no other disembodied minds: Case's mind is the only human one out there. On the Matrix, Case communicates with artificial intelligences, computer viruses, and

computer constructs. This empty high-tech orientalist space parallels the textual construction of the Orient in early scholarly studies that focused on ancient civilizations. These studies, as Said has argued, treated the Orient as empty; the "real" Egyptians orientalist scholars encountered – if these scholars traveled to Egypt at all – were treated as background, as relics or as proof of the degeneration of the Oriental race.[36] In cyberspace, then, as in all orientalist spaces, there are disembodied minds on the one hand and disembodied representations on the other. High-tech orientalism, like its nontech version, "defines the Orient as that which can never be a subject," since nonsubjecthood is the condition of possibility of the Occidental subject.[37]

Importantly, Gibson portrays Case as a *bad* navigator in order to show the inadequacies of Ninsei as information. In other words, Case's rehearsing of orientalism as a means of navigation and understanding does not always work. This rehearsal is intimately linked to the desire to contain the foreign, to render comprehensible a "new space" if only through desire. As Said argues, "In essence such a category is not so much a way of receiving new information as it is a method of controlling what seems to be a threat to some established view of things. If the mind must suddenly deal with what it takes to be a radically new form of life – as Islam appeared to Europe in the early Middle Ages – the response on the whole is conservative and defensive. Islam is judged to be a fraudulent new version of some previous experience, in this case Christianity. The threat is muted, familiar values impose themselves, and in the end the mind reduces the pressure upon it by accommodating things to itself as either 'original' or 'repetitious.' "[38] Orientalism, like cyberspace, emerges from contact with something new and reduces the new to previous experiences. In terms of the genesis of cyberspace, the *newness* of cyberspace has been rendered old through orientalism.

Thus, cyberpunk's twin obsessions with cyberspace and the Orient stem from the ways that the Orient serves as a privileged example of the virtual. The Orient serves to orient the reader / viewer, enabling her to envision the world as data. This twinning sustains – barely – the dream of self-erasure and pure subjectivity. Since its very inception, then, cyberspace – as orientalist heterotopia – has perpetuated and relied on differences that it claims to erase.[39]

Looking Back

Despite its focus on American underdogs-come-heroes, cyberpunk has global appeal. Most significantly, cyberpunk has influenced an already existing genre of anime, or Japanese animation, by the name of *mecha* (a Japanese transliteration and transformation of the word mechanical); through mecha, anime has gained cult status in nations such as the United States and France.[40] In Japanese cyberpunk, however, the American cowboy disappears and "bad" technology stems from American, rather than Japanese, companies. The future, though, is still Japan's, and in this section I turn to Mamoru Oshii's animated rendering of

Masamune Shirow's *Ghost in the Shell* in order to see what happens to cyberpunk when it travels *home*, so to speak.

Arguably the most "westernized" anime, *Ghost in the Shell* was released simultaneously in Europe, America and Japan and marks anime's American debut in major movie theaters. It reached No. 1 on *Billboard* magazine's video sales chart and earned the rather limited title of New York's highest-grossing film shown exclusively on a single screen in one theater.[41] *Ghost in the Shell* was a hallmark in anime production for both aesthetic and corporate reasons: it was "the most expensive and technically advanced Japanese animated feature yet made," although it still only cost $10 million – a tenth of that for *"The Hunchback of Notre Dame."*[42] It was also cofinanced and produced by Japan's Bandai and Kodansha and Chicago-based Manga Entertainment.

The plot of *Ghost in the Shell* parallels *Neuromancer* – except that, rather than an artificial intelligence seeking to be free by merging with its better half, an artificial life form (the Puppet Master) seeks to free itself by merging with the cyborg Major Motoko Kusanagi. Set in Hong Kong in 2029, *Ghost in the Shell* follows the adventures of the Major, who leads Section 9 – a secret intelligence agency filled with cyborgs of "a strange corporate conglomeration called Japan" – as she pursues the Puppet Master. A titanium "Megatech Body" has replaced the Major's entire body, or "shell." The human essence is encapsulated in one's "ghost," which holds one's memories. The "Puppet Master" is so dangerous a criminal because he ghost-hacks people, inserting false memories, controlling their actions, and reducing them to puppets. After various plot turns and chase scenes, they merge: the Puppet Master dies, and the Major receives his powers. The anime ends with her studying the expanse of the Net before her. Although she asks herself, "where shall I go now? The net is vast and limitless," the "camera" pans through the landscape of Hong Kong (see Figures 16.1 and 16.2).

Like *Neuromancer, Ghost in the Shell* is set in a foreign locale – this time Hong Kong instead of Japan. As well, both films were produced at a time of economic anxiety and impotence. Toshiya Ueno argues that "the choice of Hong Kong represents an unconscious criticism of Japan's role as sub-empire: by choosing Hong Kong as the setting of this film, and trying to visualize the information net and capitalism, the director of this film, Oshii Mamoru, unconsciously tried to criticize the sub-imperialism of Japan (and other Asian nations)."[43] Perhaps, but the choice of Hong Kong also orientalizes. Faced with the task of representing basically invisible networks of information, director Mamoru Oshii chose a location that could easily be conflated with information. He chose Hong Kong because, he explains, "In 'Ghost in the Shell,' I wanted to create a present flooded with information, and it [Japan's multilayered world] wouldn't have lent itself to that. For this reason, I thought of using exoticism as an approach to a city of the future. In other words, I believe that a basic feeling people get perhaps when imagining a city of the near future is that while there is an element of the unknown, standing there they'll get used to this feeling of being an alien. Therefore, when I went to look for locations in Hong Kong, I felt that this was it. A city without past or future. Just a flood of

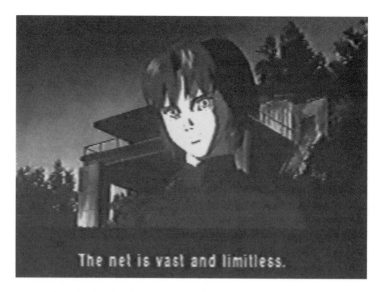

Figure 16.1 The "new Major" leaving Batou's safe house

Figure 16.2 The last frame; Hong Kong as a vast net.

information."[44] But, as the film's last sequence shows, rather than inherently having no past or no future, Hong Kong's landscape is *made* into a flood of information in order to represent the vast expanse of the Net. In order to "explain" cyberspace, the threatening city/region (Hong Kong, and by extension China) becomes data.

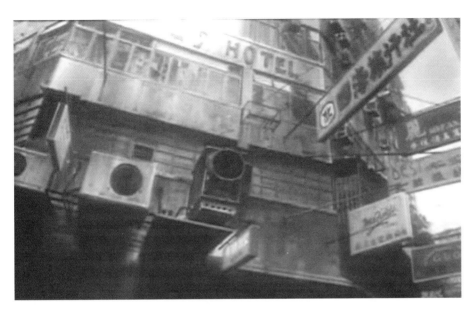

Figure 16.3 Signs in English as well as Chinese characters

To function as data, the city must also be readable. The "basic feeling" portrayed by Hong Kong, then, must be an oriented disorientation. The basic feeling that Oshii strives for is that of a *tourist* rather than a resident: tourists, not residents, *stand* in a public space, in order to get used to the feeling of being alien. In other words, it is not simply that Tokyo is more multilayered than Hong Kong, but rather that Oshii's audience is too familiar with Tokyo to be adequately disoriented.[45] After all, what city – to the tourist – is not a flood of information? By this, I do not mean to imply that all cities are alike; indeed, some are more disorienting than others. However, an unknown city confronts one with the task of navigation, and one is confronted with the necessity and inadequacy of maps. The city both inundates and leaves one looking for more information, for a way to decipher the landscape in front of oneself.

In order to effect this paradox of familiar alienation, Oshii relies on street signs: "I thought that I could express networks which are invisible to all through drawing not electronic images but a most primitive low-tech group of signboards piled like a mountain, that this would work well in drawing a world being submerged under information, in which people live like insects."[46] *Ghost in the Shell* thus relentlessly focuses on street signs that function as literal signposts for the foreign audience (see Figure 16.3). Oshii glosses over the fact that the street signs' ability to invoke information networks depends on literacy: a Japanese audience can read these signs, which are written in Chinese characters and in English. Just as "getting used to the feeling of being alien" in American cyberpunk depends on Japanese trademarks – words that have become recognizable and readable in other languages – unalienating alienation in *Ghost in the Shell* depends on literacy enabled by historic connections between East Asian countries via Confucian study and modernization.[47]

Figure 16.4 Overhead view of the market

Oshii also juxtaposes past and primitive artifacts with modern architecture in order to make Hong Kong legible. In order to construct Hong Kong as a city without history, without the complexity associated with one's home environment, he deploys historical images. As in *Blade Runner*, scenes of Oriental "teeming markets" punctuate *Ghost in the Shell*. Just as American cyberpunk's vision of Japan mixes together Edo images and ideas with high-tech equipment, Japanese cyberpunk visions of Hong Kong mix together traditional Chinese hats and teeming markets (Figures 16.4 and 16.5) with high-tech office towers.[48] The Chinese "present" marks a low-tech future that enables the viewer to make sense of this high-tech future.

This exoticism of the city of the near future enables the reader to navigate cyberspace and to view it as a guiding, yet visually poor, map. Cyberspace makes unfamiliar space mappable and understandable. The frequent segues between cyberspace and real space emphasize the ways that jacking-in serves as a means for navigation, and the ways in which cyberspace erases local particularities by translating locations into a universal video player screen (see Figure 16.6). Featured prominently and, in fact, solely – in chase scenes, cyberspace reduces the pursuit to game and hunter, and the game into a green arrow. For instance, when tracking down a garbage truck driven by one of the Puppet Master's puppets, the anime morphs from street view to cyberspace view, in which the foreign street appears as a benign green line. In cyberspace, one moves from being inundated with information to being presented with the bare necessities of direction. Thus, cyberspace and the city of the near future combine differing versions of orientalism: they play with both exotic dislocation and navigational desire (the desire to reduce other locations to navigable maps). At the same time, Oshii's version of cyberspace

Figure 16.5 Hong Kong market, replete with stereotypical Chinese figures and technology

Figure 16.6 Cyberspace view of a car chase

points to the limited means of orienting oneself: the visual simplicity of the cyber-space scenes alerts the viewer to the fact that manageable information is often poor information.

Oshii also uses the Major and the city to represent cyberspace. As he notes, "networks are things that can't be seen with the eyes, and using computers, show-ing a gigantic computer, would definitely not do the trick. Showing something like a humongous mother computer would be scary."[49] In order to represent the

network in a less "scary" way, he uses instead a humongous mother figure In this image (taken from the *Ghost in the Shell* movie poster), the Major's enormous mutilated form blots out the void in the same manner the "big mother" virus program does in *Neuromancer*. The wires attached to her body highlight her network connections and her broken form reveals her as a cyborg. Her form represents power: she dominates the scene, holding her phallus, and the cityscape shrinks in light of her connected body. Her jacked-in bare body makes cyberspace sexy rather than completely scary and impersonal (see www.moviegoods.com/Assets/product_images/1020/309426.1020.A.jpg). Thus, Oshii's rendering of cyberspace is both erotic and simplistic, or perhaps erotic in its simplicity.

Like *Neuromancer*, then, *Ghost in the Shell* represents cyberspace by relying on maps and by reducing others and other locations to information. Both American and Japanese versions of cyberpunk, that is, rely on *other* locations that are fictional yet recognizable in order to render comprehensible their vision of cyberspace. At the same time, both Oshii and Gibson point out the limitations of such an orientation by also presenting the ways in which foreign, exotic – oriental – locations exceed such a reduction. Whereas cyberspace, to use Certeau's definitions, reduces these locales to places (ordered), the disorienting yet orienting near city invokes ambiguity. These "oriental sites," importantly, are sources of economic anxiety and fears of economic emasculation. As Japan's economy soured in the 1990s, Hong Kong – and as a result, China – loomed as the next big economic power, and China should be the country with the largest gross domestic product sometime soon in this century. Thus, this insistence of the "soulless" informatics or mechanization of the seeming burgeoning other, combined with dreams of conquering, serve as a way to cope with, to fantasize about, to relieve perhaps barely concealed anxieties over economic impotence.

Who's Zooming Who?

Given the merging of the Puppet Master and the Major at the end of *Ghost in the Shell*, it would be easy to read this anime as celebrating the emergence of Japan as a technological powerhouse. Just as the Major receives technological advances from the Puppet Master, Japan takes technology from a dying West – and there is no American cowboy with which Americans can identify. If this is so, why would anime be so popular within the United States, and especially among "minority" Americans, such as Korean-Americans, who have no special fondness for Japan? Annalee Newitz suggests that translating and viewing anime may be a means by which viewers "convert a Japanese product into a uniquely American one. What might be satisfying for Americans about this is that it essentially allows them to 'steal' Japanese culture away from Japan."[50] This conversion supports the notion of anime producing a "Peeping Tom" or spying effect. Indeed, Antonia Levi, who argues that anime enables a great cultural exchange,[51] also portrays it as enabling a penetrating view into Japanese society. Anime, she posits, "can show you a side of

Figure 16.7 Cyberspace "jacked into" the Major

Japan few outsiders ever even know exists ... But be warned. What you learn about Japan through *anime* can be deceptive. This is not the way Japanese really live. This is the way they fantasize about living."[52]

Similarly, Frederik Schodt, who argues for anime as a rosetta stone for mutual understanding,[53] also argues that the form allows one to see beyond "the surface or *tatemae* level of Japanese culture."[54] The great mirror, or illusion, of anime gives the impression of looking beyond surfaces, to what *really is* – which is, appropriately enough, fantasy.

More concretely, the American subject gets inserted into *Ghost in the Shell* through the gaze and through fantasy. When asked why he uses the fisheye effects, Oshii replied, "If you pressed me, you could say that these are the 'eyes' that look at the world of the film from the outside – that these are the eyes, in fact, of the audience."[55] The eyes of the audience often coincide with the view of the Major – enabling the viewer to see through her eyes – but, even more often, this coincidence enables the viewer to see over her shoulder. This effectively puts the gaze on the screen, so that the viewers identify with the camera's gaze rather than with specific characters. As Kaja Silverman argues, "fantasy is less about the visualization and imaginary appropriation of the other than about the articulation of a subjective locus – that is 'not an *object* that the subject imagines and aims at but rather a *sequence* in which the subject has his own part to play."[56]

The viewer's role as voyeur has a precedent within cyberpunk fiction itself, namely in Case's relationship with Molly in *Neuromancer*. Case literally jacks into Molly, seeing what she sees and feeling what she feels. Similarly, the viewer jacks into the Major and the portrayal of the Major's connections to cyberspace makes this explicit: in *Ghost in the Shell*, the trodes emerge from the other and penetrate the Major (see Figure 16.7). Unlike Gibson's version of merging with the Net, *Ghost in the Shell* portrays a feminine connection where the cyborg is the female

connector and the computer is the male connector. And the camera becomes the network connection – when we look over the Major's shoulder we are literally in the position of the Net/console cowboy logging into her and seeing what she sees. This jacking in functionally parallels "passing" on the Internet. Rather than offering people an opportunity for others to lose their body or to understand others to be whoever or whatever they want to be, cyberspace offers simstim – the illusion of jacking into another being, seeing what they see and pretending to be who they are, and being invisible while doing so.

Thus, anime allows viewers to employ cyberpunk fantasies about the Orient already in place in order to insert themselves into narratives that do not seem to offer them a character with which to identify. The inability to comprehend Japanese and to read all the signs afforded him, rather than alienating the viewer, places him a position structurally mimicking cyberpunk heroes. The viewer in *anime* puts into place lessons learned from Western cyberpunk. Moreover, the position of the viewer – who sees without being seen – strengthens this parallel.

Thus, cyberspace – or more properly, *narratives* of cyberspace – rely on the incomprehensibility of the Orient for their comprehensibility. Faced with making computer networks readable to others, influential writers such as Gibson draw on Asia (mistakenly collapsed into Japan, even though in Japan, Asia does not equal Japan) as a land easily reduced to information, yet also exotic enough to overload the viewer with information. To be clear, I am not arguing that cyberspace is limited to Gibson's, Oshii's, or Shirow's conception of it; nor am I arguing that orientalism is the only "other space" relied on to make cyberspace comprehensible. I *am* arguing that the conjunction of narratives about cyberspace and orientalism domesticates fiber-optics narratives. Narratives of cyberspace that make reference to orientalism seek to contain what they also create, even if they show cyberspace as exceeding information. That is, these narratives view the Orient as challenging one's navigational assumptions, but still rely on the logic of the navigable, of the symbolic as readable. The confusion the viewers feel stems from their position as tourists viewing the exotic. The unreadability of these locations serves to enhance their exoticism rather than challenge the viewers' assumptions about the symbolic and about orientation and orientalism. The point, then, is to see the ways in which this challenge of disorientation in the face of the foreign can disrupt everyday locations and understandings rather than being reserved for those *other* spaces. The point is to see the ways in which heterotopias disrupt "normal" spaces, rather than lie neatly outside them.

Going Native

This orientalizing of the digital landscape, this entry into cyberspace as entry into world of oriental sexuality, is not limited to literary and animated conceptions of the Internet. Marty Rimm, whose senior thesis became the notorious Carnegie Mellon report on the consumption of pornography on the information superhighway, argues that cyberspace introduces nine new categories of pornography,

two of which are "Asian" and "interracial." What is interesting in this supposedly identity-free public sphere is not simply that Asian pornography has emerged as a popular genre, but rather that *Asian* has itself effectively become a pornographic category.[57]

The Internet also revises our understandings of orientalism, disengaging it from the Orient. Through high technology, orientalism is made to travel: it is cited and disseminated in ways that untether the relationship between orientalism and the Orient. Oriental mail-order-bride sites such as *Asian Rose Tours* offer women from the former Soviet Union as well as the Philippines. Some oriental pornography sites offer pictures of white women, albeit women who are either bound or mutilated. The conceit behind these oriental pornography sites is that oriental women are submissive and in some way lacking the independence and status of their female contemporaries (notably, the visitors to these sites are predominantly American and Japanese men). The inclusion of Russian women exposes the economic base behind this assumption, but also reveals the flexibility of the category *oriental* to include all economically disadvantaged women. High-tech orientalism, then, disperses orientalism, in all the meanings of the word *disperse*. High-tech orientalism seems to be all about dispersal – specifically, the dispersal of global capitalism.

To conclude, the Internet is not *inherently* oriental, but has been made oriental. The narrative of the Internet as orientalist space accompanies narratives of the Internet as disembodied space. In other words, the Internet can only be portrayed as a space of the mind if there is an accompanying orientalizing of difference, if there is an accompanying display of orientalized bodies. However, this binary of disembodied mind on the one hand, and embodied and orientalized other on the other is not sustainable. This binary breaks down not because the orientalized other is suddenly afforded the status as subject, but rather because the boundary between self and other, self and self, breaks down whenever one jacks in. Or, to be more precise, this division between self and other is itself a response to connectivity, which means that connectivity precedes the "user" – which means that this boundary is a screen rather than a shield.

Notes

1. *Cinematograph*, a neologism introduced in the late nineteenth-century, itself refers to the process by which "films" are experienced. Coined by Auguste and Louis Lumiere and originally spelled *kinematograph*, it is comprised by two Greek words: *kinlund, kinhmato* [motion] + *graph* [written].

2. Gibson first coined the term in his short story "Burning Chrome," which was published in the July 1982 edition of *Omni*. He developed the concept of cyberspace more fully in his 1984 novel *Neuromancer* (New York: Ace Books, 1984).

3. Gibson, *Neuromancer*, 51.

4. The term *burning desire* refers to Geoffrey Batchen's analysis of the conception of photography, *Burning with Desire: The Conception of Photography* (Cambridge, MA: MIT Press, 1997).

5. John Perry Barlow, "Across the Electronic Frontier," (7/10/1990), online at <www.eff.org/Publications/John Perry Barlow/HTML/eff.html>. This earnest conflation of the future and cyberspace would become key to the selling of the Internet as an endless space of opportunity for individualism and/or capitalism.

6 Dave Healy argues in "Cyberspace and Place: The Internet As Middle Landscape on the Electronic Frontier," in *Internet Culture*, ed. David Porter (New York: Routledge, 1997), 66, that cyberspace is "'middle landscape' between space (empty frontier) and place (civilization) that allows individuals to exercise their impulses for both separation and connectedness." He sees us as "heirs not only of the primitivist philosopher Daniel Boone, who 'fled into the wilderness before the advance of settlement,' but also the empire-building Boone, the 'standard bearer of civilization'" (66). However, placing cyberspace as a middle landscape assumes that the Internet is a landscape to begin with, and this overlooks the work needed to construct the Internet as such. Rather than mediating between space and place, the Internet allows us to space out about the difference between space and place. For more on the space and cyberspace, see Kathy Rae Huffman, "Video, Networks, and Architecture," in *Electronic Culture: Technology and Visual Representation*, ed. Timothy Druckrey (New York: Aperture, 1996), 200–7; Chris Chesher, "The Ontology of Digital Domains," in *Virtual Politics: Identity and Community in Cyberspace*, ed. David Holmes (London: Sage, 1997), 79–93; and Mark Nunes, "What Space is Cyberspace? The Internet and Virtuality," in Holmes, ed., *Virtual Politics: Identity and Community in Cyberspace*, 163–78.

7 Healy, "Cyberspace and Place," 57.

8 Michel de Certeau, *The Practice of Everyday Life*, trans. Steven Rendall (Berkeley and Los Angeles: University of California Press, 1984), 117.

9 Thinking of electronic spaces in terms of "time" rather than "space" nuances our understandings of Internet space and brings out the repressed similarities and differences between the Internet and television. This is elaborated in more detail in my *Sexuality in the Age of Fiber Optics* (forthcoming).

10 Certeau, *The Practice of Every day Life*, 117.

11 Edward Said, *Orientalism* (New York: Vintage Books, 1978), 1.

12 Ibid., 3.

13 Lisa Lowe, *Critical Terrains: British and French Orientalisms* (Ithaca, NY: Cornell University Press, 1991), 15.

14 Michel Foucault, "Of Other Spaces," trans. A. M. Sheridan Smith, *diacritics* 16, 1 (1986), 24.

15 Ibid. Boats, of course, also have an alternate history that place them as dystopian heterotopias. The Middle Passage and the Vietnamese boat people also show the dreams enabled by boats as nightmares. Neal Stephenson plays on both images of boats in *Snow Crash* (New York: Bantam, 1992).

16 For more on disruptive identifications, see Diana Fuss, *Identification Papers* (New York: Routledge, 1995).

17 Said, *Orientalism*, 52.

18 Ibid., 93.

19 Gibson, *Neuromancer*, 6.

20 Pam Rosenthal, "Jacked-in: Fordism, Cyberspace, and Cyberpunk," *Socialist Review* 21, 1 (1991): 85.

21 Gibson, quoted in Rosenthal, "Jacked-in," 85.

22 Gibson, *Neuromancer*, 3.

23 This juxtaposition of Turkey's open sexism with the bad-ass coolness of Molly allows *Neuromancer* to project the (false) image of a world without sexism, since some women can opt to augment their bodies so they can be as physically tough as many men, again naturalizing technology.

24 For other "Japanified" futures, see Ridley Scott's 1982 film *Blade Runner*; William Gibson, *Count Zero* (New York: Ace, 1986); William Gibson, *Mona Lisa Overdrive* (New York: Bantam, 1988); William Gibson, *Idoru* (New York: G. P. Putnam's Sons, 1996); and Stephenson, *Snow Crash*.

25 Yoshimoto Mitsuhiro, "The Postmodern and Mass Images of Japan," *Public Culture* 1, 2 (1989): 18.

26 Lisa Nakamura, "Techno-Orientalism and Cyberpunk: The 'Consensual Hallucination' of Multiculturalism in the Fiction of Cyberspace," paper delivered at the 1999 Association of Asian American Studies conference, Philadelphia, n.p.

27 Gibson, *Neuromancer*, 11.

28 Ibid., 3.

29 Ibid., 11.

30 See Fredric Jameson, "Progress versus Utopia; or, Can We Imagine the Future?" *Science-Fiction Studies* 9, 2 (1982): 147–58.

31 Fuss, *Identification Papers*, 149.

32 Frederick Buell, "Nationalist Postnationalism: Globalist Discourse in Contemporary American Culture," *American Quarterly* 50, 3 (1998): 566.

33 David Morley and Kevin Robins, "Techno-Orientalism: Futures, Foreigners and Phobias," *New Formations* 16 (1992): 139.

34 Beard, quoted in Morley and Robins, "Techno-Orientalism," 154.

35 Gibson, quoted in Rosenthal, "Jacked-in," 85; emphasis added.

36 Said, *Orientalism*, 52

37 Naoki Sakai, quoted in Morley and Robins, "Techno-Orientalism," 146.

38 Said, *Orientalism*, 59.

39 Although Gibson consistently uses Japanese as mimics, other cyberpunk authors such as Neal Stephenson do not, even as they employ Japanese and East Asian geographies. Stephenson's *Snow Crash* is especially interesting since his cyberspace is not empty and characters become avatars online. In effect, his characters pass as others rather than as disembodied minds. In *Snow Crash*, racial stereotypes serve as prototypes for such online avatars as Brandy.

40 Although popular Japanese mecha series such as *Robotech* and *Astroboy* predate cyberpunk, mecha is now most often translated as cyberpunk, with posters for such popular series as *The Bubblegum Crisis* prominently featuring the English word "cyberpunk." For the "global" popularity of *mecha*, see Anime Web Turnpike, online at <http://www.anipike.com>; and Laurence Lerman, "Anime vids get Euro-friendly," *Variety*, June 24, 1996, 103.

41 Elizabeth Lazarowitz, "COLUMN ONE: Beyond 'Speed Racer,'" *Los Angeles Times*, December 3, 1996, 1.

42 Ibid.

43 Toshiyo Ueno, "Japanimation and Techno-Orientalism," online at <www.t0.or.at/ueno/japan.htm>.

44 "Interview with Mamoru Oshii," *ALLES* (n.d.), online at <www.express.co.jp/ALLES/6/oshii.html> (5/1/99). The portrayal of Hong Kong as a city with no past or future is problematic. First, it denies the colonial history of Hong Kong; second, it perpetuates an image of a timeless Hong Kong at a time when Hong Kong's identity is at stake. As Ackbar Abbaz argues in *Hong Kong: Culture and Politics of Disappearance* (Minneapolis: University of Minnesota Press, 1997), in the period before the 1997 handover there was a fast and furious attempt to delineate a Hong Kong culture – a

problematic attempt that focused on such culture as disappearing.

45 Abbaz divides Hong Kong's architecture into three forms: merely local, anonymous, and placeless; Abbaz, *Hong Kong*, 79–90.

46 "Interview with Mamoru Oshii." Ridley Scott previously used this technique in *Blade Runner*. Although Oshii does not comment directly on his citations of *Blade Runner*, they are numerous and mostly relate to questions of representing technology. For instance, the long musical scene in which the Major tours Hong Kong ends with mannequins similar to those that appear in *Blade Runner* when Deckard tracks down the snake-stripping replicant Zhora.

47 Abbaz argues that signs have the opposite effect on Hong Kong city dwellers. If tourists gaze at these signs and in some way try to read them, "Bilingual, neon-lit advertisement signs are not only almost everywhere; their often ingenious construction for maximum visibility deserves an architectural monograph in itself. The result of all this insistence is a turning off of the visual. As people in metropolitan centers tend to avoid eye contact with one another, so they now tend also to avoid eye contact with the city." (Abbaz, *Hong Kong*, 76).

48 Further, to link this to the mixing of high- and low-tech in cyberpunk, Japanese anime often features a trip into "Chinatown" or Chinese tea rooms that are marked as inferior or perpetrating bad employment practices. In the popular *Bubble Gum Crisis* series, for example, the two women bond over a trip to Chinatown. In the "prequel" to the *Bubble Gum Crisis*, the *AD Police Files*, bad labor practices at a Chinese tea room marks the onset of a crisis with boomers. In *Ranma 1/2*, Ranma turns into a girl when splashed with cold water – female Ranma has red hair, and the male Ranma has black hair. As Annalee Newitz argues in "Magical Girls and Atomic Bomb Sperm: Japanese Animation in America," *Film Quarterly* 49, 1 (1995): 11, "Ranma is not only feminized, but also associated with China, a country invaded and occupied by Japanese imperialist forces several times during the 20th century. Ranma's 'curse' is in fact a Chinese curse, which he got during martial arts training with Genma in China. Moreover,

Ranma wears his hair in a queue and his clothing is Chinese: at school, the students often refer to him as 'the one in Chinese clothing.'" As well, Chinese and Korean characters are visually marked as different from Japanese characters through eye size. Only the Japanese characters are given the enormous eyes that many critics mistake for a "racially ambiguous" look.

49 "Interview with Mamoru Oshii."

50 Newitz, "Magical Girls and Atomic Bomb Sperm," 2.

51 According to Antonia Levi, "The new generations of both Japan and America are sharing their youth, and in the long run, their future. However much their governments may argue about trade and security in the Pacific, American's Generation X and Japan's *shin jinurui* will never again be complete strangers to one another. The connection is not only with Japan. *Anime* has already spread across most of Asia. Future social historians may well conclude that the creation of the American *otaku* was the most significant event of the post-Cold War period." See Levi, *Samurai from Outer Space: Understanding Japanese Animation* (Chicago: Open Court, 1996), 1–2.

52 Ibid., 16.

53 Frederik Schodt argues, "Ultimately, the popularity of both anime and manga [Japanese comic books] outside of Japan is emblematic of something much larger – perhaps a postwar "mind-meld" among the peoples of industrialized nations, who all inhabit a similar (but steadily shrinking) physical world of cars, computers, buildings, and other manmade objects and systems." (See Schodt, *Dreamland Japan: Writings on Modern Manga* (Berkeley: Stone Bridge Press, 1996), 339.)

54 Ibid., 31.

55 Carl Gustav Horn, "Interview with Mamoru Oshii," in *Anime Interviews: The First Five Years of Animerica, Anime and Manga Monthly (1992–97)*, ed. Trish Ledoux (San Francisco: Cadence Books, 1997), 139.

56 Kaja Silverman, *Male Subjectivity at the Margins* (New York: Routledge, 1992), 6.

57 As of 2002, an Internet search on Google for "Asian + woman" produced porn sites, whereas a search for "pornography" failed to produce pornography in the first ten answers. For more on this, see Chun, "Scenes of Empowerment: Virtual Racial Diversity and Digital Divides," *New Formations* special issue on "Race and/or Nation" 45, (winter 2001): 169–88.

Further readings

Cybertyping and the Work of Race in the Age of Digital Reproduction, in *Cybertypes: Race, Ethnicity, and Identity on the Internet*, Lisa Nakamura (New York: Routledge, 2002).

Good Politics, Great Porn: Untangling Race, Sex, and Technology in Asian American Cultural Productions, Thuy Linh Nguyen Tu, in *Asian America.Net: Ethnicity, Nationalism and Cyberspace*, Rachel Lee and Sau-ling Cynthia Wong eds. (New York: Routledge, 2003).

Related Internet links

Kristina Wong (Big Bad Chinese Mama): http://www.bigbadchinesemama.com/

Prema Murthy (Bindi Girl): http://www.thing.net/~bindigrl

17

Spatial "wRapping":
A Speculation on Men's Hip-Hop Fashion

SCOTT L. RUFF

Since the early 1990s men's hip-hop fashion has become ubiquitous. All across the country, in the American heartland, in popular advertising, and even in elitist private academies, one can find young people wearing the latest "urban" apparel, decked out in FUBU, Pelle Pelle, Wu Wear, Karl Kani, etc. Piggybacking on the wave of globalization, hip-hop's influence has spread: oversized "goose bombers," hoodies, rugby shirts, baggy jeans and variations of Timberland/Lugz boots are seen across the world.

While the purpose of this essay is to speculate on some of the cultural references, reverberations, and oblique connections suggested by the late twentieth-century and early twenty-first-century hip-hop street fashion, it is not intended to offer definitive answers.[1] Instead, I posit a series of possible scenarios that theoretically attempt to link the development of hip-hop fashion to African-diasporic resistance. This essay is meant to form a background for further discussion and speculation on a current cultural practice. This, I believe, marks an evolution from a definition of space through ephemeral elements such as music and dance into the development of a conception of personal/cultural space that is based on the material practices of clothing and architecture.[2] Most importantly, I want to situate the eruption of hip-hop fashion beyond Black culture within the context of a longer tradition of sartorial flamboyance born out of material and political stresses.

Resistance

It would be useful, if not too general, to argue that there exists – within the US and abroad – an overarching African-diasporic sensibility that could help explain the complexity of the creative processes that hip-hop manifests in manners of dress, modes of dance, and music. What I will argue, however, is that hip-hop is a

Keywords

hip-hop
street fashion
African diaspora
cultural resistance
material practices
architecture
non-Western aesthetics
self-expression
clothing
the body
movement

Global Visual Cultures: An Anthology, First Edition. Edited by Zoya Kocur.
© 2011 Blackwell Publishing Ltd except for editorial material and organization © Zoya Kocur. Published 2011 by Blackwell Publishing Ltd.

non-Western aesthetic. Its affinities syncopate with other forms of Black creative resistance including Jamaican sound systems, Puerto Rican and Dominican *sonero* styles, inner city resourcefulness, and Afro-Caribbean-Brazilian movement forms such as *capoeira* and *mani*.

Turning from the spatial plane to the temporal, one sees a periodic resurfacing of multiple but consistent themes of "Africanisms." Contemporary hip-hop fashion is one of these controversial yet sustained eruptions. It makes explicit the tensions between generations within the African-American community. It reveals the interface of capitalist consumerism with cultural self-identity movements and the struggle for self-expression. Hip-hop is an identity statement that simultaneously articulates a resistance to a deep-seated mental colonization and a utopian re-imagining of the possibilities of resistant identities.

Clothing is both representational and material, offering the promise of more substantive articulations of personal and cultural identities in space. Hip-hop culture has not only broken from traditional Eurocentric notions of individual space; it has formalized this rupture into what could be considered an elementary architecture. The logic is quite clear: skin for African Americans – and by extension clothing – has historically been both a mark of oppression and a site of resistance, the bedrock upon which a dislocated people, lacking other institutionalized social space, may construct a home. Many find hip-hop's appeal in the fact that it symbolizes resistance. Even those who are not part of an African-diasporic experience can inhabit through hip-hop fashion the many characteristics that dominant white culture attributes to Black resistance, including hyper-masculinity, "gangsta-ness," danger, mystique, urbanity, physicality, and street credibility. One can, in other words, wear the skin of resistance without paying the price.[3] In the US, this mainstream appropriation of hip-hop fashion has occurred largely amongst middle-class adolescents, most of whom are white and who wear the hip-hop "skin" only as an expression of generational dissidence. Most of them will probably grow out of this socially accepted demonstration of rebellion, and later see their flirtation with blackness and hip-hop culture as a passing phase. However, as a living process of creative resistance rooted in Black diasporic experience, hip-hop is no passing phase. Furthermore, alongside creative and resistant utopian possibilities, hip-hop also functions to transmit white-centered American global culture and capital far beyond its boundaries.

Three Origin Stories[4]

It has been established that hip-hop music and dance are linked to West African and African-diasporic traditions. It is not unreasonable to postulate that hip-hop clothing may share similar origins. Within the tradition of West African clothing, large pieces of untailored rectangular fabric are put to multiple uses as pants, tunics, and head wraps. For pants, large swaths of fabric, which sometimes reach the length of seven feet, are gathered together causing a sagging appearance in the

Figure 17.1 *Vitruvian Man in West African Garb*, 2002. Digital collage: Scott Ruff

mid-section of the silhouette.[5] The West-African shirt is described as a large piece of cloth or small strips of fabric sewn together to become a whole with openings for the head and the arms to pass through. This traditional type of clothing is still worn in some parts of Western Africa (Figure 17.1). The following quote is the description of a Senegalese male dress from 1686:

> The apparel of the prime men is a sort of shirt, or frock of striped cotton of several colors; such as yellow, blue, white, black … Some of these are plaited about the neck, others plain, having only a hole, or slit for the head to pass through, and reach from the neck to the knees with large open sleeves. Under this cloth, they wear a thick cloth, made up after the fashion of long wide breeches, by them called Jouba … plaited and tied around the bottom; and is very inconvenient, as much obstructing the motion of the legs, because of the wideness and the thickness of the cloth it is made of.[6]

One attribute of male hip-hop fashion that serves as a connection to resurfaced African aesthetic sensibilities can be found in its silhouette. The male hip-hop silhouette sets itself apart from contemporary American clothing trends by means of its loose-fitting contour and its preference for baggy as opposed to form-fitting garments. Oversized jerseys and extra baggy pants that taper slightly and gather down around the ankles are the main-stay of the fashion.

It is difficult to make a definitive connection to clothing traditions of West Africa at this time, given the processes that have led to, what Orlando Patterson calls, "natal alienation" and exile from the African continent. The erasure of history through slavery, Western colonization of the African continent, and cultural genocide have left the Black diasporic identity with vast silences and unreadable historical gaps. Hip-hop clothing speaks a formal language that attempts to bridge some of those gaps and silences by means of a patchwork process that operates across discrepant historical spaces.

Another possible parallel evolution, one that draws rather from an American source, is the "sack suit." The draping semi-bell shape appearance of the male hip-hop clothing can be seen as an exaggerated alteration of the sack suit silhouette, which is arguably one of the major types of contemporary western men's fashion.[7] Characteristic of this silhouette is a shapeless rectangular form with a non-darted torso and narrow unpadded shoulders:

> [The sack suit] hides the shape of its wearer and takes away any sense of individuality. The reason it has managed to exist successfully for such a long period of time is simply that it appeals to the common denominator. Since it is so anonymous, it offends no one, enabling the wearer to walk into any environment and be acceptably attired.[8]

The hip-hop silhouette both literally and figuratively expands on this image by having the appearance of one-size-fits-all. A men's fashion style that appears to bridge the West African silhouette and the American Sack Suit is the "Zoot suit," a highly stylized formal suit, with large baggy pants and a long overcoat, which is said to have African-diasporic roots.[9] During the late 1930s and 40s, this style was extremely popular within Chicano, Latino, and Black communities.[10]

Socio-economic and environmental factors also impact male hip-hop fashion. One example is the necessary ability to make the best of whatever is available. Children and adults alike commonly wear "hand-me-down" clothing, which does not quite fit properly. In this situation, it is preferable for an article of clothing to be slightly too large than to be slightly too small. One can also observe the practice of wearing oversized clothing in institutions where uniforms are required. The disproportionate number of African-diasporic peoples incarcerated during their lifetime thus offers a possible referent for hip-hop. In many jail systems, the issuance of clothing has been standardized for years with the result that inmates are provided with oversized clothing and no belts to keep their pants up. It is possible to imagine these men integrating mannerisms and values cultivated in prison into life outside of prison after their release.[11]

All of these factors may have played a part in the development and the perpetuation of male hip-hop fashion; but then again, it is possible that other factors were more influential. Hip-hop, after all, could just be a fad whose time has come. Perhaps, instead of going away, it will continue to evolve and transform itself like many before it: spirituals, gospel, blues, jazz, rock-n-roll, soul, funk, soul food, and "ebonics."

Elements of Hip-Hop Fashion

It is hard to identify a pattern as to how the elements of hip-hop fashion are chosen. Football jerseys and sneakers, as well as hockey jerseys, are the staple element of this style. The color composition and the logos on the clothing communicate territorial and social affiliations. The components of this fashion, much like hip-hop music, are a "sampling" from a pluralistic reservoir, from many diverse sources traversing the terrains of high fashion, working/industrial clothing, sports gear, and so on.[12]

If one item of clothing had to be selected as being foundational within men's hip-hop fashion, it would probably be the trademark baggy and sagging jeans. Jeans were originally workers' clothing, but they have gradually become a staple in contemporary mainstream fashion for both men and women. Hip-hop fashioners are possibly one of the first to extend this typology into baggy and extra baggy jeans. Baggy is an adjective related more to a manner of carrying the pants and less to a style of cut.[13] This stylized manner of wearing pants is very important as an example of hip-hop fashion's ability to transform the wearer's experience in space. Analyzing the wearing of baggy pants, we see an alteration in body movement, an adaptation of devices such as belts and ropes, and a system of overlapping and layering materials. It is important for the pants to drape from the body to the point of nearly falling down. Because the fabric gathers between the legs and the center of the pants, a person's walking pattern changes, enhancing the syncopation in movement. Each person has to individually develop and negotiate their own style of walking and keeping their pants up while maintaining the appearance of effortless motion.[14] Another consequence of the "low riding" of the pants is that the wearer's underwear is exposed, underneath the tunic-like tops. This requires the person to wear colorful, attractive, and sensual underwear for the purpose of providing voyeuristic moments to others.

Work boots, another element of hip-hop clothing, are a remnant from the industrial working class. In milder climates or in the spring and summer, basketball sneakers coexist with boots. Often times, shoes are worn with untied laces so that the heels can be dragged upon the ground, adding an auditory effect to the rhythm of the walk. Their weighty appearance pays homage to the reality of gravity and groundedness. However, immediately behind this expression of reality exists the notion of "lightness" and being free and unbounded within space.

Regardless of what type – jersey, button-down shirt, winter "Bomber" jacket, or "hoodie" – tops have to be oversized and loose-fitting in order to provide space to move. This adds to an appearance of increased body mass. There exists a preference for flaring at the base of the garment, as opposed to a tapered, tucked-in, or straight hang from the shoulders, giving the silhouette a bell shape. Thus, these three primary components of clothing (shirt, pants and boots) work together to enhance the effect that gravity has upon the body. Everything appears to become weighted down at the lower portions of the body. The appearance of a slow, fluid, and rhythmic motion often contrasts with the actual attributes of the body beneath the clothes.

Hip-hop headgear consists of a series of artifacts that are quite particular to African-influenced hairstyling. The "doo rag" a cloth that has conventionally been worn at night to style the hair has finally found the light of day within hip-hop fashion. Worn like an Islamic turban, it furthers the image of hip-hop's African origin. A variety of hats are worn, and the only common characteristic of these various hats is that they sit on the head at an angle often displaying some kind of logo. Logos on hip-hop clothing can be indicators of many things: advertisement, political statements, material wealth, or territorial signification. All these symbols reinforce the use of clothing as a site of socio-spatial projection.[15] The logo claims space through complex and convoluted social relationships alluding to the wearer's economic prowess, place of origin, or affiliations, informing all who care to read the signs. There also exist within the world of men's hip-hop fashion many other accessories. One example is the use of heavy jewelry, which supports allusions to heaviness and massiveness as well as material wealth and power. Adorning the body, jewelry may include large necklaces, earrings, bracelets, rings, and anklets as well as gold and platinum-covered teeth. With regional variations on common themes, such accessories play an important part in the makeup of the hip-hop mystique and enhance connections to the African continent.

This list of elements found within men's hip-hop fashion is far from complete; in fact, this account only begins to scratch the surface of the origins, content, and implications of each component. The main objective of this essay has been to present hip-hop fashion as a cultural practice that does not conform to pre-conceived western notions of fashion, that is fashion understood as coming from high culture down. Instead, it may be said that hip-hop fashion "just grew" within the mass of African-diasporic experience.[16] Hip-hop culture thus continues a tradition of resistance to cultural erasure. It is my hope that that through speculations such as this essay, African-diasporic cultures may be able to construct more substantive "homes" for themselves. This is why it is important to study, contemplate an understand the creative processes of these cultures in the past, present, and future. That may be too much to ask from something like hip-hop fashion; nevertheless it a small, albeit significant, step in a process of cultural rebuilding.

Notes

1 Women's hip-hop fashion will not be the focus of this essay because of its overwhelming complexity. This is a discussion that requires its own space.

2 Clothing is considered to be the first shelter of the body; it is a shallow physical space.

3 That is, without facing the circumstances that necessitated the resistance in the first place.

4 Although foundation myths can be distracting, the following accounts are meant to offer a background against which the hip-hop silhouette can be investigated.

5 "The 'silhouette' is the term used by the clothing industry to describe the cut or shape of a suit... the shape of a garment sets the tone of a person's appearance ... The fabric and details, which may

add to a suit's attractiveness, and even the fit should be of secondary concern, since it is the silhouette that actually determines the longevity of the garment." Alan J. Flusser, *Style and the Man* (New York: Harper Style, 1996): 25.

6 Cado Masto cited in Roy Sieber, *African Textiles and Decorative Arts* (New York: Museum of Modern Art, 1972): 23.

7 Flusser, 26.

8 Ibid.

9 Shane White and Graham White, *Stylin': African American Expressive Culture from its Beginnings to the Zoot Suit* (Ithaca, NY: Cornell University Press, 1998): 253–54.

10 Ibid. It is important to note that this is one of few instances in American history during which Chicano peoples chose to identify with African-diasporic peoples.

11 Of the possible scenarios presented here, the socio-economic status of black people and the "institutional connection" clearly have the most contemporary Impact.

12 A fundamental principle of hip-hop is sampling and absorption.

13 The style of cut is something that manufacturers use for marketing purposes. In hip-hop fashion, for example, it is desirable to wear a pair of pants with a size 44″ waist, even though the person might have a 32″ waist.

14 Some people go so far as to develop special tie systems under their clothing.

15 As such, logos are similar to *kente*, clothes that are worn in Ghana and other West African countries and that communicate social status, clan, family affiliations, and proverbs.

16 "Just grew" is an Anglocized version of "jus' grew," a term used by Ishmael Reed in his novel *Mumbo Jumbo*. I use it in this essay to explain the pluralistic origins of many African-diasporic cultural developments. Like jazz music, hip-hop fashion cannot be linked to only one specific person or source, but it is the result of many factors working in similar but varied ways. Ishmael Reed, *Mumbo Jumbo* (New York: Doubleday, 1972).

Further readings

True Heads: Historicizing the Hip_Hop "Nation" in Context, R. Scott Heath, *Callaloo*, 29(3), 2006.

Hip Hop + Architecture, James Garrett Jr: http://www.communityarts.net/readingroom/archivefiles/2004/03/resonant_spaces.php

Related Internet links

Hip Hop Roots, interview with Raquel Rivera: http://www.politicalaffairs.net/hip-hop-roots-interview-with-raquel-rivera-print-edition/

Hip Hop history: http://www.globalartistscoalition.org/hiphophistory.html

18

Self-Styling

Sarah Nuttall

Keywords

Y (Loxion) culture
Johannesburg
the black body
post-apartheid
 generation
politics of resistance
style
consumerism
economic class
township culture
hybrid culture
"post-racial" identities
advertising

This chapter explores the rise of a youth cultural form widely known as 'Y Culture'. Y Culture, also known as *loxion kulcha* for reasons I explain below, is an emergent youth culture in Johannesburg which moves across various media forms. It articulates the clear remaking of the black body, its repositioning by the first post-apartheid generation. More specifically, it signals the supercession of an earlier era's resistance politics by an alternative politics of style and accessorization, while simultaneously gesturing, in various ways, toward the past. It is a culture of the hip bucolic which works across a series of surfaces, requiring what Paul Gilroy (2000) calls 'technological analogies', in order to produce enigmatic and divergent styles of self-making. While drawing on black American style formations, it is an explicitly local reworking of the American sign – a reworking that simultaneously results in and underscores significant fractures in Gilroy's paradigm of the Black Atlantic.[1] The conception of the body as a work of art, an investment in the body's special presence and powers, a foregrouding of the capacity for sensation, marks Y culture. Selfhood and subjectivity are presented less as inscriptions of broader institutional and political forces than as an increased self-consciousness about the fashioning of human identity as a manipulable, artful process.

The chapter draws on a notion of self-styling, or self-stylization, a concept invoked by Foucault (1987) to describe those practices in which individuals 'create a certain number of operations on their own bodies and souls, thoughts, conduct and ways of being so as to transform themselves' (p. 225). Foucault wanted to explore how such 'technologies of the self' negotiated the transition between the moment of political liberation and 'practices of freedom' as such. His notion of self-styling bears on the forms of emerging selfhood and bodily life I discuss below, though in ways that certainly Foucault himself did not have in mind. The chapter shows, too, that in attempting to understand Y cultural forms, cultural analysis which relies on ideas of translation or translatability are useful only up to a point,

Global Visual Cultures: An Anthology, First Edition. Edited by Zoya Kocur.

and that what is required is an understanding of how cultural forms *move*. While 'translation' relies on an idea of a gap – a gap between one meaning or text and another – what is needed in order to properly understand this cultural form is something closer to an interface in which meaning morphs into something else, rather than 'loses' its initial sense. While the idea of the gap in meaning inhabits our theorizing about culture generally, it deserves elaboration and adjustment when it comes to reading the innovations of contemporary urban cultural forms, I argue.

In the second part of the chapter, I consider a recent set of advertisements that have appeared on billboards and in magazines in the wake of Y Culture. I show how they simultaneously engage with and push in unexpected directions one of the most striking aspects of Y/loxion culture, an attempt at rereading race in the city. In analysing the ads, I consider ways in which commodity images, and the market itself, come to produce some of the most powerful reimaginings of race South Africa has known in some time. At the same time, the idea of the gap (here between what you have and what you want) is continually reconstituted at the heart of the commodity in order to propel new desires.

I first began writing the chapter in 2002. At the time, Y culture/loxion kulcha was a new phenomenon, just beginning to take major cultural – and commercial – shape. I was captivated by its social potential. By its capacity, that is, to generate ideas, images and ways of being in the city quite different from before. To me, it retained a political edge since, as we will see, it involved a rereading, a citing of the apartheid past while drawing increasingly on a stylistics which spoke to the future. It intersected with a rising commodity culture, but could also be thought of as a youth movement, a concerted attempt at creating a sub-culture in the city which defined the youth, trading on their powerful political role in the apartheid era. Subsequently, as we will see, brand managers began to capitalize on its stylistics as a means of reading 'the youth market'.

Loxion culture is now, in 2008, more visible in Johannesburg than ever before: large billboards signal its prominence as you drive into the city from the airport. At the same time, the critique of consumer culture, of consumerism, has grown apace. This is directly linked to rising debates about ongoing poverty, partly in the build-up to elections in 2009 and specifically, the election of a new president. Battle lines have been drawn, as analysts and politicians increasingly denounce wealth accumulation, consumer culture, black empowerment for some at the expense of the many. While social grants have been boosted to R70 million a year, and reach ten million of the poorest people, and while the transition from apartheid author-itarianism to a decent democracy, from crude group exploitation to affirmative action, black economic empowerment and significantly improved welfare pay-ments continues to generate a powerful social impetus, shifts towards the deifica-tion of personal wealth and unrestrained free market capitalism have begun to result in a growing rebuke of the greedy. As Johannesburg's black middle class rapidly outgrows its white counterpart, urban teenagers now represent a con-sumer base that spends R6.4 billion a year. This is a result in part of the immense

coincidence of the end of apartheid and the rise of globalization, new media cultures and cultures of consumption. The power of this concatenation of forces, political, cultural and economic, and the velocity with which it has engendered change on a national level, is patently clear.

Where does all this leave the cultural critic and, more specifically, the work of this chapter? The first task is to be able to account for, by attending closely to, the rapid pace of change amongst contemporary urban youth cultural forms. Too often, academic critiques of commodity culture and the inequities bred by globalization miss the cultural shifts that commodity-based formations signify, their growing intra-class dimensions, and their manipulation of surfaces, long disfavoured by a scholarly establishment accustomed to reading for depth. I attempt to do that here. Secondly, it is in the nature of such work that its subject is constantly changing. Thus, as Y/loxion culture evolves in time, it may well lose some of its initial potential and edge. As it becomes increasingly commercialized, as the ads that have appeared in its wake suggest it will, it may indeed take on the vacuousness of much commodity culture around the world. What I try to do here, though, is to capture a moment in which it seems to me to have spoken in powerful terms about, and contributed to, a culture in transition. It inhabits, if on terms quite different from those examined in earlier chapters of this book, a rubric of entanglement insofar as it emerges from a context in which school kids in Johannesburg increasingly attend racially mixed schools and which steers a cultural and often market-driven course which is necessarily cross-racial. This is notwithstanding the fact that it is shaped specifically by the increasing social and cultural power of the black body in this city. Nor do such forms of entanglement explored below belie the need to remain cognizant of the political ramifications of work such as I undertake here, as a global crisis rises in which the rich get richer and the poor poorer. The argument is that we need the analytical tools to read the cultural forms of a younger generation which increasingly rely on terms and dimensions not available to an earlier generation.

Y Culture, Johannesburg Circa 2006

Y Culture was first launched by a radio station called YFM, today South Africa's largest regional station, beamed over the airwaves from Johannesburg to nearly two million listeners. The station was set up in 1996. Its primary audience was young, mostly black people, who tuned in to hear a mix of popular, mostly local, music. When democracy came to South Africa in 1994, there was nowhere, on the AM or the FM dial, for the majority of the country's young people to gather, no airspace dedicated to them. The South African Broadcasting Corporation (SABC) had a spare frequency, which it handed over to the team that would eventually found YFM. Stringent conditions were attached: the station would only be granted a license if 80 per cent of its capital was black-owned, 50 per cent of its staff was

female and, within three years, at least half its play-list was made up of South African music. The station was to be a multi-lingual, urban entity that informed, educated and entertained a young audience. All of this was well in line with the founding team's goals. YFM, says general manager Greg Maloka, was to be a 'phenomenon … for us and by us. We saw [its creation] as another June 16, 1976,' he adds, alluding to the spontaneous uprising of tens of thousands of children and adolescents in Soweto, a massive call-to-action against the apartheid state which marked the beginning of the end of the white regime. Twenty-two years had gone by. Apartheid was officially dead. Suddenly, 'the youth market' was all the rage (see McGregor, 2005).

YFM launched *kwaito*, South Africa's first globally recognized local music form, a potent blend of city and township sound that emerged after the democratic transition in 1994, mixing the protest dancing and chanting known as *toyi-toyi* with slow-motion house, local pop (known as 'bubblegum'), and a dash of hip-hop. In 1998, the station spawned a print spin-off, *Y Magazine* (or *YMag*). Making use of state-of-the-art branding techniques, the magazine associated itself closely with both YFM and *kwaito*. Its tagline, prominently displayed on the spine of each issue, is an anthem to the art of being in the know – hip, cool, plugged in: 'Y—Because You Want to Know.' The same is true of the name chosen by the company that owns the publication, YIRED, a play on notions of being young and 'wired' – up to date and connected in all the right places. In 2002, the YFM stable launched a fashion label called Loxion Kulcha.[2] 'Loxion' is an SMS-type contraction of the word 'location', a synonym of 'township'; 'Kulcha' is an ironic deformation of the word 'culture'. The brand name invokes a remixing: an infusion of black township culture, long kept at a violent remove from the urban centre, into the heart of the (once white) city itself. In *YMag*, Loxion Kulcha is described as a 'pride-driven line', a 'brand born of the YFM era', one that remixes African-American styles to its own purposes and in ways that speak to its own, particular cultural precursors (Mtsali, Masemola and Gule, 2000, p. 61). Its designers, Wandi Nzimande and Sechaba 'Chabi' Mogale, are 'typical generation Yers, children of the 1980s who are old enough to understand what the political fuss [of the apartheid era] was about, yet young enough to keep an open mind [to the present and future]' (p. 62).

Y Culture is located most visibly in an area called The Zone, in Rosebank, a residential neighbourhood-cum-business district that has been attracting a young hip workforce since the 1980s thanks to a concentration of information technology, travel and tourism enterprises, retail and fashion outlets, cinemas and restaurants. Increasingly, to serve this young workforce, a process of infill has occurred, in which shopping complexes expand by incorporating spaces and structures that predate them. The Zone – home to the YFM studios and to shops showcasing Loxion Kultcha and related fashion labels such as the popular Stoned Cherrie brand[3] – is one of these infills. Here, enclosed shopping venues and open areas are linked by indoor and outdoor 'roads', in an approach to architecture that, as one critic observes, turns the notion of public space inside out (Farber, 2002, p. 73).

In the Zone, yellow and blue neon tubes, glitter tiles, columns clad in reflective aluminum, and exposed steel trusses give it an industrial look that combines elements of the factory and the club. As one makes one's way through its spaces, one is struck by their fluidity. Distinctions – thresholds – between public and private, pavement and mall, inside and out, seem to fall away. The Zone's indoor roads sometimes feel like catwalks – and at others like a state-of-the-art gym (television screens hang over the walkways). Throughout, surfaces (shiny, mirror-like) and colours (an energetic metallic grey flecked with primary colours) differentiate the space from the neutral beige found in the city's other shopping centres.[4] Wherever possible, the Zone's architecture maximizes the intersection of gazes: people on the escalators produce a spectacle for diners seated at strategically located restaurants; the main indoor roads function simultaneously as means of access and vantage points; signifiers one would usually rely on to orient oneself outside (street signs, for instance) are re-appropriated to define interior spaces (Farber, p. 87).

As a locus of social interaction, The Zone is complex. On the one hand, as a privatized public space, it speaks of exclusion: though it is possible for poorer citizens to come to the Zone, they are not welcome there.[5] At the same time, it is one of Johannesburg's relatively few up-market open spaces where some manner of the unexpected is possible: theatre, mime, and dance groups perform here, parades are organized, and people come from all over the continent to trade in a large African craft market located near its entrance. The Zone is by no means a place of extensive social mixing. Heavily regulated and subjected to close scrutiny by expedient mall governors, the craft market at its door underscores this. Still, as a result of its presence, there is a sense here of broader horizons: a young person (or anyone else) walking around The Zone circulates within an imagined Africa much larger than Johannesburg alone.

Thus, despite the influence on it of American models of mall design and commerce, the Zone does not yet display the nihilism that characterizes consumer culture in the United States – an approach to selling 'style' and 'individuality' in which each customer is pegged to a specifically managed and increasingly reified identity. This in part is due to the still recent emergence of the black body from its history of 'invisibility' under apartheid – an 'erasure' from the city which Y Culture, in certain respects, seeks to recall, but that it is largely bent on transforming – and to the relative fluidity with which black middle-class culture locates itself in the urban matrix after a long period of exclusion. Elaborating on this point, we could perhaps also argue that under apartheid, black people faced the oppressive binaries of either being made entirely invisible – or being made hypervisible. It is this hypervisibility which Y culture, but especially the advertisements I discuss in the second part of this chapter, works with, and parodies.[6]

The Zone, as well as housing smaller fashion outlets like the Stoned Cherrie brand store and Young Designers Emporium, is home to the ubiquitous mall chain stores. Among these are Exclusive Books and CD Warehouse. Both are found at shopping arcades throughout the city and in urban centres across the country. At this particular branch of Exclusive Books, the bestsellers are not what they are

elsewhere. The books that sell the best in most Exclusive Books locations are by pulp US authors like John Grisham and Dan Brown. In The Zone, they take second billing. The top sellers are Niq Mhlongo's *Dog Eat Dog* (2004) and Phaswane's Mpe's *Welcome to our Hillbrow* (2000). The first is the story of a young Sowetan trying to hustle his way through Wits University, long a bastion of white education; the second is a tale of xenophobia and AIDS in inner city Johannesburg. The Zone branch of CD Warehouse also differs from its sister-stores elsewhere in the city. It carries a prominent and exhaustive range of kwaito cds as well as some of the best sounds from the continent and black America. Next to CD Warehouse is the YFM internet café and the Y-Shoppe, where local designers showcase their work and whose designs generally invoke the city by name or image, draw on puns or pastiches of the past and play with the 'Y' logo.[7] The shop leads to the heart of the radio station, the Y Studios, a slick, black-lined maze of sound-proof booths. Through large windows, one can see DJs at work creating the Y sound at banks of sophisticated equipment. The DJs themselves are young, glamorous, mostly black-skinned and black-clad (see McGregor, 2005).

Remix

Y is a hybrid phenomenon that appeals to young people across borders of class, education, and taste. Key to its success in this regard is a dual remixing it effects – of the township and the city and the township *in* the city. The young designers who launched the Loxion Kulcha label are incarnations of this intra-culture. Wandi styles himself a *kasi*, or 'township boy', Chabi a *Bana ba di Model C* (a 'Model C kid'). As such, they represent the remix at work in the making of Y. A *kasi* is typically someone who grew up in a black township, a world often associated with poverty, crime, overcrowding and lack of resources. At the same time, while this is indeed the environment in which Wandi was raised and which he references in speaking of himself as a *kasi*, the word today has acquired so many connotations that it can now stand alone, quite apart from location, to imply a certain way of life. Chabi's take on himself tells of a different world. When the South African education system was first integrated post-1994, privileged schools in formerly white, bourgeois neighbourhoods opened their doors to black students. These schools were classified as 'Model C' establishments. Though the term is no longer used as a formal education category, over time it has acquired a meaning of its own. It refers to black high-school students who have taken on a cross-racial style and social set.

Loxion Kulcha's intra-cultural success is less a matter of appearance than a matter of branding. The point may be to bring the township into the city, and cultural knowledge of where 'township culture' is heading is certainly at the heart of what makes Wandi and Chabi hip, but Loxion Kulcha is not about spreading a 'township look'. The label – the brand, explicitly set forth and marketed with brio – is the thing here, as Mpolokeng Bogatsu (2003) quite accurately points out. This

privileging of brand over look simultaneously reflects and shapes structures of class and race within the city's emergent youth culture.

Although Loxion Kulcha's market is intra-class (to the extent that it encompasses both city youth and those living in generally lower middle class township homes), sartorial markings are often seen to reveal sharp distinctions between Zone kids (well-to-do young people who make a habit of coming to Rosebank) and township kids, who do frequent the Zone, but do so to a far lesser extent and are not particularly welcome there. Rocking the brand is good, essential even, but it doesn't occult where you come from. Young people interviewed in the Zone make this quite clear: 'Township girls,' says one, 'wear Rocabarroco [brand] shoes that are square-shaped with laces. … They will wear bright [coloured] jeans with a collar-type shirt. A Zone kid will wear [blue] jeans and a nice [read hip, collarless] top.' Another glosses this as: 'They dress similarly, but you can tell them apart. Model C girls have an air of sophistication, whereas township girls could snap anytime.' Some interviewees focus less on sartorial differences than on skin color. This they do, however, in ways that stand at a distinct remove from earlier, pre-94 discourses of race and, by extension, class. Notes one young Zoner: 'In our generation, we all kind of dress the same. Some blacks dress outrageously wrong and some whites do too, but we all wear the same things. If you check around, you can't notice a difference between whites and blacks here, apart from the colour of their skin' (Farber, pp. 11–16). Difference is still located on the skin, as colour, even as skin colour becomes less determined within this sartorially inflected set of practices and signs.

The foregoing underscores the fact that racial identities emerging from Y/ loxion culture are new in relation to the apartheid era legal classification of people as 'White', 'Black', 'Indian', or 'Coloured'. These categories operated on an everyday basis through processes of urbanization, policing, and the manipulation of cultural difference to political ends. Since 1994, when this system was officially abolished, young people have occupied these categories in changing ways, using them to elaborate shifting identities for themselves in the new, 'postracist' dispensation. Nadine Dolby (2000) argues that 'taste' at times comes to displace orthodox constructs of race and culture as the carrier of social distinctions amongst urban school-going youths – this as popular culture comes to increasingly contest the church, family, and neighbourhood as the primary site where racial identities are forged. The criteria that define bodies, clothing, and culture as 'White', 'Coloured', or 'Black' are not stable, as fashion and music tastes undergo one metamorphosis after another. Class dynamics work into the constitution of racialized taste patterns, at times taking on charged connotations despite constant style fluctuations. What is clear is that new youth cultures are superseding the resistance politics of an earlier generation, while still jamming, remixing, and remaking cultural codes and signifiers from the apartheid past.

How these codes are re-appropriated and transformed makes for fascinating cultural (and business) practice. Stoned Cherrie, one of the most popular fashion labels at the Zone, puts signs of the past to striking use. Notably, it recycles images

of boxing champions, beauty queens, and musicians from *Drum*, a politically engaged magazine for black readers popular during the 1950s, integrating them into contemporary fashion styles. *Drum* was associated with places like Sophiatown, the heart of Johannesburg's counterculture in the 1950s. It courted and actively constructed an expressly cosmopolitan target audience, 'the new African cut adrift from the tribal reserve – urbanized, eager, fast-talking and brash' (Nkosi, 1983). Stoned Cherrie's designs speak in several registers. In part they play on the taste for 'retro' (a current global trend in styling), by drawing on 50s imagery – imagery for which *Drum*, a showcase for some of the best urban photography in South Africa, is a particularly fruitful source. At the same time, they make extensive use of parody, as they brand unquestionably dated, *vieux jeu*, images onto mass-produced T-shirts. Retro and parody, in turn, combine to invoke nostalgia for 'the location'. Emblematic figures of Johannesburg's mid-20th century past – *pantsulas*, the 'bad boys' of the 1950s; migrant and blue-collar workers; black cover girls whose very existence and whose sophistication stood on its head white culture's claim to superiority [8] – are re-created, brought to life anew and remixed, in Loxion Kulcha. This past, recalled and re-worked, is in turn cross-pollinated with references to African-American culture(s) and styles. In an analysis of how Loxion Kulcha remakes township culture and, more specifically, blends *pantsula* and African-American street culture styles, Nthabiseng Motsemme (2002) shows how *isishoeshoe* and *iduku* (shoes and headcloths worn by black married township and rural migrant women employed as domestic workers in the city during the apartheid era) have been recaptured, reinterpreted, and transformed into iconic fashion items on display in Rosebank. The point, here, is not a political one – not, in any event, in the sense that resistance movements to apartheid understood the term. There is no real (or intended) engagement here with the horrors of the pre-1994 past. This is underscored by another Loxion Kulcha product: a recent line of low-cut, tight-fitting T-shirts on which liberation theorist and apartheid martyr Steve Biko's image and name appear in a brilliant, stylized red.[9] It is not so much the Black Consciousness message spread by Biko that is being commemorated here, although 'BC' still has a broad resonance for young people only vaguely aware of its message. Rather, something different is being introduced: a sartorial style is being marked as an in-your-face contemporary phenomenon through the remixing and recoding of an icon.

While township culture and identity have existed as long as the townships themselves, it is the *performance* of township culture that has emerged with new vigor in the contemporary context. 'Like kwaito music', writes Bogatsu, 'Loxion Kulcha claims the streets of South Africa's townships as its cultural womb but occupies the centre of the city with its new forms' (p. 14). Township culture is translated from a socio-economically stagnant into a high-urban experience. The latter gives rise to what is increasingly known as 'Afro-chic'. A case in point: in the 2000–2002 Loxion Kulcha collections, overalls were big. Mostly, they were single-colour outfits, inspired by the work clothes of migrant labourers and miners. Their design was similar to that of *mdantsane*, two-piece cover-alls consisting of pants and a zip-up

jacket generally worn by workers on a factory assembly line or by miners in a shaft. Unlike the protective garments on which they were modelled, however, the LK pieces emphasized bright, eye-catching primary colours. The utility-oriented, mass-produced overall was made chic, appropriated with great success to new cultural ends.

Here too, class and race, re-thought Y-style, emerge as key concerns. In LK's designs, the township is referenced – gestured to explicitly – yet, in the same breath, cast aside. To sport LK gear is to say one wants out of (or to brag that one has definitely left behind) the location. An insistence on staying in the township, Bogatsu notes, is increasingly marked within Y Culture as a self-defeating show of 'negritude' (p. 21); wearing LK's flash-in-your-face overalls makes it clear: this is emphatically not how you plan live your life. You have no intention of toiling the way your parents did. The economic violence done them is not forgotten, but neither is it openly critiqued. Instead a largely uncritical celebratory focus is placed on the city's burgeoning service economy. LK's overall becomes the signifier, worn with pleasure and pride, of a young workforce whose members labour as waiters and shop attendants in the Zone, becoming both providers for wide family networks and, when off duty, consumers who buy clothes and music in the area and hang out in Rosebank's many clubs.

A stylistics of sensation

Turning to a series of images from *YMag*, we can see how Y Culture signals to, but increasingly breaks with, the past in its adoption of an elaborated stylistics of sensation and singularization. A cover image accompanied by the words 'Kwaito-Nation' reveals a striking example of the foregrounding of the capacity for sensation, of the new investment in the body's special presence and powers, and of the ascendancy of the sign of blackness. Here, selfhood and subjectivity can no longer be interpreted as merely inscriptions of broader institutional and political forces; instead, the images project an increased self-consciousness of the fashioning of human identity as a manipulable, artful process.

Representations of the self as an expressive subject have for some time been seen by scholars to signal a subject that is fractured, multiple, shifting, and produced through performativity (see Butler, 1993, 1999). What loxion kulcha's image-texts emphasize, by contrast, are practices based on specific aesthetic values and stylistic criteria and enabled by various emerging techniques of the self (Foucault, 2001). The *Y Mag* 'Kwaito-Nation' cover image bears this out, as do others published of late by the magazine. It shows sixteen *kwaito* artists. All are black men, and all are dressed in black, with one or two white shirts showing underneath. The emphasis is on the glamour and style of blackness, reflected metonymically in the color of the clothes themselves. In a fashion sequence six months later called 'Angel Delight' the theme is the color white, and the shoot is dominated this time by women but also by a cross-racial group: white and Coloured women are foregrounded, and cross-racial and cross-gendered sexual desire is clearly being played

with in the image (*Ymag*, Oct–Nov 2002). Here, then, is a quite different version of *Y Magazine*'s projected reader, and this difference is part of a broader remixing of identity, including racial identity, in a shifting signifying chain.

The identities and forms of selfhood projected here are compositional. The self in this instance is above all a work of art. So too are the stylizations of the self projected in the magazine's images based on a delicate balance between actual emerging lifestyles of middle-class black youth and the politics of aspiration. An exchange in the letters-to-the-editor column in the June–July 2002 issue underscores this: 'After reading Y-mag for a while now I've concluded that it would appeal more to the "miss-thangs" and "brother mans" living or trying to live the so-called hip life in Jozi. Some of us live in different areas in the country and you only portray a certain kind of youth. The rest of us then feel like the odd ones out, making us feel like aliens or something. Please broaden your scope so that most people can find it appealing, not just those who live in Jozi.'[10] The editors' reply follows: 'We are all aliens if you think about it, depending where you come from. But seriously, though, Y-mag is for you. *Y-mag doesn't necessarily portray reality as each of us would see it, that is, we're aspiring as well* [my emphasis]. We obviously can't reflect every kind of person under the good sun but every young person can and will find at least one thing they like inside Y-mag' (*Ymag*, June–July 2002, p. 12).

In acknowledging that their product is made for those who aspire to (but cannot necessarily claim) hip, cutting-edge, largely middle-class lifestyles in the city, the editors signal a potential 'gap' – a gap of potential – between what is and what could be. The present and the possible interlace to form a stylistics of the future. We could also draw out this idea of a gap from the words of one young South African whom Tanya Farber interviewed in the Zone: 'We understand where we come from, but I am not interested in politics and about what happened in the 80s because I wasn't there. And even if I was, I live for the future' (p. 28). Since this interviewee is in his early twenties, he was in fact 'there' in the 1980s, during the worst of the apartheid struggle and the height of the resistance to it. Indirectly acknowledging this by his phrase 'and even if I was,' he nevertheless insists on the fact that his project and investment lie in a search for the future. His words, we could say, mark him as a public representative of 'the now' in South Africa, as he signals the remainders of the past but also speaks the future-oriented language of Y-Gen aspiration.

Y Magazine, in naming a subject who aspires, also draws consumers into a competitive system in which not everyone can have what he or she aspires to. In *Lifebuoy Men, Lux Women* (1996), Tim Burke, one of the few theorists of African consumer culture, points to pitfalls inherent in such processes. As the pleasures of consumption in the 20th (and 21st) century have become increasingly and explicitly tied to satisfaction of the flesh and its needs, he asks, have we not perhaps made too much of the body as a unique site for the elaboration of forms of self-stylization? And in so doing do we not 'risk separating individuals from their bodies, seeing, for example, the bodies of women as separate from the selves of women'? This, of course, is not a specifically African phenomenon. Chakrabarty is similarly concerned with

the gap between body and self that a culture of commodification would seem to imply: the commodification of culture as lifestyle, he argues, can never completely encompass the life-worlds upon which it draws. On the one hand, it requires a suppression of embodied idiosyncrasies and local conjunctures, but on the other it needs the tangibility of objects and people, a 'corporeal index', as Beth Povinelli (2001) puts it, to lend credibility and desirability to its abstract claims. Thus Chakrabarty draws attention to the gap at the heart of the commodity form, caught as it is between embodiment and abstraction.

Yet the making of the contemporary self is not so easily readable in the self-representations and subjective practices, the powerful parodic languages, the processes of self-styling in which the body plays such an important part – in the seductive 'surface forms' of youth culture Critics generally disavow the 'surfaces' of youth culture as an insufficient analytic space. (see Jean and John Comaroff, 2001) Yet, arguably it is here, on the surfaces of youth culture, that we come most powerfully to encounter the enigmatic and divergent ways of knowing and self-making that mark its forms. Pursuing the surfaces of cultural form implies a reading, however, that positions itself at the limit of the by now ubiquitous cultural analytic notion of translatability:[11] it demands that we push beyond the dual notions of 'reading' and 'translating' to 'understand'.

Mind the Gap

A conventional reading of Y Culture would rely on tropes of translatability – and indeed the latter can take us quite far into the analysis of this cultural form. The cover stories of *Y Mag* signal a transnational, multilingual hybridity which a focus on translation goes a long way toward explicating. The title 'Skwatta Kamp: Hard to the Core Hip-Hop', for example, suggests the influence of American hip-hop on the local scene (Skwatta Kamp is a local rap group), even as it invokes the local topography of the squatter camp – the ubiquitous sign of homelessness and poverty in urban South Africa (*Ymag*, Aug–Sept 2002). 'Vat en Sit: Shacking Up in Y2K' explores how young black South African couples flout older orthodoxies of sex and marriage; it draws simultaneously on the Afrikaans expression *vat en sit* ('take and live with', a colloquialism used by black migrant workers who would meet and live with women in the city despite having a wife in the rural area or town they came from – a practice of which both women were often aware) and on the English word *shack* (used to denote the makeshift quarters of the poorest in South Africa's townships and squatter camps) (*Ymag* June–July 2002). 'The Colour of Music: Whiteys and Kwaito' signals an interest in and a projection of crossover cultural and racial cultural codes in postapartheid South Africa, as does 'Darkies and Ecstasy: Is it the New Zol?' (*Ymag* Feb 2000).[12]

Translatability and multilingualism are built into the text of *Y Magazine*. This is less visible in the body of the text, as the main articles are written in English, than in the interstices. It is in the in-between spaces – the soundbites, the gossip pages,

the reviews – that language emerges most forcefully as a locus for practices of translation. Acronyms, wordplay, colloquialisms, and 'deep' meanings are some of the devices drawn on within the culture of translatability at work here. A review of a new CD release by local kwaito act Bongo Maffin reads, in Zulu, *Aahyh, Ngi yai bon 'indlela en'ibalwe BM* ["Ah, I see the road and it says BM (Bongo Maffin)"]. (Nappy Head, 1998) The phrasing plays on the widely admired style and road performance of BMWs, and also recalls a classic of South African music, Dorothy Masuka's classic 'Imphi indlela' ('Where's the road / the way').[13] The same review then shifts from Zulu to Tswana: *Kego tsaela 99, Bongo Maffin ifhlile* ['I'm telling you straight up, Bongo Maffin has arrived'].

These shifts in language and frame of reference question standard notions of location and publics. They show us that the 'world' appears increasingly as a set of fragments, bits and pieces with which young people grapple. Sutured onto these bits and pieces are the histories of isolation from, and connection to, the world that South Africans carry.[14] These fragments come to be refracted in ways that produce resemblances across different signs and languages between signs – what Achille Mbembe (2002) has referred to as 'the powers of the false' (p. 14) – revealing the ability of Africans to inhabit several worlds simultaneously. As these fragments and their multiple meanings travel they also encounter resistant edges, and in Y culture one of these edges is the sign of black America. As Y youth come to inhabit a culture of selfhood shaped in part by African American hip-hop culture, they also rebel against it, resulting in a form of pastiche. A cut-and-paste appropriation of American music, language, and cultural practices is simultaneously deployed and refuted. An example of this can be found in the self-styling of Trompies, a kwaito group that epitomizes the contemporary version of *mapantsula*. The group is now sponsored by FUBU (For Us By Us), an African American clothing label often worn by US rap artists. In the June–July 2000 issue of *Y Mag*, Trompies is accused of making a 'fashion faux pas', since they call themselves *pantsulas* yet adopt a hip-hop style (Mstali, Masemola and Gule, *Ymag*, 2000, p. 19) At the same time, it is also acknowledged that the 1950s *pantsula* culture emanated from America. Although the black American is embraced as a 'brother', the *Y* reader does not want to be assimilated into his culture (Masemola, 2000, p. 47)[15]

Tropes of translatabilty can reveal much, then, about the workings of Y culture – but they can only take us so far. The idea of (cultural) translation relies, like the theorizations of Burke and Chakrabarty discussed above, on an idea of 'the gap'. Increasingly, however, scholarly work on the technologies of public forms, including popular cultural forms, has tended to move toward a focus on circulation and transfiguration, replacing or at least complicating earlier preoccupations with meaning and translation. As analytic vectors of the social, the latter rely on methods of reading derived from the tradition of the book, a tradition that stipulates that a cultural text be meaningful – 'that it be a text and confront us as a text whose primary function is to produce meaning and difference and to captivate us in the dialectic play between these two poles' (Goankar and Povinelli, 2003). Such a tradition, moreover, implies a theory of translation grounded in the question of

how to translate *well* from one language to another, as meaning is borne across the chasm of two language codes. Once we set foot in a 'terrain of chasms and gaps' as Gaonkar and Povinelli note, 'we are swept up in the maelstrom of debates about incommensurability, indeterminacy, and undecidability in translation': translation is seen as a productive failure (p. 388). Rather than, or in addition to, asking what happens to meaning as it is borne across languages, genres, or semiotic modes (to 'read for meaning'), we might ask what movements of cultural form and techniques for mapping them appear in worlds structured increasingly by cultures of circulation. In other words, as Gaonkar and Povinelli so usefully put it, we need 'to foreground the social life *of* the form in question rather than reading social life *off* it' (p. 394).

Such an approach proves particularly productive in understanding Y/loxion culture. The latter is a cultural form which cuts across sound, sartorial, visual and textual cultures to reveal a process of 'compositional remixing'. In this setting, processes of circulation, parallels and slippages between genres, play a fundamental role. In the reviews pages of *Y Mag*, crossover styles are elaborated so that a sound might be used to describe an image, or an image a word, or a clothing line a taste. 'His writing is reminiscent of Tracy Chapman's singing', writes one book reviewer (Davis, 2000, p. 130). Another describes a book by way of allusion to a TV chat show (Gule, 2000, p. 89). A review of a CD by Thievery Corporation in Y's sister magazine *SL* references fashion to describe sound: 'Picture some cool geezer in a black Armani shirt, grey slacks, and DKNY sandals, smoking a doobie like a zeppelin. That pretty accurately describes the sound of Thievery Corporation' (Campbell, *SL*, 1999, p.105).[16] Thus the processes of self-stylization that emerge from *Y Mag* further accessorize a range of cultural texts that, reframed within crossover media forms, become elements in the aestheticization of the self.[17] Race, especially blackness, as it plays out across these surfaces of form, itself becomes more of a mutating formation than before, less a finished and stable identity than something open to transformation, even proliferation – a phenomenon that actively resists attempts at reading or translation.

Revisiting the Analytics of the Gap

I turn, now, to a second set of cultural texts, a series of advertisements which have appeared since 2005 both in *Y Mag* and on billboards around Johannesburg. The ads elaborate on the cultural opening that Y Culture has provided, particularly in relation to the prominence given to 'style' in the making of contemporary identity in the city. They take up notions of self-making and stylization in order to deconstruct South Africa's racial past – and they do so through an attempt at beginning to define notions of the 'post-racial'.[18] Drawing on the enormous popularity of Y Culture itself amongst young South Africans, they use irony and parody to work even more specifically and provocatively than *Y Mag* and its related brands have in the past with questions of race. A mix of image and text (a point I return to later),

Figure 18.1 Advertisement for a brand of sports shoes called K-Swiss, an American make recently introduced in the South African market. Reproduced by courtesy of K-Swiss, South Africa

the ads emerge as important sites for reading the South African 'now' for they just begin to make explicit ideas and passions that are 'out there' in society, and therefore have an articulatory function – a function that palpably affects life worlds. Each of the advertisements can be thought of in terms of the commodity image. The latter, as William Mazarella (2003) reminds us, can be theorized as a compelling point of mediation between culture and capital and as an index of wider transformations within the field of public culture. The commodity image is at once a flashpoint for the key ideological issues of the day, a rendering of national community as aesthetic community, and, conventionally at least, a vector of cultural difference offered up for consumption.

The first two advertisements are for a brand of sports shoes called K-Swiss, an American make recently introduced in the South African market. The first is filmed against the backdrop of what was formerly a lower middle-class section of Johannesburg and is now a mixed-income neighbourhood (Figure 18.1). Though the neighbourhood is not identified, it is in all likelihood Brixton, a part of the city popular among a certain set for its 'retro' look. The ad shows a person in the process of being arrested by the police while others look on. The people on the street stand beneath a sign that says 'Whites Only'. The scene is an explicit allusion to a widely known genre of image: an urban scene typical of 1970s South Africa,

Figure 18.2 Advertisement for a brand of sports shoes called K-Swiss, an American make recently introduced in the South African market. Reproduced by courtesy of K-Swiss, South Africa

depicting a black man being arrested on grounds that he is not carrying a 'pass' to legitimize his presence in the city. The image relies on both irony and parody to achieve its effect: it is not quite what it seems. The crime that the man being arrested has committed, it turns out, is not a 'pass' but a 'style crime': he is not dressed properly. Specifically he is not dressed in the colour white; most egregiously, he is not wearing the white sports shoes that are being advertised. The image works on many levels: it suggests that the greatest crime is now a 'style crime'; that whiteness (and therefore blackness) is a matter less of race than of style; and that style is itself a cross-over phenomenon, working across race. It also comments on the style pecking order in contemporary urban South Africa: in the style stakes marked out on the street, the average white guy languishes at the back; next comes the black woman; coolest of all is the black man, shown here sporting a 1970s (now retro-cool) Afro hairdo and a body language that suggests cultural confidence and hipness as well as street credibility. In general, the ad plays with the notion that the way you look – the way you dress – defines you as 'in' or 'out', legal or illegal, official or unofficial: it insists on self-styling as a critical mode of self-making.

The second ad in this series works on the same principle: the past is acknowledged but ironically recast in the post-apartheid present (Figure 18.2). Here, the scene is a men's urinal. One man is cleaning the floor while others make use of the

urinal. We might recall that under apartheid the spaces of segregation included macro-spaces such as schools, churches and cemeteries, but also, importantly, micro-spaces, which functioned as key loci for the staging of humiliation. One such locus was the 'whites only' urinal, which a black man could enter under one condition only: to clean it. The image with which we are concerned gestures to that past and its legacy in South Africa's collective memory, but with a twist. The men using the urinal are both black and white. What differentiates the users from the man cleaning the floor is not skin colour but the colour of their respective clothes. The users are dressed in the 'sign' of whiteness, white clothes, and more specifically white shoes; the man cleaning the floor is *not* wearing the right shoes – he is badly dressed, the ad suggests, out of style, unwilling or incapable of playing the market to project a particular (life)style.[19]

The adverts were launched in 2004. South Africa was celebrating its first ten years of democracy and the company wanted to run a campaign that spoke to this particular context. The target market K-Swiss was aiming at was 14–26 year olds: young people whom market research showed were increasingly thinking and acting in a cross-racial manner. The ads had been a success with this group; surveys showed that young people found the ads clever and 'funny' (the only group who were not amused, he added, were 50–65 year old white Afrikaans men).[20] They were based on market research showing that whereas South Africa was once the ultimate signifier of race difference, the situation is now much more striated and complex. A recent survey released by the Human Sciences Research Council shows that, in 1997, 47 per cent of respondents described themselves in terms of racial categories. By 2000, the figure had fallen to only 12 per cent (in the same period, references to gender- and class-related identities declined, while allusions to religious identity increased). What had been a fairly limited and predictable set of self-descriptions had given way to what the authors of the survey termed 'a whole range of individual, personalized descriptions' (Klandermans, Roefs and Olivier, 2001) Another survey, 'TrendYouth' (2005), which focused on black and white youth from emerging and affluent households in major metropolitan areas (and which included 2400 face to face interviews and 30 focus groups), shows clothing brands to be the main ingredients in the development of a 'new and clearer South African identity' and notes that the country's 7–24 year olds 'are the most racially integrated [group] in the country, with friendships now based more on shared interests like music and fashion than on skin colour'.

The K-Swiss ads underscore, on the one hand, that the cross-racial lifestyles of urban youth today, while strikingly different from those one might have encountered 20 years ago, still cite (or quote) a racially segregated past that remains in the collective memory; on the other hand, they reveal that, increasingly, 'desegregation' takes place under the sign of a reinscribed 'whiteness', this time elaborated around social class rather than race. Formerly, the ads state in no uncertain terms, you had to be white to adopt a particular lifestyle; now you have to know how to be stylish – stylish, that is, by K-Swiss' standards. What they don't say but of course imply is that you no longer have to be white, but you do have to be middle class, or at least you must find the money to buy products such as those celebrated in the

ads. Increasingly in fact young people who are not middle class are buying *fong kong*: fake products available especially in the inner city which are cheaper versions of Y or loxion cultural style, this is enabling them to circumvent some of the restrictions of class and economic status.

Two further images, forming a paired advertisement, play on similar notions. Both are close-ups of men's faces, one black and one white. Together, they suggest a message that is at once subjective and 'in your face'. The visuals in the ads depend for their effect on the verbal text that accompanies each image, making the meaning of the paired images explicit and, again, distinctly 'in your face'. The text in the first ad reads:

> I HATE BEING BLACK. If it means some people think that they know my criminal record. My rhythm. My level of education. Or the role affirmative action has played in my career. I'm not someone else's black. I'm my own. And I LOVE BEING BLACK. (Figure 18.3)

The second text reads:

> I HATE BEING WHITE. If it means some people think that I'm not a real South African. That I'm racist. Privileged. Paranoid. Or Baas. I'm not someone else's white. I'm my own. And I LOVE BEING WHITE. (Figure 18.4)

Taken together, these ads suggest an imperative that is both anti-racist ('I hate being black'; 'I hate being white') and pro-race ('I love being black; 'I love being white'). The message they project is that the fact of being white or black becomes banal, that older meanings can be erased or evacuated in order to be able to inscribe onto the words 'black' and 'white' whatever meanings one wishes. Yet in the ads themselves, the racial habitus remains – at the same time as, socially, culturally and politically speaking, there are now more possibilities for entering new racial spaces. While these ads appear to rely on the texts for their impact (as I first suggested above) – to domesticate the visual, as it were – one could also note that a visual medium itself is being used here to critique conventional notions of the image, to show the extent to which we rely on the verbal to narrate and explicate the visual.[21] Thus the ads stage a fascinating engagement with the nature of contemporary visuality.

As I remarked above, all of the ads aim to work towards what one could tentatively term 'post-racial' configurations, while also revealing the complexity of this task. The difficulty of it all is underscored by a striking feature of the adverts: they can simultaneously be seen to move beyond and to reconfirm the power of race in the contemporary public sphere of the city. A fine line is involved. The ads attempt to 'soften' race and class difference by invoking the powerful notion of style and in particular self-stylization. Working with the idea that 'everyone' wants to be stylish – to wear good shoes, for example – the ads undercut a more 'antagonistic' reading of race and class difference. As we have seen, they rely for their effect on citation or quotation of historical, political context. Simultaneously, they tap into deeper issues at stake relating to the psychic life of things. That is, they tap into the

Figure 18.3 I HATE BEING BLACK. Two images, forming a paired advertisement (see Figure 18.4), play on similar notions. Both are close-ups of men's faces, one black and one white. Reproduced by courtesy of The South African Breweries Ltd

Figure 18.4 I HATE BEING WHITE. Two images, forming a paired advertisement (see Figure 18.3), play on similar notions. Both are close-ups of men's faces, one black and one white. Reproduced by courtesy of The South African Breweries Ltd

place things occupy in a given historical moment, what desires they organize, what fantasies they provoke, via what epistemologies they are assigned meaning – or, as Bill Brown (2003) puts it, how they represent us, comfort us, help us, change us (p. 12). The psychic life of things activates deep impulses of desire which are commonly shared beyond race: it is these that the ads seek to draw out, rather than relying on less sophisticated technologies of race and class. The shift is made from a form of crude governmentality so characteristic of the apartheid period to a different sort of social potency, which displaces the terms of recognition. Earlier in this chapter I considered some of the limits of a theory of 'the gap'. What these ads return us to is not only the gap of the social, which middle-class commodity cultures rely on in the very moment of aiming to bridge the gap of race, but also how the gap (of desire) is continuously reconstituted at the heart of the commodity. For while the commodity seems to eliminate the gap, it must constantly reopen it in order to propel new desires – to sell itself.

Finally, it is worth considering the ads I have discussed above in relation to the history of consumerism and the production of the modern subject. In relation to the first, we might reflect on a long history of denial of Africans as consumers – either through their portrayal as eternally rural or as being objects of charity – that is, as receiving commodities rather than by purchasing them as modern subjects. Green and Lascaris (1988) show that early advertising in South Africa was aimed at the white settler. In the inter-war years, there was a growing American presence in the South African economy rather than growing black participation in the market. In the 1930s, ads were aimed not at the black consumer but at the 'black specifier' (the person who decides what is to be bought [for his white employer]). Also in the 30s, black job-seekers began to advertise themselves ('capable, clean houseboy, very quick and obliging, honest', read one ad in 1937). The latter implied an acceptance of race classification, but also revealed new references to education. By 1957, a personal ad in *The Star*, read: 'Situation wanted: African undergraduate seeks position as clerk, general office work'). By the late 1950s, the affordable transitor radio came to South Africa – and more and more black people made it a priority purchase. At this time, too, print media emerged aimed specifically at black readers (*Drum* magazine in 1951, *Bona* in 1956). Until the 70s, Green and Lascaris observe, a schitzophrenic marketing scene was in place in relation to black viewers, based on uncertainty as to whether a) the black consumer would respond best to ads in black media, featuring black faces and black situations, with a message which had particular relevance for a black consumer (the assumption until then), or b) would an ad aimed at an ostensibly white audience have such 'aspirational pull' that black consumers would be irresistably drawn into the target market? (p. 41). It was only in the late 70s/early 80s that marketers started to look at similarities between race groups rather than concentrating on the characteristics which divided them – with Brazil rather than the US and Europe as their case study and reference point. It was then that the cross-over market emerged with a vengeance, and a system of marketing brands no longer based on race (though still revealing, in Green and Lascaris' terms, the realities of being black, white and brown in South Africa today.

Consumerism is frequently equated with the production of the modern subject – an equal and modular citizen brought into being through the possession of mass produced goods. What seems distinctive about post-apartheid South African consumerism (though its current cross-over appeal could be seen to have taken root by the late 80s) is that it seeks to recoup the modernist moment described above but to do so through prevailing postmodern technologies – and within an active cultural project of desegregation. Advertizing, such as examples I have looked at above, emerges, then, as an attempt to give content to modernist subjectivity and to engage with ideas about citizenship – and South Africa's future.[22]

Y Culture reveals the preoccupations of increasingly middle-class young black people in Johannesburg and the intricacy of their modes of self-making. The city itself becomes the engine for this self-stylizing. I have argued that the emergence of new stylizations of the self, embedded in cultures of the body, represents one of the most decisive shifts of the postapartheid era. Integral to this shift has been the use of a range of cultural texts, which, reframed within cross-over media forms, become elements – accessories – in an aestheticization of the self.

A notion of the 'gap' remains central in cultural theory, while also testing its limits and the notion of translatability on which it relies, and vice versa. Increasingly what is needed is a theory of the circulation of forms, one which necessarily draws on technological analogies, and which is also alert to how consumer cultures (which draw on youth cultures such as Y/loxion kulcha) re-open the gap of desire. Thus we need a cultural theory of contemporary forms which takes the surfaces of form more seriously as an analytic construct, registers the limits of the gap, as well as its continual re-opening as cultural forms and consumerism draw closer and closer together.

I considered ways in which a series of advertisements take up aspects of Y Culture's increasing remixing of race and attempt more explicitly to reconfigure race along the lines of the market. The market, here, comes to the fore as a powerful vector for claiming the contemporary in a setting characterized by the emergence of a politically empowered black middle class and the presence of a substantial white minority that holds considerable economic power and cultural clout. As an earlier discourse of 'non-racialism' has increasingly shown its limits, the market begins to project ideas of race which rework that earlier discourse.[23] Now, new work needs to be done on the intersection of cultures of consumption and poverty in South Africa. There, no doubt, the 'gap' will prove more complex, more treacherous and, potentially, more productive still.

Notes

1 In his book *The Black Atlantic: Modernity and Double Consciousness* (Harvard University Press, 1993), Gilroy introduces the idea of a transatlantic black culture – which he terms the 'black Atlantic' – whose practices and ideas transcend both ethnicity and nationality. Black people, he argues, shaped a shared, transnational, diasporic culture which in turn shaped the history of modernity. He explores this transatlanticism in black music and writing and reveals the shared contours of black and Jewish concepts of diaspora. Although he does not write about them in his

book, both Brazil and South Africa partook of, and in turn helped to shape, this 'black Atlantic culture'.

2 Loxion Kulcha began with a collection of hand-knitted beanies (hats) that then grew into urban street-wear, mainly denims, printed T-shirts, and sports shoes. Recent designs include branded overalls and men's suits.

3 The name 'Stoned Cherrie' plays on a series of puns and local references. 'Stoned' refers in part to the violence of the 1980s in the townships but also to being high on marijuana. 'Cherrie' recalls the fruit of the same name but this particular spelling also refers to a slang term, originally from Afrikaans, meaning girl or woman or girlfriend. In 1965, for example, Casey Motsisi, writing in *Drum* magazine, wrote: 'I had to invite that most fascinating cherie in this man's town, Sis Sharon with goo goo eyes'. Perhaps the use of the term also derives in part from the French term 'cherie', meaning 'my love'. Thus the term Stoned Cherrie contains numerous resonances, including the 'retro' term for young townships girls of the 50s and 60s. It places the girl/woman at the centre of its frame of reference but also stands for a general sense of having a good time.

4 I am grateful to Lindsay Bremner for her discussions with me on these points.

5 Private security at the Zone is less apparent than in regular malls around the city. CCTV cameras can sometimes be seen but in general there are few security guards and the outdoor precincts are not secured as such.

6 I am grateful to Isabel Hofmeyr for our discussions on this point.

7 For example, one set of T-shirts are emblazoned with the word 'Sharpeville!'. This is a reference to …but also plays on the colloquialism 'sharp!' which means 'cool'. It suggest that Jozi is a city with a past (a political struggle) but also a cool place to be.

8 A pantsula is a young urban person (usually a black man) whose attitudes and behavior, especially his speech and dress, are of the most popular current fashion. The term is sometimes applied retrospectively to tsotsis (gangsters) of the 1950s who dressed in expensive clothing, particularly trousers with turn-ups, fine shoes and a felt hat. More recently, a diversity of urban slang and sartorial styles has emerged.

9 Steve Biko was born in 1946 in King Williamstown, went to Medical School in Natal and was cofounder and first president of the all-black South African Students Organisation (SASO). Until then, the struggle against apartheid had been 'non-racial', but Biko asserted that black people had been psychologically affected by white racism, had internalized a sense of racial inferiority and therefore that they needed to organize politically as a separate, black group. Biko's aim was to raise 'black consciousness' in South Africa. He was banned in 1973 and assassinated in detention by apartheid police in 1977. His political and personal legacy lives on, despite South Africa's negotiated transition to democracy in 1994.

10 awww.urbandictionry.com defines 'miss-thang' as 'a person who thinks they are, are, like so totally, like better than, like, you know everyone else, like'. In other words, a woman who thinks she's way too cool. 'Brother-man' would seem to speak for itself. 'Jozi' is an increasingly popular term used by young residents of Johanneburg, referring not only to the city itself but to its surrounding townships, including Soweto and Alexandra.

11 'Translatability' emerges from the rise in the last decade or so of 'translation studies'. The latter focuses on such issues as how the translation is connected to the 'foreign text'; the relative autonomy of the translated text – and thus the impossibility of translation, since it is really a new text which is created; how the effect of translation are social, and have been harnessed to cultural, economic and political agendas including colonial projects and the production of national literatures. Translation studies is beset by arguments between those who see language as hermeneutic and interpretative, opening up the gaps of meaning, and those who see it as communicative and instrumental, which seek equivalence with the original text. In sum, an analytics of the 'gap' is at the heart of this work. (See Venuti, 2000).

12 'Zol' refers to a handrolled marijuana cigarette.

13 Dorothy Masuka (1935–) is a famous singer in Southern Africa who sang with the African Ink Spots and later with Miriam Makeba. She sang songs of political resistance which were banned in apartheid South Africa. She still sometimes performs in different parts of the world.

14 The way postapartheid youth engage with the world has been shaped by often violent histories of international connection (through migration from elsewhere in Africa and the diffusion of British and American culture) and by the fact of apartheid South Africa's international isolation (as the figure of the grotesque in the colonial historical narrative and the international sanctions and boycotts that cut it off from the rest of the African continent).

15 In the April-May issue, the editors write: 'Our relationship with black Americans is only by virtue of us all being African descendants. The reality is that their true ancestors, the slaves that crossed the ocean in the dungeons of those ships, were taken from the West Coast of the continent. We aren't preaching any anti-African-American theories. As much as we appreciate the music, there really is no need to patronize us' (*Y Mag*, August 2000, p. 52). Other instances in the magazine reveal that black South

Africans turn to the apartheid struggle and explicitly not to slavery, in the making of black identity. For a longer discussion of this, see Nuttall (2004)

16 Ymag was conceived by the YIRED publishers as a counterpart to *SL* magazine (*SL* stands for Student Life), which targets largely white but also cross-over youth audiences. The intention was to overcome the dominant industry model, in which youth magazines targeted limited 'readership ghettoes' in order to attract specialized advertising. The relationship between the two titles was initially conceived as a move toward establishing the first multi-racial youth-oriented product to succeed in South Africa. *Y* and *SL* share irony and parody as dominant rhetorical modes as well as cross-over reviewing styles and the accessorization of media forms within a broader process of self-stylization. For a discussion of this see Nuttall (2004).

17 Cultural texts – books, for example – become forms of quotation: book reviews attest to the constant dismembering of the book, harnessed to specific textual genres as readers, reviewers and magazine publics exercise the capacity to choose and discard: the book loses its supposed autonomy, its power as a self-contained artifact: there is no book in and of itself but only a textual fragment in the technological constitution of the self. For a more detailed analysis see Nuttall (2004).

18 This is a term one has to use with caution. I do so here to signal that while South Africa in general is not a 'post-racial' society, aspects of its culture are experimenting with spaces one could tentatively refer to in this way, in that the imperative, driven increasingly by what is patently a cross-racial market for goods, is that race no longer signifies as it did before, and that class, based on money, increasingly structures certain kinds of social relations. This is not to say that race doesn't – and won't in future – reassert itself in unexpected ways.

19 It is fascinating to compare these ads with those discussed by Bertelsen (1998) which appeared in the years of the mid-90s, immediately after political transition, as a measure of how much has changed in the public discourse of nation-building and identity. An ad for shoes is accompanied by the text: 'When a new nation stands on its feet…', while an ad for milk contains the text, 'Why cry over spilt milk, when we can build a healthy nation?.' For a detailed analysis, see Bertelsen's full text.

20 Telephone Interview with K-Swiss manager, April 2005.

21 I am grateful to Dilip Gaonkar and Ackbar Abbas for their comments along these lines at a Summer Institute on 'Media Cultures, Everyday Life and Cultures of Consumption' held at Honk Kong University (Hong Kong, June 2005).

22 I am very grateful to Isabel Hofmeyr for her discussion of these ideas with me.

23 Non-racialism, a term used widely during the anti-apartheid struggle, and intended to signify the idea of a society freed from the credo of race, has faded from public political discourse in the 90s and after, as the politics of black empowerment have moved centre stage and have played an important role in shifting inherited institutional power structures. This has occurred at the same time as many more choices have become available to people in terms of racial identification, especially in metropolitan centres and especially in the sphere of culture.

References

Bertelsen, E. 1998. 'Ads and Amnesia: Black Advertizing in the New South Africa'. In S. Nuttall and C. Coetzee, eds. *Negotiating the Past: the Making of Memory in South Africa*. Cape Town: Oxford University Press.

Bogatsu, M. 2003. "Loxion Kulcha: Cultural Hybridism and Appropriation in Contemporary Black Youth Popular Culture". Honours Research paper. University of the Witwatersrand, Johannesburg.

Brown, B. 2003. *A Sense of Things: The Object Matter of American Literature*. Chicago: University of Chicago Press.

Burke, T. 1996. *Lifebuoy Men, Lux Women: Commodification, Consumption, and cleanliness in Modern Zimbabwe*. Durham: Duke University Press.

Butler, J. 1993. *Bodies That Matter: On the Discursive Limits of 'Sex'*. New York and London: Routledge.

Butler, J. 1999. *Gender Trouble: Feminism and the Subversion of Identity*. New York and London: Routledge.

Campbell, R. 1999. *Review of 'Thievery Corporation'*. SL, February.

Comaroff, J. and Comaroff, J. 2001. 'Millenial Capitalism: First Thoughts on a Second Coming'. In J. Comaroff, and J. Comaroff, eds. *Millenial Capitalism and the Culture of Neo-Liberalism*. Durham: Duke University Press.

Davis, A. 2000. Review of "Magnum Chic" by Harper Engler. *YMag*. November.

Dolby, N. 2000. *Constructing Race*. New York: State University of New York Press.

Farber, T. 2002. 'Loaded with Labels: The Meanings of Clothing Amongst Urban Black Youth in Rosebank, Johannesburg'. MA thesis, University of the Witwatersrand, Johannesburg.

Foucault, M. 1987. 'The Ethics of Care for the Self as a Practice of Freedom'. In P. Rabinow, ed. *Michel Foucault: Ethics, Subjectivity and Truth*. New York: The New Press.

Foucault, M. 2001. *Hermeneutique du Suject*. Paris: Gallimard.

Gilroy, P. 2000. *Against Race: Imagining Political Culture Beyond the Colour Line*. Cambridge, MA: Belknap Press of Harvard University Press.

Goankar, D. and Povinelli B. 2003. 'Technologies of Public Forms: Circulation, Transfiguration, Recognition'. *Public Culture*, 15.

Green, N. and Lascaris, R. 1988. *Third World Destiny: Recognizing and Seizing the Opportunities Offered by a Changing South Africa*. Tafelberg: Human and Rousseau.

Gule, P. 2000. Review of 'Yesterday I Cried' by Iyanla Vazant. *Ymag*, October.

Klandermans, B. Roefs, M. and Olivier, J. 2001. *The State of the People: Citizens, Civil Society and Governance in South Africa 1994–2000*. Pretoria: Human Sciences Research Council.

Masemola, T. 2000. 'Dlala Mapantsula'. *Ymag*, June-July.

Mazarella, W. 2003. *Shovelling Smoke: Advertizing and Globalization in Contemporary India*. Durham and London: Duke University Press.

Mbembe, A. 2002. 'On the Power of the False'. *Public Culture*, 14.

McGregor, L. 2005. *Khabzela*. Johannesburg: Jacana Books.

Mtsali, B. Masemola, T. and Gule, T. 2000. 'Manga-Manga'. *Ymag*. June–July

Nappy Head. 1998. 'Into Yam, Bongo Maffin'. *Ymag*. October-November.

Nkosi, L. 1983. *Home and Exile and Other Selections*. London: Longman.

Nuttall, S. 2004. 'Stylizing the Self: The Y Generation in Rosebank, Johannesburg'. *Public Culture*, 16(3).

Povinelli, E. 2001. Consuming Geist: Popontology and the Spirit of Capital in Indigenous Australia. In J. Comaroff and J. Comaroff, eds. *Millenial Capitalism and the Culture of Neo-Liberalism*. Durham: Duke University Press.

Venuti, L. (ed.) 2000. *Translation Studies Reader*. London: Routledge.

Further readings

Aesthetics of Superfluity, Achille Mbembe, *Public Culture*, 16(3), 2004.

Gendered Experiences of Blackness in Post-Apartheid South Africa, Nthabiseng Motsemme, *Social Identities*, 8(4), 2002.

Related Internet links

Y FM radio website: http://www.yfm.co.za/

Loxion Kulca website: http://www.loxionkulca.com/

Website for The Zone shopping center at Rosebank: http://www.thezoneatrosebank.co.za/

"Straight" Women, Queer Texts

Boy-Love Manga and the Rise
of a Global Counterpublic

ANDREA WOOD

Keywords

Japan
boy-love *manga*
 (*shonen-ai* and *yaoi*)
transnationalism
global circulation
gender performance
sexual fantasy
production
consumption
transculturalism
queer counterpublics

In recent years Japanese manga (comics) have exploded onto the North American comics market, rapidly taking over the graphic novel sections of book and comic stores and generating fans among adolescent audiences.[1] Most comics being translated and published in the United States are aimed at this age group and along clear gender lines. **Shonen** comics are considered to be primarily for boys and tend to focus on action and adventure narratives, while *shojo* comics for girls typically present more romantically oriented stories. More than a passing fad, manga have become a firmly established segment of the US publishing industry, and in 2004 total manga sales for the United States and Canada were up to $207 million (Memmott 2005, 4d). The manga industry in Japan is even larger, with "gross revenues totaling 531 billion yen ($5 billion)" in 2001 (Thorn 2004, 169).

Japanese manga are flourishing in North America, but the majority of texts translated and sold are heterosexually oriented despite the fact that there is a wide array of more sexually transgressive manga being published in Japan. Therefore, when Tokyopop, a US publisher of Japanese manga, released several new queer series in the fall of 2003 they took a brave leap in introducing what I will be referring to as "boy-love manga" to the US comics market. As the name suggests, boy-love manga present romantic narratives that visually depict homoerotic love between male protagonists. By and large, these comics are created by and for women. They have a well-established history in Japan and have generated a huge following of female readers, particularly teenage girls. It is their recent emergence on the North American manga market that raises several interesting questions. In particular, how does the transnational circulation of these comics require us to consider their popularity in new ways? And how do boy-love manga, by virtue of their queer content, work subversively within a more global context?

To clarify my terms, in this paper I will be using *boy-love manga* as a larger all-encompassing genre term, while distinguishing between the two separate

Global Visual Cultures: An Anthology, First Edition. Edited by Zoya Kocur.
© 2011 Blackwell Publishing Ltd except for editorial material and organization © Zoya Kocur. Published 2011 by Blackwell Publishing Ltd.

categories of *shonen-ai* and *yaoi* that fall under it.[2] *Shonen-ai* manga tend to empha-
size elaborate romances that contain imagery more suggestive than sexually
explicit. A palpable thread of erotic tension is, however, present and maintained,
predominantly through visual cues such as sudden longing looks, unexpected
caresses, suggestive body language, and intimate kissing scenes. Typical panels are
often erotically charged as readers catch a glimpse of a tongue here and a wander-
ing hand there, ultimately leaving more to the imagination than meets the eye. In
contrast, the often pornographically explicit boy-love manga known as *yaoi* gener-
ally forgo coherent plot development in favor of using every available opportunity
to get the beautiful male characters in bed together. In fact, *yaoi* is an acronym in
Japanese that ironically translates as "no climax, no punchline [*sic*], no meaning"
(Schodt 1996, 37).

Despite the steadily growing publishing market for boy-love manga outside
Japan, current scholarship has not focused at great length on the increasingly glo-
bal nature of the readership or the function and effect of such widespread textual
circulation. Mark McLelland (2000a) argues that there is a clear distinction between
how Japanese and Western audiences receive homosexual texts, which necessitates
a restricted cultural analysis:

> Although Japanese society is no more tolerant of men or women expressing a gay or
> lesbian identity in real life than many western [*sic*] societies, as a fantasy trope for
> women male homosexuality is understood to be a beautiful and pure form of
> romance. Hence, it is possible in Japan for mainstream bookstores to carry many
> boy-love manga titles (among them classics such as *June* and *B-boy*) that depict stories
> about love between teenage boys often featuring illustrations of anal sex and fellatio,
> which can be purchased freely by anyone, including their intended audience of high
> school girls. Japanese society clearly responds to depictions of male homosexuality
> in ways very different from societies in the west [*sic*]. (287–8)

While McLelland is right to point out the fact that Japan has a long artistic tradi-
tion of aestheticizing certain male homoerotic relationships as representative of a
"beautiful and pure form of romance,"[3] it is also pertinent to consider the ways in
which different cultural contexts may actually provide new readings of texts.
Indeed, the growing popularity of boy-love manga in the United States suggests
that the differences between Japanese and Western readers are not prohibitive to
enjoying these comics.

Our current moment, therefore, seems ripe for a new assessment of boy-love
manga and the increasingly global nature of their circulation and readership for
several reasons. On the one hand, assessments of the genre have frequently invoked
as a key factor in female readers' interest in these texts the patriarchally oppressive
environment in which Japanese women live, and the ways in which female sexual-
ity in Japanese culture is confined to the reproductive function within the sanc-
tioned space of marriage (Aoyama 1988; Behr 2003; Kinsella 2000; McLelland
2000b). While this information offers insight into the culturally specific context of

Japanese female readers, it can also risk oversimplifying the situation and Japanese women's responses to it. Nor does this cultural information provide an equally accessible frame of reference when considering other readers and other contexts. I would argue, therefore, that the transnational readership of boy-love manga requires new ways of thinking about this phenomenon beyond the cõnfines of Japan. The Internet is already facilitating discourse and textual circulation among fans in different countries, generating what I perceive to be a global counterpublic that is both subversive and fundamentally queer in nature. I will show how this queerness both demonstrates that the readership is not coherent, monolithic, or singular and opens a discursive space for multiple and fluid readings of boy-love manga to be circulated and shared among an intimate network of strangers around the world.

Despite what I perceive to be the markedly queer content of these comics, US publishers of boy-love manga, like their Japanese counterparts, market and advertise to an audience that is generally characterized as both female and straight. Consequently, when popular media critics investigate this new publishing trend they reach very normative conclusions about boy-love manga. Such is the case with a recent *Los Angeles Times* article (Solomon 2004) that concludes with the very safe assurance that these comics, because they are romantic narratives aimed at women, must "portray relationships that are heterosexual at their foundation." Not surprisingly, therefore, most considerations of the phenomenon continue to categorize readers of boy-love manga as a group of "straight" women. While some scholars have been quick to point out that readers' sexual orientation is difficult if not impossible to accurately ascertain, and undoubtedly more complex than publishers believe, there is still a general tendency to refer to the readership as heterosexual (Behr 2003, 25; Kinsella 2000, 117; Mizoguchi 2003, 56; Thorn 2004, 172). Although some have acknowledged the limitations of assessing these texts and their popularity within heterosexual paradigms (Behr 2003; Mizoguchi 2003; McLelland 2000a; Nagaike 2003) there has not been a sustained discussion of how concepts of queerness might help us to begin thinking about how these manga function in a global context. I would like to consider this idea in more detail, by first assessing some of the visual characteristics of boy-love manga and questions of identification and interpretation they necessarily raise.

The gender representations and sexuality visualized in boy-love manga challenge and trouble the belief that these categories are ontologically coherent, contained, and one dimensional – something that is at the very heart of queerness. For as Eve Sedgwick argues, "queer" involves "the open mess of possibilities, gaps, overlaps, dissonances and resonances, lapses and excess of meaning [that occur] when the constituent elements of anyone's gender, of anyone's sexuality aren't made (or *can't be* made) to signify monolithically" (1993, 8). In other words, boy-love manga are not simply queer because they depict homoerotic love stories between men, but rather because they ultimately reject any kind of monolithic understanding of gendered or sexual identity. At the same time, erotic fantasies about love between beautiful and often androgynous young men, as depicted in

these comics, transgress and queer *how* and *what* their supposedly "straight" female readers are expected to fantasize about sexually.

Indeed, the very fact that characters' gender and sexual ambiguities are encoded visually allows for myriad shifting and fluid identifications and interpretations among readers. Lead characters are often highly stylized and drawn to emphasize their beauty and sensuality, which departs from more traditional romance narratives that tend to focus on describing the uber-macho and phallic masculinity of male heroes. While I do acknowledge that this tendency is more particularly a Western one, it is relevant to note that many Japanese manga by and for men reinforce the notion of an idealized man being ultramasculine and phallic in nature. Female manga artists have been characterized as reacting against this by producing more androgynous and aesthetically beautiful men (Allison, 1996; McLelland 2000b). Thus, one might see a *bishonen* (beautiful boy) in a typical boy-love manga with long flowing hair and rather androgynous facial features, wearing stylish clothing that can best be described by contemporary Western standards as "metrosexual." As McLelland notes, "characters in these stories are drawn in a style typical of women's comics: they are androgynous, tall, slim, elfin figures with big eyes, long hair, high cheekbones, and pointed chins" (2000a, 277). For example, in Figure 19.1 we see the protagonist (Shuichi Shindo) of Maki Murakami's *Gravitation* (2003) meeting the man he will fall in love with (Yuki Eiri) for the first time. Two entire pages are devoted to this moment, highlighting its significance to the narrative, and the perspective from which the scenes are viewed is predominantly Shuichi's as he gazes at Yuki. Both characters have delicate facial features that emphasize their large eyes and artfully coiffed hair. No language is necessary here as the images are left to convey the eroticized nature of the moment by themselves. Yuki is highlighted as the central object of desire and we see Shuichi gazing on him with open awe. Indeed, *bishonen* are often posed in a deliberate manner to engage the viewer's gaze. This is frequently achieved by taking up an entire page to draw a character in a very carefully staged manner that maximizes his sex appeal. Often flower imagery is drawn in the background or around the border surrounding the framed *bishonen* to emphasize his beauty. Consequently, although bishonen are superficially gendered male, their very androgynous appearance allows for them to be read inside a variety of different gender and sexual paradigms.

Most notably, there is the very obvious possibility of lesbian desire being encoded within these characters.[4] In Figure 19.2, we see the lead characters of Sanami Matoh's series *Fake* standing in front of a fictionalized New York City backdrop. Dee, the dark-haired character, almost appears to be wearing lipstick and has a feminine profile coupled with a more butch haircut. His light-haired partner, Ryo, shares a similar melding of butch-femme/femme-butch physiognomy that upon closer inspection gives the impression that their faces mirror one another's. At the same time, the bodies of both characters are obscured by the bulky clothing that they wear and by the segmentation of panels that focus in on their androgynous faces and leave the viewer with great latitude for somatic interpretation. This kind of gender indeterminacy opens up ample space for "perverse" readings (Sedgwick

Figure 19.1 Shuichi sees Yuki for the first time. Image provided courtesy of Tokyopop Inc. © 2002 Maki Murakami. All Rights Reserved. First published in Japan in 1996 by Gentosha Comics Inc. Tokyo. English translation rights arranged with Gentosha Comics Inc. Tokyo through Tohan Corporation, Tokyo

1993) of these characters that speak not only to possible lesbian desires and fantasies, but also other queer, transgender, and transsexual ones. *Shonen-ai* manga showcase these possibilities most powerfully, because they do not reveal genital imagery.

Although most *shonen-ai* manga are more focused on the development of a romantic plot line between male protagonists, sexual desire is not simply "slight or incidental" (Thompson 2003, 43) as some popular critics suggest. A successful series such as *Gravitation* relies on sexual innuendo, comedic double entendres, and coded visual references in order to maintain an erotic undercurrent that is not sexually explicit in nature. Such strategies can often be found in traditional romance fiction as well, and readers become familiar with these kinds of tropes and are able to read beyond the surface in order to glean the sexually charged interactions between characters that might otherwise seem innocent. Part of the pleasure in

Figure 19.2 Dee and Ryo Kissing. Image provided courtesy of
Tokyopop Inc. © 2000 Sanami Matoh. All Rights Reserved. First
published in Japan in 2000 by Biblos Co, Ltd Tokyo. English
translation rights arranged through Biblos Co, Ltd

this kind of reading is based precisely on the
fact that sex is *not* in plain view. The visual
nature of manga makes this even more
powerfully felt, by establishing heightened
sexual tension between characters imagisti-
cally. As shown in the images of Shuichi and
Yuki kissing (Figure 19.3), bodies are frag-
mented in each panel, deliberately conceal-
ing the entirety of what is happening. We
do momentarily catch a glimpse of Yuki's
wandering hand, but in other panels we are
only privy to the sight of their faces as
they're kissing while the rest of their bodies
remain obscured or hidden. This tantalizing
and suggestive imagery leaves a lot to the
reader's imagination, allowing for many dif-
ferent readings, identifications, and stimuli
for fantasies.

In contrast, *yaoi* manga have no qualms
about depicting hard-core sex between *bis-
honen* that reveal genitalia in often explicit
detail. These comics raise different ques-
tions about the fantasies presented therein
and issues of reader identification. On the
one hand, the possibility that female read-
ers find voyeuristic pleasure in scenes of
anal sex and fellatio between beautiful men
challenges the desirability of heteronorma-
tive constructs of masculinity, which nega-
tively perceive a male desire to be sexually
penetrated, as "a voluntary abandonment
of the culturally constructed masculine
identity in favor of the culturally con-
structed feminine one" (Halperin 1993, 422). Consequently, sex scenes in *yaoi*
manga have the potential to catalyze certain homophobic fears. Heterosexist
understandings of gender generally affirm that being penetrated is de facto disem-
powering and ultimately feminizing, and that as a result penetration must be per-
formed as an act that asserts power and masculine primacy. Boy-love manga,
however, tend to argue visually for the pleasure of both penetrating and being
penetrated, and relationships between male characters display equality and mutu-
ality on an emotional level, especially in their erotic moments together.[5]

Although the narratives emphasize the need for lovers to develop an equal
romantic partnership, they do tend to clearly position characters in roles of sexual
"top" and "bottom." The older male character is usually the sexual instigator and

"top," known as the *seme*, while his often younger partner is the "bottom, or *uke*" (McLelland 2000a, 279–80). What I find particularly interesting about the *seme-uke* dichotomy in boy-love manga is the fact that the *possibility* of changing roles often serves as a point of teasing humor and even sexual excitement between partners, suggesting that these comics are much more cognizant of the performative nature of such roles than one might first imagine. For instance, in the third volume of Kazuma Kodaka's *Kizuna* series (2004), which is being published in North America by Be Beautiful, there is a comical erotic moment when Ranmaru initiates sex with his partner, Kei, who is the *seme*. The visually comedic nature of this moment is reflected in the fact that Kei has been unwittingly forced into the position of *uke* (Figure 19.4). As Ranmaru (the light-haired character) becomes more sexually aggressive, the panels humorously focus on Kei's facial expressions, which range from confusion, mock fear, and disbelief as he mentally questions what is happening with increasing anxiety. Just when it appears that Ranmaru is going to reverse the roles for real, he instead enacts his own penetration and the two exchange teasing banter before proceeding to make love. This particular scenario highlights the culturally constructed nature of sex roles, managing to find humor in them while questioning them at the same time. While *Kizuna* merely

Figure 19.3 Shuichi and Yuki kissing. Image provided courtesy of Tokyopop Inc. © 2002 Maki Murakami. All Rights Reserved. First published in Japan in 1996 by Gentosha Comics Inc. Tokyo. English translation rights arranged with Gentosha Comics Inc. Tokyo through Tohan Corporation, Tokyo

plays with the notion of switching sex roles, there is a subgenre of *yaoi* in Japan categorized as "reversible" that actually presents reversible couples "who never draw borders between *uke* and *seme* sexualities" (Nagaike 2003, 88). But as of yet, only one reversible series, Youka Nitta's *Embracing Love* (*Haru wo Daiteita*) (2005), is being published in the United States.[6]

Despite the fact that the more rigidly upheld *seme-uke* dichotomy tends to reinforce notions of active/passive sex roles, it is important to emphasize that in general these comics do not *visually* infuse the role of *uke* with negative or disempowering connotations. Instead, the *uke* is often depicted in a state of ecstasy, while his partner is more focused on *giving* him pleasure than on simply taking it

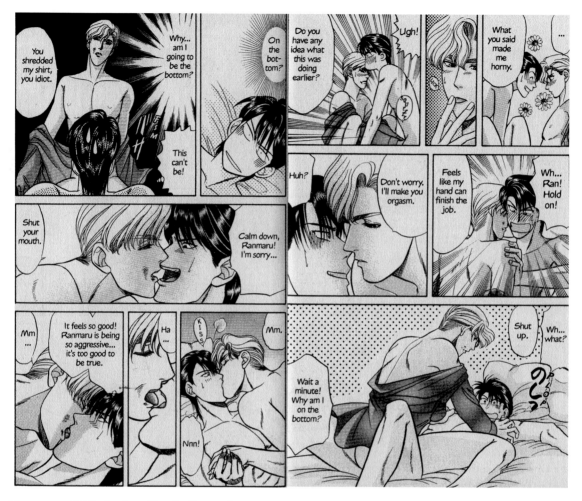

Figure 19.4 Kei finding himself on the "bottom." "Kizuna vol. 3" © 1996 Kazuma Kodaka. Originally published in Japan in 1996. English translation rights arranged with Libre Publishing Co. Ltd

for himself. In Figure 19.5, from You Asagiri's *Golden Cain*, the *uke* Shun's pleasure is highlighted, as we see his head thrown back, eyes closed, and mouth open in a moment of ecstasy. His partner, Cain, the *seme* in the relationship, is revealed in profile only. We cannot see his facial response, only that his eyes are focused on gazing at Shun, watching his pleasure and thus implying that this is important and perhaps necessary for his own sexual gratification. Therefore, in opposition to a one-sided visualization of pleasure that emphasizes the importance of the penetrating partner's orgasm, a mainstay of heterosexual pornography, *yaoi* manga are more interested in illustrating both partners' erotic fulfillment and gratification.

There have been a wide array of approaches to and conclusions about reader/ viewer identification with boy-love manga, but they have nonetheless remained focused primarily within a Japanese context. One of my aims here, in contrast, is to

Figure 19.5 Uke partner in ecstasy. "Kin no Cain" © 2003 You Asagiri. Originally published in Japan in 2003. English translation rights arranged with Libre Publishing Co. Ltd

suggest that the increasingly transnational readership for boy-love manga stymies efforts to make universalizing claims about processes of identification. More particularly, I would argue that one of the fundamentally queer facets of boy-love manga is that they can be read quite differently depending on the subjective lens through which they are viewed. The gender ambiguity and sexual fluidity that I have located at the heart of the visual aesthetics of these comics express a queerness that refuses complete coherence. While these images may be read or perceived quite differently in diverse cultural and artistic contexts, the erotic nature of their content seems to speak intimately to the many desires and fantasies of different

women on an increasingly global scale.[7] For as Akiko Mizoguchi has noted, "fantasies, realities, and representations are always related in *yaoi* texts, but their relationships are never transparent" (2003, 65).

At the same time, transnational readers' shared investment in queer subcultural texts establishes them as part of a resistant counterpublic, and one that subverts the accustomed expectation of a "romance reading" public of women as only being interested in heterosexist narratives deemed acceptable because they are believed to reinforce the gender status quo.[8] As Michael Warner argues, the discursive exchange of a counterpublic is "structured by alternative dispositions or protocols, making different assumptions about what can be said or what goes without saying" (2002, 56–7). The engagement with boy-love manga on the part of female readers, who are perceived by and large as "straight" women, and thus coded as part of a larger "mass" normative public, concurrently positions them as part of a counterpublic resistant to blithely consuming idealized heteronormative media. Referring to the complex and transnational network of readers of boy-love manga as part of a public or, in my view, counterpublic is more efficacious than describing them as an audience. My reasoning here stems in part from the fact that readers often lack the clear specificity of a concrete audience, especially now that these comics are being read across different countries, genders, sexualities, and age groups. Indeed, "a public is always in excess of its known social basis" because the self-organization of a public is "as a body of strangers united through the circulation of their discourse" (Warner 2002, 74, 86). This of course makes it difficult to then quantify and assess a public as social scientists would like to.

Because boy-love manga are erotic in content, they necessarily speak to intimate desires and fantasies, both conscious and unconscious, among readers. How does one quantitatively assess individuals' sexual desires and fantasies? The very intangible and often unconscious nature of such things makes this nigh on impossible, most especially because researchers'[9] interpretations of such information often affect how it is presented or read. In her book *Female Masculinity*, Judith Halberstam elucidates this point when she paraphrases R. C. Lewontin's suggestion that "people tend not to be truthful when it comes to reporting on their own sexual behavior (men exaggerate and women downplay, for example), and there are no ways to make allowances for personal distortion within social science methods" (1998, 11). While surveys can provide important insight on small groups of individuals, they can never adequately represent the entirety of a large and nebulous public; nor can they ascertain definitive or collective truths about fluid and indistinct fantasies and desires, especially across multiple cultural, linguistic, and national divides. It is my contention, therefore, that a more productive methodological avenue lies in considering the growing global readership for boy-love manga as a counterpublic that establishes discursive connections between strangers, reflecting their intimate engagements with texts and their differing subjective and cultural contexts for reading boy-love manga. Indeed, not everyone has to read boy-love manga in the same way in order to be part of this counterpublic.

Publics come into being "only in relation to texts and their circulation" (Warner 2002, 66), which is the foundation of boy-love manga readership and fandom. Those who read boy-love manga do not remain passive receivers of the texts. Instead, these comics often act as a gateway to a "concatenation of texts" (90). Fans begin to create their own *doujinshi* (fan manga), write their own fiction stories, participate in related areas like slash fandom, establish their own Web sites, begin their own translation and scanlation projects,[10] attend anime and manga conventions, chat in online forums, and so on. The discourse of this rather varied and increasingly Web-based counterpublic relies on shared circuits of textual circulation that often transcend even the rather obvious constraints of language barriers. Because so much of boy-love manga requires imagistic reading practices, discourse often happens at the level of shared images that do not require words. At the same time, the concatenation of texts has also established a certain degree of shared terminology among all language groups. Words like *yaoi, shonen-ai, doujinshi, uke, seme,* and *bishonen* become part of the collective jargon of this particular counterpublic discourse, regardless of an individual's native language.

A great deal of boy-love manga, especially doujinshi created by amateur fans, focuses on parody – frequently taking prominent male characters from other manga or anime and developing romantic and sexual relationships between them. This is very similar to the practice of slash writing, a crossover area of fandom for many Western readers, although more emphasis is placed on the visual images than on the written content. In boy-love manga, the love between male characters often transcends concerns about gender and sexuality, which tend to be seen as irrelevant or beside the point. Some critics have noted similar tendencies in slash fiction, or more particularly the propensity to leave the sexuality of characters open or unresolved and thus allow for "a much greater range of identification and desire" for readers (Penley 1992, 488). Although I see boy-love manga narratives as containing radical queer potential, I do not want to universalize them or suggest that they are queerly or otherwise utopian and free of problems in their articulations of same-sex desire. Most stories contain moments in which lead characters express fears or concerns about revealing their relationships, and being labeled as gay and thus socially perceived as feminine in negative ways. What I do want to emphasize here is that characters generally overcome these fears and embrace their love for one another despite what society may think of them, which in my mind is a significant fantasy of resistance.

Unlike slash fiction, a great deal of boy-love manga is commercially published.[11] Many prominent *yaoi mangaka* (professional manga artists) began their careers as amateur doujinshi artists who gained enough popularity to begin producing and commercially distributing their own original manga.[12] It is also worth noting here that independently produced doujinshi is frequently sold noncommercially at fan conventions in Japan such as the annual Comiket, and that the Internet has provided a space for amateur artists in Japan and other countries to share their work with other fans often free of charge. Similarly, "the activity/productivity of *dōjinshi* groups occurs *outside* the mainstream of Japanese society and economy, rendering

it invisible to those studying more conventional forms of production" (Orbaugh 2003, 112). Therefore, although the publishing industry for boy-love manga flourishes in Japan and is growing in the United States, noncommercial production and circulation of texts still plays a predominant role in the development of this counterpublic discourse. The Internet has become an incredibly valuable tool for sharing, sometimes illegally, scanlations and images from both published and fan-produced manga. This then allows for a greater concatenation of texts across cultural boundaries so that, for instance, Western fans are now producing their own *doujinshi* narratives in English, some of which are being published by the very newly established Yaoi Press.[13] Similarly, Japanese *doujinshi* artists are creating boy-love manga for popular English texts such as those of the Harry Potter franchise, demonstrating the artistic and textual appropriations and fusions occurring cross culturally among fans. These connections also reinforce the crucial importance of technology in broadening the network of fans and their discourse.

Without a doubt, publishers are already aware of this fact. For instance, Tokyopop makes many of its publication decisions based on the desires of the English-speaking fan community. They conduct online surveys regularly on their Web site to allow fans to vote for and offer suggestions for titles they want published.[14] This requires that fans already be aware of titles currently circulating in Japan, but not yet translated and commercially sold in North America – something they can usually best achieve via Internet communication and file sharing. In fact, there are numerous Web sites in which fans offer up amateur translations, and even scanlations, of texts not yet available in English. Outside the World Wide Web, fans may also participate in various anime and manga conventions, many of which are now organizing special sessions and panels on boy-love themes as the popularity of these texts increases. And even more particularly, there is now an established Yaoi-Con devoted exclusively to *yaoi* and *shonen-ai* anime and manga that takes place each year in San Francisco.[15] This convention also works to foster international relations between fans by welcoming attendees from all over the world and by inviting a different boy-love manga artist as their special guest each year.

At present, many of the bigger US publishers such as Tokyopop have been aggressively marketing all their manga, *shonen-ai* titles included, at major bookstores, including Barnes and Noble, Borders, and Waldenbooks, bringing these comics out of the realm of the Internet underground and into the mainstream.[16] Even the more sexually explicit *yaoi* titles are becoming more widely published and readily available in mainstream bookstores. Central Park Media has launched its very own *yaoi* publishing line of manga for those eighteen and over called Be Beautiful Manga.[17] Other publishers, among them Digital Manga, Kitty Media, Viz, and Dark Horse, are quickly leaping on the bandwagon as they become more attuned to the demand among readers.[18] US consumers are evidently buying these texts and in a quantity sufficient to propel other publishers into the foray of boy-love manga at an increasingly rapid rate.[19]

Tokyopop claims that their overall manga readership is about 60 percent female and, as in Japan, this percentage for their *shonen-ai* readership is presumably higher

given that they are being marketed primarily toward teenage girls (Reid 2003, par. 7).[20] However, in the United States, strong efforts have been made to restrict teenagers from being able to purchase the more explicit *yaoi* texts.[21] Publishers have not only been shrink-wrapping these graphic novels, but also putting clear warnings on the covers that indicate they are "for adults only" and adding disclaimers emphasizing that none of the characters depicted are under the age of eighteen. This is particularly interesting because many characters, in keeping with the androgynous aesthetic of boy-love manga, often appear to be rather young, rendering the distinction between adolescent and adult murky at best save for the reassurance of the publisher's note. As numerous English-language fan-based *yaoi* Web sites and conventions attest, teens are still a large part of this market although they often have to employ covert means of getting copies of more racy texts. As a result, many of them are downloading free boy-love manga scanlations from the Internet. The fact that young girls as well as women are reading boy-love manga challenges Western efforts to maintain a rigid distinction between adult and child sexuality, the latter of which is often denied or strictly policed in order to protect a mythologized ideal of erotic innocence (Kincaid 1998). In contrast, I find it somewhat ironic that teenage girls in Japan can readily buy *yaoi* manga without the same kind of social constraint. Indeed, "Japanese society has not traditionally made as severe a distinction between adult and child sexuality as has the west [*sic*]" (McLelland 2000a, 284).

Precisely because the targeted readership for these comics, especially *shonen-ai* titles, consists largely of girls who are at a liminal stage between childhood and adulthood, they powerfully showcase certain cultural anxieties about sexual control surrounding bodies, and specifically female ones, that do not satisfactorily fit into the child or adult category. Indeed, the counterpublic itself queers such understandings, troubling the lines between adolescent and adult in much the same way that it complicates gender and sexual identity among readers and characters in the texts themselves. This in itself is what is presumably so worrying to those who want to enforce these distinctions in order to restrict access to erotic media. As Gayle Rubin (1992) has argued, "rather than recognizing the sexuality of the young and attempting to provide for it in a caring and responsible manner, our [American] culture denies and punishes erotic interest and activity by anyone under the local age of consent ... [minors] are forbidden to see books, movies, or television in which sexuality is 'too' graphically portrayed" (20). In light of such attitudes, technology can become a gateway for shared communication between teens who are part of the boy-love manga counterpublic, while at the same time serving as a restrictive barrier to their parents and other adults, who are often unfamiliar with such methods of textual circulation and networking and who seemingly remain largely unaware of the phenomenon itself. The Internet not only provides the means for teens to access such erotic media but also offers them the opportunity to create their own erotic fan fiction and art and distribute them to others. It also allows them the freedom of anonymity and the potential to construct or present an online identity resistant to social constraints surrounding age, gender, race,

class, and sexuality. It is reasonable to suggest, therefore, that important shifts in how these readers conceptualize and fantasize about love and sex can be observed through their participation in Internet communication, discourse, and textual circulation that mark them as part of a global counterpublic.

While US media has begun to take more notice of the popularity of manga among children and teenagers, those texts that belong to the boy-love genre have largely remained below the radar of the more conservative mainstream as yet. Women's investment in boy-love manga, both here and in other countries, already suggests certain dissatisfactions with the fantasies offered by mainstream media and traditional heteronormative romance. Instead, these comics and the circulation of fan discourse surrounding them seem to project a more promising queer vision of love and desire. For as Judith Butler makes clear in *Undoing Gender*, "in the same way that queer theory opposes those who would regulate identities or establish epistemological claims of priority for those who make claims to certain kinds of identities, it seeks not only to expand the community base of antihomophobic activism, but, rather, to insist that sexuality is not easily summarized or unified through categorization" (2004, 7). I have attempted to demonstrate throughout this essay that the cross-cultural and global intersections of the boy-love manga counterpublic make it problematic to theorize about the popularity of these texts by segregating communities of readers along cultural lines. When this occurs, we run the risk of falling into troubling universalizations of those communities of readers that not only ignore their differences within those cultural contexts, but also attempt to explain their individual desires and fantasies in totalizing ways. Examining this phenomenon at the level of counterpublic discourse can offer us new perspective into how boy-love manga has become a compelling site for transnational readership and communication in a growing network of intimate and diverse strangers. It is my contention that the global nature of this counterpublic in fact facilitates subversive queer identifications and desires by generating productive tensions between heterogeneous and incoherent transcultural contexts and the intimate fantasies and engagements of readers that are never fully explicit, accessible, or quantifiable.

Notes

1 Manga are also being published widely in Western Europe, but for the sake of scope I am confining my discussion to North America only.

2 One of the difficulties with terminology lies in the fact that these words are constantly changing signification in Japan, and new terms are rapidly being coined to replace old ones. In point of fact, the term *shonen-ai* has apparently become obsolete in Japan, while *yaoi* has been replaced by *Boys' Love*, also referred to as *BL*. Internet fan communities appear to be more up-to-date on these changes than the academic print world, and Aestheticism. com provides one of the more detailed breakdowns of terms at http://www.aestheticism.com. For the purposes of this essay, I will refer to the texts currently published by Tokyopop and their competitors as *shonen-ai*, in line with their own advertisement of them as such, and retain *yaoi* as a contrasting term for more sexually explicit manga that such presses as CPM, Digital Manga, and Kitty Media are all using. This is partly necessary as well because of the time gap in publication of titles in

English-speaking countries versus those in Japan, as ours are generally several years behind. Various English spellings of the term *shonen-ai* exist, but I have chosen to use the version employed by Tokyopop.

3 Although I would note here that Joshua Mostow (2003) suggests that male sexual behavior in earlier periods of Japanese history and artistic production cannot be properly contained within the binary of heterosexual and homosexual, and that we "need studies that look critically at the whole range of sexual activity and desire" (70) in previous time periods.

4 There is a corresponding genre of girl-love manga in Japan that is often referred to as *shojo-ai* or, for more sexually explicit texts, *yuri*. However, the genre is much smaller and has fewer publications in Japan. Interest in these texts is growing though and in the United States AniLesboCon (ALC) Publishing is currently releasing some *yuri* anthologies with manga from Japanese artists as well as other Western amateur manga artists.

5 While some sexual power play occurs in certain boy-love manga, it is generally playful, and erotic encounters between the main characters are still overwhelmingly marked by tenderness and a mutuality that emphasize the equal importance of both characters' sexual and emotional needs. However, I must note here that there is a subgenre of BDSM *yaoi* for women in Japan (BDSM is a common abbreviation used to refer to anything dealing with bondage, domination, submission, sadism, and/or masochism). CPM recently brought out the first *yaoi* manga containing BDSM tendencies in North America when it released Ayano Yamane's *Finder Series 1: Target in the Finder* in September 2005.

6 The first volume in this series was very recently released by Be Beautiful, in September 2005.

7 McLelland has noted that there are already numerous *yaoi* Web sites "in Chinese, Portuguese, French, Italian, and Spanish, although they are vastly outnumbered by those in English" (2000a, 283). This is one compelling example of the increasing transnational popularity of these comics.

8 As Janice Radway notes in her revised introduction to *Reading the Romance: Women, Patriarchy,* *and Popular Literature*: "Even the most progressive of recent romance continues to bind female desire to a heterosexuality constructed as the only natural sexual alliance, and thus continues to prescribe patriarchal marriage as the ultimate route to the realization of a mature female subjectivity" (16).

9 Slash fiction is a form of fan fiction writing that originated in the 1970s among female *Star Trek* fans who began writing homoerotic love stories about Kirk and Spock. The term *slash* itself was coined in relation to the tendency to refer to pairings between male characters with a stroke or slash, as in, for example, *Kirk/Spock* or *K/S*.

10 *Scanlation* refers to the fan-based practice of translating manga texts into another language (in this case English) and scanning them online with the translations inserted into the necessary frames and dialogue bubbles of the comic.

11 As explained in "Normal Female Interest in Men Bonking" (1998): "Slash stories circulate within the private realm of fandom, are published in zines, distributed through the mails, through e-mail, or passed hand to hand among enthusiasts. The noncommercial nature of slash publishing is necessitated by the fact that these stories make unauthorized use of media characters" (10).

12 There are many examples of this, but one of the more popular figures is Ayano Yamane, whose work is currently under license to CPM for US publication.

13 For more information, visit their Web site at http://www.yaoipress.com

14 Other publishers are following Tokyopop's lead, and most of their Web sites now have surveys and forms for visitors to fill out that usually ask about what titles they would like to see in future.

15 Yaoi-Con is a fan-based convention centered on *yaoi* and *shonen-ai* themed anime and manga. It was founded in 2001 and occurs annually in San Francisco. Attendees come from all over the world to participate in this weekend long event. There are many activities for fans to participate in such as: games, video screenings, discussion panels, amateur karaoke, costume competitions, and shopping in the dealer's room. However, due to legal restrictions in the state of California that do not allow minors entrance where adult materials

are being sold, only those eighteen and older can attend. The fan organizers of Yaoi-Con keep everyone updated on future conventions and archive information and pictures from previous years at http://www.yaoicon.com

16 It is significant to note that thus far, the *shonen-ai* titles have not been separated from other titles, but rather integrated with them. Bookstores are organizing all manga titles together alphabetically in their graphic novels sections.

17 Be Beautiful's main advertising tagline is "Romantic graphic novels by women ... for women." Information about this line is available at their Web site: http://www.bebeautifulmanga.com

18 At the time that this essay was being prepared for publication, several new companies, DramaQueen and Blu Manga, emerged online indicating that they are planning to release a slew of *yaoi* titles in late fall 2005.

19 According to a recent article in *Publishers Weekly*, boy-love manga titles are indeed selling well.

The most recent volume in Viz's shonen-ai series, *Descendants of Darkness*, by Yoko Matsushita, sold ten thousand copies a few months after its publication. Digital Manga's *yaoi* graphic novel *Only the Ring Finger Knows* (2004), by Satoru Kannagi and Hotaru Odagiri, is now in its third printing and has sold more than twelve thousand copies. Other Digital Manga titles are also selling in the thousands, according to this report, and more titles are set to be released soon (Cha 2005).

20 It is important to note here that Tokyopop also publishes heterosexual manga. Therefore, the overall readership is somewhat more divided. As of yet, the company has not released any statistics specifically about their boy-love manga readership.

21 Not surprisingly, heterosexual romance novels are not policed in the same manner, even though they often contain explicit descriptions of sexual acts.

References

Allison, Anne. 1996. *Permitted and Prohibited Desires: Mothers, Comics, and Censorship in Japan*. Berkeley and Los Angeles: University of California Press.

Aoyama, Tomoko. 1988. "Male Heterosexuality as Treated by Japanese Women Writers." In *The Japanese Trajectory: Modernization and Beyond*, ed. Gavan McCormack and Yoshio Sugimoto. Cambridge: Cambridge University Press.

Asagiri, You. 2004. *Golden Cain*. New York: Be Beautiful.

Behr, Maiko. 2003. "Undefining Gender in Shimizu Reiko's *Kaguyahime*." *US-Japan Women's Journal* 25(December):8–29.

Butler, Judith. 2004. *Undoing Gender*. New York: Routledge.

Cha, Kai-Ming. 2005. "Yaoi Manga: What Girls Like?" *Publishers Weekly*, 7 March.

Green, Shoshanna, Cynthia Jenkins, and Henry Jenkins. 1998. "Normal Female Interest in Men Bonking: Selections from *The Terra Nostra Underground* and *Strange Bedfellows*." In *Theorizing Fandom: Fans, Subculture and Identity*, ed. Cheryl Harris and Alison Alexander. Cresskill, NJ: Hampton Press.

Halberstam, Judith. 1998. *Female Masculinity*. Durham, NC: Duke University Press.

Halperin, David M. 1993. "Is There a History of Sexuality?" In *The Lesbian and Gay Studies Reader*, ed. Henry Abelove, Michele Aina Barale, and David M. Halperin. New York: Routledge, 416–31.

Kannagi, Satoru, and Hotaru Odagiri. 2004. *Only the Ring Finger Knows*. Carson, CA: Digital Manga.

Kincaid, James R. 1998. *Erotic Innocence: The Culture of Child Molesting*. Durham, NC: Duke University Press.

Kinsella, Sharon. 2000. *Adult Manga: Culture and Power in Contemporary Japanese Society*. Honolulu: University of Hawaii Press.

Kodaka, Kazuma. 2004. *Kizuna: Bonds of Love*. vol. 3. New York: Be Beautiful.

Matoh, Sanami. 2004. *Fake*. vol. 7. Los Angeles: Tokyopop.

McLelland, Mark. 2000a. "No Climax, No Point, No Meaning? Japanese Women's Boy-Love Sites on the Internet." *Journal of Communication Inquiry* 24(3):274–91.

———. 2000b. "The Love Between 'Beautiful Boys' in Japanese Women's Comics." *Journal of Gender Studies* 9(1):13–25.

Memmott, Carol. 2005. "Japanese Manga Takes Humongous Step." *USA Today*, July 6, 4d.

Mizoguchi, Akiko. 2003. "Male-Male Romance by and for Women in Japan: A History of the Subgenres of *Yaoi* Fictions." *US-Japan Women's Journal* 25(December):49–75.

Mostow, Joshua S. 2003. "The Gender of *Wakashu* and the Grammar of Desire." *Gender and Power in the Japanese Visual Field*, ed. Joshua S. Mostow, Norman Bryson, and Maribeth Graybill. Honolulu: University of Hawaii Press, 49–70.

Murakami, Maki. 2003. *Gravitation*. Vol. 1. Los Angeles: Tokyopop.

Nagaike, Kazumi. 2003. "Perverse Sexualities, Perverse Desires: Representations of Female Fantasies and *Yaoi Manga* as Pornography Directed at Women." *US-Japan Women's Journal* 25(December): 76–103.

Nitta, Youka. 2005. *Embracing Love (Haru wo Daiteita)*. New York: Be Beautiful.

Orbaugh, Sharalyn. 2003. "Creativity and Constraint in Amateur *Manga* Production." *US-Japan Women's Journal* 25(December):104–24.

Penley, Constance. 1992. "Feminism, Psychoanalysis, and the Study of Popular Culture." *Cultural Studies*, ed. Lawrence Grossberg, Cary Nelson, and Paula A. Treichler. New York: Routledge, 479–94.

Radway, Janice. 1991. *Reading the Romance: Women, Patriarchy, and Popular Literature*. Chapel Hill: University North Carolina Press.

Reid, Calvin. 2003. "Manga is Here to Stay." *Publishers Weekly*, 20 October, 74–6.

Rubin, Gayle. 1992. "Thinking Sex: Notes for a Radical Theory of the Politics of Sexuality." In *The Lesbian and Gay Studies Reader*, ed. Henry Abelove, Michele Aina Barale, and David M. Halperin. New York: Routledge, 3–44.

Schodt, Frederic L. 1996. *Dreamland Japan: Writings on Modem Manga*. Berkeley: Stone Bridge Press.

Sedgwick, Eve Kosofsky. 1993. "Queer and Now." *Tendencies*. Durham, NC: Duke University Press, 1–20.

Solomon, Charles. 2004. "Young Men in Love." *Los Angeles Times*, June 30, E3.

Thompson, David. 2003. "Hello Boys." *New Statesman*, September 8, 43–4.

Thorn, Matthew. 2004. "Girls and Women Getting Out of Hand: The Pleasure and Politics of Japan's Amateur Comics Community." *Fanning the Flames: Fans and Consumer Culture in Contemporary Japan*, ed. William W. Kelly. Albany: State University of New York Press, 169–87.

Warner, Michael. 2002. *Publics and Counterpublics*. New York: Zone Books.

Yamane, Ayano. 2005. *Finder Series 1: Target in the Finder*. New York: Be Beautiful.

Further readings

Shojo and Adult Women: A Linguistic Analysis of Gender Identity in *Manga* (Japanese comics), Junko Ueno, *Women and Language*, 29(1), 2006.

Queering the Homeboy Aesthetic, Richard T. Rodríguez, *Aztlán: A Journal of Chicano Studies*, 31(2), Fall 2006.

Related Internet links

Shonen-ai entry, Anime News Network website: http://www.animenewsnetwork.com/encyclopedia/lexicon.php?id=26

Digital Manga website: http://www.digitalmanga.com/

Kitty Media website: http://www.kittymedia.com/

Part IV

Afterimage
Trauma/History/Memory

Introduction

The themes of history, trauma, and memory figure in each of the contributions in
this section, through the experience and recounting of events such as the Holocaust,
the 9/11 attacks and Hurricane Katrina; the dispossession of Vietnamese refugees
and Latin American migrant laborers; and fragments of other, more obscure his-
tories. The essays in Part IV explore the relationship of images to traumatic events,
suggesting that in these specific contexts images take on many functions: as wit-
ness, evidence, signifier of abjection, call for political resistance, vehicle for subli-
mation. Additional questions include: what is the relationship of memory to the
traumatic event, and to history? Do some images represent events more "truth-
fully" than others? Is it acceptable, or ethical, to aestheticize the traumatic event?

In recent decades, historiographic practices have expanded under the influence
of deconstruction, New Historicism, new art history and related fields, resulting in
a proliferation of narratives from multiple perspectives, away from a unitary notion
of history and toward personal explorations of the archive. The essays in Part IV
provide examples of these types of narratives while illustrating the critical role of
visuality in representations of history.

For example, combining archival research with deconstructive method, Jaimie
Baron constructs a reading of documentary films that engage in a selective and
personal mining of the archive with its implicit relationship to death, extinction, and
loss. Jon Bird describes his own experience in New York on 9/11, and then refers to
Carolyn Steedman's *Dust: The Archive and Cultural History* on the metaphor and
materiality of dust inhaled by eighteenth- and nineteenth-century leather and parch-
ment workers, linking it to the dust breathed in by people escaping the collapse of
the World Trade Center. Connecting personal experience to a larger socio-historical

Global Visual Cultures: An Anthology, First Edition. Edited by Zoya Kocur.
© 2011 Blackwell Publishing Ltd except for editorial material and organization © Zoya Kocur. Published 2011
by Blackwell Publishing Ltd.

narrative, Simon Leung begins his essay on the dispossessed, stateless body with an autobiographical anecdote, recalling a childhood experience at a bus stop with his brother. Joy James recounts a trip with her students to post-Katrina New Orleans, in order to share impressions of the experience, but more crucially, to describe how the need to process disturbing images became a catalyst for action. Ernst van Alphen draws on graphic personal testimonies from Holocaust survivors as a method for accessing and interpreting history.

In each of these histories, accompanied by visions – the dust falling over New York City on 9/11, the sight (and trans-valuation) of abject squatting bodies, the emaciated victims of the Holocaust, the terrible aftermath of Hurricane Katrina – it is not simply the image, but the visualization, brought forth by language, that allows the reader to "see" and therefore understand what is at stake.

Simon Leung's *Squatting Through Violence* revolves around the figure of the abject, squatting body. Invoking *"Les techniques du corps"* (*"Techniques of the Body"*) by the French anthropologist Marcel Mauss, Leung focuses on the habits of the body and its status as bearer of social, psychological, and biological relations. Taking up the act of squatting in particular, Leung identifies this technique with social and economic displacement in Western(ized) societies.

Leung extends Mauss's observations to the examples of Vietnamese immigrants and Latin American migrant workers in California, and to the situation of Vietnamese guest workers who came to Germany during the 1980s and were forcibly repatriated in 1992. These squatting bodies symbolize and enact the trauma of displacement, dispossession, and violence. Leung then describes his own symbolic effort to "put back on the street" the expelled Asian bodies. For this project, posters of a nearly life-size squatting figure were pasted on the bus stops and walls of Berlin in reference to the violence done to bodies that squat, whose bodily techniques signify "alien" and Other, but who also – to paraphrase Leung – offer a counter-architecture of resistance, a refusal to let go of what is dear.

Noting that the technology of filmmaking, with its intimate links to both history and memory, emerges from an archival impulse to record and preserve, Jaimie Baron's *Contemporary Documentary Film and "Archive Fever": History, the Fragment, the Joke*, explores the relationship between the human subject and history as interpreted through changing technologies of memory.

Via discussion of four independent documentaries in which the archive figures prominently, Baron suggests that documentary filmmakers have entered into a new relationship with the archive/archival practices and that methods of both New Historicism and deconstruction inform the way the archive is mobilized by these artists. The four films chosen by Baron raise questions about how archiving technologies affect what is remembered, the ways archival materials circulate, who has access, and what stories they are made to tell. Among the films discussed are Adele Horne's *Tailenders*, constructed around the sound recordings of an evangelical missionary group, and Michael Gitlin's *The Birdpeople*, which borrows the archival object of the taxidermied body of the ivory-billed woodpecker but whose subject ultimately is the human predisposition to observe, collect, and catalog.

The films deliberately emphasize the archival fragment and also employ the structure of the joke as productive "misuse," insisting on the inadequacy of a single narrative to construct a complete history. The refusal of these documentaries to conclusively interpret their archival materials signifies for Baron the "disruptive, metonymic role of the fragment."

Jon Bird's *The Mote in God's Eye: 9/11, Then and Now*, a reflection on New York City and the events of September 11, 2001, employs the trope of "dust" as a dominant visual symbol. Bird conjectures, "If the iconic image of an uncertain post-war world is the mushroom cloud ... then the visual legacy of 9/11, surely, is 'dust,'" which fell over the city "casting a cloud over our capacity to comprehend this complex and traumatic moment in history." New York City is defined for many by its image, its architecture, and spectacle, into which the images of 9/11 were incorporated. Bird notes the city's prominence as a place of dreams (and nightmares), inscribed through numerous Hollywood and mass media portrayals, with the destruction of the city often at the center of dystopic visual fantasies.

In his recounting of art and architectural proposals and speculations on the impacts on "lifestyle" (including trends in fashion and dining) as a result of 9/11, Bird raises the question of appropriateness of aesthetic responses to this event. In the end, he affirms the possibilities for a communal transformation via the sublime, concluding that "it is the realm of the social that attests to the wounds of the traumatic event and maps the processes of internalization and adjustment to a changed world."

In *Caught by Images*, Ernst van Alphen employs psychiatrist Pierre Janet's definitions of traumatic memory (memories that resist integration due to their dramatic or traumatic nature) and narrative memory (consisting of mental constructs which people use to make sense out of experience) in order to analyze the role of the visual in Holocaust testimonies. Interested in the role of visual memory in the processing of traumatic events, van Alphen cites the writing of Toni Morrison: "Morrison insists on the grounding function of specifically visual images in the re-membering, the healing activity of memory ..."

Through the example of written testimonies of Holocaust survivors, van Alphen seeks to demonstrate how the Holocaust disrupted conventional Western notions about the nature of vision and the act of seeing. He reminds us that one of the implications of seeing is apprehension of what is being seen, but argues that "this link between seeing and comprehension has been radically disrupted in the experiences of Holocaust victims." Van Alphen asserts that in the testimonies of survivors the visual "functions more like the unmodified return of what happened instead of as a mode of access to or penetration into" events that occurred in the past, drawing on Sidra DeKoven Ezrahi's distinction between two literary modes of representing the Holocaust, aesthetic attitudes she defines as either static or dynamic. Van Alphen argues that "sight is, in fact, what distinguishes two radically different types of beings – those who have not, from those who have, worked through history." The difference, he suggests, is attached to vision.

Political Literacy and Voice, by Joy James, from an anthology about the aftermath of Hurricane Katrina, offers images of post-hurricane New Orleans as present day documents, as evidence of the repetition of history, and as a catalyst for what she terms political literacy in the context of a nation that has historically devalued black bodies.

James describes the post-Katrina photos of tanks patrolling the streets, black men on the ground being searched by uniformed white men as they tried to flee the flooded city, a newspaper caption of a black man "looting" juxtaposed with that of a white couple "searching for food." James places these recent images in the context of a historical disenfranchisement of African Americans, evoking the memory and image of Emmett Till, the Chicago boy murdered by white suprema-cists in 1955 while visiting family in Mississippi. The image of Till's mutilated body, displayed in the open casket insisted upon by his mother, was seen across the nation and beyond.

James's essay summons historical narratives to shed light on present day disas-ter, trauma, and displacement and calls for political literacy as a response to neglect and inaction on the part of the state. Just as the casket photo of Emmett Till sparked the incipient civil rights movement that in James's words turned trauma into hope and struggle, she recognizes that "underneath spectacle is a spark where empathy and compassion – not sympathy and charity – function as precursors for radical activism." In James's telling, the image is a defiant witness, an agent of mobilization toward social justice and political transformation.

20

Squatting Through Violence

Simon Leung

Many years ago, my younger brother told me in passing an anecdote which I remember to this day. He was probably twelve or thirteen, waiting for the bus in San Jose, California, the suburban city where we grew up, with a few other people whom he took to be Vietnamese immigrants. What struck him about this otherwise innocuous moment, and perhaps what located the foreignness of these strangers for him, was the position of their bodies while they were waiting – they were squatting. Although they were not squatting to call attention to themselves, that was exactly the effect as they rested their un(der)assimilated Asian bodies in a habitual position of waiting, incongruous with the sun-bathed sidewalks of a California suburb. What rendered this a particularly unusual scene to my young brother's eyes, so much so that he told me about it, was the fact that the bus stop provided seats, which remained empty while these strangers squatted, waiting.

In "Les techniques du corps," an essay dated from 1934, Marcel Mauss made the often-quoted ethnographic assertion that "humanity can be divided into those who squat and those who sit."[1] What sort of statement is this? Is it a replay of the Enlightenment morphology, which schematically represents Western humanity as upright and historical while others are base and subservient, living in timeless savagery? Given ethnography's obsession with racial classification, including precisely the difference between European sitters and dark-skinned squatters, Mauss' statement seems on the surface to harbor the desire to locate essence through the body. But the opposite is the case. "Les techniques du corps" is an affirmation of the power of artifice in all attitudes of the body – a study of the technological education of bodies, which refuses to define technology merely as the instrument of science, speed, and war.

"Les techniques du corps" describes the ways in which bodies are themselves instruments used in an acculturated, mechanical process, constrained by social tradition and utility. To emphasize the role of the social in these unconscious,

<div style="float: right">

Keywords

squatting
Marcel Mauss
the body
displacement
"aliens"
abjection
violence
globalized labor
sovereignty
borders
resistance
geopolitics

</div>

Global Visual Cultures: An Anthology, First Edition. Edited by Zoya Kocur.

repetitive actions of the body, Mauss returns to the Latin word habitus, one he contrasts with the French habitude (habit or custom), which signifies an individual's "acquired ability" or "faculty."[2] In contradistinction, habitus, where the techniques of bodies are located, connotes a structural process which "[does] not vary just with individuals and their imitations; they vary especially between societies, educations, proprieties and fashions, types of prestige. In them, we should see the techniques and work of collective and individual practical reason rather than, in the ordinary way, merely the soul and its repetitive faculties."[3] For Mauss, the habits of the body which constitute "techniques" are precisely the effects of "inhabiting" a social enactment of space. Like his famous articulation of the three-way trajectory in the economy of the gift (to give, to receive, to reciprocate), the acquisition of a particular technique of the body necessitates the indissoluble mix of three factors: social, psychological, and biological.

> The child, the adult, imitates actions that have succeeded which he has successfully performed by people in whom he has confidence and who have authority over him....It is precisely this notion of the prestige of the person who performs the ordered, authorized, tested action vis-a-vis the imitating individual, that contains all the social element. The imitative action that follows contains the psychological element and the biological element.[4]

"Humanity can be divided into those who squat and those who sit" was not proclaimed in the name of hierachal differences across the divide of "civilized" and "primitive" bodies; rather, it was an appreciation of the preservation of the gift of the squat, which to Mauss was neither abjected nor necessarily the mark of his racial/ethnic other:

> The child normally squats. We no longer know how to. I believe that this is an absurdity and an inferiority of our races, civilizations, societies. An example: I lived at the front with Australian (whites). They had one considerable advantage over me. When we made a stop in mud or water, they could sit down on their heels to rest, and the "flotte," as it was called, stayed below their heels. I was forced to stay standing up in my boots with my whole foot in the water. The squatting position is, in my opinion, an interesting one that could be preserved in a child. It is a very stupid mistake to take it away from him. All mankind, excepting only our societies, has so preserved it.[5]

This drama of the purging and preserving of squatting highlights the point that the body techniques we inhabit (which are continually being forgotten and relearned, written and erased) are analogous to other mediating forms, such as writing or speech in that they function both as agency and sign. While the two are inextricably bound together, these squatting fragments you hold in your hands are an attempt at a sustained movement from a reading of the latter to a proposal of the former. This is not a manifesto for squatting (although I for one would welcome one), nor is it a study of its repression per sé (in which case, innumerable

bodies would have to be summoned to testify on its behalf, not the least of which would be women's bodies in labor – in all senses of the word). Rather, these notes are limited to performing the role of a temporary interpreter, attending to the split-second when the habitual sitter encounters (and is divided from) his double in the habitual squatter.

They were squatting, waiting for a bus....In the late 1970s and early 80s, San Jose was one of the American cities where recent Vietnamese refugees, many of them "boat people," were relocated after gaining asylum in the US. Just as their eyes, over-saturated with the devastation of war, needed to adjust to the panorama of American culture, their displaced bodies needed to negotiate the corrosive space between the alien and the assimilated in learning acceptable ways of presenting themselves on suburban American streets. What made an anecdote which implied the alien abjection of squatting Asian bodies poignant for me, and perhaps what made the grounded squatting bodies uncanny for my brother, was the fact that we also inhabit Asian bodies – that previous to our own immigration to the US with our family just a few years before, we lived in a hemisphere where squatting bodies in public places, though not exempt from class connotations, would have remained unremarkable. An assimilated immigrant child's observation of the squatting everyday shifted into something remarkable in the violent process of dis-identification with newly-foreign bodies, which to other's (i.e. American) eyes probably resembled his own. Assimilation is a continual grasping of fragmented information, displacing of old habits – an ecology of the Self in which differences are enacted against the terms of the self. A displaced body that squatted where seats were available bespoke the difference between material availability and technological access: perhaps the squatters had not availed themselves of seats out of habit, perhaps my brother had lost access to a body that can squat. In a sense, they were anachronisms to one another. This belatedness is crucial, for the habitual squatter carries through the city a body's time-frame that is measured against the schedule of the city's own identity.

The violence that my brother (didn't quite know he) saw in the figures of squatters has been re-choreographed in the ensuing fifteen or so years. In the Vietnamese community of San Jose today, which is now among the largest in America, habitual public squatting has probably been unlearnt by many, re-routed to exclusively private spheres by some, and retained by a few. At the same time, this mode of squatting has also been accessed by others, most ubiquitously itinerant migrant laborers, who as a denotable collective has always made use of it. In almost all cities in California, the brown bodies of Latin American migrant (mostly illegal) day-laborers wait on designated street corners from daybreak on for employers who drive by with offers of a day's or a few hour's work. Often these are squatting bodies resting on their haunches, for such bodies, even at rest between long stretches of waiting, must connote the willingness to get up at any point to work. The squatting position, poised between standing and sitting, allows for no intermediary moment between obsequious patience and ready servitude: the squatter is already on his feet, ready for hire, at your service. The fact that these bodies (among others)

are the target of the passed, but suspended, Proposition 187,[6] only underscores the obscenity of the power relations involved in such a transaction. For such bodies, willing to uproot themselves following capital's demands, while having had always submitted to systematic denials in full participation in society, are in effect forced to be ever more willing to squat under the gaze of the rich nation across the border from the poor nations of their birth.

Squatting places the power differential between bodies through the terms of sovereignty – "He who is sovereign," says Maurice Blanchot, "is the one who does not have to wait." The bodies of obsequious squatters on the other hand, have always figured the abjection of those who must wait: the migrant worker; the coolie; and in a larger context, the squatters seen purely as such in the media – the refugees from famine and war – who are hostages to such images, since the financing of international efforts for their relief are based precisely on sympathy generated by the same images of the same squatting bodies, tucked under faces forever looking up at the cameras of the donor nations, awaiting their uncertain fate. Like the squatting migrant workers who must compete for work on the street corners of California, these squatting bodies must also be submitted to a competition with other abject bodies in their own pathetic depiction, for only "extensive coverage of a catastrophe by the international media [can] exert pressure upon governments to contribute."[7] The technological media(tion) that facilitates this spectacle not only overwhelms the reading of refugee bodies as images for consumption, but simultaneously announces its own ethical insufficiency – for there is no possibility of communication, of reciprocation, in such a gesture – and its ideological interests in "what can be shown."[8]

Whether rendered (re)markable as the jarring habit of the alien set against local habits, or unremarkable as the banal matter of course in the imaging of the pathetic other, squatting conjugates the body in a field of violence. Where can there be an outside to this field from our perspective when the First and Third Worlds collapse onto the geography of a squatting body? The "Geo," as Gayatri Chakravorty Spivak reminds us, "has already been grafted,"[9] and in turn so have the bodies which cross its lines. The squatters in the metropolitan West, like their counterparts who have been strategically displaced by the violence of warfare or the violence of the policies of the World Bank (here one thinks of farmers in sub-Saharan Africa who have been made refugees when centuries-old food production and distribution systems are destroyed through new agricultural technologies and global economic policies), are continually embattled, embroiled in border disputes. The lines of containment created by such positions in demarcating the transient refugee / migrant bodies are rewriting always and again those bodies as sub-sovereign – that is, non-subjects of the state, literally abject to the sovereign nation. Squatting, as a form of inscription, cannot in and of itself figure the abjection of its occupants. Yet, when it functions as a signifier which inversely reflects one's own servitude to (a sitter's, or a citizen's) identity, such signification secures the citation of sovereignty in the sitter while exiling squatters from the realm of identity. Seen as a trace of the primitive, the servile, the alien, the homeless, the fecal, a squatting body does not

Figure 20.1 Simon Leung, Squatting Project/Berlin, 1994. A project of 1000 wheat-pasted posters on the streets of Berlin. Photo reproduced by courtesy of Simon Leung

cite an authority that is recognized, neither from the highly centralized and differentiated flows of capitalism's media technology (where the representation of authoritative bodies, including the body of the state, are rigorously regulated); nor is it individuated (one does not squat, but sit for ones portraits, after all), invested with the connotations of the modern body that "belongs" to the sovereign subject of the West, the transcendental being from which we all cite, albeit in reduced dosages, in diffused forms.

This winter, answering a call from the Neue Gesellschaft für Bildende Kunst (NGBK) in Berlin for an exhibition of which the subject was "the business of violence," I disseminated on the walls of buildings and bus stops throughout the city's streets the image of a slightly less-than-life-size squatter (with his back to the viewer, his face in eclipse just enough for it to be discerned as Asian) multiplied on a thousand wheat-pasted posters (Figure 20.1).

I had re-imaged the squatters at the bus stop from my brother's anecdote because it is in the recess of such a moment that there lies another framing of violence, one which figures the belated relationship violence has to its "situation." Through this belated situational frame, one finds once again squatting as the historical grounding of the recurrent residual trauma of the Vietnam War, this time in Berlin: in 1992, 50, 000 of the 60, 000 Vietnamese "guest workers" who came to work in East German cities since the 1980s – due to their homeland's ravaged poverty that was kept destitute by a US-led economic embargo – were forcibly repatriated back to

Vietnam. My project of a thousand squatters was thus just a modest attempt to put back onto the streets of Berlin some of the Asian bodies which have been expelled. While the "new" Germany shrouds itself in the rhetoric of "openings," it has also taken the opportunity to exercise its "sovereign right" in redrawing the threshold for non-German immigration – in 1993, the German Parliament revised the asylum laws to make it more difficult for would-be immigrants and refugees to enter.

It is perhaps today's Berlin without the wall, called once again to its former identity, which allows this thinking of the violence of identity in its place. For violence, even simply in the practical sense of thinking it, is not just an entity of actions, such as the recent attacks on foreigners; but a breach with the space of the other, which is unlocatable "as such" for the simple reason that the true ethical space, the non-violent space one occupies with the other, is a project in the imaginary and cannot, as its raison d'être, be completed in the past. Thus the other to violence (not merely "non-violence" in the common sense, since passivity and indifference can also be great violence, indeed) is a call to responsibility which involves a process of becoming in order that we may develop its possibility. An adequate response to violence necessitates the negotiation of a contract with the future. Squatting has taught me to wait.

What is certain is that the scarred disjunction that is Berlin, divided and reunified, wealth and rubble, thrown for decades into the anxiety in waiting, already houses the symbolic body of the squatter as a subject of violence, for such a city is already familiar with a certain metaphysics of the Squat.[10] The bound symbol of Germany's hopes and wounds, Berlin is still waiting. It is, as they say, "a question mark."[11]

Literally centered by the "emptiness" which remained after Allied bombing and the erection/demolition of the Berlin wall, the city has dived into a massive physical reconstruction in seeking to rehabilitate its identity through architecture. This new found center of gravity has also involved a gleeful real-estate development and systematic de-squatting of Berlin, which was common in both the East and the West before unification. In this light, the alien habit of a squatting position, almost never seen, need only be grafted upon the familiar practice of squatting as habitat, now diminishing.

The impropriety, the obstinate lowliness of squatting in polite society no doubt gave rise in part to the term's common definition as a crime against the owner of property. Squatting, in the colloquial sense as we understand it in English – illegal habitation of property without permission, right, or title – underscores this "improper" gesture in the presence of the Law only more literally than the image of a squatting body. Just as the squatter squats a building, the squatting alien is seen to squat a country. Sometimes they occupy the same space; certainly, they occupy the same abject relationship to the respective "real estates" they squat against.

Through this parallax view, I read, with the technology of squatting, a sentence in NGBK's invitation letter for the exhibition: "In Germany, violence in the street and violence against the other, against foreigners and the foreign, have received

serious public attention only in the last few years." What we are confronted with in witnessing propaganda and literal acts of this stinging resentment against "the other" is the reminder that the ethos of national identity and sovereignty, epitomized in this case by unification – materialized also "only in the last few years" – is a structural process of naming certain others, "foreigners," against the violent fiction of its own unadulterated integrity. Squatters, literal or metaphorical, are resubjected to the terms of its rule: squatted property is reclaimed by the entitled; guest workers contracted before unification are expelled; laws are changed to deter further immigration, based at least in part on a "reconsideration" of the "role of aliens" in the new Germany. In this age of capitalism's triumph, can one really be surprised that the purging of the alien work force in Western Europe – that is, a purging of the squat from the body politic – coincides with the new outlets for cheap labor opened up by the "new world order?" Previously invited or at least tolerated "guests" are now made to appear, through the rhetorical manipulation of images of the very violence against them, more and more unassimilatable. Just as this "post-modern racism" (Slavoj Žižek's term) or "meta-racism" (Etienne Balibar's) is a shock-effect of the aftermath of the Cold War,[12] racism in another manifestation – physical violence "against foreigners and the foreign" – only reminds us of the continual embattledness which houses the bodies of the veterans we call immigrants, foreigners, refugees. The ethical breach with the other has grave historical resonance in Germany; yet, as California, the former-Yugoslavia, and other places have shown, the desecration of the alien is waged as warfare on a global dimension. At stake once again are borders: who will (again) be the one who squats in the re-alignment of capital? Berlin as Capital. Germany as Capital. Europe as Capital.[13]

In the volume under the heading of "Sovereignty" in his collection of writings, The Accursed Share, Georges Bataille calls for a trans-valuation of values in the understanding of the very word, sovereignty. An anti-rationalist project, Bataille in this critique/manifesto posits the edifice of "traditional sovereignty" as resting on formally "crude" foundations, since it actually "assert[s] itself in the sphere of knowledge,"[14] in collapsed and collapsing cosmologies in which Bataille has little faith and cannot imagine a return. To submit squatting to this thorough exegesis of sovereignty would be another project. What I would like to extract for our purpose here (in the same manner that I've snagged and sniped the image of the squatter), is the tenuousness Bataille ascribes to the "sovereign moment." "We should calmly ask ourselves," he writes, "if the world we have conceived in accordance with reason is itself a viable and complete world. It is a world of the operation subordinated to the anticipated result, a world of sequential duration; it is not a world of the moment."[15] Bataille aimed to salvage the sovereign moment from the modern ghetto of the unconscious, to pose it head on against the servitude to utility that permeates the timescape of the modern world.

For Bataille, past institutions of sovereignty, sited in objective recognition of their unification of sovereign moments (e.g. the figure of the king) can only exist for the individual in representation and cannot be experienced from within.[16] On

the other hand, the sovereign moment is experienced subjectively, but at the same time, we have an objective knowledge of it.

> We speak of laughter, of tears, of love, beyond the experience we have of them, as objectively conditioned impulses....If we go instead from an isolated consideration of those moments to the notion of their unity, we are referred back, provided we attain it, to deep subjectivity.[17]

What deep subjectivity ultimately experiences is "nothing." It is a "subjective experience of an objectlessness," a negative collection of disappearances.

> This disappearance corresponds to the object of those effusions that acquaints us with sovereign moments: they are always objects that dissolve into NOTHING, that provoke the moment of effusion when the anticipation that posited them as objects is disappointed.[18]

In moments, objects dissolve into nothing, but it is exactly through this vanishing point of the "nothing" that we can perceive a unity, a "global experience whose composite object is made of the fusion, into a single object, of the different objects of the different effusions at the moment of the dissolution."[19] The multifaceted dimensions of a single object, its "erotic, laughable, terrifying, repugnant or tragic value" are all in essence present as the indivisible collection of its moments objectively given to the imagination. In the same vein I ask: What is a moment of squatting? What awaits squatting? What "nothing" disappears into the recess of its moment? Squatting is also "nothing."

It is through such an understanding of the fragility of the moment that I re-pose squatting as a counter-technology of resistance – a resistance to the technology of wars declared in the name of sovereignty, yes; but also a resistance to the very terms of sovereignty imposed onto the abjected squatter. To resist is to not let go of what one holds dear. On certain bodies, squatting is the resistant position which reflects the history and events, the space between the arrivals and departures in the life of its occupant. On the streets of a city of sitters like Berlin, what I intended to bring forth (to bear as a gift) from that trace into the public realm was a poetics of squatting, the promise of a gesture sent into the future which depends on another body, not mine.[20] In doing so, I am merely reciprocating the gift of squatting strangers had given to me, mediated by my brother's words. To paraphrase Hannah Arendt, "We are strangers who stand (squat) in need of being welcomed."[21]

The bus stop provided seats, which remained empty while these strangers squatted. … In attenuating the distance between the many years since my brother's passing anecdote and today's regimes of violent resentment against otherness, in honoring the fragility of the other's gift, I, echoing Mauss and others, reaffirm the squat in its potentiality. The proposal for a scattered proliferation of squatters in the eroded space of the public cannot function as an organized "counter-position" per sé; but rather, as a way of retaining violence in a form in

which one can re-inhabit it humbly, with a minimal amount of violence, while slowly transforming the erosion of this public sphere into an internal frame which imagines its other, squatting is a form of counter-architecture. On five hundred of the thousand posters an additional text surrounded the figure of the squatter:

Proposal

1. Imagine a city of squatters, an entire city in which everyone created their own chairs with their own bodies.
2. When you are tired, or when you need to wait, participate in this position.
3. Observe the city again from this squatting position.

Notes

1 There are variations in how this sentence has been translated. In the translation I'm using for this text, for example, it reads: "You can distinguish squatting mankind from sitting mankind." See Marcel Mauss, "Techniques of the Body" in Jonathan Crary and Sanford Kwinter, eds., *Incorporations* (New York: Zone Books, 1992), 454–77. Witold Rybczynski, in his book *Home: A Short History of an Idea* (New York: Viking, 1986) wrote: "Regarding posture there are two camps: the sitter-up (the so-called Western world) and the squatters (everyone else)" (78). He does not cite Mauss as a source, perhaps illustrating just how often-quoted and dispersed such a statement is. He does, however, add a footnote to the sentence: "This bipartite division has been remarkably consistent; there is only one example of a civilization in which both sitting and squatting coexisted: ancient China." I have, on another occasion, also made use of the different in inflections sitting and squatting have accrued in a Chinese context. See my "Marine Lovers, another Sit(t)ing," *BE* (Berlin: Kunstlerhaus Bethanien, October 1994), 100–7.

2 Ibid., Mauss, 458.

3 Ibid.

4 Ibid., 459.

5 Ibid., 463.

6 Proposition 187 was an initiative passed in California in November 1994, denying illegal immigrants the right to medical care, education, and other services provided by government agencies.

7 John Damton, "UN Swamped by a World Awash with Refugees," originally published in *The New York Times*, also in *International Herald Tribune*, August 9, 1994, Al. According to the United Nations, there are 49 million refugees and "internally displaced people" in the world today. A 1993 UN report stated that "displacement of people is not the by-product of war but one of its primary purposes." Thus not only is displacement and famine used as a weapon, but the images generated by such atrocities also circulate through the mediation system as mechanisms of war.

8 Echoing Derrida's observation that "what a photograph really shows is the Law" – that is, what can be shown under the rule of the Law – Avital Ronell has analyzed the operation of televisual obscenity (literally "off-scene," off-stage, that which cannot be shown) during the time of the Gulf War when its violence was displaced onto the simultaneous moment of the Rodney King beating. See Avital Ronell, *Finitude's Score* (Lincoln, Nebraska and London: University of Nebraska Press, 1994).

9 Gayatri Charkravorty Spivak, "Inscriptions: Of Truth to Size," *Outside in the Teaching Machine* (New York: Routledge, 1993), 211.

10 It seems the metaphysics of squatting continues to occupy the infrastructure of Berlin. The return of its status as capital has been pushed back repeatedly. The latest projection is that the year

2000 will officially mark the occasion after Christo's wrapping of the Reichstag, Germany's once and future House of Parliament. He's said to have waited decades for the project to be approved.

11 See Paul Goldberger, "Reimaging Berlin," *The New York Times Magazine* (February 5, 1995): 45–53.

12 See Slavoj Žižek, "The Violence of Liberal Democracy," *Assemblage*, no. 20, (April 1993): 92–3, among other essays.

13 For a reading of the realignment of capital and the experience of aporia sited in Europe after 1989, see Jacques Derrida, *The Other Heading: Reflections on Today's Europe* (Bloomington and Indianapolis: Indiana University Press, 1992). It was originally published in French as *L'autre cap* in 1991 when the news of the day was the Gulf War, not Bosnia. Yet that other heading – that headline

news – soon returned to "the day" which haunts Derrida's *Reflections on Today's Europe*.

14 Georges Bataille, *The Accursed Share: Volumes II & III*, (New York: Zone Books, 1993), 228–9.

15 Ibid., 227.

16 Ibid., 233.

17 Ibid., 233–4.

18 Ibid., 234.

19 Ibid., 235.

20 Here I am morphing Avital Ronell's reading of Heidegger's analysis of the formal and spiritual congruence between the greeting and the poem. Avital Ronell, "The Sacred Alien: Heidegger's reading of Hölderlin's Andenken," lecture given at Deutches Haus New York University, February 23, 1995.

21 Ibid. From Arendt's reading of Kant, quoted by Ronell.

Further readings

Zones of Indistinction: Giorgio Agamben's "Bare Life" and the Politics of Aesthetics, Anthony Downey, *Third Text*, 23(2), 2009.

Techniques of the Body, by Marcel Mauss, in *Incorporations*, Jonathan Crary and Sanford Kwinter, eds. (New York: Zone Books, 1992).

Related Internet links

On Leung's *Squatting Project/Berlin*: http:/reconstruction.eserver.org/092/paice.shtml

Vietnamese guest workers in the in Czech Republic: http://www.migrationonline.cz/e-library/?x=2179824

Migrant issues blog: http:/citizenorange.com/orange/

21

Contemporary Documentary Film and "Archive Fever"
History, the Fragment, the Joke

Jaimie Baron

*But if Derrida's Mal d'archive [Archive Fever] provokes that more serious thing,
which is a joke, it is because the shade of the history writing that haunts its pages is
– really – no laughing matter. In this light, then, if there is laughter, it will be some
kind of homage, or at very least, a recognition, of what it is that has been revealed.*
– Carolyn Steedman, *Dust: The Archive and Cultural History*

Keywords

Derrida
the joke
the archive
the fragment
documentary film
New Historicism
deconstruction
narrative
memory
time
death
metonymy

Adele Horne's documentary *The Tailenders* (2005) begins with an image of a flat, square piece of cardboard labeled "Card-talk." A hand reaches into the frame, unfolds the cardboard to form a box equipped with a tiny record needle, places a phonograph record beneath the needle, and then uses a pen inserted into a hole in the record to spin the disc (Figure 21.1). What emerges is a man's voice speaking in English and reciting a simple, didactic lesson that answers the question, "What is a Christian?" His voice is slightly distorted by the fact that the record is cranked by hand, but it is nonetheless intelligible.

The Tailenders' odd inaugural object sets up an enigma, one not so much resolved by the film as used as an entry point into complex issues of archivization, information dissemination, and power. Over subsequent black-and-white archival images of people standing near similar hand-cranked phonographs, a woman's voice, Horne's, tells the story of Gospel Recordings, an evangelical missionary group founded in 1939 with the intention of recording Bible stories in every existing language and dialect in order, they say, to spread the same Christian message, translated but unchanged, across the world. The film then cuts to interviews with contemporary Gospel Recordings missionaries explaining their project and showing off their archive, which, they boast, contains recordings of more languages than any other archive in the world. The Cardtalk record in the first shot turns out to be a fragment from this vast collection.

Global Visual Cultures: An Anthology, First Edition. Edited by Zoya Kocur.
© 2011 Blackwell Publishing Ltd except for editorial material and organization © Zoya Kocur. Published 2011
by Blackwell Publishing Ltd.

Figure 21.1 The missionary group Gospel Recordings'
hand-cranked "Card-talk" record player in The Tailenders
(Adele Horne, 2005). Photo by Karin Johansson.

Documentary film has long been enmeshed in a complex relationship with archives and archival practices. While many documentary filmmakers have drawn on archival materials – whether film footage, photographs, or other artifacts, like *The Tailenders'* recordings – as illustration or evidence, others have radically eschewed archives and relied only on their own footage. This split has at times been quite pronounced, especially in cases in which different modes of documentary practice are used to address the same historical subject. Alain Resnais' short documentary *Night and Fog* (1955), which makes use of shocking archival photographs of Auschwitz taken during the Holocaust, is often contrasted with Claude Lanzmann's nine-hour epic *Shoah* (1985), which relies only on footage shot by Lanzmann himself over a period of eleven years (Bruzzi 105). Certain found footage documentaries, like Emile de Antonio's "collage junk films" (24–5), contain nothing but skillfully edited archival footage, while orthodox direct cinema filmmakers insist on "being there," using only material that they can capture through observing and recording their subjects firsthand. For the most part, however, documentary filmmakers rely on a combination of archival materials and their own contemporary footage, creating heterogeneous texts that oscillate in their relationship to present and past, made and found.

In the past few years, however, a number of independent documentaries have entered into a new relationship with archives and archival practices. Rather than simply mobilizing archival materials in a transparent manner, the four films I wish to discuss – *The Tailenders* (Adele Horne, 2005), *The Birdpeople* (Michael Gitlin, 2004), *okay bye-bye* (Rebecca Baron, 1998), and *spam letter + google image search = video entertainment* (Andre Silva, 2005) – figure the archive itself and thus simulate for the viewer the experience of being in an archive, of following and trying to make sense of fragments and traces. More specifically, these documentaries begin by mobilizing material or textual objects to which the filmmaker has some personal connection and follow not the defined trajectory of a journey but, rather, the tentative movements of an exploration. This exploration is often indirect, dispersed, and nonlinear. It foregrounds process, digression, and discovery rather than a straightforward recovery of "the facts." What is most interesting to me, however, is that, in the films I discuss here, the first archival fragment leads to further fragments and, more specifically, to the archive. Part of what is discovered is the archive itself and varying forms of archivization. Thus, each film treats a fragment as a jumping-off point that leads to a relationship with "the real" yet simultaneously interrupts any such unmediated relationship. Each film, in its own particular way, articulates a tension between the figuration of the archive and the use of fragments as well as between the acts of finding things and of making films.

While discourse about documentary has endlessly rehashed the truism that no documentary film is objective despite its implied truth claims, less has been written about the relationship between documentary as a historiographic process and contemporary changes in the wider field of historiographic theory.[1] Like other forms of historical inquiry, documentary is concerned with questions of how the past may be experienced or understood in the present. Thus, it seems productive to locate documentary practice within this broader historiographic context. Here, I argue that these four contemporary documentaries that figure archives and mobilize archival fragments do so in a way inflected by the methods both of New Historicism in academic historiographic practice and of deconstruction in academic literary and cultural practice. The archive is the common historiographic concept and technology around which these two diverse (and often contradictory) discourses converge. I also suggest, borrowing from historiographer Hayden White, that, in the context of the emergent digital era, the emplotment of the narrative of the archive and hence of the historical project itself in these films is that of satire, accompanied by the partial redemption of comedy and tragedy. Finally, I argue, building on the work of historiographic theorist Eelco Runia, that these films are part of a larger trend in the approach to history, a move away from the "transfer of meaning," or the attempt to narrate and explain history, toward a "transfer of presence," or a sense of contact with the historical past that cannot be reduced to facts and chronologies (17). Indeed, refusing to assert a stable narrative of the past, each of these documentaries offers, rather, an experience of the confrontation with the vast yet always partial and discontinuous archive of materials that precedes any construction of historical understanding.

In my view, what is ultimately at stake in all four films is the relationship between the human subject and the historical past as mediated through different and changing technologies of memory. As material objects are increasingly overwhelmed and outnumbered by digital documents, it has become ever more urgent for us to find new ways of sorting through these traces and to invent new methods for encountering and articulating the past. While many films engage the archive in various ways, these particular films figure the archive in such a way that they dramatize the larger shifts taking place in our cultural and theoretical conception of history. Indeed, they exemplify an emergent strategy within independent documentary film production for dealing with the traces of the past while simultaneously rejecting any simple notion of access to historical meaning, which seems increasingly untenable in the information age. Reflecting this historiographic crisis, they inhabit and thematize the desire for a coherent history confronted by the unruly vestiges of its passage.

Historiography, Deconstruction, Documentary

Since the 1980s there has been a marked democratization and personalization of historiographic practice at large that has been at least partially spurred by the development of New Historicism. According to preeminent scholars Catherine

Gallagher and Stephen Greenblatt, New Historicism begins from the premise that there is no single, universal history but rather many histories based in the unique, the particular, and the individual (6). Furthermore, Gallagher and Greenblatt emphasize the way in which New Historicism has opened up the range of topics considered worthy of historical investigation. By conceiving of individual cultures as sets of texts, New Historicists have been able to use almost any aspect of cultural production as a potential historical site for reading and interpretation (Gallagher and Greenblatt 8). New Historicists also acknowledge the fact that any exploration of history is necessarily in part subjective and based in the historian's desire to experience the "touch of the real" (Gallagher and Greenblatt 31). Thus, they often search the archive for eccentric anecdotes and enigmatic fragments in order to construct counterhistories that interrupt the homogenizing force of grand narratives by grounding themselves in the contingent and "the real," all the while acknowledging that the real is never accessible as such (Gallagher and Greenblatt 49). It is the archives and their vast amalgamation of unrelated objects that make the New Historicist project possible. The four documentaries I wish to discuss here are particularly allied with New Historicist strategies in that their self-conscious exploration of the archive and their emphasis on the fragment that disrupts grand narratives bring them into closer alignment than other current documentary forms with the New Historicist project.

Nonetheless, despite commonalities between New Historicism proper and these particular documentary practices, several important distinctions must be made between them. First of all, while New Historicists note the common problems of the excess and inexhaustibility of the cultural archive, they respond in written documents that do not have the same indexical relationship to the historical world as do photographic, filmic, or other audiovisual media, in which issues of excess are even more pronounced. Indexical images as well as sound recordings, quite simply, are even less easy to contain than written documents; their tangibility and ambiguity are often even more unruly. While every trace, written or otherwise, is open to interpretation, indexical audiovisual recordings are especially resistant to full comprehension or interpretation. As Friedrich Kittler has argued, the indexical sign, unlike writing, records all the uncensored, unfiltered "noise," which resists signification (86). Given their unruly excess, audiovisual media often demonstrate (whether intentionally or not) the excess, ambiguity, and disruptive real that are key elements upon which New Historicists base their work. Second, expressed through different media, they differ in their relationships to time and presence. Several of the filmmakers discussed here, in fact, use New Historicist methods not primarily to seek out and disclose the past but rather to explore the present as it is moving into the past, to examine the relationship between past and present, or to seek out traces of the past *in* the present.

While New Historicism provides one framework for understanding these documentaries, elements of deconstructive practice also emerge forcefully within these works. Deconstructive practice extends from the premise that language and signification are inherently multivalent and that therefore meaning itself can never be

stabilized. Its practitioners often interrogate the processes by which texts are made to "mean" something in order to question larger cultural assumptions. Indeed, the use or revelation of the pun or the "play on words" in order to reveal the slippage of the meaning of the signifier is one of the defining tools of deconstructive practice. New Historicists Gallagher and Greenblatt explicitly distance themselves from the critical practice of deconstruction, arguing that it does not take cultural and historical specificity into account (14). I would argue, however, that these documentaries discover and dramatize shared ground between New Historicism and deconstruction. That is, they generate and maintain a productive tension between the description of the specificity of a given cultural and historical situation and an interrogation of textuality itself.

In *Dust: The Archive and Cultural History* Carolyn Steedman has indicated a way in which rigorous archival research can be combined with deconstructive method. Steedman notes that deconstruction uses the form – not the affect – of the joke, which employs "the calculated naivety involved in the literal interpretation of a trope," thereby "missing the point, in order to make another one" (11). Steedman, in fact, makes use of this joke structure in her book, using Derrida's figurative notion of "archive fever" (*mal d'archive*) to examine the literal way in which nineteenth-century archives harbored the anthrax virus in the binding of books. Steedman literalizes the metaphor of archive fever in order to begin historicizing bookbinding and industrial diseases, including that of the scholar (28). The joke, which literalizes a metaphoric trope, is thus a form of "misuse" that is also historically productive. In all of the documentaries discussed here metaphors associated with the archive are literalized, thereby revealing the slippages in the meaning of the signifier. The literality of these "jokes," however, is grounded in particular in the specificity of the indexical audiovisual trace, thereby mitigating the New Historicist concern that deconstruction is ahistorical and decontextualizing. In sum, the common elements of all these films are, first, the fact that they share a fascination with the archive and archival objects and, second, the fact that they mimic the structure of the joke. This raises the question, What is the affinity between the historical archive and the joke? I would suggest that it has to do with the fundamental ambiguity of the meaning of the archival object as both figurative and literal, which lends itself not only to factual assertion but also to misuse and play.

At this historical moment in particular, when the ever-expanding digital archive threatens to overwhelm all narrative coherence, the question of how to organize archival traces and narrate from them any history at all has come to feel increasingly urgent. Hayden White has argued that all historical narratives are emplotted, primarily in the modes of romance, comedy, tragedy, and satire. While the story of the archive itself has often been emplotted in the romantic genre as a recovery and redemption of the past in the form of historical narrative, now the sheer volume of archival materials threatens to undermine the lofty goals of historians descended from Jules Michelet, who dreamed of "raising the dead." Indeed, the romance of the archive now verges on collapse, and the attempt to narrate the

experience of engaging the archive seems to have (d)evolved into satire. According to White, "Satire is the precise opposite of this Romantic drama of redemption; it is, in fact, a drama of diremption, a drama dominated by the apprehension that man is ultimately a captive of the world rather than its master, and by the recognition that, in the final analysis, human consciousness and will are always inadequate to the task of overcoming definitively the dark force of death, which is man's unremitting enemy" (9).

I would argue that the structure of the joke as it is mobilized in these films is most closely aligned with satire and its recognition of the inability of any narrative or signification to create a meaningful history in the face of not only the passage of time and of death but also the contemporary proliferation of archival materials. The vacillation between the literal and the metaphoric, and the very glut of signification, renders the presumed meaning of any signification suspect. Indeed, as Freud has pointed out, the uncanny pun signals the death of any absolute meaning ("The Uncanny"). The anxiety about the archive, which is often invoked as a place where the dead are preserved in order to be reanimated by the historian, seems to stem from the fear that the meaning of the traces left by the dead cannot be stabilized. If there is one overarching joke to which all these documentaries subscribe, it may be that, when it comes to history, the joke is on us. No matter how much archival material we may uncover (or perhaps because we have uncovered too much), a coherent history is always just out of reach. Nevertheless, along with the stuff of satire, the joke is also comic, which, according to White, opens up the possibility of some partial redemption (9). Freud, too, notes the association of the joke not only with anxiety but also with freedom, play, and the opportunity to think outside the habitual confines of rational thought (*Jokes* 10–11). This liberatory potential – the possibility for a playful attitude toward history in the act of writing it – allows these four documentaries to reassert the partial redemption of the comic, as well as the tragic, in the face of a nihilistic view of documentary as nothing but "mockumentary" and of history as pure farce.

The Archive of Noise

On several levels, Adele Horne's film *The Tailenders* is structured like a joke, which is not to say that it is overtly comic but rather to point to its productive "misuse" of its materials. To begin with, Horne herself actively misuses the archive of recordings collected by Gospel Recordings and "misses" the intended point of their archive in a subtly critical way in order to show not only its ambiguous nature but also the ambiguous effects of its use on the communities the missionaries target.[2] In the manner of the New Historicists, Horne uses an odd archival fragment – in the form of the Cardtalk record – to disrupt the grand narrative of Western progress uplifting the non-Western world through religion and technology.[3] Horne, who never appears on-screen, follows a group of Gospel Recordings missionaries to the Solomon Islands, Baja California, and India to document them carrying out

their work. Rather than focusing solely on the missionary organization, however, Horne uses their hand-cranked record player and archive of Bible recordings to explore the experiences of the consumers of the missionaries' wares, the power of the disembodied voice, and the complexities of carrying a particular message across languages and cultures. Without ever overtly condemning their project, Horne is able to use Gospel Recordings' archival mission to trace the legacy of colonialism and the flow of evangelism, in concert with the spread of global capitalism and consumerism, into poverty-stricken communities whose traditions and languages are quickly being quashed by all these forces, even as the missionaries attempt to translate "themselves" into the cultures in question. Thus, while telling the history of Gospel Recordings, Horne also tells another history, which is one of exploitation, oppression, and extinction rather than one of uplift and salvation

On this most basic level, the film can be seen as a joke on Gospel Recordings. Yet deconstruction also emphasizes the breakdown of any clear opposition between subject and object, in this case, between the filmmaker and the missionaries, an opposition that Horne herself rejects. Indeed, the film is also concerned with its own textuality as well as with the question of textuality itself. Horne's voice-over, while not the male voice of authority associated with more traditional documentary practice, is, like the sound that emanates from the missionaries' recordings, disembodied. Rather than ignore this "voice of God" transcendence, Horne interrogates the form as she mobilizes it. Without overt wordplay, she literalizes the notion of "Cardtalk," a card that talks, asking what it means for an inorganic object (like a film) to speak with a human voice. Over images of sound recording and playback devices, Horne's disembodied voice asks, "Why are disembodied voices so captivating? ... Separated from its body, the voice becomes superhuman. It can speak to more people than any single person could. Evangelists began using the disembodied voice in the twenties and thirties." So, too, in the 1930s, one might add, did documentary filmmakers. Thus, without being overtly funny, Horne mobilizes the structure of the joke in order to move from a singular object to much broader questions of power in which her own practice is implicated. She thereby also disrupts the convention of the documentary voice-over that so often, like missionary recordings, speaks with disembodied and transcendental authority.

The Cardtalk record player, which emits the disembodied voice, also directs the film toward the much larger archive of such voices and toward a consideration of the power of archives in general. Horne's film functions, in many ways, as a meditation on the processes of archiving and the collection of the indexical trace, in this instance the audio trace. Like the disembodied voice, archives are about power. As Derrida has pointed out, the archives in ancient Greece were administered by archons, who controlled the gathering and preservation of documents as well as their interpretation and hence their meaning (2). Here, the Gospel Recordings missionaries take on the role of the archons, choosing what is to be collected. Without overtly judging the collection of recordings, *The Tailenders* produces a sense of ambivalence about the missionaries' archive, which contains recordings of over five thousand languages and dialects, many of which are no longer spoken or are

soon to be lost. Clearly, there is an allure to this archive of dead or disappearing languages, but there is also a clear sense of the archive's selectivity, the fact that whoever decides what to archive also controls what traces will be available in the future. On the one hand, these are valuable indexical traces of certain languages that are gone or soon to be gone. Indeed, it is difficult not to admire an organization that has been able to amass recordings in so many languages and dialects. On the other hand, this admiration is accompanied by the realization that these recordings are only of Christian Bible stories: what is saved is determined by the missionaries, who have the privilege of deciding what counts.

Yet (and this is part of the joke, too), the film also points to the fact that archives and the indexical traces they preserve often escape the control of the archons. These traces mean more than the archons might intend or wish. Film theorist Mary Ann Doane, following Kittler, has suggested that the ability of technologies of mechanical reproduction to create indexical traces holds both the allure of the preservation of the past and the threat of preserving too much, of generating only an "archive of noise" (65). New Historicists Gallagher and Greenblatt emphasize the seductive lure of the archive as the place where one may encounter "the touch of the real" and the "luminous detail" (15), but, at the same time, they acknowledge the potential problem of counterhistory as a practice, in which anything may constitute a trace of the real (72). Horne's film expresses a similar experience of allure and threat, but it also, simultaneously, thematizes and literalizes this notion of the "archive of noise." For one thing, the missionaries' recordings themselves go beyond the control of meaning as intended by the missionaries. Most fundamentally, the film illustrates the problem of the subtle transformations of meaning inherent even in an "accurate" translation from one language to another. Furthermore, in one interview a Gospel Recordings member discusses some of the additional problems of making recordings in languages that the missionaries themselves do not understand. Sometimes, he explains, the translators themselves "misuse" the recording process, making mistakes and taking liberties with the biblical stories, as in the example of one translator who turned the story of the prodigal son into the story of the prodigal pig. The intended biblical meaning is transformed into "nonsense." Even more crucial to the "archive of noise" in the film, however, are the *literal* noises on these missionary soundtracks. Missionary interviews and written archives attest to the fact that local conditions often do not allow for a clean, crisp recording. Crickets, domestic animals, children playing, and other noises are captured on the recording and cannot be eliminated. The "thickness" of the indexical sound recording produces an unintended encounter with and description of "the real" and thus generates the threat – for the missionaries – of losing control of meaning, of excess and inexhaustibility. However, rather than seeing noise as threat, *The Tailenders* celebrates the liberatory effect of "noise" as the breakdown of the missionaries' control. For Horne, the problems encountered by Gospel Recordings point to the fact that local realities cannot be fully contained or silenced by the voice of Western missionaries and the global marketplace. An archive of instrumental power is subverted, (mis)used

for different ends – or for no end at all, for play. While, on the one hand, the film satirically narrates the archive as an instrument of social control rather than of truth, it also reasserts the comedy of the archive as a site of liberation from these very sources of control through misuse and play.

Appropriately, the film itself rejects the role of the archon, refusing to offer a definitive account of the historical significance of its own materials. Like the New Historicists, Horne uses her objects and anecdotes not to construct a grand narrative but to throw such narratives off track without establishing any other unitary meaning. The film offers potential insights into the archival process and its consequences, and yet, by withholding explicit judgment, it hovers on the edge of itself becoming "noise." It works to provoke and evoke rather than to judge or explain. In the end, although we know much more *about* it, the disembodied voice emanating from the Cardtalk record player remains a subtly disturbing enigma.

The Archive as Taxonomy and Taxidermy

The uncanny encounter with an archive of bodiless voices in *The Tailenders* finds an echo in Michael Gitlin's film *The Birdpeople*, in which the taxidermic body of the (most likely) extinct ivory-billed woodpecker is the ambiguous and opaque object that structures the film (Figure 21.2). The New Historicists suggest that archival fragments are alluring because of their radical alterity and their ability to puncture historical platitudes. The taxidermic body suggests just such radical alterity. It also exists in a special relation to time. As Steedman writes, "In the practice of History (in academic history and in history as a component of everyday imaginings) something has happened to time: it has been slowed down, and compressed. When the work of Memory is done, it is with the things into which this time has been pressed" (79). In Horne's film time has literally been "pressed" into the Cardtalk record in a record press. In Gitlin's film the stuffed body of the ivory-billed woodpecker becomes the technology of memory into which time has been pressed. Nonetheless, it would be misleading to say that the film is *about* the ivory-billed woodpecker. Like Horne's "misuse" of Gospel Recordings' recordings and archives, Gitlin's film is also structured as a joke. Gitlin uses the stuffed, dead body of the ivory-billed woodpecker and the marginal practices of bird-watching, bird banding, and avian taxidermy to address larger questions about the impulse to observe, preserve, catalog, and archive by turning his subjects' strategies of archivization back on themselves – and by reflecting on film as an archival medium itself.

As in New Historicism, in which idiosyncratic fragments are used to illuminate historical norms, marginal practices of archivization in the film serve to underscore the normative status of the urge to collect experiences, data, and objects. *The Birdpeople* provides a catalog of different kinds of avian archives, their justifications and their production of "evidence," which become part of larger archives of knowledge or experience. Each type of activity represented in the film serves as an instance of a particular technology of memory available at a given cultural

Figure 21.2 The taxidermic body of the ivory-billed woodpecker in *The Birdpeople* (Michael Gitlin, 2004)

moment. The film, in fact, creates an overt *taxonomy* of these mnemonic technologies and the "birdpeople" ("birders," "banders," "scientists," and "searchers") who put these technologies into practice. Himself an amateur birder, Gitlin does not so much make fun of the people who obsessively collect sightings of birds as ponder their impulse to look and then to catalog these looks in written or unwritten transcripts. Birders thus produce an archive of what they have seen without necessarily preserving an image or any other indexical form of representation. Their prosthetic tool is the binoculars rather than the camera, and their archives exist mostly in individual memories or on slips of paper inscribed with name, date, and location. Meanwhile, catching live birds in nets, the banders document the numbers of bird species present in an area and take measurements of these live birds before tagging and setting them free, thereby producing extensive facts and figures about bird populations even as this "living archive" of tagged bird bodies wings its way through the trees. This is not to say that nature itself is an archive but rather that the banders attempt to impose an order on nature through their taxonomic activities. While the banders seek to control the excess of nature in the present, the avian taxidermists attempt to impose a similar order onto nature in the past tense, preserving the bodies of dead birds as museum exhibits or tools for future research. For the searchers, people who spend months in the swamps looking for a visual or audio trace of the vanished ivory-billed woodpecker, the living body of this bird is figured as a redemptive icon of the past in its ultimate sense: extinction. These searchers do not produce an archive but, rather, like the historian in the archive, attempt to do no less than raise the dead. In doing so, they point to what is missing in the archives produced by the birders, banders, and taxidermists, to the absences that are an inherent part of every archive.

The archive as a raising of the dying, the dead, and the extinct is perhaps the underlying logic of all of these practices. At the same time, however, there is a sense that the archive is beyond the control of any of the individuals within the film. The birders may have the most control over their archive, for they are the only ones who can access it, but their archive of personal encounters is limited in that it cannot be used by anyone else. By contrast, the banders' data become part of a larger instrumental archive within which the banders themselves have almost no control. Similarly, one taxidermist says, "Twenty years down the road, people may be thinking about things we can't even envision right now, and these specimens that I laid down two decades ago will be really important." Although the

taxidermist speaks in a utopian tone, his comment also serves to underscore the fact that his work – his archival data – could be used for almost any purpose in the future. Meanwhile, the searchers produce only a failed archive of false sightings and recordings, and their motivation for seeking evidence of the extinct wood-pecker's continued existence is entirely unclear. It seems like pure obsession and, to a great degree, undermines all of the justifications all of the birdpeople make in the film for their actions. The impulse to create an archive, to produce evidence of "having been there," of "having seen," to assert control by stalling or turning back death, is more powerful than any rational motive.

Like Horne, Gitlin recognizes his own complicity in archivization. The impulse to make films, Gitlin subtly implies, especially the urge to make documentaries, may be the result of the same obsession. André Bazin's description of cinema as a result of the historical obsession with likeness and as a preservation against death, which he calls the "mummy complex" (9), already points to the connection between filmmaking and taxidermy. Fatimah Tobing Rony extends this compari-son in her discussion of the "ethnographic taxidermy" practiced by documentary filmmakers like Robert Flaherty, who tried to make a dead indigenous culture look alive for white consumption (99–126). Filmmaking itself is a technology of history and memory and thus emerges from an archival impulse to record and save. Indeed, because Gitlin's film is structured as a taxonomy rather than a narrative, it echoes the non-narrative, categorical structure of an archive. Moreover, the taxo-nomic structure and the formal parallels drawn between human bodies and animal bodies produce a blurring of the boundaries between animals and humans, nature documentary and ethnographic film, taxidermy and filmmaking.

Indeed, purporting to be about people who watch, band, stuff, and search for birds, *The Birdpeople*, in fact, turns the birdpeople's own archival strategies back on themselves. For one thing, the film is as much about watching people as it is about watching birds. While Gitlin's film simulates the act of bird-watching through bin-oculars, it also performs an ethnographic inspection. As he documents the proc-esses of avian archiving, Gitlin also films the birders themselves, revealing the voyeuristic aspect of birding. As he points out, the birds look back at the camera or the binoculars, but theirs is an ambiguous gaze, although not the threatening or threatened returned gaze of the ethnographic subject. The bird is a "safe" other whose gaze does not matter. Gitlin's camera, however, is another matter. When he frames the birdpeople individually, standing silent and almost motionless in long takes, he seems to be literally producing "ethnographic taxidermy" in the form of images. In most cases the birdpeople's discomfort at being looked at and recorded is palpable. Although compelled by the archival impulse, most of the birdpeople seem much less comfortable being themselves preserved in the archival medium of cinema.

This discomfort comes as no surprise, since the verbal discourse produced by all of the birdpeople in the film reveals the theme of death, extinction, and loss implicit in all archival practices. In fact, the birdpeople perform a displacement of the discourse of "salvage ethnography" from the ethnographic subject to the

animal subject, anthropomorphizing the bird, who, like the Native American "noble savage" in colonial discourse, is posited as always already disappearing (Rony 91). Thus, the gaze of the birder is revealed as a colonizing gaze, while the gaze of Gitlin's camera is precisely a taxidermic gaze, since the images will presumably outlast the individuals that Gitlin films. Indeed, *The Birdpeople* moves from an archive of dead bird bodies to a taxonomy and taxidermy of living human bodies, creating an uncanny parallel between looker and looked-at, mummified and photographed, and producing the sort of laughter that is edged with anxiety and the thought of death.

The Unintended Reader

Like *The Tailenders* and *The Birdpeople*, Rebecca Baron's film *okay bye-bye* both represents and interrogates archival forms. It takes an epistolary form, a cinematic letter addressed to an unspecified "you" from a quasi-autobiographical "I" narrated by the filmmaker. Here again the structure of the joke appears as a literalization of the metaphor of the archive. The epistolary format is, of course, one of the most common forms of archival document. Indeed, along with the official record and the photograph, the letter may be the archival document par excellence. Steedman points out, however, that, like the reader of a letter sent to someone else, the historian who uncovers any object in the archive will always, in some sense, steal or misuse it: "The Historian who goes to the Archive must always be an unintended reader, will always read that which was never intended for his or her eyes. Like Michelet in the 1820s, the Historian always reads the fragmented traces of *something else* … an unintended purloined letter" (75). The act of viewing a documentary film is always in some way an act of "reading" a purloined letter. However, *okay bye-bye* literalizes this situation by actually placing the viewer in the position of the historian in the archive, reading letters addressed to someone else. That is, we never find out exactly who the narrational "I" is or to whom she is writing, but we remain intensely aware that we are reading someone else's letter.

Although the film text does not begin with a fragment, a fragment of film both was the actual instigation of the film and becomes the impetus for the narrator's search to understand its meaning in relation to herself. In a few silent seconds of a Super-8 film fragment a Cambodian man gestures and talks, as if telling an exciting story. The filmmaker / narrator – who are not entirely coincident – found this piece of film, labeled with the name of a Cambodian city, on a sidewalk in San Diego, California, and it serves as a starting point for (among other things) an investigation of the Cambodia genocide under Pol Pot, the role of the United States in Cambodia during the Vietnam War, and the Cambodian immigrant population in Southern California. The film makes use of a variety of archival materials: microfiche copies of the *New York Times*, old ethnographic (Figure 21.3) and military footage, and – most strikingly – the online databases of photographs of the victims of the Cambodian genocide, taken, in fact, by Pol Pot's Khmer Rouge

in the S-21 camp right before the prisoners were shot and killed. All of these archival materials are presented as actively found by the filmmaker/narrator, not as simply given. In fact, the film is very much about the personal process through which these further fragments were discovered and about their promise of a coherence that ultimately cannot be realized. While all of the films discussed here are about how the past – or elements of it – is preserved in one form or another, this film is the most explicitly about memory and how technologies of archiving affect what and how a culture remembers as well as what and how it forgets. Baron's film not only enacts the desire to turn archival fragments into a narrative but also suggests that certain fragments can never be contained by a story. Indeed, the film fragment that sets off the narrative is ultimately unassimilable to narrative; its meaning is left open and unresolved.

While the epistolary format puts the film viewer in the position of an unintended reader, the narrator is explicitly aware that she herself is reading a set of "letters" that are not addressed to her. The S-21 archive is perhaps the most distressing of these, for its contents were "written" by the Khmer Rouge, who took pictures of their victims moments before their deaths. To whom could these images have been addressed? For what purpose were they

Figure 21.3 A strip of found archival film showing a boxer in *okay bye-bye* (Rebecca Baron, 1998)

intended? Is this some grisly historical joke? The Khmer Rouge photographers surely could not have imagined the contexts into which the images they made would be put: a museum exhibit, a coffee-table book, an online database, or an experimental documentary film. These "letters," "sent" by the Khmer Rouge (perhaps to themselves), have been archived, appropriated, and "misused." Thus, like *The Tailenders* and *The Birdpeople*, Baron's film raises the question of how archival materials circulate and how they are made to speak according to circumstances that long postdate their production. The narrator of *okay bye-bye* realizes that she is responding to the images in terms of their strange beauty and uncanny attraction, the people's hair and men's beards, the lighting of the shots. Certain thoughts, it seems, are inappropriate to the objects, and yet there is no denying the aesthetic allure of these death masks, now archived online. Here, the fact of the digital archive in particular raises questions about the leveling of images and their meanings. The dystopian nightmare of the digital age involves the way in which the Internet, the archive, and perhaps any technology of memory are both selective and valueless. What finds its way into the digital archive depends on who finds what images and chooses to make them available. Even more frighteningly, all images on the Internet have the potential for a problematic equivalence, for becoming just another combination of ones and zeroes that may generate

moments of enlightenment but that may also generate meaninglessness. At the same time, the utopian dream of the Internet is that of access, communication, and connection, through which relatives of the S-21 victims may recover their dead. While the first view coincides with the satirical recognition of archival meaninglessness, the second offers some hope for the redemption of meaning, although emplotted more in the mode of tragedy than comedy. White writes: "The reconciliations that occur at the end of Tragedy are much more somber [than those in Comedy]; they are more in the nature of resignations of men to the conditions under which they must labor in the world. These conditions, in turn, are asserted to be inalterable and eternal, and the implication is that man cannot change them but must work within them" (9).

okay bye-bye may be read as both satire and tragedy in its emplotment of the story of the archive. The found fragment of film (a piece of detritus on the street), the epistolary missives of the narrator, and the many archival documents shown neither cohere as a unified narrative nor establish a definitive meaning. Instead, the film acts as a succession of encounters and interruptions that are only tentatively held together by a delicate narrative thread of reflexive meditations. Nonetheless, the film asserts the need to continue to sort through archival traces even if they will never yield any definitive conclusions.

The Archive as Spam

While films categorized as "found footage films" often engage with the archive in various ways, *okay bye-bye* may be better classified as a "finding footage" film, in which the found fragment provides only a starting point for the documentary filmmaker's confrontation with and attempt to convey some aspect of the historian's impossible task. Indeed, the film discovers not only a fragment but also the vast archives that give the fragment the promise – unfulfilled, because it cannot be fulfilled – of meaning. The same is true of a very different film, which begins not from a piece of film but rather from a spam letter. Andre Silva's *spam letter + google image search = video entertainment* seems – at least at first glance – in line with what William Wees has called the "appropriation film," a postmodern form of found footage film that, instead of "quoting history" like the "compilation film," "quotes the media, which have replaced history and virtually abolished historicity" (45). I would argue, however, that rather than being abolished by Silva's film, historicity, by its absence, is precisely its topic. While this film is more likely to be classified as an experimental film than as a documentary, I wish to make the argument that it is indeed a documentary, precisely because it illustrates and simulates the relationship between the contemporary reader and the digital archive and because all of its constituent parts are found rather than invented by the filmmaker. Moreover, its use of the archive is so disturbing to conventional notions of history that, I contend, the film is forced to change genres, ousted from the realm of documentary to be classified and contained in the category of the experimental. Looking at it as

a documentary, however, challenges the distinction between "proper" and "improper" uses of the archive as well as reified notions of the historical.

As in *okay bye-bye*, issues of the letter to the unintended reader and of the endless digital archive are also taken up by Silva's three-minute film. Silva, like many of us, was the recipient of a generic spam letter sent to thousands of users ostensibly from a lawyer in Nigeria asserting that, because the addressee bears the same last name as his deceased client, the addressee is the client's next of kin, and thus, with the addressee's help, the client's money can be repatriated to the United States, whereupon the lawyer and the addressee can split the profits. Silva took the letter and performed a Google image search of each word in the letter. He then programmed the letter into the computer's voice generator. In the film, as each word of the letter is spoken by the computer, it is accompanied by the first Google image that came up for each word. The result is a bizarre sequence of images that bear heterogeneous and often incomprehensible relationships to the words they "represent." Every element of the film is drawn from (virtual) objects that, like the letter itself, circulate in the vast, active archive of the web. The spam letter acts as the fragment that leads to this greater archive.

In this case, the fragment is literally a spam letter received by an unintended reader. The name of the dead man, whose last name Silva is supposed to share, is actually not "Silva." Moreover, spam letters and most web pages, like films and other technologies of memory, are epistles sent into cyberspace that can be read by anyone and interpreted by anyone who happens to receive the message. In this perverse form of epistolary documentary, the letter is meant to be read – by anyone with a checkbook. On the one hand, the Internet's field of messages presents a utopian vision of the active, agentic reader who has access to all material. And yet again, on the other hand, we once again encounter an "archive of noise," of meaninglessness or nonsense, of letters not intended for us in particular or perhaps for anyone in particular. The film is a Frankenstein patchwork of voices and images, the digital archive talking to itself about everything and nothing. If there is anything at all that controls what is meaningful here, it is the search engines, inhuman technologies of memory (or the navigation of memories) without affect or intentionality. How can one think of history here? And yet, precisely because history is so thoroughly devastated by the film, the question of – even the demand for – historicity returns in all of its insistence.

Of all of these films structured like a joke, *spam letter* is both the most satirical and unambiguously funny. The most humorous moments are those when a word is used aurally in one manner but is accompanied by an image that is associated with another – and often literal – meaning of the same word. For instance, the possessive pronoun "mine," used in the voice-over to mean "belonging to me," is accompanied by an image of a miner's lamp. Other combinations require other kinds of leaps of (il)logic, for Google image search, of course, is not based on contextual thought. The resultant humor is informed by the threat of the archive (specifically, the digital archive of the Internet): that even uncanny double meaning will be overwhelmed by meaninglessness. As in all of the films discussed

above, the death of meaning is closely associated in this film with death itself: the dead client in the spam letter, images of death offered by the search engine, and "dead" web pages, no longer meant for anyone. Death always seems to accompany the archive. At the same time, however, the film is terribly funny and enjoyable, which suggests that comedy reasserts itself even within this nihilistic satire. Perhaps, the film suggests, in the face of the satire of history, the only possible response is to laugh and go on seeking the past through its traces, in all of their terrible excess.

The Fragment as Metonym

Ultimately, all of these films can be read as both enacting and representing the impulse to create archives while simultaneously engaging the viewer in the historian's experience of confronting the excess of the archive. Furthermore, since textuality and signification are constantly in question in these films, none of the films purports to be comprehensive or fully coherent, closing the book, as it were, on the *meaning* of its subject. Indeed, the fragment that structures each film does not act so much as a metaphor as a metonym. Runia argues that today the key historical trope is not metaphor but metonymy. He writes, "Metonymy may be described as the willfully inappropriate transposition of a word that belongs to context 1 ... to context 2[,] ... where it subsequently stands out as just slightly 'out of place'" (15–16). For Runia, unlike the metaphor, which is concerned with a "transfer of meaning," the metonym is concerned with a "transfer of presence," that is, a transfer of experience and affect generated by the uncanny contrast between words, objects, and contexts that are incommensurable with one another (17). In this sense, the metonym has much in common with the literalizing joke, which, in literalizing a metaphor, rejects the metaphoric and its promise of a corresponding meaning. Each archival fragment in these films can be seen as a metonym, for it does not so much make meaning as offer a point of entry – through something out of place – to an experience of the uncanny. Metonymy, unlike metaphor, refuses to reduce or comprehend meaning. "Whereas metaphor 'gives' meaning, metonymy insinuates that there is an urgent *need* for meaning. Metaphor ... weaves interrelations and makes 'places' habitable. Metonymy, on the other hand, disturbs places" (19). The refusal of these documentaries to come to any conclusive interpretations can thus be seen as a function of the disruptive, metonymic role of the fragment. Although potential meanings emerge in each film, the most powerful effect of each film is a sense of the disturbing and overwhelming presence of the cultural archive, with its seemingly infinite and yet always partial store of images, sounds, and objects. Against the already-accepted yet unstable norms of the information age, these films question the nature of "data" and "information": what they consist of, who determines access to them, and to what multifarious uses they can be put. It is, then, the metonym rather than the metaphor that offers the comic or tragic

release from the satire of meaning(lessness) in the form of a transfer of the *presence* of history, rather than its meaning, to the viewer. The joke, the fragment, and the metonym in these films all hold the potential for epiphany or at least the revelation of this disorienting contemporary situation.

The stake of these films is the ability of our society in general, and documentary film in particular, to engage in this present moment with the past, with the dead and what they have left behind. All four films confront the question of death that haunts each of the fragments – dead languages, dying cultures, dead species, victims of genocide, dead clients, dead letters, and dead web pages – as well as the need for new ways to sort through their traces, through all that does *not* go away. Steedman argues that the logic of "dust" is precisely the logic of the indestructibility of matter (164). Matter may be transformed but never destroyed. At this historical juncture, material traces of all kinds are being transformed by digital media. As Derrida has pointed out, new technologies of memory may alter our conception of the psychic apparatus and, by way of these new technologies, transform human memory itself (16–17). One question raised by all of these documentaries is what exactly will survive this particular transformation.

New Historicists have recognized the threat of the excess of material in the cultural archive that has expanded to include almost any cultural object. The deconstructive mobilization of the literalizing structure of the joke offers one way in which to deal with the paradoxical situation of the overwhelming accumulation and presence of information accompanied by the irreversible loss of people and animals that have left only a limited field of traces. Following fragments and "misusing" them as metonyms that offer both a satire of meaning and a redemptive "transfer of presence" is thus one strategy for navigating the excess and impermanence of the information age in which only what is digitized matters but in which it is hard to distinguish between meaningful evidence and meaningless spam. These four documentaries, combining the techniques of New Historicism and deconstruction, use the fragment as an occasion to obliquely address these larger questions of how we can deal with textual production that has already gone far beyond any individual's – and even perhaps any state's or organization's – control. The liberatory effects of this transition cannot be separated from the anxiety that this loss of control entails.

Notes

1 For a broader theorization of the relationships between documentary, historiography, and indexicality see Rosen (225–63).

2 The missionaries call their potential converts "tailenders" because the missionaries believe that these people are the last on earth to learn about the Christian faith and therefore to be "saved."

3 Although she never says so in the film, in an interview Horne has said that she has a personal connection to this kind of record player because her family had one when she was a child.

References

Bazin, André. *What Is Cinema? Volume 1.* Trans. Hugh Gray. Berkeley: U of California P, 1967.

Bruzzi, Stella. *New Documentary: A Critical Introduction.* London: Routledge, 2000.

Derrida, Jacques. *Archive Fever: A Freudian Impression.* Trans. Eric Prenowitz. Chicago: U of Chicago P, 1995.

Doane, Mary Ann. *The Emergence of Cinematic Time: Modernity, Contingency, the Archive.* Cambridge: Harvard UP, 2002.

Freud, Sigmund. "The Uncanny." *The Standard Edition of the Complete Psychological Works of Sigmund Freud.* Vol. 17. Ed. and trans. James Strachey. London: Hogarth, 1953. 219–52.

Freud, Sigmund. *Jokes and Their Relation to the Unconscious.* Trans. James Strachey. New York: Norton, 1960.

Gallagher, Catherine, and Stephen Greenblatt. *Practicing New Historicism.* Chicago: U of Chicago P, 2000.

Kittler, Friedrich. *Gramophone, Film, Typewriter.* Trans. Geoffrey Winthrop-Young and Michael Wutz. Stanford: Stanford UP, 1986.

Rony, Fatimah Tobing. *The Third Eye: Race, Cinema, and Ethnographic Spectacle.* Durham: Duke UP, 1996.

Rosen, Philip. *Change Mummified: Cinema, Historicity, Theory.* Minneapolis: U of Minnesota P, 2001.

Runia, Eelco. "Presence." *History and Theory* 45.1 (2006): 1–29.

Steedman, Carolyn. *Dust: The Archive and Cultural History.* New Brunswick: Rutgers UP, 2002.

Wees, William. *Recycled Images: The Art and Politics of Found Footage Films.* New York: Anthology Film Archives, 1993.

White, Hayden. *Metahistory: The Historical Imagination in Nineteenth-Century Europe.* Baltimore: Johns Hopkins UP, 1973.

Further readings

The Emergence of Cinematic Time: Modernity, Contingency, the Archive, Mary Ann Doane (Cambridge: Harvard University Press, 2002).

Dust: The Archive and Cultural History, Carolyn Steedman (New Brunswick: Rutgers University Press, 2002).

Related Internet links

Michael Gitlin: http://michaelgitlin.com/birdpeople/birdpeople.html

Adele Horne: http://www.adelehorne.net/

Rebecca Baron: http://www.vdb.org/smackn.acgi$tapedetail?OKAYBYEBYE

The Mote in God's Eye
9/11, Then and Now

Jon Bird

MOTE: *A particle of dust; especially one of the specks seen floating in the sunbeam: an irritating particle in the eye or throat … (Oxford English Dictionary)*

If the classic interval is giving way to the interface, politics in turn is shifting within exclusively present time. The question is then no longer one of the global versus the local, or of the transnational versus the national. It is, first and foremost, a question of the sudden temporal switch in which not only inside and outside disappear, the expanse of the political territory, but also the before and after of its duration, of its history: all that remains is a real instant over which, in the end, no one has any control. (Virilio, 1997: 18)

Telling Stories

Where do we begin our narratives of September 11th? How is this singular event to be framed in our individual and collective accounts, in the official and unofficial discourse that proliferates in a spiraling out from the traumatic moment; what falls within the frame, and what lies outside? Around the world, courtesy of the global media, millions were united in a shared specularity that would become a marker for all our futures. And echoing the question, 'where were you?' that accompanies any recollection of those other days that remain logged forever in the collective unconscious – the assassination of JFK, the fall of the Berlin Wall – 9/11 is now programmed into our lives like a renegade gene that lies dormant, carrying its secret message until triggered into action; a memory that casts its shadow across all our worlds. In the immediate aftermath, the explanatory frameworks were already being severely restricted in the search for agency; thus we are given the narrative of al-Qaida's relation to the Taliban and the support given to

Keywords

dust
history
trauma
9-11
memory
images
terror
Ground Zero
New York City
Hollywood film
art
architecture
aesthetics
the sublime
Gerhard Richter

them by the USA in the 1990s, or Osama Bin Laden's family history interpreted visually in the repeated images of his youthful, smiling presence in a large family photo contrasted with the post 9/11 images and blurred video footage, or in the tracing of the lives of the terrorists piloting the planes, their everyday actions scanned and repetitively interpreted for the signs of the apocalypse to come. Even as the news channels flashed unforgettable live images around the world, the vacuum created by these moments of uncertainty was rapidly filled by the ticker-tape messages running across our screens preparing us for a narrative of terror, war and retribution.

For the dominantly 'hawkish' US administration, attributing agency justifies retaliation, a deliberate reduction of the contradictions of competing narratives, of other meanings which might be found in the complexities of the power relations embedded in economic and political history and religious divides: an impatient dismissal of anything outside the frame of binary oppositions: good vs evil, with us or against us, civilization vs barbarism, freedom vs fanaticism: the old and all-too-familiar narrative of an imperialistic mind-set.[1] Add to this the blanket solution of 'zero tolerance' thrown over everything from drugs, home-lessness, criminality and the whole gamut of social inequalities, and it would seem that the American people have long been conditioned to accept escalating degrees of punishment as the only and necessary repressive response. Writing in *The New York Times* five days after the event, the novelist Mary Gordon declared 'To have an enemy with no name and therefore no face, or even worse, a name and face that can only be guessed at, is the stuff of nightmare.' And the cause of our fear and the figure of our nightmares is the 'terrorist' whose naming implies an oppositional negation of all that lies unknown, yet menacingly, outside the frame. This necessity to foreclose meaning extends to the name given to Bin Laden's organization – al-Qaida – which first appeared in the Western media in 1996 and then became general usage after the 1998 bombings of the US embas-sies in East Africa, but has never been used in communiqués by Bin Laden or any of his associates. For the US administration, conceptualizing the enemy was a necessary prerequisite to a rhetoric and a policy of retaliation. Among the many explanations for this particular attribution is the suggestion of Giles Fodden (*The Guardian*, 24 August 2002) that Bin Laden may have read, and been influenced by, the classic 1951 sci-fi work of Isaac Asimov – '*Foundation*' – which translates into Arabic as 'qaida'. (Fodden and others have also read into al-Qaida's actions a par-allel with the plot line of Asimov's trilogy, although 'evil empires' opposed by the actions of a committed and crusading militant group is a common trope of the genre.)

Arundhati Roy's impassioned, but considered critique of US foreign policy (*The Guardian*, 27 September 2001) was met with accusations by *The New York Times* of actual complicity with al-Qaida, whereas a roundtable of 29 invited reflections on 9/11 published by the *London Review of Books* (4 October 2001) and, in particular, Mary Beard's suggestion that the USA was 'paying the price for its glib definition of "terrorism" and its refusal to listen to what the terrorists have to say', resulted

in a letter from American academic Marjorie Perloff not only canceling her own subscription to the magazine, but telling all her students to do likewise, an action that accurately represents the climate of fear and repression dominating the Academy and implicitly endorsing George W. Bush's virulent 'if you're not with us, you're against us' creed. At present, it seems that to admit any pre-history as relevant to 9/11 threatens the moral certainties of agency, clouds the picture and so gets fitted into the 'them or us' equation.[2]

Against the suppression of dissent and the narrowly prescriptive statements of the US administration – the 'official' discourse of the 'war on terror' – the production of data has increased incrementally; a combination of texts, images and numbing statistical facts and analyses. Since 9/11, 672 books in English have appeared on the subject in print and over 30,000 articles in the UK press; if the internet is included the production runs into millions. (Another inevitable by-product, the internet, lists over 69,000 articles offering alternative explanations to the origins and authorship of the attacks.) Some facts still retain their shock value irrespective of the number of repetitions; a macabre economy of loss – a total of 3212 dead from the four attacks, 291 bodies recovered intact and 19,858 body parts of which 4598 have been positively identified, 1.8 million tons of debris removed to the Fresh Kills Landfill site on Staten Island in 105,000 truck-loads over a nine month period by 800 people a day working in shifts around the clock. The final clearance from Ground Zero happened on 31 May 2002. Other figures signify a different economy of losses and gains – the financial impact on the US of the destruction of property and insurance claims of between US$25 to 50 billion, of job losses in lower Manhattan of around 100,000 and in the US as a whole of 1.8 million. But some benefit: 116,000 US flags were sold by Wal-Mart on September 11th; in the January budget, President Bush increased spending on defence by US$30 billion, 1 billion of which has gone to the CIA to increase the agency's staffing from 500 to 5000. Furthermore, Bush has proposed establishing a new Department of Homeland Security, a 170,000 strong workforce with an annual budget of US$38 billion, a state apparatus dedicated to the preservation (or, maybe, the restoration) of the security of the American people!

What produces the relay of associations that make our memories communal as well as individual? For many of a certain age and political persuasion, another previous 9/11 figures in the list of losses: September 11th 1973. On this day the opposition forces of General Pinochet, backed by the CIA, bombed the Presidential Palace in Santiago, initiating the violent end to Salvador Allende's socialist government of Chile, and thus terminating one-and-a-half centuries of almost unbroken democracy. Allende's final broadcast on that day was to find its despairing echo in the doomed messages dispatched to loved ones last September: 'This is certainly the last time I shall speak to you ...', and the 'official' death toll from that equally barbaric act, 3197, almost exactly matches that of September 2001. The multiple scenes of grieving relatives and friends holding aloft photographs of the missing in New York have their origins in 'los desaparecidos', the 'disappeared' of

earlier US-backed military adventures. And this forgetting still continues – at the anniversary commemoration at the Pentagon, the address given by the Chairman of the Joint Chiefs of Staff, General Myers, listed other September Elevens from US military history, but made no mention of Chile. Covert operations have always been the underbelly of American foreign policy and that hidden history goes some way towards answering the question 'Why do they hate us?'[3]

> ... for it is also a question of a war of images and the question of the image is central to the whole affair. (Meddeb, 2002)

Signs of the City

New York has always been a city of images – images that precede any visit and cast an anticipatory veil over our initial perceptions: images from the cultural reservoir of movies, photography, advertising and literature that is part of the western symbolic unconscious. Its architectural and aural spaces and places constantly emphasize perspective, point of view, spectacle – a destination made for visualization ...

In retrospect, it might seem that the cultural industries have long been preparing us for the actual event and the profusion of images that are and will be for most people the record of 9/11 are haunted by the presence of earlier representations. Thus we internalize our Americas and for much of the 20th century it has been the US that has supplied the dominant narratives that fashioned the cultural stereotypes of the age.

Hollywood has long fantasized about the unthinkable, and for every awestruck or utopian image of New York, its dystopian other haunts our imaginings – from Jules Dassin's 1947 film *The Naked City* (and its TV spin off with the definitive closing line: 'There are eight million stories in the Naked City, this has been one of them') to Gershwin romancing the Brooklyn Bridge and downtown in Woody Allen's *Manhattan*, from the uncanny and idealized city in *Ghostbusters* (1984) to the alien attack in *Independence Day* (1996). And, in recognition of the power of the virtual, the CIA requested Hollywood scriptwriters to imagine even more spectacular plot-lines and doomsday scenarios with, presumably, the results being fed directly into the military and defence think-tanks, a Baudrillardian slant on the insurmountable void between terror and its representations. The Twin Towers have themselves appeared countless times in both film and TV, either as a significant feature in the narrative – in the awful 1975 remake of the classic *King Kong* with the ape scaling their shiny surfaces, or as the alienating and threatening environment for the CIA's tracking of a fugitive Robert Redford in *Three Days of the Condor* (1975) – or as an identifying visual signifier of 'New Yorkness' in the opening sequence of every edition of *Sex and the City*. As Slavoj Žižek (2001) has argued, 'It is not that reality entered our image: the image entered and shattered our reality ...' (p. 18)

Recognizing the potency of the image and its capacity for resignification, to shift meanings, would seem to have been strategically central to the planning and coordination of the day's events. As Abdelwahab Meddeb (2002) has suggested:

> The terrorists used the technical means masterfully and they accurately thought through the relays of the event's diffusion as image. We have witnessed the optimum use of the current means, this quasi-instantaneity between the event and its transmission throughout the world.

Using the technology of their adversaries, he argues, allowed the Muslim fundamentalists to exploit the immediacy and reach of the global media, rearranging the topography of margin and centre to reoccupy the 'stage of that culture that is henceforth the world's culture'. At the level of representation, what Hollywood sows, Hollywood reaps. Another battle over representation occurred in the days following as the brittle war speech of the US administration and George Bush's John Waynesque attitudes contrasted starkly with the quiet, measured, almost hypnotic tones of Osama Bin Laden. These images were quickly redeployed as the emblematic signs in the discourse of civilization and freedom versus barbarism and fanaticism.

The 'war of images' also finds its necessity in the unequal geo-political relations between the USA and the 'axis of evil'. Al-Qaida, the primary signifier for terror, exists as a virtual state, a borderless but global network of alliances that, nonetheless, possesses many of the attributes of a real state – an army and intelligence corps, a complex social structure, a treasury and forms of economic exchange, a health, education and welfare system and, significantly, effective communications and propaganda. At this level, what 9/11 may have changed is the nature of 21st-century warfare as the doctrine of pre-emptive strikes is presented as the only effective defence against an elusive and diasporic army utilizing the latest developments in computer technology, biogenetic pathogens, transportation systems and lightweight nuclear capability. However, as many of the critical and historical analyses of US foreign policy in the post-Vietnam period reveal, pre-emptive strikes also serve the far-reaching goals of a US administration pursuing global hegemony through unchallengeable military power, an intention first mapped out by Paul Wolfowitz for George Bush senior towards the end of his administration and adopted by George W. Bush as an official policy 'to prevent the emergence of any "peer competitor" anywhere in the world'.[4]

My own New York story begins in the early 1980s when I made my first visit at the invitation of the artists Leon Golub and Nancy Spero, but I had been an imaginary tourist ever since art school in the 1960s. I had my first direct encounter with American Art when I came to London to the Tate Gallery to see the exhibition 'Painting and Sculpture of a Decade: 54–64', organized by the Gulbenkian Foundation. This megashow included works by Diebenkorn, Frankenthaler, Guston, Pollock, de Kooning, Johns, Rauschenberg, Morris Louis, Reinhardt, Lichtenstein, David Smith, and many others who were a revelation to a Midlands

boy raised on a diet of Kenneth Clark and European Modernism. Later, as a Fine Art student at the Central School, I was frequently the first to the library to get my hands on each new issue of *Artforum* and *Art in America*, and sometime in the late 1960s I acquired the book, *New York: The New Art Scene* (1967), with photographs by Ugo Mulas and an accompanying text by Alan Solomon.

These grainy photos of New York artists in their studios were my imaginary – a document of the contemporary artist as an urbanite living and working in the city of modernity's promise. Somehow they appeared to express an attitude of mind which was both serious and flirtatious, a libidinal economy of studio lofts depicted as an extension of the city – places of work and pleasure, a porous mixture of studio, sidewalk, gallery, cafe, bar, nightclub – a historical construction surely, think of Paris, Moscow, Barcelona, etc. but now firmly uprooted from Europe to the new world – the place I most wanted to be. This was the cutting-edge, from elder statesmen Duchamp, a debonair and wryly observant figure, and Newman, plump, homely, slightly officious, to the roster of 'second generation' American artists: Rauschenberg, Johns, Lichtenstein, Warhol, Stella, Noland, etc., a celebrity artists' 'A' list of the movers and the shakers. Still very much presented as a man's world, women appear seldom and then mostly as either wife/girlfriend, or as a presence in the studio; the only featured artists are Lee Bontecu and the dancer Trish Brown. Yet, despite Solomon's narrative of the mid-1960s artistic milieu as a 'new spirit' and of artists sharing 'similar sentiments about the need to live life intensely' (at one point he describes the prevailing attitude as 'optimistic existentialism'), the dominant impression created by the images is not one of 'intensity' but of ennui – that peculiarly fin de siècle mood of detachment and world-weariness that, in more recent reflective accounts, is recoded as the (postmodern) turn to the ironic. And this surely became the mental state, or 'lifestyle' most closely associated with New York's cosmopolitanism (by the late 1990s, 40% of New Yorkers were immigrants) and the cause of distrust and antipathy towards the 'Big Apple' exhibited by much of the rest of America, including the present President. Whatever – although *New York: The New Art Scene* was an important part of the baggage of impressions that I internalized and took with me on that first visit, it now seems, post 9/11, just another lost world. So when I finally managed to convert my received cultural capital of the city and its artists into the reality of a return ticket, I anticipated an experience of revelation and confirmation …

I flew on 'People Express', the first of the low-cost airlines, into Newark airport – then a rather run down, under used base for cargo and internal flights. All the major airlines used JFK, but from Newark the route to Manhattan was by bus along the New Jersey turnpike which presented the revelatory visual moment of the City skyline interrupted by the unmistakable silhouettes of the Twin Towers and the Empire State Building. And my first tourist actions were to ascend those markers of American modernity, although I always preferred the view from the Empire State. (Perhaps in this I was also influenced by the memories of an all-night screening at the National Film Theatre of Andy Warhol's 8-hour epic and the accompanying partying that erupted to break the boredom of the event!) But the Twin Towers,

completed in 1973 and 1976, were the point of reference for both spatial orientation and checking the time – the way the vertical girders trapped the sunlight, deep gold on their eastern side during early morning, turning to a shimmering silver at mid-day, deepening as evening fell to a pearly luminescence. At night, the 110 illuminated floors stretched impossibly upwards, a city within the city, half the population of Oxford suspended in layer upon layer of tiny bright squares piercing the night sky – a steel and neon termites' nest of social and economic interaction and stratification, the result of the ruthless desire of Austin Tobin, chief of the Port Authority of New York and New Jersey, and his architect Minoru Yamasaki (who was selected from a short list which included Walter Gropius and Philip Johnson), to turn downtown Manhattan into the most valuable square mile of real estate on the planet.

The pre-history of the Twin Towers starts in 1946 when the idea of a World Trade Center in New York was first raised, and then advanced in the 1950s by David Rockefeller, the brother of the then Governor, Nelson Rockefeller. The overall plan and its ideological underpinning – 10 million square feet of office, retail and commercial space to establish the USA's hegemonic position in international trade, reinvigorate the real estate of lower Manhattan and create a symbolic icon of the interdependence of global commerce and world peace – were fleshed out by the Port Authority of New York in the early 1960s. (In fact, Yamasaki's architecture had already suffered a destructive implosion when his Pruitt-Igoe housing estate in St Louis was demolished in a controlled explosion in 1972, a moment which in many accounts came to represent the symbolic failure of a certain kind of rationalized urban modernism, and the introduction of postmodern architecture.) Yamasaki worked with the New York firm of Emery Roth & Sons and the final design of two towers in excess of 100 floors was publicly unveiled in 1964. The proposed buildings would become the world's largest office complex, a position previously held by the other target on 9/11, the Pentagon. In fact, many architectural and ideological similarities exist between the two complexes, despite their horizontal and vertical axes – including the networking of state/corporate functions into global communication flows and the smooth operating of military or economic authority. The structural system of the towers consisted of a dense ring of steel columns at their external perimeters and a reinforced central service core, thus allowing the stacking of floor upon floor and freeing the internal area for maximum spatial flexibility. A further factor that now appears almost cruelly ironic is the part that Yamasaki's agoraphobia played in the positioning of each column – the gap between them of just 22 inches he judged sufficient to create the impression of a protective shell against the external vista as the altitude became increasingly apparent. As numerous diagrams and several TV programmes have since demonstrated, this was also a structural system that would implode under the enormous force of the impact and the subsequent conflagration.

'The Manhattan skyline shimmered in the imaginations of all the nations, and people everywhere cherished the ambition, however unattainable, of landing one day upon that legendary foreshore', so Jan Morris wrote in her celebratory account of postwar New York, *Manhattan '45* (1998: 7). For nearly three decades, that most

pictured city skyline has been defined by the midtown and downtown vertices of the Empire State and the Twin Towers. Just as panoramas up to the early 1970s appeared nostalgic reminders of the hopes and desires of High Modernism, now the enforced recovery to that 'lost' outline marks a fracture in our visual memories, and what was once so familiar has itself become only an image. And I wonder how many countless personal albums repeat the photographs in my own collection …

During many subsequent visits over the years New York became something like a second home – a place of possibilities where desires could be fulfilled and wishes realized … a sense of belonging in a vibrant culture of hybridity and difference that accommodated every language, culture, religion – a semiotic overload impacting upon the senses and the imagination.

> This is what the captivating image of the collapse of the WTC was: an image, a semblance, an "effect", which, at the same time, delivered "the thing itself." (Žižek. 2001: 19)

The Personal is Political

I was in New York that September as a result of the Leon Golub Retrospective I had curated during 2000–1. A spin-off exhibition of his paintings was running in the gallery of the Cooper Union College of Art, he had a show of new work opening in SoHo and I had been invited to participate on a panel at Cooper on the evening of the 11th. (In retrospect, of all the reasons for being in New York at that particular time, there is for me a compelling justification in being asked to discuss the work of an artist whose practice has, for 50 years, addressed the relations of representation between historical event and aesthetic response; paintings which answer to the demands of the pictorial as they attest to the operations of power across the social body.) However, despite endless self-reflection and an obsessive pursuit of the mountain of post 9/11 documentation, the processes of recollection and 'working through' are inadequate to the experiential reality. My own story parallels many of the accounts I have read of those others who also bore witness to a time when 'being there' transformed autobiography into history; our experiences, both shared and individual, a testimony to a moment when a seismic shift occurred in the global coordinates whose realignment can barely be predicted from this dangerously uncertain conjuncture. And my visual and aural memories blur into the general narrative of the day, but always marked by the specificity of place and subjectivity: hearing the first plane pass directly overhead – too loud, too low – followed by a double 'boom' (later identified as the impact and then the explosion of fuel); then on the street about a mile from the epicenter, the gut-wrenching shock as the second plane impacted – like, and yet so unlike its screen imaginings. Then the Towers imploded and lower Manhattan entered a night world of ashes and dust and utter desolation. Later in the day I joined the thousands being

evacuated over the Manhattan Bridge, a silent, numbed procession, everyone taking great care not to jostle their neighbour, our collective gaze cast in the direction of the columns of smoke smearing the intense blue sky over the financial district, slowly drifting over the Hudson River in the direction of New Jersey.

After, as consciousness fought with perception at the overwhelming totality and precision of the attack, just details: the colours in the sky, the blackness of the smoke, flying glass twinkling in the sunbeams, the shape of the gaping hole in the first tower, dazed and incredulous people listening to car radios as the enormity of the operation filtered through. Like everyone in New York, I moved compulsively between the TV coverage and the street, dislocated between the rawness of a traumatic reality and its mediation. At one point in the day the virtual and the real converged in a surreal moment of serendipity when the flattened firetruck I had been watching on CNN was towed past as I stood on the sidewalk.

The next few days now seem like a disarticulation in the normal temporal flow: a transitory period between the before and after of a world-historical event during which all the familiar points of reference transformed into their opposites. I was caught in the 'frozen zone' – the area between 14th St and Houston where nothing was allowed to enter or leave for four days. Now the busyness of impatient traffic was replaced by pedestrians, individually or in small groups, some bearing the evidence of personal tragedy in the posters and placards seeking information on the missing; now the vibrating rhythms of cosmopolitan street life faded into long periods of silence, an uncanny aural emptiness broken only by the staccato interruptions of emergency vehicles and the buzzing of helicopters; now the routes and shortcuts traversing lower Manhattan became an obstacle course of barricades and police lines. And, wherever a wall or other surface presented itself, the messages, photographs, drawings and improvised memorials, a bricolaged anthem of tenderness and loss that presented a counter-narrative to the US administration's increasingly combative and vengeful rhetoric. By the Saturday, Mayor Giuliani had extended the access downtown to Canal St and immediately the souvenirs and memorabilia began to surface. Against the backdrop of the smoke obliterating the whole WTC complex, a huge movie poster carried the snarling face of Arnold Schwarzenegger advertising *Collateral Damage*, later removed as the distributors read the general mood and postponed the release for five months. And always, depending upon the prevailing wind, the suffocating ash and dust and carried with it increasingly as the days passed, the smell …

The dust was so thick it crunched underfoot, coating trees like a snowfall from hell.

Dust

If the iconic image of an uncertain post-war world is the mushroom cloud (which, like the repressed, seems always to return), then the visual legacy of 9/11, surely, is 'dust'. It even has its own human symbol in 'the Dust Lady' – Marcy Borders – whose

shrouded figure emerging from the rubble was reproduced across much of the visual documentation of the day. *The Guardian* (3 September 2002) mentions a flyer taped to a lamp-post in Battery Park requesting participants for a study into the 'post-9/11 exposure to dust', and describes the display in the window of Chelsea Jeans on Broadway, 'where a rack of denims and sweatshirts still stands, thickly crusted with yellow dust, frozen in time within a glass cabinet'.

A few months after returning to London I read Carolyn Steedman's wonderful collection of papers, *Dust* (2001). My reading coincided with the ongoing fear of the threat of biological weapons and the investigation into the perpetrator(s) of the anthrax attacks in the USA – all three 'texts' (9/11, Steedman and anthrax) somehow coalesced in my thoughts, the references criss-crossing and intermingling in a wild semiosis of connections and contingencies. 'Dust', she writes, 'is the immutable, obdurate set of beliefs about the material world, past and present, inherited from the 19th century, with which modern history-writing has to grapple …' (Preface).

Steedman's essays are, to my mind, suffused with a predictive melancholy bearing upon the events of September 11th. Dust is the by-product of our everyday lives – a large proportion of household dust is, in fact, us – our own skin shed each day – and it is a particularly pernicious aspect of contemporary urban life, from the effects of all forms of pollutants to the problems of waste disposal. But, as Steedman argues, there is a special kind of irritating dust derived from the processes of leather-working and parchment-making, whose 18th- and 19th-century legacy is the 'occupational hazard' of certain forms of scholarship: its name is anthrax. She vividly illustrates this hazard of historical research in an account of the time spent in the Parisian National Archives by the 19th-century historian and encyclopedist, Jules Michelet, and in a section worth quoting in full the associative relay to 9/11 becomes startlingly apparent:

> … we can be clearer than Michelet could be, about exactly what it was that he breathed in: the dust of the workers who made the papers and parchments; the dust of the animals who provided the skins for their leather bindings. He inhaled the by-product of all the filthy trades that have, by circuitous routes, deposited their end-products in the archives. And we are forced to consider whether it was not life that he breathed into 'the souls who had suffered so long ago and who were smothered now in the past', but death, that he took into himself, with each lungful of dust. (Steedman, 2001: 27)

I can't read this without remembering the dust that fell steadily and persistently on lower Manhattan in the aftermath of 9/11, its location and density determined by the wind and occasional rain. (There was a storm during the night on the 12th which thankfully dampened down the worst effects, although it also hampered the rescue efforts at Ground Zero.) This fine, white, choking powder that blanketed everyone and everything in the immediate vicinity became the representational summation of the event – the dust of vaporized bodies, buildings and their contents; we were all breathing the dust of the dead. But there was also the dust of

data and information that accrued (and contained to accumulate during the following weeks and months) from the official and media response, an equally choking and veiling residue that rapidly hardened into a language of militant reaction driving the 'war against terror' against the 'axis of evil': so are the complexities and contradictions of unequal development dispatched to the dustheap of history …

Finally, in July of this year, the Environmental Protection Agency began the mammoth task of cleaning and testing thousands of apartments in lower Manhattan smothered in the debris from 9/11 – reopening the question: 'What was in the air, and where did it go?' Jean Couttien, who lives on the 31st floor at 310 Greenwich St, cleaned repetitively and excessively after returning to her apartment. She stripped the wallpaper in the kitchen and removed all the carpeting – laboriously cutting it into strips to roll up and take to the street. But after opening another closet and seeing the shadow of dust on shelves and clothes, she closed the door and stopped dusting: 'However much I do, it's never enough' (*New York Times*, 1 July 2002).

How will history writing grapple with a materiality where, in the space of a few hours, two totally contrasting historical perspectives collided with such spectacularly catastrophic results? Part of our understanding of the historical antecedents to the act and crucial to recognizing the incompatibility of the cultural narratives lies in the immediate precursor to 9/11, the Taliban's attack on the 1700-year-old statues of the Buddha in the Bamiyan Valley in Afghanistan. After massacring many of the Shia Hazaras in the spring of 2001, the Taliban destroyed these twin sandstone statues, an action that had been preceded by threats since 1998 and a fatwa against all figurative statues in Afghanistan issued in February 2001 by Mullah Muhammad Omar. Despite international appeals along the lines of 'they do not "belong" to Afghanistan but to a universal heritage', to, in Meddeb's words (2002) 'that irreplaceable part that remains symbolic and that does not materially enrich the nations and the peoples', they were destroyed in March by dynamite, artillery and tank fire. The parallels between the two attacks are obvious: both participated in a cataclysmic action against an aesthetics of the sublime, an aesthetic which, we must presume, signified the power of a threatening other raised to demonic proportions.

If the history of Michelet describes the 19th-century search for a representation completely adequate to its object – to tell it like it really was metaphorically figured in the fiction of photographic 'truth' – our contemporary research is burdened with a less 'innocent' eye. We only see 'through a glass, darkly', as psychoanalysis reminds us that the search is endless, the 'lost object' can never be fully recovered and what is found is always a substitute. Thus, the suggestion that the Towers should be rebuilt exactly as before has perhaps little to do with planning, but a great deal to do with the processes of unbearable loss, whereas the twin beams of light that were briefly projected into the night sky as a temporary memorial, came closer to the fragility of our imaginings and touched upon the transformative potential of art. Not only are the accounts of 9/11 that currently fill the pages and screens of the western media caught in a historical bind – that nothing goes away, but that everything has changed – but as the question of what should replace the Towers and fill the gap that is Ground Zero presses upon the

present, and upon our memories of its awesome finality, the question is what counter-image could possibly impose itself, and thus deflect meaning onto other paths. Herein lies the essential 'aesthetic' of the act and its legacy ...

After Ground Zero

I returned to New York last February and for the first time observed the altered skyline. (When I left in September the clouds of smoke still obscured most of the World Trade Center site.) It was a deeply disorienting experience struggling to adjust to a panorama that was simultaneously familiar, yet strange – a realignment of the spatial coordinates of the city which have shifted the metaphorical weight from downtown back to midtown and the axis of the Empire State and the Chrysler Building. A few days later I stood on the observation platform at Ground Zero with a hundred or so others, looking across the void that was the WTC ringed by scorched office blocks, boarded-up windows and gridded safety nets slung across their facades. Even after only a few months, it was hard to recall the exact locations and sheer verticality of the Towers; the site seemed reduced by their absence, a curious effect as their massive scale had previously seemed to expand everything else in the vicinity.

At the Max Protech Gallery in Chelsea an exhibition displayed 60 proposals for a new WTC by architects, designers and artists, a list which included Michael Graves, Zaha Hadid, Hans Hollein, Daniel Libeskind, Vito Acconci, Mel Chin and others. These ranged from the futuristically fantastic – Paolo Soleri's 'transnational structure', a 400 metre parasol covering lower Manhattan, whose 50-odd floors would employ a system of 'magnetic levitation' to transport the occupants from top to bottom in less than 60 seconds, or Rani Rashid's organic replacement towers constructed of taught surface skins responding to internal and external stimuli, penetrated by openings to 'accommodate sky gardens and large pools suspended high above the city' – to Zaha Hadid's provocative, if somewhat vague, proposal which described the Twin Towers as the ultimate symbolic expression of Fordism in architecture, suggesting instead 'an entity of a higher order than what one usually considers as "building" or even "ensemble", an entity that recreates within itself approximations of the multiplicity, complexity and effectiveness of the urban ...'. One proposal, a joint initiative from John Bennett, Gustavo Bonevardi, Julian LaVerdiere, Paul Marabtz and Richard Nash-Gould, was realized: 'twin white beacons of light that would rise from lower Manhattan as a symbol of strength, hope and resiliency: a reclamation of New York City's skyline and identity' acting as a 'tribute to rescue workers and a mnemonic for all of those who lost their lives.' Many of the designs included water features and/or surfaces which altered chromatically – skins of light reflecting the changing patterns of the city below. Only Libeskind explicitly acknowledged the trauma of the loss and the essential role of memory in any reconstruction: 'This emptiness will remain and cannot be obliterated by any building.'[5]

Since then, all the various architectural schemes have fallen far short of an adequate, let alone generally acceptable plan which would incorporate the complex

and possibly contradictory elements of replacing the 11 million sq. ft. of lost office space insisted upon by the Lower Manhattan Development Corporation, with the civic necessity for a public space for commemoration and healing. The six schemes recently exhibited by the New York firm of Beyer Blinder Belle have all been universally rejected and *The New York Times* has commissioned a group of internationally renowned architects, and included Maya Lin, the designer of the Washington Vietnam memorial – one of the most critically acclaimed monuments of the postwar period – to collaborate on an alternative design for the whole area. Meanwhile, Larry Silverstein, the owner of the lease on the Twin Towers, has Skidmore, Owings and Merrill working on a project which includes a new tower of the same height as the originals, a memorial garden and a railway station. Recently Rudy Giuliani (*Time*, 9 September 2002) entered the debate calling for the commemorative function to have priority over all other demands, suggesting that 'a soaring structure should dominate the site … visible for miles to demonstrate the spirit of those who gave their lives to defend freedom.' This seems a little late in the day for the ex-mayor who seldom, during office, favoured public space over the private.

Perhaps any attempts at rebuilding are already overdetermined by the searing images that repetitively documented the event in all its chaotic specularity. Late last year, the New York Historical Society played host to an exhibition made by 11 photographers working for the Magnum Agency. Magnum, founded by Robert Capa and Henri Cartier-Bresson in 1947, had always encouraged a Hemingwayesque ideology of being 'where the action is' and Capa himself was blown up when he stepped on a landmine in Vietnam in 1954. The Magnum photo-journalists were among the first to document Ground Zero and, partly through the wide distribution of their work, produced many of the iconic images of the destruction and carnage of the day. (In fact, soon after, Giuliani declared photography and filming at the site a criminal offence.) The cumulative effect of this visual record is numbing in its repetitiveness, a trauma aesthetic that tends to deny the claim to authenticity that Roland Barthes saw as the photographs' indexical claim to access the 'real'; if anything, they suffer from a surfeit of reality-effect. Earlier in 2002, Tate Britain exhibited 19th-century landscapes from the USA under the title 'American Sublime' and it is, surely, the Romantic Sublime, with its connotations of awe and terror, of the elemental engulfing the signifiers of human habitation, that generically defines much of the visual documentation of 9/11. High up on the list of the philosopher Edmund Burke's definitions of the 'Sublime' is 'Whatever is fitted in any sort to excite the ideas of pain or danger …'. Indeed, the composer Karlheinz Stockhausen was castigated for describing the event as 'Lucifer's masterpiece'.

The 'sublime' figures recurrently in the narratives of the New York art world's postwar ascendancy as it came to displace Paris as the dynamo for aesthetic modernity. For Barnet Newman, immersed in Jewish mysticism and the belief that the aesthetic always preceded the social, the sublime was the matter to be extracted from the chaos of the blank canvas and the infinite possibilities of form, and was the rightful inheritance of an America 'free from the weight of European culture' (1948). For Mark Rothko, nothing less than the 'infinite' would suffice – a claim that

made imperious demands upon the viewer. The aesthetic sublime re-emerged that September not only in much of the photographic documentation of the day's events, but also in an exhibition of Gerhard Richter's new paintings at the Marian Goodman gallery which opened just three days after the attack. Richter was himself a casualty of the post-strike evasive action: flying into New York for the preview his plane was diverted to Canada and he never made it to his own show, returning to Europe a few days after. Richter's 'abstractions' ('Abstraktes Bild') can be seen as the endgame of a reconciliatory metaphysics, arts disenchantment of the world. Even for as rigorous a critic as Benjamin Buchloh, these paintings approach the transcendental or, at least, provoke a meditation upon the possibility of its (pictorial) signification as an 'enactment of desire' (Buchloh, 2001). Last September, Richter's scuffed and occluded grey surfaces and veiled imagery coincidentally echoed the imagery from the World Trade Center, but stripped of its moral outrage. Earlier this year, the artist Hans Haacke was commissioned to design a poster. Adopting the standard size and format of street poster advertising, he removed two parallel rectangles from the white paper – voids that framed whatever lay beneath wherever it appeared across New York, a resignifying of absence as presence which absorbed the city's surfaces into the iconography of the missing towers. And *Time* magazine's 9/11 anniversary issue displayed the World Trade Center on its cover – a collage by Robert Rauschenberg of news photos recording the performative gestures of daily commemoration and flowers, overprinted with a ghostly image of the two towers.

The question of the validity of any aesthetic response to 9/11 applies equally to high and mass cultural forms. Maya Lin's Vietnam Memorial succeeds in transforming the aftermath of war and turning it into an act of revelation. Something insufferable, the legacy of mourning and loss, has become bearable by making the passage into a communal symbolism that, bearing the evidentiary trace of conflict – the names of the dead and missing – unites its audience as witness. The actual experience, warfare and its aftermath, is the point of departure – the space between sublimation and its source.

Another order of sublimation was evidenced immediately after the event with *The New York Times* speculating on how it might impact on everything from eating to dressing. For example, Clark Wolf, a New York restaurant consultant, predicted a drop in prices and an increase in comfort foods and family get-togethers, whereas, in fashion, competing opinions suggested either a shift to streamlined silhouettes with no frippery (in the words of one designer, 'You want to be able to move quickly, you want to feel ready to bolt …'), or a need to offer a diversion to everyday anxieties. Similarly, interior designer Victoria Hagan foresaw the showplace apartment being replaced by 'protective, cocoon-like shelters', a sentiment echoed in the advice to post-9/11 clubbers to look for evidence of increased surveillance and security. As Scott Santiano, manager of SPA, commented, 'clubgoers must feel safe to be sexual, to get loose …'

If these suggestions appear inadequate or offensive in their studied narcissism, we should recognize that it is the realm of the social that attests to the wounds of the traumatic event and maps the processes of internalization and adjustment to a

changed world. In this, Baudrillard was the first prophet of terror's disruption of the social order through identifying the effect of indiscriminate, but disastrous action against the anonymous mass. In a mocking reminder of the promotional advertising for the National Lottery, the message of terror from Gaza to Kabul, Belfast to Barcelona, London to New York, is 'It could be you'.

Notes

1 This reductive and oppositional mindset is specifically the condition of the current alliance between Christian fundamentalists and hardline Zionists who, since September 11th, construct their nationalist agenda along racialist lines, defining the threatening other as both Arab and Muslim.

2 Besides the overwhelming global superiority of American arms, the hegemons of the World Bank, the International Monetary Fund and the World Trade Organisation are combining in various ways to ensure that 4 percent of the planet's population consumes 40 percent of its resources, all of which amounts to a neo-imperial pursuit of national interests.

3 As the slide towards war with Iraq accelerates, opposition is growing in the US led by the campaign 'Not In Our Name' which recently took a page in *The New York Times* to assert a 'Pledge of Resistance'.

4 In 1992, Paul Wolfowitz was under-secretary for policy in Dick Cheney's Defense Department and presided over the drafting of a broad directive to the military – 'Defense Planning Guidance' – which argued that, with the demise of the Soviet Union as a credible superpower, the United States should ensure that no new rival emerge to challenge America's global supremacy. See Keller (2002) and Lieven (2002).

5 These quotations come from the press release issued by Max Protech gallery to accompany the exhibition, 'A New World Trade Center: Design Proposals', curated by Max Protech and Aaron Betsky, in collaboration with *Architectural Record* and *Architecture* magazines. The exhibition included sketches, renderings, statements and multi-media projections.

References

Buchloh, B. (2001) 'Archeology to Transcendence: A Random Dictionary for/on Gerhard Richter', exhibition catalogue, New York.

Keller, B. (2002) 'The Sunshine Warrior', *New York Times Magazine*, 22 September.

Lieven, A. (2002) 'The Push For War', *London Review of Books*, 3 October.

Meddeb, A. (2002) 'Islam and its Discontents: An Interview with Frank Berberich', *October 99*: 3–20.

Morris, J. (1998) *Manhattan' 45*. Baltimore, MD, Johns Hopkins University Press.

Solomon, A. (1967) *New York: The New Art Scene*. New York: Holt Rinehart & Winston.

Steedman, C. (2001) *Dust*. Manchester: Manchester University Press.

Virilio, P. (1997) *Open Sky*, trans. Julie Rose. London: Verso.

Žižek, S. (2001) *Welcome to the Desert of the Real*. New York: Wooster Press.

Further readings

The Architectural Edifice and the Phantoms of History, Mirjana Lozanovska, *space and culture*, 6(3), 2003.
Open Sky, Paul Virilio (London: Verso, 1997).

Related Internet links

Max Protech Gallery, World Trade Center exhibition: http://www.loc.gov/exhibits/911/911-maxprotech.html
Gerhard Richter at Mariam Goodman, 2001: http://mariangoodman.com/mg/nyc.html

<div align="center">

23

Caught by Images

Ernst van Alphen

</div>

Keywords

Holocaust
memory
history
ethics
representation
vision
Pierre Janet
narrative
trauma
Auschwitz
survivor literature

… except what I saw with my wide-open eyes.
 (*Tadeusz Borowski*, This Way for the Gas, Ladies and Gentlemen.)

A Vision that Does Not See

"Someday you be walking down the road and you hear something or see something going on. So clear. And you think it's you making it up. A thought picture. But no, it's when you bump into a rememory that belongs to somebody else" (36). Toni Morrison, in her novel *Beloved* (1987), here writes about the importance and reality of what she calls "rememories," and what students of the Holocaust call, with a contradictory term, "traumatic memories." The key word here is "pictures." In an interview, Morrison the writer insists on the visual quality of these images: "What makes it fiction is the nature of the imaginative act: my reliance on the image – on the remains – in addition to recollection, to yield up a kind of truth. By 'image,' of course, I don't mean 'symbol'; I simply mean 'picture' and the feelings that accompany the picture" ("Site of Memory," 1987, 111). It is my conviction that current interest in specifically visual art related to the Holocaust finds in these statements by Morrison its raison d'être: both its explanation and its theoretical justification. Morrison is a writer, not a visual artist. Yet she insists on the founding, grounding function of specifically visual images in the "re-membering," the healing activity of memory that present-day culture, facing the disappearance of the eyewitness, is struggling to articulate and implement. Paradoxically, it is most clearly and convincingly through creative written texts, commonly called "fiction," that this visuality and its truthfulness can be assessed. This assessment is necessary to come to terms with history – to "work it through." This chapter, then, is about the "'picture' and the feelings that accompany the picture."

Joan B., one of the Holocaust survivors whose testimony was videotaped by the Fortunoff Video Archive for Holocaust Testimonies at Yale University in New Haven, Conn., recounts the following. She worked in the kitchen of a labor camp. When one of the inmates was about to give birth, the camp commandant gave the order to boil water: "Boil water. But the water wasn't to help with the act of giving birth. He drowned the newborn baby in the boiling water." The appalled interviewer asks, "Did you see that?" "Oh, yes, I did," the witness imperturbably replies. "Did you say anything?" the dialogue continues. "No I didn't." Later Joan B. offers the following comment: "I had a friend ... who said that now when we are here, you have to look straight ahead as if we have [blinders] on like a race horse ... and become selfish. I just lived, looked, but I didn't feel a thing."[1]

Although Joan B. has seen what has happened to the newborn baby, her act of looking seems to involve no more than the recording of a visual impression. One of the epistemological implications of seeing, namely, apprehension, to discern mentally, to attain comprehension or grasp, seems to be lacking in her act of seeing. That which was visually distinguishable has been imprinted on her memory like an immutable photograph, but the traces of that visual imprint seem never to have been emotionally experienced, let alone worked through. She recounts an event that is no more than a visual recording. In her narration of it, the event seems not to have had any emotional or ethical dimensions.

Joan B.'s testimony is emblematic of the profound way in which the Holocaust has disrupted conventional notions of seeing in the visual domain in Western culture. Since the Enlightenment, observation of the visual world has enjoyed a privileged epistemological status: it is a precondition and guarantee of knowledge and understanding. Being an "eyewitness" automatically implies that one apprehends and comprehends the observed situation or event.

This link between seeing and comprehension, however, has been radically disrupted in the experiences of Holocaust victims.[2] And as Morrison aptly reminds us, thinking about such traumatic experiences also revivifies the memory of slavery. As I will argue, it is because of this disruption that "to see" and the description of visual imprints have such a central role in the testimonies of Holocaust survivors. But these eyewitnesses' testimonies of visual imprints concern events that cannot be processed in the same manner as those recounted in the eyewitness account in a police report. In Holocaust testimonies the visual functions more like the unmodified return of what happened instead of as a mode of access to or penetration into what happened and instead of being the raw material to be processed into understanding. Even after all this time, that first step has still not been made. Yet the image is there; it refuses to budge.

Perhaps it is because of this strong yet problematic nature of vision in the face of a disaster of the magnitude of the Holocaust that so much intense debate concentrates today on visual art that represents it. Films such as *La vita è bella* and, before it, *Schindler's List* are criticized in terms of the "authenticity" of the representation and blamed for lacking in that regard.[3] These films have been unfavorably compared with the classic *Shoa*, Claude Lanzmann's documentary film

recording testimonies of survivors. Lanzmann's witnesses were there: hence, their eyewitness accounts are authentic. They saw with their own eyes what happened, and the images are imprinted forever on their retinas. Begnini and Spielberg mocked this obsession with authentic vision by having the events represented by acting, the quintessential art of feigning, faking, cheating, and pretending. It is as if art itself is suspect in the face of the cultural need for authenticity.

Given how strongly vision has been bound up with truth and authenticity in the Western imaginary since the Renaissance, it comes as no surprise that the question of historical truth in the face of a truth that is unbearable is played out so strongly today in the domain of visual art.[4] An intense discussion is going on, as eyewitnesses become rarer and fiction is one of the few remaining options for keeping the memory of the events alive. Visual artists such as Christian Boltanski and Armando struggle to come up with strategies of representation that supplement the documentary mode that is no longer possible.[5] And whereas the thrust of their work is obsessively singular in this attempt, the term "authenticity" does not apply to it at all. And insofar as their work is primarily visual, a case might be made for the separation or distinction between the question of authenticity and vision per se.

But that distinction does not require surrendering the primacy of vision. Instead, my thesis will be that it might be productive to distinguish vision from its most obvious vehicle, the eye. The issue is more complex than such media essentialism as that privileging of the visual medium suggests. It is, in fact, twofold. First, vision does not automatically lead to "authentic" witnessing. For witnessing requires, in addition to seeing, accounting for what is seen, and the problem may be situated in that mediation or transmission. This problem of transmission occurs strongly in the face of traumatic experiences, and, as I will argue, it is not resolved unless language intervenes. Second, vision does not necessarily lead to representation. There are other modes of communicating – or not-being-able-to-communicate – vision, in whatever medium. The artists I mentioned, among many others, are involved in searching for such alternative modes. I propose first to probe the importance and modalities of vision itself in this context. That is to say, I will attempt to articulate what vision can mean, do, and achieve in the face of its most untenable confrontation, such as the one exemplified by Joan B.'s testimony. On the one hand, there is the visual imprint; on the other, the need to deal with it.

Visual Incapacitation

Tadeusz Borowski's *This Way for the Gas, Ladies and Gentlemen* (1976), acts out the dominant role of visual imprints in Holocaust "memories" in an impressive way.[6] I will take this collection of short stories as a starting point to assess the place of visuality, seeing, and visual incapacitation in the commemoration of the Holocaust. The short stories are inspired by Borowski's concentration camp experiences. But this does not mean that they can be read like first-person testimonies in which the experiences of the narrator are central. Nor do they read that way. The first person

in these stories identifies himself more like a reporter of a documentary: he recounts what happens around him. The order of the stories in the book is more or less chronological, although this order does not necessarily concern the chronological ordering of the life of the narrator. Rather, they are ordered according to the chronology of the generic event of "the camp." Thus, the first story deals with arrivals in the camp, those that follow describe life in the camp, then we are told about the liberation. The last three stories, "The January Offensive," "A Visit," and "The World of Stone," recount life after having survived the Holocaust.

Given the inevitably retrospective nature of such accounts, the moment of narration in a Holocaust testimony is by definition situated after the liberation. That is why in the case of *This Way for the Gas*, the last stories possess an essential relevance for the meaning of testimony as such. It is only in these stories that the narrated events are clearly distinguished from the narration of the events: the narration takes place after the liberation. In the stories set during life in the camp, in contrast, the often-used present tense, but also the typically narrative past tense, describe moments of narration that could, in a fictional mode, be cotemporaneous with the events.

"A Visit" begins as if it tells about life from within the camp: "I was walking through the night, the fifth in line. An orange flame from the burning bodies flickered in the center of the purple sky" (174). The first-person narrator then discusses explicitly the impossibility of relating his feelings or self-experience. He presents himself as a kind of machine that could only record what he saw: "In the soft darkness, I held my eyes open wide. And although the fever in my bleeding thigh was spreading throughout my entire body, becoming more and more painful with every step I took, I can remember nothing about that night except what I saw with my wide-open eyes" (174). The leitmotif of the visual act, of "what the first-person narrator saw" emphatically structures most of the following text, thus qualifying the nature of that act itself:

> In the days that followed I saw men weep while working with the pickaxe, the spade, in the trucks. I saw them carry heavy rails, sacks of cement, slabs of concrete; I saw them carefully level the earth, dig dirt out of ditches, build barracks, watch-towers and crematoria. I saw them consumed by eczema, phlegmon, typhoid fever, and I saw them dying of hunger. And I saw others who amassed fortunes in diamonds, watches and gold and buried them safely in the ground. ... And I have seen women who carried heavy logs, pushed carts and wheelbarrows and built dams across ponds. ... And I also saw a girl (who had once been mine) covered with running sores and with her head shaven. (175)

This narrative act of recounting what he has seen is first legitimized by the narrator as a kind of moral obligation to those who died in the Holocaust. This is a recurrent *topos* in many Holocaust testimonies. It is also presented as a last act of relating – recounting as a way of establishing a relationship – that the dying requested, in their desperate attempt to stay related. For "every one of the people

who, because of eczema, phlegmon or typhoid fever, or simply because they were too emaciated, were taken to the gas chamber, begged the orderlies loading them into the crematorium trucks to remember what they saw. And to tell the truth about mankind to those who do not know it" (175). But gradually it becomes clear that the narrator does not tell what he has seen out of moral obligation. He simply cannot do anything else. It is still the only thing he sees, long after, even though historically the Holocaust belongs to the past.

It is only at the end of the story that it becomes clear that the story is told from the position of having survived the Holocaust. "I sit in someone else's room, among books that are not mine, and, as I write about the sky, and the men and women I have seen, I am troubled by one persistent thought – that I have never been able to look also at myself" (176). This impossibility implies that the narrator is unable to pay attention not only to what happened to him in the camp but also not to his life in the present, after the Holocaust, either. The two incapacities are, of course, causally linked, but the subject caught in its web cannot perceive causality. He can only see again what he has seen before. The substance of narration is the visual equivalent of a broken record. The record got stuck and the same images repeat themselves.

The images from the past are more vivid and intense than what he sees in the present. The impossibility of reintegrating himself in the present of post-Holocaust life is demonstrated in the last story. "The World of Stone": "In contrast to years gone by, when I observed the world with wide-open, astonished eyes, and walked along every street alert, like a young man on a parapet, I can now push through the liveliest crowd with total indifference and rub against hot female bodies without the slightest emotion" (178). And: "I climb unimpressed up the marble staircase, rescued from the fire and covered with a red carpet. ... I pay no attention to the newly installed windows and the freshly painted walls of the restored building. I enter with a casual air the modest but cozy little rooms occupied by people of importance" (179). The impossibility of the narrator's seeing the world around him after he survived the Holocaust forces us to reconsider the indication of time in the story "A Visit." At first sight time indications like "that night I saw ..." and "in the days that followed I saw ..." seem to refer to specific moments during the life in the camp. But they now have become ambiguous. They can also refer to specific moments after the narrator survived from the camp, moments in which he did not see anything other than these visual imprints from the past, more intense and immediate than the impressions in the present.

The distinctions made by Pierre Janet among habit memory, narrative memory, and traumatic memory can be helpful in further assessing the role of visual imprints in Holocaust testimonies.[7] Janet, a French psychiatrist who worked at the beginning of this century and who influenced Sigmund Freud, defines habit memory as the automatic integration of new information without much conscious attention to what is happening. Humans share with animals the capacity for this kind of automatic synthesis. Narrative memory, a uniquely human capacity, consists of mental constructs, which people use to make sense out of experience.

Current and familiar experiences are automatically assimilated or integrated into existing mental structures. But some events resist integration: "Frightening or novel experiences may not easily fit into existing cognitive schemes and either may be remembered with particular vividness or may totally resist integration" (Kolk and Hart 1995, 160). The memories of experiences that resist integration into existing meaning schemes are stored differently and are not available for retrieval under ordinary conditions. It is only for convenience's sake that Janet has called these unintegrable experiences "traumatic *memory*." In fact, trauma is fundamentally different from memory because "it becomes dissociated from conscious awareness and voluntary control" (160).

Trauma is failed experience, and this failure makes it impossible to remember the event voluntarily. This is why traumatic reenactments take the form of drama, not narrative. Drama just presents itself, or so it seems: narrative as a mode implies some sort of mastery by the narrator, or the focalisor. This is a fundamental difference that will be shown to define the role of vision in memories of the Holocaust. Because of their fundamentally dramatic nature, traumatic reenactments are dependent on the time frame of the "parts" scripted in the drama. In Bal's words: "All the manipulations performed by a narrator, who can expand and reduce, summarize, highlight, underscore, or minimize elements of the story at will, are inaccessible to the 'actor' who is bound to enact a drama that, although at some point in the past it happened to her, is not hers to master".

Although from a formal perspective Borowski's stories are narrative, not drama, the narration is overruled by the compulsive need to relate the traumatic reenactments of visual imprints. Or to put it differently: Borowski's narration loses control over what the narrator has recorded in the past. The logical coherence produced by narration fades away and we get a random sequence of descriptions of visual imprints. Within his narration Borowksi demonstrates and enacts trauma.

Janet's clinical distinction between narrative and traumatic memory ultimately concerns a difference in distance from the situation or event. A narrative memory is retrospective; it takes place after the event. A traumatic memory – or better, reenactment – does not know that distance from the event. The person who experiences a traumatic reenactment is still inside the event, present at it. This explains why these traumatic reenactments impose themselves as visual imprints. The original traumatic event has not yet been transformed into a mediated, distanced account. It reimposes itself in its visual and sensory directness.

Kinds of Memories

The writings of French Holocaust survivor Charlotte Delbo convey quite intensely this feeling that she is still inside the event that she relates.[8] In her stories she does not narrate "about" Auschwitz, but "from" it. It is first of all the visual directness of her narration that produces this effect. But from time to time she explicitly comments on the position from which she speaks. The words she gives to her character Mado

also account for her own writing: "People believe memories grow vague, are erased by time, since nothing endures against the passage of time. That's the difference; time does not pass over me, over us. It doesn't undo it. I am not alive. I died in Auschwitz but no one knows it" (267). "That's the difference": difference, as absolute as that between traumatic "memory" and narrative memory in Janet's theory, defines the importance and specific function of vision in Holocaust memories. Delbo tersely indicates that traumatic reenactments imply a different ordering of time. The traumatic event, which happened in the past, does not belong to a distanced past: it is still present in the present. In language, this would be the difference between the preterit or simple past, a narrative form that represents a punctual event that once happened and is now gone, and the imperfect, a form indicating an event whose effect continues in the present. In the rest of this chapter I will show how this ordering of time caused and implied by trauma brings with it a reliving of the traumatic event as intensely sensory and especially visual.

Delbo joined a resistance group in Paris. Her husband was also a member of that group. In March 1942 she and her husband were arrested by the French police in their apartment, where they were producing anti-German leaflets. The police turned them over to the Gestapo. Delbo's husband was executed in May. She herself was sent to Auschwitz in January 1943 at age thirty in a convoy of 230 French women, most of whom (like Delbo) were not Jewish but were involved in underground activities. Until January 1944 she stayed in Auschwitz and in the camp Raisko, not far from Auschwitz. Then she was sent to Ravensbruck. Near the end of the war she was released to the Red Cross, who moved her to Sweden to recover from malnutrition and ill health. Delbo has written many plays, essays, poems, and stories, all of them based on her camp experiences. Her most famous work is the trilogy *Auschwitz et après* (translated into English as *Auschwitz and After* [1996]). She wrote the first part of this trilogy, *None of Us Will Return*, as early as 1946, but published it only in 1965 (*Aucun de nous reviendra* [1970]). The second part, titled *Useless Knowledge* and also written immediately after the Liberation, appeared in 1970 (*Une connaissance inutile*), and the third part *The Measure of Our Days* (*Mesure de nos jours* [1971]) was published shortly after that.[9]

In her essays Delbo has made a distinction between "common memory" and "deep memory." This distinction is comparable to Janet's distinction between narrative memory and traumatic memory. Common memory is capable of situating Auschwitz within a chronological ordering. If a survivor can remember Auschwitz as integrated into a chronological ordering, the very act of survival has served as redemption from the terrible events. Auschwitz is now at a distance: it belongs to the past. "Deep memory," on the contrary, does not succeed in situating the events in the past, at a distance. Auschwitz still does not belong to the past in the experience of those survivors who remember in the mode of "deep memory."

Delbo makes another distinction that acknowledges yet another crucial aspect of trauma: the one between "external memory" and "sense memory." External memory is articulated in the distancing act of narration. The person who has external memories knows that her or she remembers. When Delbo narrates

"about" Auschwitz her words do not stem from deep memory but from common, external memory. The emotional and physical memory of Auschwitz is, in contrast, only approached by means of sense (deep) memory. The memory is not narrated; rather, it makes itself felt. This kind of memory is symptomatic for Auschwitz: it is not a mediated account but a leftover that makes its ongoing presence felt.

Being Inside the Event

In her narrative texts Delbo again and again lets external memories of events from the past slip into sense memories, which convey the events as taking place in the present. The text "Roll Call" in *None of Us Will Return* is a good example of such a slippage. The text starts out as a description of a unique event belonging to the past: "SS in black capes have walked past. They made a count" (22). The narrated event seems to concern an event that is circumscribed in time: it is not an arbitrary roll call but a specific one. The two short sentences are, however, followed by a third one: "We are waiting still." The past tense has been exchanged for the present tense; the progressive form of this third sentence is the linguistic marker of this exchange. The event, which is punctual, and hence delimited in time, has been transformed into an event that is durative, that is, which is ongoing in time and cannot be situated within a chronology.[10]

After this sentence eleven paragraphs follow, each consisting of a few (usually one) short sentences.

We are waiting.
For days, the next day.
Since the day before, the following day.
Since the middle of the night, today
We wait.
Day is breaking.
We await the day because one must wait for something.
One does not live in expectation of death. One expects it.
We have no expectations.
We expect what happens. Night because it follows day. Day because it follows night.
We await the end of the roll call. (22)

The transition from past tense to present tense and from punctual to durative event brings with it a transition in kinds of memory. The text, which begins as a narration of a memory that can be situated in a chronological past, slips into the narration of a situation that continues into the present.

This slippage into the present is accompanied by a change in the position of the narrating subject. The narrator of this eternal waiting is still "inside" the visual and sensorial experience of waiting that she describes. In the most physical way, the

sensorial experiences of this eternal waiting crawl upon the narrator and upon us, the readers. The memory of the infinity of waiting is not described "at a distance" but is brought about sensorially and visually.

A similar effect is solicited in the story "One Day," also in *None of Us Will Return*. It is again produced by a subtle shift in grammatical tense. The title evokes the conventional beginning of a chronologically ordered account. First we read three long paragraphs in the past tense. In these paragraphs the efforts of a totally exhausted woman to remain on her feet, that is, to stay alive, are described in great detail:

> She was clinging to the other side of the rope, her hands and feet grasping the snow-covered embankment. Her whole body was taut, her jaws tight, her neck with its dislocated cartilage straining, as were her muscles – what was left of them on her bones.
> Yet she strained in vain – the exertion of one pulling on an imaginary rope. (24)

The woman's struggle is focalized externally, from a distance. After some paragraphs, the description suddenly switches to the present tense: "She turns her head as if to measure the distance, looks upward. One can observe a growing bewilderment in her eyes, her hands, her convulsed face" (24).

As unexpected as this change in grammatical tense, another change takes place: external focalization is exchanged for character-bound focalization. The thoughts of the woman are directly quoted: "Why are all these women looking at me like this? Why are they here, lined up in close ranks, standing immobile? They look at me yet do not seem to see me. They cannot possibly see me, or they wouldn't stand there gaping. They'd help me climb up. Why don't you help me, you standing so close? Help me. Pull me up. Lean in my direction. Stretch out your hand. Oh, they don't make a move" (24–5). After this quotation of the woman's thoughts, the narration falls back into the past tense and the third person for a paragraph, and after that, a first-person narrator takes the place of the external narrator.

This time, however the first person is not the struggling woman but one of the crowd of witnessing women. These onlookers are like Joan B., unable to relate to what they see themselves, hence, unable to relate to the lone woman they are getting imprinted on their retina: "All of us were there, several thousand of us, standing in the snow since morning – this is what we call night. Since morning starts at three A.M. Dawn illuminated the snow that, until then, was the night's sole light – the cold grew bitter" (25). We read another page of the third-person narration of the dying woman. Then, the first-person narrator/witness returns: "I no longer look at her. I no longer wish to look. If only I could change my place in order not to see her. Not to see the dark holes of these eye sockets, these staring holes. What does she want to do? Reach the electrified barbed-wire fence? Why does she stare at us? Isn't she pointing at me? Imploring me? I turn away to look elsewhere. Elsewhere" (26). Looking elsewhere first takes on a spatial meaning: she looks at

another woman – a dancing female skeleton – in front of the gate of block 25. This object of the look is just a continuation of the sight of the dying woman she could not bear any longer. But then the "looking elsewhere" is transformed into a temporal displacement. The following sentence constitutes a paragraph in itself: "Presently I am writing this story in a café – it is turning into a story" (26). "Presently" (*maintenant*) marks a present, the moment at which the text is being narrated or written. The description of the woman's death struggle, however, also slips into the present: the past tense is again and again exchanged for the present tense. There seem to be two "presents," existing not after each other but next to each other.

The narrator's remark that her words are turning into a story seems to imply a negative judgment on her narration. When her words are forming a story the narrated events are situated at a distance, that is, in the past. Such a mode of narration does not do justice to her immediate and visual experience in the present of these events, which consists of nothing but witnessing.

The text that follows introduces an alternative mode of narration. With no indication of the changes, the narrative situation keeps transforming, even within a single paragraph. First-person narrators change in identity: the "I" who looks on and who witnesses transforms into an "I" who narrates a childhood experience: this "I" becomes the first person, who transforms into the dying woman:

> She no longer looks at us. She is huddling in the snow. His backbone arched. Flac is going to die – the first creature I ever saw die. Mama, Flac is at the garden gate, all hunched up. He's trembling. André says he's going to die.
>
> "I've got to get up on my feet to rise. I've got to walk. I've got to struggle still. Won't they help me? Why don't you help me all of you standing there with nothing to do."
>
> Mama, come quick, Flac is going to die.
>
> "I don't understand why they won't help me. They're dead. They look alive because they're standing up, leaning one against the other. They're dead. As for me. I don't want to die." (27)

Voices and temporalities intermingle and seem to merge: it is almost impossible to distinguish them from one another, to become part of a single present. This merging seems to be the narrative alternative for the witnessing women who cannot bear to see what they are watching. Although they are not able to relate to the dying woman (they are not in a position to do that), they absorb her into their self-experience. They and she become one.

When an SS man's dog finally kills the woman with a bite, a scream is heard: "And we do not stir, stuck in some kind of viscous substance which keeps us from making the slightest esture – as in a dream. The woman lets out a cry. A wrenched-out scream. A single scream tearing through the immobility of the plain. We do not know if the scream has been uttered by her or by us, whether it issued from her punctured throat, or from ours. I feel the dog's fangs in my throat. I scream.

I howl. Not a sound comes out of me. The silence of a dream" (28–9). The absolute distance that had until now defined the relation between the dying woman and the witnessing women has ultimately disappeared. The external memory in the past tense of a dying woman in the camp changes gradually into the sensorial experience of someone who is dying herself. The text we have read is by the end no longer the witnessing account of a specific event in the past. It has transformed into a direct experience in the flesh. When, in *Auschwitz*, the act of seeing has been fundamentally disrupted and, as a result, "to see" no longer implies relating to the object of the look – when seeing can still only mean witnessing – then a narrative solution is introduced to heal the insufferable condition of witnessing. Instead of seeing the other (focalizing her), the narrator becomes her by absorbing the woman's voice into hers.

The final paragraph of the story is a telling variation on the earlier reflection on the act of narrating this text. After a blank space, the following sentence ends the story: "And now I am sitting in a café, writing this text" (29). This writing no longer consists of producing a testimony of what has happened in the past. In a painstaking process, Delbo's writing transforms before our eyes into a performance that gives voice to the object of her look: to the woman who died in the camp while she just looked on. The present in which this writing takes place emphatically does not situate the represented events in relation to it. It is not continuous with it; it rather is a second present next to the present in which the text is being written. Since the end of the woman's death struggle is systematically written in the present tense, this other or second "present" has to be explicitly marked in order not to merge with it: "And *now* I am sitting in a café, writing this text."

Trauma and Aesthetics

The title of the second part of Delbo's trilogy, *Useless Knowledge*, can be read as an outspoken statement to the effect that the visual and sensorial imprints left by life in the camps should not be confused with the substance of memory. The story "The Stream" is an especially good example of this distinction. The Holocaust is ineffable, unnarratable because of the monotony of the days. There were barely any specific events. The text begins as follows:

> Strange, but I don't recall anything about that day. Nothing but the stream. Since all the days were the same, a monotony interrupted only by heavy penalties and roll calls, since the days were the same, we certainly had roll call, and, following roll call, work columns were formed, I must have been careful to stay in the same column as my group, and later, after a long wait, the column must have marched through the gate where the SS in the sentry box counted the ranks passing through. And after? Did the column go right or left? Right to the marshes, or left toward the demolition work, or the silos? How long did we walk? I have no idea. What work did we do? Neither do I recall that. (147)

While the narrator tries to recall a particular day – to represent it to her mind – she only remembers those things that recurred day after day. Nothing came to interrupt the repetition of the same.

The lack of markings in time can be sensed in the sentence that goes on and on. Just as the days were no longer separate units of time, Delbo's sentences espouse that sameness and continuity. Both are but a stream as formless as the stream in the marshes near which they were forced to dig. Now and then a comma marks a slowdown, but there is no full stop to mark the end of the sentence.

The narrator remembers only the stream. The memory of that stream has cast out all other impressions. But there are certain things that she can reconstitute: among them, how many women of her convoy were still alive on a particular day. The day of which she remembers only the stream must have been in early April, for it was sixty-seven days after their arrival in the camp. That day there were still seventy women of the group living. In the stream that is life in the camp, the only marked – the only remarkable – fact is the presence of the other women with whom she was taken to Auschwitz.

But there is a second reason why life in the camp cannot be remembered in narratable moments. And, like the strong visuality we have seen at work so far, this reason belongs to the domain of the senses. The stench in the camp was unbearable. The constant stench of the crematorium, the stench of one's own body and that of others, so many smells numbed one's senses, so that none could be specifically smelled:

> What amazes me, now that I think of it, is that the air was light, clear, but that one didn't smell anything. It must have been quite far from the crematoria. Or perhaps the wind was blowing in the opposite direction on that day. At any rate, we no longer smelled the odor of the crematoria. Yes, and what also amazes me is that there wasn't the slightest smell of spring in the air. Yet there were buds, grass, water, and all this must have had a smell. No, no memory of any odor. It's true that I can't recall my own smell when I lifted my dress. Which proves that our nostrils were besmirched with our own stink and could no longer smell anything. (149–50)

After this testimony to the death of the sense of smell, the narrator describes in great detail the moment of that one day when the kapo allowed her to wash in the stream. Yet the text ends with the sentence: "It must have happened like this, but I have no memory of it. I only recall the stream" (153).

This contradiction does not mean that the narrator invented what happened that one spring day. It means only that this day is part of her "external memory" of Auschwitz. Her deep or sense memory only sees, feels, smells the monotonous stream. It is this stream that defines life in Auschwitz and the only possible memory of it. Washing in the stream, that one event that stands out, is, in this sense, the one moment in which she could wash herself of the stream.

The existence of two kinds of Holocaust literature confirms Janet's psychiatric distinction between narrative and traumatic memory, as it confirms Delbo's

distinction between ordinary and deep memory and between external and sense memory. These two kinds of literature maintain a distinctive, defining relationship with visual images as either imprints or "relatable" images – capable of entering into a relationship as well as being narrated. Thus, we can conclude that visuality, the specific power of images, is definingly significant for the specific kind of memory that struggles to survive the Holocaust and remember it, yet transform the visual fixation that assaults into the active visual remembrance that works through.

Images confirm and further qualify a distinction made in an important article by Sidra DeKoven Ezrahi (1996). Ezrahi distinguishes two different ways of representing the Holocaust that reflect, in fact, two different aesthetics. Though I wish to differentiate these two kinds of literature in terms of their relationship to vision, they share a common point of departure, which is at the same time their point of arrival: Auschwitz is the ultimate point of reference. It is a spot or event with which imaginative representations correspond or fail to do so. Both writer and reader are constantly positioned in relation to this epicenter, this point of no return. But Auschwitz as epicenter of the earthquake that the Holocaust was in human history is both a literal and a metaphoric notion. Auschwitz, writes Ezrahi, has become the metaphor of the earthquake that destroyed not only people and buildings but also the "measure" through which destruction can be gauged (122).

This destruction of the ability to measure destruction results in Auschwitz's fundamental ambiguity as a historical site and event as well as a symbol: forever caught in the ambiguity of its signifying force, Auschwitz can never be more than a symbol of what can no longer be symbolized. For we have lost the measure to decide of what Auschwitz is a symbol. In this sense, too, Auschwitz, and the Holocaust for which it synecdochically stands, cannot be represented. For the metaphorical principles of language have ceased to function. As a metaphor, /Auschwitz/ is overdetermined: "it" is so rich in meaning that nothing can be metaphorically compared to it. At the same time, /Auschwitz/ is underdetermined as a metaphor because it has no precise, measurable meaning. As an "empty" metaphor, it cannot illuminate new or unexpected aspects of human existence, as metaphors are called on to do.

Ezrahi then proceeds to distinguish between two possible attitudes toward this paradoxical status of Auschwitz – as reference point of a metaphor that is both over- and underdetermined. One can adopt either a static or a dynamic attitude. The static or absolute attitude places the subject in front of a historical reality that is unbending and from which we can never be liberated. The dynamic attitude approaches the representation of the memory of Auschwitz as a construction made up of strategies deployed in order to come to terms with this historical reality, over and over again (122). This dynamic attitude implies, for example, that the unbudging reality of this past can sometimes be made livable by the deployment of certain conventions to represent the past. Such softening cannot be acceptable within the absolute attitude. For when a softening or even a curing emerges within

the memory or representation of Auschwitz, the threatened relativization of the ultimate evil that happened there threatens Auschwitz's status as the ultimate point of reference of that evil.

It is here that Delbo's use of visuality can be of help. As in the case of Janet's distinction between narrative and traumatic memory, the issue is the distance that can be achieved from Auschwitz. The absolute attitude maintains that any distance is ethically unacceptable – indeed, cognitively impossible. Auschwitz is a historical reality that continues in the present; in grammatical terms, it is the agent of a progressive form. The dynamic attitude is continuous with narrative memory, whereas the absolute attitude appears to be the consequence of traumatic memory. As it happens, Ezrahi cites Borowski's use of the present tense as an example. Borowski writes that "all of us walk around naked," implying that in post-Holocaust times we can only walk around naked. The ordering of temporality in his work is the temporality of trauma in which the past is like a second present, continuously determining the present.

According to Ezrahi, Primo Levi writes about his experiences in Auschwitz from a totally different position. His mission is to testify to the events that he experienced in the past. He communicates something that is over and belongs to the past. Thanks to that it can be narrated by means of conventional modes. This is why Levi can write in such a clear and accessible style. He does not have to struggle with a past that persists in the present in which he writes. For him, Auschwitz is an event delimited in history.

It is important to emphasize that Ezrahi's claims about Borowski and Levi are not psychological conclusions about the feelings of these authors. Her conclusions concern the position in time from which they write in relation to the time they write about. They are conclusions about different kinds of narration. From this perspective she even goes so far as to make a distinction between Levi's suicide and those of Borowski and the poet Celan. According to her, Levi's suicide was not "caused" by Auschwitz because when he killed himself Auschwitz belonged for him to the past. It must have been something arbitrary that made him do it. The suicides of Borowski and Celan, however, were direct consequences of Auschwitz. Although they survived, they still lived "inside" the Holocaust after their survival. Until their suicides, they remained "forever trapped within the electrified barbed wire" (125).

Ezrahi's analysis can help us understand the specific role of visuality. For it helps to characterize Delbo's writings as analyses of visuality as memory sense. Delbo's writings are exemplary for the aesthetic that Ezrahi has called "the static attitude towards the events." This attitude makes itself felt by the extreme visuality of the Holocaust past: it is so visual and direct that this past is experienced as present. Her character Mado's descriptions of her memories of the other inmates in the camp in *The Measure of Our Days* do not show any distance in time. She sees the other inmates and joins them. "I'm not alive. I'm imprisoned in memories and repetitions. I sleep badly but insomnia does not weigh on

me. At night I have the right not to be alive. I have the right not to pretend. I join the others then. I am among them, one of them. Like me they're dumb and destitute. I don't believe in life after death, I don't believe they exist in a beyond where I join them at night. No, I see them again in their agony, as they were before dying, as they remained with me" (261). In this passage, Delbo emphatically distances herself from the idea that her visions are dreams or hallucinations of a life beyond. Her visions are her memories. They are just as visual as dreams are.

But here, a tragic irony appears. Past and present change places. Whereas memories of the past appear to her as radically visual, her sensorial awareness of life after Auschwitz is veiled. There is something in between the present and her access to it. She cannot really, clearly, see that present.

Sight is, in fact, what distinguishes two radically different types of beings – those who have not, from those who have, worked through history. The difference is attached to vision. She describes her and her husband's different conditions of being in the present as two different kinds of sight. "For him, I'm there, active, orderly, present. He's wrong. I'm lying to him. I'm not present. Had he been deported too it would have been easier, I think. He'd see the veil over the pupils of my eyes. Would we then have talked together like two sightless people, each possessing the inner knowledge of the other?" (267). Whereas her sight of the past is bright, her sight of the present is veiled. Life in the present is literally overshadowed by the persistence of the visual and sensorial directness of when the Holocaust events happened to her in the past. Thus, the most crucial perversion the Holocaust wrought consists of blinding and sharpening sight but in inverse proportion to what makes life livable. Past horror occupies the eye, blinding it to a present that can therefore not redeem, not erase, and not facilitate forgetting.

In the tradition of Western science and art, visuality has been the domain of both truth-in a positivist epistemology of observation-and imagination-as in visual art that "presents before our eyes" what is to be seen as possessing meaning, beauty, or tragedy. This is paradoxical. The paradox is reinforced when we realize that a third domain invoked through thinking about vision is that of affect, both in sentimental and in – to cite an example that seems utterly out of place here – pornographic terms. With Delbo's probing of a vision that does not see as an image of a memory that cannot relate, a past vision whose present makes the present invisible, we understand the different possibilities of vision better. If we wish to understand the modalities of memorializing the Holocaust, as we must if we wish to prevent the past from recurring by its hallucinatory power over us, we must distinguish between different kinds of vision, different kinds of looking. It may be perverse, but then it may be for that reason only too appropriate, to invoke verbal memories written down by those who were there, to understand how it is that art, today, can work over, elaborate, work through, and keep in visual touch with a past that no image can represent.

Notes

1 Lawrence Langer also discusses this video taped testimony in his 1991 book *Holocaust Testimonies: The Ruins of Memory*. (New Haven, CT: Yale University Press), 123.

2 For an extensive analysis of why Holocaust experiences have disrupted the ability to remember, see my book *Caught by History: Holocaust Effects in Contemporary Art, Literature and Theory* (1997, Stanford: Stanford University Press), esp. ch. 2, "Testimonies and the Limits of Representation."

3 See for instance Sander Gilman's essay on Benigni's film (2000) "Is Life Beautiful? Can the Sheah Be Funny? Some Thoughts on Recent and Older Films," *Critical Inquiry*, 26(2), 279–308.

4 Shakespeare's *Lucrece* is entirely structured around the opposition between vision as "true" and language as a fallen state of man, in which deception is the order of the day. But already there, the opposition falls apart. And so it does today. For a discussion of Shakespeare's *Lucrece* in these terms, see Mieke Bal's "The Story of W," in her *Double Exposures* (1996, New York: Routledge)

5 For a more extensive discussion of Armando's work, see my book *Armando : Shaping Memory* (2000, Rotterdam, NA: Publishers)

6 These originally Polish texts have since 1976 been available in English under the title *This Way for the Gas, Ladies and Gentlemen* (London: Cape).

7 For a discussion of Janet's ideas, see Bessel A. van der Kolk and Onno van der Hart, "The Intrusive Past: The Flexibility of Memory and the Engraving of Trauma," in C. Caruth (ed.) (1995) *Trauma: Explorations in Memory* (Baltimore: Johns Hoplains University Press, 158–82).

8 Charlotte Delbo, *Auschwitz et après*. (Paris, Les Éditions de Minuit) This trilogy consists of *Aucun de nous reviendra* (1965), *Une connaisance inutile* (1970) and *Mesure de nos jours* (1971). The trilogy has been translated into English by Rosette C. Lamont as *Auschwitz and After*, with an introduction by Lawrence Langer (New Haven, CT: Yale University Press, 1995). Quotations in the text are from this edition.

9 For a more extensive account of Delbo's life, see the introduction by Lawrence Langer to the English translation of her triology *Auschwitz and After*.

10 For the distinction between punctual and durative events, see Bal, *Narratology: Introduction to the Theory of Narrative* (Toronto: University of Toronto Press, 1997, 93).

Reference

Ezrahi, S. D. "Representing Auschwitz." *History and Memory*, 7(2), 1996: 121–54.

Further readings

Is Life Beautiful? Can the Shoah Be Funny? Some Thoughts on Recent and Older Films
Sander L. Gilman, *Critical Inquiry*, 26(2), 2000.
Pathologising Memory: From the Holocaust to the Intifada, Yosefa Loshitzky, *Third Text*, 20(3–4), 2006.

Related Internet links

Arrivals, Departures, Charlotte Delbo: http://www.pbs.org/auschwitz/learning/guides
Fortunoff Video Archive for Holocaust Testimonies: http://www.library.yale.edu/testimonies/

24

Political Literacy and Voice

Joy James

Keywords

New Orleans
black Americans
Hurricane Katrina
literacy
media images
resistance
government
 neglect
history
Jim Crow
Emmett Till
radical activism
teaching

We do not believe that the American people who have encouraged such scenes by their indifference will read unmoved these accounts of brutality, injustice and oppression. We do not believe that the moral conscience of the nation – that which is highest and best among us – will always remain silent in face of such outrages.

(Ida B. Wells, "Mob Rule in New Orleans," 1900[1])

Read Three Images

A *Monthly Review* photograph of a tank with armed soldiers – actually members of the State Police Tactical Unit who with their assault weapons pointed down or slightly up just look like armed soldiers – patrolling the streets of New Orleans while black residents outside a shelter of "last resort" call out for help.[2]

A Reuters photograph of uniformed white men disciplining black men sprawled face down on dry concrete; the white men patting down and surveying the black men, who've been stopped in their efforts to flee catastrophe (marked as carjackers?); one officer positioning a foot inside the door of the postal vehicle he has just rescued. The caption reads: "Texas game wardens watch over people who were caught using a mail truck to try to escape New Orleans. They were freed but forced to continue on foot."

The image of a white couple wading through water with groceries juxtaposed with the image of a young black man wading through water with groceries – their respective captions identifying the white couple as "searching" for food and the black man "looting" for his.

Speak Three Words: Shoot to Kill

Redundant death or overkill is mapped onto black New Orleans so strongly that most are silenced or speak feeble responses to the realities of institutional abandonment, neglect, paternal contempt and caretaking, and state and social violence before and after Katrina landed. Witness those who walk in and through a city turned urban graveyard – first moving and floating, then drying in mire – struggling to gain a foothold, and to voice a literacy that counters denials and executioners' commands levied against those "left to die." (Survivors wrote on a chalkboard in St. Mary's middle school, where they sought refuge from the waters flooding the Ninth Ward, "They left us here to die.") Challenging silence on the state's responsibility for death and social instability, *What Lies Beneath: Katrina, Race, and the State of the Nation* creates space for vocal, politically literate voices.

The images and language of post-Katrina New Orleans, like that of post-9/11 United States, inspire new voices, such as those presented in this anthology, and an infusion of radicalism into common sense or everyday politics to promote literacy relevant to crises where deadly domestic and foreign policies increasingly intersect (a quarter of the Louisiana National Guard was absent from relief efforts due to deployment in Iraq, where over 600 000 Iraqis, according to a Johns Hopkins study, and approximately 3000 US citizens have died since the US invasion). This volume provides us with a grammar book shaped by previous battles for justice, love, and safety for self and community. The voices represented here, whether native New Orleanians or not, build a foundation to resist dehumanization, and so as part of the "voices of Katrina," echo historical narratives that frame and shape the meanings of current trauma, dislocation, and death.

Litany for Survival

Months before I traveled to New Orleans, searching for a "litany for survival," I reached for Ida B. Wells's writings on lynching and police brutality, assigning "Mob Rule in New Orleans" to my students as a grammar book on antiblack racism and social and state violence. Vilifying and policing, containing and punishing black bodies seemed more important to state officials than saving black lives in the days and weeks during which state officials and media sought to interpret and assign blame for human loss and man-made or compounded disaster following Katrina. That the state placed abandoned survivors under a shoot-to-kill edict to criminalize their right to survival left some of us momentarily speechless, and required more political literacy and critical voice than that readily available through the language of conventional politics.

As Governor Kathleen Babineaux Blanco and President George W. Bush drew a bulls-eye target around largely black survivors we had witnessed trying to survive – and some failing and so dying – without assistance from a state to which they swore some allegiance or belonging ("we're American, too"), words drew me

and destabilized me until I realized that I had to translate my disgust and distress into political literacy. It was not human suffering per se, but suffering accompanied by repression embedded in the injunction of death for the resourceful who didn't want to roll or rot in misery that radicalized me into seeking more voice.

Literacy transports us into politics. Not always coherent or seamless, radical literacy is at least alive to possibilities for change and social transformation, possibilities for resistance. Resistance may start in crisis. If you reach a point where the state, by its own rhetoric, promises to use lethal force against responsible people who are trying to prevent their children, themselves, or others from prematurely dying or needlessly suffering, then you're at a crossroads. Here, the moment of crisis is compounded by the government, so that it seems logical to suggest, given the "shoot-to-kill" decrees, that good or competent (black) parents and community-minded survivors secure bulletproof vests before seeking ("looting") bottled water, baby formula, and pampers; or before taking vehicles to flee danger; or, having been stripped of technology at gunpoint by game wardens from an adjoining state, before attempting to cross bridges on foot into surrounding parishes – only to be turned away at gunpoint by state officials. In the continuity of blacks in crisis amid the discontinuity of ecological and manufactured disaster crises, will it matter if we are called "Americans" rather than "refugees"? When and where is nation-state membership a passport that possesses tangible value in terms of mobility and survivability, a value that state and civil society must respect for bodies first and foremost recognized as black and impoverished rather than *human*? And who or what can demand, maintain, and enforce that respect when it has been denied?

Struck by and drawn to the voices of historical black mothers trying to keep their children alive and healthy in earlier eras, I hear the continuity of contempt for black humanity amid the discontinuity of epochal disaster and warfare and the continuity of resistance. In Ida B. Wells and Mamie Till-Mobley, a literacy and voice encourage hope and struggle for viability and independence despite institutions that promote premature death and misery through neglect and punishment. Ancestral voices are able to give a literacy that comprehends death edicts coded as law-and-order mandates to be something other than isolated phenomena. The voices of past radicals provide a legibility that enables us to read and then act against the mapping of oppression onto our everyday and extraordinary realities.

State-sanctioned death and dying, overkill for the black frame, have historically been features of US official and unofficial policies towards racially fashioned subjects, the stated or understated enemies to be contained at home and abroad. Policing rhetoric and practices include the visceral: scarred black civilian bodies from the murderous force used in the Danzinger Bridge tragedy, in which police engaged in a shooting spree of innocents as they sought snipers; self-deputized posses, white citizens grinning as they describe to Spike Lee, on tape, their stockpiled weapons for shooting (black) people in order to protect their property (Lee questions, after hearing the gun inventory, if the homeowners are hunting for Bin Laden).

We have heard and seen this before, hence the familiarity to some. Centuries-old grammar books of resistance document the hunter and the prey. Yet when I

traveled to New Orleans, I was floored to see the new forms of policing and containment, despite the historical memory and meaning of earlier activists and writers that shaped my ability to read and speak.

Southern Horrors

When Howard, a former member of the New York City chapter of the Black Panther Party, drove me through the Lower Ninth Ward in March 2006, I saw how 21st-century traumas evoke 19th-century terrors. In the Lower Ninth, post-Reconstruction lynching described in *Southern Horrors* resurfaces. Here, though, only clothes flutter in tree limbs.[3] Here, the dead haven't left bodies behind, to be cut down and buried, to shock the living into mourning. Here is just the suggestion of departed frames, in shirtsleeves and pants legs swaying in breezes or hanging limply from branches, clothing not retrieved months or years after they rooted in the trees of the Lower Ninth. Can there be lynching without a formalized lynch party? Is Billie Holiday's "strange fruit" the predictable harvest from an apartheid city-state left with paltry resources, whose impoverished and outcast have been left to die?

Survivors straggle back by any means necessary to a beloved city, where the majority outside of institutional power never traveled from home, to counter the narrative that they were strung up and are dispossessed. They may read not only a history of repression and resistance into themselves (recalling when levees were "blown up" in earlier eras) but themselves into history (as black New Orleans registers as one of the eviscerating moments of recognition – a fast-forward blur of shared identities through slave codes mutating into black codes and Jim Crow, lynching, the convict prison lease system and current prison mandates) – the historical legacy of black expendability amid racial, economic, and political exclusion.

In March, when Howard pointed out that the exterior walls of homes, propped up on or pushed off of their foundations, had been turned into tombstones by police agencies, funeral markers in the absence of funerals, I had to read again. *Not the absence of agency, agency existed: people were resourceful, found their loved ones, tended the traumatized, buried the dead, worked to rebuild lives and communities.* Radical literacy is not a victim narrative or a mere lamentation; so what was underneath what the police had written on the walls?

I read policing mechanisms that sought to destabilize black agency and autonomy, while constructing graveyards to serve as a staging ground for real estate emptied of "undesirables." So, the NOPD (New Orleans Police Department), the TFW (Texas, Fish and Wildlife), the National Guard, and others spray-painted an acronym, the alleged date of entry into the building, the number of those found alive, the number of dead bodies retrieved, and then encased their quartered codes with a circle to be read clockwise. The deeper we drove into the Ninth, the more painted funeral markers, absent funerals that dignified death, and the longer the

wait time before "help" came. The waters came in August 2005, but the state did not, at least for the Ninth Ward. While Howard drove slowly through neighborhoods, I began to see entry dates for the 9th, the 10th, then the 12th months of that year. Mourners from the Ninth Ward would say later that the colorful police tags and graffiti were part truth and part fiction: Police claimed to check homes that they never entered, as unfortunate relatives later discovered when they found unrecognizable corpses.

If the state waits until months after the waters recede, why (claim to) enter at all? Is this a performance of accountability and care? Surely the pretense of rescue takes place on stage, while the concreteness of relief is tossed to private charities or outraged activists and compassionate individuals or resilient people who claim New Orleans as their own: birthplace, hometown, future. The "rescue" or abandonment of the living and/or the remains of those who met or failed to meet the tests are determined by federal, state, and local entities (tests included makeshift levees, tepid warning systems, early non-mandatory evacuation orders, denial of public transportation out of a flood zone and disaster area, and the militarization of humanitarian relief and social stability).

Perhaps in the private graveyards of homes, or the larger graveyards of the most disenfranchised sector of the city, state officials and employees opted for a "closed casket" approach to human suffering – to not witness or at least claim to have not witnessed. In doing so, public servants repeatedly failed their own test, as well as the test for political loyalty and allegiance they demanded from the literate, despite our varied ideologies, and the illiterate (such failures, at home and abroad, have an impact on national elections).

Half a century after Wells wrote her liberation manifesto, and half a century before we began writing what we discerned was "underneath" Katrina, Till-Mobley had an open casket funeral for her son Emmett. She did so for a reason. Defying the injunction by Mississippi police to keep the coffin sealed, and their lining it with lye to hasten the disappearance of the returning teen – defying even the black mortician, who, against her wishes not to alter the face of a mutilated boy, stitched his mouth closed and removed his severed eyes from the sockets – she made him reappear as political and personal trauma. Miss Till-Mobley placed her son on display and dared the world to punish her for publicly mourning and raging against this assault. If we could watch this – rage and grief turning devoted mother momentarily into outlaw (and later into an icon for national embrace), then we could witness, and participate in, the start of a freedom movement. Months before Miss Rosa sat down, Emmett floated, and then putrid and floating was reclaimed, and resurrected, some say through a mother's love turned to hate, to galvanize a movement when thousands attended his funeral in Chicago and tens of thousands witnessed him in his casket in the black press.

Perhaps we have been able to look in the casket to see the alien, and wonder why it looks so familiar, so close, despite the nonhuman and terrifying appearance. Some imagine that that mutilated boy's body was and is part of our legacy, our vulnerability, a sign of ancestors, living kin and community, and future born. As well, some

pass on that literacy, become the kind of parent or communicator that would bring a child before an open casket and hold their hand while saying "look" – and look with them. To translate trauma into educational development seems a necessity for those designated to social death by dominant elites and political economies and granted a privileged place for premature physical death from governments that neither protect nor serve. To look into a city turned coffin and see more than police or social/drug violence, dysfunctional governments using incompetence to excuse elites of complicity in violent and premature death for disenfranchised communities, is an act of political literacy.[4]

Look into the casket, as the *Jet* photographer did fifty years ago, and then turn trauma (by proxy) into hope and a massive struggle and fight for life and a dignified death. Political literacy and voice require that we look and act. Those floating in waters have voices amplified in an echo chamber built by imperial policies and our own social failings. What is heard is not only disregard for human life, and the proclivity for grave digging, but resistance.

Our Ground Zero

When Kim encourages me to visit New Orleans during spring break in 2006, he tells me early on that New Orleans is "our ground zero." I take my class and watch it disintegrate as I become ill from environmental toxins in the Ninth Ward and shift my attention between the few students who planned to work and contribute and the majority who seek spectacle to acquire the trophies of trauma tourism. Fight trauma tourism, make mistakes, and realize that you can fly over or touch down (as evident in varied arrays of photo opportunities); and that a class is a microcosmic reflection of a campus, a community, and general society. What is different from fly-over or drop-in trauma tourism, and inept organizing and political factionalism on the ground (which harbor their own forms of narcissism) is to recognize humanity as we witness suffering (our own and others) and recognize that underneath spectacle is a spark where empathy and compassion – not sympathy and charity – function as precursors for radical activism. Which might explain why deep emotions, so difficult to come by and sustain, have a value that exceeds words, even those of transformative literacy.

Notes

1 Ida B. Wells, *Southern Horrors and Other Writings: The Anti-Lynching Campaign of Ida B. Wells, 1892–1900*, ed. Jacqueline Jones Royster (Boston: Bedford Press, 1997), 160.

2 Robert Caldwell, "New Orleans: The Making of an Urban Catastrophe," *MR Zine*, December 9, 2005, http://mrzine.monthlyreview.org/caldwell120905.html.

3 Wells, *Southern Horrors*.

4 There are always counter-narratives seeking to undermine or question literacy: claims to non-racism as an acquisition that absolves rather than attachments to justice through antiracism as labor against racial supremacy and its genocidal logic. Secretaries of state Condoleezza Rice and Colin Powell, copresidents Bush and Dick Cheney inform

that the president and government care about (black) people. Reassurances fail as public officials publicly wish for urban ethnic cleansing, fund forced relocation programs, and dispersals turn into disappearance and the denial of the right to return.

The pre-flood time of a black city marked by impoverishment, disenfranchisement, neglect, corruption, police brutality, and social violence, as well as the commoditization of black culture for consumers, has been noted by activists and scholars. During the flood period, print and electronic media documented the national indifference or aversion toward environmental restoration of wetlands,

funding for levees that do not buckle, the incompetence or hostility of federal agencies and relief organizations such as the Army Corps of Engineers, Federal Emergency Management Agency, and the Red Cross. In the post-flood phase, struggles focus on the right of return for the under-resourced and largely black communities, that is, for the right of children to return with their parents, for partners and families to be reunited. To have homes in adequate and safe infrastructures and healthy environments requires massive material support as well as counseling for post-trauma grief and rage. At the same time, many in the United States desire nothing more than political amnesia.

Further readings

The Obscurity of Black Suffering, Jared Sexton, in, *What Lies Beneath: Katrina, Race, and the State of the Nation* (Cambridge, MA: South End Press, 2007).
New Orleans and the Wisdom of Lived Space, Timothy Gibson, *Space and culture*, 9(1), 2006.

Related Internet links

Media Awareness Network web site on Hurricane Katrina: http://www.media-awareness.ca/english/resources/educational/teachable_moments/katrina_2_photo.cfm
Mamie Till-Mobley, American Experience, NPR: http://www.pbs.org/wgbh/amex/till/peopleevents/p_parents.html
Trouble the Water, Spike Lee: http://www.troublethewater film.com/

Index

Note: page numbers in italics denote illustrations when separated from the textual reference

Global Visual Cultures: An Anthology, First Edition. Edited by Zoya Kocur.
© 2011 Blackwell Publishing Ltd except for editorial material and organization © Zoya Kocur. Published 2011 by Blackwell Publishing Ltd.